Education Feminism

Education Feminism

Classic and Contemporary Readings

Edited by

Barbara J. Thayer-Bacon

Lynda Stone

Katharine M. Sprecher

Published by State University of New York Press, Albany

For information, contact State University of New York Press, Albany, NY
www.sunypress.edu

Production by Eileen Nizer
Marketing by Anne Valentine

Library of Congress Cataloging-in-Publication Data

Education feminism : classic and contemporary readings / edited by Barbara J. Thayer-Bacon,
 Lynda Stone, and Katharine M. Sprecher.
 pages cm
 Includes bibliographical references and index.
 ISBN 978-1-4384-4895-4 (hardcover : alk. paper)
 ISBN 978-1-4384-4896-1 (pbk. : alk. paper)
 1. Feminism and education. 2. Women—Education. 3. Minority women—Education. 4. Sexism
in education. I. Thayer-Bacon, Barbara J., 1953– editor of compilation. II. Stone, Lynda, editor of
compilation. III. Sprecher, Katharine M., editor of compilation.

LC197.C53 2013
370.82—dc23 2013000113

10 9 8 7 6 5 4 3 2 1

For the Contributors and our Students

Contents

CLASSICS

I. EDUCATION AND SCHOOLING

II. Teaching and Pedagogy

CONTEMPORARY

I. Education and Schooling

II. Teaching and Pedagogy

Acknowledgments

No project as big as a classics and contemporary collection of work is without many people to thank for their contributions and support. We refer the readers to Lynda Stone's original acknowledgments page for her thank you's. Here, we must thank Lynda for her encouragement and support in helping to see the book republished. It is great to see all this feminist scholarship in print, and it would not have been possible without Lynda's cheering us on. The book has been a labor of love for the three of us, but Thayer-Bacon's research assistant, Tracia Cloud, helped it along in its final stages. Tracia was tenacious in tracking down the straggler copyright permissions and helping us negotiate for reduced rates. She also collected all the pdf copies of essays for us. There are many institutions we must thank for making the authors' work available at no charge, in particular the Philosophy of Education Society, Caddo Gap Press, the *Journal of Education*, the *Harvard Education Review*, and The University of Massachusetts Press. Other institutions offered us copyright permission at a much reduced rate: The University of Chicago Press, Springer Netherlands, Sage, and Taylor & Francis. The *Journal of Education, Journal of Negro Education,* and *Human Kinetics* offered us a half rate that made the cost doable. And, both the University of Akron, in particular Sharon Kruse, department head of Educational Foundations and Leadership, and the Department of Educational Studies at University of British Columbia helped to pay for their faculty copyright costs as the discounted amount offered by Wiley-Blackwell was still beyond our means. We are troubled by the loss of important essays we were not able to include due to prohibitive copyright costs, and now recognize this is an issue scholars in our fields of study need to address. Scholarship that is only under the control of for-profit businesses is becoming prohibitive to reprint, thus limiting its availability. Limiting access harms the continuing development of the scholarship. We thank our own institutions, the University of Tennessee, Knoxville, in particular Steve McCallum, department head of Educational Psychology and Counseling, and the University of North Carolina, Chapel Hill for their support of our research efforts. We want to thank Catherine Bernard, senior publisher at Routledge, for while she not able to help us reissue the book with the original publisher, she did release the book and encourage us to submit it elsewhere. Our deepest gratitude belongs to Beth Bouloukos at SUNY Press for enthusiastically embracing the book and helping us see it to completion. We are grateful for the staff at SUNY Press and the work they did on our behalf.

Notes to the Text

Classics Selections

Arnot, Madeleine, "Male Hegemony, Social Class and Women's Education," *Journal of Education*, 164 (1) (1982): 64–89. Reprinted by permission of the Editorial Board, *Journal of Education*, Boston University, School of Education.

Martin, Jane Roland, "Excluding Women from the Educational Realm," *Harvard Educational Review*, 52(2): 133–148. Copyright © 1982 by the President and the Fellows of Harvard College. All rights reserved. Reprinted by permission of the publisher.

Dill, Bonnie Thornton, "Race, Class, and Gender: Prospects for an All-Inclusive Sisterhood." This article is reprinted from *Feminist Studies*, 9(1) (1983): 130–150, by permission of the publisher, *Feminist Studies* Inc., c/o Women's Studies Program, University of Maryland, College Park, MD 20742.

Zambrana, Ruth Enid, "Toward Understanding the Educational Trajectory and Socialization of Latina Women," *The Broken Web: The Educational Experience of Hispanic American Women*, eds. Teresa McKenna and Flora Ida Ortiz, pp. 61–77. Reprinted by permission of the publisher, copyright © 1988 by The Tomás Rivera Center, 710 North College Avenue, Claremont, CA 91711.

Grumet, Madeleine R., "Conception, Contradiction, and Curriculum," reprinted from *Bitter Milk: Women and Teaching*, by Madeleine R. Grumet (Amherst: University of Massachusetts Press, 1988). Copyright © 1988 by The University of Massachusetts Press. Chapter 1, "Conception, Contradiction, and Curriculum," pp. 3–30.

McKellar, Barbara, "Only the Fittest of the Fittest Will Survive: Black Women and Education," from *Teachers, Gender, and Careers*, 1989, ed. Sandra Acker, Taylor and Francis, Inc., Washington, D.C., Chapter 5, "Only the Fittest of the Fittest Will Survive: Black Women and Education," pp. 69–85. Reprinted with permission.

Stone, Lynda, "Toward a Transformational Theory of Teaching," ed. James Giarelli, *Philosophy of Education 1988*, vol. 44, pp. 186–195. (Normal, Illinois: Philosophy of Education Society, 1989).

Contemporary Selections

Li, Huey-li, "Ecofeminism as a Pedagogical Project: Women, Nature, and Education," *Educational Theory*, 57(3) (2007): 351–368. Reprinted by permission of Wiley-Blackwell.

Elenes, C. Alejandra, "*Transformando Fronteras:* Chicana feminist transformative pedagogies," *International Journal of Qualitative Studies in Education*, 14(5) (2001): 689–702. Reprinted with permission.

Grumet, Madeleine R. and Stone, Lynda, "Feminism and Curriculum: Getting Our Act Together," *Journal of Curriculum Studies*, 32(2) (2000): 183–197. Reprinted with permission.

Beauboeuf-Lafontant, Tamara, "A Womanist Experience of Caring: Understanding the Pedagogy of Exemplary Black Women Teachers," *The Urban Review*, 34(1) (March, 2002): 71–86. Reprinted with permission.

Delgado Bernal, Delores, "Critical Race Theory, Latino Critical Theory, and Critical Raced-Gendered Epistemologies: Recognizing Students of Color as Holders and Creators of Knowledge" *Qualitative Inquiry*, 8(1) (2002): 105–126. Reprinted with permission.

Sykes, Heather, "Turning the Closets Inside/Out: Towards a Queer-Feminist Theory in Women's Physical Education," *Sociology of Sport Journal*, 15 (1998): 154–173. Reprinted with permission.

Ruitenberg, Claudia, "Queer Politics in Schools: A Rancièrean Reading," *Educational Philosophy and Theory*, 42(5–6) (2010): 618–634. Reprinted by permission of Wiley-Blackwell.

Chinnery, Ann, "Cold Case: Reopening the File on Tolerance in Teaching and Learning Across Difference," ed. Kenneth R. Howe, *Philosophy of Education 2005*, pp. 200–208. (Urbana, IL: Philosophy of Education Society, 2005). Reprinted with permission.

Todd, Sharon, "Unveiling Cross-Cultural Conflict: Gendered Cultural Practice in Polycultural Society," ed. Daniel Vokey, *Philosophy of Education 2006*, pp. 283–291. (Urbana, IL: Philosophy of Education Society, 2007). Reprinted with permission.

Introduction

Barbara J. Thayer-Bacon, PhD
University of Tennessee, Knoxville

The Background

In 1994 Lynda Stone published an outstanding collection of feminist writers who were writing about feminist theory and pedagogy in connection to educational theory and practice.[1] Right around the same time, Barbara Thayer-Bacon developed a "Feminist Epistemology and Education" course that she began teaching at Bowling Green State University (BGSU). This course employed Belenky, Clinchy, Goldberger, and Tarule's *Women's Ways of Knowing* as the starting point, continuing with the articles and essays of current work in feminist epistemology (which eventually evolved to using Thayer-Bacon's own book, *Relational "(e)pistemologies,"*) and ending with Lynda Stone's edited book, *The Education Feminism Reader.*[2] The course was cross-listed with Women's Studies and Educational Foundations and Inquiry, and offered graduate students a possible course toward a graduate certificate in Women's Studies. Students from various programs across the campus such as American Studies and Communications Studies took the course and found the connections between feminist theory and educational theory important and exciting.

When Thayer-Bacon was hired by the University of Tennessee (UT) in 2000, she found that there was a shortage of course options available to graduate students who wanted a certificate in Women's Studies, which was offered at UT as well. This was especially the case for students earning degrees in the College of Education. She introduced her "Feminist Epistemology and Education" course (CSE 609) to the UT curriculum, and when another feminist scholar joined the Cultural Studies in Education program, the title of the course was broadened to "Feminist Theory and Education" so either one of us could teach CSE 609, and each offer our own unique course design. Thayer-Bacon continues to follow the same list of readings for her course, as it has been very successful and students' feedback continues to be that they are not being exposed to this material in other courses. The readings provide the students a foundational base in feminist theories in education, and many students have gone on to use the works in diverse and creative ways for their own scholarly projects. Over the past eighteen years, Thayer-Bacon has witnessed many students shape master's theses and doctoral dissertations around various

scholarship that is included in the course, which is exciting indeed. The last several years CSE 609 has been offered, Stone's *The Education Feminism Reader* has become harder and harder to find as it is now out of print. Students have been able to find copies through on-line purchases, but this has become more difficult each year. Thayer-Bacon's students have pretty much bought up what is available. She began to worry that once again women's work was going to no longer be available for students, and that once again we would find ourselves having to recover important feminist work that was lost to public knowledge. That concern is what originally motivated her to seek a way to republish the book, *The Education Feminism Reader*.

Katharine Sprecher (Thayer-Bacon's Graduate Assistant at the time) worked with Thayer-Bacon on updating our feminist reading list for CSE 609 to include work from this past decade to add to the readings, thinking they would at least have these to use in the next teaching of CSE 609. We wanted to make sure students understand that this work is continuing, and they too can add to the scholarship on feminist theory and education. At the end of the fall semester, 2010, students in CSE 609 were polled for their feedback, and they all requested that we *not* lose the current, what we are now calling the classic selections in Stone's *The Education Feminism Reader*. The students in CSE 609 wanted us instead to *add* to what is already there (there were 18 students in the course from various programs across the campus, including Nursing, Sports Studies, Child and Family Studies, Applied Educational Psychology, as well as Cultural Studies in Education). Sprecher and Thayer-Bacon searched for another text to use instead of *The Education Feminism Reader*, but we have not been able to find anything. What we find are collections of important feminist theory essays, classic and contemporary, but not feminist theory that relates directly to educational issues. The book Lynda Stone published in 1994 is unique and there is nothing like it on the market that can be used directly in a College of Education feminist theory course.

As Stone (1994) so eloquently describes in her original Introduction: "(t)he title *The Education Feminism Reader* names a new theoretical formulation and is itself a claiming in the tradition of Adrienne Rich" (who is quoted in her opening, in Rich's speech that calls for women to claim an education rather than receive one[3]). "The claim for education feminism is important because of the special conditions that surround the lives of women in professional education. 'Professional education' is the arena most closely associated with the lives of most of the authors of this collection and with the feminist issues about which they write. It also names as a significant category teaching candidates and education graduate students, pre-collegiate practicing teachers and administrators, teacher educators and education researchers. . . . The structural context of women and feminism in professional education is especially complex given that as a distinct institution it is highly 'feminized,' that is, populated primarily by women" (pp. 1–2).

"Any institution in which women are predominant, common sense dictates, ought to be relatively free of discrimination against its majority. Such, in subtle and not so subtle ways, is not the case for women in professional education" (pp. 1–2). Stone goes on to describe discrimination that has several institutional locations: one—in pre-collegiate schools in the form of the patriarchy within which the practitioner works, two—in col-

leges and universities where feminists are mistrusted by teachers out in the field because they do not work in the schools and are not considered "real scholars" because they are not viewed as members of the general academy, and three—in the devaluing of feminist work within higher education by not only "pure scholars" but also by "applied scholars" and by their academic sisters (p. 2).

. . .

"An initiating point: the education feminist scholarship of this book, representative of an emerging and already vigorous field of study and practice, seeks to demonstrate its own evolving history and attempts to influence future education and feminist theory and practice" (p. 3).

Sprecher and Thayer-Bacon have honed down the original list of readings from Stone's collection to the one's most responded to and used by students in CSE 609 in the past, and we have simplified the way the readings are divided, in terms of basic categories to help instructors with their grouping of the material for reading assignments. We then began reading and selecting material to include in a Contemporary Readings section. We don't want our students to think feminist work is over, or passé. We want them to see how third wave feminist criticism in the 1990s has had an impact on feminist work, and that this work continues today in diverse and exciting ways. Thayer-Bacon approached Stone in spring, 2011, on the idea of redoing *The Education Feminism Reader* with a classics and contemporary section, and she was interested in the project and willing to support our efforts. Since she is the one who put together the original collection, with help from her graduate assistant, it is only fitting that she be listed as one of the editors. Sprecher should also be listed, as she has done much to search for possibilities and help with the reading and selecting process as well as the indexing. Thayer-Bacon is heading up the project as she wants the book available to use in her course. We all strongly support the continuing development of education feminist theory.

The Features

Education Feminism: Classic and Contemporary Readings is a rich collection of important essays feminist scholars have contributed to the field of education. The collection now begins with 1982 and continues to 2011. The authors are once again college and university professors teaching primarily in programs, departments, schools, and colleges of education located in the United States, Canada, Europe, and New Zealand. They are diverse in their ethnic backgrounds as well as their discipline backgrounds, including philosophy, psychology, sociology, and curriculum studies. The individual essays are concise and well written, and the collection is arranged in such a way that it is easy for instructors to assign various essays around themes of their own choosing, or allow the students to choose which ones they are interested in reading and present them to the class. Thayer-Bacon assigns 3–4 readings per week that we all read, then in class she has the students form small groups for discussion of a particular essay that stirred them, then we get back into a large group discussion to share various topics and issues that students may want to write about for

a position paper. *Education Feminism: Classic and Contemporary Readings* format is great for using with graduate students in various programs as they find it accessible, and yet it also offers high quality scholarship, and numerous sources for topics and issues students will want to pursue on their own.

Professors will find *Education Feminism: Classic and Contemporary Readings* is a valuable text to add to their class list of books. Due to its high quality of selected essays and their significant treatment of major current feminist theories, it is possible to use *Education Feminism: Classic and Contemporary Readings* as a central text in a course on feminist theory and education, and then give students assignments to research individual scholars on their own.

Education Feminism: Classic and Contemporary Readings is timely, and forward thinking, with its addition of a new section of contemporary work from the past decade, as well as addressing major theories from the past that have contributed to our current feminist theories, as we have chosen essays for the contemporary section that reference earlier feminist work by the scholars included in the "classics" section. Indeed, some of the scholars have essays in both sections. In this way, a conversation continues, and we can see that feminist theories continue to grow and further develop. The timely quality of this book will make it possible for students to not only be aware of the history of feminist theory as it relates to education, but also help them understand current issues and concerns being debated. From a professorial standpoint, this is also an attractive feature as current perspectives are usually in article or paper form, rarely found in one text, as they will be presented here.

Education Feminism: Classic and Contemporary Readings will be a valuable book for professors to use in graduate courses that consider feminist theory, especially in relation to education, as a topic. This includes at least people who teach graduate courses in philosophy of education, curriculum theory, women's studies, and cultural studies. *Education Feminism: Classic and Contemporary Readings* is intended to make a significant contribution to scholarship in the field of educational theory, from diverse feminist perspectives across all fields of study that seek to include feminist work. Examples are: nursing, social work, child and family studies, women's studies, sports studies, as well as educational studies. Feminist theory has a wide reach and is applicable to most fields of study and educational issues also have a wide reach, giving *Education Feminism: Classic and Contemporary Readings* a broad market. However, the market becomes even broader when we recognize that *Education Feminism: Classic and Contemporary Readings* addresses critical multicultural educational issues and has an inclusive, diverse selection of feminist scholars that bring race, class, sexual orientation, religious practices, and colonial/post-colonial perspectives to bear on their theory. A critical multicultural educational focus makes this text relevant to faculty in teacher education programs who teach future teachers multicultural educational issues and policy makers who address policy issues regarding schools and diverse cultural populations. It will also be relevant to teachers, parents, and administrators who work in culturally diverse settings and whose children attend such settings.

As a final outstanding feature of *Education Feminism: Classic and Contemporary Readings*, it is our goal to offer support to feminist theories that are making significant

contributions to the scholarly discussion on gender and education. *Education Feminism: Classic and Contemporary Readings* is a text that graduate students and scholars in the field of feminist theory will want to read for its scholarly value and the contributions it makes toward furthering our understanding of gender. We predict that this is a book people will want to keep on their shelves and refer to throughout their careers.

The Classics Frame

In the Classics Section, we have subdivided the retained readings into two basic categories, "Education and Schooling," and "Teaching and Pedagogy." We have retained the scholars who brought important diverse perspectives to the original text as well as strong scholarly contributions, as can be measured by how often their work is cited in other feminist scholarship. Essays that were prior to 1982 we have dropped, so that the classics section covers the time frame of 1982–1993 (the original text was published in 1994). We have tried to balance the maintaining of most of the original collection with concerns that the text not become too large and costly. At the same time, we want to reach a wide audience as we think this work has a wide range of interest and applicability.

Our classics selection now includes:

Classics

Part I. *Education and Schooling*

Madeleine Arnot, "Male Hegemony, Social Class, and Women's Education" (1982)
Jane Roland Martin, "Excluding Women from the Educational Realm" (1982)
Bonnie Thornton Dill, "Race, Class, and Gender: Prospects for an All-Inclusive Sisterhood" (1983)
Ruth Enid Zambrana, "Toward Understanding the Educational Trajectory and Socialization of Latina Women" (1988)
Madeleine R. Grumet, "Conception, Contradiction, and Curriculum" (1988)
Barbara McKellar, "Only the Fittest of the Fittest Will Survive: Black Women and Education" (1989)

Part II. *Teaching and Pedagogy*

Lynda Stone, "Toward a Transformational Theory of Teaching" (1988)
Nel Noddings, "An Ethic of Caring and Its Implications for Instructional Arrangements" (1988)
Patti Lather, "The Absent Presence: Patriarchy, Capitalism, and the Nature of Teacher Work" (1987)
Sue Middleton, "Schooling and Radicalisation: Life Histories of New Zealand Feminist Teachers" (1987)

Elizabeth Ellsworth, "Why Doesn't This Feel Empowering?: Working through the Repressive Myths of Critical Pedagogy" (1989)

Joyce E. King, "Dysconscious Racism: Ideology, Identity, and the Miseducation of Teachers" (1991)

Deanne Bogdan, "When is a Singing School (Not) a Chorus?: The Emancipatory Agenda in Feminist Pedagogy and Literature Education" (1993)

CHAPTER OVERVIEW

What follows is a brief description of each chapter as described in Stone's original Introduction, but reordered to follow our new classics structure (pp. 9–12). We have pulled together the essays that take up schools and education as institutions within which women have been denied equality into Part I. "Authors herein claim that this inequality relates to broader male-defined norms arising from the role of the family during industrialization, the definitions of gender and of education, and the relationship of class and gender to schooling" (p. 9).

"Madeleine Arnot offers the first "critical" piece to the collection in an important theorizing from British "new sociology of knowledge." Here the relationship of social class is added to that of gendered education. With much distinction, Arnot poses an early critique of social reproduction theory, and concepts like hegemony and contradiction are used. For Arnot, gender becomes a social construction that is at once arbitrary and nonessentialist, and based on difference.

Jane Roland Martin's classic chapter takes up the place of women in the philosophy of education. In an account that later is part of her important book, Martin (also a founder of the field) traces the conception of education from ancient times and finds women excluded. This account is complemented by an analysis of the meanings of education, liberal education, and teaching from recent analytic philosophy of education. To the standard picture are added the gendered lives of women.

Bonnie Thornton Dill makes a significant contribution with her sociological history of sisterhood and the feminist movement and their places in African-American women's experience. Dill overviews a conception of sisterhood for Black women, relates the struggle against racial injustice for women and men of color, offers the initial critique of white feminism in this book, and poses strategies for a more all-inclusive sisterhood.

Ruth Enid Zambrana adds the perspective of Latina women to issues of education and socialization. In an acknowledged working from Dill's theorizing, Zambrana traces the lack of studies about the lives of women who are *not* white and middle-class and adds her own critique of feminist theory. This is followed by a suggestive model that builds in culture along with the relationships of gender, race, class, and language in understanding the choices for educational lives.

Madeleine R. Grumet's chapter introduces yet another strand of educational theory in her "reconceptualization" of curriculum in terms of the lives of women. Herein the term "reproduction" assumes both a biological and a phenomenological sense as it is tied

to education. Grumet revisits Chodorow and makes salient psychoanalytic theory prior to that of Walkerdine. Contradiction also plays a part in the curriculum "of the fathers" and in a call for another, feminist, conception.

Barbara McKellar presents an unusual perspective on the diversity of women teachers, that as a black woman who is a teacher educator in Britain. McKellar documents and discusses the way that structures of both society and knowledge influence the success of black people in education. The central role of black women in the family and wider community is a related topic. Issues for teachers include access to higher education, pedagogical interests, and promotion.

Part II of the classics section "takes up theorizations of who teaches and how. Again, previous topics intersect but in new ways: questions of identity, conditions of education, theories of knowledge as they influence conceptions of teachers and teaching." Diversity of perspectives continue in these eight essays. "These perspectives come from philosophy, history, sociology, and curriculum theory, as well as from empirical and non-empirical research. Each paper, working from many others in the book, presents a critique of standard, nonfeminist theorization."

Lynda Stone posits a transformation of teaching theory based in an understanding of its philosophical roots. Objective and subjective models of education found analogous conceptions of teaching. Both, however, are male-defined, as Stone's gender critique reveals. A new conception related to the work of Martin and Noddings is proposed, a conception based not in a dualistic, but rather in a relational, feminist epistemology.

Nel Noddings introduces the now famous "ethic of caring" in her chapter. Writing in the field of philosophy rather than a more dominant psychology, this senior author in education feminism begins from a moral orientation to education, teaching, and instructional arrangements. She posits the need to change almost every aspect of present schooling, a change that should be centered in the ethical relation between each teacher and student. Two important elements are dialogue and confirmation.

Patti Lather continues the strand of 'critical theory' in the book with her important critique of the nature of teacher work as it relates to feminism, Marxism, and capitalism. Lather begins with a review of neo-Marxist research in education and points to the general absence of gender. As a source for theoretical reformulation Lather considers 'Marxist feminism,' as a perspective that takes on issues for teachers that involve the public-private split, subjectivity, and the danger of reductionism.

Sue Middleton utilizes the methodology of sociological life history research in her interesting chapter about the school experiences of two feminist teachers in New Zealand. One has a British background and the other is Maori with adopted Pakeha (European-background) parents. Each tells her story about postwar education and becoming a feminist radical teacher. Each describes her own experience of discrimination and marginality. Middleton concludes with implications for feminist pedagogy.

Elizabeth Ellsworth's chapter is identified as one of the most significant in education feminism today (at the time of Stone's writing, 1993–94), coming out of critical, post-structural theory. Ellsworth poses a critique of 'critical pedagogy' that is based in her own university teaching, a critique of what she came to recognize as subtle repressive

elements of empowerment, student voice, dialogue, and critical reflection. What emerges is a pedagogical vision constituted of multiple contexts and perspectives.

Joyce E. King's chapter is the only one of the (original) collection that is not feminist in intent. Rather it points by implication to present divergences between multicultural and feminist education and to the issue of feminist essentialism. King demonstrates in her own teaching what she calls "dysconscious racism," the taking of white norms of educational equality as givens. This chapter again connects to critical, liberatory pedagogy and raises important issues of race and ethnicity for education feminism.

Deanne Bogdan's chapter reaches . . . for interest in literature and connects education feminism to the important tradition of feminist literary criticism. Bogdan also works from Ellsworth and presents a story of her own teaching. The writings of Sandra Bartky, Robin Morgan, and Shoshana Felman are clearly influential here. The chapter closes the (classic section of the) book with a . . . reminder of the vivacity and diversity that now characterizes education feminism" (pp. 9–12).

The Contemporary Frame

In the Contemporary Section, we begin with 1998 and carry the work forward to 2011. The scholars included are current feminist scholars, predominantly philosophers of education but not exclusively, and again the pool of scholars is a diverse group. We have maintained the same two basic themes; "Education and Schooling" and "Teaching and Pedagogy" and purposely selected essays that continue the conversation begun in the classics section, for example: Cris Mayo's and Barbara Thayer-Bacon's essays include Barbara Houston's earlier work from Stone's original text, as does Barbara Applebaum's essay, which includes Houston, Mayo, and Thompson. Tamara Beauboeuf-Lafontant brings Noddings' work forward in her essay on care theory, as well as Dill's and McKellar's work. Thompson's essay further engages Martin and Noddings on care theory. Some of the scholars in this contemporary section are responding to each other's scholarship as well. For example, Thayer-Bacon's essay includes a discussion of Laird's work on befriending girls, Applebaum's essay on resistance to White complicity includes a discussion of Mayo's and Thompson's work on moral agency, and Elenes refers to Delgado's work in her own Chicana feminist theory and pedagogy. All of the scholars included in the contemporary section are responding to criticisms of earlier feminist work in education and extending that work in diverse ways. Several of the essays, Mayo's, Thompson's, and Stone's & Grumet's, offer good, yet differing historical analyses of feminist scholarship which will help to give students historical overviews and frameworks to help position the new work.

All of the authors included in the new, contemporary collection of feminist work are excited and honored to be included with such a distinguished group of scholars. It has been so rewarding to have their responses of enthusiasm for the publication of *Education Feminism: Classic and Contemporary Readings.* We are eager to have the book in our hands for use in our classes.

Contemporary

Part I. *Education and Schooling*

Cris Mayo, "Gender Disidentification: The Perils of the Post-Gender Condition" (2000)

Barbara Applebaum, "Situated Moral Agency: Why it Matters?" (2003)

Audrey Thompson, "Not the Color Purple: Black Feminist Lessons for Educational Caring" (1998)

Susan Laird, "Befriending Girls as an Educational Life-Practice" (2003)

Barbara J. Thayer-Bacon, "Befriending (White) Women Faculty in Higher Education?" (2011)

Huey-li Li, "Ecofeminism as a Pedagogical Project: Women, Nature, and Education" (2007)

C. Alejandra Elenes, "*Transformando Fronteras:* Chicana feminist transformative pedagogies" (2001)

Part II. *Teaching and Pedagogy*

Madeleine R. Grumet and Lynda Stone, "Feminism and Curriculum: Getting Our Act Together" (2000)

Tamara Beauboeuf-Lafontant, "A Womanist Experience of Caring: Understanding the Pedagogy of Exemplary Black Women Teachers" (2002)

Delores Delgado Bernal, "Critical Race Theory, Latino Critical Theory, and Critical Raced-Gendered Epistemologies: Recognizing Students of Color as Holders and Creators of Knowledge" (2002)

Heather Sykes, "Turning the Closets Inside/Out: Towards a Queer-Feminist Theory in Women's Physical Education" (1998)

Claudia Ruitenberg, "Queer Politics in Schools: A Rancièrean Reading" (2010)

Ann Chinnery, "Cold Case: Reopening the File on Tolerance in Teaching and Learning Across Difference" (2005)

Sharon Todd, "Unveiling Cross-Cultural Conflict: Gendered Cultural Practice in Polycultural Society" (2007)

CHAPTER OVERVIEW

What follows is a brief description of each chapter, similar to what was included above for the Classics selections. In Part I we have again pulled together essays that take up schools and education as institutions within which gender matters. Within these eight essays we still find the themes of identity (and disidentity), multiple identities, subjectivity, complicity (and the denial of complicity), care theory further developed as well as troubled, the befriending of girls, and the horizontal violence girls and women do against

each other, especially in terms of whiteness. Perspectives include an Asian ecofeminist's critique of the women-nature affinity, and a Chicana feminist offering of critical raced-gendered epistemologies.

Cris Mayo's essay addresses the young women she teaches who deny a need to worry about gender-related bias and who agree with the media that feminism is dead. Her students "disidentify" with gender and perceive that they are living in "a post-gender world." Mayo argues that while these young women neither suffer from false consciousness nor achieve full transgression through their strategy of "disidentification," their refusal of gender identification fails to change how they are potentially perceived by others, potentially shuts down the conversation on identity, and most problematic, leaves them without a basis for solidarity.

Barbara Applebaum's essay explores the relationship between moral agency and social group location. Using Linda Alcoff's understanding of subjectivity in the sense of lived experience, and Iris Marion Young's notion of "gender as seriality," she outlines a notion of situatedness that elucidates the complex and mutual sustaining relationship between the individual and social structure. Her concept of situatedness explains how dominant group identities can unintentionally support oppressive social systems, and it also suggests a notion of agency that can account for the possibility of dominant group resistance. She then shows how these insights on self and moral agency can be applied to social justice pedagogy, using an example from Cris Mayo's work that advocates for a pedagogy of unknowing or of never knowing for certain.

Audrey Thompson's essay's follows Applebaum's where her work concerning whiteness is discussed, to help us better understand Thompson's emergent and critical approach. In this important essay for our collection, Thompson addresses care theory's "colorblind-ness" through an examination of Carol Gilligan's pyshological theory on an ethic of care, and Nel Noddings and Jane Roland Martin's theories of caring in education. Because of their political and cultural assumptions, they are vulnurable to the charge of not only colorblindness, but also to charges of essentializing and feminizing care theory. She calls for a reexamination of the whiteness embedded in these colorblind theories, and shows how differently themes of these care theories are interpreted if a Black feminist perspective is assumed rather than a liberal White feminist perspective. Thompson seeks to call our attention to how we think about, develop, and implement an anti-racist curriculum and practice in classrooms.

Susan Laird seeks to conceptualize for educators what it might mean to "befriend girls" as an educational life-practice, with an illustration from the novel *Push*, by Sapphire, and Miz Blue Rain's relationship with the girls in her class. Following Iris Marion Young's lead, like Applebaum, Laird also conceives of women as a series and gender as seriality, "a dynamic structure that puts constraints on the modes and limits of people's actions." Her hope is that by theorizing on "this educational life-practice, *befriending girls* might be more widely acknowledged, valued, taught, learned, understood, undertaken, and critiqued—also much more aggressively financed."

Barbara Thayer-Bacon uses Laird's theorizing on *befriending girls*, as well as Paulo Freire's concept of *horizontal violence* to explore the chilly climate in higher education

that most women experience. Thayer-Bacon describes examples of what she perceives to be White women's horizontal violence against each other. Houston's earlier essay on gender bias in public schools and Pagano's essay on women in higher education feeling like plagiarists, as well as Martin's report of current conditions for women in higher education, help her with her analysis as she considers how to protect oneself from the horizontal violence while learning how to befriend women in higher education.

Huey-li Li's essay introduces us to ecofeminists' work, and their analyses of the woman-nature affinity, showing us that "ecofeminism sheds light on how gender ideology influences our worldview and the construction of educational institutions." Li focuses her ecofeminist analyses on the conception of "nature" within the environmental education movement, bringing a cross-cultural perspective to bear on Euro-western theories that link women with nature by contrasting this with China where nature has not historically been associated with woman. Li thus illustrates for us an important contribution feminist theory is making to the ecological justice movement and the establishment of new ethical norms in the global community.

C. Alejandra Elenes's essay on Chicana feminist transformative pedagogies extends the work of Joyce King from the classics section with her focus on finding ways in which women of color faculty can deal with their White women students' racism that exists in many contemporary educational settings. Based on Gloria Anzaldúa's concept of *mestiza consciousness*, border/transformative pedagogies propose ways in which teachers and students can enact a practice that tries to undo dualistic thinking. Through her self-reflective classroom observations and analysis of student evaluations, Elenes seeks to find ways to bring multiple ideologies and points of view to classroom discussion where productive discourse is enabled. The discussion also centers on the contradictions to the goals of democracy that are present in classrooms that seek to be liberatory.

In Part II of the Contemporary section, we again turn to theorizations of who teaches and how. Again, previous topics intersect in new ways: "questions of identity, conditions of education, theories of knowledge as they influence conceptions of teachers and teaching." Whereas the classics section offers papers that critique standard, nonfeminist theorizing, the authors in this section describe the limitations of feminism, in particular liberal feminism, and push us to embrace diversity and uncertainty. Our authors continue to represent diverse perspectives themselves in these seven essays.

Lynda Stone and Madeleine R. Grumet, both authors included in our classics section, start off this section with a collaborative essay written at the turn of the millennium that examines the possibilities of feminism and curriculum mutual influences. Stone and Grumet consider liberal feminism, which is the hierarchical, dualistic structure of gender that pervades western life, and its advances and limitations. They attend to dualisms as they connect to the history and theorizing of feminism, describing experiential, categorical, psychoanalytic, and deconstructive approaches. They argue that only formations that connect self and language, reproduction and representation will affect curriculum.

Tamara Beauboeuf-Lafontant's essay explores a particular form of caring exhibited in the pedagogy of exemplary black women teachers. In describing the characteristics of "womanist caring" that is an epistemological perspective based on the collective experiences

of black women, she describes teachers who embrace the maternal with political clarity and an ethic of risk. Beauboeuf-Lafontant provides historical and contemporary evidence to demonstrate that womanism is a long-standing tradition among African-American women teachers. She concludes with recommendations for better informing pre- and in-service educators.

Delores Delgado Bernal uses the work of earlier feminist standpoint epistemologies, such as Harding, Ladson-Billings' description of "systems of knowing," and the work of a number of education scholars talking about critical, raced, and raced-gendered episte-mologies, such as Delgado Bernal, to demonstrate how Latino Critical Theory (LatCrit) and Critical Race Theory (CRT) provide an appropriate lens for qualitative research in the field of education. She looks at how different epistemological perspectives view students of color by comparing and contrasting a Eurocentric perspective and a specific raced-gendered perspective to show that they offer very different interpretations of the educational experiences of Chicana/Chicano students. Critical raced-gendered epistemol-ogy recognizes students of color as holders and creators of knowledge who have much to offer in transforming educational research and practice.

Heather Sykes's essay concerns women's physical education, furthering the Houston essay from our classics section, and also connecting in important ways to what Pagano developed in our classics section as well about teachers' identities. Sykes uses feminist and queer theories to explain why the closet has featured so prominently in women's physi-cal education. She offers a poststructuralist analysis of how the closet was constructed in the life histories of six lesbian and heterosexual physical educators, and illustrates how silences inside the closet acquired meaning only in relation to everyday talk about heterosexuality. Sykes uses deconstruction to suggest how heterosexuality can sometimes find itself inside the closet, thus undermining the binaries inside/outside, silence/speech, and lesbian/heterosexual.

Claudia Ruitenberg uses examples of different school initiatives by and/or for queer students to explore the contested goals of perceptibility and intelligibility from the per-spective of Jacques Rancière's conception of politics. She analyzes conditions of visibility and sayability and the political risks and benefits that these carry for queer students and teachers. Her essay brings Rancière's distinction between identification and subjectifica-tion into conversation with Judith Butler's work on the governing of intelligibility by social norms, and the promise of "insurrectionary speech." We learn that taking queer politics *qua politics* seriously in schools means not resting content with gaining permission to be visable and sayable in the existing school order, but, instead, seeking to change the "grid of legibility" of that existing order itself.

Ann Chinnery describes in her essay an undergraduate course on ethical issues in education in which she planned to show a video made by her of several local high school students' views on issues such as racism, sexism, homophobia, and class privilege, only to discover that one of the students she interviewed five years ago was now a student in her class. Added to the ethical dilemma of showing a video that would reveal the stu-dent's identity is the fact that the student expressed homophobic views in the interview not knowing that his current teacher (said interviewer) is a lesbian who clearly disagrees

with his position on the moral status of homosexuality. Chinnery shares with us how she modeled for her students, future teachers, how to handle such a situation; that we cannot abandon the attempt to communicate with our students, even across apparently incommensurable differences. In turning to *tolerance* for help, and foregrounding the student-teacher relationship through Noddings' care theory, she hopes to keep open the possibility of genuine moral dialogue somewhere in the future.

For our final essay in this section, Sharon Todd takes up the case of the right of Muslim girls and women to wear *hijab* to school as one of the most salient debates to emerge in the European context over the past fifteen years. Todd acknowledges the different shape the debate has taken in various countries across Europe, such as Sweden, Belgium, Germany, and France and yet "what is common to all these countries' ways of dealing with the educational rights of Muslims is the singling out of Muslim girls and women as symbols of deep tensions within their respective societies." Her aim is to highlight the nature of gender in developing a complex understanding of culture, and to propose a shift from describing society as multicultural (containing a variety of cultures) to polycultural (embodying cultural variety).

Just as Stone dedicated the original *The Education Feminism Reader* to the contributors of the book, we do the same again. As she said, "it is their book after all. Along with many others who presently labor for feminisms' ideas and practices in professional education, they (we) offer exemplars of this work as a beginning for enduring, transformative change" (p. 12). We do not want the earlier work to be lost to the social memory nor do we want it to appear as if feminist work is now complete. There is plenty of work that we continue to do; we truly are still continuing to work for what we hope will be enduring, transformative change.

Notes

1. Stone, L. (Ed.), (1994). *The education feminism reader.* New York, London: Routledge.

2. Belenky, M., Clinchy, B., Goldberger, N., and Tarule, J. (1986). *Women's ways of knowing.* New York: Basic Books. Goldberger, N., Tarule, J., Clinchy, B., and Belenky, M. (Eds.), (1996). *Knowledge, Difference, and Power.* New York: BasicBooks, HarperCollins. Thayer-Bacon, B. (2003). *Relational "(e)pistemologies."* New York: Peter Lang.

3. Rich, A. (1979). Claiming an education, in *On lies, secrets, and silence.* New York: Norton.

CLASSICS

I. Education and Schooling

Male Hegemony, Social Class, and Women's Education

Madeleine Arnot
University of Cambridge, UK

At any given time, the more powerful side will create an ideology suitable to help maintain its position and to make this position acceptable to the weaker one. In this ideology the differentness of the weaker one will be interpreted as inferiority, and it will be proven that these differences are unchangeable, basic, or God's will. It is the function of such an ideology to deny or conceal the existence of a struggle.

—Horney, 1967, p. 56

According to Sheila Rowbotham (1973) in *Woman's Consciousness, Man's World*, the concept of male hegemony, like that of female oppression, is not new, but then as she also points out, it is one thing to encounter a concept, quite another to understand it. That process of understanding requires one to perceive the concept of male hegemony as a whole series of separate "moments" through which women have come to accept a male-dominated culture, its legality, and their subordination to it and in it. Women have become colonized within a male-defined world, through a wide variety of "educational moments" that seen separately may appear inconsequential, but which together comprise a pattern of female experience that is qualitatively different from that of men. These educational moments when collated can provide considerable insights into the collective "lived experience" of women as women. For example, in the educational autobiographies of women edited by Dale Spender and Elizabeth Sarah (1980), what emerges is that in education women have "learnt to lose" and more than that they have learnt *how* to lose, even though they may have had the ability to succeed academically. Through such experience, they have learnt to accept that "the *masculine* man is one who achieves, who is masterful: the *feminine* woman is one who underachieves, who defers" (Brewster, 1980, p. 11).

Research into the experience of women in education also raises numerous problems, however, not just in terms of doing the research (e.g., Llewellyn, 1980) but also at the level of theorising about education and its relationship to the political and economic

context. Here I shall focus upon existing work in British sociology of education to show the differences between two bodies of research into women's education which I call the cultural and political economy perspectives. I will also discuss the relationship between studies of women's education and recent Marxist theories of education. I will examine the interaction between class and male hegemony in education and then attempt to develop a different and very elementary framework within which to conceive of research questions in this area, as a starting point for a more cohesive study of class and gender. The problems raised through attempting to put together theories of two different structures of inequality will at least point to the complexity of combining, in everyday life, the demands of two sets of social relations and their interrelations.

In a previous paper (MacDonald, 1980b) I have argued that both class and gender relations constitute hierarchies in which material and symbolic power are based. Inside these hierarchies, the dialectics of class and gender struggles are waged. If we want therefore to research the role of schools as one social "site" in which the reproduction of the socio-sexual division of labour occurs, then it is necessary to be aware of the nature of these *two* forms of social struggle, the different stakes involved, and how such struggles are "lived through" by individuals who negotiate terms within these power relations and who construct for themselves specific class and gender identities.

The need to describe the processes of gender discrimination in education and its effects—female subordination in the waged and domestic labour forces—is circumscribed by the political commitment to offer suggestions, proposals, and programmes for educational reform that will help liberate women. That political cause should not allow us, however, to stop at the immediate level of ethnographic or quantitative description and prescription. We need to go further and analyse in depth the processes of the *production* of gender differences both inside and outside schools and to analyse the forms of gender reproduction which are inherent in, and not independent of, the patterns of class reproduction, class control, and class struggles.[1] This political and economic context of gender reproduction sets the limits and influences the forms and outcomes of gender struggles. It critically affects the impact of any education reform and its effectiveness. In this paper, therefore, I shall retain my original position:

> In so far as class relations (in other words the division between capital and labour) constitute the primary element of the capitalist social formation, they limit and structure the form of gender relations, the division between male and female properties and identities. I do not believe that one can disassociate the ideological forms of masculinity and femininity, in their historical specificity from either the material basis of patriarchy nor from the class structure. If one definition of femininity or masculinity is dominant, it is the product of patriarchal relations and also the product of class dominance, even though these two structures may exist in contradiction. (MacDonald, 1980b, p. 30)

The analysis of the origins and nature of gender differences will make reference to the existence of a bourgeois and male hegemony that has controlled the development of

female education. The concept of hegemony used here refers to a whole range of structures and activities as well as values, attitudes, beliefs, and morality that in various ways support the established order and the class and male interests that dominate it. By putting the concept of hegemony rather than "reproduction" at the fore of an analysis of class and gender, it is less easy in doing research to forget the *active* nature of the learning process, the existence of dialectic relations, power struggles, and points of conflict, the range of alternative practices that may exist inside, or exist outside and be brought into, the school. Further, it allows us to remember that the power of dominant interests is never total nor secure. Cultural hegemony is still a weapon that must be continually struggled for, won, and maintained. Women in this analysis must offer unconsciously or consciously their "consent" to their subordination before male power is secured. They are encouraged "freely" to choose their inferior status and to accept their exploitation as natural. In this sense the production of gender differences becomes a critical point of gender struggle and reproduction, the site of gender control.

Cultural and Political Economy Perspectives

In contrast to studies in the United States, where a considerable amount of research has been carried out on gender socialisation, there is relatively little research on girls' and women's schooling in British sociology of education. It is almost as if the "left wing" stance of much British sociology of education has precluded investigation into the area of gender and race relations within schooling, even though these other structures of inequality are contained within, affect, and even exaggerate the effects of class divisions as Westergaard and Resler (1975), Byrne (1978), and King (1971) amongst others have discovered. By and large, the analysis of gender divisions has developed separately from that of class divisions and still seems to have had little or almost no impact upon those who remain within that tradition. Even those who appear to have moved away from a strict "correspondence" model, such as researchers at the Centre for Contemporary Cultural Studies (CCCS) who now argue that one should recognise that schools face *two* directions—towards the family and towards the economy—have done little to rectify the class bias of their analysis. In their new publication, *Unpopular Education* (1981), the analysis of state educational policy and forms of struggle at particular historical conjunctures very quickly leaves the study of parenthood and the relationship between class- and gender-determined education on the sidelines. Cultural studies, as Angela McRobbie (1980) has argued, are also guilty of being sex-blind since either they equate "working-class culture" only with that of the male working class or they focus specifically on working-class boys and ignore the sexism inherent in their particular form of subcultural "style" or version of masculinity.[2] In terms of classroom ethnography, which is still a major methodological tradition and strand within contemporary British sociology of education, the neglect of gender is even more noticeable and less excusable since it implies that the observer in the classroom is blind to the process of gender discrimination that, according to recent feminist work (e.g., Clarricoates, 1980; Delamont, 1970;

Lobban, 1975), occurs most of the time in teacher-pupil interaction, classroom lessons, and pupil control in British primary and secondary schools. Fortunately, there is now a growing amount of research, published for example in Deem (1980) and Kelly (1981), which uses a variety of research techniques to investigate the process of gender ascription, labelling, and discrimination in schools.

The development of work on gender in education in Britain, I believe, has employed what I have called the cultural perspective (Arnot, 1981). I have argued that those who use the cultural perspective focus upon the patterns of "sex-role socialization," that is, upon the processes internal to the school that determine and shape the formation of gender identities.[3] Their concern is with educational "underachievement," with the analysis of the overt curriculum and the hidden curriculum, with classroom interaction, with girls' attitudes to schools as well as with teachers' and career officers' attitudes to girls' futures. What this cultural perspective appears to have in common with the political economy model is that it also refers to the processes involved in the "reproduction" of gender. "Reproduction" here is not a Marxist concept, however. Several critical differences distinguish the political economy and cultural perspectives—only a few of which I can cover here. Perhaps the most important difference is that cultural analysis concentrates upon *how* rather than *why* schools function to reproduce the patterns of gender inequality—the focus is therefore upon internal rather than external processes. The origin of these processes lies in the concept of "sex-role ideology" (or some equivalent concept), yet, paradoxically, this ideology is also produced and reproduced in the school. It is thus both the *cause* and the *effect* of gender inequality since each new generation of pupils in turn becomes the new generation of parents, teachers, employers, etc., carrying with them the assumptions of such "sex-role ideology." Therefore, what is portrayed is a vicious circle of attitudes in which the learnt attitudes of one generation constrain the new generation and so on. It is in this sense that the concept of "reproduction" is used.

This work challenges traditional sociology of education to recognise the complexity of factors that are to be found in schools and that produce the educational, and later the social, inequality between men and women. These analyses make it difficult to hold any belief that we have achieved formal equality of opportunity within schools by eradicating overt forms of gender discrimination. Further, this challenge is directed towards state educational policy makers, who tend to gloss over the nature and extent of discrimination in education against women. The political orientation of much of this research is therefore to challenge the success of the programme for equality of opportunity and to demand that women receive genuine equal opportunity with men. With such a political goal and audience, researchers tend therefore not to address themselves to the radical sociological tradition within sociology of education but rather to aim to influence teachers, local educational authorities, and the Department of Education and Science.

There are two results of such an orientation. First, even though it challenges official views of education, much of this literature takes for granted and uses the official ideology that schools are neutral agents in society and the official definition that if women do "underachieve" relative to men, then it is an "educational problem," and an "educational solution" must be sought. Second, this literature does not search too deeply into the

class basis of the inequality of opportunity that boys suffer. Educational achievement in Britain is still closely correlated with the class origins of students. The implication then appears to be that girls should match the class differentials of educational achievement and access to occupations that boys experience. Equality of opportunity in this context therefore appears to mean similar class-based inequalities of opportunity for both men and women. One could say, equal oppression!

What the cultural perspective lacks is precisely the cutting edge that caused the development of Marxist reproduction theory in the first place—that of a need to provide a critique of educational policy and practice, to get behind the illusion of education's neutrality and the myth of equality of opportunity, and to explain the relationship of schools to the economy, dominant class interests, and the hierarchical structures of economic and cultural power. Ironically, what the cultural perspective gains by neglecting this analysis of the socioeconomic context of schooling is its optimism, its belief in educational reform and teachers' practice. What it loses is an adequate political analysis of the context in which these reforms would have any impact and the constraints under which schools realistically operate. By failing to provide a critique of liberal ideology and its view of education, much of the research into gender appears to be undertheorised and to have little concern for the *origins* and the conditions of school processes or the *sources* of potential conflict and contradiction within gender socialisation.

Nevertheless, there are also several advantages in such cultural theory, particularly for the development of a feminist analysis of the operation of *male hegemony* in education. What such research can show is the unity of girls' experiences across class boundaries by focussing upon female education as a common experience vis-à-vis that of boys. Clarricoates (1980), for example, concludes from her research of four primary schools that even though femininity varies, "the subordination of women is always maintained."

> All women, whatever their "class" (economic class for women is always in relation to men—fathers and husbands) suffer oppression. It is patriarchy in the male hierarchical ordering of society, preserved through marriage and the family via the sexual division of labour that is at the core of women's oppression, and it is schools, through their different symbolic separation of the sexes, that give their oppression the seal of approval. (Clarricoates, 1980, p. 40)

The advantage of the alternative perspective, that of political economy, is precisely the reverse of cultural theories, since what this perspective can reveal is the *diversity* of class experience and the nature of *class hegemony* in education.[4] What becomes clear from this analysis is that working-class boys and girls do actually share some experiences in school such as alienation from the school values of discipline and conformity, estrangement from school culture, and skepticism as to the validity of an ideology that stresses the possibility of individual social mobility. Admittedly most of the research on social class experience in schools has been conducted on boys, showing the homogeneity of their experiences within one social class (e.g., Corrigan, 1979; Hebdige, 1979; Willis, 1977). Empirically, there are very few studies of working-class girls or middle-class girls (Lambert

1976; McRobbie, 1978; McRobbie and Garber, 1975; Nava, 1981; Sharpe, 1976). As Delamont (1970) and King (1971) amongst others have pointed out, this is an incredibly underresearehed area in the sociology of education as a whole. Most of the work in the political economy perspective has been theoretical or at a macro-level of analysis.

What researchers using this perspective have in common is their concern for constructing a theory of class and gender education and for bridging the gap between Marxist theories of class reproduction and theories of gender divisions.[5] Curiously, in this work one finds perhaps more references today to the Marxist theories of social reproduction that were popular in the mid 1970s in British sociology of education than in any other body of current educational literature.[6] The aim of most of this Marxist feminist work is to develop a political economy of women's education that moves out and away from the limitations of a purely cultural theory of gender and which addresses itself to questions about the determinants of girls' schooling as well as its processes and outcomes. The starting point for much of this work has tended to be social rather than cultural reproduction theory, and in particular the theory of Louis Althusser. The reason for this interest in Althusser's (1971) work on ideological state apparatuses is that he makes the distinction between the reproduction of the labour force and the reproduction of the social relations of production. Much of the domestic labour debate has focused attention upon the role of women in fulfilling the former function for capital through biological reproduction of the next generation of workers and the daily reproduction, through servicing, of the work force (e.g., Hall, 1980; Secombe, 1973). The question that concerns Marxist feminist sociologists of education is that of the role of schooling in the social, reproduction of the female waged and domestic labour forces. The differential experience of boys and girls for the first time assumes particular importance in the analysis of the social reproduction of a capitalist labour force and capitalist social relations of production. Sexual divisions of labour which segregate women and men and maintain the male hierarchy within the workplace and domestic life come into direct contact with the forms of class oppression and exploitation, as well as with class cultures of resistance, in these two sites.

Feminism and Social Reproduction Theory

In the context of patriarchal capitalism, explaining the nature of women's education) has also created a variety of problems for the analysis of class reproduction and it is these that encourage a reformulation of that theory.[7] Let me for a moment give two brief examples of how existing accounts of class reproduction through education must be modified to take account of gender difference. If we look at the explanations that have been offered for the rise of mass compulsory schooling, in nineteenth-century Britain, we find none of them can adequately account for the fact that girls were educated at all. Why bother to educate girls in preparation for becoming a skilled work force when few women became such workers? Why educate women to be a literate electorate when they did not have the vote? If women were educated to become docile and conforming

workers, why did they receive a different curricula from boys—since their class position would have meant that working-class boys and girls had similar experiences. According to Davin (1979), none of these explanations of schooling can account for the particular pattern of girls' education. Instead one must recognise that what schools taught was the particular bourgeois family ideology in which women played a special role as dependent wife and mother. Davin argues that it was this need to educate girls into domesticity that encouraged educational policymakers to establish schools for girls as well as boys. By limiting oneself to a strictly "economic" or "political" model of schooling, the saliency of family life within the concept of "social order" would be missed entirely.

If we turn briefly now to the twentieth century, when human capital theory provided the ideological basis for so much of educational planning and decision making, we find that even within this framework we cannot account for the development of women's education. If human capital theory did influence educational development to the extent that, for example, Bowles and Gintis (1976) suggest, then we understand that all children were prepared strictly for their future place in the work force. However, as M. Woodhall (1973) argues, human capital theorists used the concepts of "investment in *man*" and "*man*-power planning," not without reason since they were mainly if not exclusively referring to men. Human capital theorists viewed women's education very differently from that of men: they saw it as "either a form of consumption, or an unprofitable form of investment given the likelihood that women have to leave the labour force after marriage, or may work short hours or in low paying occupations" (Woodhall, 1973, p. 9). The returns in terms of cost-benefit analysis on women's education would therefore be low and hardly worth the effort. According to T. W. Schultz (1970), himself a renowned human capital theorist:

> If one were to judge from the work that is being done, the conclusion would
> be that human capital is the unique property of the male population—despite
> all of the schooling of females and other expenditures on them they appear
> to be of no account in the accounting of human capital. (p. 302–3)

Can one then ignore the differential investment in men's and women's education and the different purposes for which schooling was meant? It must be remembered that the motto "education for production" or "education for economic efficiency and productivity" takes on specific meaning in the ideological climate of patriarchy.

If these explanations of the nineteenth- and twentieth-century development of schooling are inadequate to account for the rise of girls' schooling, then so are the theories that have used them as a basis for criticism, such as the work of Johnson (1970) and Bowles and Gintis (1976). Theories of class cultural control and the social reproduction of class relations are inadequate precisely because they have lost the sense of the specificity of class experiences in terms of gender. While there are similarities between members of each social class there are also differences, which often can give them common ground and shared experiences with members of another class (with whom they could potentially form alliances). The problem then becomes one of trying to sort out these similarities

and differences. Certainly one way in which the analysis can be improved is through the recognition of the dual origins and destinations of female *and* male students—that of the waged and domestic labour forces and the sets of social relations within both the labour process and domestic life. Another way is to recognise that women's position within the hierarchy of class relations is different from that of men. There are far fewer women employers, managers, members of high status professions, and supervisors. Very few women are likely therefore to give orders and enforce obedience. Indeed they are more likely to be what Bernstein (1977) called the agents of "symbolic control" (teachers, social workers) presenting the "soft face" of capital rather than what Althusser (1971) called the "agents of exploitation and repression." Women therefore are not easily described by a concept of class structure that is defined by the distribution of male occupations and male hierarchies of control.

Another problem in theories such as Bowles and Gintis's (1976) is that there is no identification and analysis of the reproduction of the patriarchal basis of class relations in the workplace and in the school. They ignore the fact that so many women number in the ranks in what they call the "secondary labour market" in a segmented labour force. If the principle of capitalist social relations of production is one of "divide and rule," then one cannot ascribe sex segmentation of the labour force as a subsidiary principle of class division. In my view it is a major medium of class control and also the most visible form of the principle of "divide and rule" (see MacDonald, 1981a).

Bowles and Gintis did not really get involved in discussing patriarchal relations within the social relations of production and schooling because of their view that the reproduction of the sexual division of labour occurs primarily in the family, with the mother playing an active role. They argue that it is because the family is semiautonomous and is actively engaged in the reproduction of *gender* divisions and the private-emotional life of the family, that capital has increasingly corne to use the educational system as its primary agency for the reproduction specifically of the *class* structure and its relations. The thesis in *Unpopular Education* (CCCS, 1981) is similar; its authors argue that there are different social "sites" for the reproduction of social relations that are hard to disentangle, especially in their combined effects.

> Nonetheless it is useful to think of "the factory" (in shorthand) as the main
> site of class relations, and the family as strongly organised around relations
> of gender, sexuality and age. (p. 25)

We have to be careful of this thesis of the physical and social separation of the two sites of reproduction precisely because it tends to result in giving legitimacy to research that ignores gender divisions in schools and workplaces and that assumes the production of gender all happens outside the school and factory walls. Second, this thesis begs the question of the nature of the relationship between class and gender divisions and between processes of class and gender reproduction that occur simultaneously in the family, the school, and the workplace. Third, implicit in this separation is the assumption that the family and the workplace are indeed separate and distinct destinations for both men

and women and that their preparation for one location is different from the preparation for the other. But this separation is itself an ideological construction that has originated in the context of bourgeois hegemony (see Hall, 1980). It is extremely difficult to use such a dividing line for the destination of women since for many the distinction is blurred in terms of the location of their productive work (e.g., domestic industries) and their time. The reproduction of family life and the domestic sexual division of labour could just as well be described as the reproduction of class position so far as women are concerned, especially if one wished to include housewives in, rather than exclude them from, a class analysis.

The family is indeed the site of gender reproduction, but it also reproduces class cultures, ideologies, and values that are critical components of class relations. The simultaneous operation of these two processes means that specific class forms of gender divisions are constructed and reproduced in this site. Similarly, the school is another site in which the two processes occur simultaneously. What is especially significant, therefore, is not the separation of the two sites, but rather the nature of family-school interrelations. (See David [1978] who argues for the analysis of the "Family-Education Couple.") The transition from the private world of the family and its "lived" class culture into the public world of class divisions and sex segregation is one which is fraught with conflict between the "familiar," received class and gender identities and those taught in the school. It is the process of transition that is the critical point at which we shall understand the ways in which the reproduction of both sets of power relations occurs. At the end of their school days, school children leave as young adults who, despite their different class origins, are meant to have learnt the more elaborated[8] and abstract definition of masculinity and femininity and to have placed themselves, using such class and gender identities, in the hierarchies of the domestic and waged labour forces.[9]

The development of a Marxist feminist theory of gender education, like cultural theory, has been affected by the assumptions of the body of knowledge that it is criticising. It is unfortunate that much of the political economy of gender education has repeated many of the mistakes of social reproduction theory. I am thinking here of the four major problems that Johnson (1981) argues lie in the social reproduction model requiring some modification of the model if it is to be used at all. He argues that social reproduction theory has a tendency toward functionalism, especially insofar as it does not refer to the reproduction of the contradictions and conflicts that are integral to the social relations of production and the points of class struggle arising during the process of capital accumulation. I would also add that Marxist feminist theories of social reproduction have a very real tendency to ignore any notion of gender struggle and conflict, of forms of gender resistance, of contradictions within the process of the social reproduction of the female waged and domestic work forces, and of the patriarchal relations in the family and the labour processes. They too suffer from inherent functionalism. Social reproduction theories conflate educational conditions with educational outcomes, giving the appearance that the rationales and rhetoric of state policy successfully determine the products of the educational system. This tendency is just as clear in cultural theories of gender as in the Marxist feminist analysis of the sexual division of labour. It would appear from

such work that girls become "feminine" without any problems. They acquire the mantle of femininity through the experience of the family and the school and keep it for the rest of their lives. As a result, in searching historically for the common pattern of girls' schooling, there has been an overwhelming emphasis upon the pattern of subordination of girls through education, with very little emphasis upon the patterns of resistance and struggle. And yet one of the greatest women's struggles has been fought over the right of access to and social mobility through the educational system. The fight for the right to be educated represents the most public of gender struggles and yet in contemporary accounts of schooling it is either forgotten or relegated to a marginal event since it was, after all, a struggle by middle-class women for middle-class rights and privileges. And yet it had repercussions for all women. Also, in the analysis of contemporary education, the most visible of struggles over education and the most visible set of problems that confronts teachers is that of controlling working-class boys. The degree of attention paid by educationalists to the disciplining of boys, their degree of concern over male delinquency and truancy rates, is reflected in the amount of attention paid to working-class boys in socio-logical studies. There is considerable neglect of the more "silent" forms of resistance by girls, whether it takes the form of daydreaming (Payne, 1980) or the form of painting their nails in class. (Llewellyn, 1980; McRobbie, 1978) or of "nonattendance" at school (Shaw, 1981).

By ignoring gender struggles, Marxist feminist analyses of schooling fall into the trap of social determinism, even while rejecting as totally false other theories of determinism, such as the biological. Hence de Beauvoir can write:

> The passivity that is the essential characteristic of the "feminine" woman is a trait that develops in her from the earliest years. But it is, wrong to assert a biological datum is concerned; it is in fact a *destiny* imposed upon her by teachers and by society [my emphasis]. (Quoted in Freeman, 1970, p. 36)

Such determinism means that social reproduction theory suffers from a latent pessimism and can leave women, and women teachers particularly, with a sense of fatality and helplessness. In the case of feminism, the "hold" of the system over women seems especially fatalistic in that women are, according to the CCCS (1981), "doubly determined."

> The position of women is doubly determined and constrained: by patriarchal relations and the sexual division of labour within the home and by their patriarchally structured position within waged labour outside. (CCCS, 1981, p. 156)

However, this can be put another way. What we can say is that the "consent" of women is sought to their subordination in both the home and in the waged labour force, and it is on both these fronts that they fight against class and gender control. If we forget to refer to women's struggles, we also lose sight of the victories gained. Not surprisingly then, it is very hard to find an account of the political economy of women's education

that point's out the gains women have made in forcing their way through the barriers of social prejudice and the obstacles that then have placed in front of them to prevent their appropriation of male culture and of male-dominated professions, status; and power. It must be remembered that access to education can be liberating even within a class-controlled system, since it is not only at the level of class "relations that oppression occurs. What the Marxist feminist accounts lose sight of, because of their overriding concern for Marxist class categories, is that patriarchal oppression has its own dynamic and its own "stakes" in gender struggles, and one of the most important ones has been access to, and achievement in, education as a source of liberation.

Contradictions in Theories of Gender Education

Let us now for a brief moment look at the theoretical assumptions of the two traditions within the analysis of gender education and notice the contradictions that emerge between the different analyses. It is at these points of contradiction that research possibilities are opened up and new directions can be taken in the analysis of class and gender. Here I shall identify three major contradictions between the cultural and the political economy perspective.

First, let us look at the different analyses of the relationship between the home and the school. Cultural theorists have argued that there is, by and large, a *continuity* between the home and the school. Gender socialisation appears to start at birth and continue undisturbed to adulthood. Gender definitions are not therefore class specific but societal in source and nature. Thus the school's role is to extend and legitimate the same process begun at home whatever the material circumstances of the particular family or community. The political economy perspective, on the other hand, stresses the impor-tance of the *discontinuity* and distance between the culture of the home and the school. Working-class culture is seen as markedly different from the bourgeois culture transmitted in the school. The school's role in this latter case is to select from class cultures and to legitimate only some cultural forms and styles. From this perspective school knowledge is seen as attempting to ensure the ratification of class power in an unequal society that is divided by class conflict. If this is the case, it becomes improbable that *one* pattern of gender socialisation into *one* set of gender stereotypes extends across different class cul-tures and across the divide of family and school. What is more likely is that the family culture and gender definitions of the bourgeoisie are transmitted in the school and it is the middle-class child who will experience the least difficulty with gender roles taught in school. This view is given support, not just by personal accounts of women such as Payne (1980), who was a working-class girl sent to a middle-class grammar school, but also by the class history of girls' education. Marks (1976), for example, shows how defi-nitions of masculinity and femininity were prominent categories in the development of an English school system that was class divided. She argued that her analysis had shown that "notions of femininity vary both historically and between social classes; and [are shown] to be dialectically related to the changing roles of women in society" (p. 197).

Purvis's (1980, 1981) historical research also supports this view. She has shown that what was appropriate for one social class in terms of gender was not necessarily appropriate for another. In the nineteenth century, what Purvis found was the imposition by the bourgeoisie of a different concept of femininity for the middle classes (the "perfect wife and mother") from that imposed upon the working class (the "good woman").

> The ideal of the "good woman" may be seen . . . as an attempt by the bourgeoisie to solve the various social problems associated with industrialisation and urbanisation. The "good woman" was a dilution of the higher status ideal of the perfect wife and mother and thus it may be interpreted as a form of "intervention" into working class family life, an attempt to convert and transmit that part of bourgeois family ideology that insisted that a woman's place was in the home, that she was responsible for the quality of family life and that her domestic skills were more important than, say, vocational skills that might be used in waged labour. The "good woman" was, therefore, a form of class cultural control . . . an attack upon the patterns of working class motherhood and parenthood as perceived by the middle classes. (Purvis, 1980, p. 11)

The second contradiction that arises between the cultural and political economy theories is in terms of the expected effect and outcome of the education system. So much of the work on gender which has come out of the cultural perspective has stressed that the difference between Western European definitions of masculinity and femininity lie precisely in the fact that while femininity is defined as "docility, submission, altruism, tenderness, striving to be attractive, not being forceful or bold or physically strong, active or sexually potent" (Loftus, 1974, p. 4), masculinity means being aggressive, independent, competitive and superior, learning to take initiative, and lead an active out-of-doors life, etc, (Belotti, 1975). Yet according to Bowles and Gintis's (1976) version of social reproduction theory or even Althusser's (1971), what working-class children, and in particular working-class boys, learn through schooling is to obey, to take discipline, to follow rules, and to submit to hierarchy. They learn docility, which according to cultural theory is a "female" gender attribute. How then do boys cope with this difference in social expectations?

It is impossible to answer this question at the present time since there has been so little research on the problem of class and gender as competing power structures within school environments. However, as I have argued above, it is more likely that there is a discontinuity between the home and the school as a result of class divisions. This will mean that working-class boys and girls will have to negotiate their way not just through class identities, but also through gender identities. Bourdieu (1977a) has argued that the response of the working-class boy and man to the "femininity" of bourgeois school culture is one of resistance, through the use of "coarse" language, manners, dress, etc. This reaffirms their class-identity but also protects their masculinity from negation by the "effeminate" style of bourgeois culture. According to Bourdieu, working-class girls, on the other hand, can more easily negotiate school life and its values since the feminine-identity

derived from their families also stresses docility and passivity. This analysis forgets the importance of the mental-manual division and the hierarchy of knowledge, not just in the school curriculum, but also in the forms of girls' response to schooling. The inversion of the mental-manual division allows working class "lads" to celebrate their masculine identity (Willis, 1977), but also a similar inversion allows working class women to celebrate their femininity through a rejection of male culture that stresses the value of hierarchies (particularly mental over manual work), objective versus subjective knowledge, and individual competition above cooperation (see Spender, 1980b). Paradoxically then, femininity, the supposed essence of docility and conformity can become the vehicle for resisting forms of class reproduction. By playing off one set of social expectations against the other, working-class girls can resist the attempts of schools to induce conformity. Unfortunately, like the forms of resistance of the "lads" that confirm their fate as manual workers, the resistance of girls only leads them to accept even more voluntarily their futures as dependent and subordinate to men, and as semi- or unskilled workers with low pay and insecure working conditions, and often in dead-end jobs. Furthermore, in neither case are the forms of class resistance of working-class boys or girls likely to negate their preconceived notions of gender derived from their families. If anything, they may reinforce the patriarchal relations specific to that social class by granting it more social value and potency in class resistance.

The third contradiction between the two bodies of theory lies in their conceptions of the ideology of schooling. According to cultural theories, girls' educational "underachievement" is a result of the fact that girls are "taught how to fail." Horner (1971) described the process of education as one in which girls learn to avoid and "dread success," since it means becoming a failure as women.[11] Alison Kelly (1981) in her study of girls' failure to study or be successful in science in schools, argues that the school actually discourages girls from achieving in these subjects in a variety of different ways. This process, which she calls a "discouraging process," involves either not making science available to girls or putting them off it through conscious advice or unconscious bias in favor of boys. In contrast to this rather negative view of schools, theories of class reproduction have argued that the dominant ideology of education taught through education is that of equality of opportunity. According to these theories, students are encouraged to see failure as individual, resulting from their lack of ability. Now this may be the case today, where class is a hidden category of education practice and where the categories of educational divisions are in terms of high to low academic ability. However, it is still possible to find gender being used as a very explicit allocating device for curriculum design, options, and routes, as well as for classroom organisation, the labelling of pupils, etc., in a way that is no longer socially acceptable with social class. It is also still possible to find girls' failure at school described as natural since "she is only a girl." Female students as a group can expect not to succeed and their collective failure is visible. Indeed as Wolpe (1976) has argued, the official ideology of equality of opportunity was modified to fit the "special needs or interests" of girls, so that it referred to future expectations of domestic life rather than the rewards to be gained from social mobility through better employment prospects. The illusion of meritocracy, which Bowles and Gintis attacked as being "prevalent in

schools, must be treated with caution therefore since it may only be an illusion of *male meritocracy*, taught to the working class. What is even more interesting is that when the expansion of the universities occurred in Britain in the 1960s, it was with some despair that Hutchinson and McPherson (1976) reported from their studies of Scottish University undergraduates that equality of opportunity had benefitted middle-class women *at the expense* of working-class men. These women had, in their words, "displaced" those working-class men who had successfully made their way through the school system and were knocking upon the university doors. There were therefore two "competing" ideologies of equality of opportunity, not one. No concern was shown for the drastically low numbers of working-class women who reached the university and whose numbers were quoted as being "stable" (hence uninteresting) *despite* the expansion of the university sector. The impression is gained therefore that class equality of opportunity refers to the male working class and gender equality of opportunity to middle-class women. Possibly the fact that working-class women have not gained by this opening up of opportunities is because their subjective assessment of their objective possibilities for entry into higher education and for social mobility has led them to limit their own education aspirations. Their assessment may well have "penetrated" (to use Willis's term) the fact that meritocracy is for men. Perhaps, as Sharpe's (1976) study has suggested, they have accepted a more satisfying alternative—the ambition to become a wife and mother—rather than compete in vain for access to a male world.

Developing a Theory of Cultural Production

Up until now, I have focussed on some of the problems of using social reproduction theory to develop a feminist account of girls' schooling, and I have pointed out some of the dangers of not addressing oneself to the questions concerning the determinants of schooling under capitalism. Here I shall turn to theories of cultural reproduction, which I think have been ignored by feminists using either the cultural or the political economy perspective. It is possible that cultural reproduction theories have been avoided because the relevance of this work for a theory of gender is not obvious, especially since it appears to refer only to class. However, even though Bernstein's (1977, 1980) research has been adopted (and transformed) in the context of Marxist theories of education developed in the 1970s, I believe that his theory of classification systems, of the social construction of categories and "classes" (in the neutral sense of social groups), can be very useful in developing a general theory of gender differences and relations and in setting out the premises for research in schools. I think that one can develop a theory of gender codes that is class based and that can expose the structural and interactional features of gender reproduction and conflict in families, in schools, and in workplaces. The idea of a gender code relates well to the concept of hegemony since both concepts refer to the social organisation of family and school life where the attempt is made to "win over" each new generation to particular definitions of masculinity and femininity and to accept as natural the hierarchy of male over female, the superiority of men in

society. The concept of code also allows one to develop a structural analysis of school culture that avoids seeing the problem of gender inequality as one simply of attitudes that have no material basis. The political and economic distribution of power between men and women in our society is reproduced through the structural organisation of school life, as one of its major agencies; yet schools are also the critical reproductive agencies of class cultures and their principles of organisation. In this sense gender codes can be related to an analysis of class codes in schools.

The first major premise of any theory of gender must be that gender categories are in a very important sense arbitrary social constructs. The arbitrary nature of their contents, both historically and in terms of social class, is the product of "work" carried out by a variety of social institutions and agents (e.g., schools, churches, the mass media—teachers, priests, authors, film producers). The active nature of the production of a category called gender is captured nicely in Eileen Byrne's (1978) definition:

> Gender is the collection of attitudes, which society *stitches together* (dress behaviour, attributed personality traits, expected social roles, etc.) to clothe boys and girls [emphasis added]. (p. 254)

Gender classification differs from that of sex in the sense that whereas the former is totally socially constructed, the other is biologically based. What I believe they have in common, however, is that, like the notions of male and female sex, gender is in fact an arbitrary dichotomy imposed upon what is essentially a continuum. The questions we have to ask then are how and why are gender categories constructed in the way they are? We obviously need an historical analysis to sort out the specificity of our particular version of this dichotomy, our principle of classification, so that we can seek the source of that principle in the changing class relations contained within educational history. Further, we need to look for alternative sources of gender division that can be found in those social classes that have not appropriated the medium of the school to transmit their principles of gender difference.

The second premise is that gender classifications are not universal, nor societal, nor are they static or simple. Indeed they are highly complex in the sense that in order to construct two seemingly mutually exclusive categories that can apply to any range of social contexts, considerable work has to be done to pull together, or as Byrne put it, to "stitch together" a diversity of values and meanings. The tension within each category is as great as that between each category. Think for example of the contradiction that women face in trying to make sense of such antagonistic images of femininity as being both dependable and dependent, of being a sexual temptress and sexually passive, of being childlike and mothering, and of being a capable and intelligent consumer as well as being politically and economically inept. Unfortunately, so much of the work identifying stereotypes in masculinity and femininity has focussed on the consistency rather than the contradiction within these categories. The imposed compatibility of different "narrative structures" in which girls have to construct a coherent female identity has to be "worked at" rather than assumed to exist, in order to produce what Althusser might have called a "teeth gritting harmony."

The third major premise is that gender categories are constructed, through a concept of gender difference that Chodorow (1979) has argued is essential to the analysis of male hegemony. The hierarchy of men over women is based upon an ideology of gender difference that is manifested in the structural division of men and women's lives, their education, their dress, their morality, and their behaviour, etc. The ideology may be founded upon a theory of supposed natural divisions. This ideology then successfully hides the fact that gender is a cultural variable and one that is constructed within the context of class and gender power relations. The source and nature of the imposition of gender differences is so concealed that the power of the dominant class and the dominant sex is increased by such unconscious legitimation.

Yet how is the consent won to particular arbitrary definitions of masculinity and femininity by both men and women, so that they treat such classifications as natural and inevitable? One of the ways in which male hegemony is maintained is obviously through schooling, where it is most easy to transmit a specific set of gender definitions, relations, and differences while appearing to be objective. The opportunity to transmit a gender code is, however, not open to any social class, but rather to the bourgeoisie who have appropriated, more than any other class, the educational system for themselves. The dominant form of male hegemony within our society is therefore that of the bourgeoisie. That is not to say that the classification of gender used by the working class or the aristocracy has not entered the school. As we have already seen in the work of Willis and McRobbie, it is these categories and definitions of masculinity and femininity from the working class that provide the vehicle for classroom and social class resistance. The aristocratic ideal of masculinity can be found in the English public schools, where the concept of the amateur sportsman, the gentleman, and the benevolent paternal leader are in contrast to the grammar school bourgeois ideals of the hard-working scientist, scholar, or artist. Matched to each ideal is its antithesis of "nonmasculinity"—the complementary ideals of femininity—the hostess, the good wife and mother, the career woman, etc.

If we return very briefly to the separation of home and work discussed earlier, we can now relate it to the production of gender difference through a class-based classification system. Historically, as Davin (1979) and Hall (1980) have shown, the nineteenth century saw the development of the bourgeois family form (with its male breadwinner, its dependent housekeeping wife, and dependent children) and its imposition upon the working class through educational institutions. Implicit in this social construction was the notion of two spheres that distinguished and segregated the world of women and men. This classification of male and female worlds was made equivalent to and imposed upon a further classification—that of work and family (or put another way, the distinction between the public world of production and the private world of consumption). This latter ideological construction, despite having a material basis as the continuing development of the factory and office systems, nevertheless has to be continually reinforced in day-to-day life. In this sense, the division between family and work that so many sociologists of education take for granted can also be seen as an *ideological* division that is part of bourgeois hegemony. The structural imposition of the gender classification upon this other division unites the hierarchy of class relations with that of gender relations since it allows for the exploitation

of women by both men and capital. Hence the productive world becomes "masculine" even though so many women work within it, and the family world becomes, "feminine" even though men partner women in building a home. As Powell and Clarke (1976) argue, this classification helps create the political and economic "invisibility" of women.

> It is the dominant ideological division between *Home* and *Work* which structures the invisibility of women and not their real absence from the world of work. Their identification solely with the "privatised" world of the family has masked, firstly, the historical (not natural—and for a long time very uneven) removal of work from the home, and secondly the continuing presence of working women. (It also masks the man's presence in the home). Men and women do not inhabit two empirically separated worlds, but pass through the same institutions in different relations and on different trajectories. (p. 226)

In understanding the differential experience of girls and boys in schools, we should pay particular attention to the way in which the school *constructs* a particular relationship between, for example, home and work and how it prepares the two sexes in different ways for these two destinations. Thus boys and girls are meant to learn a different relation to the bourgeois classification of public and private worlds, of family and work, of male and female spheres. Schools teach boys how to maintain the importance of those distinctions and to see their futures in terms of paid work. (There is little if any training for fatherhood in schools.) Boys are trained to acquire the classification in its strongest form, to make the distinction between work and nonwork, masculinity and nonmasculinity. Hence they avoid academic subjects that are considered to be "feminine," "domestic," and personal/emotional. Their masculinity is premised upon maintaining the distinctiveness of the two spheres, since it is in that hierarchy that their power is based. Girls on the other hand, are taught to *blur* the distinction between family and work for themselves, to see an extension of identity from domestic activities to work activities, to extend their domestic skills to earn an income, and to use their employment for the benefit of their domestic commitments, rather than for themselves. Their construction of the work/family division differs from one that they accept as natural for men, and so they too maintain the classification even though it is not directly applicable to themselves. Thus as Powell and Clarke (1976) point out, the dimensions of possible activity for both sexes are constructed around the oppositions of work/nonwork, management/labour, and work/leisure, but in the case of women, the opposition family/nonfamily overshadows all the others.

We can describe through research the ways in which the schools structure the experience of boys and girls in such a way as to transmit specific gender classifications with varying degrees of boundary strength and insulation between the categories of masculine and feminine and a hierarchy of male over female, based upon a specific ideology of legitimation. Through classroom encounters where boys and girls experience different degrees and types of contact with the teacher, through the different criteria for evaluating boys' and girls' behaviour, and through the curriculum texts and the structured relations

of the school, limits are set to the degree of negotiation of gender that is possible within the school. In this sense the school *frames* the degree and type of response to that gender code. What is relevant therefore is not just an analysis of the structural aspects of gender codes but also the *form* of interaction within school social relations.[12]

Using a notion of gender code, we can recognize that while the school attempts to determine the identities of its students, it is also involved in a process of transmission in which the student takes an active role. First the student is active in inferring the underlying rules from a range of social relations between men and women (between parents, teachers, pupils, etc.). Students learn to recognise and make sense of a wide range and variety of contradictory and miscellaneous inputs, and the results are not always predictable, especially since they relate these school messages to the alternatives that they have experienced or derived from their families, their peer group, the mass media, etc. The student will undergo a process of actively transforming these various messages and will produce at the end, in a temporary sense, a constellation of behaviour and values that can be called "femininity" or "masculinity." What the school attempts to do is to produce subjects who unconsciously or consciously consent to the dominant version of gender relations. This does not mean, however, that if it fails, patriarchal relations are challenged, since, it must be remembered, in all social classes it is the men who are dominant and hold power.

Men and women become the embodiment of a particular gender classification by internalising and "realising" the principle that underlies it. They externalise their gendered identities, through their behaviour, language, their use of objects, their physical presence, etc. It is through this process of "realisation" that the dialectics of objective structures and social action are created. In the process of producing classed and gendered subjects who unconsciously recognise and realise the principles of social organisation, the reproduction of such power relations is ensured. Thus individuals internalise the objective and external structures and externalise them, albeit transformed but not radically challenged. The potential for rejecting such definitions is inherent within the process, for as Bernstein (1980) argues, the recognition of principles of classification does not determine the realisation (or practice); it can only set the limits upon it. What appears to be a smooth process of repetition is in fact one in which the contradictions, the struggles, and the experience of individuals are suppressed. As Bernstein (1980) has argued, "any classification system suppresses potential cleavages, contradictions and dilemmas."

The fact that there is a dominant gender code (i.e., that of the bourgeoisie) means that there are also dominated gender codes (those of the working class or different ethnic groups). The experience of learning the principles of the dominant gender code is therefore the experience of learning class relations where working-class family culture is given illegitimate and low status at school. The form of class reproduction may occur through the very formation of gender identities that we have been talking about. Further class resistance may be manifested through resistance to gender definitions. However, and this is really a very important point, in neither the dominant nor the dominated gender codes do women escape from their inferior and subordinate position. There is nothing

romantic about resisting school through a male-defined working-class culture. It is at this point that women across social class boundaries have much in common.

Concluding Remarks

Briefly then, I think that any research in the area of women's education should have two essential features. First, it should recognise the existence of both class and male hegemony within educational institutions and the sometimes difficult relationship that exists between them. Second, it should be aware that any set of social relations, such as class or gender relations, constitutes a social dynamic in which the forces of order, conflict, and change are contained. The process of what Freire (1972) called "domestication" in the case of girls implies a dialectic of oppression and struggle against class-based definitions of femininity. It is the dual nature of that struggle that allows women to seek allies simultaneously in their own social class and amongst women in different social classes. Somehow our research must capture the unity *and* the diversity of the educational lives of women.

Notes

Arnot, Madeleine, "Male Hegemony, Social Class and Women's Education," *Journal of Education*, 164 (1) (1982): 64–89. Reprinted by permission of the Editorial Board, *Journal of Education*, Boston University, School of Education.

1. Production is used here to refer to the act of *social construction* either by institutions such as schools, the mass media, etc., or by individuals.

2. Angela McRobbie is referring here to the work of Paul Willis (1977) and Dick Hebdige (1979).

3. Examples of a "cultural perspective" are Kelly (1981), Frazier and Sadker (1973), Belotti (1975), Delamont (1980), Lobban (1975).

4. Examples of a "political economy perspective" are Barrett (1980), David (1978, 1980), Deem (1978, 1981), MacDonald (1980b, 1981a), Wolpe (1978a, 1978b). For full references see Arnot (1981).

5. By social reproduction theory, I am referring to the work of Althusser (1971) and Bowles and Gintis (1976).

6. It is interesting that despite the development of the cultural theory of gender, the cultural reproduction theory found in Bernstein (1977) and Bourdieu and Passeron (1977b) has not generally been used, or even referred to.

7. The most contentious area, which cannot be treated here, is obviously the appropriateness of using existing Marxist definitions of social class for describing women's economic and political position. For this debate see, for example, Barrett (1980), MacDonald (1981a), West (1978).

8. I am using Bernstein's (1977) concept here to show that in schools, children are taught the middle-class cultural definition of gender that appears to be "context independent" and thus neutral and generalisable.

9. This would obviously only occur in times, of full employment. In the present context, being "working-class" and "female" is often a qualification for unemployment.

10. See B. Bernstein (1977), Introduction.
11. Similar arguments are put forward in contributions to Spender and Sarah (1980).
12. See "On the Classification and Framing of Knowledge," Bernstein (1977).

References

Althusser, L. Ideology and ideological state apparatuses. In L. Althusser (Ed.), *Lenin and philosophy and other essays*. London: New Left Books, 1971.

Arnot, M. Culture and political economy: Dual perspectives in the sociology of women's education. *Educational Analysis*, 1981, *3*, 97–116.

Barrett, M. *Women's oppression today*. London: Verso, 1980.

Belotti, E. G. *Little girls*. London: Writers and Readers Publishing Cooperative, 1975. First published Milan: G. Feltrienelli Editore, 1973.

Bernstein, B. *Class codes and control*. Vol. III, 2nd ed. Boston and London: Routledge and Kegan Paul, 1977.

———. Codes, modalities, and the process of cultural reproduction: A model. *Pedagogical Bulletin* (No. 7). University of Lund, Sweden: Department of Education, 1980.

Bourdieu, P. The economics of linguistic exchange. *Social Science Information*, 1977a, *16*, 6.

Bourdieu, P. and J. C. Passeron. *Reproduction in education, society and culture*. London: Sage Publications Ltd., 1977b.

Bowles, S., and H. Gintis. *Schooling in capitalist America*. Boston and London: Routledge and Kegan Paul, 1976.

Brewster, P. School days, school days. In D. Spender and E. Sarah (Eds.), *Learning to lose*. London: Women's Press, 1980.

Byrne, E. *Women and education*. London: Tavistock, 1978.

Centre for Contemporary Cultural Studies (CCCS). *Unpopular education*. London: Hutchinson, 1981.

Chodorow, N. Feminism and difference: Gender relation and difference in psychoanalytic perspective. In *Socialist Review*, 1979, 9, 4, 51–70.

Clarricoates, K. The importance of being earnest . . . Emma . . . Tom . . . Jane. The perception and categorization of gender conformity and gender deviation in primary schools. In R. Deem (Ed.), *Schooling for women's work*. Boston and London: Routledge and Kegan Paul, 1980.

Corrigan, P. *Schooling the smash street kids*. New York: Macmillan, 1979.

David, M. E. The family—education couple: towards an analysis of the William Tyndale dispute. In G. Littlejohn et al. (Eds.), *Power and the state*. London: Croom Helm, 1978.

———. *The state, family, and education*. Boston and London: Routledge and Kegan Paul, 1980.

Davin, A. Mind you do as you are told: Reading books for boarding school girls 1870–1902. *Feminist Review*, 1979, *3*, 80–98.

Deem, R. *Women and schooling*. Boston and London: Routledge and Kegan Paul, 1978.

Deem, R. (Ed.) *Schooling for women's work*. Boston and London: Routledge and Kegan Paul, 1980.

Deem, R. State policy and ideology in the education of women, 1944–1980. *British Journal of Sociology of Education*. 1981, *2*, 2, 131–144.

Delamont, S. The contradictions in ladies education. In S. Delamont and L. Duffin (Eds.), *The nineteenth century woman*. London: Croom Helm, 1978a.

———. The domestic ideology and women's education. In S. Delamont and L. Duffin (Eds.), *The nineteenth century woman*. London: Croom Helm, 1978b.

————. *Sex roles and the school.* London: Methuen, 1970.

Frazier, N., and Sadker, M. *Sexism in school and society.* New York: Harper and Row, 1973.

Freeman, J. Growing up girlish. *Trans-Action,* 1970, *8,* (Nov.–Dec.), 36–43.

Freire, P. *Pedagogy of the oppressed.* Harmondsworth. Penguin, 1972.

Fuller, M. Black girls in a London comprehensive school. In R. Deem (Ed.), *Schooling for women's work.* Boston and London: Routledge and Kegan Paul, 1980.

Hall, C. The history of the housewife. In E. Malos (Ed.,), *The politics of housework.* London: Alison and Busby, 1980.

Hebdige, D. *Subculture: The meaning of style.* London: Methuen, 1979.

Horner, M. S. Femininity and successful achievement: A basic inconsistency. In J. Bardwick, E. M. Douvan, M. S. Horner, and D. Gutmann (Eds.), *Feminine personality and conflict.* California: Brooks Cole Publishing, 1971.

Horney, K. The flight from womanhood. In H. Kelman (Ed.), *Feminine psychology.* Boston and London: Routledge and Kegan Paul, 1967.

Hutchinson, D., and A, McPherson. Competing inequalities: The sex and social class structure of the first year Scottish University student population 1962–1972. *Sociology,* 1976, *10.*

Johnson, R. Educational policy and social control in early Victorian England. *Past and Present, 49,* 96–113.

————. *Education and popular politics.* Milton Keynes: Open University Press, 1981.

Kelly, A. (Ed.), *The missing half.* Manchester: Manchester University Press, 1981.

King, R. Unequal access in education—Sex and social class. *Social and Economic Administration,* 1971, *5,* 3, 167–175.

Lambert, A. The sisterhood. In M.Hammersley and P. Woods. (Eds.), *The process of schooling.* Boston and London: Routledge and Kegan Paul, 1976.

Levy, B. The school's role in the sex-role stereotyping of girls: A feminist review of the literature. *Feminist Studies,* 1972, *1,* 1. Reprinted in M. Wasserman (Ed.), *Demystifying schools.* New York: Praeger Publishers, 1974.

Llewellyn, M. Studying girls at school: The implications of confusion. In R. Deem (Ed.), *Schooling for women's work.* Boston and London: Routledge and Kegan Paul, 1980.

Lobban, G. M. Sexism in British primary schools. *Women Speaking,* 1975, *4,* 10–13.

Loftus, M. Learning sexism and femininity. *Red Tag,* 1974, *7,* 6–11.

MacDonald, M. Cultural reproduction: The pedagogy of sexuality. *Screen Education,* 1979–80, *32/33,* 141–153.

————. Socio-cultural reproduction and women's education. In R. Deem (Ed.), *Schooling for women's work.* Boston and London: Routledge and Kegam Paul, 1980a.

————. Schooling and the reproduction of class arid gender relations. In L. Barton, R. Meighan, and S. Walker (Eds.), *Schooling, ideology and the curriculum.* Barcombe, Sussex: Palmer Press, 1980b. Reprinted in R. Dale, G. E. Esland, R. Fergusson, and M. MacDonald (Eds.), *Education and the state: Politics, patriarchy, and practice.* Vol. II. Barcombe, Sussex: Falmer Press, 1981.

————. *Class, gender, and education.* Milton Keynes: Open University Press, 1981a.

————. See Arnot, M., 1981, 1981b.

Marks, P. Femininity in the classroom: An account of changing attitudes. In J. Mitchell and A. Oakley, *The rights and wrongs of women.* Harmondsworth: Penguin, 1976.

McRobbie, A. Working class girls and the culture of femininity. In Women's Studies Group, Centre for Contemporary Cultural Studies, *Women take issue.* London: Hutchinson, in association with the CCCS, 1978.

————. Settling accounts with subcultures: A feminist critique. *Screen Education,* 1980, *34,* (Spring).

McRobbie, A., and J. Garber. Girls and subcultures. In S. Hall and T. Jefferson (Eds.), *Resistance through rituals*. London: Hutchinson, 1975.

Nava, M. Girls aren't really a problem. *Schooling and Culture*, 1981, *9*.

Payne, I. Working class in a grammar school. In D. Spencer and E. Sarah (Eds.), *Learning to lose*. London: Women's Press, 1980.

Powell, R., and J. Clarke. A note on marginality. In S. Hall and T. Jefferson (Eds.), *Resistance through rituals*. London: Hutchinson, in association with the CCCS Birmingham, 1976.

Purvis, J. *Towards a history of women's education in nineteenth century Britain: A sociological analysis.* Paper presented at the International Sociological Association Conference, Paris, August 7–8, 1980.

————. *The double burden of class and gender in the schooling of working class girls in nineteenth century Britain.* Paper presented at Westhill College, Conference on the Sociology of Education, unpublished (1981).

Rowbotham, S. *Woman's consciousness, man's world.* Harmondsworth: Penguin, 1973.

Schultz, T. W. The reckoning of education as human capital. In W. L. Hansen (Ed.), *Education, income and human capital.* New York: National Bureau of Economic Research, 1970.

Secombe, W. The housewife and her labour under capitalism. *New Left Review*, 1973, *83*, (Jan.–Feb.), 3–24.

Sharpe, S. *Just like a girl.* Harmondsworth: Penguin, 1976.

Shaw, J. *Family, state, and compulsory education.* Milton Keynes: Open University Press, 1981.

Spender, D. Education or indoctrination? In D. Spencer and E. Sarah (Eds.), *Learning to lose.* London: Women's Press, 1980a.

————. Educational institutions where co-operation is called cheating. In D. Spender and E. Sarah (Eds.), *Learning to lose.* London: Women's Press, 1980b.

West, J. Women, sex, and class. In A. Kuhn and A. M. Wolpe (Eds.), *Feminism and materialism.* Boston and London: Routledge and Kegan Paul, 1978.

Westergaard, J., and H. Resler. *Class in a capitalist society.* Heinemann Educational Books, 1975.

Willis, P. *Learning to labour.* Farnborough, Saxon House: Teakfield Ltd., 1977.

Wolpe, A. M. The official ideology of education for girls. In R. Dale et al., (Eds.), *Education and the state: Politics, patriarchy, and practice* (Vol. II). Barcombe, Sussex: Falmer Press, 1976.

————. Girls and economic survival. *British Journal of Educational Studies*, 1978a, 26, 2, 150–162.

————. Education and the sexual division of labour. In A. Kuhn and A. M. Wolpe (Eds.), *Feminism and materialism.* London: Routledge and Kegan Paul, 1978b.

Woodhall, M. Investment in women: A reappraisal of the concept of human capital. *International Review of Education*, 1973, *19*, 1, 9–28.

Excluding Women from the Educational Realm

Jane Roland Martin

University of Massachusetts, Boston

Women have been traditionally underrepresented in the scholarship of the academic disciplines. Jane Roland Martin, continuing a line of thought she initiated in a recent article (HER, August 1981), examines the exclusion of women from philosophy of education both as subjects who have written about education and as objects of educational study and thought. She traces this exclusion from a misunderstanding of the writings of Plato, Rousseau, and Pestalozzi on the education of women, and builds a comprehensive critique of the concepts of education, liberal education, and teaching which are accepted by analytic philosophers of education. Martin proposes a possible reconstruction of the field of philosophy of education to include women, and describes the benefits of such a needed undertaking.

In recent years a literature has developed which documents the ways in which intellectual disciplines such as history and psychology, literature and the fine arts, sociology and biology are biased according to sex. The feminist criticism contained in this literature reveals that the disciplines fall short of the ideal of epistemological equality, that is, equality of representation and treatment of women in academic knowledge itself—for example, in scientific theories, historical narratives, and literary interpretations. The disciplines exclude women from their subject matter; they distort the female according to the male image of her; and they deny the feminine by forcing women into a masculine mold. While certain aspects of philosophy have been subjected to feminist scrutiny,[1] the status of women in the subject matter of philosophy of education has not yet been studied. This is unfortunate, for philosophy of education has more than theoretical significance; in dealing with prescriptive questions of education which touch all our lives, it has great practical significance. Furthermore, as a consequence of state teacher certification requirements and the fact that public school teaching is primarily a women's occupation, a large proportion of philosophy of education students are women. It is important to understand, therefore, that, although throughout history women have reared and taught the young and have themselves been educated, they are excluded both as the subjects

and objects of educational thought from the standard texts and anthologies: as subjects, their philosophical works on education are ignored; as objects, works by men about their education and also their role as educators of the young are largely neglected. Moreover, the very definition of education and the educational realm adopted implicitly by the standard texts, and made explicit by contemporary analytic philosophers of education, excludes women.

Invisible Women

In an earlier issue of this journal I argued that the common interpretation of Rousseau's educational thought cannot explain what he has to say about the education of Sophie, the prototype of woman.[2] Rather than admit to the inadequacy of the accepted interpretation, the standard texts either ignore Rousseau's account of the education of Sophie or treat it as an aberration in his thought.

Rousseau's account of the education of girls and women is no aberration; on the contrary, it is integral to his philosophy of education. Nor is Plato's account of the education of women in Book V of the *Republic* an aberration; yet a number of the standard texts and anthologies omit all references to Book V. Others neither anthologize nor comment on those sections containing Plato's proposal that both males and females can be rulers of the Just State and that all those who are suited to rule should, regardless of sex, be given the same education.[3] Moreover, the texts which mention Plato's views on the education of women do so in passing or with significant distortion.[4]

A study done by Christine Pierce has shown that translators and commentators have consistently misinterpreted Book V of Plato's *Republic*; they have been unable to comprehend that such a great philosopher sanctioned the equality of the sexes.[5] Few writers of the standard texts in the history of educational philosophy seem able to grasp this either. Other scholars, for example John Dewey and Thomas Henry Huxley, have also treated women's education seriously.[6] Nonetheless, only one standard text lists girls and women in its index.[7] The others do not perceive sex or gender to be an educational category, even though many of the philosophers whose thought constitutes their subject matter did.

The standard texts have also ignored what philosophers of education have said about the educative role of women as mothers. In his classic pedagogical work, *Leonard and Gertrude*, Johann Heinrich Pestalozzi presents Gertrude neither—to use his biographer's words—"as the sweetheart of some man nor, in the first place, as the wife of her husband but as the mother of her child."[8] As such, Pestalozzi presents her as the model of the good educator. When the nobleman Arner and his aide visit Cotton Meyer in Gertrude's village, Meyer describes Gertrude as one who understands how to establish schools which stand in close connection with the life of the home, instead of in contradiction to it.[9] They visit Gertrude and closely observe her teaching methods. Arner's aide is so impressed by Gertrude that he resolves to become the village schoolmaster. When he finally opens a school, it is based on principles of education extracted from Gertrude's practice.

Pestalozzi is not discussed in as many of the standard texts as are Plato and Rousseau. Insofar as the texts do include his thought, however, they scarcely acknowledge that he thinks Gertrude's character and activities "set the example for a new order."[10] Pestalozzi's insight that mothers are educators of their children and that we can learn from their methods has been largely ignored in educational philosophy.

Just as the exclusion of women as objects of educational thought by historians of educational philosophy is easily seen from a glance at the indexes of the standard texts, their exclusion as subjects is evident from a glance at the tables of contents in which the works of women philosophers of education have been overlooked. The one exception is Maria Montessori, whose work is discussed at length by Robert Rusk.[11] However, she is neither mentioned nor anthologized in the other texts I have surveyed, including Robert Ulich's massive anthology, *Three Thousand Years of Educational Wisdom*.

Montessori's claim to inclusion in the standard texts and anthologies is apparent, for her philosophical works on the education of children are widely known. She is not, however, the only woman in history to have developed a systematic theory of education. Many women have been particularly concerned with the education of their own sex. For example, in *A Vindication of the Rights of Woman*, Mary Wollstonecraft challenged Rousseau's theory of the education of girls and developed her own theory.[12] Wollstonecraft, in turn, was influenced by the writings on education and society of Catherine Macaulay, in particular her *Letters on Education*.[13] In numerous books and articles Catharine Beecher set forth a philosophy of education of girls and women which presents interesting contrasts to Wollstonecraft's;[14] and the utopian novel *Herland*, written by Charlotte Perkins Gilman, rests on a well-developed educational philosophy for women.[15]

While Montessori's work was certainly familiar to the authors and editors of the standard texts and anthologies, it is doubtful that Macaulay, Wollstonecraft, Beecher, and Gilman were even known to these men, let alone that they were perceived as educational philosophers. It is possible to cite them here because feminist research in the last decade has uncovered the lives and works of many women who have thought systematically about education. The works of these women must be studied and their significance determined before one can be sure that they should be included in the standard texts and anthologies. This analytic and evaluative endeavor remains to be done.

It should not be supposed, however, that all the men whose educational thought has been preserved for us by the standard texts are of the stature of Plato and Rousseau or that all the works represented in the anthologies are as important as the *Republic* and *Emile*. On the contrary, a reader of these books will find writings of considerable educational significance by otherwise unknown thinkers, and writings of questionable educational value by some of the great figures of Western philosophy. Thus, while criteria do have to be satisfied before Macaulay, Wollstonecraft, Beecher, Gilman, and others are given a place in the history of educational thought, they cannot in fairness be excluded simply for being regarded as less profound thinkers than Plato.

The question remains whether the women cited here can be excluded because their overriding interest is the education of their own sex. In view of the fate of Sophie, Gertrude, and Plato's female guardians as objects of educational thought, one can only

assume that, had the works of these women been known to exist, they also would have been ignored by the standard texts and anthologies of the field. From the standpoint of the history of educational thought, women thinkers are in double jeopardy: they are penalized for their interest in the education of their own sex because that topic falls outside the field; and, as the case of Montessori makes clear, those who have written about education in general are penalized simply for being women.

Defining the Educational Realm

Lorenne Clark has shown that, from the standpoint of political theory, women, children, and the family dwell in the "ontological basement," outside and underneath the political structure.[16] This apolitical status is due not to historical accident or necessity but to arbitrary definition. The reproductive processes of society—processes in which Clark includes creation and birth and the rearing of children to "more or less independence"—are by fiat excluded from the political domain, which is defined in relation to the public world of productive processes. Since the subject matter of political theory is politics, and since reproductive processes have been traditionally assigned to women and have taken place within the family, it follows that women and the family are excluded from the very subject matter of the discipline.

The analogy between political theory and educational philosophy is striking. Despite the fact that the reproductive processes of society, broadly understood, are largely devoted to childrearing and include the transmission of skills, beliefs, feelings, emotions, values, and even world views, they are not considered to belong to the educational realm. Thus, education, like politics, is defined in relation to the productive processes of society, and the status of women and the family are "a-educational" as well as apolitical. It is not surprising, then, that Pestalozzi's insight about Gertrude is overlooked by historians of educational philosophy; for in performing her maternal role, Gertrude participates in reproductive processes which are by definition excluded from the educational domain. If Gertrude is outside the educational realm, so is Sophie, for the training Rousseau intends for her aims at fitting her to be a good wife and mother, that is, to carry on the reproductive processes of society.[17] Yet, the exclusion of these processes from education does not in itself entail the exclusion of training *for* them; people could be prepared to carry on reproductive processes through bona fide educational activities even if the processes themselves are outside of education. However, since educational philosophy defines its subject matter only in terms of productive processes, even this preparation is excluded.

We can see the boundaries of the educational realm in the distinction commonly made between liberal and vocational education. Vocational education is clearly intended to prepare people to carry on the productive processes of society.[18] Liberal education, on the other hand, is not seen as preparation for carrying on its reproductive processes. Even though disagreements abound over which intellectual disciplines are proper to liberal education and the way they are to be organized, no one conceives of liberal education as

education in childrearing and family life. The distinction between liberal and vocational education corresponds not to a distinction between the two kinds of societal processes but to one between head and hand *within* productive processes. Liberal education is thus preparation for carrying on processes involving the production and consumption of ideas, while vocational education is preparation for processes involving manual labor.

Historians of educational philosophy have no more interest in Sophie than they do in Gertrude, for Rousseau places Sophie in the home and tailors her education to the role he assigns her there. Indeed, educational philosophy has no ready vocabulary to describe the kind of education Rousseau designs for Sophie. It is not a liberal education, for she will learn coquetry and modesty and skill in lacemaking, not science, history, literature, or rational thinking.[19] Like vocational education, her training has narrow and clearly specified ends. Yet vocational education programs prepare their graduates to enter the job market, whereas Sophie's education is designed to keep her out of that arena.[20]

Philosophy of education has no ready classification for the training Rousseau would provide women because it falls outside the educational domain. However, there is a classification for the training Plato would provide the women guardians of his Just State. For Plato, ruling is a matter of knowing the Good, which involves using one's reason to grasp the most abstract, theoretical knowledge possible. Thus, the education he prescribes for the guardian class is a type of liberal education—one which greatly influences educational thought and practice even today. How, then, are we to explain that historians of educational philosophy ignore Plato's theory of the education of women? In a field which excludes the reproductive processes of society from its subject matter and identifies women with these processes, Plato's theory is an anomaly. Plato places women in the public world and prescribes for them an education for the productive processes of society. Although their education falls squarely within the educational realm as defined by the field and can be readily classified, the fact that *women* are to receive this education is lost to view. The position of women in the history of educational philosophy is not an enviable one. Excluded from its subject matter insofar as they are commonly tied by theory to the reproductive processes of society, women are denied recognition even when a particular theory such as Plato's detaches their lives and their education from childrearing and the family.

The Analytic Paradigm: Peters's Concept of Education

Contemporary philosophical analysis has made explicit the boundaries of the educational realm assumed by the standard texts in the history of educational philosophy. In *Ethics and Education*, R. S. Peters writes that education is something "we consciously contrive for ourselves or for others" and that "it implies that something worthwhile is being or has been intentionally transmitted in a morally acceptable manner."[21] Peters distinguishes between two senses of the word "education." As an activity, education must fulfill three

conditions—intentionality, voluntariness, and comprehension—for it involves the *intentional* transmission of something worthwhile, an element of *voluntariness* on the part of the learner, and some *comprehension* by the learner both of what is being learned and of the standards the learner is expected to attain.[22] As an achievement, education involves also the acquisition of knowledge, understanding, and cognitive perspectives.[23]

The analytic literature in philosophy of education is filled with discussions of Peters's concept of education, and at various points in his career he has elaborated upon and defended it.[24] Over the years he has come to acknowledge that there are two concepts of education: one encompassing "any process of childrearing, bringing up, instructing, etc.," and the other encompassing only those processes directed toward the development of an educated person.[25] Peters considers only the second, narrower concept to have philosophical significance. He has analyzed this concept in one work after another and has traced its implications in his book, *The Logic of Education*. This narrow concept is the basis not only for his own philosophical investigations of education but also for those of his many collaborators, students, and readers.

Peters is no insignificant figure in the philosophy of education. Indeed, his concept of education, which excludes the reproductive processes of society, defines the domain of the now-dominant school of philosophy of education—analytic philosophy of education.[26] Peters has given analytic philosophy of education a research paradigm which defines the types of problems, approaches, and solutions for the field only in terms of the productive processes of society. Thus from its standpoint, when Gertrude teaches her children, she is frequently not engaged in the activity of education. While a good deal of what she does fulfills Peters's condition of intentionality, and although she always acts in a morally acceptable manner, there are many occasions on which the children fail to meet the condition of voluntariness.

At times, however, the children are voluntary learners, as when the neighbor children implore Gertrude to teach them spinning:

"Can you spin?" she asked.

"No," they answered.

"Then you must learn, my dears. My children wouldn't sell their knowledge of it at any price, and are happy enough on Saturday, when they each get their few kreutzers. The year is long, my dears, and if we earn something every week, at the end of the year there is a lot of money, without our knowing how we came by it."

"Oh, please teach us!" implored the children, nestling close to the good woman.

"Willingly," Gertrude replied, "come every day if you like, and you will soon learn."[27]

However, with her own children Gertrude constantly instills manners and proper conduct without their permission:

"What business was it of yours to tell the Bailiff day before yesterday, that you knew Arner would come soon? Suppose your father had not wished him to know that he knew it, and your chattering had brought him into trouble."

"I should be very sorry, mother. But neither of you said a word about its being a secret."

"Very well, I will tell your father when he comes home, whenever we are talking together, we must take care to add after each sentence: 'Lizzie may tell that to the neighbors, and talk about it at the well; but this she must not mention outside the house.' So then you will know precisely what you may chatter about."

"O mother, forgive me! That was not what I meant."

Gertrude talked similarly with all the other children about their faults, even saying to little Peggy: "You mustn't be so impatient for your soup, or I shall make you wait longer another time, and give it to one of the others."[28]

There are numerous questions about the transmission of values by the family which philosophy of education could answer: What does "transmit" mean in this context? Which values ought to be transmitted by the family? Should the values transmitted by the family be reinforced by schools or should they be challenged? Do schools have the right to challenge them? Yet as its subject matter is presently defined, philosophy of education cannot ask them, for they are questions about the reproductive processes of society which are inappropriate to raise, let alone to answer.

From the standpoint of contemporary analytic philosophy of education, Gertrude's educational activities and those of mothers in general are irrelevant. Indeed, any account of mothering is considered outside the field. For example, Sara Ruddick's recent innovative account of maternal thought, which gives insights into a kind of thinking associated with the reproductive processes of society, has no more place in the field than Pestalozzi's insights about Gertrude in her capacity as mother.[29]

The kind of maternal thought Ruddick describes and Gertrude embodies is the kind Sophie must exhibit if she is to perform well the traditional female role Rousseau assigned her. As Ruddick makes clear, however, "maternal" is a social, not a biological category: although maternal thought arises out of childrearing practices, men as well as women express it in various ways of working and caring for others.[30] Thus it is something Sophie must learn, not something she is born with. Notice, however, when Sophie learns maternal skills from her mother and in raising her own children, this learning will also

fall outside the educational realm. It will lack Peters's voluntariness and intentionality and will be part of the childrearing processes he would have philosophers of education ignore. In sum, the definition of education used by analytic philosophers today excludes the teaching, the training, and the socialization of children for which women throughout history have had prime responsibility.[31]

The Analytic Paradigm: Hirst's Concept of Liberal Education

Yet Sophie's learning would not be admitted to the educational realm even if it were designed in such a way that it met Peters's criteria of an educational process. It would still include unacceptable goals and content. According to Peters, the goal of education is the development of the educated person, who does not simply possess knowledge, but has some understanding of principles for organizing facts and of the "reason why" of things. The educated person's knowledge is not inert, but characterizes the person's way of looking at things and involves "the kind of commitment that comes from getting on the inside of a form of thought and awareness." This involves caring about the standards of evidence implicit in science or the canons of proof inherent in mathematics and possessing cognitive perspective.[32] At the center of Peters's account of education and the educated person is the notion of initiation into worthwhile activities, the impersonal cognitive content and procedures of which are "enshrined in *public traditions*."[33] Mathematics, science, history, literature, philosophy: these are the activities into which Peters's educated person is initiated. That person is one who has had, and has profited from, a liberal education of the sort outlined by Peters's colleague Paul Hirst in his essay, "Liberal Education and the Nature of Knowledge":

> First, sufficient immersion in the concepts, logic and criteria of the discipline for a person to come to know the distinctive way in which it "works" by pursuing these in particular cases; and then sufficient generalization of these over the whole range of the discipline so that his experience begins to be widely structured in this distinctive manner. It is this coming to look at things in a certain way that is being aimed at, not the ability to work out in minute particulars all the details that can be in fact discerned. It is the ability to recognise empirical assertions or aesthetic judgments for what they are, and to know the kind of considerations on which their validity will depend, that matters.[34]

If Peters's educated person is not in fact Hirst's liberally educated person, he or she is certainly the identical twin.

Hirst's analysis of liberal education has for some time been the accepted one in the field of philosohy of education.[35] In his view, liberal education consists of an initiation into what he takes to be the seven forms of knowledge.[36] Although in his later writings he carefully denies that these forms are themselves intellectual disciplines, it is

safe to conclude that his liberally educated people will acquire the conceptual schemes and cognitive perspectives they are supposed to have through a study of mathematics, physical sciences, history, the human sciences, religion, literature and fine arts, and philosophy. These disciplines will not necessarily be studied separately; an interdisciplinary curriculum is compatible with Hirst's analysis. But it is nonetheless their subject matter, their conceptual apparatus, their standards of proof and adequate evidence that must be acquired if the ideal liberal education is to be realized.

In one way or another, then, the intellectual disciplines constitute the content of Peters's curriculum for the educated person. Since the things Rousseau would have Sophie learn—modesty, attentiveness, reserve, sewing, embroidery, lacemaking, keeping house, serving as hostess, bringing up children—are not part of these disciplines and are not enshrined in public traditions, they fall outside the curriculum of the educated person. But this is to say that they fall outside of education itself for, as we have seen, education, in Peters's analysis, is necessarily directed to the development of the educated person. Just as Rousseau's curriculum for Sophie is excluded from the educational realm, curricula in Beecher's domestic economy, Ruddick's maternal thinking, and Nancy Chodorow's mothering capacities would also be excluded.[37] Given the analyses of the concepts of education, the educated person, and liberal education which are accepted in general outline by the field of philosophy of education, no curriculum preparing people for the reproductive processes can belong to a realm which is reserved for the ways of thinking, acting, and feeling involved in *public* traditions. Since girls and women are the ones who traditionally have carried on the reproductive processes of society, it is *their* activities of teaching and learning and *their* curriculum which are excluded from the educational realm. Sophie and Gertrude are as irrelevant to analytic philosophers of education as they are to the writers of texts in the history of educational philosophy.

The Analytic Paradigm: The Rationality Theory of Teaching

I have said that Gertrude teaches her children even though analytic philosophers of education would say she is not educating them. Yet according to Peters, only a fraction of what Gertrude does could be called "teaching." This is because the concept of teaching is so closely linked to the concept of education that, in ruling out so many of Gertrude's activities as instances of education, Peters's analysis also rules them out as instances of teaching.

But quite apart from Peters's criteria, Gertrude fails to qualify as a teacher according to the accepted analysis of the concept of teaching. Perhaps the best brief statement of this analysis—what I have elsewhere called the rationality theory of teaching[38]—is found in a little known essay by Israel Scheffler. Beliefs, Scheffler says,

> can be acquired through mere unthinking contact, propaganda, indoctrination,· or brainwashing. Teaching, by contrast, engages the mind, no matter what the subject matter. The teacher is prepared to *explain*, that is, to acknowledge

the student's right to ask for reasons and his concomitant right to exercise his judgment on the merits of the case. Teaching is, in this standard sense, an initiation into open rational discussion.[39]

In this passage Scheffler harks back to the original account of teaching he gave in his earlier book *The Language of Education* where he states that to teach "is at some points at least to submit oneself to the understanding and independent judgment of the pupil, to his demand for reasons, to his sense of what constitutes an adequate explanation." And he adds:

Teaching involves further that, if we try to get the student to believe that such and such is the case, we try also to get him to believe it for reasons that, within the limits of his capacity to grasp, are *our* reasons. Teaching, in this way, requires us to reveal our reasons to the student and, by so doing, to submit them to his evaluation and criticism.[40]

Scheffler is not the only contemporary philosopher of education who has emphasized connections between teaching and rationality. Numerous colleagues and critics in the field have elaborated upon and modified his analysis of teaching, and others have arrived independently at conclusions similar to his.[41] The relevant point for the present inquiry is that, according to this analysis of the concept of teaching, the learner's rationality must be acknowledged in two ways: the manner in which the teacher proceeds and the type of learning to be achieved. Thus, the rationality theory holds that to be teaching one must expose one's reasons to the learner so that the learner can evaluate them, and also that one's aim must be that the learner also have reasons, and attain a level of learning involving understanding.

On some occasions Gertrude does approximate the conception of teaching which the rationality theory embodies. When she tries to get her children to learn that virtue must be its own reward, she cautions them to give away their bread quietly so that no one may see them and reveals to them her reason that "people needn't think you want to show off your generosity."[42] When one son asks her to give him a mouthful of bread for himself since he is giving his portion away, she refuses to do so. He asks for her reason and receives the reply: "So that you needn't imagine we are only to think of the poor after our own hunger is satisfied."[43] Yet one is left wondering what Gertrude would say and do if her children ever questioned the values she instills in them. One suspects that she would quickly resort to appeals to authority, a move of which the rationality theory would not approve.

Consider now the occasion on which Gertrude attempts to transmit her values to some neglected children by washing them, combing their hair, dressing them with care, and scrubbing their house. She neither gives reasons for the values of cleanliness and order in which she so firmly believes nor tries to *acknowledge the rationality* of the children in other ways.[44] And on another occasion when Gertrude invites these children to pray with her own children, and then accompanies them to their house with a "cheery parting, bidding them to come again soon,"[45] the intention is that they acquire good habits,

but the mode of acquisition is quite divorced from the giving of explanations and the evaluation of reasons. Gertrude expects that through her kindness, good example, and the efficacy of unconscious imitation, these derelict children will adopt her values. She does not seem to care whether they understand the habits and values they are adopting or have proper backing for the associated beliefs they are acquiring.

It must be made clear, however, that the rationality theory does not function as an account of *good* teaching. It is not meant to be prescriptive; rather its function is to tell us what *constitutes* or *counts as* teaching. If Gertrude's actions do not meet its twofold requirement of rationality in the manner in which the teacher proceeds and in the type of learning to be achieved, adherents of the theory will not judge her teaching to be deficient; they will judge her not to be teaching at all. They will do so, moreover, no matter how reasonable or appropriate her actions may be. That Gertrude's actions are appropriate, given the value she places on cleanliness and godliness, the age of the neighbor children, and their condition, will be evident to readers who know young children. However, the rationality theory is not concerned that teaching be a rational activity in the ordinary sense that the actions constituting it be suited to the ends envisioned. Its sole concern is that the learner's reason be taken into account. Thus there are many contexts in which an activity meeting the requirements of the rationality theory of teaching will not be rational from the standpoint of the demands of the particular context.

In the process of bringing new infants to the point of independence, parents often do things which fit the rationality theory's criteria of teaching. Yet most of the teaching and learning which takes place in relation to the reproductive processes of society do not fit these criteria.[46] Values are transmitted, sex roles are internalized, character traits are developed, skills are acquired, and moral schemes and world views are set in place. Yet, if the teacher's reasons are not revealed or the learner's rationality is not acknowledged, the rationality theory denies the labels of "teacher" and "learner" to the parties involved.

The analysis of teaching which occupies a central position in philosophy of education today embodies a Socratic conception of both teaching and learning. The give and take of Socrates and his friends philosophizing in the marketplace, the Oxford tutor and his tutee, the graduate seminar: these are the intuitively clear cases of teaching and learning on which the analytic paradigm is based. Gertrude teaching her children a song to sing to their father when he returns home or the neighbors to count as they are spinning and sewing, Marmee helping Jo to curb her temper, Mrs. Garth making little Lotty learn her place—the activities and processes of childrearing which have traditionally belonged to women as mothers are at best considered to be peripheral cases of teaching and learning and are more likely not to qualify under these headings at all.[47]

A Servant of Patriarchal Policy

In defining education and the questions that can be asked about it, the analyses of contemporary philosophy of education make women and their activities and experiences invisible. The question naturally arises whether this matters. As long as women

can enter the educational realm in practice—as they can and do today—what difference does it make that educational philosophy does not acknowledge gender as a bona fide educational category? As long as Plato and Rousseau discussed the education of girls and women in major works and Pestalozzi recognized the ability of mothers to teach, what difference does it make that the texts in the history of educational philosophy ignore their accounts and that the paradigms of analytic philosophy of education do not apply to Sophie, Gertrude, or women in general?

It matters for many reasons. When the experience of women is neither reflected nor interpreted in the texts and anthologies of the history of educational philosophy, women are given no opportunity to understand and evaluate the range of ideals—from Plato's guardians to Sophie and Gertrude—which the great thinkers of the past have held for them. When Wollstonecraft and Montessori are ignored in these texts, students of both sexes are denied contact with the great female minds of the past; indeed, they are denied the knowledge that women have ever thought seriously and systematically about education. What is more important is that, when the works of women are excluded from texts and anthologies, the message that women are not capable of significant philosophical reflection is transmitted.

By placing women outside the educational realm or else making them invisible within it, the contemporary paradigms of philosophy of education also contribute to the devaluation of women. Peters's conviction that only the narrow sense of education is worthy of philosophical inquiry keeps us from perceiving the teaching which takes place in child-rearing as a serious, significant undertaking; it makes women's traditional activities appear trivial and banal. Similarly, in defining teaching in terms of a very narrow conception of rationality—the giving and understanding of reasons—the rationality theory of teaching makes the educational activities of mothers, and by implication mothers themselves, appear nonrational, if not downright irrational.

In a report on recent contributions to philosophy of education, Scheffler protested that philosophy is not a handmaiden of policy. "Its function is not to facilitate policy," he said, "but rather to enlighten it by pressing its traditional questions of value, virtue, veracity, and validity."[48] Yet by its very definition of its subject matter, philosophy of education facilitates patriarchal policy; for in making females invisible, philosophy of education helps maintain the inequality of the sexes. It reinforces the impression that girls and women are not important human beings and that the activities they have traditionally performed in carrying on the reproductive processes of society are not worthwhile. Furthermore, philosophy's traditional questions of value, virtue, veracity, and validity cannot be asked about the education of females because females are unseen in the educational realm. Thus the enlightenment that philosophy is capable of giving is denied to policies which directly affect girls and women.

I do not know if philosophy can ever be as divorced from policy as Scheffler would have it. But as long as there is no epistemological equality for women in philosophy of education, that discipline will serve patriarchal policy, albeit unintentionally. For when the activities and experiences of females are excluded from the educational realm, those of males provide our norms. Thus, the qualities Socrates displays in his philosophical con-

versations with his male companions in the marketplace are built into our very definition of teaching even as the ones Gertrude displays in her interactions with her children are overlooked. Similarly, the traditional male activities of science and mathematics, history and philosophy are built into the curriculum of the educated person even as activities traditionally assigned to females are ignored.

Do not misunderstand: I am not suggesting that the curriculum Rousseau prescribed for Sophie should become the norm or that cooking and sewing should be placed on a par with science and history. An education for coquetry and guile is not good for either sex; and, while there is nothing wrong with both sexes learning how to cook and sew, I am not advocating that these skills be incorporated into the liberal curriculum. Nor am I endorsing Pestalozzi's claim that Gertrude's particular mode of teaching should be a model for all to emulate. My point is, rather, that when the activities and experiences traditionally associated with women are excluded from the educational realm and when that realm is defined in terms of male activities and experiences, then these become the educational norms for all human beings.

It has been shown that psychological theories of development have difficulty incorporating findings about females because they are derived from male data.[49] It should now be clear that the paradigms of analytic philosophy of education are also based on male data. The examples which generate the rationality theory of teaching, Peters's concept of education and the educated person, and Hirst's theory of liberal education all derive from male experience. The response of the psychologists to the difficulty presented them by female data is to impose on their female subjects a masculine mold. The response of philosophers of education to female data is similar: Gertrude's teaching is at best defective; education for carrying on the reproductive processes of society is at best illiberal. Thus, the male norms which are implicit in the concepts and theories of philosophy of education today devalue women, and thereby serve patriarchal policy. But this is only part of the story. A corollary of this devaluation of women is that men are denied an education for carrying out the reproductive processes of society. In this way, the traditional sexual division of labor is supported.

Reconstituting the Educational Realm

The exclusion of women from the educational realm harms not only women; the field of philosophy of education itself is adversely affected. As the example of Rousseau's *Emile* illustrates, interpretations of works by major educational thinkers in which the education of both males and females is discussed will be deficient when they are based solely on material concerned with males. My discussion of the rationality theory of teaching—a theory which is quite implausible as an account of the teaching of young children—makes clear that analyses of concepts are likely to be inadequate when the cases which inform them and against which they are tested are derived solely from male experience. Furthermore, when gender is not seen to be a relevant educational category, important questions are begged.

When the educational realm embodies only male norms, it is inevitable that any women participating in it will be forced into a masculine mold. The question of whether such a mold is desirable for females needs to be asked, but it cannot be asked so long as philosophers of education assume that gender is a difference which makes no difference.[50] The question of whether the mold is desirable for males also needs to be asked; yet when our educational concepts and ideals are defined in male terms, we do not think to inquire into their validity for males themselves.

Perhaps the most important concern is that, when the educational realm makes women invisible, philosophy of education cannot provide an adequate answer to the question of what constitutes an educated person. Elsewhere I have argued at some length that Hirst's account of liberal education is seriously deficient—it presupposes a divorce of mind from body, thought from action, and reason from feeling and emotion—and that, since Peters's educated person is for all intents and purposes Hirst's liberally educated person, Peters's conception should be rejected.[51] Simply put, it is far too narrow to serve as an ideal which guides the educational enterprise and to which value is attached: it provides at best an ideal of an educated *mind*, not of an educated *person*, although, to the extent that its concerns are strictly cognitive, even in this sense it leaves much to be desired.

An adequate ideal of the educated person must join thought to action, and reason to feeling and emotion. As I pointed out in an earlier section, however, liberal education is designed to prepare people to carry on the productive processes of society, in particular those involving the production and consumption of ideas. Thus Peters's educated person is intended to inhabit a world in which feelings and emotions such as caring, compassion, empathy, and nurturance have no legitimate role to play. To incorporate these into a conception of the educated person would be to introduce traits which were not merely irrelevant to the desired end, but very likely incompatible with it.

Peters's conception of the educated person is untenable, yet the remedy for its narrow intellectualism is unavailable to philosophers of education as long as the criteria for what falls within the educational realm mirrors the distinction between the productive and the reproductive processes of society. An adequate conception of the educated person must join together what Peters and Hirst have torn asunder: mind and body; thought and action; and reason, feeling, and emotion. To do this the educational realm must be reconstituted to include the reproductive processes of society.

It is important to understand that the exclusion of both women and the reproductive processes of society from the educational realm by philosophy of education is a consequence of the structure of the discipline and not simply due to an oversight which is easily corrected. Thus, philosophical inquiry into the nature of those processes or into the education of women cannot simply be grafted onto philosophy of education as presently constituted. On the contrary, the very subject matter of the field must be redefined.

Such a redefinition ought to be welcomed by practitioners in the field, for there is every reason to believe that it will ultimately enrich the discipline. As the experiences and activities which have traditionally belonged to women come to be included in the educational realm, a host of challenging and important issues and problems will arise. When philosophy of education investigates questions about childrearing and the

transmission of values, when it develops accounts of gender education to inform its theories of liberal education, when it explores the forms of thinking, feeling, and acting associated with childrearing, marriage, and the family, when the concept of coeducation and concepts such as mothering and nurturance become subjects for philosophical analysis, philosophy of education will be invigorated.

New questions can be asked when the educational realm is reconstituted, and old questions can be given more adequate answers. When Gertrude, Sophie, and Plato's female guardians are taken seriously by historians of educational thought and when Rousseau's philosophy of education is counterbalanced by those of Wollstonecraft, Beecher, and Gilman, the theories of the great historical figures will be better understood. When analyses of the concept of teaching take childrearing activities to be central, insight into that prime educational process will be increased When the activities of family living and childrearing fall within the range of worthwhile activities, theories of curriculum will be more complete.

It is of course impossible to know now the precise contours of a reconstituted educational realm, let alone to foresee the exact ways in which the inclusion of women and the reproductive processes of society will enrich the discipline of philosophy of education. Yet the need for a redefinition of its subject matter is imperative if philosophy of education is to cease serving patriarchal policy. The promise of enrichment is real.

Notes

This essay was written while I was a fellow at the Mary Ingraham Bunting Institute, Radcliffe College. I wish to thank Naomi Chazan, Anne Costain, Ann Diller, Carol Gilligan, Diane Margolis, Michael Martin, Beatrice Nelson, and Janet Farrell Smith for helpful comments on the original draft.

1. See Kathryn Pyne Parsons, "Moral Revolution," in *The Prism of Sex*, ed. Julia A. Sherman and Evelyn Torton Beck (Madison: Univ. of Wisconsin Press, 1979), pp. 189–227; and Lawrence Blum, "Kant's and Hegel's Moral Rationalism: A Feminist Perspective," *Canadian Journal of Philosophy*, forthcoming.

2. Jane Roland Martin, "Sophie and Emile: A Case Study of Sex Bias in the History of Educational Thought," *Harvard Educational Review*, 51 (1981), 357–372.

3. See Robert Ulich, ed., *Three Thousand Years of Educational Wisdom* (Cambridge, Mass.: Harvard Univ. Press, 1948) and his *History of Educational Thought* (New York: American Book, 1945); Robert S. Brumbaugh and Nathaniel M. Lawrence, *Philosophers on Education: Six Essays on the Foundations of Western Thought* (Boston: Houghton Mifflin, 1963); Paul Nash, Andreas M. Kazemias, and Henry J. Perkinson, ed., *The Educated Man: Studies in the History of Educational Thought* (New York: Wiley, 1965); Kingsley Price, *Education and Philosophical Thought*, 2nd ed. (Boston: Allyn & Bacon, 1967); Paul Nash, comp., *Models of Man: Explorations in the Western Educational Tradition* (New York: Wiley, 1968); and Steven M. Cahn, comp., *The Philosophical Foundations of Education* (New York: Harper & Row, 1970).

4. For example, although Brumbaugh and Lawrence call Plato "the great educational revolutionist of his time" in part because of his "insistence on the equality of women" (*Philosophers on Education*, p. 38), they say not another word about that insistence. Robert S. Rusk, who presents Plato's position on the education of women in some detail in his anthology, is apparently so distressed by it that he says what any reader of the *Republic* knows to be false, namely, "Plato can only secure the unity of the state *at the cost of sacrificing all differences*" (*The Doctrines of the Great Educators*, rev. 3rd ed. [New York: St. Martin's, 1965], pp. 28–29, emphasis added). Nash comments that Plato's model of the educated person applies "only to those rare men *and rarer women* who are capable of understanding the underlying harmony of the universe," (*Models of Man*, p. 9, emphasis added) without acknowledging that Plato himself never makes a comparative judgment of the ability of males and females in his Just State to grasp The Good.

5. Pierce, "Equality: *Republic* V," *The Monist*, 57 (1973), 1–11.

6. See, for example, John Dewey, "Is Coeducation Injurious to Girls?," *Ladies' Home Journal*, 28 (1911), pp. 60–61; Thomas Henry Huxley, "Emancipation—Black and White," *Lay Sermons, Addresses, and Reviews* (New York: Appleton, 1870; rpt. in Nash, pp. 285–288).

7. Nash, *Models of Man*.

8. Kate Silber, *Pestalozzi* (New York: Schocken Books, 1965), p. 42.

9. John Heinrich Pestalozzi, *Leonard and Gertrude*, trans. Eva Channing (Boston: Heath, 1885), ch. 22.

10. Silber, p. 42.

11. Rusk, ch. 12.

12. *A Vindication of the Rights of Woman* (New York: Norton, 1967); see also Mary Wollstonecraft Godwin, *Thoughts on the Education of Daughters* (Clifton, NJ: Kelley Publishers, 1972).

13. *Letters on Education*, ed. Gina Luria (New York: Garland, 1974). For discussions of Macaulay's life and works, see Florence S. Boos, "Catherine Macaulay's *Letters on Education* (1790): An Early Feminist Polemic," *University of Michigan Papers in Women's Studies*, 2 (1976), 64–78; Florence Boos and William Boos, "Catherine Macaulay: Historian and Political Reformer," *International Journal of Women's Studies*, 3 (1980), 49–65.

14. For a list of Beecher's published works, see Kathryn Kish Sklar, *Catharine Beecher: A Study in American Domesticity* (New York: Norton, 1973).

15. *Herland* (New York: Pantheon Books, 1979).

16. "The Rights of Women: The Theory and Practice of the Ideology of Male Supremacy," in *Contemporary Issues in Political Philosophy*, ed. William R. Shea and John King-Farlow (New York: Science History Publications, 1976), pp. 49–65.

17. See Susan Moller Okin, *Women in Western Political Thought* (Princeton: Princeton Univ. Press, 1979), ch. 6; Lynda Lange, "Rousseau: Women and the General Will," in *The Sexism of Social and Political Theory*, ed. Lorenne M. G. Clark and Lynda Lange (Toronto: Univ. of Toronto Press, 1979), pp. 41–52; and Martin, "Sophie and Emile."

18. See Marvin Lazerson and W. Norton Grubb, ed., *American Education and Vocationalism* (New York: Teachers College Press, 1974).

19. Rousseau, ch. 5. For the account of liberal education which dominates the thinking of philosophers of education today see Paul H. Hirst, "Liberal Education and the Nature of Knowledge," in *Philosophical Analysis and Education*, ed. Reginald D. Archambault (London: Routledge & Kegan Paul, 1965), pp. 113–138; rpt. in Paul H. Hirst, *Knowledge and the Curriculum* (London: Routledge & Kegan Paul, 1974). Page references will be to this volume.

20. I recognize that I have omitted from this discussion all reference to home economics education. Briefly, home economics education has historically been classified as vocational educa-

tion (see Lazerson and Grubb). However, in the form which is relevant to the present discussion, namely, the preparation of women for their place in the home, it lacks the distinguishing mark of other vocational studies in that it is not intended as training for jobs in the marketplace. Furthermore, contemporary philosophy of education has seldom, if ever, recognized its existence.

21. *Ethics and Education* (Glenview, Ill.: Scott, Foresman, 1967), pp. 2, 3.

22. Peters, p. 17.

23. Peters, p. 27.

24. See Peters, "What is an Educational Process?," in *The Concept of Education*, ed. R. S. Peters (London: Routledge & Kegan Paul, 1967); Paul H. Hirst and R. S. Peters, *The Logic of Education* (London: Routledge & Kegan Paul, 1970); R. S. Peters, "Education and the Educated Man," in *A Critique of Current Educational Aims*, ed. R. F. Dearden, Paul H. Hirst, and R. S. Peters (London: Routledge & Kegan Paul, 1972); R. S. Peters, J. Woods, and W. H. Dray, "Aims of Education—A Conceptual Inquiry," in *The Philosophy of Education*, ed. R. S. Peters (London: Oxford Univ. Press, 1973).

25. See, for example, Peters, "Education and the Educated Man," p. 8.

26. In this section and the ones to follow I will only be discussing paradigms of analytic philosophy of education. There are other schools within philosophy of education, but this one dominates the field today as the recent N.S.S.E. Yearbook, *Philosophy and Education*, testifies (ed. Jonas Soltis [Chicago: The National Society for the Study of Education, 1981]).

27. Pestalozzi, pp. 87–88.

28. Pestalozzi, p. 44.

29. "Maternal Thinking," *Feminist Studies*, 6 (1980), 342–367.

30. Ruddick, p. 346.

31. I do not mean to suggest that these activities have been in the past or are now carried on exclusively by women. On the contrary, both men and women have engaged in them and do now. Our culture assigns women responsibility for them, however.

32. Peters, *Ethics and Education*, p. 8ff.

33. Peters, *Education as Initiation* (London: Evans Brothers, 1964), p. 35, emphasis added.

34. Hirst, "Liberal Education," p. 47.

35. For an extended critique of Hirst's analysis in this respect, see Jane Roland Martin, "Needed: A New Paradigm for Liberal Education," in *Philosophy and Education*, pp. 37–59.

36. In "Liberal Education," p. 46, Hirst listed the seven as: mathematics, physical sciences, human sciences, history, religion, literature and fine arts, and philosophy.

37. See Ruddick; Chodorow, *The Reproduction of Mothering* (Berkeley: Univ. of California Press, 1978); and Catharine M. Beecher, *Suggestions Respecting Improvements in Education* (Hartford, Conn.: Packard & Butler, 1829).

38. Martin, *Explaining, Understanding, and Teaching* (New York: McGraw-Hill, 1970), ch. 5.

39. "Concepts of Education: Reflections on the Current Scene," in Israel Scheffler, *Reason and Teaching* (Indianapolis: Bobbs-Merrill, 1973), p. 62.

40. *The Language of Education* (Springfield, Ill.: Thomas, 1960), p. 57.

41. See, for example, Thomas F. Green, "A Topology of the Teaching Concept," *Studies in Philosophy and Education*, 3 (1964–65), 284–319; and his "Teaching, Acting, and Behaving," *Harvard Educational Review* 34 (1964), 507–524.

42. Pestalozzi, p. 55.

43. Pestalozzi, p. 54.

44. Pestalozzi, p. 87.

45. Pestalozzi, pp. 88–89.

46. Philosophy of education is not alone in placing Gertrude and the mothers she represents in the "ontological basement." In ch. 2 of *Worlds Apart* (New York: Basic Books, 1978), Sara Lawrence Lightfoot discusses mothers and teachers but never acknowledges that mothers *qua* mothers teach.

47. These examples of mother-teachers are taken from Louisa May Alcott, *Little Women* (Boston: Little, Brown, 1936); and George Elliot, *Middlemarch* (Boston: Houghton Mifflin, 1956).

48. "Philosophy of Education: Some Recent Contributions," *Harvard Educational Review*, 50 (1980), 402–406.

49. See Carol Gilligan, "In a Different Voice: Women's Conceptions of Self and Morality," *Harvard Educational Review*, 47 (1977), 481–517; "Woman's Place in Man's Life Cycle," *Harvard Educational Review*, 49 (1979), 431–446.

50. Jane Roland Martin, "Sex Equality and Education," in *"Femininity," "Masculinity," and "Androgyny": A Modern Philosophical Discussion*, ed. Mary Vetterling-Braggin (Totowa, NJs: Littlefield, Adams, 1982).

51. Martin, "Needed: A Paradigm for Liberal Education"; "The Ideal of the Educated Person," *Educational Theory*, forthcoming.

Race, Class, and Gender

Prospects for an All-Inclusive Sisterhood

Bonnie Thornton Dill

University of Maryland

The concept of sisterhood has been an important unifying force in the contemporary women's movement. By stressing the similarities of women's secondary social and economic positions in all societies and in the family, this concept has been a binding force in the struggle against male chauvinism and patriarchy. However, as we review the past decade, it becomes apparent that the cry "Sisterhood is powerful!" has engaged only a few segments of the female population in the United States. Black, Hispanic, Native American, and Asian American women of all classes, as well as many working-class women, have not readily identified themselves as sisters of the white middle-class women who have been in the forefront of the movement.

This article examines the applications of the concept of sisterhood and some of the reasons for the limited participation of racially and ethnically distinct women in the women's movement, with particular reference to the experience and consciousness of Afro-American women. The first section presents a critique of sisterhood as a binding force for all women and examines the limitations of the concept for both theory and practice when applied to women who are neither white nor middle class. In the second section, the importance of women's perception of themselves and their place in society is explored as a way of understanding the differences and similarities between Black and white women. Data from two studies, one of college-educated Black women and the other of Black female household workers, are presented to illuminate both the ways in which the structures of race, gender, and class intersect in the lives of Black women and the women's perceptions of the impact of these structures on their lives. This article concludes with a discussion of the prospects for sisterhood and suggests political strategies that may provide a first step toward a more inclusive women's movement.

The Limitations of Sisterhood

In a recent article, historian Elizabeth Fox-Genovese provided a political critique of the concept of sisterhood.[1] Her analysis identifies some of the current limitations of this concept as a rallying point for women across the boundaries of race and class. Sisterhood is generally understood as a nurturant, supportive feeling of attachment and loyalty to other women which grows out of a shared experience of oppression. A term reminiscent of familial relationships, it tends to focus upon the particular nurturant and reproductive roles of women and, more recently, upon commonalities of personal experience. Fox-Genovese suggests that sisterhood has taken two different political directions. In one, women have been treated as unique, and sisterhood was used as a basis for seeking to maintain a separation between the competitive values of the world of men (the public-political sphere) and the nurturant values of the world of women (the private-domestic sphere). A second, more recent, and progressive expression of the concept views sisterhood as an element of the feminist movement which serves as a means for political and economic action based upon the shared needs and experiences of women. Both conceptualizations of sisterhood have limitations in encompassing the racial and class differences among women. These limitations have important implications for the prospects of an all-inclusive sisterhood.

Fox-Genovese argues that the former conceptualization, which she labels bourgeois individualism, resulted in "the passage of a few middle class women into the public sphere," but sharpened the class and racial divisions between them and lower-class minority women.[2] In the latter conceptualization, called the politics of personal experience, sisterhood is restricted by the experiential differences that result from the racial and class divisions of society.

> Sisterhood has helped us, as it helped so many of our predecessors, to forge ourselves as political beings. Sisterhood has mobilized our loyalty to each other and hence to ourselves. It has given form to a dream of genuine equality for women. But without a broader politics directed toward the kind of social transformation that will provide social justice for all human beings, it will, in a poignant irony, result in our dropping each other by the wayside as we compete with rising desperation for crumbs.[3]

These two notions of sisterhood, as expressed in the current women's movement, offer some insights into the alienation many Black women have expressed about the movement itself.

The bourgeois individualistic theme present in the contemporary women's movement led many Black women to express the belief that the movement existed merely to satisfy needs for personal self-fulfillment on the part of white middle-class women.[4] The emphasis on participation in the paid labor force and escape from the confines of the home, seemed foreign to many Black women. After all, as a group they had had higher rates of paid labor force participation than their white counterparts for centuries, and

many would have readily accepted what they saw as the "luxury" of being a housewife. At the same time, they expressed concern that white women's gains would be made at the expense of Blacks and/or that having achieved their personal goals, these so-called sisters would ignore or abandon the cause of racial discrimination. Finally, and perhaps most important, the experiences of racial oppression made Black women strongly aware of their group identity and consequently more suspicious of women who, initially at least, defined much of their feminism in personal and individualistic terms.

Angela Davis, in "Reflections on the Black Woman's Role in the Community of Slaves," stresses the importance of group identity for black women. "Under the impact of racism the black woman has been continually constrained to inject herself into the desperate struggle for existence. . . . As a result, black women have made significant contributions to struggles against racism and the dehumanizing exploitation of a wrongly organized society. In fact, it would appear that the intense levels of resistance historically maintained by black people and thus the historical function of the Black liberation struggle as harbinger of change throughout the society are due in part to the greater objective equality between the black man and the black woman."[5] The sense of being part of a collective movement toward liberation has been a continuing theme in the autobiographies of contemporary black women.

> Ideas and experiences vary, but Shirley Chisholm, Gwendolyn Brooks, Angela Davis and other Black women who wrote autobiographies during the seventies offer similar . . . visions of the black woman's role in the struggle for Black liberation. The idea of collective liberation . . . says that society is not a protective arena in which an individual black can work out her own destiny and gain a share of America's benefits by her own efforts. . . . Accordingly, survival, not to mention freedom, is dependent on the values and actions of the groups as a whole, and if indeed one succeeds or triumphs it is due less to individual talent than to the group's belief in and adherence to the idea that freedom from oppression must be acted out and shared by all.[6]

Sisterhood is not new to Black women. It has been institutionalized in churches. In many black churches, for example, membership in the church entitles one to address the women as "sisters" and the men as "brothers." Becoming a sister is an important rite of passage which permits young women full participation in certain church rituals and women's clubs where these nurturant relationships among women are reinforced.[7] Sisterhood was also a basis for organization in the club movements that began in the late 1800s.[8] Finally, it is clearly exemplified in Black extended family groupings that frequently place great importance on female kinship ties. Research on kinship patterns among urban Blacks identifies the nurturant and supportive feelings existing among female kin as a key element in family stability and survival.[9]

While Black women have fostered and encouraged sisterhood, we have not used it as the anvil to forge our political identities. This contrasts sharply with the experiences of many middle-class white women who have participated in the current women's

movement. The political identities of Afro-American women have largely been formed around issues of race. National organizations of Black women, many of which were first organized on the heels of the nineteenth-century movement for women's rights, "were (and still are) decidedly feminist in the values expressed in their literature and in many of the concerns which they addressed, yet they also always focused upon issues which resulted from the racial oppression affecting *all* black people."[10] This commitment to the improvement of the race has often led Black women to see feminist issues quite differently from their white sisters. And, racial animosity and mistrust have too often undermined the potential for coalition between Black and white women since the women's suffrage campaigns.

Many contemporary white feminists would like to believe that relations between black and white women in the early stages of the women's movement were characterized by the beliefs and actions of Susan B. Anthony, Angelina Grimke, and some others. The historical record suggests however, that these women were more exceptional than normative. Rosalyn Terborg-Penn argues that "discrimination against Afro-American women reformers was the rule rather than the exception within the woman's rights movement from the 1830's to 1920."[11] Although it is beyond the scope of this article to provide a detailed discussion of the incidents that created mistrust and ill-feeling between black and white women, the historical record provides an important legacy that still haunts us.

The movement's early emphasis upon the oppression of women within the institution of marriage and the family, and upon educational and professional discrimination, reflected the concerns of middle-class white women. During that period, Black women were engaged in a struggle for survival and a fight for freedom. Among their immediate concerns were lynching and economic viability. Working-class white women were concerned about labor conditions, the length of the working day, wages, and so forth. The statements of early women's rights groups do not reflect these concerns, and "as a rigorous consummation of the consciousness of white middle-class women's dilemma, the (Seneca Falls) Declaration all but ignored the predicament of white working-class women, as it ignored the condition of Black women in the South and North alike."[12]

Political expediency drove white feminists to accept principles that were directly opposed to the survival and well-being of blacks in order to seek to achieve more limited advances for women. "Besides the color bar which existed in many white women's organizations, black women were infuriated by white women's accommodation to the principle of lynch law in order to gain support in the South (Walker, 1973) and the attacks of well-known feminists against anti-lynching crusader, Ida Wells Barnett."[13]

The failure of the suffrage movement to sustain its commitment to the democratic ideal of enfranchisement for all citizens is one of the most frequently cited instances of white women's fragile commitment to racial equality. "After the Civil War, the suffrage movement was deeply impaired by the split over the issue of whether black males should receive the vote before white and black women . . . in the heated pressures over whether black men or white and black women should be enfranchised first, a classist, racist, and even xenophobic rhetoric crept in."[14] The historical and continued abandonment of universalistic principles in order to benefit a privileged few on the part of white

women is, I think, one of the reasons why Black women today have been reluctant to see themselves as part of a sisterhood that does not extend beyond racial boundaries. Even for those Black women who are unaware of the specific history, there is the recognition that under pressure from the white men with whom they live and upon whom they are economically dependent, many white women will abandon their "sisters of color" in favor of self-preservation. The feeling that the movement would benefit white women and abandon Blacks, or benefit whites at the expense of Blacks, is a recurrent theme. Terborg-Penn concludes, "The black feminist movement in the United States during the mid 1970's is a continuation of a trend that began over 150 years ago. Institutionalized discrimination against black women by white women has traditionally led to the development of racially separate groups that address themselves to race determined problems as well as the common plight of women in America."[15]

Historically, as well as currently, Black women have felt called upon to choose between their commitments to feminism and to the struggle against racial injustice. Clearly they are victims of both forms of oppression and are most in need of encouragement and support in waging battles on both fronts. However, insistence on such a choice continues largely as a result of the tendency of groups of Blacks and groups of women to battle over the dubious distinction of being the "most" oppressed. The insistence of radical feminists upon the historical priority, universality, and overriding importance of patriarchy in effect necessitates acceptance of a concept of sisterhood that places one's womanhood over and above one's race. At the same time, Blacks are accustomed to labeling discriminatory treatment as racism and therefore may tend to view sexism only within the bounds of the Black community rather than see it as a systemic pattern.[16] On the one hand, the choice between identifying as black or female is a product of the "patriarchal strategy of divide-and-conquer"[17] and therefore, a false choice. Yet, the historical success of this strategy and the continued importance of class, patriarchal, and racial divisions, perpetuate such choices both within our consciousness and within the concrete realities of our daily lives.

Race, of course, is only one of the factors that differentiate women. It is the most salient in discussions of Black and white women, but it is perhaps no more important, even in discussions of race and gender, than is the factor of class. Inclusion of the concept of class permits a broader perspective on the similarities and differences between Black and white women than does a purely racial analysis. Marxist feminism has focused primarily upon the relationship between class exploitation and patriarchy. While this literature has yielded several useful frameworks for beginning to examine the dialectics of gender and class, the role of race, though acknowledged, is not explicated.

Just as the gender-class literature tends to omit race, the race-class literature gives little attention to women. Recently, this area of inquiry has been dominated by a debate over the relative importance of race or class in explaining the historical and contemporary status of Blacks in this country. A number of scholars writing on this issue have argued that the racial division of labor in the United States began as a form of class exploitation which was shrouded in an ideology of racial inferiority. Through the course of U.S. history, racial structures began to take on a life of their own and cannot now

be considered merely reflections of class structure.[18] A theoretical understanding of the current conditions of Blacks in this country must therefore take account of both race and class factors. It is not my intention to enter into this debate, but instead to point out that any serious study of Black women must be informed by this growing theoretical discussion. Analysis of the interaction of race, gender, and class fall squarely between these two developing bodies of theoretical literature.

Black women experience class, race, and sex exploitation simultaneously, yet these structures must be separated analytically so that we may better understand the ways in which they shape and differentiate women's lives. Davis, in her previously cited article, provides one of the best analyses to date of the intersection of gender, race, and class under a plantation economy.[19] One of the reasons this analysis is so important is because she presents a model that can be expanded to other historical periods. However, we must be careful not to take the particular historical reality which she illuminated and read it into the present as if the experiences of Black women followed some sort of linear progression out of slavery. Instead, we must look carefully at the lives of Black women throughout history in order to define the peculiar interactions of race, class, and gender at particular historical moments.

In answer to the question: Where do Black women fit into the current analytical frameworks for race and class and gender and class? I would ask: How might these frameworks be revised if they took full account of black women's position in the home, family, and marketplace at various historical moments? In other words, the analysis of the interaction of race, gender, and class must not be stretched to fit the proscrustean bed of any other burgeoning set of theories. It is my contention that it must begin with an analysis of the ways in which Black people have been used in the process of capital accumulation in the United States. Within the contexts of class exploitation and racial oppression, women's lives and work are most clearly illuminated. Davis's article illustrates this. Increasingly, new research is being presented which grapples with the complex interconnectedness of these three issues in the lives of Black women and other women of color.[20]

Perceptions of Self in Society

For Black women and other women of color an examination of the ways in which racial oppression, class exploitation, and patriarchy intersect in their lives must be studied in relation to their perceptions of the impact these structures have upon them. Through studying the lives of particular women and searching for patterns in the ways in which they describe themselves and their relationship to society, we will gain important insights into the differences and similarities between Black and white women.

The structures of race and class generate important economic, ideological, and experiential cleavages among women. These lead to differences in perception of self and their place in society. At the same time, commonalities of class or gender may cut across racial lines providing the conditions for shared understanding. Studying these interactions

through an examination of women's self perceptions is complicated by the fact that most people view their lives as a whole and do not explain their daily experiences or world view in terms of the differential effects of their racial group, class position, or gender. Thus, we must examine on an analytical level the ways in which the structures of class, race, and gender intersect in any woman's or group of women's lives in order to grasp the concrete set of social relations that influence their behavior. At the same time, we must study individual and group perceptions, descriptions, and conceptualizations of their lives so that we may understand the ways in which different women perceive the same and different sets of social structural constraints.

Concretely, and from a research perspective, this suggests the importance of looking at both the structures which shape women's lives and their self-presentations. This would provide us not only with a means of gaining insight into the ways in which racial, class, and gender oppression are viewed, but also with a means of generating conceptual categories that will aid us in extending our knowledge of their situation. At the same time, this new knowledge will broaden and even reform our conceptualization of women's situations.

For example, how would our notions of mothering, and particularly mother-daughter relationships, be revised if we considered the particular experiences and perceptions of Black women on this topic? Gloria I. Joseph argues for, and presents a distinctive approach to the study of black mother-daughter relationships, asserting that

> to engage in a discussion of Black mothers and daughters which focused on specific psychological mechanisms operating between the two, the dynamics of the crucial bond, and explanations for the explicit role of patriarchy, without also including the important relevancy of racial oppression . . . would necessitate forcing Black mother/daughter relationships into pigeonholes designed for understanding white models.
>
> In discussing Black mothers and daughters, it is more realistic, useful, and intellectually astute to speak in terms of their roles, positions, and functions within the Black society and that society's relationship to the broader (White) society in America.[21]

Unfortunately, there have been very few attempts in the social sciences to systematically investigate the relationship between social structure and self perceptions of Black women. The profiles of Black women that have been appearing in magazines like *Essence*, the historical studies of Black women, fiction and poetry by and about Black women, and some recent sociological and anthropological studies provide important data for beginning such an analysis. However, the question of how Black women perceive themselves with regard to the structures of race, gender, and class is still open for systematic investigation.

Elizabeth Higginbotham, in a study of Black women who graduated from college between 1968 and 1970, explored the impact of class origins upon strategies for educational attainment. She found that class differences within the Black community led not only to different sets of educational experiences, but also to different personal priorities

and views of the Black experience.[22] According to Higginbotham, the Black women from middle-class backgrounds who participated in her study had access to better schools and more positive schooling experiences than did their working-class sisters. Because their parents did not have the economic resources to purchase the better educational opportunities offered in an integrated suburb or a private school, the working-class women credited their parents' willingness to struggle within the public school system as a key component in their own educational achievement. Social class also affected college selections and experience. Working-class women were primarily concerned with finances in selecting a college and spent most of their time adjusting to the work load and the new middle-class environment once they had arrived. Middle-class women, on the other hand, were freer to select a college that would meet their personal, as well as their academic, needs and abilities. Once there, they were better able to balance their work and social lives and to think about integrating future careers and family lives.

Among her sample, Higginbotham found that a larger proportion of women from working-class backgrounds were single. She explained this finding in terms of class differences in socialization and mobility strategies. She found that the parents of women from working-class backgrounds stressed educational achievement over and above other personal goals.[23] These women never viewed marriage as a means of mobility and focused primarily upon education, postponing interest in, and decisions about, marriage. In contrast, women from middle-class backgrounds were expected to marry and were encouraged to integrate family and educational goals throughout their schooling.

My own research on household workers demonstrates the ways in which class origins, racial discrimination, and social conceptions of women and women's work came together during the first half of the twentieth century to limit work options and affect family roles and the self perceptions of one group of Afro-American women born between 1896 and 1915.[24] Most of them were born in the South and migrated North between 1922 and 1955. Like the majority of black working women of this period, they worked as household workers in private homes. (During the first half of the twentieth century, labor force participation rates of Black women ranged from about 37 percent to 50 percent. Approximately 60 percent of black women workers were employed in private household work up until 1960.)[25]

The women who participated in this study came from working-class families. Their fathers were laborers and farmers, their mothers were housewives or did paid domestic work of some kind (cooking, cleaning, taking in washing, and so forth). As a result, the women not only had limited opportunities for education, but also often began working when they were quite young to help support their families. Jewell Prieleau (names are pseudonyms used to protect the identity of the subjects), one of eight children, described her entrance into work as follows: "When I was eight years old, I decided I wanted a job and I just got up early in the morning and I would go from house to house and ring doorbells and ask for jobs and I would get it. I think I really wanted to work because in a big family like that, they was able to feed you, but you had to earn your shoes. They couldn't buy shoes although shoes was very cheap at that time. I would rather my mother give it to the younger children and I would earn my way."

Queenie Watkins lived with her mother, aunt, and five cousins and began working in grammar school. She described her childhood jobs in detail.

> When I went to grammar school, the white ladies used to come down and say "Do you have a girl who can wash dishes?" That was how I got the job with the doctor and his wife. I would go up there at six o'clock in the morning and wash the breakfast dishes and bring in scuttles of coal to burn on the fireplace. I would go back in the afternoon and take the little girl down on the sidewalk and if there were any leaves to be raked on the yard, I'd rake the leaves up and burn them and sweep the sidewalk. I swept off the front porch and washed it off with the hose and washed dishes again—for one dollar a week.

While class position limited the economic resources and educational opportunities of most of these women, racial discrimination constricted work options for Black women in such a way as to seriously undercut the benefits of education. The comments of the following women are reflective of the feelings expressed by many of those in this sample:

> When I came out of school, the black man naturally had very few chances of doing certain things and even persons that I know myself who had finished four years of college were doing the same type of work because they couldn't get any other kind of work in New York.
>
> In my home in Virginia, education, I don't think was stressed. The best you could do was be a school teacher. It wasn't something people impressed upon you you could get. I had an aunt and cousin who were trained nurses and the best they could do was nursing somebody at home or something. They couldn't get a job in a hospital. I didn't pay education any mind really until I came to New York. I'd gotten to a certain stage in domestic work in the country and I didn't see the need for it.
>
> Years ago there was no such thing as a black typist. I remember girls who were taking typing when I was going to school. They were never able to get a job at it. In my day and time you could have been the greatest typist in the world but you would never have gotten a job. There was no such thing as getting a job as a bank teller. The blacks weren't even sweeping the banks.

For Black women in the United States, their high concentration in household work was a result of racial discrimination and a direct carry-over from slavery. Black women were in essence "a permanent service caste in nineteenth and twentieth century America."[26] Arnold Anderson and Mary Jean Bowman argue that the distinguishing feature of domestic service in the United States is that "the frequency of servants is correlated with the availability of Negroes in local populations."[27] By the time most of the women in this sample entered the occupation a racial caste pattern was firmly established. The occupation was dominated by foreign-born white women in the North, and Black

freedwomen in the South, a pattern which was modified somewhat as southern Blacks migrated north. Nevertheless, most research indicates that Black women fared far worse than their white immigrant sisters, even in the North. "It is commonly asserted that the immigrant woman has been the northern substitute for the Negro servant. In 1930, when one can separate white servants by nativity, about twice as large a percentage of foreign as of native women were domestics. . . . As against this 2:1 ratio between immigrants and natives, the ratio of Negro to white servants ranged upward from 10:1 to 50:1. The immigrant was not the northerner's Negro."[28]

Two major differences distinguished the experiences of Black domestics from that of their immigrant sisters. First, Black women had few other employment options. Second, Black household workers were older and more likely to be married. Thus, while private household work cross-culturally, and for white women in the United States, was often used as a stepping-stone to other working-class occupations, or as a way station before marriage, for Black American women it was neither. This pattern did not begin to change substantially until World War II.

Table 1. Percentage of Females of Each Nativity in U.S. Labor Force Who Were Servants, by Decades, 1900–1940

	1900	1910	1920	1930	1940
Native white	22.3	15.0	9.6	10.4 ⎫	11.0
Foreign-born white	42.5	34.0	23.8	26.8 ⎭	
Negro	41.9	39.5	44.4	54.9	54.4
Other	24.8	22.9	22.9	19.4	16.0
Total	30.5	24.0	17.9	19.8	17.2
(N, in thousands)	(1,439)	(1,761)	(1,386)	(1,906)	(1,931)
(Percent of all domestic servants)	(95.4)	(94.4)	(93.3)	(94.1)	(92.0)

Source: George J. Stigler, *Domestic Servants in the United States: 1900–1940,* Occasional Paper no. 24 (New York: National Bureau of Economic Research, 1946), p. 7.

Table 1 indicates that between 1900 and 1940 the percentage of Black women in domestic service actually increased, relative to the percentage of immigrant women which decreased. The data support the contention that Black women were even more confined to the occupation than their immigrant sisters. At the turn of the century, large numbers of immigrants entered domestic service. Their children, however, were much less likely to become household workers. Similarly, many Black women entered domestic service at that time, but their children tended to remain in the occupation. It was the daughters and granddaughters of the women who participated in this study that were among the first generation of Black women to benefit from the relaxation of racial restrictions which began to occur after World War II.

Finally, Black women were household workers because they were women. Private household work is women's work. It is a working-class occupation, has low social status, low pay, and few guaranteed fringe benefits. Like the housewife who employs her, the private household worker's low social status and pay is tied to the work itself, to her class, gender, and the complex interaction of the three within the family. In other words, housework, both paid and unpaid, is structured around the particular place of women in the family. It is considered unskilled labor because it requires no training, degrees, or licenses, and because it has traditionally been assumed that any woman could or should be able to do housework.

The women themselves had a very clear sense that the social inequities which relegated them and many of their peers to household service labor were based upon their race, class, and gender. Yet different women, depending upon their jobs, family situations, and overall outlooks on life, handled this knowledge in different ways. One woman described the relationship between her family and her employer's as follows: "Well for *their* children, I imagine they wanted them to become like they were, educators or something that-like [sic]. But what they had in for my children, they saw in me that I wasn't able to make all of that mark but raised my children in the best method I could. Because I wouldn't have the means to put *my* children through like they could for their children." When asked what she liked most about her work, she answered, "Well what I like most about it, the things that I weren't able to go to school to do for my children. I could kinda pattern from the families that I worked for, so that I could give my children the best of my abilities." A second woman expressed much more anger and bitterness about the social differences which distinguished her life from that of her female employer. "They don't know nothing about a hard life. The only hard life will come if they getting a divorce or going through a problem with their children. But their husband has to provide for them because they're not soft. And if they leave and they separate for any reason or (are) divorced, they have to put the money down. But we have no luck like that. We have to leave our children; sometime leave the children alone. There's times when I have asked winos to look after my children. It was just a terrible life and I really thank God that the children grow up to be nice." Yet while she acknowledged her posisiton as an oppressed person, she used her knowledge of the anomalies in her employers' lives—particularly the woman and her female friends—to aid her in maintaining her sense of self-respect and determination and to overcome feelings of despair and immobilization. When asked if she would like to switch places with her employers, she replied, "I don't think I would want to change, but I would like to live differently. I would like to have my own nice little apartment with my husband and have my grandchildren for dinner and my daughter and just live comfortable. But I would always want to work. . . . But, if I was to change life with them, I would like to have just a little bit of they money, that's all." While the women who participated in this study adopted different personal styles of coping with these inequities, they were all clearly aware that being black, poor, and female placed them at the bottom of the social structure, and they used the resources at their disposal to make the best of what they recognized as a bad situation.

Contemporary scholarship on women of color suggests that the barriers to an all-inclusive sisterhood are deeply rooted in the histories of oppression and exploitation that Blacks and other groups encountered upon incorporation into the American political economy.[29] These histories affect the social positions of these groups today, and racial ethnic women[30] in every social class express anger and distress about the forms of discrimination and insensitivity which they encounter in their interactions with white feminists. Audre Lorde has argued that the inability of women to confront anger is one of the important forces dividing women of color from white women in the feminist movement. She cites several examples from her own experience which resonate loudly with the experiences of most women of color who have been engaged in the women's movement.[31]

> After fifteen years of a women's movement which professes to address the life concerns and possible futures of all women, I still hear, on campus after campus, "How can we address the issues of racism? No women of color attended." Or, the other side of that statement, "We have no one in our department equipped to teach their work." In other words, racism is a Black women's problem, a problem of women of color, and only we can discuss it.
>
> White women are beginning to examine their relationships to Black women, yet often I hear you wanting only to deal with the little colored children across the roads of childhood, the beloved nursemaid, the occasional second-grade classmate. . . . You avoid the childhood assumptions formed by the raucous laughter at Rastus and Oatmeal . . . the indelible and dehumanizing portraits of Amos and Andy and your daddy's humorous bedtime stories.

bell hooks points to both the racial and class myopia of white feminists as a major barrier to sisterhood.

> When white women's liberationists emphasized work as a path to liberation, they did not concentrate their attention on those women who are most exploited in the American labor force. Had they emphasized the plight of working class women, attention would have shifted away from the college-educated suburban housewife who wanted entrance into the middle and upper class work force. Had attention been focused on women who were already working and who were exploited as cheap surplus labor in American society, it would have de-romanticized the middle class white woman's quest for "meaningful" employment. While it does not in any way diminish the importance of women resisting sexist oppression by entering the labor force, work has not been a liberating force for masses of American women.[32]

As a beginning point for understanding the potential linkages and barriers to an all-inclusive sisterhood, Lorde concludes that "the strength of women lies in recognizing differences between us as creative, and in standing to those distortions which we inherited

without blame but which are now ours to alter. The angers of women can transform differences through insight into power. For anger between peers births change, not destruction, and the discomfort and sense of loss it often causes is not fatal, but a sign of growth."[33]

Prospects for an All-Inclusive Sisterhood

Given the differences in experiences among Black women, the differences between Black and white women, between working-class and middle-class women, between all of us, what then are the prospects for sisterhood? While this article has sought to emphasize the need to study and explicate these differences, it is based upon the assumption that the knowledge we gain in this process will also help enlighten us as to our similarities. Thus, I would argue for the abandonment of the concept of sisterhood as a global construct based on unexamined assumptions about our similarities, and I would substitute a more pluralistic approach that recognizes and accepts the objective differences between women. Such an approach requires that we concentrate our political energies on building coalitions around particular issues of shared interest. Through joint work on specific issues, we may come to a better understanding of one another's needs and perceptions and begin to overcome some of the suspicions and mistrust that continue to haunt us. The limitations of a sisterhood based on bourgeois individualism or on the politics of personal experience presently pose a very real threat to combined political action.

For example, in the field of household employment, interest in the needs of a growing number of middle-class women to participate in the work force and thus find adequate assistance with their domestic duties (a form of bourgeois individualism) could all too easily become support for a proposal such as the one made by writer Anne Colamosca in a recent article in the *New Republic*.[34] She proposed solving the problems of a limited supply of household help with a government training program for unemployed alien women to help them become "good household workers." While this may help middle-class women pursue their careers, it will do so while continuing to maintain and exploit a poorly paid, unprotected, lower class and will leave the problem of domestic responsibility virtually unaddressed for the majority of mothers in the work force who cannot afford to hire personal household help. A socialist feminist perspective requires an examination of the exploitation inherent in household labor as it is currently organized for both the paid and unpaid worker. The question is, what can we do to upgrade the status of domestic labor for *all* women, to facilitate the adjustment and productivity of immigrant women, and to ensure that those who choose to engage in paid private household work do so because it represents a potentially interesting, viable, and economically rewarding option for them?

At the same time, the women's movement may need to move beyond a limited focus on "women's issues" to ally with groups of women and men who are addressing other aspects of race and class oppression. One example is school desegregation, an issue which is engaging the time and energies of many urban Black women today. The struggles over school desegregation are rapidly moving beyond the issues of busing

and racial balance. In many large cities, where school districts are between 60 percent and 85 percent Black, Hispanic, or Third World, racial balance is becoming less of a concern. Instead, questions are being raised about the overall quality of the educational experiences low-income children of all racial and ethnic groups are receiving in the public schools. This is an issue of vital concern to many racially and ethnically distinct women because they see their children's future ability to survive in this society as largely dependent upon the current direction of public education. In what ways should feminists involve themselves in this issue? First, by recognizing that feminist questions are only one group of questions among many others that are being raised about public education. To the extent that Blacks, Hispanics, Native Americans, and Asian Americans are mise-ducated, so are women. Feminist activists must work to expand their conceptualization of the problem beyond the narrow confines of sexism. For example, efforts to develop and include nonsexist literature in the school curriculum are important. Yet this work cannot exist in a vacuum, ignoring the fact that schoolchildren *observe* a gender-based division of labor in which authority and responsibility are held primarily by men while women are concentrated in nurturant roles; or that schools with middle-class students have more funds, better facilities, and better teachers than schools serving working-class populations. The problems of education must be addressed as structural ones. We must examine not only the kinds of discrimination that occur within institutions, but also the ways in which discrimination becomes a fundamental part of the institution's organization and implementation of its overall purpose. Such an analysis would make the linkages between different forms of structural inequality, like sexism and racism, more readily apparent.

While analytically we must carefully examine the structures that differentiate us, politically we must fight the segmentation of oppression into categories such as "racial issues," "feminist issues," and "class issues." This is, of course, a task of almost over-whelming magnitude, and yet it seems to me the only viable way to avoid the errors of the past and to move forward to make sisterhood a meaningful feminist concept for all women, across the boundaries of race and class. For it is through first seeking to understand struggles that are not particularly shaped by one's own immediate personal priorities that we will begin to experience and understand the needs and priorities of our sisters—be they black, brown, white, poor, or rich. When we have reached a point where the differences between us *enrich* our political and social action rather than divide it, we will have gone beyond the personal and will, in fact, be "political enough."

Notes

Dill, Bonnie Thornton, "Race, Class, and Gender: Prospects for an All-Inclusive Sister-hood." This article is reprinted from *Feminist Studies*, 9(1) (1983): 130–150, by permission of the publisher, *Feminist Studies* Inc., c/o Women's Studies Program, University of Maryland, College Park, MD 20742.

The author wishes to acknowledge the comments of Lynn Weber Cannon and Elizabeth Higginbotham on an earlier version of this article.

1. Elizabeth Fox-Genovese, "The Personal is not Political Enough," *Marxist Perspectives* (Winter 1979–80): 94–113.

2. Ibid., 97–98.

3. Ibid., 112.

4. For discussions of black women's attitudes toward the women's movement see Linda LaRue, "The Black Movement and Women's Liberation," *Black Scholar* 1 (May 1970): 36–42; Renee Ferguson "Women's Liberation has a Different Meaning for Blacks," in *Black Women in White America: A Documentary History,* ed. Gerda Lerner (New York: Pantheon, 1972); Inez Smith Reid, *"Together" Black Women* (New York: Emerson-Hall, 1972); Cheryl Townsend Gilkes, "Black Women's Work as Deviance: Social Sources of Racial Antagonism within Contemporary Feminism" (paper presented at the Seventy-fourth Annual Meeting of the American Sociological Association, Boston, August 1979).

5. Angela Davis, "Reflections on the Black Woman's Role in the Community of Slaves," *Black Scholar* 2 (December 1971): 15.

6. Mary Burgher, "Images of Self and Race," in *Sturdy Black Bridges*, ed. Roseann P. Bell, Bettye J. Parker, and Beverly Guy-Sheftall (Garden City, NY: Anchor Books, 1979), 118.

7. For a related discussion of black women's roles in the church, see Cheryl Townsend Gilkes, "Institutional Motherhood in Black Churches and Communities: Ambivalent Sexism or Fragmented Familyhood" (published paper).

8. For a discussion of the club movement among black women, see, in addition to Lerner's book, Alfreda Duster, ed., *Ida Barnett, Crusade for Justice: The Autobiography of Ida B. Wells* (Chicago: University of Chicago Press, 1970); Rackham Holt, *Mary McLeod Bethune: A Biography* (Garden City, NY: Doubleday & Co., 1964); Jeanne L. Noble, *Beautiful, Also, Are the Souls of My Black Sisters: A History of the Black Woman in America* (Englewood Cliffs, NJ: Prentice-Hall, 1978); Mary Church Terrell, *A Colored Woman in a White World* (Washington, DC: Ransdell Publishing Company, 1940).

9. Carol Stack, *All Our Kin* (New York: Harper & Row, 1970); and Elmer P. Martin and Joan Martin, *The Black Extended Family* (Chicago: University of Chicago Press, 1977).

10. Gilkes, "Black Women's Work as Deviance," 21.

11. Rosalyn Terborg-Penn, "Discrimination Against Afro-American Women in the Woman's Movement, 1830–1920," in *The Afro-American Woman: Struggles and Images*, ed. Sharon Harley and Rosalyn Terborg-Penn (Port Washington, NY: Kennikat Press, 1978), 17.

12. Angela Davis, *Women, Race, and Class* (New York: Random House, 1981), 54.

13. Gilkes, "Black Women's Work as Deviance," 19. In this quotation Gilkes cites Jay S. Walker, "Frederick Douglass and Woman Suffrage," *Black Scholar* 4 (7 June 1973).

14. Adrienne Rich, "'Disloyal to Civilization': Feminism, Racism, and Gynephobia," *Chrysalis*, no. 7 (1978): 14.

15. Terborg-Penn, 27.

16. Elizabeth Higginbotham, "Issues in Contemporary Sociological Work on Black Women," *Humanity and Society* 4 (November 1980): 226–42.

17. Rich, 15.

18. This argument has been suggested by Robert Blauner in *Racial Oppression in America* (New York: Harper & Row, 1972); and William J. Wilson in *The Declining Significance of Race: Blacks and Changing American Institutions* (Chicago: University of Chicago Press, 1978).

19. Davis, "Reflections on the Black Woman's Role."

20. See Cheryl Townsend Gilkes, "Living and Working in a World of Trouble. The Emergent Career of the Black Woman Community Worker" (PhD diss., Northeastern University, 1979); and Elizabeth Higginbotham, "Educated Black Women: An Exploration in Life Chances and Choices" (PhD diss., Brandeis University, 1980).

21. Gloria I. Joseph and Jill Lewis, *Common Differences: Conflicts in Black and White Feminist Perspectives* (Garden City, NY: Anchor Books, 1981), 75–76.

22. Higginbotham, "Educated Black Women."

23. Elizabeth Higginbotham, "Is Marriage a Priority? Class Differences in Marital Options of Educated Black Women" in *Single Life,* ed. Peter Stein (New York: St. Martin's Press, 1981), 262.

24. Bonnie Thornton Dill, "Across the Boundaries of Race and Class: An Exploration of the Relationship between Work and Family among Black Female Domestic Servants," (PhD diss., New York University, 1979).

25. For detailed data on the occupational distribution of black women during the twentieth century, see U.S. Bureau of the Census, *Historical Statistics of the United States: Colonial Times to 1970.* H. Doc. 83–78, (Washington, DC: GPO, 1973).

26. David Katzman, *Seven Days a Week: Women and Domestic Service in Industrializing America* (New York: Oxford University Press, 1978), 85.

27. Arnold Anderson and Mary Jean Bowman, "The Vanishing Servant and the Contemporary Status System of the American South," *American Journal of Sociology* 59 (November 1953): 216.

28. Ibid., 220.

29. Elizabeth Higginbotham, "Laid Bare by the System: Work and Survival for Black and Hispanic Women," forthcoming in Amy Swerdlow and Hannah Lessinger, *Race, Class, and Gender: The Dynamics of Control* (Boston: G. K. Hall); and Bonnie Thornton Dill, "Survival as a Form of Resistance: Minority Women and the Maintenance of Families" (Working Paper no. 7, Inter University Group on Gender and Race, Memphis State University, 1982).

30. The term "racial ethnic women" is meant as an alternative to either "minority," which is disparaging; "Third World," which has an international connotation; or "women of color," which lacks any sense of cultural identity. In contrast to "ethnic," which usually refers to groups that are culturally distinct but members of the dominant white society, "racial ethnic" refers to groups that are both culturally and racially distinct, and in the United States have historically shared certain common conditions as oppressed and internally colonized peoples.

31. Audre Lorde, "The Uses of Anger," *Women's Studies Quarterly* 9 (Fall 1981): 7.

32. bell hooks, *Ain't I a Woman: Black Women and Feminism* (Boston: South End Press, 1981), 146.

33. Lorde, 9.

34. Ann Colamosca, "Capitalism and Housework," *New Republic,* 29 March 1980, 18–20.

Toward Understanding the Educational Trajectory and Socialization of Latina Women

Ruth Enid Zambrana
UCLA School of Social Welfare

I will keep on working and continue to fight for what I believe is right, and for my people. I have been able to express myself when I had nobody to teach me anything. I think it is a very beautiful thing when a person has within the ability to survive.

—Josephine Turrietta, *Las mujeres*[1]

The overwhelming majority of Latina women have had to teach themselves.[2] An analysis of educational attainment of Latina women reveals that Latinas indeed lag far behind middle-class majority culture Anglo-American women. In part, this situation reflects the fact that access to higher education only became a viable option for a significant number of Latinas in the 1960s and 1970s.[3] Nevertheless, the educational experiences of Latinas have received little attention, particularly in the area of higher education.

Although all minority women have experienced some improvement in their educational and occupational achievements, only 10 percent of Mexican American women and 15 percent of Puerto Rican women hold professional or managerial positions. Hispanic women differ from Anglo American women in that they are twice as likely to be operatives and half as likely to be professionals. Moreover, less than one-half of one percent (0.3 percent) of all Spanish-origin women earn $25,000 per year or over.[4] These statistics reflect the reality that most professional Latina women are concentrated in low-level management positions, are trainees, are in community-based organizations, and/or are simply drastically underpaid.

Latinas represent a very diverse group that includes Mexican Americans (60 percent), who are concentrated in the southwest; Puerto Ricans (14 percent), who are concentrated in the northeast; and Cubans (6 percent), who are concentrated in the southeast. In addition, 20 percent of Latinas are immigrants from South and Central America, economic refugees, and/or undocumented workers. Among this last group are

a number of Latina professionals who came as adults to the United States. In general, we know very little about the educational experiences of all Latina women. Under what conditions have they attended school? Were their educational experiences positive, or were they made to feel inadequate? If they were made to feel inadequate, did they become passive recipients of information or did they become enraged with the experience? The purpose of this essay is threefold: to provide a brief review and critique of traditional paradigms that have been used to explain the educational experiences of Latina women; to explore dimensions of feminist theory that may contribute to a better understanding of Latina women, as well as the limitations of that theory; and finally, to suggest a psychosocial model for interpreting the nature of experiences within the educational trajectory of Latina women.

A Critique of Traditional Paradigms

Latina women have been the subject of very little social science and historical research. Studies of American society generally focus on the majority group and fail to deal with the plight of racial/ethnic minorities, especially Latina women.[5] This critical absence of scholarly work on racial/ethnics is exacerbated by the "problem orientation" of the majority of existing studies. This orientation has a number of important features. First, there is an emphasis on differences of the group with reference to the dominant culture. Second, there is an equally strong emphasis on differences among the groups. Third, the majority of studies do not acknowledge the relationship of these groups to the social structure nor their influence on the larger culture. Fourth, the studies tend to exclude or overlook the roles of women within the culture, or when they are included they offer only myopic and negative views of those roles.[6]

In the 1960s and 1970s a significant number of studies on racial/ethnic communities were generated that, with few exceptions, were purely descriptive and ahistorical. These descriptions emphasized not only problems of "deficiencies" within the communities—that is, according to White middle-class standards—but also the differences in regard to these "problems" between Blacks, Puerto Ricans, Chicanos, and Asians. Focus was on cultural distinctiveness and/or how close these groups approximated the values and norms of the dominant society as measured by upward mobility and acculturation.

The "problem" orientation characterizes a plethora of biased studies of pathology and other disturbances in racial/ethnic communities. This perspective presented distorted views of the lives of racial/ethnics and contributed to their inferior status in the United States. Ladner, when commenting on research on Blacks, noted that "the myths of 'cultural deprivation,' 'innate inferiority,' 'social disorganization,' and the 'tangle of pathology' characterize the writing of many sociologists up to (and including) the present time."[7] This problem orientation has inhibited the emergence of a major paradigm of relations that takes into account the history of racial/ethnic groups' interactions with the majority group in society. By encouraging the identification of the problems of groups in a vacuum, one neglects details of how racial/ethnic groups are in constant conflict, par-

ticularly in their ongoing struggles with the dominant group to secure their basic rights and to maintain their own culture.

The most limiting aspect of the majority of studies has been their neglect of the relationship of racial/ethnic groups to the social structure. In his review of the literature on race and ethnicity, Katznelson provides a cogent critique of the limited vision that social theorists have developed in their study of this area. He writes:

> To the extent that this corpus of work has stressed the attitudinal and neglected the structural, it has been tacitly ideological. It has directed attention from differential ethnic and racial distribution of wealth, status and political power, and from an examination of the way in which ethnic and racial groups are linked to each other and to the polity.[8]

As such, these works fail to acknowledge the roles of social structure and social organization in shaping the lives of racial/ethnic minorities. Many authors, unconvinced of the existence and pervasiveness of racism, view people of color as if they had all the options and choices of White, middle-class Americans. Clearly this is not the case, and we must continue to examine the ways in which racism reduces options and limits choice. Further, such works detract attention from the centrality of systematic exclusion (various forms and stages of racism) in the lives of oppressed people. Instead they focus on cultural traits that are identified as the source of a group's ability or inability to succeed and be upwardly mobile in the United States.[9] This approach is most dramatic when one examines the neglect of minorities in relation to social organizations such as schools. Only recently has there been an attempt to examine how the schools hinder the educational achievements of Latinos. In a recent dissertation that examines the relationship between immigrant status and stress among Mexican American boys and girls, it was found that stress in the school environment was related to students' perceptions of lack of interest and support by teachers and counselors.[10]

As a group, Latinos have been troubled by the lack of research depicting their struggles and conflicts. The dearth of scholarship leaves this group vulnerable to stereotypic notions that are easily accepted by others—as well as, perhaps, by themselves—in the absence of empirical research that presents more accurate views of their lives.[11] In this vacuum, perceptions of Mexican American inferiority persist and, as a consequence, continue to justify the inability of members of this group to pursue higher education. Thus, the lack of research hampers the group's mobility efforts. This is particularly true for Latinas, who are often maligned in images that neither acknowledge nor reflect these women's particular difficulties.

Alternately, an examination of existing studies clearly shows that being researched is not in and of itself a real advantage. The lack of a grounded historical perspective has led to the frequent omission of Latinas or else to their identification as a source of their group's problems. The myths vary with the cultures of the groups: Black women are the matriarchs, Latina women are too maternal and submissive to men, and Asian women are passive and content with their roles. Women are either targeted for abuse because

they work and contribute to their families, or else they are criticized for not working and having babies. Details on the range of roles and lifestyles of Latina women are missing.

Mainstream scholarship has not provided useful paradigms for understanding Latina women. Similarly, much of the recent feminist, scholarship merely presents new stereotypes of women's roles, rather than seriously addressing how historical and social structural differences construct a different range of options and choices for women.

Feminist Theory: A Limited Vision

Recent descriptions of the historical and material conditions of White women in this country have begun to challenge centuries-old myths of womanhood and femininity. Scholars and activists have begun to use this knowledge to foster social change. Yet, this new feminist scholarship has not been successful in assessing how race and class mediate the experiences of women and result in systematic diversity. Most feminist scholarship is grounded in the experiences and beliefs of White, middle-class women of the majority society and has failed to appreciate the larger context of racial oppression and its impact on the lives of women of color. The historian Phyllis Palmer provides an explanation for this oversight when she notes:

> White academics, in particular, have formulated theories grounded in notions of universal female powerlessness in relation to men, and of women's deprivation to men's satisfaction. Often treating race and class as secondary factors, feminist theorists write from experiences in which race and class are not felt as oppressive elements in their lives.[12]

The feminist scholarship that emerged in the 1970s challenged common notions about women in the humanities and the social sciences and exploded the myth of gender-neutral research. Scholars such as Heidi Hartman called into question basic premises of traditional social theory and empirical research. Prior to this time, male theorists failed to consider women's experiences as a legitimate topic for serious study. Of course researchers had looked at issues such as women in the family and their voting behavior patterns. Such scholarship, however, viewed the differential treatment of males and females in the society as the natural order, rather than the result of their differential positions in the society. With the feminist challenge, women and sexism became central topics of exploration, including mechanisms by which women are socialized to follow specific gender roles, discriminatory barriers that shape women's educational attainment and employment prospects, and sanctions for women who deviate from prescribed gender roles.[13] After centuries of wearing blinders when it came to gender, social theorists were forced to acknowledge that sexist institutions were responsible for maintaining women's place in the family and limiting their participation in the labor market and social institutions outside the home.

Feminist theory has essentially emerged from the experience of White, upper-middle-class women, and as such it is based on sexual stratification, with little recognition of racial and class stratification. There are also a number of concepts, for example the notions of patriarchy and the public/private dichotomy, which do not fit or aptly describe the reality of Latina women in the United States. Patriarchy implies that men have power and access to resources. Historically this has not been the case for Latinos. In our case, neither men nor women nor the communities had power. This does not deny the fact that men by virtue of being male were ascribed a higher status in society, but it was the Latino community that was powerless, not only the women. White feminists have neglected to recognize this issue. Second, the notion of public versus private makes an assumption that women were excluded from the work force. Again, this was not the case for women of color and White working-class women. Not by choice, the majority have had to work in poorly paid employment outside the home. There are innumerable differences between the lives of White women and women of color. Recognizing these differences is a first step in better understanding the lives, options, and choices of Latina women.

Nonetheless, some concepts developed by White feminist scholars are powerful in illuminating the conditions of racial/ethnic women. Yet, often it has been the case that concepts developed for White women have had to be modified to provide insights into the lives of women of color. That the historical conditions of racial/ethnic women have differed dramatically from those of White women is an important central thesis. But it must be recognized that rather than simply deviating from the lives of White women, women of color have a radically different material basis for their experiences. This fact is most evident in the areas of paid employment and market work that have consequences for the shape and nature of family life and women's involvement in society. Consequently, it is apparent that gender oppression along with racial and class oppression have shaped the unique positions of women of color. From this perspective, racial and class stratification are essential to understanding the context within which gender roles are developed.

Materials to Construct a Theory: A Beginning Model

To establish the conceptual basis needed to construct a model for understanding the educational trajectory of Latina women, one needs to build on recent work in history, observational studies, and the empirical knowledge available.[14] Importantly, such an effort requires an interdisciplinary foundation with a specific focus on a broader reformulation of concepts such as socialization, identity, culture, bicultural socialization, and recognition of institutional dimensions. There is also a need to examine and understand what psychological mechanisms are used by Latina women to reconcile their ascribed status and their own perceptions of their status in society.

In its broadest sense, socialization can be viewed as a process through which a person consciously and unconsciously participates in a number of diverse and complex

roles. When the opportunity is present, what are the factors that influence the decision to participate in roles? In other words, the notion of *choices*, and how and why people make them, is critical.

Historically and up to the present, Latinas' choices have been limited due to their ascribed status as minorities and as women within the social structure. Gender, race, class, and language facility can be defined as personal dimensions. Cultural dimensions have also circumscribed choices, resulting in the increased importance of the family as a source of rootedness and increased needs for collective efforts. In many respects, this dimension represents a false choice, as it is related to the lack of acceptance of racial/ethnic minorities in the larger social structure. This idea may suggest that Latino culture has served a role that has perhaps limited choices, but this role has been reinforced by the exclusionary practices of the dominant culture. Clearly, the Latino culture is a dynamic entity that has changed in response to structural conditions. Baca Zinn has aptly stated that one difficulty in the social science literature is the underlying assumption that culture is static; we must instead view culture as dynamic, historically relevant, and changing.[15]

Culture is a behavioral repertoire that develops as a function of one's historical roots as well as in response to the social conditions under which one lives. Culture helps individuals to better deal with life but does not lock one into a particular lifestyle if options and choices are available. Culture also, and most importantly, socializes individuals to think and act in particular ways to assure survival. Therefore, culture is a dynamic entity that fosters a sense of self-respect and dignity and contributes to a solid identity. When cultural values are violated (i.e., disregarded or ridiculed), the basic foundation of human experience is shaken. On the other hand, the danger remains that culture is interpreted as determining events rather than mediating events, or as a way of explaining events instead of providing a context in which to perhaps understand them. For example, when one examines the roles in which Latina girls and women participate at home and within the family, it is clear that they have had the opportunity to be active participants and learn many skills, to initiate tasks and be creative and resourceful. This of course does not belie the fact that our cultural values of respect and dignity negatively influence how we are perceived in the dominant culture. In other words, the majority of Latinos, both women and men, are perceived as "nice." Latina women, however, are expected to remain that way and men are expected to assume more assertive characteristics. At this point, the interrelationship or linkage between personal, cultural, and institutional dimensions becomes clearer.

Institutional dimensions have already been aptly described in terms of exclusionary practices in the areas of curriculum, organizational activities, teacher expectations, tracking, and educational counseling.[16] For example, Latina student aspirations dramatically decrease after the ninth grade.[17] Institutions are a major socializing force in a child's life and exhibit all the "isms" of the dominant culture—racism, classism, and sexism. Clearly, these institutions erect barriers that Latina women must confront within the educational system. The psychological effects of the barriers is an area that requires extensive inquiry. One way to conceptualize the psychological component of the perceived barriers is the notion of cultural assault. The following case example may help to illustrate the nature and effect of a cultural assault:

A 35-year-old Latina woman in graduate school was having difficulty in taking exams and in making verbal reports in class. It was clear that she knew the material but was terrified of expressing or reporting verbally. Upon discussion with her regarding the problem, there was a clear sense of anger, pain, and injustice. After several meetings it became obvious that the nature of past educational experiences of being ridiculed and ashamed of her language and culture had severely damaged her self-esteem and confidence. Those feelings immediately came to the surface under similar circumstances, when she felt put in a position where there was a possibility of shame or ridicule.[18]

The notion of assault or injury to one's sense of identity and self-esteem are complex psychological dimensions. One can speculate that the continuous experience of those assaults leads to stress and tension.

For Latina women, these assaults lead to different patterns of behavior. There will be those women who have a traditional stance and who make themselves subservient to the codes of others. Others may become marginal, find self-worth in the denial of their cultural heritage, and in turn feel guilt and experience self-hatred. Alternately, there are those women who develop a sense of pride in their cultural heritage or ethnic consciousness, are aware that racism, sexism and elitism are integral to the system, and somehow learn the prevailing norms that are different.

The question, then, is under what conditions do these assaults lead to a sense of giving up and under what conditions do they lead to constructive anger and engagement? For example, I have spoken to a number of Latina women who at some point became angry and said, "I'm going to show them that I can do it." The anger enabled them to mobilize all their resources to succeed. What are the costs of using all this anger to succeed? Anger represents one way of coping with our status as a cultural, gender, and ethnic minority. Yet it is only one way of coping. We must also determine what other types of coping mechanisms are used by Latina women as they proceed toward their educational and career goals. Use of social support systems and role modeling constitute another coping mechanism. Role modeling also has a number of dimensions. It implies that the individual has an opportunity to observe and learn new roles that fit with expectations and aspirations, and it implies that the role model incorporates the concept of the individual and her ability to learn and that learning will be useful to her future.

Another case study illustrates the importance of social support and role modeling for young Latina women:

Maggie was a 25-year-old Puerto Rican woman. She had been in college for five years and had done very poorly. She was about to be expelled. She was living at home with her parents. The father worked in a handbag factory and the mother was a homemaker. Maggie was depressed and unable to move on her goals, which were to complete college and become a teacher. She had been working with Carole, a young, bright, progressive Anglo social worker. Carole asked me to talk with her advisee since she felt she had exhausted all her resources with her and was still unsuccessful. I asked Maggie to come see

me. She missed many appointments, was late and quite reticent. We talked at first about her dreams and goals. After about three months, it became clear to me that Maggie was afraid to get good grades because she would become a professional and have to give up her family and community. She also felt stupid because she was shy and the instructor tended to ignore her. I helped Maggie to understand that she could use her education to help others in the community like her and that she had a quiet strength that was valuable. These two themes dominated the next two years. She repeated two college years and obtained all A's and B's. She graduated and two years later successfully completed her master's degree and obtained a teaching position.[19]

In the last ten years I have worked with a number of Latina women who have experienced these fears or who have not achieved the balance of how to retain their own culture and participate in the structure. Social support and role models of successful Latinas have been critical, however, in enabling individuals to handle the situation better and overcome the barriers. Clearly, this positive response requires a fine balance between retaining or maximizing cultural stability and exploring ways of participating in the social structure. Most importantly, these observations and anecdotes suggest that Latina women must see and use social support and resources such as family and friends outside the educational institutions because these settings do not provide the necessary resources required for achievement.

The major question remains. How can Latina women make the transition into a world that is different from theirs? How do they reconcile or learn different values and norms without losing who they are? How do they overcome some of the cultural assaults from their peers, the schools, and the like? Some individuals have attempted to explain these transitions in terms of the concept of bicultural socialization.[20] This approach integrates role modeling as a major determinant of socialization, as well as developing a solid identity in terms of race, gender, and class.

Bicultural socialization is the process by which individuals from an ethnic minority group are instructed in the values, perceptions, and normative behaviors of two cultural systems. There are at least six factors that influence the process.

1. The degree of overlap of commonality between the two cultures with regard to norms, values, beliefs, perceptions, and the like.

2. The availability of culture translators, mediators, and models.

3. The amount and type (positive or negative) of corrective feedback provided by each culture regarding attempts to produce normative behavior.

4. The conceptual style and problem-solving approach of minority individuals and their mesh with prevalent or valued styles of the majority culture.

5. The individual's degree of bilingualism.

6. The degree of dissimilarity in physical appearance from the majority culture, such as skin color and facial features.[21]

This model provides a conceptual framework, but it offers little specific information on the mechanism through which dual socialization occurs. Another related variable is ethnic consciousness, which can be loosely defined as that awareness in the individual, early or later on (is there a critical stage for its development?), that her options and choices are circumscribed by race, class, ethnicity, and gender. In this author's opinion, recognition of these barriers, which can be passed on by family members, role models, siblings, or self-observations, enable the individual to withstand some of the cultural assaults. There is an understanding that the assaults are external and not necessarily related to one's particular abilities, skills, or identify.

Thus the development of a model that attempts to understand the educational trajectory of Latina women must begin with a broad definition of socialization as a group of roles and skills acquired to negotiate the educational system within which they must participate and must also acknowledge that the institutional framework, as well as the social structure, works toward delimiting opportunities and choices. In effect, a reformulation of socialization and its relationship to identity development, and what psychological mechanisms are used to reconcile our own perceptions of ourselves with those of the dominant culture, is sorely lacking. Which coping mechanisms are most widely used by Latina women, and which are the most helpful in mediating their stressful environment? Concepts of ethnic consciousness and bicultural socialization serve as important mediating variables that help the individual to function in two worlds without losing sight of one's status and/or identity in either.

Socialization is also directly influenced by social factors such as institutional settings. Schooling is a powerful determinant in the socialization experiences of Latina women. Two of the most critical elements in the schooling experience are tracking for ability and the types of courses that are available. Data on schools has consistently shown that minority low-income students are more likely to be placed in nonacademic tracks than others; that girls receive less attention and encouragement than boys; and that inner-city schools, in particular, have few role models and/or counseling personnel who can encourage the educational aspirations of Latina women. A review of my preliminary data indicates that a substantial number of Latinas feel that their elementary and secondary school experiences failed to prepare them for higher education, and the majority of respondents felt no encouragement to pursue higher education. One respondent remembered her picture being put on a board with the caption beneath it, "A Common Girl."[22]

Thus, institutional factors must be examined as important contributors to the socialization of Latina women, with particular reference to the impediment to, or facilitation of, educational attainment. The focus of inquiry, however, must be on the interactive nature of institutional dimensions on the socialization experiences of Latina women and its influence on the educational aspirations and achievements of Latina women.

This model is, of course, a beginning attempt based on existing knowledge and observations to provide a framework for interpreting Latinas' success and lack of success in the educational system. A first step is to operationalize the variables and to test under what conditions they help to explain, under what conditions they fail to explain, and whether their variations are based on class, status, color, and availability of social support systems. Second, the relationship between institutional factors and educational attainment must be examined.

Clearly, we can no longer afford to use our intellectual energy to fight stereotypes and illogical conclusions. Battling these myths has bound racial/ethnic scholars in a research ghetto and has hampered theoretical growth. The double bind has resulted in the inability of scholars to examine the relationship between new research and theory and/or to use new research to modify existing theory or to generate it. In part this dilemma has been perpetuated by a lack of intellectual support by social scientists for new theoretical developments in the field as a whole.

Myths, of course, will continue to exist because of the general lack of knowledge about and interest in racial/ethnics. Our task, however, is to assure that our research is not circumscribed within the parameters set up by the myth. We must move forward in proactive rather than reactive ways to address the issues of concern to Latina women. In the process of creating new approaches to these concerns, we will also debunk the myths. The question, then, is how do we move forward?

First, it seems that there must be clear recognition that the historical conditions of Latina women continue to be different from those of dominant culture women.[23] These material conditions have dictated roles for Latina women whereby they have interacted with social institutions from a different vantage point than White women. The perception of Latina women as deviant, or shy, passive, and unambitious because they are not following prescribed gender roles is at best unfair and clearly ignores the reality of these women's experiences. Latina women actively participate in the outside world of work and community institutions.[24] They observe the treatment of their families, spouses, and children. They are cognizant of the restrictions, limited options, and mythical characteristics ascribed to them and their cultural group. Consequently, they have a vision of life that is broader than dominant culture women. Based on their vision, there is also an impetus to develop and seek community and familial support structures to reinforce their identity.

Thus the analysis of Latina women needs to emerge from a description of their own experiences. Perhaps there will be many similarities with majority culture women based on gender alone. We must cease, however, making assumptions related to personal and institutional variables that have repeatedly been proven erroneous. We must move forward to find answers that reveal the reality that belies the myth.

Notes

Zambrana, Ruth Enid, "Toward Understanding the Educational Trajectory and Socialization of Latina Women," *The Broken Web: The Educational Experience of Hispanic American Women*, eds. Teresa McKenna and Flora Ida Ortiz, pp. 61–77. Reprinted by permission of the publisher, copyright © 1988 by The Tomás Rivera Center, 710 North College Avenue, Claremont, CA 91711.

I wish to acknowledge the theoretical contributions of Dr. Bonnie Dill and Dr. Elizabeth Higginbotham toward the formulation of many of the concepts in this paper. I worked with these colleagues on the Intersection of Race and Gender Project at the Center for Research on Women at Memphis State University. I also would like to acknowledge the support of the Ford Foundation and the UCLA Academic Senate Faculty Research Fund.

1. N. Elsasser, K. MacKenzie, and Y. Tixier y Vigil, interview with "Josephine Turrietta," *Las mujeres* (Old Westbury, NY: Feminist Press, 1980), 28–35.

2. The terms "Latina" and "Hispanic Woman" will be used interchangeably. These two terms will primarily reflect research and observations of Mexican American and Puerto Rican women.

3. C. M. Haro, "Chicanos in Higher Education: A Review of Selected Literature," *Aztlán: International Journal of Chicano Studies Research* 14, no. 1 (Spring 1983): 35–77.

4. U.S. Congress, House of Representatives Report of the Subcommittee on Census and Population of The Committee on Post Office and Civil Service, 21 April 1983.

5. The term racial/ethnic is used to refer to historically subjugated, racially identifiable ethnic groups in the United States. Those groups of interest are any collectivity whose membership is derived from a shared racial identify with high visibility in the society and who have a devalued social status, such as Chicanos, Puerto Ricans, and Blacks. See R. Staples and A. Mirande, "Racial and Cultural Variations Among American Families: A Decennial Review of the Literature on Minority Families," *Journal of Marriage and The Family* 42 (Nov. 1980): 887–903.

6. M. Baca Zinn, "Mexican American Women in the Social Sciences," *Sings: Journal of Women in Culture and Society* 8, no. 2 (1982):259–272; M. J. Vásquez, "Confronting Barriers to the Participation of Mexican American Women in Higher Education," *Hispanic Journal of Behavioral Sciences* 4, no. 2 (1982): 147–165; S. J. Andrade, "Family Roles of Hispanic Women: Stereotypes, Empirical Findings, and Implications for Research," in *Work, Family, and Health: Latina Women in Transition,* ed. R. E. Zambrana (New York: Hispanic Research Center, Fordham University, 1982), 95–106.

7. J. Ladner, *Tomorrow's Tomorrow* (Garden City, NY: Anchor Books, 1972), xxi.

8. I. Katznelson, "Comparative Studies of Race and Ethnicity: Plural Analysis and Beyond," *Comparative Politics* 5, no. 1 (1972): 137.

9. S. Steinberg, *The Ethnic Myth* (New York: Athenaeum, 1981).

10. V. H. Silva-Palacios, "Immigration and Stress Among Mexican Adolescents" (PhD diss., Wright Institute, Los Angeles, 1985).

11. Staples and Mirande, *Racial and Cultural Variations Among American Families.*

12. P. Palmer, "White Women/Black Women: The Dualism of Female Identity and Experience in the United States," *Feminist Studies* 9 (Spring 1983): 154.

13. R. K. Unger, "Advocacy vs. Scholarship Revisited: Issues in the Psychology of Women," *Psychology of Women Quarterly* 7, no. 1 (Fall 1982): 5–17.

14. A. Camarillo, *Chicanos in a Changing Society* (Cambridge: Harvard University Press, 1984); M. Barrera, *Race and Class in The Southwest* (Notre Dame: University of Notre Dame Press, 1979).

15. Baca Zinn, "Mexican American Women in the Social Sciences."

16. T. P. Carter and R. D. Segura, *Mexican Americans in School: A Decade of Change* (New York: College Entrance Examination Board, 1979).

17. V. E. Lee, *Black, Hispanic, and Working-Class Students* (Washington, DC: American Council on Education, 1985).

18. Based on personal observations and experiences in academic institutions.

19. See note 18.

20. D. de Anda, "Bicultural Socialization: Factors Affecting the Minority Experience," *Social Work* 29, no. 2 (1984): 101–107.

21. Ibid.

22. A cross-sectional survey conducted by UCLA asked two hundred women of Mexican origin about factors that contribute to the successful completion or noncompletion of higher education degrees. Results are available from the author, the researcher.

23. Elsasser, MacKenzie, and Tixier y Vigil, *Las mujeres*; Barrera, *Race and Class*; Camarillo, *Chicanos in a Changing Society*; M. Baca Zinn, "Mexican Heritage Women: A Bibliographic Essay," *Sage Race Relations Abstracts* 9, no. 3 (Aug. 1984): 1–12.

24. A nationwide study was conducted by the National Network of Hispanic Women. It is a survey of 304 women on the "Work and Family Life Experiences of Professional Hispanic Women." The study was designed to provide (for the first time on a national level) a clear and comprehensive profile of patterns of organizational experiences of upwardly mobile professional Hispanic women; sources of stress and resources for coping with stress; health and mental health status of successful Hispanic women. The report is available from the NNHW in Los Angeles, California.

5

Conception, Contradiction, and Curriculum

Madeleine R. Grumet
University of North Carolina, Chapel Hill

I suspect that I am about to present a feminist argument, and that's not easy. A feminist argument is unavoidably convoluted:

> It is the argument of whoever is fed up with being a "dead woman"—Jewish mother, Christian virgin, Beatrice beautiful because defunct, voice without body, body without voice, silent anguish choking on the rhythms of words, the tones of sounds, without images; outside time, outside knowledge—cut off forever from the rhythms, colorful, violent changes that streak sleep, skin, viscerales: socialized, even revolutionary but at the cost of the body; body crying, infatuating but at the cost of time; cut-off swallowed up on the one hand the aphasic pleasure of childbirth that imagines itself a participant in the cosmic cycle, on the other, sexuality under the symbolic weight of law, (paternal, familial, social, divine) of which she is the sacrificed support, bursting with glory on the condition that she submit to the denial of nature, to the murder of the body.[1]

This is a secret that everybody knows. It is body knowledge, like the knowledge that drives the car, plays the piano, navigates around the apartment without having to sketch a floor plan and chart a route in order to get from the bedroom to the bathroom. Maurice Merleau-Ponty called it the knowledge of the body-subject, reminding us that it is through our bodies that we live in the world.[2] He called it knowledge in the hands and knowledge in the feet. It is also knowledge in the womb. Eve knew it, but she let on and was exiled from Eden, the world of divine law, for her indiscretion.[3] We, her daughters, have kept silent for so long that now we have forgotten that knowledge from and about the body is also knowledge about the world. The project of this text is to draw that knowledge of women's experience of reproduction and nurturance into the epistemological systems and curricular forms that constitute the discourse and practice of public education. It is an argument drawn from the experience in my own life that is most personal and at the same time most general as it links me to those who share my

sex and gender and those who also acknowledge reproductive responsibility for the species. The argument takes off from a commitment in my life for which I accept responsibility with no doubts, hesitations, or second thoughts—parenting—and lands in a field of utter confusion: curriculum. What I hope to show is that the relation between this certain beginning and doubtful end is not accidental but inevitable, the end determining the beginning and the beginning the end.

The reproduction of society, its class structure, cultural variations, institutions, is currently a dominant theme in the sociology of education. Gramsci's concept of hegemony has caught our interest, for it articulates what the experience of our daily lives has led us to suspect, that the forms of our social and individual existences are not merely imposed upon us but sustained by us with our tacit if not explicit consent.[4] I want to take this term, "the reproduction of society," literally.

Now, it is not a new idea that schooling transmits knowledge or that education reproduces culture. But like so much of our language, this phrase, "reproduction," has traveled so far from home that we cannot even tell what part of the country it is from. Curriculum has provided safe shelter for these linguistic orphans so long as they relinquish their specificity and identification with their historical and social sources as they enter the discourse of the academy. I am not advocating that we withhold our hospitality from them, but I am suggesting that it is within their interest and ours that we connect these phrases to their roots and, in so doing, take their figurative function literally. Metaphor matters. If our understanding of education rests on our understanding of the reproduction of society, then the reproduction of society itself rests on our understanding of reproduction, a project that shapes our lives, dominating our sexual, familial, economic, political, and, finally, educational experience.

I want to argue that *what is most fundamental to our lives as men and women sharing a moment on this planet is the process and experience of reproducing ourselves.*

There are two phrases contained within this proposition that I wish to situate within my own understanding. They mark the intersections of action and reflection in my own experience that have generated the themes of this paper. The first is this word "fundamental." I confess to being constantly drawn to the lure of this word. When I was in graduate school, Husserl's call "back to the things themselves" was compelling, drawing me into his phenomenological texts and rigorous, if elusive, method.[5] The method promised clarity, a way of cutting through the thick, binding undergrowth that covers the ground of daily life to reveal a clear path. In 1972 when I went back to school, my children were three, seven, and eight years old, and clear paths were well hidden by the debris of sneakers, Play Dough™ and cinnamon toast and interrupted by endless detours to nursery schools, grocery stores, and pediatricians. In those years, when there was a high probability that at any given moment one of the children was either incubating or recuperating from an ear infection, I found Husserl's stance of the disinterested observer, bracketing the natural attitude, a posture to be practiced and mastered. I am suggesting that there is a dialectical relation between our domestic experience of nurturing children and our public project to educate the next generation. It is important to maintain our sense of this dialectic wherein each milieu, the academic and the domestic, influences the

character of the other and not to permit the relation to slide into a simplistic one-sided causality. The presence of the children was just one expression of my situation at that time, coinciding with other themes of my early thirties. It coincided with being the age of my own parents as they appear to me in memories of my own childhood. It coincided with my husband's professional development and our sense of economic security, which offered the family a brief respite from the pursuit of social mobility and class status until the children would be required to derive their sustenance from their own labor rather than ours. It coincided with what was for me a much more difficult bracketing of the natural attitude, the choice not to have more children.

Though any and all of these biographic issues may be probed to understand their relation to this search for the fundamental that kept me riveted to the chair by the dining room table, digging through the dense, often impenetrable passages of Husserl, Merleau-Ponty, and Sartre, they are not the explicit content of this discourse. The dining room table became the locus of this research not because its design was conducive to meditations on eidetic form but because of its proximity to the life world being carried on in the adjoining kitchen. I summon these scenes here because, although I may not directly address them again, they are currents that run through this text, linking the metaphors of epistemology and curriculum to the motives that choose and organize them. I present the passage through these rooms as an alternate route for the argument of this chapter and as a reminder of the many levels of experience that constitute the conceptual order that we employ here to inform, confront, and mystify each other.

This chapter, too, continues this search for the fundamental. The children, the work, the mother, the student are several years older, and the detours are different. The frequent trips to the grocery store have fallen into one 'hurmongous' (as the kids say) trip a week, but the frequency has been retained by daily trips to Geneva, New York, where I go to teach. The path is not any clearer for the passage of time, and every route is a detour. "Back to the things themselves" no longer provides an adequate slogan for the project. The cadence of the command falls too decisively on the things themselves, encouraging an idealism fascinated with essential forms.

The search for origins has capitulated to the pursuit of mediations. The world "as given" is never received as such. The world we have is constituted in the dialectical interplay of our freedom and facticity. What the stripping away of phenomenological reductions reveals most clearly is not the things themselves but the conditions, relations, perspectives through which their objectivity evolves.

If the fundamental is an epistemological chimera, it is also a political ploy that promises cohesion but delivers domination. The fundamental is suspect if it suggests a single way of addressing the project and process of reproduction. To be a gendered human being is to participate in the reproductive commitments of this society, for reproduction is present as a theme in human consciousness without providing a norm for human behavior. Male or female, heterosexual, homosexual, bisexual, monogamous, chaste, or multipartnered, we each experience our sexuality and attachments within a set of conditions that contain the possibility of procreation. Our identities incorporate our position relative to this possibility. They encode our assent, or our refusal, our ambivalence, our

desire, our gratification, or our frustration. Whether we choose to be parents or to abstain from this particular relation to children, the possibility of procreation is inscribed on our bodies and on the process of our own development. Even if we choose not to be a parent, we are not exempt from the reproductive process, for we have each been a child of our parents. The intentions, assumptions, emotions, and achievements of educational practice and theory are infused with motives that come from our own reproductive histories and commitments. What is fundamental is not the nuclear family of an orange juice commercial enjoying a suburban breakfast in the family room. What is fundamental is that although there is no one way of being concerned with children, we cannot deny our responsibility for the future whatever form our projects of nurturance assume.

Conception

Stephen Strasser's concept of dialogic phenomenology more closely approximates the notion of the fundamental that this text addresses.[6] For Strasser, what is fundamental is the interpersonal basis for human experience, and so the primary question is no longer how one comes to constitute a world but how a world evolves for us. The very possibility of my thought, of consciousness, rests upon the presence of a "you" for whom I exist. My thought is a moment suspended between two primordial presences, the "you" who thinks me, and the "you" whom I think.

> My affirmation of the "you" must transcend all doubt for me; it must be characterized as the "primordial faith" upon which all my further cogites rest. For the nearness of the "you" is a primordial presence, one that makes me believe that relations with other beings also are meaningful. My turning-to a "you" is the, most elementary turning-to, one that causes my intentionality to awaken. In short, only the "you" makes me be an "I." That is why, we repeat, the "you" is always older than the "I."
>
> This principle holds for every aspect and all levels of human life. Husserl speaks of primordial faith in connection with the "being given" of the things that are experienced. It is precisely through the mediation of a "you" that I know at all that there are things worth touching, tasting, looking at, listening to. A "you" teaches me also that there exists reality which can be manipulated, "utensils" destined for particular use (Heidegger), matter which I must modify in my work (Marx). Without the active-receptive interplay with a "you" I would not know that my existence has a social dimension (Merleau-Ponty). . . . My "thinking"—no matter what one may mean by it—is never a sovereign act. I cannot think without attuning the mode of my thinking to that which must be thought. . . . But because the "you" is the "first thinkable" I must in the first place attune my thinking to the being of the "you." We may even say that generally speaking, my thinking comes about, because there is a "you" that thinks and invites me to a thinking "response." It is the

"you" that makes it clear to me for the first time that thinking is possible and meaningful. This also shows the finite, social, and historical character of my cogito.[7]

When Strasser asserts that it is not only the original intentional object but intentionality itself that is generated through human relationships, he is in effect acknowledging that the very ground of knowledge is love. This bonding of thought and relation is consummated in our word "concept." It is derived from the Latin phrase *concipere semina*, which meant to take to oneself, to take together, or to gather the male seed. In this etymology both the child and the idea are generated in the dialectic of male and female, of the one and the many, of love.

What is most fundamental to our lives as men and women sharing a moment on this planet is the process of reproducing ourselves. It is this final phrase, reproducing ourselves, that contains multiple meanings for me. First there is the obvious meaning that refers to the biological reproduction of the species. Then there is the reproduction of culture, the linking of generations, each conceived, born, and raised by another, parenting by extending the traditions and conventions with which it was parented. But by situating reproduction in culture we need not collapse it into the habits, aversions, and appetites that testify to the persuasions of ideology. For reproducing ourselves also brings a critical dimension to biological and ideological reproduction by suggesting the reflexive capacity of parents to reconceive our own childhoods and education as well as our own situations as adults and to choose another way for ourselves expressed in the nurture of our progeny. It is this last, critical interpretation of the phrase that I wish to address here because I see curriculum as expressing this third intention. Curriculum becomes our way of contradicting biology and ideology. The relationship between parent and child is, I suggest, the primordial subject/object relationship. Because these initial relationships are mediated by our bodies and by history, distinct masculine and feminine epistemologies have evolved. Although the initial stages of the parent/child relationship are influenced by the biological processes of conception, gestation, birth, and breastfeeding, the epistemologies that evolve from them do more than merely mirror the biological bonds; they intertwine them with subjective aims representing the power of the human species to negate biology with culture. Hence, these male and female epistemologies and the curricula that extend them into our daily lives stand in a dialectical relation to the original terms of the parent/child bond.

Subjectivity, objectivity, epistemology: Abstraction falls from these terms like a veil, blurring their relation to the men and women who create them, believe them, and use them. We forget that they are lifted from our loins and lungs, from our labor and our love and our libido. And we forget that they in turn pervade our breath, lust, fears, joy, and dreams. The very word "epistemology" is drawn from the Greek word for understanding, *episteme*, and is extended into the word "epistles," or letters that Paul sent to the apostles. In contrast to *gnosis*, a Greek word denoting the immediate knowledge of spiritual truth, epistemology refers to knowledge that is intersubjective, developed through social relations and negotiations. I am interested in understanding the ways in which epis-

temological categories of subject and object and their implied relations are rooted in the psychosocial dynamics of early object relations as they are experienced by both children and parents. The three interpretations of reproduction—the biological, the ideological, and the critical—never exist independently of one another, and although my discussion of them will be organized in the order just given, often you may hear all three voices.

It is within the infant's social relationships that the terms "subject" and "object" first evolve. Derived from psychoanalysis and cultural anthropology, object relations theory investigates the genesis of personality in the interplay of the aggressive and libidinal drives seeking satisfaction and the social relationships that surround the infant and in which it participates. In *The Reproduction of Mothering* Nancy Chodorow declares that object relations theory eschews both instinctual and cultural determinism. Instead of portraying a passive subject, driven by biology or hypnotized by culture, object relations theory presents biology and social relationships as themes that influence consciousness without subsuming it.[8] Chodorow shows us how the infant transforms the relationships in which he or she participates into psychic structure through the processes of fantasy, introjection, projection, ambivalence, conflict, substitution, reversal, distortion, splitting, association, compromise, denial, and repression.[9] The relationship of curriculum to the experience of the birth and nurturance of children will not proceed, you will be glad to learn, with my psychosexual history, or yours, dear reader. There would be no point in making reference to our own situations, for it is obvious that there are no remote, authoritarian fathers, no binding, seductive mothers among the readers of this feminist study of education. The analysis is structural and thematic and, as such, abuses the specificity of each of us even as it respects our privacy and defenses.

Yet there is one moment I would remember, the day following the birth of my daughter, my first child, when my skin, suffused with the hormones that supported pregnancy, labor, and delivery, felt and smelled like hers, when I reached for a mirror and was startled by my own reflection, for it was hers that I had expected to see there. Over and over again we recapitulate and celebrate that moment, even as we struggle to transcend it.

The child is mine. This child is me. The woman who bears a child first experiences its existence through the transformations of time and space in her own body. The suspension of the menstrual cycle subordinates her body's time to another, contained and growing within her. The pressure of labor and the wrenching expulsion of the infant (the term "delivery" must have been created by those who receive the child, not those who release it) physically recapitulate the terrors of coming apart, of losing a part of oneself. The symbiosis continues past parturition, as the sucking infant drains her mother's swollen breasts of milk, reasserting the dominance of the child's time over the mother's as lactation and sleep as well respond to the duration and strength of the child's hunger and vigor.[10]

In contrast, paternity is uncertain and inferential. Supported and reinforced by the intimacy and empathy of the conjugal relationship, the experience of paternity is transitive, whereas maternity is direct. Paternity, always mediated through the woman, originates in ambiguity. Subject/object relations as experienced on the biological level of the reproduction of the species are concrete and symbiotic for mothers, abstract and transitive for fathers. If the "other" to whom the biological individual is most closely

related is the child, then the definition of subjectivity as that which is identical with myself and of objectivity as that which is other than myself originates in an experience of reproduction that differs for men and women. So long as it is woman and not test tubes who bear children, conception, pregnancy, parturition, and lactation constitute an initial relation of women to their children that is symbiotic, one in which subject and object are mutually constituting.[11]

It is important to acknowledge at this point that I am not assuming that all women experience the identification or that all men experience the ambiguity associated here with the anatomical and biological conditions for reproduction. The response to these conditions will vary for different cultures and specific individuals according to the inter-action of these conditions with the physical environment, division of labor, organization of families, ritual and legal customs, and so on.

"This child is mine, this child is me" is an index of relation that will vary with every speaker. What it means to be mine, to be me, depends on the way each" speaker knows herself. The maternal ego reaches out to another consciousness that is of her and yet not in her, and self-knowledge grows in this process of identification and differentia-tion with this other, this child, "my child." The process of thinking through the world for and with the child invites a mother to recollect her own childhood and to inspect the boundaries of her own ego. Indeed, as Vangie Bergum's study of women's experiences of becoming mothers suggests, the extension of a mother's own ego identity to another who is her child is a doubling that fosters and intensifies reflexivity.[12]

But what of the mother who is a child herself? Or the mother who is exhausted from the care of too many children, or from strenuous or monotonous work, or from malnutrition? And what about the mother who has been raped or abandoned? "This child is mine, this child is me" is a lullaby sung and chanted, whistled and hummed, keened and whispered, almost, maybe never, uttered.

In order to investigate the interaction of biology and culture in our milieu, I shall turn to the work of Nancy Chodorow, whose book, *The Reproduction of Mothering*, investigates the patterns of parenting that are dominant in our culture. Chodorow's pat-terns may not provide the score for my song of motherhood or for yours. But the tune of her theory may remind us of our own perhaps unsung tunes and theories. That is the way that general interpretations function in psychoanalysis. The dramas that Freud offered us, Jürgen Habermas points out, were not intended as literal portrayals of our family relations, or as templates for their development.[13] They provided narratives against which the scenes and accounts of the analysand's experience could be perceived in their specificity *and* in their difference. Chodorow's schematic presentation of object relations is a magnificent contribution to those of us who work to understand the relation of gender to the symbol systems that constitute knowledge, curriculum, and schooling. Her work, which describes the constitution of the gendered human subject coming to form in relationships that contain the objects of the child's love and thought, has given us a subject/object schema that permits us to analyze, criticize, and, it is hoped, transform the subject/object relations that organize curriculum and the disciplines.

At the outset of her argument, Chodorow suggests that, even as the biological determinants of mothering have lessened as birth control and bottle-feeding have become

established, biological mothers have come to have ever-increasing responsibilities for child care. Her observation is reinforced by Bernard Wishy's historical study of child nurture in American culture, which indicates that as urban industrialization drew fathers away from home and the household ceased to be the primary economic unit, the responsibility for moral, social, and emotional development of children devolved upon the women who stayed home to care for them.[14] Our own time has accentuated this process. The economy's demand that working parents be mobile has isolated child nurture from extended kin, isolating mothers and their children from the aunts, uncles, and grandparents who may formerly have shared the tasks and pleasures of nurturance.

These social and economic developments support Chodorow's thesis that the infants of both sexes, though polymorphous and bisexual at birth, as in Freud's view, are immediately introduced into a social field in which they become predominantly matrisexual. Gender identity, which has evolved by the age of three, becomes a precondition for the oedipal crises, and it is the preoedipal relationships of the boy or girl child that, Chodorow argues, are most significant in influencing ego structure, gender, and, ultimately, patterns of parenting in succeeding generations. When the mother is the primary caretaker of her infant, the preoedipal attachment to her precedes the infant's attachment to his or her father and influences it profoundly. Peaking during the first half-year, the infant's symbiotic relation with its mother is upset by the asymmetry in their relation. For the infant there is only the mother, whereas for the mother there are others: husband, other children, the world. She is the first object, the "you" in Strasser's dialogic *cogito*, and it is within the tension produced by her intermittent presence and absence that the infant evolves as a subject. It is at this developmental juncture that Chodorow distinguishes the mother's response to her sons from her response to her daughters. Acknowledging the sexual gratification that the mother experiences suckling and tending to children of both sexes, she notes that the mother identifies with the daughter but, perceiving her son as sexually other, more closely monitors her contact with her male child:

> Correspondingly, girls tend to remain part of the dyadic primary mother-child relation itself. This means that a girl continues to experience herself as involved in issues of merging and separation, and in an attachment characterized by primary identification and object choice. . . . A boy has engaged and been required to engage in a more emphatic individuation and a more defensive firming of ego boundaries . . . from very early then, because they are parented by a person of the same gender, girls come to experience themselves as less differentiated than boys, as more continuous with and related to the external object world and as differently oriented to their inner object world as well.[15]

The achievement of masculine gender requires the male child to repress those elements of his own subjectivity that are identified with his mother. What is male is "that which is not feminine and/or connected with women"[16] This is another way in which boys repress relation and connection in the process of growing up. Girls, on the other hand, need not repress the identification with their mothers. Whereas the dyadic structure of

preoedipal parent/child relations is extended into the male oedipal period, with the male child transferring his identification from mother to father and repressing the internal preoedipal identifications, the female oedipal crisis is less precipitous and decisive. The dyadic relationship with her mother is sustained rather than repressed, and the father is introduced as a third element, creating what Chodorow calls a relational triangle. For both boys and girls, the father, who is more immersed in the public world, represents an external presence, often called a "reality principle," although that term expresses the very denigration and marginalization of the preoedipal relation that we are trying to rescue from centuries of oblivion and sentimentalization. Identification with the father presents the girl with a means of dealing with the ambivalence she experiences as the intense identification with her mother threatens to subsume her own autonomy. Nevertheless, because that ambivalence, also shared by the male child, is not accompanied by the dramatic repression that accompanies the incest taboo in the male oedipal crisis, the female child sustains the intuitive, emotional, and physical connectedness that the male represses, and for her, external objectivity becomes an alternative postoedipal object relation rather than a substitute for the powerful and emotional experiences of early childhood, which she retains as well. The reciprocity and mutual dependency of a concrete subjectivity, here bonded to the child and a concrete objectivity, the preoedipal other, who is the mother, are sustained for the postoedipal girl; and a more abstract objectivity associated with the external world and the father becomes a third term that mediates the mother/daughter, subject/object relationship.

This story of palpable presence and shadowy absence, of turning to and turning away, is and is not my story. Over and over again it contradicts the intimacies of my own childhood. It obscures my mother's energy and activity in the public world just as it erases my father's attentiveness and care. He walked with me in the dark morning hours when I would not relinquish the world for sleep. She gave speeches and came home late after the meeting, her eyes glowing, showing me the beautiful pin that she had been given to recognize her achievement. The theory fails to notice the photo in our album of my son, sleeping on my husband's chest, and the presence of their father's humor and inflections in our daughters' voices. These moments of familial specificity achieve meaning for me as they both confirm and contradict the relations that Chodorow describes. My father's participation in my infant care, my mothers leadership were both achieved in opposition to the politics of separation and connection that Chodorow presents. Furthermore, the meaning of their actions cannot be separated from this contradiction, for it was in opposition to those norms that my mother talked and my father walked. And sometimes the actors themselves, located somewhere between connection and separation lose their grasp of their own experience. My mother puts my father on the phone to talk to the landlord. My father never talks about his business at home. My son asks about my work and reads my papers, but he is careful not to mention that the research that he is citing in his college classroom was written by his mother.

I reclaim the specificity of my own gender formation as I read these memories of identification and differentiation through the lens of pre- and postoedipal politics. I begin to grasp the dialectic that makes me a particular personality who is, nevertheless,

a Woman. Because education mediates this passage between the specificity of intimate relations and the generalities of the public world, because cognition requires perpetual negotiation between general concepts and specific perceptions and intuitions, our understanding of our work as educators is enhanced when we grasp the interplay of the general and the specific in the constitution of our own gender identities.

Theory is cultivated in the public world. It is an interpretive and speculative enterprise that the community undertakes to make sense of our collective past, present, and future. Theory grows where it is planted, soaking up the nutrients in the local soil, turning to the local light. A theory of education that is cultivated in the academy, the library, or the laboratory accommodates to its environment. For educational theory to comprehend the experience and implications of reproduction we must generate a dialectical theory that gathers data and interpretation from both the public and the domestic domains.

Psychoanalytic theory abandons mothers and children at the very moment when we make room for Daddy. Though the presence of the father is gathered into the symbolic representation of the third term in the object relations of both mother and child, the entrance of the father and the world he brings with him need not be construed as obliterating the world that mother and child have shared. Too often psychoanalytic theory portrays the mother/child symbiosis as undifferentiated, as if mother and child spent the early days of infancy plastered up against each other, allowing no light, no space, no air, no world to come between them. Mother/child interaction, as the research of Daniel Stern has shown us, is a much more dynamic and differentiated relation than classical psychoanalytic theory would suggest.[17] This is not to dismiss the significant contribution to the life of the mother and the life of the child that the father, the friends, the world provide. A relation to this third term is achieved by both mother and child through their shared history of attachment and differentiation. What we have to remember, however, is that the father does not create the world, although he may enrich and extend it.

In constructivism the symbolic status of the world is acknowledged as the construct that evolves from the interacting and mutually constituting reciprocity of subject and object.[18] Underneath every curriculum, which expresses the relation of the knower and the known as it is realized within a specific social and historical moment, is an epistemological assumption concerning the relation of subject and object. In an attempt to understand how we come to have and share a world, the various epistemologies relegate differing weights to consciousness and facticity. Each epistemology offers a negotiated peace between these two competing terms to account for this intersubjective construct, this ground of all our cognitions, "this world." Materialist epistemologies favor facticity; idealist epistemologies favor consciousness or mind. Whereas both materialist and idealist epistemologies permit the third term to collapse into one or the other poles of the dyad, the constructivist epistemology of Piaget retains the third term as constituted simultaneously by the interaction of the two and as constituting them in turn. Whereas constructivism mirrors the configurations of the symbiosis of the mother/child bond and the extension of that continuity beyond the oedipal crisis in the mother/daughter relationship, the tenuous father/child bond and harsher repression of the mother/son preoedipal bond reflect the dyadic structure of materialist and idealist epistemologies.

The shift between dyadic and triadic epistemologies marks the contradictory moment that transforms the structure of conception into the structure of curriculum. The paternal relation is first constituted in three terms, as the father's relation with the child is mediated by the mother. The paternal compensation for this contingency is to delete the mother, to claim the child, and to be the cause, moving to a two-term, cause/effect model, where the father is the cause and the child his effect. The original maternal relation, on the other hand, is dyadic, and it is through the process of differentiation as mother and child grasp the world in which they found each other that the third term appears. So where constructivism may represent a preoedipal past for masculine epistemology, it suggests a postoedipal injure for feminine epistemologies. This conclusion is mirrored in the collaborative research of Belenky, Clinchy, Goldberger, and Tarule. They develop five categories to describe the epistemological perspectives held by the women they interviewed:

> *Silence*, . . . women experience themselves as mindless and voiceless and subject to the whims of external authority; *received knowledge*, . . . women conceive of themselves as capable of receiving, even reproducing knowledge from the all-knowing external authorities but not capable of creating knowledge on their own; *subjective knowledge*, . . . truth and knowledge are conceived of as personal, private, and subjectively known or intuited; *procedural knowledge*, . . . women are invested in learning and applying objective procedures for obtaining and communicating knowledge; and *constructed knowledge*, . . . women view all knowledge as contextual, experience themselves as creators of knowledge, and value both subjective and objective strategies for knowing.[19]

This study of women's ways of knowing settles on constructivism as the epistemology that celebrates the creativity and responsibility of the knower as well as the context and relations within which knowing takes place and comes to form. Within their developmental argument, these authors make it clear that the constructivist position is an achievement, earned as women bring together the parts of their experience that the politics of gender, of family, school, and science has separated. What I have called masculine epistemology may be found in their categories of received and procedural knowledge and the silence that their politics produces.

Masculine epistemologies are compensations for the inferential nature of paternity as they reduce preoedipal subject/object mutuality to postoedipal cause and effect, employing idealistic and materialistic rationales to compensate as well for the repressed identification that the boy has experienced with his primary object, his mother. The male child who must repress his preoedipal identification with his mother negates it, banishing this primary object from his own conscious ego identity. As his mother is not he, objective reality also becomes not he, and his own gender, more tentative than that of the female, is constituted by the symbolic enculturation of his culture's sense of masculinity, a conceptual overlay that reinforces his own sense that his subjectivity (that preoedipal maternal

identification) and objectivity (that primary object, mother) are alienated from each other. Chodorow's point is that masculine identification processes stress differentiation from others, the denial of affective relations, and categorical, universalistic components of the masculine role, denying relation where female identification processes acknowledge it. She concludes that both as infants and as adults, males exist in a sharply differentiated dyadic structure, females in a more continuous and interdependent, triadic one.

If psychoanalytic theory has given too much power to the father, it has taken too much power from the son. The harshness of the son's repression of his preoedipal relation to his mother, though necessary for the development of male gender identity, may be somewhat diminished if that mother is not portrayed as a cloistered recluse, wallowing in regressive fantasies. The mother who is in the kitchen and in the world may nurture both sons and daughters for whom male and female, private and public, knowing and feeling are not so harshly dichotomous and oppositional.

Although Chodorow acknowledges the contributions of biology to the infant's matrisexual experience and subsequent maternal symbiosis, she maintains that the oedipal crisis is culturally specific. She demands that we acknowledge culture, the organization of families and labor, as responsible for the oedipal crisis, which in Freudian theory is attributed to a biological determinism of shifting zones of libidinal expression. For Chodorow the interpretive shift from biology to culture is significant for it acknowledges human agency, assuming that, if biology makes us, we make culture. Culture, she claims, is not a species characteristic but evolves as a response to the repressions demanded by those social relations that prevail in a particular era and milieu. Chodorow argues that the object relations she describes are sustained by a highly rationalized economic system of capitalism that draws men away from parenting and into institutions that require behavioral obedience and an orientation to external authority, thus reinforcing the repressions of the preoedipal experience. Such an argument coincides with the work of critical theorists such as Herbert Marcuse and Christopher Lasch who argue that mass culture, media, and the glorification of the adolescent peer culture have undermined the role of the father as a palpable authority in a child's life, vitiating the oedipal struggle and the autonomy that is the reward of the child who survives it.[20]

Although we must acknowledge the resemblance of this profile of contemporary culture to the world we know, I find its analysis skewed in the weight it gives to the labor and love of the fathers in determining the character of our culture and world. This scheme suggests that the female, domestic, and maternal influence prevails in our time as a consequence of patriarchal default and continues to represent the consequences of female influence as regressive, binding the children left to us to infantilized, undifferentiated, and narcissistic futures. The broad strokes that paint sociology's portrait of culture necessarily present its surface, most visible and accessible structures for its total reality. The very clarity of the structural scheme that has permitted the generative analogies we draw between object relations and epistemology may mislead us, if it overwhelms us with a description of our situation that is too coherent. In a culture such as ours, where the symbol systems that dominate our social worlds, are most often designed, distributed,

and credentialed by men, it is not surprising that a sociological portrayal, locating itself in a description of our common situation, depicts a patriarchal order.

An attempt to provide a more complex and dialectical sense of culture is suggested in a study such as Julia Kristeva's *About Chinese Women*, which combines history and sociology to examine the cataclysmic changes in Chinese culture and their impact on the lives of Chinese women.[21] Kristeva describes an era in Chinese history that parallels the preoedipal period of psychological development in the West. Her analysis is interesting because it suggests that despite the 8,000-year-old repression of a putative matrilineal and matrilocal culture, contemporary Chinese women may be able to draw upon the deep streams that have run through their history, linking them to a cultural and historical epoch in which preoedipal symbiosis and continuity of internal and external structures were political realities rather than psychological repressions. Of course, the comparison that I make between Kristeva's and Chodorow's portraits of culture also marks the location of my own perception, as I find the one that deals with my own culture too general because I am so familiar with its complexities and am persuaded by the study of the culture so distant from me.

Contradiction

Although our culture may lack the matriarchal history that might reveal our latent possibilities and the perspectives to reassure us that all is not lost and we have a past ready to reclaim, within us resides the power to imagine, if not remember, the negations of the conditions of our existence.[22] I think we attempt to accomplish this negation in the worlds we construct for our children. The contradiction is not merely altruistic, designed for them, for it also extends the projects of our own development as adults trying to extricate ourselves from our own childhoods and our own children. Unlike other organisms, we do not spawn and die. We not only survive the birth of our children, but from the moment of their conception, their time and ours intermingle, each defining the other. Biology and culture influence our contemporary categories of gender and attitudes toward parenting as well as our epistemologies and curricula. This study of women and curriculum is claiming a space in culture for the women who care for children other than the great empty void assigned to us by the absent fathers and homesick sociologists. It presents a reading of curriculum that attributes the motive of differentiation to the mothers rather than the fathers, whose bureaucracies and collusions extend their own wishes to own and be owned. And if Kristeva finds in archaic Chinese history a female consciousness and promise of transformation contained, yet present, in collective memory, I suggest that our revolutionary female consciousness is lodged not in the recesses of time, but in the work that women do daily teaching children in classrooms.

While claiming, even flaunting, the preoedipal symbiosis of mother and child, we must be suspicious of portrayals of that primal relation that disqualify it as a way of knowing, of learning, of being in the world. If we bury our memories of this relation we

knew as children and again as mothers under language, under law, under politics, and under curriculum, we are forever complicit in patriarchal projects to deny its adequacy, influence, and existence. Kristeva maintains that our culture and codes of communication contain not only the linguistic rules and conventions that constitute our postoedipal symbolic systems but also the imagistic, inflected, and gestural semiotic codes that signal the continued presence of our preoedipal pasts in our adult experience.[23] Similarly, the method of this discourse invites us to read the work of women in classrooms as a text of our repressions and compromises. It invites us to read the texts of educational experience and practice as semiotic as well as symbolic systems. Curriculum is a project of transcendence, our attempt while immersed in biology and ideology to transcend biology and ideology. Even in the most conventional scene of classroom practice we can find traces of transformative consciousness, no matter how masked in apparent compliance and convention. This perception invites us to refuse to run the classroom like a conveyance, designed to transport children from the private to the public world, but to make it instead a real space in the middle, where we can all stop and rest and work to find the political arid epistemological forms that will mediate the oppositions of home and workplace.

Curriculum

The assertion that curriculum is motivated by our projects to transcend the biological and cultural determinations of our reproductive experience seriously undermines the assumption that curriculum design is a rational activity resting on needs assessments, systems analyses, or values clarification. The degree to which our support for open schooling, back-to-basics, moral education, or minimum competency testing is lodged in the relationships of our infantile psychosexual milieu is the degree to which our choices are overdetermined and our praxis vitiated. It would be simple if the relationships were direct, if schooling were just one great funnel into which we poured the entire social, emotional, political contents of our lives. Instead, rather than merely replicating the society from which they spring, schools contradict many of the dominant social and familial themes in our society. The history of education in this country provides countless instances of institutional, curricular, and epistemological configurations that emerge to contradict a particular condition in the culture. The famous "Olde Deluder Satan Law," passed in the Massachusetts Bay Colony in 1647, empowered the minister to compel illiterate children to attend his lessons so that they could learn to read Scripture and be saved. It did not merely reflect the colonists' religious fervor and commitment to the Bible. It also revealed the decline of the colonists' religious fervor and the commitment to the Bible. It was compensatory. The very notion of childhood itself, argue both Aries and Wishy, is also compensatory, for it endowed youth with the innocence and protection that adults, adjusting to pluralistic urban centers, lacked in their own daily experience.[24] We do not have to turn back to fourteenth-century Europe or the Massachusetts Bay Colony to discover contradictions. The democratic ethos of American schooling, equality of opportunity leading to social mobility based on achieved rather than ascribed

characteristics, belies the actual commitments of the upper and middle classes to retain their class status and the function of the schools in support of their privilege. Racial integration and busing contradict racial distrust and antagonism.[25] Essentialist and "Great Books" curricula contradict our immersion in the imagery of contemporary video, our cultural pluralism, and our infatuation with technology.

Because schools are ritual centers cut off from the real living places where we love and labor, we burden them with all the elaborate aspirations that our love and labor are too meager and narrow to bear. Contradicting the inferential nature of paternity, the paternal project of curriculum is to claim the child, to teach him or her to master the language, the rules, the games, and the names of the fathers. Contradicting the symbiotic nature of maternity, the maternal project of curriculum is to relinquish the child so that both mother and child can become more independent of one another.

Nevertheless, when negation is collapsed into a simple antithesis, a polar contradiction of one extreme by another, the alternative is as restricting as the condition it strives to repudiate. Just as the mother may succumb to the pleasures of sensuality or the shallow comfort of individualism, the father is also menaced by the contradictions he employs to negate conditions of paternity. As a parent, the father contradicts the inferential and uncertain character of his paternity by transforming the abstraction that has been felt as deficiency into a virtue, into virtue itself. Co-opting the word, and transforming it into the law, the fathers dominate communal activity. Tying procreation and kinship to the exchange of capital, the fathers master the pernicious alchemy of turning people into gold, substituting the objectification of persons for the abstraction implied by paternity and amplified by technology and capitalism. The project to be the cause, to see the relation of self and other as concrete, is expressed in monologic epistemologies of cause and effect, of either/or constructions of truth, and of social science that denigrate the ambiguity and dialectical nature of human action to honor the predictability and control of physical and mechanistic phenomena.

Who are these fathers? They are our sons. They are the children the incest taboo estranges from their mothers, repressing their symbiotic experience of connection and identification with the other, the mother, the first object and the conditions of their own sense of self. They are the ones for whom gender identification requires a radical negation that violates the mutual dependency of child and parent, of subject and object. (Hence the "null hypothesis" of social science, which assumes there is no relation between variables and requires substantial quantification before a "significant" relation can be asserted.) Split off from identification with his mother, his primary object, the boy's later identification with his father is supported by his growing capacity to symbolize, to associate signs with experience, genitals with gender, words with power. As a man he will seek to reestablish the connectedness of infancy through work and culture and family; and if he can escape the depersonalizing, bureaucratic alienation of work and the positivistic, objectivizing dehumanization of culture—both of which combine to estrange him from his family—he may succeed. Masculine epistemology reflects this search for influence and control. It is oriented toward a subject/object dyad in which subject and object are not mutually constituting but ordered in terms of cause and effect, activity and passivity.

Masculine curriculum reflects this epistemology, contradicting the ambiguity of paternity, in forms differentiated by class interests. Though more closely identified with class status than women, men of all classes hope to engage in work that will be acknowledged as productive. They seek to be acknowledged as agents, who can claim the crop, the engine, the legal code, the party, the cure, the peace as theirs. For those engaged in manual labor the product, if not fragmented beyond recognition by the assembly line or trick shift, is concrete and tangible. For white-collar workers it becomes more abstract: the plan or the report, or the paycheck. For others it becomes an investment portfolio, an office with a window, a two-year improvement in reading scores. The product, material or symbolic, is public and can be traced, if not to a particular individual, then to the group to which he lends his name.

Competency testing, back-to-basics, and teacher accountability were the expressions of this process/product paradigm in the curriculum trends of the 1970s.[26] They accompanied the historical development of increasing bureaucracy and rationalization of the means of production and, in particular, the repudiation of the educational initiatives of the "sexties," rife with sensuality, ambiguity, rebellion against the paternal order. In the eighties fundamentalist assaults on the curriculum have sought a totalitarian solution for the family's incapacity to reproduce its world view in its children. The attempt to control and shape the child through schooling is also present in the recent criticisms of schooling that have appeared in the proliferating "school reports" of this decade. These documents reinforce the authority of the traditional disciplines and the rationalization of the workplace in their curriculum proposals, demanding higher standards, fewer electives, reliance on the literary canon, more homework, better use of time, merit designations for staff, and higher salaries. No longer rationalizing schooling as the path to success for the entrepreneurial "self-made man" in an era when small business has given way to the corporation, it is the economic prosperity of the nation, no less, that is depicted in some of the reports as resting on the quality of instruction in schools. As we lose ground in our competition with other countries for international markets and military technology because of the greed and mismanagement of corporate production and trade agreements, blame is deflected from the men who establish these policies onto the women who teach the children who fail.[27]

For all the simplistic positivism of the programs of the seventies and the proposals of the eighties, there is a courage in their paternalism that I celebrate. There is courage in their assertions, however self-serving, and in those who designed them. There is courage in their willingness to address the future and to try to shape its character. They are political.

In contrast, even though the curriculum reform that grew out of the counterculture movement of the seventies was a serious political response to the arbitrary and abstract politics that brought us the Vietnam atrocities and Watergate, its open classrooms, alternative schools, and interdisciplinary curricula came to be seen as attempts to retreat from the world rather than as projects to redesign it. The curriculum of the open classroom mirrors the characteristics that Chodorow identifies as characteristic of women's work rather than men's.[28] Whereas men's work in the office or the factory is contractual, delimited in time, organized around a defined progression toward a finite product, women's

work is nonbounded and contingent on others.[29] Women's work is seen as maintenance, repeated in daily chores required merely to sustain life, not to change it.

Ironically, the child-centered philosophy of the open school, the curriculum movement that might have extended the vigor and specificity of maternal nurturance from home to classroom, shifted the stasis attributed to women's work and lives to children. Rachel Sharp and Anthony Green argue that the ethos that supported the individuation of the child was the expectation that, left to his or her own developmental agenda, the child would express an inner nature, realizing. what she or he *is*.[30] But they maintain that this ontological view of the child that honors what the child is, rather than what the school will make him become, ultimately served to sustain class differences, masking that teleological agenda and allerning it to function even more efficiently than it had in the traditional setting because its assumptions were no longer explicitly articulated. Their critique suggest that the maternal, ontologic ethos of such schools, its commitment to the "whole child," and apparent willingness to honor the specificity of each child's background and developmental level, masked the patriarchal teleologic project to produce class distinctions and advance the interest of the middle class that proceeded unimpeded by the new "familial" organization and ambience of the classroom. Because the innovations in curriculum often stopped at the classroom door and did not penetrate programs of evaluation or credentialing, the acceptance that they extended to the individual child trapped the poor child in a repertoire of behaviors that did not conform to the standards set to recognize and celebrate middle-class culture. Oblivious to the far-reaching epistemological and political implications of this approach to schooling, the teachers who had transformed their classrooms into places of active exploration and group process failed to create the political and ideological structures required to sustain and enlarge the movement. It disappeared almost as quickly as it came, leaving an empty terrarium, Cuisenaire rods, and an occasional learning center in its wake.

The degree to which schooling continues to imitate the spatial, temporal, and ritual order of industry and bureaucracy indicates the complicity of both men and women in support of paternal authority. That pattern becomes even more obvious in the social arrangement of faculty within schools, where male administrators and department chairmen dominate female teaching staffs, who, secretive and competitive, vie for their fathers' approval while at the same time disregarding the rational schemes and programs that emanate from the central office in favor of a more contextual, idiosyncratic curriculum of their own. Docile, self-effacing, we hand in our lesson plans, replete with objectives and echoes of the current rationale, and then, safe behind the doors of our self-enclosed classrooms, subvert those schemes, secure in their atheoretical wisdom, intuitive rather than logical, responsive rather than initiating, nameless yet pervasive. The programs stay on paper, the administrators' theory barred from practice, the teachers' practice barred from theory by the impenetrable barriers of resistance sustained by sexual politics.

Dorothy Dinnerstein argues that so long as primary parenting remains within the exclusive domain of women, both men and women will seek and support the paternal order as a refuge from the domination of the mother.[31] She maintains that from the early years in which mother is the source of all satisfaction as well as its denial, the audience

for our humiliations as well as our triumphs, the supporting, inhibiting, protecting, abandoning agent through whom, and despite whom, we discover the world, we retain a rage at our own dependency and disappointment. The sons *and* the daughters turn to the fathers for relief; they who seem free of her dominion, substituting paternal authority for the maternal order.

It is the female elementary school teacher who is charged with the responsibility to lead the great escape. At the sound of the bell, she brings the child from the concrete to the abstract, from the fluid time of the domestic day to the segmented schedule of the school day, from the physical work, comfort, and sensuality of home to the mentalistic, passive, sedentary, pretended asexuality of the school—in short, from the woman's world to the man's. She is a traitor, and the low status of the teaching profession may be derived from the contempt her betrayal draws from both sexes. Mothers relinquish their children to her, and she hands them over to men who respect the gift but not the giver.

Who are these teachers? They are our daughters. Because mothers bear so much of the weight of parenting, as Dinnerstein has pointed out, we are very powerful figures for our children. That power would seem less threatening if it were not confined, however, to the domestic sphere. The discrepancy that children experience between their mother's influence in their home, compared to her influence in the public world, must undermine their comfort and confidence in maternal strength. Though their own intimate experience of her power is not diminished, it becomes suspect if it appears to be confined only to the forms of domestic nurturance. Whereas the sharper repression of the symbiotic tie permits her son to feel safe from her, the stronger identification of the daughter increases her vulnerability, and she turns to her father to escape the maternal presence that threatens to subsume her. Dinnerstein maintains that "both men and women use the unresolved early threat of female dominion to justify keeping the infantilism in themselves alive under male dominion."[32] The infant's rage, projected onto the mother, is reinforced by the disappointments and denials encountered in adult life, whereas the child's aspirations for autonomy along with the enduring desire for dependency are transferred to the father. Identification with paternal authority becomes a spurious symbol of autonomy, while the acquiescence it requires satisfies the unresolved desire to be managed and deny responsibility.

Kim Chernin's study of mother/daughter relationships in *The Hungry Self* suggests another motive for the daughter's emigration to the father's world. Chernin explores the daughter's identification with her mother's experience of stasis, frustration, and disappointment. She sees daughters struggling with their sense of their mothers' unrealized ambitions, unexpressed talents. So the daughter who flees may be attempting to escape her memory of maternal dominion as she simultaneously attempts to compensate her mother for her disappointments by achieving what was denied to her.[33]

The lure of patriarchy is an index to the enduring power of the mother/daughter bond. The symbiotic, concrete, polymorphic, preoedipal attachment of mother and child links our lives across neighborhoods, time zones, and generations. As the woman creates the child, the child completes the woman. Particularly in Western culture, where female sexuality is acknowledged and tolerated only in its capacity for procreation, mother-

hood bonds sexuality and gender. It legitimizes desire. It permits the woman to reclaim her body and her breasts from their status as erotic objects hitherto perceived only in their capacity to attract and seduce man. It dissolves the stigma of menstruation, inherited from the Old Testament, in the glory of creation. It releases the woman from the guilt of her secret sexuality as it repudiates the myth of the Virgin impregnated by the Word. As the child realizes his or her form within the woman, the woman realizes her form through the child. They constitute each other, subject and object dependent upon each other for both their essence and their existence. Chodorow endows this somewhat idealistic portrait of intersubjectivity with its erotic life when she argues that whereas the male reexperiences the preoedipal intimacy with his mother through coitus with a woman, the female ultimately reexperiences that bond not through the sexual relation to the male but in the intimacy she experiences with the child.[34] This dialectical interdependence obtains not only in the early months of the child's life but throughout its development, for the mother is able to differentiate from the child only insofar as the child is able to differentiate from her. The facticity and freedom of both mother and child are contingent upon their relationship. Psychoanalytic theory celebrates both maternal absence and maternal presence as the basis of ego development. It is argued that it is only in the mother's absence that the child begins to perceive his or her own selfhood so that their intermittent separation is the basis for the first identification of self. Yet the converse is also true. For the willingness and capacity for separation rest upon the prior and anticipated satisfaction of the child's needs for intimacy, dependence, and nurturance. The developmental needs of both mother and child simultaneously sustain and contradict the concrete, symbiotic origins of their relationship. A feminist epistemology reflects this dialectical dependence of subject and object.

Although the presence of open, nongraded classrooms seemed to suggest that a feminine epistemology had penetrated the patriarchal pedagogues of elementary education, the movement has collapsed, its foundations eaten away by technological methods that subvert it as well as by an ethos of individualism that has drained it of social promise and political power. This educational initiative finally failed to address the dilemma that has always plagued public education: the tension between addressing the needs of each individual student and developing the cohesion and identity of the group that contains that student. The project of differentiation that supports ego boundaries and personal strength is too often translated into a laissez-faire individualism that surrenders a vision of the world we might share to a project of individual development that repudiates intersubjectivity and interdependence.

Bonded, interminably, it would seem, to her mother and then to her child, the woman who survives the demands of these relationships to work in the world as a curriculum theorist, school administrator, or teacher is often engaged in the project of her own belated individuation and expression. Furthermore, as I shall argue later, our relations to other people's children are inextricably tied to our relation to our own progeny, actual and possible, and to the attribution of rights and influence that we attribute to that affiliation. If it is our relation to our own children that is contradicted by the curriculum we develop and teach, we must remember that what we develop we teach not to

our own but to other people's children. It is with them that the contradictions between the woman's own experiences of childhood and mothering and the curricula she supports appear. Convinced that we are too emotional, too sensitive, and that our work as mothers or housewives is valued only by our immediate families, we hide it, and like Eve, forbidden to know and teach what she has directly experienced, we keep that knowledge to ourselves as we dispense the curriculum to the children of other women. Bonded to the other in a nurturant but inhibiting symbiosis on the species and cultural level, feminine curricula reverse the patterns of species and sociocultural relations emphasizing an asocial and apolitical individuation. It is this monologic intentionality that Kristeva fears will vitiate the hidden, presymbolic power that resides within feminine experience. She fears that we sell out: we escape the binding preoedipal and postoedipal identification with our mothers by identifying with our fathers, striving for access to the word and to time; or we repudiate the dialectic of sexuality, obliterating the other in a fascistic and totalitarian mimicry of power; or we sink into a wordless ecstasy, back into the preoedipal maternal identification, mystical, melancholic, sullen, and suicidal—Virginia walking into the river. Kristeva's warning:

> To refuse both extremes. To know that an ostensibly masculine, paternal (because supportive of time and symbol) identification is necessary in order to have some voice in the record of politics and history. To achieve this identification in order to escape a smug polymorphism where it is so easy and comfortable for a woman here to remain.[35]

Bearing epistemologies and curricular projects that contradict both our psychosocial development as sons and daughters and our procreative experience as fathers and mothers, we find ourselves trapped in the activity we claim as conscious intentionality as we have been in the overdetermined, repressed experience of our early years. This compensatory and simplistic pattern of opposition demeans the dialectic, a title it hardly deserves. To qualify for that designation we would need to interpret our reproductive experience (procreation and nurturance) and our productive practice (curriculum and teaching) each through the other's terms, not obliterating the differences between them but naming their contradictions and reconceiving our commitment to the care and education of children. It is a dialectic that strives not to obliterate differences in a shallow, totalitarian image of equality but to sustain them and work for their integration.

Feminist social theory directs us to reorganize our patterns of infant nurturance, permitting fathers to assume significant nurturant activities and an intimacy with their children that will preclude the harsh, deforming repression of the rich and powerful preoedipal experience. The felt presence of both mothers and fathers in the infant's world may diminish the crippling dichotomy of internal and external, dream and reality, body and thought, poetry and science, ambiguity and certainty. These domestic arrangements clearly remain fantasy unless supported by the economic, religious, and legal systems in which we live. The task when viewed in the structural complexity of our social, political, economic situation appears herculean. Only when we suspend the despair that isolates

us from our history and our future can our reproductive capacity reclaim the procreative promise of our species, not merely to conceive but to reconceive another generation.

We, the women who teach, must claim our reproductive labor as a process of civilization as well as procreation. We can continue to escort the children from home to the marketplace as did the *paidagogos*, the Greek slave whose title and function survive in pedagogy, or we can refuse the oppositions and limits that define each place and our love and work within them. The task is daunting and not without its contradictions. These words, for all their intensity, have been sifted through the sieves of academic discourse. The very institutions that I repudiate for their perpetuation of patriarchal privilege are the ones within which I have found the voice that tries to sing the tune of two worlds. This writing has been interrupted and informed by driving the kids to the pool and to soccer practice, by the laundering of sweaty sports socks and mildewed beach towels, by the heat of the summer sun and the soft summons of the night air. As I end this chapter, I am tempted to celebrate both it and myself. But I am chastened by Kristeva:

> To be wary from the first of the premium of narcissism that such integration may carry with it: to reject the validity of the homologous woman, finally virile; and to act, on the socio-political, historical stage, as her negative: that is, to act first with all those who "swim against the tide," all those who refuse—all the rebels against the existing relations of production and reproduction. But neither to take the role of revolutionary (male or female) to refuse all roles, in order on the/contrary, to summon this timeless "truth"—formless, neither true or false, echo of our jouissance, of our madness, of our pregnancies—unto the order of speech and social symbolism. But how? By listening, by recognizing the unspoken speech, even revolutionary speech; by calling attention at all times to whatever remains unsatisfied, repressed, new eccentric, incomprehensible, disturbing to the status quo. A constant alternation between time and its "truth," identity and its loss, history and the timeless, signless, extra-phenomenal things that produce it. An impossible dialectic; a permanent alternation; never the one without the other. It is not certain that anyone here and now is capable of it. An analyst conscious of history and politics? A politician tuned to the unconscious? A woman perhaps . . .[36]

Notes

Grumet, Madeleine R., "Conception, Contradiction, and Curriculum," reprinted from *Bitter Milk: Women and Teaching*, by Madeleine R. Grumet (Amherst: University of Massachusetts Press, 1988). Copyright © 1988 by The University of Massachusetts Press. Chapter 1, "Conception, Contradiction, and Curriculum," pp. 3–30.

1. Julia Kristeva, *About Chinese Women*, trans. Anita Burrows (London: Marion Boyars, 1977), p. 15.

2. Maurice Merleau-Ponty, *Phenomenology of Perception*, trans. Colin Wilson (New York: Humanities Press, 1962).

3. In Christine Froula's study of Christian doctrine and its interpretation in Milton's *Paradise Lost*, Eve's transgression is the claim of direct experience, rather than the mediated knowledge that imputes invisibility to authority. See "When Eve Reads Milton: Undoing the Canonical Economy," in *Canons*, ed. Robert von Hallberg (Chicago: University of Chicago Press, 1984).

4. Antonio Gramsci, *Selections from the Prison Notebooks*, trans. and ed. Quinton Hoare and Geoffrey N. Smith (New York: International Publishers, 1971).

5. Edmund Husserl, *Ideas: General Introduction to Pure Phenomenology*, trans. W. R. Boyce Gibson (New York: Collier Books, 1962).

6. Stephen Strasser, *The Idea of a Dialogic Phenomenology* (Pittsburgh: Duquesne University Press, 1969).

7. Ibid., pp. 61–63.

8. Nancy Chodorow, *The Reproduction of Mothering: Psychoanalysis and the Sociology of Gender* (Berkeley: University of California Press, 1978).

9. Ibid., p. 47.

10. In *The Politics of Reproduction* (Boston: Routledge and Kegan Paul, 1981), Mary O'Brien provides a philosophy of birth and brings each of these "moments" to its meaning in the generation of the human species and the human spirit: menstruation, ovulation, copulation, alienation, conception, gestation, labor, birth, appropriation, nurture (p. 47).

11. Shulamith Firestone's startling prophesy that women will seize control of our own bodies and of reproduction, in *Dialectic of Sex* (New York: Bantam Books, 1972), has, despite its specter of a totalitarian technology, challenged us to name the experience, meaning, and politics of heterosexual reproduction as we know it. See Jean Bethke Elshtain's critique of Firestone in *Public Man, Private Woman: Women in Social and Political Thought* (Princeton, NJ: Princeton University Press, 1981).

12. Vangie Bergum, *Woman to Mother: A Transformation* (South Hadley, Mass: Bergin and Garvey, forthcoming).

13. Jürgen Habermas, *Knowledge and Human Interests*, trans. Jeremy J. Shapiro (Boston: Beacon Press, 1971), pp. 262–63.

14. Bernard Wishy, *The Child and the Republic* (Philadelphia: University of Pennsylvania Press, 1968).

15. Chodorow, *Reproduction of Mothering*, pp. 166, 167.

16. Ibid., p. 174.

17. Daniel Stern, *The Interpersonal World of the Infant* (New York: Basic Books, 1985).

18. Constructivism is the epistemological theory described by Jean Piaget. See *The Grasp of Consciousness*, trans. Susan Wedgwood (Cambridge, MA: Harvard University Press, 1976).

19. Mary Field Belenky, Blythe McVicker Clinchy, Nancy Rule Goldberger, and Jill Mattuck Tarule, *Women's Ways of Knowing: The Development of Self, Voice, and Mind* (New York: Basic Books, 1986).

20. See Herbert Marcuse, *Eros and Civilization* (Boston: Beacon Press, 1955); and Christopher Lasch, *The Culture of Narcissism* (New York: W. W. Norton, 1979).

21. Kristeva, *About Chinese Women*.

22. This concept of negation is drawn from Jean-Paul Sartre's association of negativity with the *pour-soi*, the human responsibility to reject determination and shape its own essence, developed in *Being and Nothingness*, trans. Hazel E. Barnes (New York: Washington Square Press, 1966).

23. Extensive development of this distinction can be found in Julia Kristeva, *Revolution in Poetic Language*, trans. Margaret Waller (New York: Columbia University Press, 1984).

24. Philippe Aries, *Centuries of Childhood*, trans. Robert Baldick (New York: Random House [Vintage Books], 1965); Wishy, *Child and Republic*.

25. Although the contradictions as stated, here appear to contain a simple opposition of thesis and antithesis, that simple polarity may mask other intervening terms. The polarization of racism and mandated integration masks the issue of economic class. "Back-to-basics" provides another example of an apparent opposition that masks a third term. The slogan responds to the alienating technology of our culture, to the specialized curricula of the fifties and the expressive curricula of the sixties, and to the perceived deficiencies of the high-school graduates of the seventies. The compensatory thrust of "back-to-basics" addresses itself to the failure of the school curriculum to provide adequate instruction in reading, writing, and mathematics and focuses on the profound inadequacies of these high-school graduates. The revelation of these inadequacies is used to justify the failure of the economy to provide meaningful work for these graduates while it distracts our attention from the material conditions that reduce their learning, schooling, and literacy to empty gestures.

26. Walter Doyle presents the process/product paradigm (which I am associating with the curricula associated with masculine epistemology) in contrast to the mediating process and classroom ecology paradigms in teacher-effectiveness research. The mediating process paradigm acknowledges the interdependency of teacher and student behaviors. It mirrors the emphasis on context and process noted in the mother/child preoedipal relation and the subject/object reciprocity noted in constructivism. The classroom ecology paradigm is field-centered like object relations theory itself, as it attempts to ascertain those skills that continuous experience with classroom demands engenders in the students. See "Paradigms for Research on Teacher Effectiveness," in *Review of Research in Education,* ed. Lee Shulman (Itasca, IL: F. E. Peacock, 1978).

27. It is necessary to distinguish these studies and their findings from each other as they represent various interests, ask different questions, and come up with different answers. *The Paideia Proposal*, for example, calls for rigor in the traditional disciplines and active learning directed toward the development of civic virtues. *A Nation at Risk* associates poor schooling with the nation's economic and military vulnerability in international competition. Thirty-three studies are summarized in Marilyn Clayton Felt, *Improving Our Schools* (Newton, Mass.: Educational Development Center, 1985). In *Culture Wars* (Boston: Routledge and Kegan Paul, 1986), Ira Shor argues that economic malaise has inspired these critiques of education as well as the narrow projects of control that they offer as solutions.

28. Chodorow, *Reproduction of Mothering*, p. 179.

29. Chodorow cites Rosaldo's observation that men's work brings them into a social group of peers, dominated by a single generation that cuts across lines of kinship and is defined by universal categories where women's work is kin-related and cross-generational, tied to the nurturance of both her children and, later on, her parents. Ibid., p. 181.

30. Rachel Sharp and Anthony Green, *Education and Social Control* (London: Routledge and Kegan Paul, 1975), pp. 68–113.

31. Dorothy Dinnerstein, *The Mermaid and the Minotaur: Sexual Arrangements and Human Malaise* (New York: Harper and Row, 1976).

32. Ibid., p. 191.

33. Kim Chernin, *The Hungry Self: Women, Eating, and Identity* (New York: Times Books, 1985).

34. Chodorow, *Reproduction of Mothering*, pp. 201–2.

35. Kristeva, *About Chinese Women*, p. 37.

36. Ibid., p. 115.

Only the Fittest of the Fittest Will Survive

Black Women and Education

Barbara McKellar

Department of Education, South Bank University, London

People often ask me how I have managed to progress from the primary classroom to a post in the teacher education department at a London polytechnic. This question is pertinent when there is evidence of black underrepresentation in higher education. I would not find unreliable the informal survey of teacher education institutions carried out by the Anti-Racist Teacher Education Network (Table 1). This showed that I would be one of twenty-seven black teacher educators in England, Scotland, and Wales (0.6 per cent).

Further information would be needed to establish how many of these black teacher educators are women. The small percentage the survey revealed is indicative of the way in which both race and gender operate to prohibit the recruitment and career advancement of black women in the teaching profession. Since the teacher education sector has to recruit from the pool of qualified and experienced teachers, what is needed is an analysis of the career progress of black teachers, in order to explain the percentage of 0.6 in post. What follows is an account of this progress with special reference to the ways in which race, class, and gender relations have shaped the development of my career.

Table 1. Number of Full-Time Staff in Teacher Education, with Number of Black Staff Shown in Parentheses

	Public Sector (including voluntary colleges)	University
England and Wales	2,150 (18)	1350 (8)
Scotland	709 (1)	17 (0)

Source: George J. Stigler, *Domestic Servants in the United States: 1900–1940,* Occasional Paper no. 24 (New York: National Bureau of Economic Research, 1946), p. 7.

First, I shall discuss the structural position of black women in society with a view to interpreting how this position influences the development of identity and images. Second, I shall discuss the processes of schooling that have assisted in shaping my potential to benefit from higher education. Finally, I shall look at the issues that black women face in sustaining a career in the teaching profession.

Black Women in Society

Historical Background

The position of black women in society is structured by political and economic developments, both nationally and internationally. The past holds as much explanation for the experiences of black women today as the present social and political climate. The development of racial and gender superiority coincides with the rise of capitalism as a major means of production in Europe. Such developments have also defined the roles played by all women in society and dictated the nature of the relations that could exist both between gender groups and across racial groups. It would be unrealistic to discuss the processes by which roles are structured without reference to the historical factors, not least because the same terms of reference operate to structure the progress of black women in education in Britain today. The experiences that are enjoyed in education are a reflection of the relations that exist in society at large. I would go as far as to say that when I walk down any street those I meet would not necessarily know that I am a teacher educator but *would* know that I am black and female. Therefore, the cultures to which one belongs are only important insofar as society attaches significance to them.

Throughout the last two hundred years or more there has been a predominantly accepted image of black women, whereby they are portrayed as serving and/or servicing others. The subservient role played by black women was related primarily to the development of indentured societies in the Caribbean and in Central and North America. The role of black women in such societies is not dissimilar to one played by working-class women in Britain during a parallel historical period. But in the black diaspora, the women were invariably performing this role in all spheres of life without any of the social differentiation that would have been normal in the African societies from which they came. Such societies had the potential to allow a diversity of social and economic activity, but slavery introduced the limitations of domesticity wholesale to successive generations of black women.

Quite apart from the restrictive range of social and "economic" activity, the period of slavery marked the point at which gender segregation occurred amongst black people in slave societies. Thus the gender role reconstruction, as well as cutting men and women off from each other, removed from black women the privilege of being able to exercise the trading skills that had been part of their heritage. Although this is the case, entrepreneurial traits are still to be found in the cultural practices of modern Caribbean societies, where women are market holders and participate in international trade, mostly dealing with

the American mainland: "Buying and selling, or higglering as it is called, is a common form of livelihood for women throughout Jamaica. . . . Higglers buy from the primary producers in the market at wholesale prices and retail them in villages nearby" (Clarke, 1979). This practice has expanded beyond the scale of fruit and vegetables to include all forms of commodity items. The shopfront or pavement site has been replaced by business enterprises that trade with the Americas, organized predominantly by females. So although slavery and capitalism have united to thwart the development of traditional economic patterns, despite the odds some things have managed to survive. The revival of African culture in the postindependence period has probably accelerated the trend of women adopting a higher profile within their communities.

Contemporary Forms of Oppression

The survival of traits related to the gender division of labor has occurred against a background of political struggle and extreme hardship, and the forms of oppression have assisted the construction of the particular kinds of gender relations that are to be found in black British communities. Because the norms of economic and political leadership were distinct from each other and attributable to separate gender groups in their previous culture both black women and black men are unable to assert themselves in the British context. This is because within British society women are not seen as the prime leaders in the field of business, and black men do not have access to the means of enfranchisement to the mainstream political spheres. The expectations of black people have been that they would fit into the existing patterns of gender differentiation, which are not in fact familiar to them. Moreover, when black women have become part of British society, they have been expected to assume the patterns of dependency experienced by white women, as well as to maintain continuity in the role assumed during the period of colonial rule. Colonialism had the effect of guaranteeing compatibility with the needs of industrial capitalism. Thus the possibility of fulfilling the cultural and social needs of black women is limited by the structural position of women in Britain per se. The degree to which British (white) women are second-class in status has been the source of discrimination for black women in particular and for minorities in general. One only has to refer to countries in Eastern Europe or to other moments in Britain's historical past to see how artificial is the allocation of gender roles. The existence of a correlation between power and economic activity, in addition to the conscription of women to the secondary labor market, has rendered women incapable of having access to equal status in society. The failure to meet the needs of black women is further worsened by the considerable gap in social and educational experience between the ethnic culture and the British one. When one then considers that for reproduction to occur, women must perform a dual role, it can be seen that black women have much with which to contend. That there has been social fragmentation in most parts of the black diaspora during the past cannot be disputed, and this has also meant that there was and is a greater need of urgency to stabilize the family base. The activities of many black women have this stabilization process as a prime concern.

Racism with Gender Groups

White male supremacy in international relations has been promoted via the development of patriarchal structures in European societies and via the extension of European power and influence in all parts of the world. This, in itself, has presented black men with an insuperable task in trying to regain a position of equality. In turn, the inferior position that black men hold makes more problematic the gender relations within black groups. In fact, the frame within which black women operate has to include favorable interactions with both of these groups, that is, a double source of dominant oppression. The resolution of conflicts that stem from male dominance has resulted in black women relying on their own resources. This is due in part to the fact that the dominant perspectives that influence the organizations and lobbying machinery within the women's liberation movement have not always recognized the racial dimensions of black women's experience. The birth of a movement called "Women against Racism and Fascism" sought to redress the balance. It has been suggested, however, that "the different strands of feminist and left politics were real impediments to thrashing out a common antiracist position" (Bourne, 1984, p. 9).

The inability to fuse the two perspectives that would address the issues related to black women's experience has been one of the major criticisms made by black women of the women's movement as a whole. Reasons suggested for this failure relate to the assumed differences that exist due to differences of race. When one considers that *race* is an artificial term, then many of the distinctions with regard to physical qualities, intellectual capacity, and the taboo subject of sexuality can be regarded as myth. Of the qualities referred to, it is often the physical and visual differences that are given prominence and then integrated via cultural and media representations to reproduce the ideologies that maintain the idea of significant difference. An example is the assumption that European standards in beauty are the ones by which to judge all others. Indeed the idea of racial superiority feeds assumptions about the qualitative distinctions that are mentioned above. For a long time there was assumed to be a scientific basis for the distinctions in academic achievement. The research of Mackintosh and Mascie-Taylor (Committee of Inquiry, 1985) suggests that IQ is not a reliable indicator of potential for academic achievement: "These findings tend to argue against those who would seek to provide a predominantly genetic explanation of ethnic differences in IQ" (p. 147). It is further explained that West Indian children do better in public examinations than IQ scores would indicate.

The other of the assumed differences, namely sexuality, is problematic because little has been written about sexuality and sexual relations, and what has been written has tended to remain in departments of higher education institutions and has not percolated to the world outside. It is unfortunate that this is the case, as stereotypes with regard to sexual prowess prevail to influence interracial interactions. Once again the period of slavery in the Caribbean has encouraged an image of black women as sex objects for the use of black and white men alike. It is unfortunate that the current media portrayal adopts these stereotypes to keep alive the idea that black women are strippers and prostitutes (e.g., *Eastenders*, 27 March 1988).

Campaigning and political black women leading ordinary lives are rarely seen, so the predominant stereotype is perpetuated and used for referral by all. Consequently the intergender relations of the black community have tended to overemphasize the reproductive role that women perform. It shocks many people to find out, for instance, that I have no children. It is important, therefore, that the experiences of all women are related to the political processes that express resistance to oppression. Feminists of all varieties need to ask the question, "What does it feel like to be a black woman in British society?" Until this sensitivity is seen as crucial in policy development, the effect of feminist activity will always be only to liberate white females. There has been a change in consciousness with regard to women's issues and much of this has started to influence the processes of education. It is not apparent, however, that black female identity and social development have so far been included as high priorities In either resourcing or developing educational policy. It may be a major concern of teachers in inner-city areas where there are significant numbers of black pupils, but there needs to be full permeation of antiracist and antisexist perspectives in curriculum development, regardless of geographical location. Moreover, it would be common to find the cultural isolation I experienced in the 1950s and 1960s replicated today in the nonmetropolitan areas of Britain. Pupils in the all-white school need to develop antiracist and antisexist practices as much as, if not more than, pupils from multiracial schools. It was my experience that girls within my peer group were able to develop hostile patterns of behavior in a subtle way that often went undetected by the staff. The way in which pupils interact with each other has not always been a major concern of teachers, yet the implications for the development of racial attitudes in society are just as important as the transmission of values by the mass media.

Summary

Although this is a brief account of the factors that shape the structural position of black women in Britain, what is revealed is that multiple factors operate to ensure that gender-related experiences are racially differentiated. The relations between European people and those of "African origin" have been molded by the exploitative nature of colonialism. Society's institutions that are concerned with cultural reproduction—family, church, judiciary—have all played a part in sustaining these relations. Responses to the economic, political, social, and cultural forms of oppression that have resulted from the complex interaction of factors mentioned earlier have in turn confirmed the shape and form of the political platforms of resistance.

Race, Class, and Gender in Schooling

Women, whether black or white, experience relations of sexual domination and exclusion and this, too, was central to their thinking about their lives inside and outside school.

—Fuller, 1983, p. 170

> Unless their efforts to circumvent racial and sexual exclusion in employment are successful they are likely to find themselves in unskilled and semi-skilled jobs and being paid at even lower rates of pay than their male counterparts.
>
> —Fuller, 1983, p. 179

It is dangerous to analyze racism or sexism in terms of individual achievement because, where it may be possible for small numbers of racial minorities or women to achieve success, often the structural position in society of both black people and women is not altered by such individual progress. Women are predominantly found in the lower paid sectors of employment. Together with sexual differentiation in employment, racism in employment and in education combine to produce a climate in which black girls perceive and experience the processes of schooling in an entirely different way. Evidence of racism in education can be seen in the fact that pupils from black and ethnic minority groups are rarely selected into higher education. Rather than examining all the issues simultaneously and thereby risking the creation of more generalizations, I shall look at the race and class dimensions briefly before considering the impact of gender on my school career.

Race and Class

My parents migrated to Britain from the Caribbean in the 1950s at a time when there was a positive recruitment policy for attracting workers from the Commonwealth. The flow of immigration in itself has "class" implications that, although never explicitly stated, were soon realized on arrival:

> After the war, which had killed off so many people, Britain was so desperate for workers to operate the factories, run hospitals and maintain transport and other services. In 1948 the Government passed a Nationality Act making all colonial and Commonwealth citizens British and actively recruited Black people. (IRR, 1986)

The hidden consequences of such recruitment practices had the effect of designating the housing class to which black people were assigned, while having repercussions for the lifestyles of the first generation and the life chances of the second generation. Immediately prior to the arrival of significant numbers of racial minorities, there had been an extensive period of imperialism during which the foundations of prejudice and the ideologies that underpin discrimination were laid. Despite the positive view that many of the new arrivals had of their white "hosts," it rapidly became clear that at best they were ill-informed. A view of the world in which British is synonymous with best has permeated all aspects of culture and is transmitted via all institutions, for example, the family. On arrival at school, children bring with them the tacit knowledge and values that are enshrined in their preschool experiences. Similarly, the other institutions in society

like the school absorb the prevailing culture of society to produce low expectations of black pupils by staff and other pupils alike.

Such low expectations assisted in influencing the cultural climate of the schools that I attended and in structuring the patterns of socialization into school as well as subsequently into British culture. Encoded in language and cultural practices are the predominant attitudes to "race." Teachers are educated and socialized to utilize this code, as they are a group that is drawn from a cross section of society. The mere fact of being successful in school is indicative of being able to conform to the social control mechanisms. Those who are not able to comply would not normally have a smooth career through school and would not achieve the necessary qualifications for entry to higher education.

Pupil-pupil interaction is often dismissed as being secondary to teacher-pupil relationships in the discussion of race relations in schools. Interactions with pupils, both in the classroom and the playground, can have a long-lasting effect on one's personal, emotional, and psychological development. The dynamics of social interactions in the case of minorities are numerically structured. The ratio of teachers to pupils is one : many, but the reverse is true for a peer group to a given child. Educational research reveals that teachers can only offer a small amount of individual time to each pupil in a day. Time spent with one's peer group is considerably longer. In my case there came a point when the negative attitudes of the teacher actually served to increase my determination and motivation. I began to carve out clear goals and ambitions. Instead of accepting the academic downfall signaled by failing the 11+, I sought avenues for achieving status, both in school and the world outside, as well as in the future that lay ahead of me. The swift results yielded by increased determination led to my transfer to grammar school after only a year. The consequence of this kind of thinking is that at an early age an awareness of one's overall position in society develops. Ideas emerge as to how to overcome obstacles and how long it takes to achieve one's goals: "Schooling and education provided an alternative and less undermining possibility in their search for greater freedom and control. Concentration on education as a way out was something which all the black girls whom I interviewed stressed" (Fuller, 1983, p. 172). Much of the research carried out by Fuller at a London comprehensive endorses my experience of receiving a British education.

Race and Gender

The brief account of the 'class' specificities of 'race' reveals that oppression has a double edge for those of an immigrant background. Black women experience two sorts of oppression that combine to shape the development of self-concept, as a direct result of being brought up in a racist and sexist culture. Recent attention has focused on the relative educational success of Afro-Caribbean girls in comparison to boys: "The average performance score obtained by girls was 17.7 compared to 13.7 for boys. In all ethnic groups, girls did better than boys" (ILEA, 1987, p. 7). It may be that this observation is accurate for areas outside the ILEA and relates to the differential treatment that each gender group

receives, both in school and in society at large. At school the expectations of girls are that they will be quiet, docile, and diligent and adopt the values that are presented by female role models in school. The fact that these values are "middle-class" matches the aspirations held by black parents on behalf of their daughters.

During my education my father was an active source of encouragement, offering as much support as he was able to. More importantly, given that the links between the culture of the home and school may be weak, the link between the kinds of values that are fostered in black girls and those of the mainly male-orientated culture of the school are strong. It would seem that the female gender role constructed within black families displays features that are more often associated with the male gender role in British culture. Qualities such as independence, self-reliance, and a sense of responsibility for others are very much a part of the essential attributes associated with black females. Research has shown that the school cultures actually favor those who possess such traits, and it is the view of the writer that this attitude operates to encourage the success of black girls in certain spheres of school life. It would need a deeper analysis than can be offered here as to why this attitude does not contribute to the success of the black boys in school. It has been suggested that negative stereotypes exist with regard to their behavior (Tomlinson, 1983).

In theory I should have had a distinct advantage over my peers throughout my education, but my early periods of schooling were dogged by low expectations and these were exacerbated by the absence of black female models. There was nobody within school or in an equivalent status position elsewhere in society with whom to identify. I would suggest that experiences such as these serve to ensure that a lack of awareness of self-worth develops. The position with regard to the social mobility of black and other ethnic minorities is changing but there is still a long way to go.

Due consideration of the fact that immigration did not distribute the black population vertically within the class structure nor geographically suggests that a culturally pluralist educational climate is still of importance today, as it was when I started school in the mid-1950s. During my schooling I experienced racial harassment, mostly name calling. An experience of harassment that frequently occurred at grammar school related to name calling by a girl who was not even in my class but who was in my year group. Throughout most of the period of secondary school I combed my hair in about twenty plaits and consequently I had many partings. It became fashionable for the girl and her clique to call me "streets." I was thick skinned, but initially this remark hurt not least because others laughed and thereby condoned it. There were many other pranks that yielded nicknames, but these I would put down to high spirits and immaturity. The personal nature of being called "streets" could not even be offset by having somebody with whom to share this. I find it sad that the incidence of racial harassment has increased not decreased:

> The Commission of Racial Equality's two latest reports—the one alleging widespread racial harassment in schools, the other detailing the shortage of ethnic minority teachers—came just as the all-party consensus which greeted

the Swann report three years ago shows ominous signs of cracking (*Guardian*, 5 April 1988, p. 21).

The reports indicate that the ethos is not changing, nor are the black personnel with motivation to change the position being recruited. Currently, the cultural climate is marked by a range of regressive political moves that have encouraged the collapse of consensus on issues of cultural pluralism. One such political development is the introduction of the Education Reform Act, which does not appear to encourage the trends that had been initiated at grassroots level related to multicultural education. In fact, aspects of the reform have encouraged the expression of negative racial attitudes, as illustrated by the case of the (white) Dewsbury parents' group who, in refusing places for their children at a nearby school with mostly Asian pupils, theoretically were taking up their rights under the new arrangements for open enrollment.

Personal Testimony

Rather than listing the catalogue of negative encounters that took place, I shall elicit what I did to combat the effects of stereotyping. The area of pupil-pupil interactions was made more favorable by my development of competencies displaying high prowess. I was able to accomplish peer group approval via athletics. It was possible in this area to have clear-cut results that were associated with my own innate skills, both physical and psychological. It is useful to point out, however, that towards the end of my school career there were clashes with the PE teacher, who did not accept my case that there would be times when academic work, such as summer public examinations, would take priority over practices and training. Nevertheless, athletics was an area where I could establish my worth. Doing this is important for all children as it is in this way that being the butt of scorn from one's peer group is avoided. However, it applies even more to a black child who may acquire unfortunate labels even more easily.

The reputation one develops throughout schooling has more to do with evidence of academic ability than the level of involvement in extramural activities, important though this may be. It is important to achieve academic consistency in order that achievements are not questioned. This may involve investing more time and effort across a range of subjects. It is worthy of note that the "work twice as hard" theory applies to both black and female pupils. Those children who make additional effort are off-setting the disadvantage of an inadequate educational provision themselves. The educational system is actually making additional requirements of such pupils. The responsibility of schools should primarily be that of facilitating the educational attainment of all pupils, of whatever race, gender, or class. As well as burning the midnight oil, I developed other strategies, for example, analyzing what my areas of strength were and applying them in other contexts. I found I was able to boost my confidence by previewing what I perceived as the next likely obstacle to achieving my aims. An example of this would be asking pupils in the year above me in school a range of questions about the procedures necessary to gain work experience, at

the time when I was considering career choice. Eventually I was able to pass high status subjects and enter teacher training.

Black Women in the Teaching Profession

The experiences of being black and a woman overlap with being a black teacher and with being a woman teacher. What follows may not depart significantly from what is already known about either of these but may serve to highlight the concerns of both.

Teacher Education, Ideology, and Gender

The efforts of racism are that some doors open and others remain firmly closed, due to the lower position held by racial minority groups. One such door that has remained closed for many black school leavers is the one by which entry is gained to higher education institutions. The divisions that exist in society between different social strata are engineered via the way that higher education institutions devise the criteria that select and recruit. One effect of restricted entry procedures is that for those with overseas qualifications, or without the full complement of qualifications, access is barred.

"Access" courses have been developed for those who may have or may not have had a British education and not achieved success because of reasons outlined earlier or due to disruptions to their schooling. It is significant that Access courses that were set up specifically to attract mature students who have not been able to make use of the education system are now attracting younger applicants, the majority of whom have been educated here (mostly from primary school onwards). Research I conducted for an MA dissertation revealed that a third were fully educated here, with many others arriving during the secondary period of schooling. Often the primary reason for taking an Access course is to satisfy vocational needs. It would appear that schools fall short of satisfying this need to the extent that Access is now a popular alternative. The expansion of the number and range of such provisions reflect the increase in demand.

For those with the correct qualifications, the race to qualify only begins on deciding to opt for higher education. The first stage of choosing an appropriate institution is an important one. When I applied to college, I read as much available literature as I could and once again listened to the impressions that those who had already been interviewed had of those colleges and the courses for which they had applied. The main guiding principle that I adopted was that the college should above all be situated in or near a city with a cosmopolitan population. The idea of living in total cultural isolation for three years seemed unbearable. Eventually the decision to move from London to a city in the East Midlands was a correct one. No sooner had I been exposed to the "middle-class" environment of the college campus than I found myself gravitating towards the schools in the city nearby. I did this in order that I could more easily identify with the pupils whom I taught. It became clear, too, that I could make specific contributions in such social and cultural areas because of the perspectives I could bring to the classroom and

because of my ability to empathize with pupils. A black family who lived next door to my digs in my second year was a good cultural anchor.

The ethos of many teacher education institutions is so elitist, with terms of reference that are middle-class that only the fittest of the fittest can survive. The advance preparation strategies that I utilized in order to jump all the "hurdles" during school needed to be reemployed during training. I attended a campus-style college in my late teens and so there was no escape at the end of the day by way of a home to go to. The predominantly middle-class students flew in from distant places laden with exotic souvenirs and revealed the social background from which they had come on the first day. Such experiences serve to highlight that teachers are on the "official" side of the desk representing the establishment. The realization soon dawns that as a black teacher participating in the management of the education system, one is likely to be operating against the interests of the community from which one came. The responsibilities of being a teacher, coupled with the negative experiences black people have of school, tend to limit the appeal of teaching as a career. The same arguments can be applied to other professions: witness the low recruitment rates for black and ethnic minority groups to the police force.

Teaching on the one hand, carries high status within Caribbean cultures and so there is a pull, particularly for women. On the other hand, boys' negative experience of the school system may discourage entry by them into the teaching profession. Another feature of being a member of the teaching profession is that in many ways black teachers have, of necessity, to be bicultural at school and to prioritize developing a British cultural perspective during college and subsequently during their teaching career if advancement is the aim. The period of adolescence has often signaled a reassertion of ethnicity for many black male youths. Thus the secondary forces that operate to engender success are minimized. I would go as far as to say that at college the norms of ethnic cultures do not apply and could potentially be a source of clash. Black teachers need to develop a professional identity that while accommodating British values, relates to the social status of black people in society after they qualify.

Role of the Black Teacher

The education system, having been founded by men for men, has tended not to reflect positively the contributions of women or black people. When any teacher presents or introduces a curriculum to the class that reflects this exclusionary perspective, it is clear that they are colluding with the system. The development of initiatives that respond to bias in the curriculum and to the management of pupils assists in establishing that black pupils can make a positive contribution in schools and can also improve the educational climate of the school. It is clear that the current processes of education overburden those black pupils who are keen to succeed, and so it is essential that black teachers play their part in alleviating the burden. More significant than developing innovative practice in one's classroom is the permeation of such innovations throughout the school via curriculum leadership. In order to do this, it is necessary to be a part of the process of

forming structures or organizations that will articulate the necessary issues and lobby for change. To tackle the form and content of the education process in one's own classroom is adequate when one first starts teaching, but it is not enough in the long term for the black teacher. It is a part of the role of the black teacher to think of the wider concerns of education; the positions of groups in society; the differential rates of achievement of pupils; the way schools induct pupils into different roles in society. It could be argued that all teachers need to have an overview of the processes of education, but because black women teachers are most likely to be able to understand the issues involved in throwing off oppression it becomes a part of their lot. One criticism that I would level at teachers is that the time has come for them to be involved in the development of noneducational issues in the wider community instead of confining themselves to what is traditionally seen as relevant to school. Initiatives like Industry-links are to be welcomed in encouraging a greater development of broader educational perspectives.

In my case I taught lower juniors but tried to develop links with the infant department and also worked in local youth clubs that assisted in the development of a longitudinal perspective of children with whom I worked. Where the organization of schooling fragments the experience of children, it is an important part of the politicization of the black teacher to develop a wide perspective on educational issues. One cannot form part of the discussion on the outcomes of schooling if one does not know what happens beyond the age of 10–11 in the educational system.

Promotion and the Black Teacher

It is often reported that black teachers are in the lower grades, on temporary contracts, in posts designated as Teacher above Authorized Numbers, or Section 11 (Ranger, 1988). There is some evidence to suggest that black teachers may be employed as a last resort when there is nobody else to fill a post and there is a danger that classes might be sent home. An experienced black London teacher has shared this problem since starting her career in 1970: "she has done well at interview and then not got the job. One school told her that she was very good but we don't have many blacks here" (*Guardian*, 5 April 1988, p. 21). This teacher's experience can be seen to occur for reasons previously mentioned. She taught a subject that relates to a vocational field that is regarded as women's work. Ninety percent of employees in secretarial work are women. The low status that such work confers on those women involved no doubt contributes to being perceived as inferior. Added to being black, opportunities for advancement are few.

My teaching career was marked by my entering an expanding field in which opportunities were available vertically as well as horizontally. Primary education is also regarded as women's work, but the position I held as a language teacher involved having detailed discussions with all teachers about the curriculum they taught and the progress of their children in much the same way as the headteacher would do. The key to success is being farsighted, especially in analyzing the nature of the promotional levers. Career-minded teachers who do not ask questions about the educational developments on the horizon and how they can be a part of them are going to find the progress of their career stifled.

Career advancement is also based on the level of qualifications one has, both academic and professional. No doubt the lengthy process of qualifying may deter many from working to pursue other qualifications, but it is important to see teaching and learning as inextricably linked, as well as essential to one's own professional development. There is a wealth of courses from which to choose; teachers' center courses, DES short and long courses, higher degrees, etc. I started with the first of these in my probationary year and progressed from a diploma to a master's degree within ten years. In the intervening years (between taking the diploma and master's degree) I tended to "top-up" with short courses within the local authority for which I worked. Quite apart from the knowledge gained, being involved in such courses allows contact with other teachers whose experience of teaching is as valuable as (if not more than) the course curriculum. In this way one can keep up with changing educational trends. Gaining extra qualifications alone is not sufficient from my observations. Having a good relationship with those in senior positions assists in ensuring that your professional needs are known. The possibility of communicating curriculum needs to those in a policy-making position, as well as the curriculum consequences of educational change for minority groups in schools, ought to be the aim of the black teacher.

Conclusion

The introduction of perspectives that put women, black people, and other ethnic minorities on the agenda of the school's curriculum has increasingly become important. The success of black people in education is structured by external influences in society and extends the range of what counts as valued knowledge. The path of social mobility needs to be unblocked, and education is one way of achieving this. Black women have a central role in the process, not least due to their role within the family and the wider community. Their role in education will continue to be an important one insofar as they can assist in ensuring that the extra effort that black people make is honored by the school system. Racial and sexual differentiations have assisted in producing the position whereby black women are carrying the torch.

Note

McKellar, Barbara, "Only the Fittest of the Fittest Will Survive: Black Women and Education," from *Teachers, Gender, and Careers,*1989, ed. Sandra Acker, Taylor and Francis, Inc., Washington, D.C., Chapter 5, "Only the Fittest of the Fittest Will Survive: Black Women and Education," pp. 69–85. Reprinted with permission.

References

Bourne, J. (1984). *Towards an Anti-Racist Feminism*, London: Institute of Race Relations.

Clarke, E. (1979). *My Mother Who Fathered Me: A Study of the Family in Three Selected Communities in Jamaica*. London: Allen and Unwin.

Committee of Inquiry Into the Education of Children from Ethnic Minority Groups (1985). *Education for All* (The Swann Report). London: HMSO.

Fuller, M. (1983). "Qualified Criticism, Critical Qualifications," in L. Barton and S. Walker (Eds.), *Race, Class, and Education*. London: Croom Helm.

Inner London Education Authority (1987). *Ethnic Background and Examination Results 1985 and 1986*. London: ILEA.

Ranger, C. (1988). *Ethnic Minority School Teachers: A Survey in Eight Local Education Authorities*. London: Commission for Racial Equality.

Tomlinson, S. (1983). *Ethnic Minorities in British Schools*. London: Heinemann.

II. Teaching and Pedagogy

Toward a Transformational Theory of Teaching

Lynda Stone
University of Hawaii, Manoa

In an elegant little volume introducing epistemology to undergraduates, W. V. Quine and J. S. Ulian describe knowledge as a web of belief.[1] Beliefs are tied together by a network of experience, cause, and justification. Some are easily changed through observation, some are almost impossible to change. These clusters contain explicit beliefs as well as strings of implicit beliefs that undergird them. Change of belief structures occur through attention to clusters of them and the bringing to bear of evidence. If we want to reform teaching, says Gary Fenster-macher, we must work directly with beliefs about the meaning of the concept "teaching."[2] Beliefs necessarily connect ideas from research to new forms of practice and they include ideas of its purpose, passion, and logic.

I want to begin construction of a new web of belief about teaching, to change how we think about it. To do this we need to uncover its belief structure. For instance, we need to make clear assumptions that tie theories of teaching and learning to understandings about cultural context and ethical implications. The present project looks not at beliefs about context or morality but at another significant foundation, inherent epistemological underpinnings. These require change if we believe the feminist assertion that one epistemology has defined how all persons come to understand the world. Traditionally, men have known, known in ways that are masculine, ways that are aspects of the world that comprise male experience. To consider gender bias as merely a political and ethical problem is to leave out the most significant element in its understanding, its epistemological character. The process of change, I believe, must be transformational. To see what this means, we must consider (1) theories of education, (2) an epistemological perspective, (3) a gender analysis, and (4) implications for transformation.

Theories of Education

Beliefs about teaching are encapsulated within theories of education. In a recent commentary, Kieran Egan proposes that two fundamental views underly all educational theories:

the first he identifies as Platonic and the second as Rousseauean.[3] Egan writes that, for Platonists, attention is on the end of education. This end has always had something to do with objective forms, ideas, or essences that are there for our knowing. In practice, this is teaching for objectivity, for "accumulation and internalization of disciplines and their logics."[4] Acquiring knowledge means coming to understand the accumulated wisdom of the ages, systematized as abstract concepts of the disciplines. While seen by Rousseau as a complement to the first theory, the second has nevertheless had a distinct and often conflicting theoretical history. Within it, education is a process of facilitating the development of natural dispositions; here disciplinary knowledge must be made to conform to subjective experience. Even though Egan does not do so, for the sake of the present investigation, let me label the Platonic theory "objectivist," and that from Rousseau, "subjectivist." I turn now to two examples.[5] Both are well-intentioned, articulated, and argued. Each one, I believe, is avowedly objective or subjective.

The objective model comes out of the writings of Margret Buchmann, Robert Floden, and John Schwille. For them, "education is taken to imply learning that recognizes students' rationality and enlarges the realm of their understanding."[6] Inherent is a particular definition and aim of rationality, one they take from Hegel:[7]

> The end of reason . . . is to banish natural simplicity . . . in which mind is absorbed. . . . The final purpose of education . . . is the hard struggle against pure subjectivity of feeling and . . . of inclination.[8]

Education is subjective when it is founded on sense perception and direct claims of knowing. In a process touted as down-to-earth and commonsensical, students learn primarily by living and doing. Cognitive and educational dangers are present: Immediate claims of knowing mask "anticipatory theories" with which all beliefs are impregnated[9] and further keep commonsense impervious to theoretical influence. What occurs in subjective education is a process where new information is fit merely to sometimes erroneous, old ideas—ideas then believed dogmatically.[10] Social and political consequences result. Limiting experience, leading to stunted imagination, in the larger sense leads to persons who rely on harmful egocentric and sociocentric patterns of thought and action.[11]

The opposite of subjective education is education for objectivity. Out of it comes meaningful, intellectual understanding. Like Egan's Platonic model, it emphasizes learning the concepts of the disciplines. This is valued particularly because disciplined concepts break with everyday beliefs. Through demonstration, coaching, imitation, and practice, the child masters abstract concepts as intellectual tasks, understanding them gradually and learning to modify and apply them to new situations. An ideal medium for objective learning is text. Texts come from all areas of systematic human learning, the arts as well as the sciences. An "objective stance" by the student is required toward text.[12] An objective stance, it must be understood, is not a total denial of connection to and value for subjective experience: all learning must in some ways tie new ideas to old beliefs, connections must and can be made between concepts from the disciplines and practical, instrumental life. Rather, in making connection "objectively," one begins outside of the

localized world of oneself and one's group; in this way one learns to see beyond it to and from the perspectives of others.[13]

In a stance and language seemingly far different from their objectivist counterparts, Madeleine R. Grumet and William Pinar advocate a theory of education that "honors both the historicity and agency of subjectivity."[14] Like Egan's model from Rousseau, it begins in the personal realm:

> I am experience . . . I am running a course . . . [the curriculum]. . . . The rate at which I run, the quality of my running, my sensual-intellectual-emotional experience of moving bodily through space and time: all are my creations; they are my responsibilities.[15]

Drawing on the ideas of Merleau-Ponty, Grumet defines education as the idiosyncratic dialogue of each person moving toward and extending from her own physical, historical, and social environment.[16]

Education for subjectivity responds to an existing objectified form that is a distraction to and abstraction from humanizing education. What is missing "is the study of the student's point of view from the student's point of view"[17] and what results is intellectual dullness, emotional repression and lack of moral development. To change these educational results requires knowledge-of-self . . . as knower-of-the-world.[18] What must be understood is that there is no knowledge existing for its own sake; knowledge is humanly constructed. In subjective education what is undertaken is a logical, intellectual exploration that is neither naively introspective nor merely atavistic. At the end of the journey one comes to understand the paradoxical relationships of the world and learns to find foundational uncertainties attractive and live well with them.

Pinar has named his subjective method of teaching *currere*.[19] In it, students employ free association, autobiography, and hermeneutic response to text. Content from the disciplines receives attention as students reconstruct and reconceptualize their educational biographies. Currere is a four-step process in which a person's past and future educational lives are described and juxtaposed to the educational present. A dialogical relationship is established between these stories and conceptual gestalts that capture their meaning. Interpretive lenses, particularly from literature, help substantiate the construction of knowledge.

An Epistemological Perspective

As our examples illustrate, objective and subjective theories of education imply strongly different conceptions of the roles of teacher and student and the stance each takes toward learning. Clearly, distinct belief structures underpin each theory; among these are ones concerning knowledge. To understand these, we can locate each theory as separate poles of what philosophers have called the subject-object debate. Richard Bernstein says that it is found in "almost every discipline and aspect of our lives."[20] He explains the

dichotomy: "One position is objectivist, the foundational belief that "there is or must be some permanent, ahistorical matrix or framework to which we can ultimately appeal in determining the nature of rationality, knowledge, goodness or rightness."[21] Knowledge and the language we use to tell of it must be grounded or we become mired in skepticism. The second position is relativism, the assertion that the concepts we use about the world are related to specific theoretical views, historical times, and forms of culare related to specific theoretical views, historical times, and forms of cultural life. "For the relativist, there is no substantive, overarching framework or single metalanguage" that is not subject to temporal and cultural change.[22] Relativists argue that what objectivists take as fixed, necessary, and essential is only historically enduring. Objectivists argue that their opposites are locked in a paradox, an assertion of nonfoundationalism that is itself a founding claim.[23]

What philosophers describe as the subject-object debate I now want to call the metaphysical or grand framework. I do so to distinguish it from a corresponding stance within everyone's natural attitude, what I label the epistemic orientation.[24] Natural distinctions are made by persons between whether or not we crave "ultimate constraints." One side wishes for psychologically comforting anchors and the other delights in the tenuous. One orients toward that to be known and the other toward the knower, each believing in a separate origin of knowledge.

Making the distinction between the grand framework and epistemic orientation is educationally useful. This is because the more psychologized belief about the relation of knower to known figures strongly (yet often implicitly) in conceptions of teaching and learning. Taking this notion of epistemic orientation, we could now move to reform teaching beliefs. We could look at practice, identify the orientation of the teacher, and match up the two. Teachers could identify themselves as objective or subjective practitioners. But here I call for delay. To move too quickly to epistemic orientation leaves out consideration of the metaphysical framework that undergirds it and its relation to the epistemic orientation. Here we seek consistency between the two "levels" of belief, a consistency that is not simple.[25] But once again, to merely develop a correspondence of belief structures and practice leaves something more to which we must attend. This is the subject-object construct itself, the Enlightenment duality that has characterized modern intellectual thought. We ask: Why must we accept its formulation?

A Gender Analysis

To answer this question, I want now to turn to a gender analysis of the subject-object dualism. I use this lens because of my own membership in a feminized profession and because we know historically that gender bias has pervaded both the theorizing about and the actual practice of teaching.[26] There are three aspects of gender bias, writes philosopher of science Sandra Harding.[27] The first two are the social constructions of individual identity and division of labor, both manifested materially as well as in our belief systems.[28] The third is gender totemism or symbolism, the meanings of our belief systems

and institutions. The most powerful gender totem is the epistemological dichotomy, the subject-object split just described. When we look at it through a feminist analysis, this is what we find: Traditionally, mind, the subject, has been associated with the male and nature, the object, with the female.[29] This means that what is real and certain is the female and what is irreal and uncertain is the male. That which is real poses a problem for the male, he does not know it and he must. To do this, he sets himself apart from the object of his inquiry and in so doing, objectifies the knowing process of which he is a part. As Evelyn Fox Keller says, there is a radical rejection of any commingling of subject and object.[30] In this act, mind thus assumes the active role of separating, not only as reason from emotion but also importantly from its own subjectivity. Only by ruling out subjectivity, so the masculinist-scientific mythology goes, can one objectively know.[31]

The epistemological dichotomy founds other ideological exemplifications. These come out of the one hegemonic order within which we live and within which gendered dualities are always asymmetrical. As Simone de Beauvior has so aptly defined women, she is always "other." She is always other in a hegemonic order that is hierarchical and patriarchal and built on control and domination. If we consider for one moment the following dualisms, we clearly recognize the power of gender symbolism: subjective-objective, passive-active, procreative-creative, reproduction-production, body-mind, emotion-cognition, nature-culture, private-public, submission-domination, other-person.[32] Within the system of ideological beliefs that we generally take for granted, the latter element of the pairing is more valuable than the former element. The first is feminine and the second is masculine, woman inferior to man.

Implications for Transformation

Given this gender analysis, we turn to implications for teaching reform and consideration of the two educational theories. The first point to make is that the exemplars presented are not antifeminist. I believe that the objectivists hold a liberal postition.[33] If, as must be implied, the objectivist side of the dichotomy is more culturally valued, then these well-meaning theorists advocate an educational model that provides a single and equal legitimacy for females and males. In contrast, subjectivists support a more radical view, the valuing of women's experience as equal in its own right[34] and perhaps as able to contribute something superior to the masculinist culture. My point, regardless of the extent to which these views are feminist, is to suggest that both are foundationally gender biased and therefore harmful because they have been theorized within the traditional epistemological dichotomy. Even as each attempts connection to the other side of the duality, the harm persists.[35] Importantly, within the dichotomy both male and female experience are stunted, although limited in different ways. Thus we turn to our question. If we do not wish to accept the Enlightenment split, what can we do?

To move beyond the subject-object split means to found a new epistemology and to establish a new belief structure for teaching. Here I have taken a first step by analyzing an existing structure and its bias.[36] Next we must transform the results of this and other

similar studies. To my mind a transformational view is hopeful.[37] I see it as an altered metaphysical position, one located in the realm of possibility rather than actuality in order to dream about life as it might be. It aims for a world without inequality, without hierarchy, without power differentials—it aims for transformation.

An epistemological transformation is illustrative: Harding says that what we want is science (i.e., knowledge) that is "free of gender loyalties."[38] A transformed epistemology cannot be objectivist because such a position has publicly excluded or androgenized female experience. It cannot be subjectivist because this stance has imprisoned women within their own privatized, naive experience. It is not separating nor oppositional because within such a conception, female experience is afforded one inferior side.[39] Such biases, it is emphasized, also harm males. A transformed epistemology does recognize sexual difference and "reciprocal selves" and seeks the legitimacy of a wide range of ways of being. At its heart, it is a relational epistemology.

A relational epistemology is foundationally feminist and transformational. It is feminist in arguing that relation is basic. Along with educational philosophers Nel Noddings and Jane Roland Martin,[40] I am persuaded by Neo-Freudian accounts that attribute ontological relation to women because of their gendered upbringing. The idea is that men and women develop distinct forms of self. In this process, men must undergo a process of separating and distancing from a sexually different parent, their mother. Women, in contrast, remain in connected relation to her.[41] Relation is also transformational. This is because it can be understood as central to an alternative epistemological worldview, one that differs from that of dominant western males. In many other cultures, persons are defined as existing within, and therefore in harmony with, their worlds: the individual is *only* conceived as relative to others, as part of a communal social order.[42]

Much remains for us to do to unpack the notion of relation as an epistemological and an educational ideal. I emphasize the difficulty of this task given the scarcity of descriptive examples—given the founding hegemony. This paper has been a first step. I end it by suggesting a new strategy for a next phase, that is to take changes in belief and connect them to teaching practice. This strategy takes the form of a new educational construct. This is "pedagogical structuring," an idea that emerges only with a transformational turn to relational knowing. It is the understanding and working with educational elements that constitute the social, interactive, and connective construction of knowledge. We see these elements in our two initial educational theories and in a transformed view: context, teacher, individual student, other students, text and nontext, forms of experience that are instructional and noninstructional. Pedagogical structuring is defined as systemic, relational, and operational for all teaching-learning practice. It connects beliefs about how we know to teaching to know; it incorporates beliefs about culture and morality as well. Within it, the relational norm must be made explicit for the teacher as well as for the student. Clearly this is a part of the process of change, of altering the web of belief through insight and evidence. In seeking the ultimate reform of teaching practice, I have attempted to provide some justification for its change. I am mindful that this is an insufficient first move toward transformation. I know finally that the next steps, steps that connect beliefs to ideas about practice, are crucial ones. With this connection, I believe, comes the actual catalyst for teaching reform.

Notes

Stone, Lynda, "Toward a Transformational Theory of Teaching," ed. James Giarelli, *Philosophy of Education 1988*, vol. 44, pp. 186–195. (Normal, Illinois: Philosophy of Education Society, 1989).

1. I use the web of belief as a metaphor, not necessarily accepting the behaviorist account of thinking that accompanies it in Quine's work. See W. V. Quine and J. S. Ulian, *The Web of Belief* (New York: Random House, 1970).

2. Gary D. Fenstermacher, "Philosophy of Research on Teaching: Three Aspects," in *Handbook of Research on Teaching*, ed. Merlin C. Witrock (New York: Macmillan, 1986), pp. 37–48.

3. Kieran Egan, "On Learning: A Response to Floden, Buchmann, and Schwille," *Teachers College Record 88* (1987): 508–509.

4. Egan. p. 509.

5. Other examples of subjective and objective theories of education could easily have been selected for illustration. Of the first, I think generally of the work of Elliot Eisner or Jean Clandinin and Michael Connelly; for the second, writings of Thomas Green and Robin Barrow come to mind.

6. Robert E. Floden and Margret Buchmann, *The Trouble with Meaningfulness*, Institute for Research on Teaching, Occasional Paper No. 82 (East Lansing, MI: Michigan State University, 1984), p. 4.

7. These authors draw substantiation of their ideas from a wide range of scholarly writings that include analytic philosophy of education, sociology of knowledge, and cognitive psychology.

8. Georg Hegel, *Philosophy of Right* (London: Oxford University Press, 1952), cited in Margret Buchmann and John Schwille, "The Overcoming of Experience," *American Journal and Education 9* (1983): 46.

9. Buchmann and Schwille, p. 33.

10. See Floden and Buchmann, p. 8; Buchmann and Schwille, pp. 33–34.

11. Robert E. Floden, Margret Buchmann, and John S. Schwille, "Breaking with Everyday Experience," *Teachers College Record 88* (1987): 487.

12. Floden et al., p. 498.

13. Ibid., p. 487.

14. Madeleine R. Grumet, "The Politics of Personal Knowledge,: *Curriculum Inquiry 17* (1987): 319.

15. Much of the introduction to the teaching model of William F. Pinar and Madeleine R. Grumet comes in their text, *Toward a Poor Curriculum* (Dubuque, Iowa: Kendall/Hunt, 1976). See Preface, p. vii.

16. Madeleine R. Grumet, "Existential and Phenomenological Foundations," in *Toward a Poor Curriculum*, p. 32.

17. William F. Pinar, "Self and Others," in *Toward a Poor Curriculum*, p. 17.

18. Grumet, p. 35

19. See Pinar's chapter, "The Method," in *Toward a Poor Curriculum,* pp., 51–63.

20. Richard J. Bernstein, *Beyond Objectivism and Relativism: Science, Hermeneutics, and Praxis* (Philadelphia, PA: University of Pennsylvania Press, 1983), p. 1.

21. Ibid., p. 8.

22. Ibid.

23. Within Husserl's notion of the life-world is a grand thesis about the material existence of the world; this is the natural attitude. It seems to me that one horizon we have within the natural attitude is a naive perspective that psychologically favors realism or idealism. For the most

helpful explanation of the life-world, see David Carr, "Husserl's Problematic Concept of the Life-World," in *Husserl: Expositions and Appraisals*, ed. Frederick A. Elliston and Peter McCormick (Notre Dame, Ind. University of Notre Dame Press, 1977), pp. 202–212.

24. Bernstein, p. 11.

25. For example, Kant and Husserl are subjectivist in the sense that they found knowing in mental structures and are objectivists in believing in the universality of their existing form and essential content.

26. Bias is clearly present in beliefs about teaching. The hegemony operates at both explicit and implicit levels of thought and in all aspects of our lives.

27. See the very important work by Sandra Harding, *The Science Question in Feminism* (Ithaca, NY: Cornell University Press, 1986).

28. Educational feminists have written well about the first two categories. See, e.g., Maxine Greene, "The Lived World," in *Landscapes of Learning*, (New York: Teachers College Press, 1978), pp. 213–223; and Michael Apple, "Work, Gender and Teaching," *Teachers College Record 84* (1983): 612–628.

29. The roots of this tradition are found in the writings of Aristotle. See parts of two selections, "On the Generation of Animals" and "Politics," in *Philosophy of Women*, ed. Mary Briody Mahowald (Indianapolis, IN: Hackett, 1983), pp. 266–275.

30. Evelyn Fox Keller, "Gender and Science" in *Discovering Reality*, ed. Sandra Harding and Merrill B. Hintikka (Dordrecht, Holland: D. Reidel, 1983), p. 191.

31. Feminist philosophy of science has salience for this discussion because scientific knowing has traditionally been the exemplar of knowledge and its methods of inquiry the most legitimate. Its methods further have been adopted for research in the social sciences and in education.

32. Elsewhere I have presented an argument that defines women as non-persons—incapable of human action. See Lynda Stone, *A Curriculum for Virginia Woolf*, paper presented before the College and University Faculty Assembly of the National Council for the Social Studies, New. York, November 1986, revised as "The Relationship of Women to Curriculum," *Re–Visions 1* (1987): 7–9. For an important discussion of the relation of gendered dualities to sexuality, see Ruth Bleier, *Science and Gender* (New York: Pergamon Press, 1984), beginning p. 164.

33. See Alison Jaggar's excellent account of the historical development of a range of political feminist views of *Feminist Politics and Human Sexuality* (Totowa, NJ: Powman and Allanheld, 1983).

34. Madeleine R. Grumet has written an eloquent series of feminist papers on educational topics. See particularly, "Conception, Contradiction, and Curriculum," *Journal of Curriculum Theorizing 3* (1981): 287–298; and "Pedagogy for Patriarchy: The Feminization of Teaching," *Interchange 12* (1981): 165–183.

35. Floden et al., p. 496; Grumet, "Foundations," p. 35.

36. Among these analyses must be ones that attend to class and racial/ethnic bias and the innerconnections of these with gender.

37. I take this term from my teacher, Nel Noddings, and Harding uses it also, p. 244.

38. Harding, p. 138.

39. Ibid., p. 148.

40. It seems to me that both Noddings and Martin accept relations as an ethical and not as an epistemological ideal. For their outstanding contributions to feminist educational thought, see Nel Noddings, *Caring* (Berkeley, CA: University of California Press, 1984): and Jane Roland Martin, *Reclaiming a Conversation* (New Haven CT: Yale University Press, 1985).

41. See Keller, beginning p. 192.

42. Harding warns of accepting too simply an alternative epistemology, particularly one of minority males in which minority females are then caught in a double bias. Harding, beginning p. 167. Finally, it has been suggested that references to "male" be deleted from "the dominant Western view." To do so would once again silence woman, would cover over her lack of participation in the epistemological construction, and would destroy the feminist project. However ameliorating such a step would be, justice and transformation cannot be served by it.

An Ethic of Caring and Its Implications for Instructional Arrangements

Nel Noddings
Stanford University

Until recent years, most Americans seem to have assumed that a fundamental aim of schooling should be the production of a moral citizenry. It could be argued that, although this assumption is sound and still widely held, the hypocrisy inherent in a blend of Christian doctrine and individualist ideology has created opposition to traditional forms of moral education. What is needed, then, is not a new assumption but a more appropriate conception of morality. An ethic of caring arising out of both ancient notions of agapism and contemporary feminism will be suggested as an alternative approach. After describing caring as a moral perspective, I will discuss the vast changes that such an orientation implies in schooling, and one of these will be explored in some depth. In conclusion, I will suggest ways in which educational research might contribute to this important project.

Morality as an Educational Aim

Morality has been a long-standing interest in schools. Indeed, the detachment of schools from explicitly moral aims is a product of the last few decades. It would have been unthinkable early in this century—even in programs guided by highly technical lists of specific objectives—to ask such a question as, Must we educate?[1] We sometimes forget that even Franklin Bobbitt and others who were advocates of the technological or factory model of progressivism were nonetheless interested in the development of moral persons, good citizens, adequate parents, and serene spirits. Bobbitt himself said: "The social point of view herein expressed is sometimes characterized as being utilitarian. It may be so; but not in any narrow or undesirable sense. It demands that training be as wide as life itself. It looks to human activities of every type: religious activities; civic activities; the duties of one's calling; one's family duties; one's recreations; one's reading and meditation; and the rest of the things that are done by the complete man or woman" (Bobbitt 1915, p. 20).

Yet, today it seems innovative—even intrusive—to suggest that schools should consciously aim at educating people for moral life and that perhaps the best way to accomplish this aim is to conduct the process in a thoroughly moral way. People who should know better continually claim that schools can do only one thing well—the direct teaching of basic skills. In a recent letter that apparently reflects the position espoused in their book (Gann and Duignan 1986), L. H. Gann and Peter Duignan say, "Above all, we should avoid the temptation to regard the school as an instrument that can cure all social ills. The school's job is to teach basic academic skills" (Gann and Duignan 1987). This statement captures a tiny corner of truth, but it ignores the citadel to which this corner belongs.

An honest appraisal of American traditions of schooling reveals that academic skills have long been thought of as a vehicle for the development of character. This was true in colonial days, it was true throughout the nineteenth century, and it was still true in the first half of the twentieth century. Schools have always been considered as incubators for acceptable citizens, and citizenship has not always been defined in terms of academic achievement scores. The morality stressed by nineteenth- and early twentieth-century schools contained a measure of hypocrisy, to be sure. Drawing on both Christian doctrine and an ideology of individualism, recommendations on moral education emphasized both self-sacrifice and success through determination, ambition, and competition. The influential Character Development League, for example, stated in the opening paragraph of its *Character Lessons:* "Character in its primary principle and groundwork is *self-control* and *self-giving*, and the only practical method of enforcing this upon the habit of children is to keep before them *examples* of self-control and self-sacrifice" (Carr 1909). *Character Lessons*, however, is liberally laced with success stories, and, indeed, teachers are urged to credit each child for her or his contributions to a "Golden Deed Book." In the closing paragraphs of his Introduction, Carr suggests, "A small prize for the grade having the best 'Golden Deed Book' and another to the pupil of the grade having the most Deeds to his credit, will arouse a discriminating interest . . ." (Carr 1909). Thus, educators were urged to encourage both Christian charity and American entrepreneurship. In describing a mid-nineteenth-century school's operations, David Tyack and Elizabeth Hansot comment: "These mid-century themes suggest how deeply the absolutist morality of the evangelical movement became interwoven with a work ethic and ideology favoring the development of capitalism. Just as Christianity was inseparable from Americanism, so the entrepreneurial economic values seemed so self-evidently correct as to be taken for granted. *The school* gave everyone a chance to become hard-working, literate, temperate, frugal, a good planner" (italics added; Tyack and Hansot 1982, p. 28).

The school was not expected to cure social ills; in this Gann and Duignan are correct. Rather, it was expected to teach vigorously the values of a society that thought it was righteous. The spirit was evangelical at every level from home and school to national and international politics where speakers, writers, and statesmen regularly took the position that the United States had a God-given mission to export its righteous way of life to the rest of the world.[2] However wrong we may now consider this arrogant posture,

it is clear that hardly anyone thought that the school's major or only job was to teach academic skills. This we did in the service of moral ends, not as an end in itself.

I am certainly not recommending a return to the self-righteous moralizing of the nineteenth century. On the contrary, I would argue for a strong rejection of this attitude, accompanied by a thorough study of its history and ideology. We cannot overcome a perspective, a worldview, as powerful as this one by ignoring it; we have to explore it both appreciatively and critically. Indeed, I would go so far as to suggest that proponents of "basic skills only" may really want to maintain the earlier attitude of Christian-American supremacy and that avoidance of moral issues and social ills is the only currently feasible way to accomplish this. The apparent consensus of earlier times has been lost. Further, attempts to restore the values of a diminishing majority have not been successful. Too many feisty minorities have found their voices and are beginning to suggest alternatives among moral priorities. In such a climate, the only way left for the weakening group in power is to block discussion entirely and hope that hegemonic structures will press things down into the old containers. The need for moral education is apparent to everyone, but concerns about the form it should take induce paralysis. Thus, I suggest that our forbears were right in establishing the education of a moral people as the primary aim of schooling, but they were often shortsighted and arrogant in their description of what it means to be moral.

Caring as a Moral Orientation in Teaching

Although schools and other institutions have in general withdrawn from the task of moral education (some exceptions will be noted), there is a philosophical revival of interest in practical ethics. Several authors have commented on the arrogance and poverty of philosophical views that conceive of ethics solely as a domain for philosophical analysis.[3] Further, there is increased interest in both ethics of virtue (the modeling or biographical approach advocated in *Character Lessons;* see MacIntyre 1984) and in ethics of need and love. Joseph Fletcher contrasts the latter with ethics of law and rights. "As seen from the ethical perspective," he notes, "the legalistic or moralistic temper gives the first-order position to rights, whereas the agapistic temper gives the first place to *needs*" (Fletcher 1975, p. 45). A blend of these views that tries to avoid both the elitism in Aristotle's ethics of virtue and the dogmatism of Christian agapism is found in the current feminist emphasis on ethics of caring, relation, and response (see Noddings 1984; Gilligan 1982).

As an ethical orientation, caring has often been characterized as feminine because it seems to arise more naturally out of woman's experience than man's. When this ethical orientation is reflected on and technically elaborated, we find that it is a form of what may be called *relational ethics*.[4] A relational ethic remains tightly tied to experience because all its deliberations focus on the human beings involved in the situation under consideration and their relations to each other. A relation is here construed as any pairing or connection of individuals characterized by some affective awareness in each. It is an

encounter or series of encounters in which the involved parties feel something toward each other. Relations may be characterized by love or hate, anger or sorrow, admiration or envy; or, of course, they may reveal mixed affects—one party feeling, say, love and the other revulsion. One who is concerned with behaving ethically strives always to preserve or convert a given relation into a caring relation. This does not mean that all relations must approach that of the prototypical mother-child relation in either intensity or intimacy. On the contrary, an appropriate and particular form of caring must be found in every relation, and the behaviors and feelings that mark the mother-child relation are rarely appropriate for other relations; the characteristics of *all* caring relations can be described only at a rather high level of abstraction.

A relational ethic, an ethic of caring, differs dramatically from traditional ethics. The most important difference for our present purpose is that ethics of caring turn the traditional emphasis on duty upside down. Whereas Kant insisted that only those acts performed out of duty (in conformity to principle) should be labeled moral, an ethic of caring prefers acts done out of love and natural inclination. Acting out of caring, one calls on a sense of duty or special obligation only when love or inclination fails. Ethical agents adopting this perspective do not judge their own acts solely by their conformity to rule or principle, nor do they judge them only by the likely production of preassessed nonmoral goods such as happiness. While such agents may certainly consider both principles and utilities, their primary concern is the relation itself—not only what happens physically to others involved in the relation and in connected relations but what they may feel and how they may respond to the act under consideration. From a traditional perspective, it seems very odd to include the response of another in a judgment of our own ethical acts. Indeed, some consider the great achievement of Kantian ethics to be its liberation of the individual from the social complexities that characterized earlier ethics. A supremely lonely and heroic ethical agent marks both Kantian ethics and the age of individualism. An ethic of caring returns us to an earlier orientation—one that is directly concerned with the relations in which we all must live.

A relational ethic is rooted in and dependent on natural caring. Instead of striving away from affection and toward behaving always out of duty as Kant has prescribed, one acting from a perspective of caring moves consciously in the other direction; that is, he or she calls on a sense of obligation in order to stimulate natural caring. The superior state—one far more efficient because it energizes the giver as well as the receiver—is one of natural caring. Ethical caring is its servant. Because natural caring is both the source and the terminus of ethical caring, it is reasonable to use the mother-child relation as its prototype, so long as we keep in mind the caveats mentioned above.

The first member of the relational dyad (the carer or "one caring") responds to the needs, wants, and initiations of the second. Her mode of response is characterized by *engrossment* (nonselective attention or total presence to the other for the duration of the caring interval) and *displacement of motivation* (her motive energy flows in the direction of the other's needs and projects). She feels with the other and acts in his behalf. The second member (the one cared for) contributes to the relation by recognizing and responding to the caring.[5] In the infant, this response may consist of smiles and wriggles;

in the student, it may reveal itself in energetic pursuit of the student's own projects. A mature relationship may, of course, be mutual, and two parties may regularly exchange places in the relation, but the contributions of the one caring (whichever person may hold the position momentarily) remain distinct from those of the cared for. It is clear from this brief description why an ethic of caring is often characterized in terms of responsibility and response.

A view similar in many ways to that of caring may be found in Sara Ruddick's analysis of maternal thinking (Ruddick 1986). A mother, Ruddick says, puts her thinking into the service of three great interests: preserving the life of the child, fostering his growth, and shaping an acceptable child. Similarly, Milton Mayeroff describes caring in terms of fostering the growth of another (Mayeroff 1971). Thus, it is clear that at least some contemporary therorists recognize the thinking, practice, and skill required in the work traditionally done by women—work that has long been considered something anyone with a warm heart and little intellect could undertake. Caring as a rational moral orientation and maternal thinking with its threefold interests are richly applicable to teaching.

Caring and Instructional Arrangements

Even though the emphasis during this half of the twentieth century has been on intellectual goals—first, on advanced or deep structural knowledge of the disciplines and then, more modestly, on the so-called basics—a few educators and theorists have continued to suggest that schools must pay attention to the moral and social growth of their citizens. Ernest Boyer and his colleagues, for example, recommend that high school students engage in community service as part of their school experience (Boyer 1983). Theodore Sizer expresses concern about the impersonal relationships that develop between highly specialized teachers and students with whom they have only fleeting and technical contact, for example, in grading, recording attendance, disciplining (Sizer 1984). Lawrence Kohlberg and his associates concentrate explicitly on the just community that should be both the source and the end of a truly moral education (Kohlberg 1981, 1984). But none of these concerns has captured either the national interest or that of educators in a way that might bring a mandate for significant change. The current emphasis remains on academic achievement. The influential reports of both the Holmes Group and the Carnegie Task Force, for example, almost entirely ignore the ethical aspects of education (*Tomorrow's Teachers*, 1986; *A Nation Prepared*, 1986). They mention neither the ethical considerations that should enter into teachers' choices of content, methods, and instructional arrangements nor the basic responsibility of schools to contribute to the moral growth of students.

If we were to explore seriously the ideas suggested by an ethic of caring for education, we might suggest changes in almost every aspect of schooling: the current hierarchical structure of management, the rigid mode of allocating time, the kind of relationships encouraged, the size of schools and classes, the goals of instruction, modes of evaluation,

patterns of interaction, selection of content. Obviously all of these topics cannot be discussed here. I will therefore confine my analysis to the topic of relationships, which I believe is central to a thorough consideration of most of the other topics.

From the perspective of caring, the growth of those cared for is a matter of central importance. Feminists are certainly not the first to point this out. For John Dewey, for example, the centrality of growth implied major changes in the traditional patterns of schooling. In particular, since a major teaching function is to guide students in a well-informed exploration of areas meaningful to them, learning objectives must be mutually constructed by students and teachers (Dewey [1938] 1963). Dewey was unequivocal in his insistence on the mutuality of this task. Teachers have an obligation to support, anticipate, evaluate, and encourage worthwhile activities, and students have a right to pursue projects mutually constructed and approved. It has long been recognized that Dewey's recommendations require teachers who are superbly well educated, people who know the basic fields of study so well that they can spot naive interests that hold promise for rigorous intellectual activity.

There is, however, more than intellectual growth at stake in the teaching enterprise. Teachers, like mothers, want to produce acceptable persons—persons who will support worthy institutions, live compassionately, work productively but not obsessively, care for older and younger generations, be admired, trusted, and respected. To shape such persons, teachers need not only intellectual capabilities but also a fund of knowledge about the particular persons with whom they are working. In particular, if teachers approach their responsibility for moral education from a caring orientation rather than an ethic of principle, they cannot teach moral education as one might teach geometry or European history or English; that is, moral education cannot be formulated into a course of study or set of principles to be learned. Rather, each student must be guided toward an ethical life—or, we might say, an ethical ideal—that is relationally constructed.

The relational construction of an ethical ideal demands significant contributions from the growing ethical agent and also from those in relation with this agent. There is, clearly, a large subjective component of such an ideal; modes of behavior must be evaluated as worthy by the person living them. But there is also a significant objective component, and this is contributed by the careful guidance of a host of persons who enter into relation with the developing agent. The teacher, for example, brings his or her own subjectivity into active play in the relation but also takes responsibility for directing the student's attention to the objective conditions of choice and judgment; both teacher and student are influenced by and influence the subjectivity of other agents. Hence, in a basic and crucial sense, each of us is a relationally defined entity and not a totally autonomous agent. Our goodness and our wickedness are both, at least in part, induced, supported, enhanced, or diminished by the interventions and influence of those with whom we are related.

In every human encounter, there arises the possibility of a caring occasion (see Watson 1985). If I bump into you on the street, both of us are affected not only by the physical collision but also by what follows it. It matters whether I say, "Oh, dear, I'm so sorry," or "You fool! Can't you watch where you're going?" In every caring occasion,

the parties involved must decide how they will respond to each other. Each such occasion involves negotiation of a sort: an initiation, a response, a decision to elaborate or terminate. Clearly, teaching is filled with caring occasions or, quite often, with attempts to avoid such occasions. Attempts to avoid caring occasions by the overuse of lecture without discussion, of impersonal grading in written, quantitative form, of modes of discipline that respond only to the behavior but refuse to encounter the person all risk losing opportunities for moral education and mutual growth.

Moral education, from the perspective of an ethic of caring, involves modeling, dialogue, practice, and confirmation. These components are not unique to ethics of caring, of course, but their combination and interpretation are central to this view of moral education (see Noddings 1984). Teachers model caring when they steadfastly encourage responsible self-affirmation in their students.[6] Such teachers are, of course, concerned with their students' academic achievement, but, more importantly, they are interested in the development of fully moral persons. This is not a zero-sum game. There is no reason why excellent mathematics teaching cannot enhance ethical life as well. Because the emphasis in the present discussion is on human relationships, it should be noted that the teacher models not only admirable patterns of intellectual activity but also desirable ways of interacting with people. Such teachers treat students with respect and consideration and encourage them to treat each other in a similar fashion. They use teaching moments as caring occasions.

Dialogue is essential in this approach to moral education. True dialogue is open; that is, conclusions are not held by one or more of the parties at the outset. The search for enlightenment, or responsible choice, or perspective, or means to problem solution is mutual and marked by appropriate signs of reciprocity. This does not mean that participants in dialogue must give up any principles they hold and succumb to relativism. If I firmly believe that an act one of my students has committed is wrong, I do not enter a dialogue with him on whether or not the act is wrong. Such a dialogue could not be genuine. I can, however, engage him in dialogue about the possible justification for our opposing positions, about the likely consequences of such acts to himself and others, about the personal history of my own belief. I can share my reflections with him, and he may exert considerable influence on me by pointing out that I have not suffered the sort of experience that led him to his act. Clearly, time is required for such dialogue. Teacher and student must know each other well enough for trust to develop.

The caring teacher also wants students to have practice in caring. This suggests changes beyond the well-intended inclusion of community service in high school graduation requirements. Service, after all, can be rendered in either caring or noncaring ways. In a classroom dedicated to caring, students are encouraged to support each other; opportunities for peer interaction are provided, and the quality of that interaction is as important (to both teacher and students) as the academic outcomes. Small group work may enhance achievement in mathematics, for example, and can also provide caring occasions. The object is to develop a caring community through modeling, dialogue, and practice.

Although modeling, dialogue, practice, and confirmation are all important, the component I wish to emphasize here is confirmation. In caring or maternal thinking,

we often use caring occasions to confirm the cared for. The idea here is to shape an acceptable child by assisting in the construction of his ethical ideal. He has a picture of a good self, and we, too, have such a picture. But as adults we have experience that enables us to envision and appreciate a great host of wonderful selves—people with all sorts of talents, projects, ethical strengths, and weaknesses kept courageously under control. As we come to understand what the child wants to be and what we can honestly approve in him, we know what to encourage. We know how to respond to his acts—both those we approve and those we disapprove. When he does something of which we disapprove, we can often impute a worthy motive for an otherwise unworthy act. Indeed, this is a central aspect of confirmation. "When we attribute the best possible motive consonant with reality to the cared-for, we confirm him; that is, we reveal to him an attainable image of himself that is lovelier than that manifested in his present acts. In an important sense, we embrace him as one with us in devotion to caring. In education, what we reveal to a student about himself as an ethical and intellectual being has the power to nurture the ethical ideal or to destroy it" (Noddings 1984, p. 193).

Confirmation is of such importance in moral education that we must ask about the settings in which it can effectively take place. Educators often come close to recognizing the significance of confirmation in a simplistic way. We talk about the importance of expectations, for example, and urge teachers to have high expectations for all their students. But, taken as a formula, this is an empty exhortation. If, without knowing a student—what he loves, strives for, fears, hopes—I merely expect him to do uniformly well in everything I present to him, I treat him like an unreflective animal. A high expectation can be a mark of respect, but so can a relatively low one. If a mathematics teacher knows, for example, that one of her students, Rose, is talented in art and wants more than anything to be an artist, the teacher may properly lower her expectations for Rose in math. Indeed, she and Rose may consciously work together to construct a mathematical experience for Rose that will honestly satisfy the institution, take as little of Rose's effort as possible, and preserve the teacher's integrity as a mathematics teacher. Teacher and student may chat about art, and the teacher may learn something. They will surely talk about the requirements for the art schools to which Rose intends to apply—their GPA demands, how much math they require, and the like. Teacher and student become partners in fostering the student's growth. The student accepts responsibility for both completion of the work negotiated and the mutually constructed decision to do just this much mathematics. This is illustrative of responsible self-affirmation. The picture painted here is so vastly different from the one pressed on teachers currently that it seems almost alien. To confirm in this relational fashion, teachers need a setting different from those we place them in today.

To be responsible participants in the construction of ethical ideals, teachers need more time with students than we currently allow them. If we cared deeply about fostering growth and shaping both acceptable and caring people, we could surely find ways to extend contact between teachers and students. There is no good reason why teachers should not stay with one group of students for three years rather than one in the elementary years, and this arrangement can be adapted to high school as well. A mathematics teacher might, for example, take on a group of students when they enter high

school and guide them through their entire high school mathematics curriculum. The advantages in such a scheme are obvious and multiple: First, a setting may be established in which moral education is possible—teacher and students can develop a relation that makes confirmation possible. Second, academic and professional benefits may be realized—the teacher may enjoy the stimulation of a variety of mathematical subjects and avoid the deadly boredom of teaching five classes of Algebra I; the teacher may come to understand the whole math curriculum and not just a tiny part of it; the teacher takes on true responsibility for students' mathematical development, in contrast to the narrow accountability of teachers today; the teacher encounters relatively few new students each year and welcomes back many that she already knows well.

Are there disadvantages? Those usually mentioned are artifacts of the present system. Some people ask, for example, what would happen to students who are assigned to poor teachers for three or four years. One answer is that students should not have a demonstrably poor teacher for even one year, but a better answer is to follow out the implications of this fear. My suggestion is that students and teachers stay together by mutual consent and with the approval of parents. Ultimately, really poor teachers would be squeezed out in such a system, and all the fuss and feathers of detailed administrative evaluation would be cut considerably. Supportive and substantial supervision would be required instead, because teachers—now deeply and clearly responsible for a significant chunk of their students' growth—might well seek to foster their own growth and, thus, ensure a steady stream of satisfied clients.

Suggestions like the one above for extended contact—or like Sizer's alternative idea that teachers teach two subjects to 30 students rather than one subject to 60 (Sizer 1984)—are not simplistic, nor are they offered as panaceas. They would require imagination, perseverance, changes in training, and diligence to implement, but they can be accomplished. Indeed, these ideas have been used successfully and deserve wider trials. (I myself had this sort of experience in 12 years of teaching in grades 6–12.)

It sometimes seems to feminists and other radical thinkers that this society, including education as an institution, does not really want to solve its problems. There is too much at stake, too much to be lost by those already in positions of power, to risk genuine attempts at solution. What must be maintained, it seems, are the *problems*, and the more complex the better, for then all sorts of experts are required, and, as the problems proliferate (proliferation by definition is especially efficient), still more experts are needed. Helpers come to have an investment in the helping system and their own place in it rather than in the empowerment of their clients.[7]

I have discussed here just one major change that can be rather easily accomplished in establishing settings more conducive to caring and, thus, to moral education. Such a change would induce further changes, for, when we begin to think from this perspective, everything we do in teaching comes under reevaluation. In the fifties, the nation moved toward larger high schools, in part because the influential Conant report persuaded us that only sufficiently large schools could supply the sophisticated academic programs that the nation wanted to make its first priority (Conant 1959). Now we might do well to suggest smaller schools that might allow us to embrace older priorities, newly

critiqued and defined, and work toward an educational system proudly oriented toward the development of decent, caring, loved, and loving persons.

What Research Can Contribute

If it is not already obvious, let me say explicitly that I think university educators and researchers are part of the problem. Our endless focus on narrow achievement goals, our obsession with sophisticated schemes of evaluation and measurement directed (naturally enough) at things that are relatively easy to measure, our reinforcement of the mad desire to be number one—to compete, to win awards, to acquire more and more of whatever is currently valued—in all these ways we contribute to the proliferation of problems and malaise.

Can researchers play a more constructive role? Consider some possibilities. First, by giving some attention to topics involving affective growth, character, social relations, sharing, and the pursuit of individual projects, researchers can give added legitimacy to educational goals in all these areas. A sign of our neglect is the almost total omission of such topics from the 987 pages of the third *Handbook of Research on Teaching* (Wittrock 1986). Second, researchers can purposefully seek out situations in which educators are trying to establish settings more conducive to moral growth and study these attempts at some length, over a broad range of goals, and with constructive appreciation. That last phrase, "with constructive appreciation," suggests a third way in which researchers might help to solve problems rather than aggravate them. In a recent article on fidelity, I argued:

> In educational research, fidelity to persons counsels us to choose our problems in such a way that the knowledge gained will promote individual growth and maintain the caring community. It is not clear that we are sufficiently concerned with either criterion at present. William Torbert, for example, has noted that educational research has been oddly uneducational and suggests that one reason for this may be the failure of researchers to engage in collaborative inquiry [see Torbert 1981]. There is a pragmatic side to this problem, of course, but from an ethical perspective, the difficulty may be identified as a failure to meet colleagues in genuine mutuality. Researchers have perhaps too often made *persons* (teachers and students) the objects of research. An alternative is to choose *problems* that interest and concern researchers, students, and teachers. . . . [Noddings 1986, p. 506]

Here, again, feminists join thinkers like Torbert to endorse modes of research that are directed at the needs rather than the shortcomings and peculiarities of subjects. Dorothy Smith, a sociologist of knowledge, has called for a science *for* women rather than *about* women; "that is," she says, "a sociology which does not transform those it studies into objects but preserves in its analytic procedures the presence of the subject

as actor and experiencer. Subject then is that knower whose grasp of the world may be enlarged by the work of the sociologist" (Smith 1981, p. 1).

Similarly, research *for* teaching would concern itself with the needs, views, and actual experience of teachers rather than with the outcomes produced through various instructional procedures. This is not to say that contrasting methods should not be studied, but, when they are studied, researchers should recognize that the commitment of teachers may significantly affect the results obtained through a given method. Research *for* teaching would not treat teachers as interchangeable parts in instructional procedures, but, rather, as professionals capable of making informed choices among proffered alternatives.

Research *for* teaching would address itself to the needs of teachers—much as pharmaceutical research addresses itself to the needs of practicing physicians. This suggests that research and development should become partners in education, as they have in industry. Instead of bemoaning the apparent fact that few teachers use small group methods, for example, researchers could ask teachers what they need to engage in such work comfortably. One answer to this might be materials. Researchers often assume that the answer is training, because this answer better fits their own preparation and research timetables. If materials are needed, however, the partnership of research and development becomes crucial.

Qualitative researchers may suppose that their methods are more compatible with research *for* teaching than the usual quantitative methods. Indeed, Margaret Mead said of fieldwork: "Anthropological research does not have subjects. We work with informants in an atmosphere of trust and mutual respect" (Mead 1969, p. 371).

But qualitative researchers, too, can forget that they are part of an educational enterprise that should support a caring community. Qualitative studies that portray teachers as stupid, callous, indifferent, ignorant, or dogmatic do little to improve the conditions of teaching or teachers. I am not arguing that no teachers are stupid, callous, indifferent, and so forth. Rather, I am arguing that teachers so described are sometimes betrayed by the very researchers to whom they have generously given access. What should we do when we come upon gross ignorance or incompetence? One of my colleagues argues strongly that it is our duty to expose incompetence. Would you keep silent if you observed child abuse? he asks. The answer to this is, of course, that we cannot remain silent about child abuse, and it is conceivable that some events we observe as researchers are so dangerous or worrisome that we simply must report them. But at that point, I would say, our research ends. We feel compelled to take up our duties as responsible citizens and to relinquish our quest for knowledge. So long as we seek knowledge in classrooms, we are necessarily dependent on the teachers and students who are there engaged in a constitutively ethical enterprise. To intrude on that, to betray the trust that lets us in, to rupture the possibility of developing a caring community, is to forget that we should be doing research *for* teaching.

Does this mean that we cannot report failures in the classrooms we study? Of course not. But just as we ask teachers to treat the success and failure of students with exquisite sensitivity, we should study teacher success and failure generously and report on it constructively. Teachers may be eager to explore their own failures if their successes are

also acknowledged and if the failures are thoroughly explored to locate the preconditions and lacks responsible for them. Teachers, too, need confirmation.

Conclusion

I have suggested that moral education has long been and should continue to be a primary concern of educational institutions. To approach moral education from the perspective of caring, teachers, teacher-educators, students, and researchers need time to engage in modeling, dialogue, practice, and confirmation. This suggests that ways be explored to increase the contact between teachers and students and between researchers and teachers, so that collaborative inquiry may be maintained and so that relationships may develop through which all participants are supported in their quest for better ethical selves.

Notes

Noddings, Nel. "A Ethic of Caring and Its Implications for Instructional Arrangements," *American Journal of Education*, 96(2) (1988): 215–230. Copyright © 1988, The University of Chicago Press.

1. This is a question that was seriously asked by Carl Bereiter in 1973. See Bereiter 1973.

2. See the vivid and well-documented description of this attitude in Maguire 1978, pp. 424–29.

3. Bernard Williams (1985), e.g., argues that philosophy plays a limited role in the re-creation of ethical life. Alasdair MacIntyre (1984), too, argues that morality and ethics belong primarily to the domain of social experience and that philosophy must proceed from there.

4. Daniel C. Maguire (1978) has also described approaches to relational ethics.

5. For a fuller analysis of the roles of each, see Noddings 1984.

6. Paolo Freire (1970) describes as oppression any situation in which one person hinders another in "his pursuit of self-affirmation as a responsible person."

7. For a discussion of this unhappy result, see Freire 1970; see also Sartre 1949.

References

Bereiter, Carl. *Must We Educate?* Englewood Cliffs, NJ: Prentice-Hall, 1973.

Bobbitt, Franklin. *What the Schools Teach and Might Teach.* Cleveland: Survey Committee of the Cleveland Foundation, 1915.

Boyer, Ernest L. *High School: A Report on Secondary Education in America.* New York: Harper & Row, 1983.

Carr, John W. "Introduction." In *Character Lessons*, by James Terry White. New York: Character Development League, 1909.

Conant, James B. *The American High School Today.* New York: McGraw-Hill, 1959.

Conant, James B. *The Comprehensive High School.* New York: McGraw-Hill, 1967.

Dewey, John. *Experience and Education.* 1938. Reprint. New York: Collier, 1963.

Fletcher, Joseph. "The 'Right' to Live and the 'Right' to Die." In *Beneficent Euthanasia*, edited by Marvin Kohl. Buffalo, NY: Prometheus, 1975.

Freire, Paolo. *Pedagogy of the Oppressed*, translated by Myra Bergman Ramos. New York: Herder & Herder, 1970.

Gann, L. H., and Peter Duignan. *The Hispanics in the United States: A History*. Boulder, CO: Westview, 1986.

Gann, L. H., and Peter Duignan. "How Should the U.S. Deal with Multicultural Schoolchildren?" *Stanford University Campus Report*, March 4, 1987.

Gilligan, Carol. *In A Different Voice*. Cambridge, MA: Harvard University Press, 1982.

Kohlberg, Lawrence. *The Philosophy of Moral Development*. San Francisco: Harper & Row, 1981.

Kohlberg, Lawrence. *The Psychology of Moral Development*. San Francisco: Harper & Row, 1984.

MacIntyre, Alasdair. *After Virtue*, 2d ed. Notre Dame, IN: University of Notre Dame Press, 1984.

Maguire, Daniel C. *The Moral Choice*. Garden City, NJ: Doubleday, 1978.

Mayeroff, Milton. *On Caring*. New York: Harper & Row, 1971.

Mead, Margaret, "Research with Human Beings: A Model Derived from Anthropological Field Practice." *Daedalus* 98 (1969): 361–86.

A Nation Prepared: Teachers for the 21st Century. Report of the Task Force on Teaching as a Profession. New York: Carnegie Forum on Education and the Economy, 1986.

Noddings, Nel. *Caring: A Feminine Approach to Ethics and Moral Education*. Berkeley and Los Angeles: University of California Press, 1984.

Noddings, Nel. "Fidelity in Teaching, Teacher Education, and Research for Teaching." *Harvard Educational Review* 56 (1986): 496–510.

Ruddick, Sara. "Maternal Thinking." In *Women and Values*, edited by Marilyn Pearsall. Belmont, CA: Wadsworth, 1986.

Sartre, Jean-Paul. *What Is Literature?* translated by Bernard Frechtman. New York: Philosophical Library, 1949.

Sizer, Theodore R. *Horace's Compromise: The Dilemma of the American High School*. Boston: Houghton Mifflin, 1984.

Smith, Dorothy. "The Experienced World as Problematic: A Feminist Method." Sorokin Lecture no. 12. Saskatoon: University of Saskatchewan, 1981.

Tomorrow's Teachers: A Report of the Holmes Group. East Lansing, MI: The Holmes Group, 1986.

Torbert, William. "Why Educational Research Has Been So Uneducational: The Case for a New Model of Social Science Based on Collaborative Inquiry." In *Human Inquiry*, edited by Peter Reason and John Rowan. New York: Wiley, 1981.

Tyack, David, and Elizabeth Hansot. *Managers of Virtue*. New York: Basic, 1982.

Watson, Jean. *Nursing: Human Science and Human Care*. East Norwalk, CT: Appleton-Century-Crofts, 1985.

Williams, Bernard. *Ethics and the Limits of Philosophy*. Cambridge, MA: Harvard University Press, 1985.

Wittrock, Merlin C., ed. *Handbook of Research on Teaching*. New York: Macmillan, 1986.

9

The Absent Presence

Patriarchy, Capitalism, and the Nature of Teacher Work

Patti Lather
Ohio State University

Through the questions it poses and the absences it locates, feminism argues the centrality of gender in the shaping of our consciousness, skills, and institutions as well as the distribution of power and privilege. The central premise of feminism is that gender is a basic organizing principle of all known societies and that, along with race, class, and the sheer specificity of historical circumstance, it profoundly shapes/mediates the concrete conditions of our lives.[1]

The last fifteen years of feminist scholarship argues strongly that if what we are about is understanding the intersection of choice and constraint in human experience, the relationship of social structure and consciousness, then gender cannot be ignored. This is especially true in an occupational field as tied to women's social position as is public school teaching. As Michael Apple notes (1983b, 1985), the history of teaching is the history of a gendered work force. Yet Apple calls gender "the absent presence" in most research on teaching (1983b, p. 625). Even within leftist work, where one might expect more attention to the interactive dynamics of all forms of oppression, the marginalization of gender in neo-Marxist sociology of education is well noted (O'Brien, 1984; Connell et al., 1982; Walker and Barton, 1983; McRobbie, 1980; Macdonald, 1981; Clarricoates, 1981).

It is the purpose of this paper to argue the centrality of gender in understanding and changing the work lives of teachers. After sketching the history of the stormy relationship between feminism and Marxism, I will explore what opens up both theoretically and strategically once we do pay attention to gender in our efforts to understand the nature of teacher work.

The Unhappy Marriage of Feminism and Marxism

Our subordination to men is not theorized in terms of the benefits that accrue to them and the vested interests they have in maintaining those benefits but in terms of the benefits to capitalism.

—Mahony, 1985, p. 66

In the case of women, their definition as a group and the subsequent collapsing of the group into the general category of the exploited have more to do with patriarchal astigmatism than with social reality. . . . The highlighting of the economic exploitation of women by capital and the obscuring of their oppression by men is an ideological practice—in life and in research.

—O'Brien, 1984, p. 44

Traditional Marxists acknowledge the existence of male dominance, but their recognition is not central to their theory or their practice.

—Jaggar, 1983, p. 239

"The feminist project" (Mazza, 1983) has moved from being accused of factionalism and bourgeois selfishness by male Marxists through what Rowbotham terms the "ominous politeness" of the 1970s (1981, p. 101). We are presently witnessing the "and women, of course" phenomenon, which Mary O'Brien terms "the commatization of women": Gender is tacked on to an analysis in a way that makes women's straggles tactically rather than theoretically present in neo-Marxist discourse. O'Brien argues, furthermore, that such marginalization is "not mere patriarchal prejudice but rather a consequence of serious defects in Marxist theory" (1984, p. 43). Bringing women's capacity for dissent to the center of our transformative aspirations has theoretical and tactical implications for neo-Marxist praxis that will be dealt with later in this paper. But first I want to explore the nature of the relationship between feminism and Marxism by looking at the gender blindness of so much neo-Marxist sociology of education.

While I am aware of MacKinnon's warning against the anxiety that lurks under most efforts to justify women's struggle in Marxist terms, "as if only that would make them legitimate" (1982, p. 524), I argue that Marxist thought is as essential to save feminism from its tendencies toward partiality and privatism as feminism is to save Marxism from its abstraction and dogmatism (Eisenstein, 1979; Smith, 1979; Kuhn and Wolpe, 1978; O'Brien, 1981, 1984; Sargent, 1981; Rowbotham, 1981). Feminism that disregards the workings of economic privilege and the force of material circumstance disempowers itself. Marxism that loses connection with concrete individuals living contradictory and phenomenologically dense lives abstracts itself out of the realm of the useful.

A core feminist belief is that patriarchy,[2] the socially sanctioned power of men over women, operates in both the private and public spheres to perpetuate a social order that benefits men at the expense of women (Sokoloff, 1980; O'Brien, 1981; Barrett, 1980).

Patriarchy is reproduced through the social construction of gender that reflects and rein-
forces the splits between nurturance and autonomy, public and private, male and female
(Flax, 1980; Grumet, 1981). Which biological sex we are born into makes an immense
difference in the material and psychic patterns of our lives. Patriarchal hegemony, how-
ever, obscures both male privilege and gender as a cultural construction that profoundly
shapes our lives. Such hegemony operates as much in neo-Marxist discourse as it does
in any other part of the culture.

There are exceptions. At the token end of the continuum are the sociology of
education anthologies that include an essay of gender while in no way viewing as prob-
lematic the invisibility of gender in the remaining essays (Apple, 1982; Apple and Weis,
1983; Dale, et al., 1981; Barton et al., 1981). Michael Apple's recent work clearly argues
that gender is as integral an analytical tool as is class (1983b, 1985), in contrast to his
earlier analysis of teacher deskilling where gender is largely invisible (1983a). There is
a handful of male reconceptual curriculum theorists who use gender as a key analytic
category and seem reasonably familiar with feminist discourse (Sears, 1983; Pinar, 1981,
1983; Pinar and Johnson, 1980; Taubman, 1981). There is the work of Connell et al. in
Australia where, after a year's fieldwork, the research team of academics and classroom
teachers came to the unexpected realization that the interaction of gender and class is
central to understanding what happens in schools (1982, p. 73). Both class and gender
were recognized as structures of power that involve control of some over others and the
ability of the controllers to organize social life to their own advantage. Class and gender
"abrade, inflame, amplify, twist, negate, dampen and complicate one another. In short,
they interact vigorously . . . with significant consequences for schooling" (p. 182). But
the norm among "neo-Marxist curricularists" (Schubert et al., 1984) is a lack of awareness
regarding gender issues, including the wealth of academic scholarship that has developed
over the last fifteen years.

Feminism provides a golden opportunity for Marxists to do their part in what
Aronowitz calls "the long process by which society learns to make the self-criticism
needed to save itself" (1981, p. 53). Grasping the implications for social transformation
of women's struggle for self-determination requires an end to the sexism and economism
inherent in the refusal to see cultural resistance and revolutionary struggle outside of
the "workerism" that permeates the male neo-Marxists search for revolutionary actors
(Rowbotham, 1981, p. 32; Lather, 1984).

Heidi Hartmann (1981) has termed the relationship of feminism and Marxism an
"unhappy marriage": Whether orthodox, neo- or "post-Althusserean,"[3] Marxists cannot
see women's experiences and capacities as a motor force in history. So, as in patriarchal
marriage, two become one and that one is the husband. Gender considerations become
secondary, if acknowledged at all. Class is the ultimate contradiction. To see women's
subordination as a central rather than a peripheral feature of society would require a
probing of "the epistemological contradictions of using gender analysis as an appendage
to an androcentric theoretical perspective" (Tabakin and Densmore, 1985, p. 13). It is,
of course, much easier to ignore the whole issue, especially in terms of the philosophi-
cally fundamental dimensions of the feminist challenge. The "and women, of course"

phenomenon allows male Marxist scholars to feel they have addressed gender issues—without ever asking how a field of inquiry must be reconstructed "if it is genuinely to include women's lives, experiences, work, aspirations" (Martin, 1986).

Habermas has termed feminism a new ideological offensive (1981). As such, it is, I argue, the contemporary social movement taking fullest advantage of the profound crisis of established paradigms in intellectual thought. The charge of feminist scholars is to document the specificity of how gender inequality permeates intellectual frameworks and to generate empowering alternatives. The challenge of such work to neo-Marxist sociology of education is no less than this: to bring women to the center of our transformative aspirations is an opportunity to address the "black holes"[4] that have stymied a Marxist praxis relevant to the conditions of life under advanced monopoly capitalism.

Issues of Praxis

My argument in this section is that if we want to understand and change the work lives of teachers, issues of gender are central. What follows is a sketch of what opens up both theoretically and strategically when we bring gender to the center of our efforts to understand the nature of teacher work. After an overview of the way gender has shaped the social relations of teaching, three problematic areas of Marxism will be touched upon: the public/private split, the failure to come to grips with subjectivity, and the reductionism that still typifies so much of contemporary Marxism and stymies the sustaining of systematic opposition.

Gender and the Shaping of Public School Teaching

The central claim of materialist-feminism[5] is that gender-specific forms of oppression are not reducible to the demands of capitalism. There is an interactive reciprocity and interweaving of the needs of patriarchy and capital that must be taken into account in understanding the work lives of teachers. How has gender shaped the nature of teacher work?

To see the family as a "greedy institution for women" (Coser and Rokoff, 1974, p. 545) is to understand that the conditions of maintaining capitalism via the gender system require an analysis of the reproduction of mothering by women both inside and outside the home (Chodorow, 1978: Dinnerstein, 1976; Sokoloff, 1980). Problematizing the feminization of the teaching role provides an exemplary illustration of the way women's labor in the "helping professions" becomes "motherwork": the reproduction of classed, raced, and gendered workers.

Sara Lightfoot writes: "mothers and teachers are also involved in an alien task. Both are required to raise children in the service of a dominant group whose values and goals they do not determine . . . to socialize their children to conform to a society that belongs to men" (1978, p. 70). Teaching has come to be formulated as an extension of women's role in the family: to accept male leadership as "natural" and to provide services that

reproduce males for jobs and careers, females for wives and mothers and a reserve labor force. Margaret Adams (1971) calls this "the compassion trap": Women feed their skills into social programs they have rarely designed that, while ripe with contradictions, are "fundamentally geared to the maintenance of society's status quo in all its destructive, exploitative aspects" (p. 562).

Women's subordination has been built into the very dynamics of the teaching role. This is not to deny that classroom teachers exert a form of power over their students. But Jean Baker Miller's (1976) distinction between relationships of temporary and permanent inequality is helpful here. Women are dominant in relations of temporary inequality such as parent and teacher, where adult power is used to foster development and eventually removes the initial disparity; they, are submissive in permanently unequal relations where power is used both to cement dominant/subordinate dynamics and to rationalize the need for continued inequality (pointed out in Gilligan, 1982, p. 168).

Teachers stand at the juncture of nurturing and sending out, preparing children to go from the private to the public world. To the degree women teachers serve as transmitters of cultural norms rather than cultural transformers, they, like mothers, find themselves caught in the contradiction of perpetuating their own oppression. With training for docility,[6] teaching becomes an extension of women's maternal role as capitalism's "soft cops" (Wasserman, 1974), serving the dual function of both presenting the capitalist-patriarchy's human face and providing social and political containment (Rowbotham, 1973, p. 91).

As "the secular arm of the church" (Howe, 1976, p. 85), dedicated to sacrifice and service, disempowered by the "normal school mentality" fostered by their education (Mattingly, 1975), crowded into an occupation full of structural disincentives, and oversocialized to be "good girls," women teachers have focused on responsive concern for students and worries about job performance at the cost of developing a more critical stance toward their cultural task of passing on a received heritage. The structure of the public schools has grown up around women's subordination. Little wonder, then, that the possibilities for nurturing Giroux's "oppositional teacher" (1983) or Zaret's "the teacher as transition agent" (1975) are directly linked to empowering women.

The Public/Private Split

The public/private split that is the foundation of the capitalist-patriarchy has relegated women's sphere to the periphery of social thought, the realm of the "natural" and hence unchangeable, the biological. Materialist-feminist analysis grows out of the primary female experience with reproduction and reproduction expanded to include nurturing, caretaking, and socializing work—"shadow work" that does not get counted in either the gross national product (Illich, 1982, p. 45) or Marxist theories of the motor forces of history (Jaggar, 1983). The materialist-feminist analysis insists that the forces and relations of reproduction be recognized to be as central as production in the social fabric (O'Brien, 1981; Ferguson, 1979; Bridenthal, 1976; Kuhn and Wolpe, 1979). Materialist-feminist theory posits that reproduction stands in dialectical relationship to production as the material base of history; they are, in effect, warp and woof of the social fabric.

Mary O'Brien (1981) argues that to continue dismissing change in the reproductive sector as being of no historical consequence is rooted in a biologism that contradicts Marxism's essential postulate of the dialectical relationship between nature and culture. Other major shifts in social consciousness have been rooted in the public realm. With feminism, "the private realm is where the new action is" (p. 189), as women undertake "a conscious struggle to transform a social reality that in turn will transform consciousness" (p. 208).

Coming to Grips with Subjectivity

Rosalind Coward (1983) argues that just as the great debate of nineteenth century social theory, the relationship between nature and culture, was moved forward by focusing on sexual relations, the position of women holds great hope for theoretical advances in the late twentieth-century quest to understand the relationship between consciousness and social structure. The focus on false consciousness, hegemony, and ideology that characterizes contemporary Marxist thought is rooted in the hidden nature of exploitation under advanced monopoly capitalism (Jaggar, 1983, p. 215); this results in a society where "the very *fact* of domination has to be proven to most Americans" (Giroux, 1981). Because as women, we live intimately with our patriarchal oppressors, we have been especially subjected to layers of myths about our own nature and that of the society in which we live. Studying "the extent to which gender is a world-view-structuring experience" (Hartsock, 1983, p. 231) can hence shed much light on the processes of both ideological mystification and coming to critical consciousness.

Western women presently find themselves in an extremely contradictory position. Widespread access to birth control gives women broad-based reproductive control for the first time in history. Aspirations are geometrically advancing in a no-growth era; most women put in "double days" in a culture that in practice cares little for children (Grubb & Lazerson, 1982). Some women experience double and triple oppression due to race, class, and sexual preference; many are part of the feminization of poverty. All receive double messages from our culture with schizophrenic regularity. Women are, collectively, prime candidates for ideological demystification, the probing of contradictions to find out why our ways of looking at the world do not seem to be working in our favor (Eisenstein, 1982).

"Feminism is the first theory to emerge from those whose interest it affirms" (MacKinnon, 1982, p. 543). It is rooted in a deep respect for experience-based knowledge. It is best summarized in the phrase "the personal is political"—a radical extension of the scope of politics that transcends the public/private split. Feminism is premised on an intimate knowledge of the multifaceted and contradictory elements of consciousness and the deeply structured patterns of inequality reinforced through dominant meanings and practices. As we extend the question of consent from the public to the private realm, we find that "because women's consensus shows more signs of erosion than working-class consensus, it is a more promising field for research and political praxis" (O'Brien, 1984, p. 58).

Transcending Reductionism

What a materialist-feminism refuses is to reduce Marxism solely to an analysis of capital; it insists that historical materialism can shed much light on the oppression of women and that Marxism would benefit from a focus on the interactive reciprocity and interweaving of the needs of patriarchy and capital. Perhaps most importantly, feminism argues the need for Marxism to recognize that revolutionary constituencies shift with historical circumstances. To the degree women's struggle is made invisible by economistic reductionism, Marxism loses touch with the potential that feminism offers for social transformation.

The relationship between the theoretical analysis and political strategies is a long-standing concern within Marxism. Whitty argues that change efforts in the schools must be linked to broader oppositional movements (1985, p. 24). To continue to disallow gender in our analysis of teacher work is to not tap into the potential that feminism offers for bringing about change in our schools. As Zaret wrote in 1975: "For women who are teachers, the starting point is you in your own situation" (p. 47). Until the rebirth of feminism, women had no access to oppositional ideologies that encouraged them to question the gender status quo. Making gender problematic opens one up to the layers of shaping forces and myths in our society with great implications for one's conception of the teaching role. Let us look, for example, at some of the contradictions in the lives of women teachers that a gender analysis illuminates.

- As women teachers, we are simultaneously assumed to place home and family above career and to be dedicated "professionals," which often means "a kind of occupational subservience (Dreeben, 1970, p. 34; see Darling-Hammond, 1985).

- The "paradox of conformity" (Zaret, 1975, p. 46) makes us complicitors in our own oppression to the extent that we maintain the status quo.

- As women teachers, we are simultaneously in positions of power and powerlessness. Like motherhood, teaching is "responsibility without power" (Rich, 1976). Women's subordination has been built into the very dynamics of the teaching role. Lightfoot writes of the cultural perceptions of the teacher as woman and as child (1978, p. 64). Yet we expect teachers to perform miracles, to overcome our society's most intransigent problems.

- As both teachers and mothers, we daily witness the rhetoric of America as a child-centered society versus the reality of our culture's devaluation of the care and raising of children.

- As married women teachers, we live daily the contradiction of needing the home as a refuge from the alienating dimensions of teaching versus the alienating reality of our double day (Sokoloff, 1980, p. 210; see Pogrebin, 1983, regarding how little household work American men do).

It is the central contention of this paper that taping the estrangement and sense of relative deprivation that feminism engenders in women is a key to transforming the occupation of public school teaching.

Conclusion

Given the androcentrism of Marxist theory, feminism benefits from exposure to this powerful, well-developed body of social theory that continues to dominate revolutionary discourse so long as feminists remain aware of the need to subvert the intellectual ground under our feet. We need to be sure we do not become "good wives" of a Marxist patriarch. What neo-Marxist sociology of education needs right now is a way to transcend its theoreticism, its lack of praxis, its malaise rooted in its long-standing lament regarding "the continuing absence of a movement capable of advancing alternatives" (Genovese, 1967, p. 102).

Given the intimate connection of public school teaching with the social role of women, the continued invisibility of gender in neo-Marxist analysis of public school teaching greatly limits its usefulness in restructuring the work lives of teachers. To the extent male neo-Marxists continue to ignore the forces and relations of patriarchy and to marginalize women as historical protagonists in their theory and strategy building, they are as much a part of the problem as of the solution.

Notes

Lather, Patti, "The Absent Presence: Patriarchy, Capitalism, and the Nature of Teacher Work," *Teacher Education Quarterly*, 14 (2) (1987): 25–38. Copyright © 1987 by Caddo Gap Press, 3145 Geary Boulevard, Suite 275, San Francisco, CA 94118.

1. Gender as a social construction is a key assumption of all strands of feminism. Feminism argues that what gender is, what men and women are, and what types of relations they have are not so much the products of biological "givens" as of social and cultural forces, Symbolic and ideological dimensions of culture play especially important roles in creating, reproducing, and transforming gender. See S. Ortner and H. Whitehead (Eds.), *Sexual Meanings; The Cultural Construction of Gender and Sexuality*, New York: Cambridge University Press, 1981.

2. Barrett (1980) and Coward (1983) discuss the analytic problems with the concept of patriarchy in feminist work.

3. In a continuing profusion of "kinds of Marxism," Mary O'Brien defines post-Althusserean Marxism as "attempts to re-socialize the substructural/superstructural model . . . which is problematic in any case" (1984, p. 45).

4. I first heard Jim Sears use this term at the Fifth Curriculum Theorizing Conference, Dayton, 1984.

5. I now call myself a "materialist-feminist," thanks largely to French social theorist, Christine Delphy (1984), but I have also, finally, grasped the essence of the "new French feminists" (Marks and de Courtivon, 1980): that I am a constantly moving subjectivity. To be a materialist means to understand social reality as arising in the lived experiences of concrete individuals under particular historical conditions.

6. For a feminist critique of teacher education, see Lather, "Gender and the Shaping of Public School Teaching: Do Good Girls Make Good Teachers?"; paper presented at the National Women's Studies Association annual meeting, New Brunswick, New Jersey, 1984. See, also, Ava McCall, "Learning to Teach: The Empowering Quality of Nurturance"; paper presented at the Curriculum Theorizing Conference, Dayton, 1986.

References

Adams, M. (1971). The compassion trap. In V. Gornick and B. Moran (Eds.), *Woman in a sexist society: studies in power and powerlessness*: New York: Basic Books.

Apple, M. (1982). Reproduction and contradiction in education: an introduction. In M. Apple (Ed.), *Cultural and economic reproduction in education. Essays on class, ideology and the state.* Boston: Routledge and Kegan Paul.

————. (1983a). Curricular form and the logic of technical control. In M. Apple and L. Weis (Eds.), *Ideology and practice in schooling,* (pp. 143–166). Philadelphia: Temple University Press.

————. (1983b). Work, gender, and teaching. *Teacher's College Record, 84*(3), 611–628.

————. (1985). Teaching and "women's work": A comparative historical and ideological analysis. *Teacher's College Record, 86*(3), 455–473.

Apple, M., and L. Weis (Eds.). (1983). *Ideology and practice in schooling.* Philadelphia: Temple University Press.

Aronowitz, S. (1981). *The crisis in historical materialism: Class, politics, and culture in marxist theory.* New York: Praeger.

Barrett, M. (1980). *Women's oppression today: Problems in marxist-feminist analysis.* London: Verso.

Barton, L., R. Meighan, and S. Walker (Eds.). (1981). *Schooling, ideology, and the curriculum.* Barcombe, England: Falmer Press.

Bridenthal, R. (1976). The dialectics of production and reproduction in history. *Radical America, 10,* 3–11.

Chodorow, N. *The reproduction of mothering: Psychoanalysis and the socialization of gender.* Berkeley: University of California Press.

Clarricoates, K. (1981). The experience of patriarchal schooling. *Interchange, 12*(23), 185–204.

Connell, R. W., D. J. Ashenden, S. Kessler, and G. W. Dowsett (1982). *Making the difference: schools, families, and social division.* Sydney: George Allen and Unwin.

Coser, R., and G. Rokoff (1971). Women in the occupational world: Social disruption and conflict. *Social Problems, 18,* 535–554.

Coward, R. (1983). *Patriarchal precedents: Sexuality and social relations.* Boston: Routledge and Kegan Paul.

Dale, R., G. Esland, and M. MacDonald (Eds.). (1981). *Education and the state.* Vol. 2. Barcombe, England: Falmer Press.

Darling-Hammond, L. (1985). Valuing teachers: The making of a profession. *Teacher's College Record, 87*(2), 205–218.

Delphy, C (1984). *Close to home: A materialist analysis of women's oppression.* Amherst: University of Massachusetts Press.

Dinnerstein, D. (1976). *The mermaid and the minotaur: Sexual arrangements and the human malaise.* New York: Harper Colophon.

Dreeban, R. (1970). *The nature of teacher work: Schools and the work of teachers.* Glenview, IL: Scott-Foresman.

Eisenstein, Z. (Ed.). (1979). *Capitalist patriarchy and the case for socialist-feminism.* London: Monthly Review Press.

Eisenstein, Z. (1982). The sexual politics of the new right: Understanding the "crisis of liberalism" for the 1980s. *Signs* 7(3), 567–588.

Ferguson, A. (1979). Women as a new revolutionary class. In P. Walker (Ed.), *Between labor and class.* Boston: South End Press.

Flax, J. (1980). Mother-daughter relationships. In H. Eisenstein and A. Jardine (Eds.), *The future of difference* (pp. 20–40). Boston: G. K. Hall.

Fox Keller, E. (1985). *Reflections on gender and science.* New Haven, CT: Yale University Press.

Freire, P. (1973). *Pedagogy of the oppressed.* New York: Seabury Press.

Genovese, E. (1967). On Antonio Gramsci. *Studies on the left,* 7(1–2), 83–107.

Gilligan, C (1982). *In a different voice.* Cambridge: Harvard University Press.

Giroux, H. (1981). *Ideology, culture, and the process of schooling.* Philadelphia: Temple University Press.

————. (1983). *Theory and resistance in education.* New York: J. F. Bergin.

Gray, E. D. (1982). *Patriarchy as a conceptual trap.* Wellesley, MA: Roundtable Press.

Grubb, W., and M. Lazerson (1982). *Broken promises: How Americans fail their children.* New York: Basic Books.

Grumet, M. R. (1981). Pedagogy for patriarchy: The feminization of teaching. *Interchange* 12(2–3), 165–184.

Habermas, J. (1981). New social movements. *Telos 49,* 33–38.

Hartmann, H. (1981). The unhappy marriage of marxism and feminism: Towards a more progressive union. In L. Sargent (Ed.), *Women and revolution* (pp. 1–41). Boston: South End Press.

Hartsock, N. (1983). *Money, sex, and power: Toward a feminist historical materialism.* Boston: Northwestern University Press.

Howe, F. (1981). Feminist scholarship—the extent of the revolution. In *Liberal education and the new scholarship on women: Issues and constraints in institutional change* (A report of the Wingspread Conference, October 22–24; pp. 5–21). Washington, DC: Association of American Colleges.

Illich, I. (1982). *Gender.* New York: Pantheon Books.

Jaggar, A. (1983). *Feminist politics and human nature.* Totowa, NJ: Rowman and Allan-held.

Kuhn, A., and A. M. Wolpe (Eds.). (1978). *Feminism and materialism: Women and modes of production.* Boston: Routledge and Kegan Paul.

Lather, P. (1984). Critical theory, curricular transformation, and feminist mainstreaming. *Journal of Education,* 166(1), 49–62.

Lightfoot, S. L. (1978). *Worlds apart: Relationships between families and schools.* New York: Basic Books.

Macdonald, M. (1981). Schooling and the reproduction of class and gender relations. In R. Dale et al. (Eds.), *Education and the state: Politics, patriarchy, and practice.* Vol. 2 (pp. 159–178). Barcombe: Open University Press.

MacKinnon, C. (1982). Feminism, marxism, method, and the state: An agenda for theory. *Signs* 7(3), 515–544.

Mahony P. (1985). *Schools for boys? Co-education reassessed.* London: Hutchinson.

Marks, E., and I. de Courtivon (Eds.). (1980). *New french feminisms.* Amherst, MA: University of Massachusetts Press.

Martin, J. (1986). Questioning the question. (Review of S. Harding, *The Science Question in Feminism,* 1986.) *Women's Review of Books* 4(3), 17–18.

Mattingly, P. (1975). *The classless profession: American schoolmen in the nineteenth century.* New York: University Press.

Mazza, K. (1983, April). *Feminist perspectives and the reconceptualization of the disciplines.* Paper presented at the meeting of the American Educational Research Association, Montreal, Canada.

McRobbie, A. (1980). Settling accounts with subcultures. *Screen Education 34,* 37–39.

Miller, J. (1986). *Toward a new psychology of women.* Boston: Beacon Press.

O'Brien, M. (1981). *The politics of reproduction.* Boston: Routledge and Kegan Paul.

———. (1984). The commatization of women: Patriarchal fetishism in the sociology of education. *Interchange 15*(2), 43–60.

Pinar, W. (1981). Gender, sexuality, and curriculum studies: The beginning of the debate. *McGill Journal of Education 16*(3), 305–316.

———. (1983). Curriculum as gender text: Notes on reproduction, resistance, and male-male relations. *Journal of Curriculum Theorizing 5,* 26–52.

———, and L. Johnson (1980). Aspects of gender analysis in recent feminist psychological thought and their implications for curriculum. *Journal of Education 162*(4), 113–126.

Pogrebin, L. C. (1983). *Family politics: love and power on an intimate frontier.* New York: McGraw-Hill.

Rich, A. (1976). *Of woman born: motherhood as experience and institution.* New York: Bantam Books.

Rowbotham, S. (1973). *Woman's consciousness, man's world.* Middlesex, England: Penguin Books.

Rowbotham, S., L. Segal, and H. Wainwright (1981). *Beyond the fragments: Feminism and the making of socialism.* Boston: Alyson.

Sargent, L. (Ed.). (1981). *Women and revolution: A discussion of the unhappy marriage of marxism and feminism.* Boston: South. End Press.

Schubert, W., G. Willis, and E. Short (1984). Curriculum theorizing: An emergent form of curriculum study in the U.S. *Curriculum Perspectives 4*(1), 69–74.

Sears, J. (1983, June). *Sex equity: An ethnographic account of meaning-making in teacher education.* Paper presented at the meeting of the National Women's Studies Association, Columbus, Ohio.

Smith, D. (1979). A sociology for women. In J. Sherman and E. Beck (Eds.), *The prism of sex: Essays on the sociology of knowledge* (pp. 135–188). Madison, WI: University of Wisconsin Press.

Sokoloff, N. (1980). *Between money and love: The dialectics of women's home and market work.* New York: Praeger.

Tabakin, G., and K. Densmore (1985, April). *Teacher professionalization and gender analysis.* Paper presented at the meeting of the American Educational Research Association, Chicago, Ill.

Taubman, P. (1981). Gender and curriculum: discourse and the politics of sexuality. *Journal of Curriculum Theorizing.*

Walker, S., and L. Barton (1983). *Gender, class, and education.* New York: Falmer Press.

Wasserman, M. (1974). *Demystifying school.* New York: Praeger.

Whitty, G. (1985, April). *Curriculum theory, research, and politics: A rapprochement.* Paper presented at the meeting of the American Educational Research Association, Chicago, Ill.

Zaret, E. (1975). Women/school/society. In J. Macdonald and E. Zaret (Eds.), *Schools in search of meaning.* Washington, DC: Association for Supervision and Curriculum Development.

Schooling and Radicalisation

Life Histories of New Zealand Feminist Teachers

Sue Middleton
University of Waikato

Introduction

Sociologists of education have become increasingly concerned with the school as a site of social and cultural reproduction. Rejecting the liberal view that schools are agents of social mobility and human emancipation, many sociologists have focused their analyses on how schooling constructs and reproduces the social relations of class, racism, and gender in the wider, capitalist society. In this, they have failed to account for the emergence of radicals (including sociologists) in educational settings. Sociologists have neglected to study the educational experiences of those who become radical critics of education, or radical teachers.

Since the resurgence of feminism as a mass social movement in the early 1970s, schooling has been viewed as a site of gender struggle. Many of today's feminist teachers, however, attended schools in the 1950s and early 1960s—a time when curricular provisions rested on firm, and largely unquestioned, assumptions of differentiated gender-roles. Despite the conservative intentions of the policymakers, many women of the post-World War Two generation resisted the dominant ideology of patriarchal femininity which characterised the overt selection and social organisation of school knowledge. As feminist teachers, such women have come to view schooling as a means of working towards equity in gender relations. This paper is drawn from a wider study of feminist teachers who were born and educated in New Zealand in the years immediately following World War Two (Middleton, 1985c). It analyses the school experiences of two of the women studied and explores the part played by these in their adoption, as adults, of a radical analysis of the social world.

The method used in this is life history analysis, which focuses on what Mills and others have referred to as "biography, history and social structure" (Mills, 1976; Laing, 1971; Plummer, 1983; Sedgwick, 1983). A life history approach can help the researcher to analyse both the lives of individuals and the social context of their experience, relating

"the personal troubles of milieu and the public issues of social structure" (Mills, 1975, p. 14). People are seen, not as mere passive victims of their socialisation, but as creative strategists who devise means of dealing with, resisting and resolving the contradictions they experience. The first part of this paper analyses contradictions in expectations for the New Zealand educated "post-war woman" through studying the ideas expressed by policy makers in curriculum documents. The second part presents two case studies. The focus of these is on the strategies these women developed in their school years to deal with the contradictions of femininity and their experiences of marginality and to trace the relevance of these to the beginnings of their political radicalisation.

Contradictions in the Post-War Woman's Education: The Compulsory Core Curriculum, Women's Work and the Politics of Female Sexuality

In New Zealand, as elsewhere in the Western world, the years which followed World War Two were a time of increased access to secondary schooling. During the war, the Thomas Commission produced the blueprint for post-war secondary education (Department of Education, 1944, 1959 edition). The Labour government's prescription for post-war education, as outlined in the Thomas Report (1944, 1959 edition), was both liberal and meritocratic. Schooling was conceptualised as "reconstructionist" (Codd, 1985)—as a bastion against the resurgence of fascism. A core curriculum was recommended for all pupils in the first three years of secondary school "as an aid to growth and as a general preparation for life in a modern democratic community" (Dept of Education, 1959 edition, p. 6). Schools would produce adults able to take their place in a liberal democracy as "workers, neighbours, homemakers and citizens" (Ibid, p. 5)—the only limit to their aspirations was to be the (then largely uncriticised) notion of "merit" or "ability." All pupils were to take social studies, mathematics, English, general science, music, art, and craft.

However, a feminist reading of the Thomas Report and other key policy documents of the time (Middleton, 1986) shows that expectations for the "post-war woman" were contradictory. The role expected of married women after the war was a domestic one: they would leave their war-time jobs and devote themselves to domestic life (Cook, 1985). This would ensure the rehabilitation of military men, a growing population of stable, psychologically well-adjusted children and a "booming." growing economy. Women who failed to live up to the ideal of domestic femininity were regarded as "'poorly adjusted" and in need of the curative powers of contemporary medical/psychological science (Ehrenreich & English, 1979; Friedan, 1963). The post-war woman was to experience in her schooling a set of cultural practices which were based on the assumptions of both a liberal ideology of equality and meritocracy and, at the same time, an ideology of domestic femininity. A woman's true role economically was as biological and social reproducer of the workforce (Marx, 1976 edition). The patriarchal nuclear family, with the husband as breadwinner, was seen as essential to the maintenance of social cohesion

and public morality. Schooling was to reproduce a gendered labour force. Certain jobs, such as teaching and nursing, were seen as suitable work for girls, but only as a "short adventure between school and marriage" (Watson, 1966, p. 159), or, as in the teacher shortage of the 1950s and 1960s, when their labour was seen as necessary as patriotic service in a (peacetime) "national emergency" (Department of Education, 1962, p. 585). Their "true calling" however, was domestic and, to ensure that girls were adequately prepared, a stiff dose of compulsory domestic science was included in the core curriculum:

> An intelligent parent would wish a daughter to have, in addition, the knowledge, skill and taste required to manage a home well and make it a pleasant place to live in. (Department of Education, 1959 edition, p. 7)

The Thomas Report also made specific recommendations on sex education (Middleton, 1986). Control of female sexuality was a central theme in war-time and post-war planning. According to Foucault (1980a) sexuality has acquired a

> . . . specific significance in modern times because it concerns characteristics that are at the intersection between the discipline of the body and the control of the population. (Giddens, 1982, p. 219)

Concern with a threatened drop in the birthrate had been expressed before and during the war: control of sexuality became a central political issue. It was also seen as necessary to maintain the social order and prevent "delinquency." These concerns were evident in the Thomas Report and other sex education documents (Middleton, 1986). At secondary school, children were to learn the "facts of reproduction" as preparation for marriage and family life. These were to be taught as part of the General Science curriculum: in Foucault's terms, sex was treated as a "medical" issue, reduced to "lessons in biology and in the anatomy and physiology of the reproductive system" (Department of Education, 1959 edition, p. 54). Sex education materials of the time show that they were premised on the sexual "double standard"—men had uncontrollable urges, which virtuous women, who did not have such urges, must curb for them (Middleton, 1986). Learning to be "attractive" was very much part of the overt and covert curriculum for girls (Taylor, 1984). Although one must learn to attract males, however, one must not "give in" to their sexual advances—only "delinquents" did this. Girls in academic streams who were to train for the professions were expected to delay sexual activity,[1] including marriage, until after they had finished their training. Teacher trainees who married while training lost their studentships. Overt sexuality and intellectuality/professionality were socially constructed as contradictory.

The educational expectations for women and girls in post-war New Zealand, then, were contradictory. On the one hand, girls were promised equality of opportunity on the liberal/meritocratic model—the chance to pursue study and a career, to attain personal and professional autonomy. On the other hand, they were expected upon marriage to become economically and emotionally dependent. Liberalism and femininity were

contradictory. In terms of expression of their sexuality, girls were expected to be 'attractive' but not to 'give in.' Academic study and a professional career were antithetical to full expression of their sexuality.

The recommendations in the Thomas Report were adopted and made policy in the Education (Post-primary Instruction) Regulations of 1945. However, its implementation was made difficult because of the sudden vast increase in the pupil population and the drastic shortage of teachers. Providing enough classrooms and teachers became the Education Department's main priority (McLaren, 1974; Whitehead, 1974). Secondary schools were organised as multilateral comprehensives which streamed their pupils on the basis of courses (combinations of optional subjects) taken, e.g. academic or professional streams (foreign languages), commerical and homecraft streams (Department of Education, 1962; Harker, 1975; Whitehead, 1974). By means of two case studies, I shall show how these streaming practices, based on hierarchies of knowledge, reproduced the contradictions between the expectations of liberalism and femininity and also the sexual double standard. Within the schools, the girls devised strategies to resist and resolve these contradictions (Findlay, 1973; Frame, 1983).

Feminist scholars, such as Bartky (1977), Eisenstein (1982) and Mitchell (1973) have argued that women's experiences of widespread social contradictions in the post-war years generated the "second wave" of feminism. Mitchell (1973) has argued that this resurgence of feminism as a mass social movement was largely stimulated by 'educated' women. Increased access to education gave women access to ideas with which to articulate their discontent and to the credentials which would give access to both economic and professional independence and to positions of power from which to effect change. According to Mitchell (1973, p. 38),

> . . . The belief in the rightness and possibility of equality that women share
> has enabled them to feel 'cheated' and hence has acted as a precondition of
> their initial protest . . . offered a mystifying emancipation and participating
> in an ideology of equality, the sense of something wrong is more acute than
> when women share in the openly dominative structure of feudal, semifeudal
> or early capitalist societies.

However, not all women of the post-war era who experienced contradictions became feminists. Conducive social conditions are a necessary, but not a sufficient, explanation for why some women became feminists while others did not. Furthermore, at the time these women were at school, the 1950s and 1960s, specifically feminist ideas were not yet widely accessible to help them articulate their personal experiences of contradictions as wider social issues.

Other radical theories, however, were available. New Zealanders were deeply embroiled in internal conflicts over the Vietnam War and rugby tours with South Africa—issues of racism and imperialism were widely debated in the popular media. Many school students of the time came from families which did not have a tradition of secondary and higher education—rural children and working-class children had increased access to education (Nash, 1981; NZCER, 1965; Watson, 1966). As the first in their families to

have access to secondary education, academic courses and/or professional training, their experience was often one of "marginality." Bourdieu (1971a, p. 179) commented that it was often the "marginal intellectual" in academic settings who was most likely to develop a radical critique of education:

> . . . the attacks against academic orthdoxy come from the intellectuals situated on the fringes of the university system who are prone to dispute its legitimacy, thereby proving that they acknowledge its jurisdiction sufficiently for not approving them.

The potential of "marginal people" to develop radical views of the social world has been discussed by a number of sociologists. Schutz (1944) described the "stranger" as a "cultural hybrid" with an understanding of "different patterns of group life." Plummer (1983, p. 88) argued that such a person, living at a "cultural crossroads" was of interest to sociologists because /he experienced a phenomenological "shock" or "'jolt" which threw into stark relief the normally taken-for-granted world of everyday life:

> Experiencing contrasting expectations as to how he or she should live, the subject becomes aware of the essentially artificial and socially constructed nature of social life, how potentially fragile are the realities that people make for themselves.

The experience of "not belonging" can be fraught with tension—it is not pleasant, particularly if the group to which one is "the stranger" is the dominant group. The experience of marginality (as working-class, Black, etc) is radicalising when it is understood theoretically as a manifestation of the unequal power relations in society: for example, a working-class student who interprets her sense of alienation in the top stream as a consequence of bourgeois hegemony rather than her own "ignorance," a Maori who views the clustering of Maori children in low streams as a product of institutionalised racism rather than because "Maoris are dumb or lazy." By means of two case studies, I shall argue that women who became (liberal or socialist or radical) feminists in post-war New Zealand have had personal experiences of contradictions and/or marginality, have had access to feminist and other radical ideas which helped them to perceive the contradictions and sense of marginality they experienced as *social* phenomena (rather than mere personal inadequacies) and have apprehended both the desirability and the possibility of change in their own lives and in the lives of other women. In feminist terms, the personal becomes political.

The School Experiences of Feminists: An Oral History Approach

Oral histories enable the researcher to focus on both individual agency and the power relations of the wider society and the limitations these impose on personal choice. How individuals interpret and analyse their experience becomes the focus of study. The social

world is seen, as Schutz (1970, p. 11) expressed it, in terms of "the specific meaning and relevance structure for the human beings living, thinking and acting within it." People's interpretations and explanations of biographical and/or historical events and influences, rather than the events and influences themselves, are being studied—in this case the women's *feminist* perspectives on their lives. Foucault called such as approach "writing a history of the present" (Foucault, 1979, 1980a; Sheridan, 1980).

Twelve women were selected on the basis of their espoused theoretical perspectives[2]: liberal or "equal rights" feminists, radical feminists (including lesbian separatists), Marxist/socialist feminists and Maori feminists were chosen[3]. The directions pursued in the interviews were how they had reached their present theoretical positions and how these influenced their practice as educators. The analysis of the women's lives was developed through a process of feedback and reinterviewing[4]—it should be viewed as a collective product, a result of collaboration between "researcher and researched.[5] Small portions of two of the case studies will here be discussed. The first is Marjorie,[6] a Pakeha (New Zealand European) woman, who has, as an adult, become a socialist feminist educator,[7] highly involved in anti-racist teaching. The second is Tahuri, a Maori woman who has been involved in radical Maori, as well as feminist, groups. The material selected for this discussion has been severely limited by issues of confidentiality. The studies will here be restricted to the women's school days and will focus on two central themes: the process of becoming "educationally successful[8] and the process of beginning to develop a radical political consciousness.

[1] Marjorie: A Socialist Feminist Against Racism

Marjorie described her parents as "middle-class," although her father had come from a "working-class" family. It is important to analyse the influence of both of her parents on Majorie's educational motivation and achievements. In this, Bourdieu's model is useful. According to Bourdieu, within the family children acquire the linguistic competencies, tastes, habits of mind and dispositions (*habitus*) of their parents' class/cultural group. Whereas the children of a landed aristocracy or wealthy parents may inherit property or capital, the children of professional and other middle-class families may "inherit cultural capital"—that particular *habitus* which is characteristic of the ruling or professional classes and which is validated in the academic streams of schools:

> Those whose 'culture' (in the ethnologists' sense) is the academic culture conveyed by the school have a system of categories of perception, language, thought and appreciation that sets them apart from those whose only training has been through their work and their social contacts with people of their own kind. (Bourdieu, 1971b, p. 200)

Life histories can provide the kind of information needed for a sociological analysis of the subtle influences "significant others" such as parents, teachers and grandparents, may have on a child's aspirations, expectations, achievements, and perspectives. Previous studies of

children's school success have not taken the mother's influence sufficiently into consideration, but have focused on establishing statistical correlations between father's occupation and pupil's school achievement.[9] As Madeleine MacDonald/Arnot has expressed it, sociologists should place greater emphasis on ". . . the operation of the sexual division of labour in the creation and the nature of cultural capital" (MacDonald, 1979/80, p. 151).

Marjorie was the daughter of British immigrants, although she herself was born in New Zealand. She described her mother as being of upper middle-class origins, although she had been adopted out in childhood and brought up in an orphanage until family members had financed her through a boarding school, "so she did not go to school with the children from the village."

Marjorie described her father as having had working-class origins, although his parents had had middle-class aspirations. Successful at school, he had become an accountant. His parents' working-class origins had left him with a fear of entrepreneurial risk-taking and obsessed with "security." She described her father's parents as,

> incredibly right-wing . . . even though they were poor they bought the capitalist myth. If you work hard you can make it. . . . The only future for a young man is in the office and that's where you get your pension. You don't want to go working for yourself because that's the road to ruin. You don't get anywhere. So that's why he came into office work.

In this, Marjorie's father exemplified the values described by Willis (1977) and others as characteristic of educationally successful working-class boys ("Ear 'oles" in Willis's terminology). Rachel Sharp (1980, pp. 112–113) has described these values as "petit-bourgeois ideology,"

> with its accompanying themes of ontological anxiety, exaggerated commitment to individualistic competitiveness and its conceptualisation of social hierarchies as open, natural and just . . . such people (arguably) mistakenly look to education as the key to their social improvement.

As Bernstein (1975) pointed out, this fraction of the middle-class is highly dependent on the education system for the reproduction or improvement of its class position: without property or real capital to pass on to their children, petit-bourgeois parents rely on schools to turn the "symbolic property" (Bernstein, 1975), or "cultural capital" (Bourdieu, 1971a, b, 1976) handed on in the family into school credentials,[10] Marjorie saw her father as very 'upward aspiring' and saw his aspirations for social class mobility as one of the reasons he had married her mother: educated in a private school, she had the habitus of the English middle-class lady. From her father, Marjorie acquired high academic aspirations:

> I was very much pushed into the academic thing and the leadership thing. I was really encouraged in that by my teachers and my parents.

From her mother, Marjorie learned the mannerisms and language of the cultivated middle-class Englishwoman, a habitus which was foreign to the culture of the small New Zealand country town in which she spent her primary school years:

> I had to speak 'properly' . . . I wasn't allowed to have a 'Kiwi' accent. I was brought up as an English child in New Zealand. I was brought up to despise and dislike the New Zealand bush, the New Zealand accent, all those kinds of things. I was 'different.' I always felt different from everybody else because I was English, I wasn't a New Zealander.

Marjorie described her childhood as characterised by two, related, experiences of "marginality":

> I had these two things that were separating me—the thing of being English and not New Zealand, even though I was born here, and being 'bright.' Those two things really pushed me apart from people when I was a child in a small New Zealand town.

During her primary school years, Marjorie turned her cultural marginality as English and middle-class to her own advantage. Confident of her cultural superiority to "the locals"

> I used to tell my friends that I went to boarding school in England. It was just a bullshit story that I used to make up. And I used to get most stories from Billy Bunter comics because we used to get the English comics. That made me feel very different and separate from people.

Marjorie also experienced marginality as a "bright girl" and her strategies of resistance to the contradictions of "femininity" are worthy of detailed analysis. As a child, Marjorie had sensed that her father had despised women. Accordingly, she had developed an identity as a "tomboy" as a strategy of resistance to the dominant ideology and culture of "femininity":

> I was always called a tomboy and I was very proud of that. I didn't like being a girl. I hated girls, I despised girls utterly and completely and that only changed recently when I became a feminist. I took on the beliefs of the society around me and identified with the men. As a child I was very much a tomboy. I used to climb trees and fight and do all those kinds of things and really act brash and smart to be accepted by the local community boys.

While being a "tomboy" was acceptable in childhood, at puberty and early adolescence, the early secondary school years, girls came under increasing pressure to become "feminine" and heterosexually aware. Majorie spent her third-form year in the top stream at

her local co-educational high school. Here, her desire to be "one of the boys" worked to her disadvantage academically. Femininity and intellectuality were socially constructed as contradictory—in order to be accepted by the "superior sex," Marjorie "played dumb":

> I subsided, really, in puberty . . . I got friendly with some boys and really wanted to be accepted by them and liked by them and discovered really quickly that if you're bright with boys, and brighter than them, they don't like you. So I immediately became dumb . . . I used to sit up the back of the classroom and just flirt.

After her third-form year, Marjorie's family moved to a larger town, where she attended the local state girls' school. Because of her poor reports from her previous school, she was going to put in a lower stream. Her mother forcefully intervened:

> My mother went down there and on the strength of my results I wasn't going to be put in the top class. My mother wasn't having that, thank you very much, so she went down to the school and said, 'Put my daughter in the top class.' So they said, 'all right,' because my mother was the sort of person who if she wanted something, she would get it. And they took me aside and said, 'OK, you'll be here on sufferance, deary. If you don't shape up, you ship out.'

Marjorie did well academically, attributing her success at least partly to the single-sex nature of the school:

> I had no boys there to flirt with, so I pulled my finger out and worked very hard, and of course did very well in that top class.

Her attitude to boys and sexuality changed from her "flirting" days in the third form. She became part of a virginal subculture of "swots," whose major concerns were academic success. Boys and sex were not amongst their interests. She described her top-stream peers:

> They were all pretty much the same as me—involved in their work. We were always above 'those boys.' We thought they were greasy little grotty pimply creatures and couldn't stand them basically.

Overt heterosexuality was viewed as incompatible with intellectuality. In those days before contraceptive knowledge and technology was widely available to teenagers, this attitude protected these girls from early pregnancies or involvement which would have distracted from their career ambitions. Sexuality was for the non-intellectuals. Speaking of the girls in the lower streams, Marjorie commented on the typifications constructed of them by top-stream girls. She noted that it was the *habitus* of the lower-stream girls that gave the impression that they were more sexually active as a group than their more academic counterparts:

> I don't actually know that they were all sexually active. I always had the impression that they were, because they had all these love bites . . . they used to talk, they used to make more crude jokes and it was just a stereotype we had of them. . . . As the top stream we never had anything to do with the rest of the school. We were totally into ourselves, just self-sufficient and arrogant and kept to ourselves.

During this time, however, Marjorie was under pressure to conform to more convention-ally "feminine" adolescent concerns. For example, she described her style of dress as a deliberate strategy of resistance to the image of 'femininity' to which she was expected to conform:

> My mother kept telling me that I could be quite attractive if I'd only dress bet-ter. But it was because of this whole thing that I rejected creativity, I rejected beauty right from the beginning. So I quite deliberately dressed in a sloppy and casual way, in an anti-feminine manner. I always did, and I always have, and I continue to. My mother tried desperately to buy me pretty dresses and things, but it never worked.

In her senior years at Girls' College, Marjorie specialised in science subjects, viewing this as an aspect of her rejection of the dominant attitudes towards "femininity":

> I was very good at science and I was very good at maths and I got prizes in maths. I just like it. I had a logical kind of bent and in fact that was always considered to be my downfall that I wasn't emotional, attractive and creative. I was logical and cold and unattractive.

Marjorie became interested in the political issues of the day while still at secondary school. Her interest in becoming a scientist was partly motivated by this concern: as a soil scientist, she was going to "clean up Vietnam." However, her early views on world events reflected her parents' conservatism, in particular her father's "petit-bourgeois" views of the social order as "open, natural and just" (Sharp, 1980, pp. 112–113). At first, she supported American intervention in Vietnam, supported New Zealand's involvement in this war, and National Party policies in general:

> I scrutineered for the National Party in the elections. My parents were National Party supporters and so I was too, automatically. I just took on their beliefs.

Confident and assertive, Marjorie took on leadership positions in the school and the church, where she "ran the Anglican Bible Class." When she was made Head Prefect, Marjorie conformed to the conservative and authoritarian style favoured in the school and the wider society:

I'd be like a policewoman. I used to encourage uniform checks. I did the bloody teachers' work for them. I got a prize for leadership that year. I was an up-and-coming right wing young leader.

Marjorie had, largely out of curiosity, begun taking part in protest marches against the Vietnam war. Her stand on political issues began to shift when she became increasingly aware of the sheer horror, the atrocities of that war and began to question the justification for New Zealand and American perpetuation of these. Her "conversion" to a more radical view occurred at a "gut" level—an identification with the women and children affected. She began to question her father's analysis:

At that stage I had glimmerings of feelings about 'maybe my father isn't really right about this.' It was an emotional thing. I just couldn't bear the pictures of the starving children and the napalm and the women—that started to get to me in an emotional way.

As Arlie Hochschild has pointed out (1975), sociological explanations must deal with 'feeling and emotion' as well as "rationality" in the social world.

When she first attended university, Marjorie, intending to use her scientific training in what she, like contemporary feminist scientists (Fox-Keller, 1982), viewed as a "female" way ("cleaning up the world"), enrolled in a very specialised male-dominated course which she hoped would further this end. However, she was horrified by the sexism of the lecturers and the students and very critical of the course content, which seemed removed from "human" concerns. Although she was gaining top grades, she felt so alienated from the course—its content and its people—that she dropped out to enroll in an ordinary BSc:

The students were male and they were boorish and I couldn't stand them. . . . I was developing, without realising it, a feminist consciousness, because I was top of my class and I was also incredibly critical of the course I was taking.

Marjorie, then, experienced marginality in three aspects of her education, describing these as "the strands of my beginnings, which led me to where I am now." First, her social class background had both working-class and upper-middle-class influences, giving her both a petit-bourgeois drive to "achieve" and an upper-middle-class sense of superiority. Her sensitivity to class differences later led her to a sophisticated study of Marxist theories of education when she encountered these in the course of tertiary study. Secondly, her parents' British origins, and her mother's attitudes towards New Zealanders alienated her from the country of her birth. She was later to become involved with "white women against racism" groups concerned with shaking off the British colonial mentality and seeking a national identity rooted in Maori sovereignty.[11] Thirdly, as a "bright" girl with an interest in science, she rejected the dominant image of femininity. Her cultural capital was sufficient to

enable her to theorise her sense of marginality in terms of class, nationality and gender when she had access to radical ideas (Marxism, Maori sovereignty and feminism) which enabled her to translate these personal experiences into broader social issues.

(2) Tahuri: A Radical Maori Feminist

Tahuri's career was marked by outstanding academic success and an involvement with radical Maori, as well as feminist, groups. Tahuri was brought up by adoptive parents who were "working-class" in the Pakeha (European) sense. Her whakapapa (orally-transmitted genealogy), however, traced a lineage of scholars in both Maori and Pakeha traditions: "My Maori ancestry is rich with scholars in the Maori tradition. My Pakeha ancestry is just as strong." Although her adoptive parents were not "educated," other relatives passed on knowledge which would be regarded as cultural capital at school:

> My auntie used to hang around the house a lot . . . She was delightful, she was a teacher and she had some pretty radical ideas—one of her ideas was to have any kid, any Maori kid that seemed bright and receptive, reading as soon as the kid could pick up a book . . . I don't come from a bookish environment at all, there weren't books around, but when Auntie would come, and she was my babysitter a lot of the time, she would bring books. By age four I was reading.

Tahuri was a sickly child, spending time in hospital. This alienated her from her peers, who preferred outdoor, physical pursuit to indoor ones. By the time she started primary school, Tahuri described herself as "always buried somewhere between the pages."

Because of domestic upheavals in her adoptive family, Tahuri experienced a number of changes of school, living in turn in several towns with different relatives. Some of her relatives were Catholics and one convent school experience was particularly significant to Tahuri in developing her awareness of racism and imperialism as well as providing her with examples of strong women to emulate in her own life. She identified several themes in the curriculum of this school which had a major influence on her political aware-ness—apartheid in South Africa, British Imperialism in Ireland and studies of women saints and war heroines:

> I'll tell you about the curriculum. Just thinking back—I was ten, eleven, twelve years old and I was introduced during those years to issues like apartheid, racism, the Ku-Klux-Klan, Nazi Germany, to strong, extraordinary women who flew aeroplanes and fought against spies and blew them up, wore shining armour and rode horses—those nuns, they were the daughters of the IRA.

The nuns provided Tahuri with strong female role-models through both the stories they told and their personal examples. Tahuri described some of the heroines she had heard about in the classroom:

We were told things like the story of Violet Szabo, who was the woman who got the Military Cross, and how she was a war hero and they made a movie about her called *Carve her name with Pride* and how she was so wonderful and fantastic. We were read reams about Joan of Arc and how she was a warrior and that is really good for a woman to be. We were told about the heroines of the French Resistance. We were given amazingly dynamic models of what women could do as well as men.

Tahuri was impressed with the physical strength, intellectuality, and independence of some of the nuns and cited two examples:

She coached the boys in football—in her habit. This huge nun, who was six feet tall—she was huge—in this great long black swaddling medieval garb that she sort of hitched between her legs. She'd get the back skirt, hitch it between her legs and tuck in into her belt. They had these masses of black leather wide belts with chains and beads and God knows what and she'd rope it all around her waist. She'd have big thick stockings and these great big boots and she'd pick up the football and off she's go. And no man could better her. This was her image. Such power. God, I loved that woman. My other mentor was much more sedate and certainly very much a lady of leisure. One looked at her and immediately thought of illuminated medieval manuscripts and church embroidery—the much more orthodox image of the nun. As models for me they were brilliant. Not only in their lifestyle but also in their ideas, in their celebration and reinforcement of things.

As a Maori in this particular school, Tahuri felt proud of her cultural identity. She described this convent primary school as "a true multicultural school," noting that Maoris there were in the majority. The school also had a substantial immigrant population and cultural diversity was regarded as a strength, a learning resource for the pupils. Positive in her identity as a Maori, Tahuri was horrified by stories told her at school of racism overseas, stating that they had been taught

gut-level things. We were told about the Ku-Klux-Klan and about the slaves, I can remember when Verwoed got in and we had to pray for the black babies and the nun actually weeping about apartheid and what was happening in South Africa.

In addition to the horrors of racism, she was told about the evils of imperialism and the heroism of those who stood up against oppression—in Ireland, the Civil Rights Movement in the United States. Sometimes this touched the class at a very personal level:

one of the boys, who was very Irish, came to school one day in tears and we learned that his uncle had been shot.

It was hardly surprising, then, that as a university student Tahuri would become involved with radical Maori groups. However, at primary school she had not connected the issues of racism and imperialism she knew about in overseas contexts with the situation of Maoris in New Zealand. This was to come in her secondary school years. She acknowledged her debt to these nuns for helping to prepare the ground for this later insight insofar as they had introduced topics

> like the IRA, like the French Resistance, like the Civil Rights Movement. Admittedly, it was never given a New Zealand context, but I suppose that would have been much too subversive. But the seeds were sown. God, I do owe them that. I really do.

At secondary school, Tahuri had shattering experiences of racism—on both institutional and personal levels. Here, her enculturation as a Maori was viewed as inappropriate by other pupils and by teachers and the devaluation of her culture was made explicit. In a provincial girls' school which streamed pupils at least partly on the basis of test results, Tahuri was prevented from taking Maori language:

> To get into the Maori language classes you had to be in the general stream, which meant second or third-class intellect. Certainly not remedial, or vocational or technical, but definitely not top-stream, and because I was top-stream I had to be fed a diet of French and Latin. And there was no way they were going to let me do Maori, no way at all.

Tahuri's adoptive mother, who had been severely punished at school and had such an aversion to schools that she had never been near any of Tahuri's previous schools, attempted to intervene. Whereas Marjorie's mother, as outlined in the previous case study, had successfully intervened in the school's streaming practices, Tahuri's mother was treated as ignorant. Maori knowledge was not cultural capital in the eyes of the school. She was told:

> There's no way this girl can do Maori. She has to be in the top third form and you should feel very pleased that we are putting her in the top third form because that's where she belongs.

The relative status in this school of Maori culture and the *habitus* of the Pakeha middle-class exemplify Bourdieu's (1971a, p. 175) notion of a "hierarchy of cultural works":

> The structure of the intellectual field maintains a relation of interdependence with one of the basic structures of the cultural field, that of cultural works, established in a hierarchy according to their degree of legitimacy. One may observe that in a given society at a given moment in time not all cultural signs . . . are equal in dignity and value.

Tahuri was the only Maori in '3 Professional A,' which she described as

. . . the most elitist, most exalted third form in the school which included the daughters of the town's professional and business elite. The high school teachers' kids, the doctors' kids, the lawyers' kids, the accountants' kids, the boss of the supermarket's kids, the research scientists' kids.

In order to be "any good" in the eyes of the school, Tahuri had to deny her Maoriness, which she refused to do. She teamed up with the few other outcasts in the top stream. Part of their resistance was an exaggerated display of sexuality—assuming the trappings of "tartiness." As an example of this form of resistance, Tahuri described "mufti day" at Girls' High:

> 3 Professional A would turn up in little twinsets and pearls, and beautifully cut skirt and neat shoes with discreet heels and they'd be carbon copies of their mothers. You know, with a little bit of lipstick, and maybe earrings, and terribly prissy. And I'd wear things like black pants and black shirt—in those days they had those things called jerkins, that sort of V-neck, sleeveless tunic. When I wore my black pants and black shirt with jerkin I thought I looked real smooth. And I used to Brylcream, coconut oil, my hair and get it all like Elvis. And that's how we used to go to school.

Pakeha women in my study, such as Marjorie, mentioned the stigmatising of "non-academic" girls in low streams as promiscuous. In Tahuri's school, the association of sexual promiscuity with lack of intellect was further exacerbated by racism. Maori girls were concentrated in the lower streams and seen by some of the academic girls as more sexually promiscuous. Tahuri described the headmistress of the provincial school as racist and her account of the practice of streaming suggested strongly that it reflected and reproduced the social class structure of the wider community:

> it was just so dreadful that we were in the class, degrading its quality like that. Meanwhile, down in 3 Vocational, 3 Reform and 3 Commercial B, there were all the tarts. All the tarts like us. At Girls' High the lower forms were brown. And so there was not only the class-sexuality dimension but there was also the class-sexuality-race. They were brown sluts, bags.

In this school, racism was evident not only on an institutional level, but also in the attitudes of individuals. Tahuri perceived the attitudes of her top-stream peers as overtly racist. For example, she described her experience of a class fund-raising project:

> We had a lunchtime cake-stall. Each kid had to say what they were going to bring and some brought things like coconut ice, cream sponges, this and that. And I got up and said, 'I'll bring a rawene bread.' 'Ugh, what's that,' And I said, 'Maori bread.' 'We don't want that on our stall.' And that's what they said and I can still see them rising out of their desks in mortification

that their pristine little white stall with its goddamn gingham table cloth was going to be contaminated by this ethnic presence.

Tahuri and the two other "deviants" in the class became involved in "delinquent" activities such as running away from home, breaking the rules of the school, shoplifting, stealing from lockers, truanting. For this, she was expelled. However, despite her unhappiness, she had continued to maintain high standards in her academic work.

After her expulsion, Tahuri was accepted as a pupil at a local co-educational high school. At this school, her Maoriness was viewed in a positive light—as appropriately "academic" cultural capital. This time she shared her top-stream class with other Maori pupils. Her academic career "just took off and she proceeded from high academic honours at school to a highly successful university career. Here she became involved with Maori radical student groups and, when the 'women's liberation movement' began in the early 1970s, she became active in this." The seeds of her awareness of racism and imperialism had been sown in her school years. The "academic cultural capital" from her whanau group (extended family) had enabled Tahuri to transcend the set-backs and disruptions in her nuclear family and first secondary school experiences.

Conclusions

The education system of the post-war period in New Zealand constructed and reproduced in both its stated curricular policies and its everyday cultural practices within schools a gendered intellectuality which embodied contradictions in the dominant ideology of "femininity." While the official educational ideology of the post-war years was premised on the liberal value of equality of opportunity to compete for positions in the social hierarchy, 'femininity' was socially constructed as subordination. The stratification of knowledge (hidden curriculum) brought about within schools by post-war curriculum policies created a hierarchy of youth cultures whose attitudes to sexuality and intellectuality/professionality were influenced by the contradictory sets of expectations they experienced—in their families, schools and wider social networks.

During their childhood years, the women studied had felt ambivalent about growing up female. Marjorie developed strategies of resistance to the dominant Pakeha construction of "femininity" by becoming a "tomboy": "I didn't like being a girl. I despised girls." She refused to wear 'pretty dresses' and instead "quite deliberately dressed in a sloppy and casual way." Tahuri, frequently sick and in hospital, was unable to join in the boisterous outdoor activities of her whanau group and instead became a reader, "always buried somewhere between the pages," which alienated her from her Maori peer group.[12]

The women's secondary school experiences lend support to Foucault's (1980a, p. 28) analysis of sexuality in these institutions:

On the whole one can have the impression that sex was hardly spoken of at all in these institutions. But one only has to glance at the architectural layout,

the rules of discipline, and their whole internal organisation: the question of sex was a constant preoccupation . . . What one might call the internal discourse of the institution . . . was based largely on this assumption that this sexuality existed, that it was precocious, active, and ever present.

While the intention of overt curriculum policies were to confine "sex" to a few lessons in general science, the life histories show clearly that, in the hidden curriculum of schools, sexuality was indeed "precocious, active and ever present." The interwoven cultural practices in the home and the school reproduced a gendered, racist intellectuality based on the "double standard" of female sexual morality. "Low stream," and particularly low stream Maori, girls, were typified as more sexually active and less intelligent than their top stream peers. Overtly sexual academic girls were treated as deviant. Sexuality and intellectuality were socially constructed as contradictory.

Both Marjorie and Tahuri engaged in brief periods of "deviance" in dealing with this contradiction. At first, Marjorie adopted the strategy of becoming "ultra-feminine" in order to be acceptable to males who were, she believed, the superior sex: "if you're brighter than them they don't like you. So I immediately became dumb." Tahuri, "the only Maori in the top stream," assumed the trappings of "tartiness" characteristic of the non-academic rebels in the bottom streams: "down in 3 Vocational, 3 Reform and 3 Commercial B, there were all the tarts like us." Her expression of rebellion against the "most elitist third form in the school" with their "little twinsets and pearls" was to dress in an anti-feminine way: ". . . I wore my black pants and black shirt with jerkin . . . I used to coconut oil my hair and get it all like Elvis." The *habitus* of the top-stream, Pakeha middle-class girls—what the school valued as cultural capital—was a denial of the value of Maori culture: "because I was top stream, I had to be fed a diet of French and Latin. And there was no way they were going to let me do Maori, no way at all." In Mitchell's (1973, p. 28) terms, both women had a "sense of something wrong." However, at this stage of their lives, their strategies of resistance were contributing to almost-certain school failure. Rather than being well-reasoned strategies for social change, they were merely what Giroux (1983, p. 225) termed "faint bursts of misplaced opposition that eventually incorporate the very logic they struggle against."

How, then, were these two women able to move from "faint bursts of misplaced opposition" to clearly articulated theories of human oppression and strategies aimed at bringing about educational, and broader social, change? How were they able to theorise these personal experiences of victimisation, discrimination, contradictions and marginality?

In the cases of these two particular women, both were given a second chance through a change of school. In Marjorie's case, this involved a shift to a single-sex school "where there were no boys to flirt with." In Tahuri's case, the shift was to a co-educational school which was multicultural in the sense that her Maoriness was valued as "academic cultural capital" (bi-cultural capital). Both women could have repeated their cycles of "deviance" at their new schools. However, both were strongly academically motivated and had sufficient cultural capital to believe in their abilities. Marjorie had a father who had transcended his working-class origins to achieve upward social mobility through

education (he had become an accountant) and her mother had the confidence of the private-school-educated upper-middle-class Englishwoman who believed herself superior to mere New Zealanders. Tahuri had strong male and female role-models in her extended family, past and present-scholars in both Maori and Pakeha traditions. Her adoptive parents were not "educated" ("I don't come from a bookish environment"), but she was exposed to strong female intellectuals through her other relatives and at school: "Violet Szabo, who was a war hero . . . Joan of Arc, who was a warrior . . . the heroines of the French Resistance. We were given amazingly dynamic models of what women could do as well as men." Strong images from her school days remained with her, for example, "this huge nun . . . she'd have big thick stockings and these big boots and she'd pick up the football and off she'd go. And no man could better her."

At the time these women were at school, feminist ideas were not widely accessible to help them articulate their "sense of something wrong" in terms of their experiences of the contradictions of femininity. The "second wave" of feminism did not crash across the bookstalls, newspapers and television sets of the Western world until the 1970s.[13] However, ideas about racism, imperialism and pacifism were available, in particular, the anti-Vietnam war protests, and protests against sporting contacts with South Africa. Feminist scholars such as Juliet Mitchell (1973) have noted that many women who became active in the second wave of feminism had had previous involvements in the peace and civil rights movements. The strong Maori, and overseas Black, role-models Tahuri encountered during her school years had given her a sense of both the desirability and possibility of change towards Maori self-determination and equality. She described, as particularly formative, the knowledge she had been given in school of ". . . the IRA, the French Resistance, the Civil Rights Movement."

In their senior years at school, both women experienced outstanding academic success. Tahuri was able to turn her considerable literary skills to focus on issues which concerned her. Marjorie's choice of science was a strategy for dealing with the contradic-tions of femininity: "I had a logical kind of bent . . . I wasn't emotional, attractive and creative. I was logical and cold and unattractive." Embracing intellectuality, she rejected sexuality—for those in her virginal subculture of top-stream intellectuals, boys were merely "greasy little grotty pimply creatures." However, in other ways, her love of science and her motivation for studying it was characteristically female—a nuturant concern with "cleaning up the world." Her feminist attitude to science was stimulated by her negative experiences with the sexism and boorishness of male students and lecturers at university level, the abstractness of the course and its remoteness from human problems, such as the environment devastations of war. While Marjorie had come to view change in the lives of women and oppressed people as desirable, education was going to help her make this possible. Despite the conservatism of her parents and teachers, Marjorie was "converted" to an identification with the oppressed when her study of the Vietnam War made her aware of the human suffering perpetuated by American policies and New Zealand's involvement: it was "an emotional thing. I just couldn't bear the pictures of the starving children and the women." Both Tahuri and Marjorie, then, had come into

contact with ideas which helped them to articulate their personal experiences of marginality and contradictions as social issues. They perceived change as desirable and education as a means to make it possible. Their resistance became more clearly articulated. The life history approach, then, can help educational theorists "to understand how subordinate groups embody and express a combination of reactionary and progressive ideologies, ideologies that both underlie the structure of social domination and contain the logic necessary to overcome it" (Giroux, 1983, p. 225).

This analysis has some important implications for pedagogy. Despite the dominant attitude towards subordinate, domestic, femininity evidenced in the curriculum policies and cultural practices of schooling at the time, large numbers of women rejected this ideology and became feminists. Their schooling and higher education had played an important part in this. Individual teachers had given them access to radical ideas through their handling of the curriculum and their personal examples. Schooling had also provided access to the credentials which would gain them access to higher education and to positions of power in the social hierarchy from which they could work for change. These women's experiences and analyses of these suggest that teaching should be viewed, in Giroux's terms, as "an intensely personal affair" (1982, p. 158). Teaching must help students to link "biography, history and social structure" (Mills, 1976 edition). In schools,

> students must be given the opportunity to use and interpret their own experiences in a manner that reveals how the latter have been shaped and influenced by the dominant culture. Subjective awareness becomes the first step in transforming those experiences, (Giroux, 1982, p. 124)

Correspondence: Sue Middleton, Senior Lecturer, Department of Education, University of Waikato, Private Bag, Hamilton, New Zealand.

Notes

Middleton, Sue, "Schooling and Radicalisation: Life Histories of New Zealand Feminist Teachers," *British Journal of Sociology of Education*, 8(2) (1987): 169–189. Copyright © 1987, US Carfax Publishing Company, Abington, Oxfordshire, England. Reprinted with permission.

1. Used here in the sense of being a (heterosexual) "non-virgin." The term "sexual activity" is problematic—discussed by Diorio (1984).

2. Without betraying confidentiality, I cannot be too specific about how any woman was chosen. The only way that women's theoretical perspectives could be ascertained was if they had espoused them in public situations, e.g., if they had written them down (e.g., in publications, conference or seminar presentations), if they had spoken about them at feminist gatherings, or if the women were known to me personally. I included women who described their thinking as influenced by Marxism/socialism, radical feminism, lesbian separatism, Maori radicalism and liberalism. I also included women who did not "fit" my initial categories—"anarchist" feminist, for example. The theoretical categories upon which I based my choice of women should be regarded

as a typology, a set of "ideal typifications" (Berger & Luckman, 1971): real individuals draw their theories from many different sources and their perspectives are eclectic.

3. There have been a number of reviews of theoretical tendencies in the Western women's movement, e.g., Banks (1981); Eisenstein (1981); Jaggar (1977); Jaggar & Struhl (1978); Sayers (1981). For a New Zealand study, see Bunkle (1979/80). The analysis I developed is outlined in Middleton (1984b, c).

4. More details of my methodology are given in Middleton (1984a) and 1987 (forthcoming; copies available from the author).

5. Collaborative research has been strongly advocated by feminists. See the various papers in Bowles & Klein (1983); Keohane, et al. (1982); Roberts (1981). Also Stanley & Wise (1979, 1983).

6. Not her real name. The choice of material to be discussed has been confined to the women's own school years (childhood and adolescence) and has been limited by ethical considerations of confidentiality. In a country the size of New Zealand, with a population of three million people, it is difficult to preserve the confidentiality of ones informants: to reveal somebody as Maori, a lesbian, and a kindergarten teacher would immediately identify her. My study contains much personal, e.g., sexual, material. For this reason, the wider study uses different names for different parts of the women's lives, e.g., the chapters on childhood and adult careers, the chapter on sexuality. For this reason the study has lost some of its methodological and theoretical strength and, ironically, perpetuates the contradiction between sexuality and intellectuality—inevitably since researchers and research are part of the culture they are studying (e.g., see Oakley, 1981).

7. Without risking confidentiality, I cannot reveal her adult profession. When I chose the women, I wanted a diverse range of teaching experiences. Of the 12, three had taught in pre-schools, seven in primary schools, two in secondary schools, one in a "special school," three had worked for adult community education services, two had done some part-time teaching in technical institutes and seven had done some tutoring at university level.

8. As educators, all twelve had ultimately been successful in terms of the formal education system. However, not all had proceeded straight from successful school careers: seven had been recruited to teaching as school leavers during the recruitment drives of the 1960s, four had left school after the fifth form and had resumed their education as adults. Two had been expelled from schools, some became pregnant in their teens.

9. E.g., Harker (1975); Elley & Irving (1976); Watson (1966). The invisibility of women (e.g., "housewives") in stratification studies is critiqued by Delphy (1981); Gray (1981); Oakley (1974); Irving & Elley (1977).

10. In the case of girls, school success may be seen as an aspect of "family marital strategies" aimed at class endogamy or social mobility (Bourdieu & Boltansky, 1971; Connell, et al., 1982; Tilly, 1979). For a case study, see Middleton (1985a).

11. Donna Awatere's articles (1982a, b, c) stimulated a great deal of debate in the feminist community.

12. According to Rose Pere (1983) the stereotype of passive femininity characteristic of "sex-stereotypes" identified amongst Pakehas was not true of Maori girls. Girls and boys played the same games and were of equal status.

13. Germaine Greers' visit to New Zealand in 1972 received great publicity. An early "second wave" publication was Kedgley & Cederman (1972). Broadsheet magazine was established in 1972. Useful histories are in the tenth birthday issue of Broadsheet (July/August 1982); Bunkle (1979/80); Dann (1986).

References

Awatere, D. (1982/3). Maori sovereignty, in three parts: *Broadsheet*, June 1982, pp. 38–40; October 1982, pp. 24–29; February 1983, pp. 12–19.

Banks, O. (1981). *Faces of Feminism* (Oxford, Martin Robinson).

Bartky, S. (1977). Towards a phenomenology of feminist consciousness, in: Vetterling-Braggin, M. (Ed.) *Feminism and Philosophy* (Tottowa, Littlefield Adams).

Berger, P. & Luckman, T. (1971). *The Social Construction of Reality* (London, Penguin).

Bernstein, B. (1975). Class and pedagogies; visible and invisible, in: Bernstein, B. *Class, Codes, Control*, 3, (London, Routledge & Kegan Paul).

Bourdieu, P. (1971a). Intellectual field and creative project, in: Young, M. F. D. (Ed.) *Knowledge and Control* (London, Collier Macmillan).

Bourdieu, P. (1971b). Systems of education and systems of thought, in: Young, M. F. D. (Ed.) ibid.

Bourdieu, P. (1976). The school as a conservative force: scholastic and cultural inequalities, in: Dale, R. *et al.* (Eds) *Schooling and Capitalism: a sociological reader* (London, Routledge & Kegan Paul/Open University Press).

Bourdieu, P. & Boltansky, L. (1971). Changes in social structure and changes in the demand for education, in: Archer, M. S. & Giner, S. (Eds) *Contemporary Europe* (London, Weldenfield & Nicholson).

Bowles, G. & Klein, R. D. (Eds) (1983). *Theories of Women's Studies* (London, Routledge & Kegan Paul).

Bunkle, P. (1979–80). A history of the women's movement, in five parts in five consecutive issues of *Broadsheet:* September 1979a, pp. 24–28; October 1979b, pp. 26–28; November 1979c, pp. 26–28; December 1979d, pp. 28–32; January/February 1980, pp. 30–35.

Codd, J. (1985). Images of schooling and the discourse of the state, in: Codd, J., Harker, R. & Nash, R. (Eds) *Political Issues in New Zealand Education* (Palmerston North, Dunmore).

Connell, R. W., Ashendon, DJ., Kessler, S. & Dowsett, G. (1981). *Making the Difference* (Sydney, Allen & Unwin).

Cook, H. (1985). The contradictions of post-war reconstruction: the aspirations and realities of a postwar generation of wives and mothers, in: NZ Women's Studies Association, *Conference Papers '84*, pp. 46–53 (Auckland, NZWSA, Inc).

Dann, C. (1986). *Up from Under* (Wellington, Allen & Unwin/Port Nicholson).

Delphy, C. (1981). Women in stratification studies, in: Roberts, H. (Ed.) *Doing Feminist Research* (London, Routledge & Kegan Paul).

Department of Education (1944, 1959 edition). *The Post-primary School Curriculum* (Thomas Report) (Wellington, Government Printer).

Department of Education (1962). *Report of the Commission on Education in New Zealand* (Currie Report) (Wellington, Government Printer).

Department of Health (1955). *Sex and the Adolescent Girl* (Wellington, Government Printer).

Diorio, J. A. (1984). Contraception, copulation domination and the theoretical barrenness of sex education literature. Paper presented to the Sixth Conference of the NZ Association for Research in Education, Knox College, Otago University, Dunedin, November.

Ehrenreich, B. & English, D. (1979). *For Her Own Good* (New York, Doubleday).

Ebbett, E. (1984). *When the Boys were Away: NZ women in World War Two* (Wellington, Reed).

Eisenstein, Z. (1981). *The Radical Future of Liberal Feminism* (New York, Longman).

Eisenstein, Z. (1982). The sexual politics of the new right: understanding the 'crisis of liberalism' for the 1980s, in: Keohane, N. *et al.*, (Eds) (1982). *Feminist Theory: a critique of ideology* (Chicago, Harvester).

Elley, W. B. & Irving, J. E. (1972). A socio-economic index for New Zealand based on levels of education and income from the 1966 census, *New Zealand Journal of Educational Studies*, 7, pp. 153–167.

Findlay, M. (1974). *Tooth and Nail: the story of a daughter of the depression* (Wellington, Reed).

Foucault, M. (1979). In: Morris, S. M. & Patton, P. *Power, Truth, Strategy* (Sydney, Feral Publications).

Foucault, M. (1980a). *A History of Sexuality*, 1 (New York, Vintage).

Foucault, M. (1980b). *Power-knowledge* (New York, Pantheon).

Fox-Keller, E. (1982). Feminism and science, in: Keohane, N. *et al.* (Eds) *Feminist Theory: a critique of ideology* (Chicago, Harvester).

Frame, J. (1983). *The Is-land* (Auckland, Hutchinson).

Friedan, B. (1963). *The Feminine Mystique* (London, Penguin).

Giddens, A. (1982). *Profiles and Critiques in Social Theory* (London, Macmillan).

Giroux, H. (1982). *Ideology, Culture and the Process of Schooling* (Philadelphia, Temple).

Giroux, H. (1983). *Theory and Resistance in Education* (Massachussets, Bergin & Garvey).

Gray, A. (1981). Women and class: a question of assignation, *New Zealand Journal of Educational Studies*, 16, pp. 37–42.

Harker, R. (1975). Streaming and social class, in: Ramsay, P.D.K. (Ed.) *Family and School in New Zealand Society* (Auckland, Pitman).

Hochschild, A. R. (1975). The sociology of feeling and emotion: selected possibilities, in: Millman, M. & Kanter, R. (Eds) *Another Voice* (New York, Doubleday).

Irving, J. & Elley, W.B. (1977). A socioeconomic index for the female labor force in New Zealand, *New Zealand Journal of Educational Studies*, 12, pp. 154–163.

Jaggar, R. (1977). Political philosophies of women's liberation, in: Vetterling-Braggin, M. (Ed.) *Feminism and Philosophy* (Tottowa, Littlefield Adams).

Jaggar, P. & Struhl, A. (Eds) *Feminist Frameworks* (New York, McGraw Hill).

Kedgley, S. & Cederman, S. (Eds) (1972). *Sexist Society* (Wellington, Alister Taylor).

Keohane, N. *et al.* (Eds) (1982). *Feminist Theory: a critique of ideology* (Chicago, Harvester).

Laing, R. D. (1971). *The Politics of the Family* (London, Penguin).

MacDonald, M. (1979/80). Cultural Reproduction: the pedagogy of sexuality, *Screen Education*, Autumn/Winter, pp. 141–153.

McLaren, I. (1974). *Education for a Small Democracy: New Zealand* (London, Routledge & Kegan Paul).

Marx, K. (1867, 1976 edition). *Capital, Vol. 1* (London, Penguin).

Middleton, S. (1984a). On being a feminist educationist doing research on being a feminist educationist: life-history analysis as consciousness-raising, *New Zealand Cultural Studies Working Group Journal*, 8, pp. 29–37.

Middleton, S. (1984b). The sociology of women's education as a field of academic study, in: *Discourse*, 5, November, pp. 42–62. Reprinted in Arnot, M. & Weiner, G. (Eds) (in press) *Gender and the Politics of Schooling* (London, Hutchinson).

Middleton, S. (1984c). Towards a sociology of women's education in New Zealand: perspectives and directions, in: Ramsay, P.D.K. (Ed.) *Family, School and Community* (Sydney, Allen & Unwin).

Middleton, S. (1985a). Family strategies of cultural reproduction: case studies in the schooling of girls, in: Codd, J. *et al.* (Eds) *Political Issues in New Zealand Education* (Palmerston North,

Dunmore). Reprinted in Weiner, G. & Arnot, M. (Eds) (in press) *Researching Gender and Education: new lines of inquiry* (London, Hutchinson).

Middleton, S. (1985b). Feminism and education in post-war New Zealand: an oral history perspective. Paper presented at the Westhill Conference, Birmingham, January 1987. Also published in Openshaw, R. & McKenzie, O. (Eds) (1987) *Reinterpreting the Educational Past* (Wellington, NZ Council for Educational Research).

Middleton, S. (1985c). *Feminism and Education in Post-war New Zealand: a sociological analysis,* D. Phil. thesis (University of Waikato).

Middleton, S. (1986). Workers and homemakers: contradictions in the education of the New Zealand post-war woman, *New Zealand Journal of Educational Studies,* 21, pp. 13–28.

Mills, C. Wright (1959, 1975 edition). *The Sociological Imagination* (London, Penguin).

Mitchell, J. (1973). *Women's Estate* (London, Penguin).

Nash, R. (1981). The New Zealand district high schools: a study in the selective function of rural education, *New Zealand Journal of Educational Studies,* 16, pp. 150–160.

New Zealand Council for Educational Research (1965). Data Summary 6/65.

Oakley, A. (1974). *The Sociology of Housework* (Oxford, Martin Robinson).

Oakley, A. (1981). Interviewing women: a contradiction in terms, in: Roberts, H. (Ed.) *Doing Feminist Research* (London, Routledge & Kegan Paul).

Pere, R. (1983). *Ako: concepts and learning in the Maori tradition* (Hamilton, University of Waikato, Department of Sociology Monograph).

Plummer, K. (1983). *Documents of Life* (London, Allen & Unwin).

Roberts, H. (Ed.) (1981). *Doing Feminist Research* (London, Routledge & Kegan Paul).

Sayers, J. (1982). *Biological Politics* (London, Tavistock).

Schutz, A. (1944). The stranger: an essay in social psychology, *American Journal of Sociology,* 49, pp. 499–507.

Schutz, A. (1970). Concept and theory formation in the social sciences, in: Emmett, D. & MacIntyre, A. (Eds) *Sociological Theory and Philosophical Analysis* (Basingstoke, Macmillan).

Sedgwick, C. (1983). *The Life History: a method with issues, troubles and a future,* 2nd ed. (Christchurch, Department of Sociology Monograph, University of Canterbury).

Sharp, R. (1980). *Knowledge, Ideology and the Process of Schooling* (London, Routledge & Kegan Paul).

Sheridan, A. (1980). *Michel Foucault: the will to truth* (London, Tavistock).

Stanley, L. & Wise, S. (1979). Feminist research, feminist consciousness and experiences of sexism, in: *Women's Studies International Quarterly,* 2, pp. 359–374.

Stanley, L. & Wise, S. (1983). *Breaking Out: feminist consciousness and feminist research* (London, Routledge & Kegan Paul).

Taylor, S. (1984). Reproduction and contradiction in schooling: the case of commercial studies, in: *British Journal of Sociology of Education,* 5, pp. 3–18.

Tilly, L. (1979). Individual lives and family strategies in the French proletariat, *Journal of Family History,* Summer, pp. 137–140.

Watson, J. (1966). Marriages of women teachers, *New Zealand Journal of Educational Studies,* 1, pp. 149–161.

Whitehead, L. (1974). The Thomas Report: a study in educational reform, *New Zealand Journal of Educational Studies,* 9, pp. 52–64.

Willis, P. (1977). *Learning to Labour* (Westmead, Saxon House).

Young, M. F. D. (Ed.) (1971). *Knowledge and Control* (London, Collier Macmillan).

Why Doesn't This Feel Empowering?

Working through the Repressive Myths of Critical Pedagogy

Elizabeth Ellsworth
University of Wisconsin–Madison

In the spring of 1988, the University of Wisconsin–Madison was the focal point of a community-wide crisis provoked by the increased visibility of racist acts and structures on campus and within the Madison community. During the preceding year, the FIJI fraternity had been suspended for portraying racially demeaning stereotypes at a "Fiji Island party," including a 15-foot-high cutout of a "Fiji native," a dark-skinned caricature with a bone through its nose. On December 1, 1987, the Minority Affairs Steering Committee released a report, initiated and researched by students, documenting the university's failure to address institutional racism and the experiences of marginalization of students of color on campus. The report called for the appointment of a person of color to the position of vice chancellor of economic minority affairs/affirmative action; effective strategies to recruit and retain students, faculty and staff of color, establishment of a multicultural center; implementation of a mandatory six-credit ethnic studies requirement; revamping racial and sexual harassment grievance procedures; and initiation of a cultural and racial orientation program for all students. The release of the report and the university's responses to it and to additional incidents such as the FIJI fraternity party have become the focus of ongoing campus and community-wide debates, demonstrations, and organizing efforts.

In January, 1988, partly in response to this situation, I facilitated a special topics course at UW–Madison called "Media and Anti-Racist Pedagogies," Curriculum and Instruction 607, known as C&I 607. In this article, I will offer an interpretation of C&I 607's interventions against campus racism and traditional educational forms at the university. I will then use that interpretation to support a critique of current discourses on critical pedagogy.[1] The literature on critical pedagogy represents attempts by educational researchers to theorize and operationalize pedagogical challenges to oppressive social formations. While the attempts I am concerned with here share fundamental assumptions

and goals, their different emphases are reflected in the variety of labels given to them, such as "critical pedagogy," "pedagogy of critique and possibility," "pedagogy of student voice," "pedagogy of empowerment," "radical pedagogy," "pedagogy for radical democracy," and "pedagogy of possibility."[2]

I want to argue, on the basis of my interpretation of C&I 607, that key assumptions, goals, and pedagogical practices fundamental to the literature on critical pedagogy— namely, "empowerment," "student voice," "dialogue," and even the term "critical"—are repressive myths that perpetuate relations of domination. By this I mean that when participants in our class attempted to put into practice prescriptions offered in the literature concerning empowerment, student voice, and dialogue, we produced results that were not only unhelpful, but actually exacerbated the very conditions we were trying to work against, including Eurocentrism, racism, sexism, classism, and "banking education." To the extent that our efforts to put discourses of critical pedagogy into practice led us to reproduce relations of domination in our classroom, these discourses were "working through" us in repressive ways, and had themselves become vehicles of repression. To the extent that we disengaged ourselves from those aspects and moved in another direction, we "worked through" and out of the literature's highly abstract language ("myths") of who we should be and what should be happening in our classroom, and into classroom practices that were context specific and seemed to be much more responsive to our own understandings of our social identities and situations.

This article concludes by addressing the implications of the classroom practices we constructed in response to racism in the university's curriculum, pedagogy, and everyday life. Specifically, it challenges educational scholars who situate themselves within the field of critical pedagogy to come to grips with the fundamental issues this work has raised—especially the question, What diversity do we silence in the name of "liberatory" pedagogy?

Pedagogy and Political Interventions on Campus

The nation-wide eruption in 1987–1988 of racist violence in communities and on campuses, including the University of Wisconsin–Madison, pervaded the context in which Curriculum and Instruction 607, "Media and Anti-Racist Pedagogies," was planned and facilitated. The increased visibility of racism in Madison was also partly due to the UW Minority Student Coalition's successful documentation of the UW system's resistance to and its failure to address monoculturalism in the curriculum, to recruit and retain students and professors of color, and to alleviate the campus culture's insensitivity or hostility to cultural and racial diversity.

At the time that I began to construct a description of C&I 607, students of color had documented the extent of their racial harassment and alienation on campus. Donna Shalala, the newly appointed, feminist chancellor of UW–Madison, had invited faculty and campus groups to take their own initiatives against racism on campus. I had just served on a university committee investigating an incident of racial harassment against one

of my students. I wanted to design a course in media and pedagogy that would not only work to clarify the structures of institutional racism underlying university practices and its culture in spring 1988, but that would also use that understanding to plan and carry out a political intervention within that formation. This class would not debate whether racist structures and practices were operating at the university; rather, it would investigate *how* they operated, with what effects and contradictions—and where they were vulnerable to political opposition. The course concluded with public interventions on campus, which I will describe later. For my purposes here, the most important interruption of existing power relations within the university consisted of transforming business-as-usual—that is, prevailing social relations—in a university classroom.

Before the spring of 1988, I had used the language of critical pedagogy in course descriptions and with students. For example, syllabi in the video production for education courses stated that goals of the courses included the production of "socially responsible" videotapes, the fostering of "critical production" practices and "critical reception and analysis" of educational videotapes. Syllabi in the media criticism courses stated that we would focus on "critical media use and analysis in the classroom" and the potential of media in "critical education." Students often asked what was meant by critical—critical of what, from what position, to what end?—and I referred them to answers provided in the literature. For example, critical pedagogy supported classroom analysis and rejection of oppression, injustice, inequality, silencing of marginalized voices, and authoritarian social structures.[3] Its critique was launched from the position of the radical educator who recognizes and helps students to recognize and name injustice, who empowers students to act against their own and others' oppressions (including oppressive school structures), who criticizes and transforms her or his own understanding in response to the understanding of students.[4] The goal of critical pedagogy was a critical democracy, individual freedom, social justice, and social change—a revitalized public sphere characterized by citizens capable of confronting public issues critically through ongoing forms of public debate and social action.[5] Students would be empowered by social identities that affirmed their race, class, and gender positions and provided the basis for moral deliberation and social action.[6]

The classroom practices of critical educators may in fact engage with actual, historically specific struggles, such as those between students of color and university administrators. But the overwhelming majority of academic articles appearing in major educational journals, although apparently based on actual practices, rarely locate theoretical constructs within them. In my review of the literature I found, instead, that educational researchers who invoke concepts of critical pedagogy consistently strip discussions of classroom practices of historical context and political position. What remains are the definitions cited above, which operate at a high level of abstraction. I found this language more appropriate (yet hardly more helpful) for philosophical debates about the highly problematic concepts of freedom, justice, democracy, and "universal" values than for thinking through and planning classroom practices to support the political agenda of C&I 607.

Given the explicit antiracist agenda of the course, I realized that even naming C&I 607 raised complex issues. To describe the course as "Media and Critical Pedagogy" or

"Media, Racism, and Critical Pedagogy," for example, would be to hide the politics of the course, making them invisible to the very students I was trying to attract and work with—namely, students committed or open to working against racism. I wanted to avoid colluding with many academic writers in the widespread use of code words such as "critical," which hide the actual political agendas I assume such writers share with me—namely, antiracism, antisexism, antielitism, antiheterosexism, antiableism, anticlassism, and anti-neoconservatism.

I say "assume" because, while the literature on critical pedagogy charges the teacher with helping students to "identify and choose between sufficiently articulated and reasonably distinct moral positions,"[7] it offers only the most abstract, decontextualized criteria for choosing one position over others, criteria such as "reconstructive action"[8] or "radical democracy and social justice"[9] To reject the term "critical pedagogy" and name the course. "Media and Anti-Racist Pedagogies" was to assert that students and faculty at UW–Madison in the spring of 1988 were faced with ethical dilemmas that called for political action. While a variety of "moral assessments" and political positions existed about the situation on campus, this course would attempt to construct a classroom practice that would act *on the side* of antiracism. I wanted to be accountable for naming the political agenda behind this particular course's critical pedagogy.

Thinking through the ways in which our class's activities could be understood as political was important, because while the literature states implicitly or explicitly that critical pedagogy is political, there have been no sustained research attempts to explore whether or how the practices it prescribes actually alter specific power relations outside or inside schools. Further, when educational researchers advocating critical pedagogy fail to provide a clear statement of their political agendas, the effect is to hide the fact that as critical pedagogues, they are in fact seeking to appropriate public resources (classrooms, school supplies, teacher/professor salaries, academic requirements, and degrees) to further various "progressive" political agendas that they believe to be for the public good—and therefore deserving of public resources. But however good the reasons for choosing the strategy of subverting repressive school structures from within, it has necessitated the use of code words such as "critical," "social change," "revitalized public sphere," and a posture of invisibility. As a result, the critical education movement has failed to develop a clear articulation of the need for its existence, its goals, priorities, risks, or potential. As Liston and Zeichner argue, debate within the critical education movement itself over what constitutes a radical or critical pedagogy is sorely needed.[10]

By prescribing moral deliberation engagement in the full range of views present, and critical reflection, the literature on critical pedagogy implies that students and teachers can and should engage each other in the classroom as fully rational subjects. According to Valerie Walkerdine, schools have participated in producing "self-regulating" individuals by developing in students' capacities for engaging in rational argument. Rational argument has operated in ways that set up as its opposite an irrational Other, which has been understood historically as the province of women and other exotic Others. In schools, rational deliberation, reflection, and consideration of all viewpoints has become a vehicle for regulating conflict and the power to speak, for transforming "conflict into

rational argument by means of universalized capacities for language and reason."[11] But students and professor entered C&I 607 with investments of privilege and struggle already made in favor of some ethical and political positions concerning racism and against other positions. The context in which this course was developed highlighted that fact. The demands that the Minority Student Coalition delivered to the administration were not written in the spirit of engaging in rationalist, analytical debates with those holding other positions. In a racist society and its institutions, such debate has not and cannot be public or democratic in the sense of including the voices of all affected parties and affording them equal weight and legitimacy. Nor can such debate be free of conscious and unconscious concealment of interests or assertion of interests that some participants hold as nonnegotiable no matter what arguments are presented.

As Barbara Christian has written, "what I write and how I write is done in order to save my own life. And I mean that literally. For me literature is a way of knowing that I am not hallucinating, that whatever I feel/know *is*."[12] Christian is an African-American woman writing about the literature of Afro-American women, but her words are relevant to the issues raised by the context of C&I 607. I understood the words written by the Minority Student Coalition and spoken by other students/professors of difference[13] on campus to have a similar function as a reality check for survival. It is inappropriate to respond to such words by subjecting them to rationalist debates about their validity. Words spoken for survival come already validated in a radically different arena of proof and carry no option of luxury of choice. (This is not to say, however, that the positions of students of color, or of any other group, were to be taken up unproblematically—an issue I will address below.)

I drafted a syllabus and circulated it for suggestions and revisions to students I knew to be involved in the Minority Student Coalition and to colleagues who shared my concerns. The goal of "Media and Anti-Racist Pedagogies," as stated in the revised syllabus, was to define, organize, carry out, and analyze an educational initiative on campus that would win semiotic space for the marginalized discourses of students against racism. Campus activists were defining these discourses and making them available to other groups, including the class, through documents, demonstrations, discussions, and press conferences.

The syllabus also listed the following assumptions underlying the course:

1. Students who want to acquire knowledge of existing educational media theory and criticism for the purpose of guiding their own educational practice can best do so in a learning situation that interrelates theory with concrete attempts at using media for education.

2. Current situations of racial and sexual harassment and elitism on campus and in the curriculum demand meaningful responses from both students and faculty, and responses can be designed in a way that accomplishes both academic and political goals.

3. Often, the term "critical education" has been used to imply, but also to hide, positions and goals of antiracism, anticlassism, and so forth. Defining

this course as one that explores the possibility of using media to construct antiracist pedagogies asserts that these are legitimate and imperative goals for educators.

4. What counts as an appropriate use of media for an antiracist pedagogy cannot be specified outside of the contexts of actual educational situations; therefore student work on this issue should be connected to concrete initiatives in actual situations.

5. Any antiracist pedagogy must be defined through an awareness of the ways in which oppressive structures are the result of *intersections* between racist, classist, sexist, ablest, and other oppressive dynamics.

6. Everyone who has grown up in a racist culture has to work at unlearning racism—we will make mistakes in this class, but they will be made in the context of our struggle to come to grips with racism.

Naming the political agenda of the course, to the extent that I did, seemed relatively easy. I was in the fourth year of a tenure-track position in my department and felt that I had "permission" from colleagues to pursue the line of research and practice out of which this course had clearly grown. The administration's response to the crisis on campus gave further "permission" for attempts to alleviate racism in the institution. However, the directions in which I should proceed became less clear once the class was underway. As I began to live out and interpret the consequences of how discourses of "critical reflection," "empowerment," "student voice," and "dialogue" had influenced my conceptualization of the goals of the course and my ability to make sense of my experiences in the class, I found myself struggling against (struggling to unlearn) key assumptions and assertions of current literature on critical pedagogy and straining to recognize, name, and come to grips with crucial issues of classroom practice that critical pedagogy cannot or will not address.

From Critical Rationalism to the Politics of Partial Narratives

The students enrolled in "Media and Anti-Racist Pedagogies" included Asian-American, Chicano/a, Jewish, Puerto Rican, and Anglo-European men and women from the United States; and Asian, African, Icelandic, and Canadian international students. It was evident after the first class meeting that all of us agreed, but with different understandings and agendas, that racism was a problem on campus that required political action. The effects of the diverse social positions and political ideologies of the students enrolled, my own position and experiences as a woman and a feminist, and the effects of the course's context on the form and content of our early class discussions quickly threw the rationalist assumptions underlying critical pedagogy into question.

These rationalist assumptions have led to the following goals: the teaching of analytic and critical skills for judging the truth and merit of propositions, and the interrogation and selective appropriation of potentially transformative moments in the dominant cul-

ture.[14] As long as educators define pedagogy against oppressive formations in these ways, the role of the critical pedagogue will be to guarantee that the foundation for classroom interaction is reason. In other words, the critical pedagogue is one who enforces the rules of reason in the classroom—"a series of rules of thought that any ideal rational person might adopt if his/her purpose was to achieve propositions of universal validity."[15] Under these conditions, and given the coded nature of the political agenda of critical pedagogy, only one "political" gesture appears to be available to the critical pedagogue. S/he can ensure that students are given the chance to arrive logically at the "universally valid proposition" underlying the discourse of critical pedagogy—namely, that all people have a right to freedom from oppression guaranteed by the democratic social contract and that in the classroom, this proposition be given equal time vis-à-vis other "sufficiently articulated and reasonably distinct moral postions."[16]

Yet educators who have constructed classroom practices dependent upon analytical critical judgment can no longer regard the enforcement of rationalism as a self-evident political act against relations of domination. Literary criticism, cultural studies, poststructuralism, feminist studies, comparative studies, and media studies have by now amassed overwhelming evidence of the extent to which the myths of the ideal rational person and the "universality" of propositions have been oppressive to those who are not European, white, male, middle class, Christian, able-bodied, thin, and heterosexual.[17] Writings by many literary and cultural critics, both women of color and White women who are concerned with explaining the intersections and interactions among relations of racism, colonialism, sexism, and so forth, are now employing, either implicitly or explicitly, concepts and analytical methods that could be called feminist poststructuralism.[18] While post-structuralism, like rationalism, is a tool that can be used to dominate, it has also facilitated a devastating critique of the violence of rationalism against its Others. It has demonstrated that as a discursive practice, rationalism's regulated and systematic use of elements of language constitutes rational competence "as a series of exclusions—of women, people of color, of nature as a historical agent, of the true value of art."[19] In contrast, poststructuralist thought is not bound to reason, but "to discourse, literally narratives about the world that are admittedly *partial.* Indeed, one of the crucial features of discourse, is the intimate tie between knowledge and interest, the latter being understood as a 'standpoint' from which to grasp 'reality.' "[20]

The literature on critical pedagogy implies that the claims made by documents, demonstrations, press conferences, and classroom discussions of students of color and white students against racism could rightfully be taken up in the classroom and subjected to rational deliberation over their truth in light of competing claims. But this would force students to subject themselves to the logics of rationalism and scientism that have been predicated on and made possible through the exclusion of socially constructed irrational Others—women, people of color, nature, aesthetics. As Audre Lorde writes, "The master's tools will never dismantle the master's house,"[21] and to call on students of color to justify and explicate their claims in terms of the master's tools—tools such as rationalism, fashioned precisely to perpetuate their exclusion—colludes with the oppressor in keeping "the oppressed occupied with the master's concerns."[22] As Barbara Christian describes it:

the literature of people who are not in power has always been in danger of extinction or cooptation, not because we do not theorize, but because what we can even imagine, far less who we can reach, is constantly limited by societal structures. For me, literary criticism is promotion as well as understanding, a response to the writer to whom there is often no response, to folk who need the writing as much as they need anything. I know, from literary history, that writing disappears unless there is a response to it. Because I write about writers who are now writing, I hope to help ensure that their tradition has continuity and survives.[23]

In contrast to the enforcement of rational deliberation, but like Christian's promotion and response, my role in C&I 607 would be to interrupt institutional limits on how much time and energy students of color, White students, and professors against racism could spend on elaborating their positions and playing them out to the point where internal contradictions and effects on the positions of other social groups could become evident and subject to self-analysis.

With Barbara Christian, I saw the necessity to take the voices of students and professors of difference at their word—as "valid"—but not without response.[24] Students' and my own narratives about experiences of racism, ableism, elitism, fat oppression, sexism, anti-Semitism, heterosexism, and so on are partial—partial in the sense that they are unfinished, imperfect, limited; and partial in the sense that they project the interests of "one side" over others. Because those voices are partial and partisan, they must be made problematic, but not because they have broken the rules of thought of the ideal rational person by grounding their knowledge in immediate emotional, social, and psychic experiences of oppression,[25] or are somehow lacking or too narrowly circumscribed.[26] Rather, they must be critiqued because they hold implications for other social movements and their struggles for self-definition. This assertion carries important implications for the "goal" of classroom practices against oppressive formations, which I will address later.

Have We Got a Theory for You![27]

As educators who claim to be dedicated to ending oppression, critical pedagogues have acknowledged the socially constructed and legitimated authority that teachers/professors hold over students.[28] Yet theorists of critical pedagogy have failed to launch any meaningful analysis of, or program for, reformulating the institutionalized power imbalances between themselves and their students, or of the essentially paternalistic project of education itself. In the absence of such an analysis and program, their efforts are limited to trying to transform negative effects of power imbalances within the classroom into positive ones. Strategies such as student empowerment and dialogue give the illusion of equality while in fact leaving the authoritarian nature of the teacher/student relationship intact.

"Empowerment" is a key concept in this approach, which treats the symptoms but leaves the disease unnamed and untouched. Critical pedagogies employing this strategy prescribe various theoretical and practical means for sharing, giving, or redistributing

power to students. For example, some authors challenge teachers to reject the vision of education as inculcation of students by the more powerful teacher. In its place, they urge teachers to accept the possibility of education through "reflective examination" of the plurality of moral positions before the presumably rational teacher and students.[29] Here, the goal is to give students the analytical skills they need to make them as free, rational, and objective as teachers supposedly are to choose positions on their objective merits. I have already argued that in a classroom in which "empowerment" is made dependent on rationalism, those perspectives that would question the political interests (sexism, racism, colonialism, for example) expressed and guaranteed by rationalism would be rejected as "irrational" (biased, partial).

A second strategy is to make the teacher more like the student by redefining the teacher as learner of the student's reality and knowledge. For example, in their discussion of the politics of dialogic teaching and epistemology, Shor and Freire suggest that "the teacher selecting the objects of study knows them *better* than the students as the course begins, but the teacher *re-learns* the objects through studying them with their students."[30] The literature explores only one reason for expecting the teacher to "re-learn" an object of study through the student's less "adequate understanding and that is to enable the teacher to devise more effective strategies for bringing the student "up" to the teacher's level of understanding. Giroux, for example, argues for a pedagogy that "is attentive to the histories, dreams, and experiences that . . . students bring to school. It is only by beginning with these subjective forms that critical educators can develop a language and set of practices"[31] that can successfully mediate differences between student understandings and teacher understandings in "pedagogically progressive" ways.[32] In this example, Giroux leaves the implied superiority of the teacher's understanding and the undefined "progressiveness" of this type of pedagogy unproblematized and untheoritized.

A third strategy is to acknowledge the "directiveness"[33] or "authoritarianism"[34] of education as inevitable and to judge particular power imbalances between teacher and student to be tolerable or intolerable depending upon "towards what and with whom [they are] directive."[35] "Acceptable" imbalances are those in which authority serves "common human interests by sharing information, promoting open and informed discussion, and maintaining itself only through the respect and trust of those who grant the authority."[36] In such cases, authority becomes "emancipatory authority," a kind of teaching in which teachers would make explicit and available for rationalist debate "the political and moral referents for authority they assume in teaching particular forms of knowledge, in taking stands against forms of oppression, and in treating students as if they ought also to be concerned about social justice and political action."[37] Here, the question of "empowerment for what" becomes the final arbiter of a teacher's use or misuse of authority.

But critical pedagogues consistently answer the question of "empowerment for what?" in ahistorical and depoliticized abstractions. These include empowerment for "human betterment,"[38] for expanding the "the range of possible social identities people may become,"[39] and "making one's self present as part of a moral and political project that links production of meaning to the possibility for human agency, democratic community, and transformative social action."[40] As a result, student empowerment has been defined in

the broadest possible humanist terms and becomes a "capacity to act effectively" in a way that fails to challenge any identifiable social or political position, institution, or group.

The contortions of logic and rhetoric that characterize these attempts to define "empowerment" testify to the failure of critical educators to come to terms with the essentially paternalistic project of traditional education. "Emancipatory authority"[41] is one such contortion, for it implies the presence of, or potential for, an emancipated teacher. Indeed, it asserts that teachers "can link knowledge to power by bringing to light and teaching the subjugated histories, experiences, stories, and accounts of those who suffer and struggle."[42] Yet I cannot unproblematically bring subjugated knowledges to light when I am not free of my own learned racism, fat oppression, classism, ableism, or sexism. No teacher is free of these learned and internalized oppressions. Nor are accounts of one group's suffering and struggle immune from reproducing narratives oppressive to another's—the racism of the women's movement in the United States is one example.

As I argued above, "emancipatory authority" also implies, according to Shor and Freire, a teacher who knows the object of study . . . better . . . than do the students. Yet I did not understand racism better than my students did, especially those students of color coming into class after six months (or more) of campus activism and whole lives of experience and struggle against racism—nor could I ever hope to. My experiences with and access to multiple and sophisticated strategies for interpreting and interrupting sexism (in White middle-class contexts) do not provide me with a ready-made analysis of or language for understanding my own implications in racist structures. My understanding and experience of racism will always be constrained by my white skin and middle-class privilege. Indeed, it is impossible for anyone to be free from these oppressive formations at this historical moment. Furthermore, while I had the institutional power and authority in the classroom to enforce "reflective examination" of the plurality of moral and political positions before us in a way that supposedly gave my own assessments equal weight with those of students, in fact my institutional role as professor would always weight my statements different from those of students.

Given my own history of white-skin, middle-class, able-bodied, thin privilege and my institutionally granted power, it made more sense to see my task as one of redefining "critical pedagogy" so that it did not need utopian moments of "democracy," "equality," "justice," or "emancipated" teachers—moments that are unattainable (and ultimately undesirable, because, they are always predicated on the interests of those who are in the position to define utopian projects). A preferable goal seemed to be to become capable of a sustained encounter with currently oppressive formations and power relations that refuse to be theorized away or fully transcended in a utopian resolution—and to enter into the encounter in a way that owned up to my own implications in those formations and was capable of changing my own relation to and investments in those formations.

The Repressive Myth of the Silent Other

At first glance, the concept of "student voice" seemed to offer a pedagogical strategy in this direction. This concept has become highly visible and influential in current discus-

sions of curriculum and teaching, as evidenced by its appearance in the titles of numerous presentations at the 1989 American Educational Research Association convention. Within current discourses on teaching, it functions to efface the contradiction between the emancipatory project of critical pedagogy and the hierarchical relation between teachers and students. In other words, it is a strategy for negotiating between the directiveness of dominant educational relationships and the political commitment to make students autonomous of those relationships (how does a teacher "make" students autonomous without directing them?). The discourse on student voice sees the student as "empowered" when the teacher "helps" students to express their subjugated knowledges.[43] The targets of this strategy are students from disadvantaged and subordinated social class, racial, ethnic, and gender groups—or alienated middle-class students without access to skills of critical analysis, whose voices have been silenced or distorted by oppressive cultural and educational formations. By speaking, in their "authentic voices," students are seen to make themselves visible and define themselves as authors of their own world. Such definition presumably gives students an identity and political position from which to act as agents of social change.[44] Thus, while it is true that the teacher is directive, the student's own daily life experiences of oppression chart her/his path toward self-definition and agency. The task of the critical educator thus becomes "finding ways of working with students that enable the full expression of multiple 'voices' engaged in dialogic encounter,"[45] encouraging students of different race, class, and gender positions to speak in self-affirming ways about their experiences and how they have been mediated by their own social positions and those of others.

Within feminist discourses seeking to provide both a place and power for women to speak, "voice" and "speech" have become commonplace as metaphors for women's feminist self-definitions—but with meanings and effects quite different from those implied by discourses of critical pedagogy. Within feminist movements, women's voices and speech are conceptualized in terms of self-definitions that are oppositional to those definitions of women constructed by others, usually, to serve interests and contexts that subordinate women to men. But while critical educators acknowledge the existence of unequal power relations in classrooms, they have made no systematic examination of the barriers that this imbalance throws up to the kind of student expression and dialogue they prescribe.

The concept of critical pedagogy assumes a commitment on the part of the professor/teacher toward ending the student's oppression. Yet the literature offers no sustained attempt to problematize this stance and confront the likelihood that the professor brings to social movements (including critical pedagogy) interests of her or his own race, class, ethnicity, gender, and other positions. S/he does not play the role of disinterested mediator on the side of the oppressed group.[46] As an Anglo, middle-class professor in C&I 607, I could not unproblematically "help" a student of color to find her/his authentic voice as a student of color. I could not unproblematically "affiliate" with the social groups my students represent and interpret their experience to them. In fact, I brought to the classroom privileges and interests that were put at risk in fundamental ways by the demands and defiances of student voices. I brought a social subjectivity that has been constructed in such a way that I have not and can never participate unproblematically in the collective process of self-definition, naming of oppression, and struggles for vis-

ibility in the face of marginalization engaged in by students whose class, race, gender, and other positions I do not share. Critical pedagogues are always implicated in the very structures they are trying to change.

Although the literature recognizes that teachers have much to learn from their students' experiences, it does not address the ways in which there are things that I as professor could *never know* about the experiences, oppressions, and understandings of other participants in the class. This situation makes it impossible for any single voice in the classroom—including that of the professor—to assume the position of center or origin of knowledge or authority, of having privileged access to authentic experience or appropriate language. A recognition, contrary to all Western ways of knowing and speaking, that all knowings are partial, that there are fundamental things each of us cannot know—a situation alleviated only in part by the pooling of partial, socially constructed knowledges in classrooms—demands a fundamental retheorizing of "education" and "pedagogy," an issue I will begin to address below.

When educational researchers writing about critical pedagogy fail to examine the implications of the gendered, raced, and classed teacher and student for the theory of critical pedagogy, they reproduce, by default, the category of generic "critical teacher"—a specific form of the generic human that underlies classical liberal thought. Like the generic human, the generic critical teacher is not, of course, generic at all. Rather, the term defines a discursive category predicated on the current mythical norm, namely: young, White, Christian, middle-class, heterosexual, able-bodied, thin, rational man. Gender, race, class, and other differences become only variations on or additions to the generic human—"underneath, we are all the same."[47] But voices of students and professors of difference solicited by critical pedagogy are not additions to that norm, but oppositional challenges that require a dismantling of the mythical norm and its uses as well as alternatives to it. There has been no consideration of how voices of, for example, White women, students of color, disabled students, White men against masculinist culture, and fat students will necessarily be constructed in opposition to the teacher/institution, when they try to change the power imbalances they inhabit in their daily lives, including their lives in schools.

Critical pedagogues speak of student voices as "sharing" their experiences and understandings of oppression with other students and with the teacher in the interest of "expanding the possibilities of what it is to be human."[48] Yet White women, women of color, men of color, White men against masculinist culture, fat people, gay men and lesbians, people with disabilities, and Jews do not speak of the oppressive formations that condition their lives in the spirit of "sharing." Rather, the speech of oppositional groups is a "talking back," a "defiant speech"[49] that is constructed within communities of resistance and is a condition of survival.

In C&I 607, the defiant speech of students and professor of difference constituted fundamental challenges to and rejections of the voices of some classmates and often of the professor. For example, it became clear very quickly that in order to name her experience of racism, a Chicana student had to define her voice in part through opposition to—and rejection of—definitions of "Chicana" assumed or taken for granted by other

student/professor voices in the classroom. And in the context of protests by students of color against racism on campus, her voice had to be constructed in opposition to the institutional racism of the university's curriculum and policies—which were represented in part by my discourses and actions as Anglo-American, middle-class woman professor. Unless we found a way to respond to such challenges, our academic and political work against racism would be blocked. This alone is a reason for finding ways to express and engage with student voices, one that distances itself from the abstract, philosophical reasons implied by the literature on critical pedagogy when it fails to contextualize its projects. Furthermore, grounding the expression of and engagement with student voices in the need to construct contextualized political strategies rejects both the voyeuristic relation that the literature reproduces when the voice of the professor is not problematized, and the instrumental role critical pedagogy plays when student voice is used to inform more effective teaching strategies.

The lessons learned from feminist struggles to make a difference through defiant speech offer both useful critiques of the assumptions of critical pedagogy and starting points for moving beyond its repressive myths.[50] Within feminist movements, self-defining feminist voices have been understood as constructed collectively in the context of a larger feminist movement or women's marginalized subcultures. Feminist voices are made possible by the interactions among women within and across race, class, and other differences that divide them. These voices have never been solely or even primarily the result of the pedagogical interaction between an individual student and a teacher. Yet discourses of the pedagogy of empowerment consistently position students as individuals with only the most abstract of relations to concrete contexts of struggle. In their writing about critical pedagogy, educational researchers consistently place teachers/professors at the center of the consciousness-raising activity. For example, McLaren describes alienated middle-class youth in this way:

> These students do not recognize their own self-representation and suppression
> by the dominant society, and in our vitiated learning environments they are
> not provided with the requisite theoretical constructs to help them understand
> why they feel as badly as they do. Because teachers lack a critical pedagogy,
> these students are not provided with the ability to think critically, a skill that
> would enable them to better understand why their lives have been reduced
> to feelings of meaningless, randomness, and alienation.[51]

In contrast, many students came into "Media and Anti-Racist Pedagogies" with oppositional voices already formulated within various antiracism and other movements. These movements had not necessarily relied on intellectuals/teachers to interpret their goals and programs to themselves or to others.

Current writing by many feminists working from antiracism and feminist post-structuralist perspectives recognize that any individual woman's politicized voice will be partial, multiple, and contradictory.[52] The literature on critical pedagogy also recognizes the possibility that each student will be capable of identifying a multiplicity of authentic

voices in her/himself. But it does not confront the ways in which any individual student's voice is already a "teeth gritting" and often contradictory intersection of voices constituted by gender, race, class, ability, ethnicity, sexual orientation, or ideology. Nor does it engage with the fact that the particularities of historical context, personal biography, and subjectivities split between the conscious and unconscious will necessarily render each expression of student voice partial and predicated on the absence and marginalization of alternative voices. It is impossible to speak from all voices at once, or from any one, without the traces of the others being present and interruptive. Thus the very term "student voice" is highly problematic. Pluralizing the concept as "voices" implies correction through addition. This loses sight of the contradictory and partial nature of all voices.

In C&I 607, for example, participants expressed much pain, confusion, and difficulty in speaking because of the ways in which discussions called up their multiple and contradictory social positionings. Women found it difficult to prioritize expressions of racial privilege and oppression when such prioritizing threatened to perpetuate their gender oppression. Among international students, both those who were of color and those who were White found it difficult to join their voices with those of U.S. students of color when it meant a subordination of their oppression as people living under U.S. imperialist policies and as students for whom English was a second language. Asian-American women found it difficult to join their voices with other students of color when it meant subordinating their specific oppressions as Asian Americans. I found it difficult to speak as a White woman about gender oppression when I occupied positions of institutional power relative to all students in the class, men and women, but positions of gender oppression relative to students who were White men, and in different terms, relative to students who were men of color.

Finally, the argument that women's speech and voice have not been and should not be constructed primarily for the purpose of communicating women's experiences to men is commonplace within feminist movements. This position takes the purposes of such speech to be survival, expansion of women's own understandings of their oppression and strength, sharing common experiences among women, building solidarity among women, and political strategizing. Many feminists have pointed to the necessity for men to "do their own work" at unlearning sexism and male privilege, rather than looking to women for the answers. I am similarly suspicious of the desire of the mostly White, middle-class men who write the literature on critical pedagogy to elicit "full expression" of student voices. Such a relation between teacher/student becomes voyeuristic when the voice of the pedagogue himself goes unexamined.

Furthermore, the assumption present in the literature that silence in front of a teacher or professor indicates "lost voice," "voicelessness," or lack of social identity from which to act as a social agent betrays deep and unacceptable gender, race, and class biases. It is worth quoting bell hooks at length about the fiction of the silence of subordinated groups:

> Within feminist circles silence is often seen as the sexist defined "right speech
> of womanhood"—the sign of woman's submission to patriarchal authority.
> This emphasis on women's silence may be an accurate remembering of what

has taken place in the households of women from WASP backgrounds in the United States but in Black communities (and in other diverse ethnic communities) women have not been silent. Their voices can be heard. Certainly for Black women our struggle has not been to emerge from silence to speech but to change the nature and direction of our speech. To make a speech that compels listeners, one that is heard. . . . Dialogue, the sharing of speech and recognition, took place not between mother and child or mother and male authority figure, but with other Black women. I can remember watching, fascinated, as our mother talked with her mother, sisters, and women friends. The intimacy and intensity of their speech—the satisfaction they received from talking to one another, the pleasure, the joy. It was in this world of woman speech, loud talk, angry words, women with tongues sharp, tender sweet tongues, touching our world with their words, that I made speech my birthright—and the right to voice, to authorship, a privilege I would not be denied. It was in that world and because of it that I came to dream of writing, to write.[53]

White women, men and women of color, impoverished people, people with disabilities, gays and lesbians are not silenced in the sense implied by the literature on critical pedagogy. They just are not talking in their authentic voices, or they are declining/refusing to talk at all to critical educators who have been unable to acknowledge the presence of "knowledges that are challenging and most likely inaccessible to their own social positions. What they/we say, to whom, in what context, depending on the energy they/we have for the struggle on a particular day, is the result of conscious and unconscious assessments of the power relations and safety of the situation.

As I understand it at the moment, what got said—and how—in our class was the product of highly complex strategizing for the visibility that speech gives without giving up the safety of silence. More than that, it was a highly complex negotiation of the politics of knowing and being known. Things were left unsaid, or they were encoded, on the basis of speakers' conscious and unconscious assessments of the risks and costs of disclosing their understandings of themselves and of others. To what extent had students occupying socially constructed positions of privilege at a particular moment risked being known by students occupying socially constructed positions of subordination at the same moment? To what extent had students in those positions of privilege relinquished the security and privilege of being the knower?[54]

As long as the literature on critical pedagogy fails to come to grips with issues of trust, risk and the operations of fear and desire around such issues of identity and politics in the classroom, their rationalistic tools will continue to fail to loosen deep-seated, self-interested investments in unjust relations of, for example, gender, ethnicity, and sexual orientation.[55] These investments are shared by both teachers and students, yet the literature on critical pedagogy has ignored its own implications for the young, White, Christian, middle-class, heterosexual, able-bodied man/pedagogue that it assumes. Against such ignoring, Mohanty argues that to desire to ignore is not cognitive, but performative. It is the incapacity or refusal "to acknowledge one's own implication in the

information."[56] "[Learning] involves a necessary implication in the radical alterity of the unknown, in the desire(s) not to know, in the process of this unresolvable dialectic."[57]

From Dialogue to Working Together Across Differences

Because student voice has been defined as "the measures by which students and teacher participate in dialogue,"[58] the foregoing critique has serious consequences for the concept of "dialogue" as it has been articulated in the literature on critical pedagogy. Dialogue has been defined as a fundamental imperative of critical pedagogy and the basis of the democratic education that insures a democratic state. Through dialogue, a classroom can be made into a public sphere, a locus of citizenship in which:

> students and teachers can engage in a process of deliberation and discussion
> aimed at advancing the public welfare in accordance with fundamental moral
> judgments and principles. . . . School and classroom practices should, in some
> manner, be organized around forms of learning which serve to prepare students
> for responsible roles as transformative intellectuals, as community members,
> and as critically active citizens outside of schools.[59]

Dialogue is offered as a pedagogical strategy for constructing these learning conditions and consists of ground rules for classroom interaction using language. These rules include the assumptions that all members have equal opportunity to speak, all members respect other members' rights to speak and feel safe to speak, and all ideas are tolerated and subjected to rational critical assessment against fundamental judgments and moral principles. According to Henry Giroux, in order for dialogue to be possible, classroom participants must exhibit "trust, sharing, and commitment to improving the quality of human life."[60] While the specific form and means of social change and organization are open to debate, there must be agreement around the goals of dialogue: "all voices and their differences become unified both in their efforts to identify and recall moments of human suffering and in their attempts to overcome conditions that perpetuate such suffering."[61]

However, for the reasons outlined above—the students' and professor's asymmetrical positions of difference and privilege—dialogue in this sense was both impossible and undesirable in C&I 607. In fact, the unity of efforts and values unproblematically assumed by Giroux was not only impossible but potentially repressive as well. Giroux's formula for dialogue requires and assumes a classroom of participants unified on the side of the subordinated against the subordinators, sharing and trusting in an "us-ness" against "them-ness." This formula fails to confront dynamics of subordination present among classroom participants and within classroom participants in the form of multiple and contradictory subject positions. Such a conception of dialogue invokes the "all too easy polemic that opposes victims to perpetrator," in which a condition for collective purpose among victims is the desire for home, for synchrony, for sameness.[62] Biddy Martin and Chandra Mohanty call for creating new forms of collective struggle based

on and enforcing a harmony of interests. They envision collective struggle that starts from an acknowledgment that "unity"—interpersonal, personal, and political—is necessarily fragmentary, unstable, not given, but chosen and struggled for—but not on the basis of sameness.[63]

But despite early rejections of fundamental tenets of dialogue, including the usually unquestioned emancipatory potentials of rational deliberation and unity, we remained in the grip of other repressive fictions of classroom dialogue for most of the semester. I expected that we would be able to ensure all members a safe place to speak, equal opportunity to speak, and equal power in influencing decision making—and as a result, it would become clear what had to be done and why. It was only at the end of the semester that I and the students recognized that we had given this myth the power to divert our attention and classroom practices away from what we needed to be doing. Acting as if our classroom were a safe space in which democratic dialogue was possible and happening did not make it so. If we were to respond to our context and the social identities of the people in our classroom in ways that did not reproduce the oppressive formations we were trying to work against, we needed classroom practices that confronted the power dynamics inside and outside of our classroom that made democratic dialogue impossible. During the last two weeks of the semester, we reflected in class on our group's process—how we spoke to and/or silenced each other across our differences, how we divided labor, made decisions, and treated each other as visible and/or invisible. As students had been doing with each other all along, I began to have informal conversations with one or two students at a time who were extremely committed on personal, political, and academic levels to breaking through the barriers we had encountered and understanding what had happened during the semester. These reflections and discussions led me to the following conclusions.

Our classroom was not in fact a safe space for students to speak out or talk back about their experiences of oppression both inside and outside of the classroom. In our class, these included experiences of being gay, lesbian, fat, women of color working with men of color, White women working with men of color, men of color working with White women and men.[64] Things were not being said for a number of reasons. These included fear of being misunderstood and/or disclosing too much and becoming too vulnerable; memories of bad experiences in other contexts of speaking out; resentment that other oppressions (sexism, heterosexism, fat oppression, classism, anti-Semitism) were being marginalized in the name of addressing racism—and guilt for feeling such resentment—confusion about levels of trust and commitment surrounding those who were allies to another group's struggles; resentment by some students of color for feeling that they were expected to disclose "more" and once against take the burden of doing the pedagogic work of educating White students/professor about the consequences of White middle-class privilege; and resentment by White students for feeling that they had to prove they were not the enemy.

Dialogue in its conventional sense is impossible in the culture at large because at this historical moment, power relations between raced, classed, and gendered students and teachers are unjust. The injustice of these relations and the way in which those injustices

distort communication cannot be overcome in a classroom, no matter how committed the teacher and students are to "overcoming conditions that perpetuate suffering." Conventional notions of dialogue and democracy assume rationalized, individualized subjects capable of agreeing on universalizable "fundamental moral principles" and "quality of human life" that become self-evident when subjects cease to be self-interested and particularistic about group rights. Yet social agents are not capable of being fully rational and disinterested, and they are subjects split between the conscious and unconscious and among multiple social positionings. Fundamental moral and political principles are not absolute and universalizable, waiting to be discovered by the disinterested researcher/teacher; they are "established intersubjectively by subjects capable of interpretation and reflection."[65] Educational researchers attempting to construct meaningful discourses about the politics of classroom practices must begin to theorize the consequences for education on the ways in which knowledge, power, and desire are mutually implicated in each other's formations and deployments.

By the end of the semester, participants in the class agreed that commitment to rational discussion about racism in a classroom setting was not enough to make that setting a safe space for speaking out and talking back. We agreed that a safer space required high levels of trust and personal commitment to individuals in the class, gained in part through social interactions outside of class—potlucks, field trips, participation in rallies and other gatherings. Opportunities to know the motivations, histories, and stakes of individuals in the class should have been planned early in the semester.[66] Furthermore, White students/professor should have shared the burden of educating themselves about the consequences of their white-skin privilege, and to facilitate this, the curriculum should have included significant amounts of literature, films, and videos by people of color and White people against racism—so that the students of color involved in the class would not always be looked to as "experts" in racism or the situation on the campus.

Because all the voices within the classroom are not and cannot carry equal legitimacy, safety, and power in dialogue at this historical moment, there are times when the inequalities must be named and addressed by constructing alternative ground rules for communication. By the end of the semester, participants in C&I 607 began to recognize that some social groups represented in the class had had consistently more speaking time than others. Women, international students for whom English was a second language, and mixed groups sharing ideological and political languages and perspectives began to have very significant interactions outside of class. Informal, overlapping affinity groups formed and met unofficially for the purpose of articulating and refining positions based on shared oppressions, ideological analyses, or interests. They shared grievances about the dynamics of the larger group and performed reality checks for each other. Because they were unofficial groups constituted on the spot in response to specific needs or simply as a result of casual encounters outside the classroom, alliances could be shaped and reshaped as strategies in context.

The fact that affinity groups did form within the larger group should not be seen as a failure to construct a unity of voices and goals—a possibility unproblematically assumed and worked for in critical pedagogy. Rather, affinity groups were necessary for working

against the way current historical configurations of oppressions were reproduced in the class. They provided some participants with safer home bases from which they gained support, important understandings, and a language for entering the larger classroom interactions each week. Once we acknowledged the existence, necessity, and value of these affinity groups, we began to see our tasks not as one of building democratic dialogue between free and equal individuals, but of building a coalition among the multiple, shifting, intersecting, and sometimes contradictory groups, carrying unequal weights of legitimacy within the culture and the classroom. Halfway through the semester, students renamed the class Coalition 607.

At the end of the semester, we began to suspect that it would have been appropriate for the large group to experiment with forms of communication other than dialogue. These could have brought the existence and results of affinity group interactions to bear more directly on the larger group's understandings and practices. For example, it seemed that we needed times when one affinity group (women of color, women and men of color, feminists, White men against masculinist culture, White women, gays, lesbians) could "speak out" and "talk back" about their experience of Coalition 607's group process or their experience of racial, gender, or other injustice on the campus, while the rest of the class listened without interruption. This would have acknowledged that we were not interacting in class dialogue solely as individuals, but as members of larger social groups, with whom we shared common and "also differing experiences of oppression, a language for naming, fighting, and surviving that oppression, and a shared sensibility and style. The differences among the affinity groups that composed the class made communication within the class a form of cross-cultural or cross-subcultural exchange rather than the free, rational, democratic exchange between equal individuals implied in critical pedagogy literature.

But I want to emphasize that this does not mean that discourses of students of difference were taken up and supported unconditionally by themselves and their allies. There had been intense consciousness-raising on the UW–Madison campus between African-American students, Asian-American students, Latino/a, Chicano/a students, Native American students, and men and women of color about the different forms racism had taken across the campus, depending on ethnicity and gender—and how no single group's analysis could be adopted to cover all other students of color.

Early in the semester, it became clear to some in Coalition 607 that some of the antiracism discourses heard on campus were structured by highly problematic gender politics, and White women and women of color could not adopt those discourses as their own without undercutting their own struggles against sexism on campus and in their communities. We began to define coalition-building not only in terms of what we shared—a commitment to work against racism—but in terms of what we did not share—gender, sexual orientation, ethnicity, and other differences. These positions gave us different stakes in, experiences of, and perspectives on, racism. These differences meant that each strategy we considered for fighting racism on campus had to be interrogated for the implications it held for struggles against sexism, ableism, elitism, fat oppression, and so forth.

We agreed to a final arbiter of the acceptability of demands/narratives by students of color and our class's actions on campus. Proposals would be judged in light of our

answers to this question: to what extent do our political strategies and alternative narratives about social difference succeed in alleviating campus racism, while at the same time managing *not to undercut* the efforts of other social groups to win self-definition?

A Pedagogy of the Unknowable

Like the individual students themselves, each affinity group possessed only partial narratives of its oppressions—partial in that they were self-interested and predicated on the exclusion of the voices of others—and partial in the sense that the meaning of an individual's or group's experience is never self-evident or complete. No one affinity group could ever "know" the experiences and knowledges of other affinity groups or the social positions that were not their own. Nor can social subjects who are split between the conscious and unconscious and cut across by multiple, intersecting, and contradictory subject positions ever fully "know" their own experiences. As a whole, Coalition 607 could never know with certainty whether the actions it planned to take on campus would undercut the struggle of other social groups, or even that of its own affinity groups. But this situation was not a failure; it was not something to overcome. Realizing that there are partial narratives that some social groups or cultures have and others can never know, but that are necessary to human survival, is a condition to embrace and use as an opportunity to build a kind of social and educational interdependency that recognizes differences as "different strengths" and as "forces for change."[67] In the words of Audre Lorde, "Difference must be not merely tolerated, but seen as a fund of necessary polarities between which our creativity can spark like a dialectic. Only then does the necessity for interdependency become unthreatening."[68]

In the end, Coalition 607 participants made an initial gesture toward acting out the implications of the unknowable and the social, educational, and political interdependency that it necessitates. The educational interventions against racism that we carried out on campus were put forth as Coalition 607's statement about its members' provisional, partial understanding of racial oppression on the UW–Madison campus at the moment of its actions. These statements were not offered with the invitation for audiences to participate in dialogue, but as a speaking out from semiotic spaces temporarily and problematically controlled by Coalition 607's students. First, we took actions on campus by interrupting business-as-usual (that is, social relations of racism, sexism, classism, Eurocentrism as usual) in the public spaces of the library mall and administrative offices. (The mall is a frequent site for campus protests, rallies, and graffiti, and was chosen for this reason.) These interruptions consisted of three events.

At noon on April 28, 1988, a street theater performance on the library mall, "Meet on the Street," presented an ironic history of university attempts to coopt and defuse the demands of students of color from the 1950s through the 1980s. The affinity group that produced this event invited members of the university and Madison communities who were not in the class to participate. That night, after dark, "Scrawl on the Mall"

used overhead and movie projectors to project towering images, text, and spontaneously written "graffiti" on the white walls of the main campus library. Class members and passersby drew and wrote on transparencies for the purpose of deconstructing, defacing, and transforming racist discourses and giving voice to perspectives and demands of students of color and White students against racism. For example, students projected onto the library a page from the administration's official response to the Minority Student Coalition demands, and edited it to reveal how it failed to meet those demands. Throughout the semester, a third group of students interrupted business-as-usual in the offices of the student newspaper and university administrators by writing articles and holding interviews that challenged the university's and the newspaper's response to the demands by students of color.

These three events disrupted power relations, however temporarily, within the contexts in which they occurred. Students of color and white students against racism opened up semiotic space for discourses normally marginalized and silenced within the everyday uses of the library mall and administrators' offices. They appropriated means of discourse production—overhead projectors, microphones, language, images, newspaper articles—and controlled, however problematically, the terms in which students of color and racism on campus would be defined and represented within the specific times and spaces of the events. They made available to other members of the university community, with unpredictable and uncontrollable effects, discourses of antiracism that might otherwise have remained unavailable, distorted, more easily dismissed, or seemingly irrelevant. Thus students engaged in the political work of changing material conditions within a public space, allowing them to make visible and assert the legitimacy of their own definitions, in their own terms, of racism and antiracism on the UW campus.

Each of the three actions was defined by different affinity groups according to differing priorities, languages of understanding and analysis, and levels of comfort with various kinds of public action. They were "unified" through their activity of mutual critique, support, and participation, as each group worked through, as much as possible, ways in which the others supported or undercut its own understandings and objectives. Each affinity group brought its proposal for action to the whole class to check out in what ways that action might affect the other groups' self-definitions, priorities, and plans for action. Each group asked the others for various types of labor and support to implement its proposed action. During these planning discussions, we concluded that the results of our interventions would be unpredictable and uncontrollable, and dependent upon the subject positions and changing historical contexts of our audiences on the mall and in administrative offices. Ultimately, our interventions and the process by which we arrived at them had to make sense—both rationally and emotionally—to *us*, however problematically we understand "making sense" to be a political action. Our actions had to make sense as interested interpretations and constant rewritings of ourselves in relation to shifting interpersonal and political contexts. Our interpretations had to be based on attention to history, to concrete experiences of oppression, and to subjugated knowledges.[69]

Conclusion

For me, what has become more frightening than the unknown or unknowable are social, political, and educational projects that predicate and legitimate their actions on the kind of knowing that underlies current definitions of critical pedagogy. In this sense, current understandings and uses of "critical," "empowerment," "student voice," and "dialogue" are only surface manifestations of deeper contradictions involving pedagogies, both traditional and critical. The kind of knowing I am referring to is that in which objects, nature, and "Others" are seen to be known or ultimately knowable, in the sense of being "defined, delineated, captured, understood, explained, and diagnosed" at a level of determination never accorded to the "knower" herself or himself.[70]

The experience of Coalition 607 has left me wanting to think through the implications of confronting unknowability. What would it mean to recognize not only that a multiplicity of knowledges are present in the classroom as a result of the way difference has been used to structure social relations inside and outside the classroom, but that these knowledges are contradictory, partial, and irreducible? They cannot be made to "make sense"—they cannot be known, in terms of the single master discourse of an educational project's curriculum or theoretical framework, even that of critical pedagogy. What kinds of classroom practice are made possible and impossible when one affinity group within the class has lived out and arrived at a currently useful "knowledge" about a particular oppressive formation on campus, but the professor and some of the other students can never know or understand that knowledge in the same way? What practice is called for when even the combination of all partial knowledges in a classroom results in yet another partial knowing, defined by structuring absences that mark the "terror and loathing of any difference?"[71] What kinds of interdependencies between groups and individuals inside and outside of the classroom would recognize that every social, political, or educational project the class takes up locally will already, at the moment of its definition, lack knowledges necessary to answer broader questions of human survival and social justice? What kind of educational project could redefine "knowing" so that it no longer describes the activities of those in power "who started to speak, to speak alone and for everyone else, on behalf of everyone else?"[72] What kind of educational project would redefine the silence of the unknowable, freeing it from "the male-defined context of Absence, Lack, and Fear," and make of that silence "a language of its own" that changes the nature and direction of speech itself?[73]

Whatever form it takes in the various, changing, locally specific instances of classroom practices, I understand a classroom practice of the unknowable right now to be one that would support students/professor in the never-ending "moving about" Trinh Minh-ha describes:

> After all, she is this Inappropriate/d Other who moves about with always at least two/four gestures: that of affirming "I am like you" while pointing insistently to the difference; and that of reminding "I am different" while unsettling every definition of otherness arrived at.[74]

In relation to education, I see this moving about as a strategy that affirms "you know me/I know you" while pointing insistently to the interested partialness of those knowings and constantly reminding us that "you can't know me/I can't know you," while unsettling every definition of knowing arrived at. Classroom practices that facilitate such moving about would support the kind of contextually, politically, and historically situated identity politics called for by Alcoff, hooks, and others.[75] That is, one in which identity is seen as "nonessentialized and, emergent from a historical experience"[76] as a necessary stage in a process, a starting point—not an ending point. Identity in this sense becomes a vehicle for multiplying and making more complex the subject positions possible, visible, and legitimate at any given historical moment, requiring disruptive changes in the way social technologies of gender, race, ability, and so on define "Otherness" and use it as a vehicle for subordination.

Gayatri Spivak calls the search for a coherent narrative "counterproductive" and asserts that what is needed is "persistent critique"[77] of received narratives and a priori lines of attack. Similarly, unlike postliberal or post-Marxist movements predicated on repressive unities, Minh-ha's moving about refuses to reduce profoundly heterogeneous networks of power/desire/interest to any one a priori, coherent narrative. It refuses to know and resist oppression from any a priori line of attack, such as race, class, or gender solidarity.

But participants in Coalition 607 did not simply unsettle every definition of knowing, assert the absence of a priori solidarities, or replace political action (in the sense defined at the beginning of this article) with textual critique. Rather, we struggled, as S. P. Mohanty would have us do, to "develop a sense of the profound *contextuality* of meanings [and oppressive knowledges] in their play and their ideological effects."[78]

Our classroom was the site of dispersed, shifting, and contradictory contexts of knowing that coalesced differently in different moments of student/professor speech, action, and emotion. This situation meant that individuals and affinity groups constantly had to change strategies and priorities of resistance against oppressive ways of knowing and being known. The antagonist became power itself as it was deployed within our classroom—oppressive ways of knowing and oppressive knowledges.

This position, informed by poststructuralism and feminism, leaves no one off the hook, including critical pedagogues. We cannot act as if our membership in or alliance with an oppressive group exempts us from the need to confront the "grey areas which we all have in us."[79] As Trinh Minh-ha reminds us, "There are no social positions exempt from becoming oppressive to others . . . any group—any position—can move into the oppressor role,"[80] depending upon specific historical contexts and situation. Or as Mary Gentile puts it, "everyone is someone else's 'Other.'"[81]

Various groups struggling for self-definition in the United States have identified the mythical norm deployed for the purpose of setting the standard of humanness against which Others are defined and assigned privilege and limitations. At this moment in history, that norm is young, white, heterosexual, Christian, able-bodied, thin, middle-class, English-speaking, and male. Yet, as Gentile argues, no individual embodies, in the essentialist sense, this mythical norm.[82] Even individuals who most closely approximate it experience a dissonance. As someone who embodies some but not all of the current

mythical norm's socially constructed characteristics, my colleague Albert Selvin wrote in response to the first draft of this article: "I too have to fight to differentiate myself from a position defined for me—whose terms are imposed on me—which limits and can destroy me—which does destroy many White men or turns them into helpless agents. . . . I as a White man/boy was not allowed—by my family, by society to be anything *but* cut off from the earth and the body. That condition is not/was not an essential component or implication of my maleness."[83]

To assert multiple perspectives in this way is not to draw attention away from the distinctive realities and effects of the oppression of any particular group. It is not to excuse or relativize oppression by simply claiming, "we are all oppressed," Rather, it is to clarify oppression by preventing "oppressive simplifications,"[84] and insisting that oppression be understood and struggled against contextually. For example, the politics of appearance in relation to the mythical norm played a major role in our classroom. Upon first sight, group members tended to draw alliances and assumed shared commitments because of the social positions we presumed others to occupy (radical, heterosexual, antiracist person of color, and so on). But not only were these assumptions often wrong, at times they denied ideological and personal commitments to various struggles by people who appeared outwardly to fit the mythical norm.

The terms in which I can and will assert and unsettle "difference" and unlearn my positions of privilege in future classroom practices are wholly dependent on the Others/ others whose presence—with, their concrete experiences of privileges and oppressions, and subjugated or oppressive knowledge—I am responding to and acting with in any given classroom. My moving about between the positions of privileged speaking subject and Inappropriate/d Other cannot be predicted, prescribed, or understood beforehand by any theoretical framework or methodological practice. It is in this sense that a practice grounded in the unknowable is profoundly contextual (historical) and interdependent (social). This reformulation of pedagogy and knowledge removes the critical pedagogue from two key discursive positions s/he has constructed for her/himself in the literature—namely, origin of what can be known and origin of what should be done. What remains for me is the challenge of constructing classroom practices that engage with the discursive and material spaces that such a removal opens up. I am trying to unsettle received definitions of pedagogy by multiplying the ways in which I am able to act on and in the university both as the Inappropriate/d Other and as the privileged speaking/ making subject trying to unlearn that privilege.

This semester, in a follow-up to Coalition 607, Curriculum and Instruction 800 is planning, producing, and "making sense" of a day-long film and video event against oppressive knowledges and ways of knowing in the curriculum, pedagogy, and everyday life at UW–Madison. This time we are not focusing on any one formation (race *or* class *or* gender *or* ableism). Rather, we are engaging with each other and working against oppressive social formations on campus in ways that try to "find a commonality in the experience of difference without compromising its distinctive realities and effects."[86]

Right now, the classroom practice that seems most capable of accomplishing this is one that facilitates a kind of communication across differences that is best represented by this statement: "If you can talk to me in ways that show you understand that your

knowledge of me, the world, and 'the Right thing to do' will always be partial, interested, and potentially oppressive to others, and if I can do the same, then we can work together on shaping arid reshaping alliances for constructing circumstances in which students of difference can thrive."

Notes

Ellsworth, Elizabeth, "Why Doesn't This Feel Empowering?: Working through the Repressive Myths of Critical Pedagogy," *Harvard Educational Review*, 59(3): 297–324. Copyright © 1989 by the President and the Fellows of Harvard College. All rights reserved. Reprinted by permission of the publisher.

This article is a revised version of a paper presented at the Tenth Conference on Curriculum Theory and Classroom Practice, Bergamo Conference Center, Dayton, Ohio, October 26–29, 1988. It was part of a symposium entitled "Reframing the Empirical Feminist, Neo-Marxist, and Post-structuralist Challenges to Research in Education." I want to thank Mimi Orner, PhD candidate and teaching assistant in the Department of Curriculum and Instruction, UW–Madison, for her insights and hours of conversations about the meanings of C&I 607. They have formed the backbone of this article.

1. By "critique" I do not mean a systematic analysis of the specific articles of individual authors' positions that make up this literature, for the purpose of articulating a theory of critical pedagogy capable of being evaluated for its internal consistency, elegance, powers of prediction, and so on. Rather, I have chosen to ground the following critique in my interpretation of my experiences in C&I 607. That is, I have attempted to place key discourses in the literature on critical pedagogy *in relation* to my interpretation of my experience in C&I 607—by asking which interpretations and "sense making" do those discourses facilitate, which do they silence and marginalize, and what interests do they appear to serve?

2. By "the literature on critical pedagogy," I mean those articles in major educational journals and special editions devoted to critical pedagogy. For the purpose of this article, I systematically reviewed more than thirty articles appearing in journals such as *Harvard Educational Review, Curriculum Inquiry, Educational Theory, Teachers College Record, Journal of Curriculum Theorizing,* and *Journal of Curriculum Studies* between 1984 and 1988. The purpose of this review was to identify key and repeated claims, assumptions, goals, and pedagogical practices that currently set the terms of debate within this literature. "Critical pedagogy" should not be confused with "feminist pedagogy," which constitutes a separate body of literature with its own goals and assumptions.

3. Some of the more representative writing on this point can be found in Michelle Fine, "Silencing in the Public Schools," *Language Arts, 64* (1987), 157–174; Henry A. Giroux, "Radical Pedagogy and the Politics of Student Voice," *Interchange 17* (1986), 48–69; and Roger Simon, "Empowerment as a Pedagogy of Possibility," *Language Arts 64* (1987), 370–382.

4. See Henry A. Giroux and Peter McLaren, "Teacher Education and the Politics of Engagement: The Case of Democratic Schooling," *Harvard Educational Review 56* (1986), 213–238; and Ira Shor and Paulo Freire, "What is the 'Dialogical Method' of Teaching?" *Journal of Education 969* (1987), 11–31.

5. Shor and Freire, "What is the 'Dialogical Method?' " and Henry A. Giroux, "Literacy and the Pedagogy of Voice and Political Empowerment," *Educational Theory 38* (1988), 61–75.

6. Daniel P. Liston and Kenneth M. Zeichner, "Critical Pedagogy and Teacher Education," *Journal of Education 169* (1987), 117–137.

7. Liston and Zeichner, "Critical Pedagogy," p. 120.

8. Liston and Zeichner, "Critical Pedagogy," p. 127.

9. Giroux, "Literacy and the Pedagogy of Voice," p. 75.

10. Liston and Zeichner, "Critical Pedagogy," p. 128.

11. Valerie Walkerdine, "On the Regulation of Speaking and Silence: Subjectivity, Class, and Gender in Contemporary Schooling," in *Language, Gender, and Childhood*, ed. Carolyn Steedman, Cathy Urwin, and Valerie Walkerdine (London: Routledge and Kegan Paul, 1985), p. 205.

12. Barbara Christian, "The Race for Theory," *Cultural Critique 6* (Spring, 1987), 51–63.

13. By the end of the semester, many of us began to understand ourselves as inhabiting intersections of multiple, contradictory, overlapping social positions not reducible either to race, or class, or gender and so on. Depending upon the moment and the context, the degree to which any one of us "differs" from the mythical norm (see conclusion) varies along multiple axes, and so do the consequences. I began using the terms "students of difference," "professor of difference," to refer to social positionings in relation to the mythical norm (based on ability, size, color, sexual preference, gender, ethnicity, and so on). This reminded us of the necessity to construct how, within specific situations, particular socially constructed differences from the mythical norm (such as color) get taken up as vehicles for institutions such as the university to act out and legitimate oppressive formations of power. This enabled us to open up our analysis of racism on campus for the purpose of tracing its relations to institutional sexism, ableism, elitism, anti-Semitism, and other oppressive formations.

14. Giroux and McLaren, "Teacher Education and the Politics of Engagement," p. 229.

15. Stanley Aronowitz, "Postmodernism and Politics," *Social Text 18* (Winter, 1987/88), 99–115.

16. Liston and Zeichner, "Critical Pedagogy," p, 120.

17. For an excellent theoretical discussion and demonstration of the explanatory power of this approach, see Julian Henriques, Wendy Hollway, Cathy Urwin, Couze Venn, and Valerie Walkerdine, *Changing the Subject: Psychology, Social Regulation, and Subjectivity* (New York: Methuen, 1984); Gloria Anzaldua, *Borderlands/La Frontera: The New Mestiza* (San Francisco: Spinsters/Aunt Lute, 1987); Theresa de Lauretis, ed., *Feminist Studies/Critical Studies* (Bloomington: Indiana University Press, 1986); Hal Foster, ed., *Discussions in Contemporary Culture* (Seattle: Bay Press, 1987); Chris Weedon, *Feminist Practice and Poststructuralist Theory* (New York: Basil Blackwell, 1987).

18. Weedon, *Feminist Practice and Poststructuralist Theory*.

19. Aronowitz, "Postmodernism and Politics," p. 103.

20. Ibid.

21. Audre Lorde, *Sister Outsider* (New York: Crossing Press, 1984), p. 112.

22. Lorde, *Sister Outsider*, p. 112.

23. Christian, "The Race for Theory," p. 63.

24. For a discussion of the thesis of the "epistemic privilege of the oppressed," see Uma Narayan, "Working Together Across Difference: Some Considerations on Emotions and Political Practice," *Hypatia 3* (Summer, 1988), 31–47.

25. For an excellent discussion of the relation of the concept of "experience" to feminism, essentialism, and political action, see Linda Alcoff, "Cultural Feminism versus Post-Structuralism: The Identity Crisis in Feminist Theory," *Signs 13* (Spring, 1988), 405–437.

26. Narayan, "Working Together Across Difference," pp. 31–47.

27. This subtitle is borrowed from Maria C Lugones and Elizabeth V. Spelman's critique of imperialistic, ethnocentric, and disrespectful tendencies in White feminists' theorizing about

women's oppression, "Have We Got a Theory for You! Feminist Theory, Cultural Imperialism, and the Demand for 'The Women's Voice,'" *Women's Studies International Forum* (1983), 573–581.

28. Nicholas C. Burbules, "A Theory of Power in Education," *Educational Theory 36* (Spring, 1986), 95–114; Giroux and McLaren, "Teacher Education and the Politics of Engagement," pp. 224–227.

29. Liston and Zeichner, "Critical Pedagogy and Teacher Education," p. 120.

30. Shor and Freire, "What is the 'Dialogical Method' of Teaching?" p. 14.

31. Giroux, "Radical Pedagogy," p. 64.

32. Ibid., p. 66.

33. Shor and Freire, "What is the 'Dialogical Method' of Teaching?" p. 22.

34. Burbules, "A Theory of Power in Education"; and Giroux and McLaren, "Teacher Education and the Politics of Engagement," pp. 224–227.

35. Shor and Freire, "What is the 'Dialogical Method' of Teaching?" p. 23.

36. Burbules, "A Theory of Power in Education," p. 108.

37. Giroux and McLaren, "Teacher Education and the Politics of Engagement," p. 226.

38. Walter C. Parker, "Justice, Social Studies, and the Subjectivity/Structure Problem," *Theory and Research in Social Education 14* (Fall, 1986), p. 227.

39. Simon, "Empowerment as a Pedagogy of Possibility," p. 372.

40. Giroux, "Literacy and the Pedagogy of Voice," pp. 68–69.

41. Giroux and McLaren, "Teacher Education and the Politics of Engagement," p. 225.

42. Ibid., p. 227.

43. Shor and Freire, "What is the 'Dialogical Method' of Teaching?" p. 30; Liston and Zeichner, "Critical Pedagogy," p. 122.

44. Simon, "Empowerment as a Pedagogy of Possibility," p. 80.

45. Ibid., p. 375.

46. Aronowitz, "Postmodernism and Politics," p. 111.

47. Alcoff, "Cultural Feminism versus Post-Structuralism," p. 420.

48. Simon, "Empowerment as a Pedagogy of Possibility."

49. bell hooks, "Talking Back," *Discourse 8* (Fall/Winter, 1986/87), 123–128.

50. bell hooks, *Talking Back: Thinking Feminist, Thinking Black* (Boston: South End Press, 1989).

51. Peter McLaren, *Life in Schools* (New York: Longman, 1989).

52. Alcoff, "Cultural Feminism versus Post-Structuralism"; Anzaldua, *Borderlands/La Frontera;* de Lauretis, *Feminist Studies/Critical Studies;* hooks, *Talking Back;* Trihn T. Minh-ha, *Woman, Native, Other* (Bloomington: Indiana University Press, 1989); Weedon, *Feminist Practice and Poststructuralist Theory.*

53. hooks, "Talking Back," p. 124.

54. Susan Hardy Aiken, Karen Anderson, Myra Dinerstein, Judy Lensink, and Patricia Mac-Corquodale, "Trying Transformations: Curriculum Integration and the Problem of Resistance," *Signs 12* (Winter, 1987), 225–275.

55. Aiken et al., "Trying Transformations," p. 263.

56. Shoshana Felman, "Psychoanalysis and Education: Teaching Terminable and Interminable," *Yale French Studies 63* (1982), 21–44.

57. S. P. Mohanty, "Radical Teaching, Radical Theory: The Ambiguous Politics of Meaning," in *Theory in the Classroom,* ed. Gary Nelson (Urbana: University of Illinois Press, 1986), p. 155.

58. Giroux and McLaren, "Teacher Education and the Politics of Engagement," p. 235.

59. Ibid., p. 237.

60. Giroux, "Literacy and the Pedagogy of Voice," p. 72.

61. Ibid.

62. Biddy Martin and Chandra Talpade Mohanty, "Feminist Politics: What's Home Got to Do with It?" in *Feminist Studies/Critical Studies*, ed. Theresa de Lauretis (Bloomington: Indiana University Press, 1986), pp. 208–209.

63. Martin and Mohanty, "Feminist Politics," p. 208.

64. Discussions with students after the semester ended and comments from students and colleagues on the draft of this article have led me to realize the extent to which some international students and Jews in the class felt unable or not safe to speak about experiences of oppression inside and outside of the class related to those identities. Anti-Semitism, economic and cultural imperialism, and the rituals of exclusion of international students on campus were rarely named and never fully elaborated in the class. The classroom practices that reproduced these particular oppressive silences in C&I 607 must be made the focus of sustained critique in the follow-up course, C&I 800, "Race, Class, Gender, and the Construction of Knowledge in Educational Media."

65. John W. Murphy, "Computerization, Postmodern Epistemology, and Reading in the Post-modern Era," *Educational Theory 38* (Spring, 1988), 175–182.

66. Lugones and Spelman assert that the only acceptable motivation for following Others into their worlds is friendship. Self-interest is not enough, because "the task at hand for you is one of extraordinary difficulty. It requires that you be willing to devote a great part of your life to it and that you be willing to suffer alienation and self-disruption . . . whatever the benefits you may accrue from such a journey, they cannot be concrete enough for you at this time and they are not worth your while" ("Have We Got a Theory for You," p. 576). Theoretical or political "obligation" is inappropriate, because it puts Whites/Anglos "in a morally self-righteous position" and makes people of color vehicles of redemption for those in power (p. 581). Friendship, as an appropriate and acceptable "condition" under which people become allies in struggles that are not their own, names my own experience and has been met with enthusiasm by students.

67. Lorde, *Sister Outsider*, p. 112.

68. Ibid., p. 112.

69. Martin and Mohanty, "Feminist Politics," p. 210.

70. Alcoff, "Cultural Feminism versus Post-Structuralism," p. 406.

71. Lorde, *Sister Outsider*, p. 113.

72. Trinh T. Minh-ha, "Introduction," *Discourse 8* (Fall/Winter, 1986/87), p. 7.

73. Ibid., p. 8.

74. Ibid., p. 9.

75. Alcoff, "Cultural Feminism versus Post-Structuralism"; bell hooks, "The Politics of Radical Black Subjectivity," *Zeta Magazine* (April, 1989), 52–55.

76. hooks, "The Politics of Radical Black Subjectivity," p. 54.

77. Gayatri Chakravorty Spivak, "Can the Subaltern Speak?" in *Marxism and the Interpretation of Culture*, ed. Cary Nelson and Lawrence Grossberg (Urbana: University of Illinois Press, 1988), p. 272.

78. S. P. Mohanty, "Radical Teaching, Radical Theory," p. 169.

79. Minh-ha, "Introduction," p. 6.

80. A. Setvin, personal correspondence (October 24, 1988).

81. Mary Gentile, *Film Feminisms: Theory and Practice* (Westport, CT: Greenwood Press, 1985), p. 7.

82. Gentile, *Film Feminisms*, p. 7.

83. A. Selvin, personal correspondence.

84. Gentile, *Film Feminisms*, p. 7.

Dysconscious Racism

Ideology, Identity, and the Miseducation of Teachers

Joyce E. King
Santa Clara University

They had for more than a century before been regarded as . . . so far inferior . . . that the negro might justly and lawfully be reduced to slavery for his benefit. . . . This opinion was at that time fixed and universal in the civilized portion of the white race. It was regarded as an axiom in morals as well as in politics, which no one thought of disputing . . . and men in every grade and position in society daily and habitually acted upon it . . . without doubting for a moment the correctness of this opinion.

—*Dred Scott v. Sanford*, 1857

Racism can mean culturally sanctioned beliefs which, regardless of the intentions involved, defend the advantages whites have because of the subordinated positions of racial minorities.

—Wellman, 1977, p. xviii

The goal of critical consciousness is an ethical and not a legal judgement [*sic*] about the social order.

—Heaney, 1984, p. 116

Celebrating Diversity

The new watchwords in education, "celebrating diversity," imply the democratic ethic that all students, regardless of their sociocultural backgrounds, should be educated equitably. What this ethic means in practice, particularly for teachers with little personal experience of diversity and limited understanding of inequity, is problematic. At the elite, private, Jesuit university where I teach, most of my students (most of whom come from relatively privileged, monocultural backgrounds) are anxious about being able to "deal" with all

the diversity in the classroom. Not surprisingly, given recent neoconservative ideological interpretations of the problem of diversity, many of my students also believe that affirming cultural difference is tantamount to racial separatism, that diversity threatens national unity, or that social inequity originates with sociocultural deficits and not with unequal outcomes that are inherent in our socially stratified society. With respect to this society's changing demographics and the inevitable "browning" of America, many of my students foresee a diminution of their own identity, status, and security. Moreover, regardless of their conscious intentions, certain culturally sanctioned beliefs my students hold about inequity and why it persists, especially for African Americans, take white norms and privilege as givens.

The findings presented herein will show what these beliefs and responses have to do with what I call "dysconscious racism" to denote the limited and distorted understandings my students have about inequity and cultural diversity—understandings that make it difficult for them to act in favor of truly equitable education. This article presents a qualitative analysis of dysconscious racism as reflected in the responses of my teacher education students to an open-ended question I posed at the beginning of one of my classes during the fall 1986 academic quarter to assess student knowledge and understanding of social inequity. Content analysis of their short essay responses will show how their thinking reflects internalized ideologies that both justify the racial status quo and devalue cultural diversity. Following the analysis of their responses and discussion of the findings I will describe the teaching approach I use to counteract the cognitively limited and distorted thinking that dysconscious racism represents. The concluding discussion will focus on the need to make social reconstructionist liberatory teaching an option for teacher education students like mine who often begin their professional preparation without having ever considered the need for fundamental social change (see also Ginsburg, 1988; and Ginsburg & Newman, 1985).

Critical, transformative teachers must develop a pedagogy of social action and advocacy that really celebrates *diversity*, not just random holidays, isolated cultural artifacts, or "festivals and food" (Ayers, 1988). If dysconscious racism keeps such a commitment beyond the imagination of students like mine, teacher educators need forms of pedagogy and counter-knowledge that challenge students' internalized ideologies and subjective identities (Giroux & McLaren, 1988). Prospective teachers need both an intellectual understanding of schooling and inequity as well as self-reflective, transformative emotional growth experiences. With these objectives in mind, I teach my graduate-level Social Foundations of Education course in the social reconstructionist tradition of critical, transformative, liberatory education for social change (see Gordon, 1985; Freire, 1971; Giroux & McLaren, 1986; Heaney, 1984; Shor, 1980; Searle, 1975; Sleeter & Grant, 1988). In contrast to a pedagogy for the oppressed, this course explores the dynamics of a liberatory pedagogy for the elite. It is designed to provide such teacher education students with a context in which to consider alternative conceptions of themselves and society. The course challenges students' taken-for-granted ideological positions and identities and their unquestioned acceptance of cultural belief systems which undergird racial inequity.

Thus, the course and the teaching methods I use transcend conventional social and multicultural Foundations of Education course approaches by directly addressing societal oppression and student knowledge and beliefs about inequity and diversity. By focusing on ways that schooling, including their own miseducation, contributes to unequal educational outcomes that reinforce societal inequity and oppression, students broaden their knowledge of how society works. I offer this analysis of dysconscious racism and reflections on the way I teach to further the theoretical and practical development of a liberatory praxis that will enable teacher education students to examine what they know and believe about society, about diverse others, and about their own actions.

Discovering Dysconscious Racism

Dysconsciousness is an uncritical habit of mind (including perceptions, attitudes, assumptions, and beliefs) that justifies inequity and exploitation by accepting the existing order of things as given. If, as Heaney (1984) suggests, critical consciousness "involves an ethical judgement [*sic*]" about the social order, dysconsciousness accepts it uncritically. This lack of critical judgment against society reflects an absence of what Cox (1974) refers to as "social ethics"; it involves a subjective identification with an ideological viewpoint that admits no fundamentally alternative vision of society.[1]

Dysconscious racism is a form of racism that tacitly accepts dominant white norms and privileges. It is not the *absence* of consciousness (that is, not unconsciousness) but an *impaired* consciousness or distorted way of thinking about race as compared to, for example, critical consciousness. Uncritical ways of thinking about racial inequity accept certain culturally sanctioned assumptions, myths, and beliefs that justify the social and economic advantages white people have as a result of subordinating diverse others (Wellman, 1977). Any serious challenge to the status quo that calls this racial privilege into question inevitably challenges the self-identity of white people who have internalized these ideological justifications. The reactions of my students to information I have presented about societal inequity have led me to conceptualize dysconscious racism as one form that racism takes in this post-civil rights era of intellectual conservatism.

Most of my students begin my Social Foundations course with limited knowledge and understanding of societal inequity. Not only are they often unaware of their own ideological perspectives (or of the range of alternatives they have not consciously considered), most are also unaware of how their own subjective identities reflect an uncritical identification with the existing social order. Moreover, they have difficulty explaining "liberal" and "conservative" standpoints on contemporary social and educational issues, and are even less familiar with "radical" perspectives (King & Ladson-Billings, 1990). My students' explanations of persistent racial inequity consistently lack evidence of any critical ethical judgment regarding racial (and class/gender) stratification in the existing social order; yet, and not surprisingly, these same students generally maintain that they personally deplore racial prejudice and discrimination. However, Wellman (1977) notes that this kind of thinking is a hallmark of racism. "The concrete problem facing

white people," states Wellman, "is how to come to grips with the demands made by blacks and whites while at the same time *avoiding* the possibility of institutional change and reorganization that might affect them" (p. 42). This suggests that the ability to imagine a society reorganized without racial privilege requires a fundamental shift in the way white people think about their status and self-identities and their conceptions of black people.

For example, when I broach the subject of racial inequity with my students, they often complain that they are "tired of being made to feel guilty" because they are white. The following entries from the classroom journals of two undergraduate students in an education course are typical of this reaction[2]:

> With some class discussions, readings, and other media, there have been times that I feel guilty for being white which really infuriates me because no one should feel guilty for the color of their skin or ethnic background. Perhaps my feelings are actually a discomfort for the fact that others have been discriminated against all of their life [*sic*] because of their color and I have not.
>
> How can I be thankful that I am not a victim of discrimination? I should be ashamed. Then I become confused. Why shouldn't I be thankful that I have escaped such pain?

These students' reactions are understandable in light of Wellman's insights into the nature of racism. That white teacher education students often express such feelings of guilt and hostility suggests they accept certain unexamined assumptions, unasked questions, and unquestioned cultural myths regarding both the social order and their place in it. The discussion of the findings that follows will show how dysconscious racism, manifested in student explanations of societal inequity and linked to their conceptions of black people, devalues the cultural diversity of the black experience and, in effect, limits students' thinking about what teachers can do to promote equity.

The Findings

Since the 1986 fall academic quarter I have given the student teachers in my Social Foundations course statistical comparisons such as those compiled by the Children's Defense Fund (Edelman, 1987) regarding black and white children's life chances (e.g., "Compared to white children, black children are twice as likely to die in the first year of life"; see Harlan, 1985). I then ask each student to write a brief explanation of how these racial inequities came about by answering the question: "How did our society get to be this way?" An earlier publication (King & Ladson-Billings, 1990) comparing student responses to this question in the fall 1986 and spring 1987 quarters identifies three ways students explain this inequity. Content analysis of their responses reveals that students explain racial inequity as either the result of slavery (Category I), the denial or lack of equal opportunity for African Americans (Category II), or part of the framework of a

society in which racism and discrimination are normative (Category III). In the present article I will again use these categories and the method of content analysis to compare student responses collected in the 1986 and 1988 fall quarters. The responses presented below are representative of 22 essay responses collected from students in 1986 and 35 responses collected in 1988.

Category I explanations begin and end with slavery. Their focus is either on describing African Americans as "victims of their original (slave) status," or they assert that black/white inequality is the continuing result of inequity which began during slavery. In either case, historical determinism is a key feature; African Americans are perceived as exslaves, and the "disabilities of slavery" are believed to have been passed down intergenerationally. As two students wrote:

> I feel it dates back to the time of slavery when the blacks were not permitted to work or really have a life of their own. They were not given the luxury or opportunity to be educated and *each generation passed this disability on* [italics added]. (F6–21)[3]

> I think that this harkens [*sic*] back to the origin of the American black population as slaves. Whereas other immigrant groups started on a low rung of our economic (and social class) ladder and had space and opportunity to move up, blacks did not. They were perceived as somehow less than people. This view may have been passed down and even on to black youth. . . . (F8–32)

It is worth noting that the "fixed and universal beliefs" Europeans and white Americans held about black inferiority/white superiority during the epoch of the Atlantic slave trade, beliefs that made the enslavement of Africans seem justified and lawful, are not the focus of this kind of explanation. The historical continuum of cause and effect evident in Category I explanations excludes any consideration of the cultural rationality behind such attitudes; that is, they do not explain *why* white people held these beliefs.

In Category II explanations the emphasis is on the denial of equal opportunity to black people (e.g., less education, lack of jobs, low wages, poor health care). Although students espousing Category II arguments may explain discrimination as the result of prejudice or racist attitudes (e.g., "whites believe blacks are inferior"), they do not necessarily causally link it to the historical fact of slavery or to the former status of black people as slaves. Rather, the persistently unequal status of African Americans is seen as an *effect* of poverty and systemic discrimination. Consider these two responses from 1986 and 1988:

> . . . blacks have been treated as second class citizens. Caucasians tend to maintain the belief that black people are inferior . . . *for this reason* [italics added] blacks receive less education and education that is of inferior quality . . . less pay than most other persons doing the same job; (and) live in inferior substandard housing, etc. (F6–3)

Because of segregation—overt and covert—blacks in America have had less access historically to education and jobs, which has led to a poverty cycle for many. *The effects described are due to poverty* [italics added], lack of education and lack of opportunity. (F8–7)

In addition, some Category I and Category II explanations identify negative psychological or cultural characteristics of African Americans as effects of slavery, prejudice, racism, or discrimination. One such assertion is that black people have no motivation or incentive to "move up" or climb the socioeconomic ladder. Consequently, this negative characteristic is presumed to perpetuate racial inequality: Like a vicious cycle, whites then perceive blacks as ignorant or as having "devalued cultural mores." The following are examples of Category II explanations; even though they allude to slavery, albeit in a secondary fashion, the existence of discrimination is the primary focus:

Blacks were brought to the U.S. by whites. They were/are thought to be of a "lower race" by large parts of the society . . . society has impressed these beliefs/ideas onto blacks. [Therefore] blacks probably have lower self-esteem and when you have lower self-esteem, it is harder to move up in the world. . . . Blacks group together and stay together. Very few move up . . . partly because society put them there. (F6–18)

Past history is at the base of the racial problems evident in today's society. Blacks have been persecuted and oppressed for years. . . . Discrimination is still a problem which results in lack of motivation, self-esteem and hence a lessened "desire" to escape the hardships with which they are faced. (F8–14)

In 1986 my students' responses were almost evenly divided between Category I and Category II explanations (10 and 11 responses, respectively, with one Category III response). In 1988 all 35 responses were divided between Category I (11) and Category II (24) responses, or 32 percent and 68 percent, respectively. Thus, the majority of students in both years explained racial inequality in limited ways—as a historically inevitable consequence of slavery or as a result of prejudice and discrimination—without recognizing the structural inequity built into the social order. Their explanations fail to link racial inequity to other forms of societal oppression and exploitation. In addition, these explanations, which give considerable attention to black people's negative characteristics, fail to account for white people's beliefs and attitudes that have long justified societal oppression and inequity in the form of racial slavery or discrimination.

Discussion

An obvious feature of Category I explanations is the devaluation of the African-American cultural heritage, a heritage which certainly encompasses more than the debilitating experience of slavery. Moreover, the integrity and adaptive resilience of what Stuckey (1987)

refers to as the "slave culture" is ignored and implicitly devalued. Indeed, Category I explanations reflect a conservative assimilationist ideology that blames contemporary racial inequity on the presumed cultural deficits of African Americans. Less obvious is the way the historical continuum of these explanations, beginning as they do with the effects of slavery on African Americans, fails to consider the specific cultural rationality that justified slavery as acceptable and lawful (Wynter, 1990). Also excluded from these explanations as possible contributing factors are the particular advantages white people gained from the institution of racial slavery.

Category II explanations devalue diversity by not recognizing how opportunity is tied to the assimilation of mainstream norms and values. These explanations also fail to call into question the basic structural inequity of the social order; instead, the cultural mythology of the American Dream, most specifically the myth of equal opportunity, is tacitly accepted (i.e., with the right opportunity, African Americans can climb out of poverty and "make it" like everyone else). Such liberal, assimilationist ideology ignores the widening gap between the haves and the have nots, the downward mobility of growing numbers of whites (particularly women with children), and other social realities of contemporary capitalism. While not altogether inaccurate, these explanations are nevertheless *partial* precisely because they fail to make appropriate connections between race, gender, and class inequity.

How do Category I and Category II explanations exemplify dysconscious racism? Both types defend white privilege, which, according to Wellman (1977), is a "consistent theme in racist thinking" (p. 39). For example, Category I explanations rationalize racial inequity by attributing it to the effects of slavery on African Americans while ignoring the economic advantages it gave whites. A second rationalization, presented in Category II explanations, engenders the mental picture many of my students apparently have of equal opportunity, not as equal access to jobs, health care, education, etc. but rather as a sort of "legal liberty" which leaves the structural basis of the racial status quo intact (King & Wilson, 1990). In effect, by failing to connect a more just opportunity system for blacks with fewer white-skin advantages for whites, these explanations, in actuality, defend the racial status quo.

According to Wellman, the existing social order cannot provide for unlimited (or equal) opportunity for black people while maintaining racial privileges for whites (p. 42). Thus, elimination of the societal hierarchy is inevitable if the social order is to be reorganized; but before this can occur, the existing structural inequity must be recognized as such and actively struggled against. This, however, is not what most of my students have in mind when they refer to "equal opportunity."

Category I and Category II explanations rationalize the existing social order in yet a third way by omitting any ethical judgment against the privileges white people have gained as a result of subordinating black people (and others). These explanations thus reveal a dysconscious racism which, although it bears little resemblance to the violent bigotry and overt white supremacist ideologies of previous eras, still takes for granted a system of racial privilege and societal stratification that favors whites. Like the whites of Dred Scott's era, few of my students even think of disputing this system or see it as disputable.

Category III explanations, on the other hand, do not defend this system. They are more comprehensive, and thus more accurate, because they make the appropriate connections between racism and other forms of inequity. Category III explanations also locate the origins of racial inequity in the framework of a society in which racial victimization is *normative*. They identify and criticize both racist ideology and oppressive societal structures without placing the responsibility for changing the situation solely on African Americans (e.g., to develop self-esteem), and without overemphasizing the role of white prejudice (e.g., whites' beliefs about black inferiority). The historical factors cited in Category III explanations neither deny white privilege nor defend it. I have received only one Category III response from a student at the beginning of my courses, the following:

> [Racial inequity] is primarily the result of the economic system . . . racism
> served the purposes of ruling groups; e.g., in the Reconstruction era . . . poor
> whites were pitted against blacks—a pool of cheap exploitable labor is desired
> by capitalists and this ties in with the identifiable differences of races. (F6–9)

Why is it that more students do not think this way? Given the majority of my students' explanations of racial inequity, I suggest that their thinking is impaired by dysconscious racism—even though they may deny they are racists. The important point here, however, is not to prove that students are racist; rather, it is that their uncritical and limited ways of thinking must be identified, understood, and brought to their conscious awareness.

Dysconscious racism must be made the subject of educational intervention. Conventional analyses—which conceptualize racism at the institutional, cultural, or individual level but do not address the cognitive distortions of dysconsciousness—cannot help students distinguish between racist justifications of the status quo (which limit their thought, self-identity, and responsibility to take action) and socially unacceptable individual prejudice or bigotry (which students often disavow). Teacher educators must therefore challenge both liberal and conservative ideological thinking on these matters if we want students to consider seriously the need for fundamental change in society and in education.

Ideology, identity, and indoctrination are central concepts I use in my Social Foundations of Education course to help students free themselves from miseducation and uncritically accepted views which limit their thought and action. A brief description of the course follows.

The Cultural Politics of Critiquing Ideology and Identity

One goal of my Social Foundations of Education course is to sharpen the ability of students to think critically about educational purposes and practice in relation to social justice and to their own identities as teachers. The course thus illuminates a range of

ideological interests which become the focus of students' critical analysis, evaluation, and choice. For instance, a recurring theme in the course is that of the social purposes of schooling, or schooling as an instrument of educational philosophy, societal vision, values, and personal choice. This is a key concept about which many students report they have never thought seriously. Course readings, lectures, media resources, class discussions, and other experiential learning activities are organized to provide an alternative context of meaning within which students can critically analyze the social purposes of schooling. The range of ideological perspectives considered include alternative explanations of poverty and joblessness, competing viewpoints regarding the significance of cultural differences, and discussions of education as a remedy for societal inequity. Students consider the meaning of social justice and examine ways that education might be transformed to promote a more equitable social order. Moreover, they are expected to choose and declare the social changes they themselves want to bring about as teachers.

The course also introduces students to the critical perspective that education is not neutral; it can serve various political and cultural interests including social control, socialization, assimilation, domination, or liberation (Cagan, 1978; Freire, 1971; O'Neill, 1981). Both impartial, purportedly factual information as well as openly partisan views about existing social realities such as the deindustrialization of America, hunger and homelessness, tracking, the "hidden" curriculum (Anyon, 1981; Vallence, 1977), the socialization of teachers, and teacher expectations (Rist, 1970) allow students to examine connections between macrosocial (societal) and microsocial (classroom) issues. This information helps students consider different viewpoints about how schooling processes contribute to inequity. Alongside encountering liberal and conservative analyses of education and opportunity, students encounter the scholarship of radical educators such as Anyon (1981), Freire (1971), Kozol (1981), and Giroux and McLaren (1986), who have developed "historical identities" (Boggs et al., 1978) within social justice struggles and who take stronger ethical stances against inequity than do liberals or conservatives. These radical educators' perspectives also provide students with alternative role models; students discuss their thoughts and feelings about the convictions these authors express and reflect upon the soundness of radical arguments. Consequently, as students formulate their own philosophical positions about the purposes of education, they inevitably struggle with the ideas, values, and social interests at the heart of the different educational and social visions which they, as teachers of the future, must either affirm, reject, or resist.

Making a conscious process of the struggle over divergent educational principles and purposes constitutes the cultural politics of my Social Foundations course. In this regard my aim is to provide a context within which student teachers can recognize and evaluate their personal experiences of political and ethical indoctrination. In contrast to their own miseducation, and using their experience in my course as a point of comparison, I urge my students to consider the possibilities liberatory and transformative teaching offers. To facilitate this kind of conscious reflection, I discuss the teaching strategies I myself model in my efforts to help them think critically about the course content, their own worldview, and the professional practice of teaching (Freire & Faundez, 1989). To demonstrate the questions critical, liberatory teachers must ask and to make

what counts as "school knowledge" (Anyon, 1981) problematic, I use Freire's (1971) strategy of developing "problem-posing" counter-knowledge. For example, I pose biased instructional materials as a problem teachers address. Thus, when we examine the way textbooks represent labor history (Anyon, 1979) and my student teachers begin to realize they do not know much about the struggles of working people for justice, the problem of miseducation becomes more real to them. Indeed, as Freire, Woodson (1933), and others suggest, an alternative view of history often reveals hidden social interests in the curriculum and unmasks a political and cultural role of schooling of which my student teachers are often completely unaware.

Analysis of and reflection on their own knowledge and experience involves students in critiquing ideologies, examining the influences on their thinking and identities, and considering the kind of teachers they want to become. I also encourage my students to take a stance against mainstream views and practices that dominate in schools and other university courses. Through such intellectual and emotional growth opportunities, students in my course re-experience and re-evaluate the partial and socially constructed nature of their own knowledge and identities.

My approach is not free from contradictions, however. While I alone organize the course structure, select the topics, make certain issues problematic, and assign the grades, I am confident that my approach is more democratic than the unwitting ideological indoctrination my students have apparently internalized. For a final grade, students have the option of writing a final exam in which they can critique the course, or they may present (to the class) a term project organized around an analytical framework they themselves generate.

Toward Liberatory Pedagogy in Teacher Education

Merely presenting factual information about societal inequity does not necessarily enable pre-service teachers to examine the beliefs and assumptions that may influence the way they interpret these facts. Moreover, with few exceptions, available multicultural resource materials for teachers presume a value commitment and readiness for multicultural teaching and antiracist education which many students may lack initially (Bennett, 1990; Brandt, 1986; Sleeter & Grant, 1988). Teacher educators may find some support in new directions in adult education (Mezirow, 1984) and in theories of adult learning and critical literacy which draw upon Freire's work in particular (Freire & Macedo, 1987). This literature offers some useful theoretical insights for emancipatory education and liberatory pedagogy (Heaney, 1984). For example, the counter-knowledge strategies I use in my Social Foundations course are designed to facilitate the kind of "perspective transformation" Mezirow (1984) calls for in his work. It is also worth noting that a tradition of critical African-American educational scholarship exists which can be incorporated into teacher preparation courses. Analyses of miseducation by Woodson (1933), DuBois (1935), and Ellis (1917) are early forerunners of critical, liberatory pedagogy. This tradition is also reflected in contemporary African-American thought and scholar-

ship on education and social action (see Childs, 1989; Gordon, 1990; Lee et al., 1990; Muwakkil, 1990; Perkins, 1986).

As Sleeter and Grant (1988, p. 194) point out, however, white students sometimes find such critical, liberatory approaches threatening to their self-concepts and identities. While they refer specifically to problems of white males in this regard, my experience is that most students from economically privileged, culturally homogeneous backgrounds are generally unaware of their intellectual biases and monocultural encapsulation. While my students may feel threatened by diversity, what they often express is guilt and hostility. Students who have lived for the most part in relatively privileged cultural isolation can only consider becoming liberatory, social-reconstructionist educators if they have both an adequate understanding of how society works and opportunities to think about the need for fundamental social change. The critical perspective of the social order offered in my course challenges students' world views as well as their self-identities by making problematic and directly addressing students' values, beliefs, and ideologies. Precisely because what my students know and believe is so limited, it is necessary to address both their knowledge (that is, their intellectual understanding of social inequity) and what they believe about diversity. As Angus and Jhally (1989, p. 12) conclude, "what people accept as natural and self-evident" is exactly what becomes "problematic and in need of explanation" from this critical standpoint. Thus, to seriously consider the value commitment involved in teaching for social change as an option, students need experiential opportunities to recognize and evaluate the ideological influences that shape their thinking about schooling, society, themselves, and diverse others.

The critique of ideology, identity, and miseducation described herein represents a form of cultural politics in teacher education that is needed to address the specific cultural rationality of social inequity in modern American society. Such a liberatory pedagogical approach does not neglect the dimension of power and privilege in society, nor does it ignore the role of ideology in shaping the context within which people think about daily life and the possibilities of social transformation. Pedagogy of this kind is especially needed now, given the current thrust toward normative schooling and curriculum content that emphasizes "our common Western heritage" (Bloom, 1987; Gagnon, 1988; Hirsch, 1987; Ravitch, 1990). Unfortunately, this neoconservative curriculum movement leaves little room for discussion of how being educated in this tradition may be a limiting factor in the effectiveness of teachers of poor and minority students (King & Wilson, 1990; Ladson-Billings, 1991). Indeed, it precludes any critical ethical judgment about societal inequity and supports the kind of miseducation that produces teachers who are dysconscious—uncritical and unprepared to question white norms, white superiority, and white privilege.

Myths and slogans about common heritage notwithstanding, prospective teachers need an alternative context in which to think critically about and reconstruct their social knowledge and self-identities. Simply put, they need opportunities to become conscious of oppression. However, as Heaney (1984) correctly observes: "Consciousness of oppression can not be the object of instruction, it must be discovered in experience" (p. 118). Classes such as my Social Foundations course make it possible for students to re-experience the way dysconscious racism and miseducation victimize them.

That dysconscious racism and miseducation of teachers are part of the problem is not well understood. This is evident in conventional foundations approaches and in the teacher education literature on multiculturalism and pluralism which examine social stratification, unequal educational outcomes, and the significance of culture in education but offer no critique of ideology and indoctrination (Gollnick & Chinn, 1990; Pai, 1990). Such approaches do not help prospective teachers gain the critical skills needed to examine the ways being educated in a racist society affects their own knowledge and their beliefs about themselves and culturally diverse others. The findings presented in this article suggest that such skills are vitally necessary. The real challenge of diversity is to develop a sound liberatory praxis of teacher education which offers relatively privileged students freedom to choose critical multicultural consciousness over dysconsciousness. Moving beyond dysconsciousness and miseducation toward liberatory pedagogy will require systematic research to determine how teachers are being prepared and how well those whose preparation includes critical liberatory pedagogy are able to maintain their perspectives and implement transformative goals in their own practice.

Notes

King, Joyce E. "Dysconscious Racism: Ideology, Identity, and the Miseducation of Teachers," *The Journal of Negro Education*, 60(2) (1991): 133–146. Copyright © 1991 Howard University, Washington, D.C.

1. It should be noted that dysconsciousness need not be limited to racism but can apply to justifications of other forms of exploitation such as sexism or even neocolonialism—issues that are beyond the scope of the present analysis.

2. I want to thank Professor Gloria Ladson-Billings, who also teaches at my institution, for providing these journal entries. See her discussion of student knowledge and attitudes in *The Journal of Negro Education*, 60, 2, 1991.

3. This and subsequent student comment codes used throughout this article identify individual respondents within each cohort. "F6–21," for example, refers to respondent 21 in the fall 1986 academic quarter.

References

Angus, I., and S. Jhally, (Eds.). (1989). *Cultural politics in contemporary America*. New York: Routledge.

Anyon, J. (1979). Ideology and U.S. history textbooks. *Harvard Educational Review, 49*, 361–386.

Anyon, J. (1981). Social class and school knowledge. *Curriculum Inquiry, 11*, 3–42.

Ayers, W. (1988). Young children and the problem of the color line. *Democracy and Education, 3*(1), 20–26.

Banks, J. (1977). *Multiethnic education: Practices and promises*. Bloomington, IN: Phi Delta Kappa Educational Foundation.

Bennett, C. (1990). *Comprehensive multicultural education: Theory and practice*. Boston: Allyn & Bacon.

Bloom, A. (1987). *The closing of the American mind*. New York: Simon & Schuster.

Boggs, J. et al. (1979). *Conversations in Maine: Exploring our nation's future*. Boston: South End Press.

Brandt, G. (1986). *The realization of anti-racist teaching*. Philadelphia: The Falmer Press.

Cagan, E. (1978). Individualism, collectivism, and radical educational reform. *Harvard Educational Review, 48*, 227–266.

Childs, J. B. (1989). *Leadership, conflict and cooperation in Afro-American social thought*. Philadelphia: Temple University Press.

Cox, G. O. (1974). *Education for the black race*. New York: African Heritage Studies Publishers.

DuBois, W. E. B. (1935). Does the Negro need separate schools? *Journal of Negro Education, 4*, 329–335.

Edelman, M. W. (1987). *Families in peril: An agenda for social change*. Cambridge, MA: Harvard University Press.

Ellis, G. W. (1917). Psychic factors in the new American race situation. *Journal of Race Development, 4*, 469–486.

Freire, P. (1971). *Pedagogy of the oppressed*. New York: Harper & Row.

Freire, P., and A. Faundez (1989). *Learning to question: A pedagogy of liberation*. New York: Continuum.

Freire, P., and D.Macedo (1987). *Literacy: Reading the word and the world*. South Hadley, MA: Bergin & Garvey.

Gagnon, P. (1988, November). Why study history? *Atlantic Monthly*, pp. 43–66.

Ginsburg, M. (1988). *Contradictions in teacher education and society: A critical analysis*. Philadelphia: The Falmer Press.

Ginsburg, M., and K. Newman (1985). Social inequalities, schooling and teacher education. *Journal of Teacher Education, 36*, 49–54.

Giroux, J., and P. McLaren (1986). Teacher education and the politics of engagement: The case for democratic schooling. *Harvard Educational Review, 56*, 213–238.

Gollnick, D., and P. Chinn (1990). *Multicultural education in a pluralistic society*. Columbus, OH: Merrill.

Gordon, B. (1985). Critical and emancipatory pedagogy: An annotated bibliography of sources for teachers. *Social Education, 49*(5), 400–402.

Gordon, B. (1990). The necessity of African-American epistemology for educational theory and practice. *Journal of Education, 172*, in press.

Harlan, S. (1985, June 5). Compared to white children, black children are . . . *USA Today*, p. 9–A.

Heaney, T. (1984). Action, freedom and liberatory education. In S. B. Merriam (Ed.), *Selected writings on philosophy and education* (pp. 113–122). Malabar, FL: Robert E. Krieger.

Hirsch, E. D. (1987). *Cultural literacy: What every American needs to know*. New York: Houghton Mifflin.

Howard, B. C (1857). *Report of the decision of the Supreme Court of the United States and the opinions of the justices thereof in the case of Dred Scott versus John F. A. Sandford, December term, 1856*. New York: D. Appleton & Co.

Kozol, J. (1981). *On being a teacher*. New York: Continuum.

King, J., and G. Ladson-Billings (1990). The teacher education challenge in elite university settings: Developing critical and multicultural perspectives for teaching in a democratic and multicultural society. *European Journal of Intercultural Studies, 1(2)*, 15–30.

King, J., and T. L. Wilson (1990). Being the soul-freeing substance: A legacy of hope in Afro humanity. *Journal of Education, 172*(2), in press.

Ladson-Billings, G. (1991). Beyond multicultural illiteracy. *Journal of Negro Education, 60*(2), 147–157.

Lee, C. et al. (1990). How shall we sing our sacred song in a strange land? The dilemma of double consciousness and complexities of an African-centered pedagogy. *Journal of Education, 172*,(2), in press.

Mezirow, J. (1984). A critical theory of adult learning and education. In S. B. Merriam (Ed.), *Selected writings on philosophy and adult education* (pp. 123–140). Malabar, FL: Robert E. Krieger.

Muwakkil, S. (1990). Fighting for cultural inclusion in the schools. *In These Times, 14*(37), 8–9.

O'Neill, W. F. (1981). *Educational ideologies: Contemporary expressions of educational philosophy.* Santa Monica, CA: Goodyear.

Pai, Y. (1990). *Cultural foundations of education.* Columbus, OH: Merrill.

Perkins, U. E. (1986). *Harvesting new generations: The positive development of black youth.* Chicago: Third World Press.

Ravitch, D. (1990). Diversity and democracy. *The American Educator, 14*, 16–20.

Rist, R. (1970). Student social class and teacher expectations. *Harvard Educational Review, 40*, 411–451.

Searle, C. (Ed.). (1975). *Classrooms of resistance.* London: Writers and Readers Publishing Cooperative.

Shor, I. (1980). *Critical teaching in everyday life.* Boston: South End Press.

Sleeter, C., and C. Grant (1988). *Making choices for multicultural education: Vive approaches to race, class and gender.* Columbus, OH: Merrill.

Stuckey, S. (1987). *Slave culture: Nationalist theory and the foundations of black America.* New York: Oxford University Press.

Vallance, E. (1977). Hiding the hidden curriculum: An interpretation of the language of justification in nineteenth-century educational reform. In A. Bellack and H. Kliebard (Eds.), *Curriculum and evaluation* (pp. 590–607). Berkeley, CA: McCutchan.

Wellman, D. (1977). *Portraits of white racism.* Cambridge, MA: Cambridge University Press.

Woodson, C. G. (1933). *The miseducation of the Negro.* Washington, DC: Associated Publishers.

Wynter, S. (1990, September 9). *America as a "world": A black studies perspective and "cultural model" framework.* [Letter to the California State Board of Education.]

When is a Singing School (Not) a Chorus?

The Emancipatory Agenda in Feminist Pedagogy and Literature Education

Deanne Bogdan

Ontario Institute for Studies in Education, University of Toronto

This paper addresses the conundrum of why, for some of us, the more we become sensitized to the imperatives of democratic education and student ownership of their own learning, the harder they can become actually to accomplish in a classroom. This is especially true in literature education and feminist/critical pedagogy, where personal and social transformation are implicit and explicit goals. Underlying the ethical aims of feminist pedagogy and literature education is the accepting of the Other on the Other's own terms.[1] In classrooms full of real readers reading, this principle, which informs what Elizabeth Ellsworth has called "a pedagogy of the unknowable,"[2] plays itself out in the interstices between authority and trust, academic rigor and personal empathy, community and fracture, professional and political responsibility. Recently Deborah Britzman has analyzed her student teachers' attempts to implement critical/feminist pedagogical methods in English education at the secondary school level, detailing the complexity of the tensions and contradictions that mark "not just what it means to know and be known, but how we come to know and come to refuse knowledge."[3] To espouse a liberatory agenda is often to embark on a "pedagogical encounter" that, in Britzman's words, is simply "scary."

> More often than not, things do not go according to plan: objectives reappear as too simple, too complicated, or get lost; concepts become glossed over, require long detours, or go awry. . . . In short, pedagogy is filled with surprises, involuntary returns, and unanticipated twists.[4]

My reflections arise out of my more recent experiences teaching at my home institution, the Ontario Institute for Studies in Education, which is a graduate department of education. In contrast to Britzman's grade ten class, our students are mature adults, many of them seasoned, successful teachers in their own right, who bring to the learning

environment highly diverse personal, professional, and disciplinary backgrounds. But even within this milieu, the very heightening of consciousness about the changing intellectual and political premises of English studies, heavily influenced by critical/feminist pedagogy, can threaten at any given moment to break down into solipsistic worldviews and group alienation.

References to "the Singing School" in my title (with apologies to Yeats and Northrop Frye)[5] and whether or not it is a "Chorus" signal the tension between what an instructor perceives to be happening and what may in fact be happening with respect to the learning taking place. For me, "the Singing School" has become a metaphor for what we might think of as a "dream class," that is, one in which achieving the objectives of a course becomes seamlessly incorporated into the process itself, and where the joy of teaching is indistinguishable from being a student of the students' learning.[6] The apotheosis of my dream class was my women's literature and feminist criticism class of 1988, which accepted my invitation to embark with me on a collaborative experiment to explore the feminist critique of Romanticism, a subject in which I am not a specialist. In thinking and writing about the sheer exuberance of that experience since then, I have tried in vain to isolate the factors that might account for what had seemed so successful to us all in working across difference. Was it that the more democratic collaborative setting had allowed me to comfortably shed my role as "expert"? Was it the carefully sequenced readings and exercises? Was it that the students enjoyed reader-response journal writing, for most of them a "first" in graduate education—or were we all just nice people?[7] And how accurate, in any case, is the absence of factional strife or the presence of a mutually reinforcing class dynamic as a barometer of productive learning?

By contrast, the first time I taught women's literature and feminist criticism (in hindsight probably the most transformational event in my professional life), the tenor of the class was totally the reverse of that of the Singing School. It was no euphonious chorus. Bent on taking literature personally and politically at any cost, that group of highly sophisticated but combustible readers literally mutinied against the strictures of the traditional culture of literary critical interpretation in repudiating the offensive sexist bias in John Updike's short story "A & P," becoming what at the time I thought were literary "illiterates" by reversing the norms of what was deemed "naive" and what, "educated."[8] Yet in my discussions with those students since then, we've concluded that, in the depths of all that anguish, none of us ever stopped thinking feelingly or feeling thinkingly about what we were doing and why. Psychic suffering *can* be a powerful condition of learning, but it's not that simple either. That incursions into the inner life are necessary effects of my coming to know does not give teachers licence to perform the "god trick and all its dazzling—and, therefore blinding—illuminations"[9] on unsuspecting students. Professional hubris, an occupational hazard of all teaching, which by its very nature invokes change, is especially pertinent to English studies and feminist pedagogy, whose mandate espouses liberation, whether that liberation be from the "hegemony" of The Great Tradition to the "freedom" of discourse theory, or simply toward a more egalitarian classroom.

Over the twelve years that I've been teaching at the graduate level, in both feminist literary criticism seminars and in mainstream philosophy of literature courses, I have

moved from a performance pedagogical mode and a fairly tightly structured curriculum to a more decentered classroom and a syllabus constantly open to revision. But that doesn't mean that I can tell any better when a class is "working" and when it isn't. How do I know that what looks like everyone riding our communal bicycle is not really a coercive regime masking silences and erasing hostilities? And conversely, given that my role is so fraught with paradox, especially in a feminist class, where I am invariably cast as "the bearded mother" (expected to be both supportive emotionally and rigorous scholastically),[10] how do I know that something quite wonderful is not happening to someone? What am I, for instance, to make of the remark of one of my best students who sincerely thought she was paying me a compliment with, "I really love your class. It makes me sick to my stomach"? By this I take her to mean that she was involved in what Shoshanna Felman calls "self-subversive self-reflection,"[11] a process in which her presuppositions about the conditions of her own learning were continually being thrown open to question by herself and by others whose intellectual training, political temper, and disciplinary affiliations differed markedly from hers. Though this polylogue can be productive, it can also precipitate dialogic impasse, especially in an interdisciplinary class, when one hears statements such as, "I understand where you are coming from, but have you read X?" (a book or article intended to correct what is presumed by the questioner to be Other's misguided ideology about what should count as knowledge).

Accepting the Other on the Other's own terms entails self-subversive self-reflection about our own paths of identification; it also foregrounds the ethical importance of what Northrop Frye called the "direct" or "participating" response[12]—to literature and to fervently held assumptions about one's own life. In the literary educational enterprise there is, of course, no substitute for knowledge *about* texts and their theoretical implications. *What* people say, *how* they respond, is doubtless important; but, *that they do* in this or that way is in some respects a prior consideration. That is to say, performative utterances situate students as moral beings, who in turn form the social fabric of the classroom community. This is a crucial point when dealing with the personal and the political implications of response to literature, inasmuch as the pedagogical importance of cultural codes cannot claim epistemic privilege over students' affective lives. While discourse strategies may improve conceptual understanding, they do not necessarily alter autobiographical significance, which I suggest is an educational value in need of further theorization within both feminist pedagogy and the philosophy of literature education. That is to say, while my literary interpretation may be "better" than yours, and my analysis of classroom dynamics possibly more astute, I, nevertheless, cannot make you mean.[13] The ontological force of this dictum is a logical extension of politicizing and privileging "direct" literary response at the same time (a contradictory endeavor, as we'll see).

It was this problematic of reeducating the imagination that I consciously undertook when I returned to the classroom after a year's sabbatical during which I completed a book addressing issues related to canon, curriculum, and literary response.[14] In designing the course (a mainstream course dealing with literature and values in education, also taught for the first time), I wanted to replicate the structure of my own argument in the book as well as to let the phenomenology of my journey in the feminist critique of

Frye's concept of the educated imagination unfold, as I intended that it would for my reader. Since the book was still in press and I felt uncomfortable about distributing the manuscript, I combined sequenced ancillary readings that had informed my own thinking in writing the book with class discussion and twenty-minute lectures from the text of my manuscript.

The class (twelve women and three men), composed mostly of high school and community-college English teachers, began as another "dream" Singing School, and ended, if not in a nightmare, in the purgatorial twilight zone of bruised identities and painful oppositional stances between the majority, who "got" it, and the minority who "didn't." I focus on this in order to highlight the complexities of how bringing the personal and the political simultaneously into the discussion of response to literature might help us think about the discrepancies between what we think is happening in front of us and what in fact might be going on. When, indeed, is a Singing School not a chorus? When is feeling sick to your stomach an indication, not of the "natural" part of coming to consciousness, but of the oppressive effects of too much consciousness at the wrong time and in the wrong circumstance? And when might it be producing what Teresa de Lauretis calls a "genuine epistemological shift"?[15] When does honoring the Other on the Other's own terms bridge the intrinsic and extrinsic value of literary education and when is it simply the arrogant admonition by those who presume to "know" of those who would know better? And does it matter whether it is one or the other?

Let's first look at what made me think last year's Singing School was tuneful. My sense of it as a "dream class," the feeling that it was going swimmingly or that the class was teaching itself, was confined to the first half of the course, where the students quickly took hold of my clear-cut conceptual framework. (The course examined the interdependence of the why, what, and how of teaching literature under the rubric of a "meta-problem," which juxtaposes the issues of justifying the teaching of literature [why], canon/curriculum/censorship [what], and the classroom treatment of reader response [how]). The promise of seriously working across difference came early when one of the men, Kevin, signed up to do a seminar on Julia Kristeva's concept of abjection later on in the course.[16] As time went on, I consulted with the students about revising the balance between new content and digesting what had gone before. At about the halfway point, another student, Ellen, conducted a lucid account of my taxonomy of Frye's developmental theory of reader response. Here she used a tape of John Updike reading his "A & P," the "invidious" piece that had been the site of the previous rebellion in my women's literature and feminist criticism class. Now, however, reactions were multiple: some students were chuckling with obvious enjoyment, others were grim, still others, pensive. No one, it seemed, was unengaged. The presenter herself had intentionally adhered to Frye's structure, a hierarchy of "pre-" to "post-critical" response, with "autonomous" at the top; describing her initial feminist resistant response to the story as an angry, and therefore "negative" and "lesser" stock response, she acknowledged that it had become more "refined" to a "fuller," more "literary" one as she saw herself moving through her "raw experience" to an understanding of the story as a whole in a "greater appreciation of the human condition." (Later, after reading Sandra Lee Bartky, she observed that she

was probably able to do this because she was a younger feminist and had not experienced "the double ontological shock" Bartky describes.)[17] As people began to discuss the conditions of their responses more openly, I had the feeling that this was just about the ideal class. They were doing double-takes all over the place, but really communicating. What possibly could have been better?

There was, however, a nagging doubt that just maybe the class was beginning to feel set up by the agenda of the course, which remained largely hidden from them. Ellen's presentation had in a way become a perfect foil for the following week's seminar, in which we dealt with my feminist subversion of my taxonomy. But the effect on her of that reversal and indeed of the feminist cast of the rest of the course was quite emotionally devastating, as it was for some other students. I began to ask myself whether, in the very actualizing of my pedagogical project, I had helped produce at least one casualty of its very efficacy. If so, what did that mean about my respect for my students' learning? Shouldn't students be subjects, not just objects, of their own transformations? Who is responsible for the psychological cost of such transformations? And what right did I have to do what I was doing at all? I went to the next seminar convinced that my book manuscript would still be the informing principle of the rest of the course, but not the *controlling* principle. That is, I resolved to reserve more discussion time in order to diffuse any latent hostility generated by my possibly manipulating the students into enlightenment (I had to give them more power), to loosen my hold on the structure, stop lecturing, and focus on student presentations of the secondary material without my intervention except as just another member of the class.

This proved to be yet another paradox of decentered teaching. There was no way I could divest myself of my authority, already established by the heuristic I'd set up at the beginning and reinforced by my own invisible manuscript as a major component of the course content. Even more worrisome to me was that I was increasingly becoming identified with a more rigid ideological stance toward the course material than I in fact held. At the same time, coincident with my decentering, the majority of the women and one of the three men had begun to evince their profeminist concerns more overtly; others complained that in the second half of the course there was a loss of continuity in the conceptual framework, which, of course, only I could provide. Little wonder that I felt the class was polarizing badly and that its exploratory intent seemed to have become submerged in a "search for answers."

The Updike episode had opened up the possibility of a *poetics of refusal* that had taken seriously the negative effects of the close proximity of some literary content to the lived lives of readers. These students had extended that discussion to include how being very close to the bone of real experience also affected their critical temper and their own teaching practices. Though the positive exchange in the class, as well as the students' final papers, persuaded me that the self-subversive self-reflection of most of them had indeed produced heightened sensitivity to the Other, anger, silence, and denial also surfaced. These came to the fore when another woman, Clare, did a forceful reading *with* the grain, of Robin Morgan's *The Demon Lover: The Sexuality of Terrorism*.[18] Clare's intent was to "put on" Morgan's polemic in relating social and cultural processes to systemic

misogyny. That seemed to tap into the deep but covert rage felt by some of the, until then, more "detached" feminists, who now were able to recover their voice—and did, with vehement recognition scenes. Ellen, however, did not join that chorus, but became noticeably upset, excusing herself in tears at the break. A few days later she confessed her anxieties about remaining in graduate school: the course had triggered her feelings of futility about academic work, and she thought that perhaps she should return to high school teaching. Having become alienated from literature as a living force in her life through doing an MA in a highly conservative English department, she had relished the prospect of our trek into theory; but now she had second thoughts about its value if such negativity as was being expressed in the class was still rampant after so many years of feminism. A staunch feminist as an undergraduate, she'd expected that by now feminism would have "moved ahead to something more inclusive." This, in face of the fact that figuring in her present crisis was her grief over the murder of one of her own female students. Ironically, though, Ellen's path of identification, which she confirmed in her final paper, was with the two "outsider" men in the class, both of whom were feeling embattled. One was Kevin, who told me that he was surprised to encounter so much feminist content in a course that wasn't advertised in that way.

Kevin was also full of contradictions. In his seminar on Kristeva, while he bravely grappled with her complex notion of abjection, something that he acknowledged he could understand only intellectually from his privilege as a white, heterosexual male, he ended his presentation by bringing in Robert Bly's *Iron John*,[19] thereby positioning himself as victim. And in the discussion period, he deliberately interpolated the term "terrorist" to describe what he referred to as "militant feminism." This, he said after class, was a strategic move to address the by now palpable feminist agenda of the course. When another woman, Jennifer, rewrote "A & P" from the viewpoint of "the witch about fifty, with rouge on her cheekbones and no eyebrows"[20] as a way of expressing her "epistemic privilege,"[21] her feelings of being "Othered" by Updike, Kevin simply dug in his heels, insisting that the portrayal of the males in Jennifer's rewrite didn't remotely resemble him or any guy he knew.

Perhaps Ellen and Kevin were in part both trying to find their own "safe house" in face of their loss of a certain conceptual security, which had been provided by the structural framework of the course set up at the beginning, and in face of their peda-gogical loss of the bearded mother. It is worth mentioning that in this class these losses coincided with the introduction of explicitly feminist content, which complicated the meta problem with what we might call the "feeling, power, and location problems."[22] What seems clear about Ellen and Kevin is that they were both thrown up against their own resistance—Ellen as one who already knew too much and perhaps wanted to know less, at least for now, and Kevin as one who couldn't cope with his own aware-ness of what he didn't yet know. Yet by the end of the course this playing field looked profoundly unequal: whereas Kevin was voluble, Ellen fell silent. It's difficult to assess here who "got" it and who "didn't"; moreover, what is the "it"? Did Ellen "get" "it" and just couldn't bear to feel "it," yet again, in her solar plexus? Did Kevin have to fill up the space because he couldn't hear "it," or because he could? Does he remain

an "unreconstructed male"? Is that my business? What *I* perceived was that Ellen was experiencing Bartky's "double ontological shock" more or less alone, and that Kevin's feelings were being taken care of by me and the rest of the class. When is honoring the Other on the Other's own terms truly emancipatory and when might it mask a false integrity?

This year, when I teach the course again, the students will be in possession of the text of my book; my feminist project will be more visible to them from the start; and my pedagogy will consist almost exclusively of small groups reading and rewriting each other's short papers in response to the primary and ancillary texts. That might mitigate, but will not eliminate, the incessant transferring and withdrawing of powerful psychic projections that necessarily abound when the personal and political contexts of literary response form part of the agenda of a literature classroom in grade ten English or a graduate seminar in literature education. Once we credit transformation of any kind as a legitimate goal of our teaching, literature ends up with more relevance to life than many of us who entered the profession as a partial escape from life originally bargained for. One can only be where one is in literary criticism, but to be wherever one is today is indeed a "perilous undertaking,"[23] in which the resistances of students like Ellen and Kevin have become a new body of content—inchoate, untidy, but nonetheless sacred, matter.

Does this mean that teachers of literature are the unwitting "mental health paraprofessionals" that Clara Park (in *Uses of Literature*, one of the volumes of the 1973 *Harvard English Studies*) said that we perforce become?[24] As someone professing to be a philosopher of literature education, not a clinical psychologist or bibliotherapist, I can't say that I'm really up for this.[25] But as a practitioner of feminist pedagogy, I do not find the alternatives wholly satisfactory either. Returning to uncritiqued notions of "literariness" and universalist paths of identification, innocent of political awareness, is certainly not an option for me. That only makes it easier for some to move from prefeminist or precolonial unconsciousness to appropriation without ever having to pass through comprehension. Even abandoning transformational agendas altogether—teaching the theory wars or navigating students through endless textual undoings and remakings—cannot blanket over the still monumental significance of the intervention by "words with power"[26] in the emotional lives of people who really might be changed by what they learn in school.

Felman suggests that "the most far-reaching insight psychoanalysis can give us into pedagogy" is the realization that "the position of the teacher is itself the position of one who learns, of the one who teaches nothing other than the way [s]he learns. The subject of teaching is interminably—a student; the subject of teaching is interminably—a learning."[27] And, she argues, this knowledge is a fundamentally *literary* knowledge in that it is knowledge *"not in possession of itself."*[28] A knowledge not grounded in mastery but always in the process of becoming is especially germane to the educational aim of meeting the Other on the Other's own terms. This pedagogy of the unknowable does not disclaim knowledge; it *"knows it knows but does not know the meaning of its knowledge."*[29] Within this context, students' resistance to knowing is perhaps one of the best teaching tools we have. As Felman, Frye, and others before them have observed, teaching is impossible; that is why it is difficult.[30] What, then, are we to do? In coming to solutions, we might

keep in mind the thoughts of the young Polish pianist Krystian Zimmerman, who gave a master class in Toronto last spring. In concluding his remarks to the audience and to the five students whose sparkling performances he'd unabashedly acknowledged his admiration for, he said, "Of course, we study the text, and then improvise around it. The rest is up to you. But the most important thing is to do [*sic*] mistakes, as many as possible and as soon as possible."[31]

Ellen did decide to remain in graduate school, and even won a scholarship. In her final paper, she reflected on our various mistakes when she responded to the optional question I asked about the experience of the course as a whole:

> My unusually emotional response to this course was of considerable concern to me, hence the amount of time spent analyzing my feelings and discussing the situation with friends. I have concluded that mine has been a rather ironic and yet educational experience. What I have encountered, I think, is a very real feeling, power, and location problem within a course where [these problems were] not only recognized but apparently sympathized with . . . What I am left with primarily are not feelings of alienation . . . or cynicism . . . (although these feelings do exist still); rather, I have become more profoundly aware of just how complex perception, communication, and inter[personal]relations are and just how difficult it is *not* to make assumptions, to disempower someone or to silence opposition in a group setting. I am also much more aware of how emotions, social contexts, and personal meanings and experiences affect learning, which has been traditionally seen as [only] an intellectual activity.

Here Ellen has named for herself what David Bleich has called the "affective [inter] dependency" of the classroom.[32] Perhaps a Singing School can still be a chorus, if dissonance be part of resonance.

Notes

Bogdan, Deanne, "When is a Singing School (Not) a Chorus?: The Emancipatory Agenda in Feminist Pedagogy and Literature Education," Revised version; ed. Audrey Thompson, *Philosophy of Education 1993*, vol. 49, pp. 327–336. (Urbana, Illinois: Philosophy of Education Society, 1994).

This paper was first presented at the Forty-Ninth Meeting of the Philosophy of Education Society, New Orleans, March 1993. It appears in the Proceedings of that conference and is slightly revised here; I wish to express thanks to the proceedings editor, Audrey Thompson, for permission to reprint. As well, I am grateful to Wendy Burton, James Cunningham, Hilary Davis, and Alice Pitt for their comments and suggestions on an earlier draft, and to members of 1485S who gave me permission to excerpt their work.

1. Contemporary literary theory has propelled the profession beyond unproblematized Arnoldian or Leavisite assumptions about the liberatory nature of English studies. But teaching to or for theoretical understanding does not erase the question of the powerful impetus for per-

sonal change inherent in all teaching. This is especially true of literary reading. Shoshanna Felman reminds us that any "reading lesson is . . . not a statement; it is a performance. It is not theory, it is practice . . . for (self) transformation." *Jacques Lacan and the Adventure of Insight* (Cambridge: Harvard University Press, 1987), p. 20. The rapprochement between English studies and feminist/critical pedagogy has been underscored by numerous authors, including Janice M. Wolff, who introduces her article "Writing Passionately: Students' Resistance to Feminist Readings" with the assertion that "ideological consciousness-raising is very much part of [her] faculty's concerns." *College Composition and Communication* 42 (4) (December 1991): 484, I read this paper after having completed my own, and would like to note the resemblance of its themes to this one, in particular, resistance as an instrument of learning, the gendered character of students' resistant responses, and the teacher as one who does not know.

2. Elizabeth Ellsworth, "Why Doesn't This Feel Empowering?: Working through the Repressive Myths of Critical Pedagogy," *Harvard Educational Review* 59 (3) (August 1989): 318.

3 Deborah P. Britzman, "Decentering Discourses in Teacher Education: Or, the Unleashing of Unpopular Things," *Journal of Education* 173 (3) (1991): 75.

4. Ibid., p. 60.

5. "The Singing School" is the title of the second chapter of Northrop Frye's *The Educated Imagination* (Toronto: Canadian Broadcasting Company Publications, 1963), pp. 12–33. The original citation is taken from Yeats's "Sailing to Byzantium" (quoted in Frye, p. 12).

6. See Marion Woodman, Kate Danson, Mary Hamilton, and Rita Greer Allen, *Leaving My Father's House: A Journey to Conscious Femininity* (Boston and London: Shambhala Press, 1992), p. 167.

7. See Deanne Bogdan, "Joyce, Willie, and Dorothy: Literary Literacy as Engaged Reflection," *Proceedings of the Forty-Fifth Annual Meeting of the Philosophy of Education Society*, San Antonio, Texas, April 14–17, 1989, ed. Ralph Page (Normal, IL: University of Illinois Press, 1990), pp. 168–182.

8. See Deanne Bogdan, "Judy and Her Sisters: Censorship, Identification, and the Poetics of Need," *Proceedings of the Forty-Fourth Annual Meeting of the Philosophy of Education Society*, San Diego, California, March 25–28, 1988, ed. James M. Giarelli (Normal, IL: Philosophy of Education Society, 1988); John Updike, "A & P," in his *Pigeon Feathers and Other Stories* (New York: Knopf, 1962).

9. Donna Haraway. "Situated Knowledges: The Privilege of Partial Perspective," *Feminist Studies* 14 (1988): 584.

10. Kathryn Morgan, "The Perils and Paradoxes of Feminist Pedagogy," *Resources for Feminist Research* 16 (1987): 50.

11. Shoshanna Felman, *Jacques Lacan*, p. 90.

12. Northrop Frye, *The Critical Path: An Essay on the Social Context of Literary Criticism* (Bloomington: Indiana University Press, 1971), p. 28.

13. See Susan Leslie Campbell, "Expression and the Individuation of Feeling" (PhD diss., University of Toronto, 1992), p. 291; also Felman, *Jacques Lacan*, p. 119. In her response to Charles Taylor's Inaugural Address to the University Center of Human Values at Princeton, Susan Wolf makes a related point about the justification for widening the canon. See Charles Taylor's *Multiculturatom and the Politics of Recognition, with Commentary by Amy Gutmann*, ed. Steiner C. Rockefeller, Michael Walter, and Susan Wolf (Princeton, NJ: Princeton University Press, 1992), pp. 79–85.

14. See Deanne Bogdan, *Re-educating the Imagination: Toward a Poetics, Politics, and Pedagogy of Literary Engagement* (Portsmouth, NH: Boynton/Cook-Heinemann, 1992).

15. Teresa de Laureos, *Technologies of Gender: Essays on Theory, Film, and Fiction* (Bloomington: Indiana University Press, 1987), p. 10.

16. Julia Kristeva, *Powers of Horror: An Essay on Abjection*, trans. Leon S. Roudiez (Oxford: Blackwell, 1982).

17. Bartky defines the "double ontological shock" as "first, the realization that what is really happening is quite different from what appears to be happening; and second, the frequent inability to tell what is really happening at all" (1979, 256). Sandra Lee Bartky, "Towards a Phenomenology of Feminist Consciousness," in *Philosophy and Women*, ed. S. Bishop and M. Weinzweig (Belmont, CA: Wadsworth, 1979), p. 256.

18. Robin Morgan, *The Demon Lover: On the Sexuality of Terrorism* (New York: Norton, 1989).

19. Robert Bly, *Iron John: A Book About Men* (New York: Addison-Wesley, 1990).

20. Updike, p. 187.

21. Uma Narayan, "Working Together Across Difference: Some Considerations on Emotions and Political Practice," *Hypatia* 3 (2), (1988): 34.

22. See Bogdan, *Re-educating the Imagination*, pp. 140–148.

23. Clara Clairborne Park, "Rejoicing to Concur with the Common Reader: The Uses of Literature in the Community College," in *Uses of Literature*, ed. Monroe Engel, *Harvard English Studies 4* (Cambridge: Harvard University Press, 1973), p. 231.

24. Ibid., p. 242.

25. Toronto high school teacher Brian Fellow, in an article titled "Sex, Lies, and Grade 10," describes his reader-response approach to a literature lesson on the poem, "Lies," by Yevgeny Yevtushenko. According to Fellow, the theme of this poem is "Do not lie to the young." As a way of exploring its meaning with his class, Fellow wrote on the board three columns: "The Best Lies, The Best Liars, and The Best Liees." The result was not an interpretive discussion about the poem as what we might call a "greater appreciation of the human condition" in the abstract but the palpable and painful coming to terms with the social problem of sexual pressure experienced by the girls from their boyfriends, some of whom, as attested to by one of the girls, tell the worst lie—"I love you." Such was the gravity of the unspoken crisis in that instance that the girls in the class ended up proposing the startup of a support group "like Alcholics Anonymous." *The Glove and Mail*, Toronto, Ontario, October 20, 1992, p. A32. Surely Percy Bysshe Shelley would be surprised to see this particular context for poets as the unacknowledged legislators of the world. I am not suggesting that this poem not be taught according to a reader-response model. I am simply pointing to the deep social effects that literature has in the lives of readers and that it has always claimed to have.

26. See Northrop Frye, *Words with Power: Being a Second Study of 'The Bible and Literature'* (Harmondsworth, England: Penguin, 1990).

27. Felman, *Jacques Lacan*, p. 88.

28. Ibid. p. 92.

29. Ibid.

30. Ibid., p 69; Northrop Frye, *The Stubborn Structure: Essays on Criticism and Society* (London: Methuen, 1970), p. 84.

31. See also Felman, *Jacques Lacan*, pp. 78–79, 89.

32. David Bleich, *The Double Perspective: Language, Literacy, and Social Relations* (New York: Oxford University Press, 1988), p. 94.

CONTEMPORARY

I. Education and Schooling

Gender Disidentification

The Perils of the Post-Gender Condition

Cris Mayo
University of North Carolina at Greensboro

As I get older, I am more and more tempted to think that students who disagree with me are just wrong. Clearly this is not a fully educational approach, but, particularly in the area of gender, I have increasingly encountered young women of high school or college age who distance themselves from their gender in ways that seem to me definitely wrong, and even foolhardy. This has been particularly striking in public high school discussions of sexual harassment, where young women do more than argue against feminist worries on the subject; they argue against their membership in the category of gender. While they do not deny that they are women exactly, they do deny a need to worry about gender-related bias, ostensibly because they are "not that kind of girl," that is, the kind of girl who is not capable of defending herself or thwarting socialization. Given recent *New York Times* coverage of the death of feminism (again), these young women's general "disidentification" with gender makes a certain kind of sense in what they perceive as a post-gender world. I contend however that they are just wrong to do so, because the world is not post-gender. I want to distinguish the strategy of "disidentification" from other possible interpretations (or misinterpretations) of identity. While I will argue that these young women neither suffer from false consciousness nor achieve full transgression, their strategy of "disidentification" does appear to fall somewhere beyond, but still in sight of, these other two dynamics of identity.

While I do take seriously the extent to which relations to gender change generationally and contextually, curricular and legal attempts to address gender inequity are also partially behind young women's tendency to disidentify. For instance, there has been much criticism of sexual harassment laws of late, not because they raise murky issues of "he said, she said," but because laws and their judicial interpretation have moved sexual harassment as a concept away from the larger problems of gender inequity. As Vicki Schultz has argued, courts have tied themselves up in the language of relationships, sexual attraction, and rebuff, and largely ignored the social forces behind these micro-examples.[1] Curricula and school law have also contributed to this by tending to single out personal

miscommunication and prosecute sexual relationships between students and teachers as the paradigmatic case of sexual harassment. The harder case, the persistence of gender inequity throughout social and institutional relations, is largely left unlitigated because, of course, laws require individual cases for disputes to take place. The easiest individual cases for plaintiffs to win involve age-inappropriate interpersonal sexual relationships. While these relationships may indeed be problematic, their prosecution reinforces the stereotype of sexual harassment as a problem of individuals. That young women then view sexual harassment and problematic gender relations as something they can avoid through refusal of identity does make sense within this context. But the tactics of these young women raise other questions about identity, questions that have been central to feminist attempts to explain antifeminism and poststructural attempts to refigure identity as something that can be transgressed for political gain.

As we try to bring poststructural concerns about identity into our teaching we run the risk of encountering students who, whether through liberal individualism or post-feminism feel that the old problems of identity are no longer theirs. As one colleague in women's studies used to say, "I spend the first half of the term teaching them that they are women and the second half of the term deconstructing that identity." Attempting to deconstruct identity without first putting identity in place runs the risk of reinstalling liberal individualism when students, who are unused to viewing themselves as part of an identity category, refuse to consider themselves part of a category that describes their social identity. By social identity, I mean the categories by which other people recognize these very identity-refusing students. I want to argue that these students are in something of a bind. To refuse to identify with a category does not change how they are potentially perceived by others. Ignoring the social aspects of identity does open "disidentification" to the charge of false consciousness. Clearly, identity does still have meaning to social institutions and a variety of interlocutors these students will encounter. They may be interpellated by their identity, whether they closely identify with it or not. Still I do want to give credence to disidentification as a strategy, though I will suggest a number of shortcomings later. Disidentification does remind us that identity categories are shifting and contested, and it may be that disidentification is the beginning of critically refiguring one's relationship to one's identity. It does seem to involve reading cultural codes constraining identity and refusing to participate in them. Before turning to possibilities, though, I want to distinguish disidentification, from false consciousness and then I will take up the question of disidentification's potential peril and transgressive potential.

False Consciousness and the Authority of Experience

While not all definitions of false consciousness may be in sync, false consciousness implies that someone may be blinded by ideology and not realize the truth about herself or her situation. In other words, people who succumb to false consciousness are blissfully (or not so blissfully) unaware of the problems they face. Another more Foucauldian version of false consciousness is also a useful way to look at disidentification. It is not just that

people are blinded by ideology, but they have been so fully interpellated by it that even in moments of crisis, in which the categories of common understandings of the world are in motion, and in conflict, subjects misunderstand their own general interests and become complicit in the preservation of ideologies that operate to restrain them, or to limit them. That is to say, it is not just a problem of blindness, but a problem of the structural complicities that blindness leads to. The charge of false consciousness has been a problem for feminism particularly, because if we value women, we have to value their experiences.[2] Catharine MacKinnon discusses this problem in a lengthy footnote, worth going over in some detail. She contends that feminism faces a problem when it attempts to account for women who are not feminists. This desire to distance themselves from what they perceive to be "feminist" may be part of why young women disidentify from their gender in discussions of sexual harassment or sexual abuse. There are also other reasons: for instance, the version of gender presented is not consonant with their own experience of gender. I will return to this issue later. For now, I want to grapple with how the problem of false consciousness is wrapped up in a problem of experience and knowledge.

MacKinnon contends that feminism raises the problem of "authority of interpretation."[3] How do feminists hold that patriarchy is limiting to women and at the same time account for why some women support patriarchy? She says that feminists have generally answered this in two ways. First, feminists who take for themselves a greater weight of authority contend that women who support patriarchy are victims of false consciousness. MacKinnon dismisses the view that feminism is superior to antifeminism merely because feminism is critical of women's situation, noting that such a view relies on agreement that women are oppressed. Antifeminists do not agree with this claim and contend that they occupy a critical position, with as much weight of critical authority as feminists. Their lens of criticism is simply turned toward feminism not anti-feminism because they do not accept feminism's claim that women are oppressed. MacKinnon contends that the second feminist response to the problem of antifeminist women is not any better. These feminists accept any woman's version of her experience, based on the presumption that all women are free to frame their experiences as they see fit. In addition, the claim that every woman or man can give a full and free interpretation of his or her experience, does not account for different interpretations of the same experience or conflicts in interpretation itself. MacKinnon contends this approach "tends to assume that women, as we are, have power and are free in exactly the ways feminism, substantively, has found we are not."[4] In order to sort out this problem of false consciousness, then, we have to sort out the problem of experience and authority of interpretation.

Joan Scott attempts this in her article, "The Evidence of Experience," in which she contends that in our haste to dismantle objectivity, we have instead installed the primacy of "experience" without insisting that experience's claim to authority is in need of critical work. Scott argues:

> When experience is taken as the origin of knowledge, the vision of the individual subject . . . becomes the bedrock of evidence on which explanation

is built. Questions about the constructed nature of experience, about how subjects are constituted as different in the first place, about how one's vision is structured—about language (or discourse) and history—are left aside. The evidence of experience then becomes evidence for the fact of difference, rather than a way of exploring how difference is established, how it operates, how and in what ways it constitutes subjects who see and act in the world.[5]

I think students have taken up this turn toward experience in the way they situate their claims as "just my opinion" and the way they mark out the limits of their understanding as "well, person x just doesn't have the same experiences as I do and I will never understand." This is, of course, the very worry conservatives have about multiculturalism, namely, that it will install relativism. The preceding student claims, however, are not evidence of a multicultural relativism, as these claims make one's own identity entirely individualistic, divorced from social forces and history, just as Scott warns against. It is, indeed, a relativism more likely borne of an individualism disinterested in others that makes the identity of others a thing of inscrutable categories. In the end, students wind up thinking they are themselves capable of anything but that other people are trapped by their categories.

These decontextualized notions of identity raise some problems Barbara Houston points to in her discussion of the shortcomings of gender-free education. Houston warns that misperception of gender fairness is often present in attempts to install gender-free approaches to education. She points to the problem of judging girls as doing less well than boys "even when they do as well as or better than boys at the same activity." In this case, what students' experience is that girls are not as valuable even when they perform tasks as well or better. Without examining male systems of valuation, Houston warns, we are furthermore in danger of presuming the current system of merit to be itself gender-free. Houston further notes that students misperceive teacher attention to be disproportionately directed at girls even when girls received only 34 percent of the attention. In this case, students' experience of what was "fair" was in fact biased, based as it was in a male-dominant ideal. Houston contends that "our own existing perceptual frameworks are themselves too gender-biased to provide reliable guides as to whether or not our approaches are actually gender-free."[6] Following Jane Roland Martin, Houston advocates a "gender-sensitive strategy" which would encourage questions like: "Is gender operative here? How is gender operative? What other effects do our strategies for eliminating gender bias have?"[7]

Outside Transgressing

These are questions that have been taken up less optimistically by feminist poststructuralist theorists who also wonder how we problematically reinstall normative subjectivity even as we attempt progressive feminist politics. MacKinnon and Houston see the intransigence of gender as a force organizing social relations, while poststructuralists

see the limitations of identity as a political starting point. Critiques of identity have pointed to shortcomings in the degree of agency possible in a subject position too closely connected to its own subjugation. The degree to which one can avoid this aspect of subjectivity is debatable, however. Some theorists have contended that the subject can only be wrestled out of its constraining aspects by active transgression of identity acts, boundaries, and expectations. Judith Butler, for instance, claims that only by subverting the expected codes and actions of identity can subjects highlight and begin to disengage the normalizing aspects of subjectivity.[8] Indeed, because subjectivity is constructed through repetitions that inevitably fail, subjectivity inevitably swerves from its original position to something new. The question remains: To what degree is this something new any less bound up in the problematics of identity? Importantly, agency lies in the ability to understand the context and codes of identity, as well as to productively refuse them.

Wendy Brown contends that identity groups that seek their freedom on the basis of an identity that has been normalized by power tie their struggle closely back into the very institutions that constrain their activity in the first place.[9] My contention that disidentification fails to transgress is based on the appearance it gives of tying students back into an individualist subjectivity, wherein they are responsible for their actions, as if constraining social forces and reigning conceptions of subjectivity were not even present. And yet I think these students start from within an understanding of social forces. That is, their refusal of identity occurs in the context of understanding how identity has been central in the constitution of subjectivity. In this sense then, they are attempting to transgress from within an understanding of culture, but they do so by attempting to remove themselves from its force. Neither Butler nor Brown, of course, argues that we can get outside of this normalizing power, but both essentially argue that there are better and worse ways to live under normalizing power. The better way, if one can push the normative content, is to understand the codes of power, not to do without them or move outside of ideology to where the air is fresher and the milk cheaper, but to work and rework the codes of power more responsibly and more relationally.

Brown does argue against identity politics in a way that is similar to the way students distance themselves from gender, though they are binding themselves to liberal individuality, not gender. She contends that identity politics is bound in a resentment that encourages its advocates to demand recognition and protection because of their weakness. Because so much of identity politics binds its political claims to its sense of injury, its advocates cannot embrace power without losing the ground of their critique. In other words, a politics based on resentment is a politics grounded in injury, trapped by its own project and unable to find a way out of its original problem. This means that identity politics, or any politics based on injury, derives its power from its pain. Even in the midst of agitating to have that pain relieved it cannot explicitly embrace power without losing its reason for being. As a result, Brown argues, identity politics cannot move beyond its current situation to a fuller sense of "futurity" that would be reflected in political projects that attempt to "fight for a world rather than conduct process on the existing one."[10] While I disagree that identity politics is as bounded as Brown claims,

her argument and student disidentifications do push feminism and critical pedagogy to watch for the problems of emphasizing dangers without pointing to possibilities for change. Here I think a stronger sense of relationality in identity is necessary to make "the personal political." The personal is not intrinsically political, and perhaps the supposition that it is intrinsically political is a case of a persistently bad misreading, but the personal becomes political as relations are formed over questions of identity. These articulations of identity are in play through politics, which gives rise to the original meaning of "the personal is political" as it is used in feminist politics, consciousness raising, and organizing. Brown, I think, mistakes the political purpose of identity politics and argues that identity politics' concentration on the question "Who am I?" should rather be shifted to "What do I want for us?" It is my contention, however, that these two questions are not easily separated. Public assertions of identity, as well as educational discussions of identity, can be an invitation to mutual consideration of political projects that attempt to name both injury and identity as issues for deliberation and contestation. The problem with disidentification is that it potentially shuts down the conversation on identity by simply refusing to engage the category of gender, as if history and social forces are so easily kept at bay.

Before I engage in worry over this, I do want to point out the positive potential in transgressing categories that have become too constraining, through acts of reinterpreting identity that I do not take to be disidentification. The distinction I want to make between the two is that transgressing does understand the situated meaning of the categories of identity and does not insist that they disappear. Indeed, transgressing requires an understanding of the persistence of the categories that are transgressed and presumes that one needs an audience and that one's audience will understand the transgression. In other words, transgression plays within codes that are understood to be social and historical. Disidentification, in contrast, is a refusal of history.

The history of feminism is replete with conflict over whose definition of gender will rule the day, conflicts most often raised when white, middle-class gender displays itself as unmodified gender. Indeed students argue that what adults see as sexual harassment, they see as playful sexuality, that "real" adults mistakenly equate sex play among younger people as necessarily dangerous precisely because the people involved are so young.[11] This may also be a moment when African-American female students attempt to deflect teacher criticism of the behavior of young African-American men in class, insisting on their own ability to handle themselves with young men.[12] Thus, these young women are saying that the version of gender offered by some educators is weaker than the version of gender they live. In addition, well in keeping with much criticism of white feminism from women of color, the version of female victimization that appears to be offered in anti-sexual harassment education lacks a sense of cross-gender relationality and thus a lack of racial solidarity. These tactics of insisting on a fuller understanding of the interplay of age and responsibility, race and gender, are each useful additions to an understanding of the swirl of identity relations in any interaction. Indeed, these stances toward identity do much to heighten a sense of agency and responsibility in interaction.

Perils Await Those Who Live Outside of History

Unfortunately, not all young people are as able to control their relations as the above examples would suggest. A recent report from the American Association of University Women indicates that sexual harassment in public schools is widespread. In a survey of 1,632 students, 85 percent of girls and 76 perceent of boys reported "unwanted and unwelcomed sexual behavior that interfered with their lives." African-American boys were more likely to be harassed than whites or Hispanics, while white girls were more likely to be harassed than African-American or Hispanic girls. Despite the relatively close percentages of sexual harassment across gender, the effects of the harassment varied strongly along gender lines. Girls reported significantly greater negative effects, such as not wanting to attend school and not wanting to talk in class. In addition to girls' negative responses being higher than boys', there was a larger percentage of negative responses among African-American and Hispanic girls than among white girls. Girls were also up to three times more likely to report that harassment affected their ability to pay attention and to get good grades. Girls were also twice as likely to feel embarrassed than boys and up to three times as likely to feel less self-confident or to feel self-conscious. Boys, on the other hand, were twice as likely to report that sexual harassment made them feel more popular. African-American boys were most likely to be harassed in a physical manner, either by touch or by having their clothes pulled down. The vast majority of students, 86 percent, when asked which form of harassment would bother them the most, reported that being called gay was the worst. Boys were twice as likely as girls to be the focus of anti-gay taunts.[13] Thus, it is clear from the AAUW report that sexual harassment needs to be addressed within a context of a broad range of bias-related issues that highlight the social and relational aspects of identity, rather than ignoring them.

My argument is that the refusal of the salience of gender in the lives of all students, then, is mistaken. The specifics of what is entailed in the category of gender do need to be widened and discussed, but the category itself has not disappeared. Students who contend that they are transgressing expected boundaries of gender behavior by refusing gender are thus missing the play of power that encourages them to view themselves as unmarked, liberal subjects. These tactics of disidentification are themselves tied to normalizing power; that is, these disidentificatory practices fail to engender agency. I am thinking here particularly of the response of young women in high school who acknowledge that they have been the targets of unwanted sexual attention given on the basis of a perception of their gender, but who disidentify themselves with the targets of sexual harassment. That is, they equate victimhood with femaleness and claim for themselves an identity outside of that circuit. The problems with this form of disidentification are at least twofold.

First, by acknowledging that harassment has taken place, but removing themselves conceptually from it in an attempt to transgress the limits of gender in their lives, the women who adopt this stance of disidentification neglect to attend to the consequences it has on their social, emotional, and educational outcomes. To a certain degree, then,

they deny the gendered aspects of their selves that opened them to sexual harassment and are thus unable to address the harassment as a condition of their gender. The potential here is that rather than seeing sexual harassment within a social context, they tend to blame the negative impact of sexual harassment on their own personal shortcomings. As Pauline Bart and Patricia O'Brien have noted, in the context of sexual assault, the ability of women to understand themselves as victims of a gender-related crime, rather than individually culpable for what happened to them, helps them to fight back during the assault and helps them through the recovery process after the assault.[14] Thus an understanding of one's gender identity, in this instance, helps one to gain a sense of agency at the time of an attack and to retain one's sense of agency afterward. The young women in high school who disidentify do so to avoid having to conceive of themselves as open to harassment or assault. They evince a high degree of confidence in their status as a person deserving respect, rather than a woman living in a context of potential danger. In order to avoid being a gendered victim, then, they become individualized and isolated victims, worthy of blame for their own victimhood, rather than situated in a context where, the experience of harassment and violence is increasingly prevalent.

The second problem of this disidentification is that it prevents women from connecting with other young women with similar experiences. These young women also tend to lack compassion toward other young women who experience sexual harassment, dating violence, or sexual assault, because to express support means that they too identify with the gender of the person so injured. In addition, many are inclined to blame the victim of sexual harassment rather than see sexual harassment in its social context.[15] This means that young women note that some young women may be the victims of gender-related harassment, but characterize this experience as the personal failure of those victims, thereby reinforcing their own imagined distance from a quality that would open them to harassment and reinforce their distance from people who might well need their support. Thus neither victim nor non-victim has a way to connect with the other that can enhance her perception of their potential interchangeability, and this leaves them without a basis for solidarity. Disidentification with their gender leaves them with little way to approach a world that sees them as gendered, despite their own reluctance to accept gendered identities. What each of these problems with disidentification underscores is that young women do understand what gender is, they do not form their identity outside of gender but rather against it. But rather than undertaking a critical stance toward gender relations, and thus opening discussions of what gender could and should mean, they sidestep the identification and locate themselves as individuals outside of social forces. The productive refusal of identity, rather than subverting codes of power, reinstalls these girls back into a genderless, ahistorical individuality.

Since peer support is crucial to many young adults in crisis, and peer education can be a helpful route in addressing potentially sensitive topics, it is therefore important to reconnect these young women to one another. It is also crucially important that young men be connected to the project of eliminating sexual harassment and assault, not only because they are likely to be the perpetrators, but also because they are likely to be victims as well. Despite their relatively better outcomes when sexually harassed,

young men still need to be considered in discussions (indeed, they too deal with sexual harassment as something that necessarily disidentifies them with masculinity, since to be a victim is to fail to be a man). The point here is to move an individualistic response to harassment into the realm of a political and social critique. This means that anti-harassment education needs to move beyond an individualistic model of explanation to an historicized and politicized interrogation of the various forms of violence in contemporary social interactions.

Notes

Mayo, Cris, "Gender Disidentification: The Perils of the Post-Gender Condition," ed. Randall Curren, *Philosophy of Education 1999*, pp. 356–364. (Urbana, IL: Philosophy of Education Society, 2000). Reprinted with permission.

1. Vicki Schultz, "Reconceptualizing Sexual Harassment," *Yale Law Journal* 107, no. 6 (1998): 1683–805. The point is not to trivialize the personal as disconnected from the social and political, but to warn that the personal is not the only context for sexual harassment.

2. Catharine A. MacKinnon, "Feminism, Marxism, Method, and the State: Toward Feminist Jurisprudence," in *Feminist Legal Theory: Readings in Law and Gender*, ed. Katharine T. Bartlett and Rosanne Kennedy (Boulder, CO: Westview Press, 1991), 181–200.

3. Ibid., 196, fn. 5.

4. Ibid., 197, fn. 5. We will sidestep the fact that her next move in this essay is to distinguish between liberal feminism, Marxist feminism, and radical feminism (which is "true" feminism).

5. Joan W. Scott, "The Evidence of Experience," in *The Lesbian and Gay Studies Reader*, ed. Henry Abelove, Michèle Aina Barale, and David M. Halperin (New York: Routledge, 1993), 399–400.

6. Barbara Houston, "Should Public Education be Gender Free?" in *The Education Feminism Reader*, ed. Lynda Stone (New York: Routledge, 1994), 127–28.

7. Ibid., 131.

8. Judith Butler, *Gender Trouble* (New York: Routledge, 1990).

9. Wendy Brown, *States of Injury: Power and Freedom in Later Modernity* (Princeton, N.J.: Princeton University Press, 1995).

10. Ibid., 48.

11. Umbreen Qadeer, coordinator, Eliminating Violence Through Education, Urbana, Ill., personal communication, 14 May 1998.

12. Ibid.

13. American Association of University Women, *Hostile Hallways: The AAUW Survey on Sexual Harassment in America's Schools* (Washington, DC: American Association of University Women Educational Foundation, 1993).

14. Pauline B. Bart and Patricia H. O'Brien, "Stopping Rape: Effective Avoidance Strategies" in *Feminist Frontiers III,* ed. Laurel Richardson and Verta Taylor (New York: McGraw-Hill, 1993), 413–23.

15. Debbie Nelson, director, Eliminating Violence Through Education, Urbana, ILs, personal communication, 25 Aug. 1997.

Situated Moral Agency

Why it Matters?

Barbara Applebaum

Ontario Institute for Studies in Education of the University of Toronto

In her essay, "Identity: Skin, Blood, Heart," Minnie Bruce Pratt speaks of her struggles to understand racism, sexism, and anti-Semitism.[1] In the process, she examines the moral education she received as a young, white Christian girl growing up in the United States South. Pratt maps her learned ways of seeing (and not seeing) what morality is all about. But she also recounts how, implicit in her moral education, she was

> taught to be a *judge* . . . of moral responsibility and of punishment only in relation to *my* ethical system; was taught to be a *martyr*, to take all the responsibility for change, *and* the glory, to expect others to do nothing; was taught to be a *peacemaker*, to mediate, negotiate between opposing sides because *I* knew the right way; was taught to be a *preacher*, to point out wrongs and tell others what to do.[2]

What kind of moral agency underlies the type of moral education Pratt received and does her social group location (that is, how she is positioned as raced, gendered, classed) affect the type of moral agency she develops?

Essential to any conception of moral education is the notion of moral agency; the capacity to choose and act in accordance with judgments about what is right and wrong. In traditional moral philosophy, the question of moral agency arises in conjunction with discussions of moral responsibility and has been primarily concerned with how reason makes free action possible. Conspicuously absent throughout these scholarly deliberations is the social location of the moral agent. Moral agency has been primarily analyzed from within the framework of atomic, abstract individualism. It is in one's ability to rationally choose and act upon rational judgment that one is free, and hence, responsible for one's actions. Immanuel Kant has bequeathed to philosophers a legacy alleging that persons

have moral standing by virtue of their rationality. Kant has left us with a vision of moral personhood that is impersonal, impartial, that is unembodied and devoid of emotional bonds, interpersonal relationships, particular commitments and projects. The multiple sources of social identity constituted by one's gender, race, or class have no role to place in this traditional image of the moral agent.

In his discussion of the inadequacies of theories of moral education that are grounded in the assumption of abstract individualism, Dwight Boyd compellingly argues that such an assumption actively functions to occlude the role played by privileged social positions in sustaining social injustice.[3] Valued as an equalizer, the assumption of the abstract individual subject, not only marginalizes and excludes, but also works to sustain systems of domination and oppression by concealing, naturalizing and mystifying social injustice. Boyd calls for theorists, whether in moral education or in philosophy of education, to take our situatedness seriously.

Recent work across a wide range of academic disciplines has moved away from the abstract, disembodied subject and toward the recognition of radically situated and contingent identities. Extensive explorations of the epistemological and ontological assumptions surrounding this subject, however, often come precariously close to denying the possibility of agency. Having documented the ways in which social institutions constrain and constitute who we are, researchers are often left with subjects so determined by their social world that agency becomes an incoherent and futile idea. Ann Ferguson raises some crucial questions that must be addressed before such notions of subjectivity can play a useful role in theorizing about any type of moral education.[4] Ferguson asks, if there exists institutionalized forms of oppression and domination that constitute who people are and that narrow the options of certain groups in a way that increases the benefits of other groups, who is responsible for perpetuating them? And if it is not possible to point to who is responsible, how can change occur? Ferguson refers to this as the "determinism-responsibility problem" and she contends that

> any theory that purports to explain how these systems work and how oppressive social inequalities are maintained must not be so framed as to imply that those who benefit from them are not free to change them. Otherwise they would not be morally culpable for their part in perpetuating the system.[5]

This essay explores the relationship between moral agency and social group location. Using a feminist model of self, in what follows I attempt to outline a notion of situatedness that elucidates the complex and mutually sustaining relationship between the individual and social structure. Not only does this notion of situatedness explain how dominant group members can unintentionally support oppressive social systems but it also suggests a notion of agency that can account for the possibility of dominant group resistance. Finally, I illustrate why situated moral agency should matter to dominant group members committed to social justice.

Positionality and Seriality as a
Way of Understanding Situatedness

Concerned with the postmodern challenge to the essentialist idea of self and the political dangers of rejecting the category of "women," Linda Alcoff and Iris Marion Young separately propose novel and fascinating accounts of gender and the self that compliment each other.[6] For Alcoff, understanding subjectivity begins with ontology—not in the sense of biology but rather in the sense of lived experience. Specifically accentuating practices, habits and discourses that are historical, fluid, contingent and revisable, Alcoff construes the category "women" as *positionality*. Positionality has two dimensions—as the social context in which one is situated and as a political point of departure.

In order to explain positionality as social context, I find It helpful to turn to Young's notion of "gender as seriality." A series "is a social collective whose members are passively unified by objects their actions are oriented around or by the objectified results of the material effects of the actions of others."[7] Just as the succession of things in a series is often ordered and arranged by external goals, so too, the notion of "women" should be defined not by a set of internal biological or psychological attributes, but rather by the external context within which such people are situated. Women are not women because of some internal characteristic but rather external factors make them so. Returning to Alcoff, the category "women" is not defined primarily by a set of attributes, but rather by a particular position or relation:

> [T]he internal characteristics of the person thus identified are not denoted so much as the external context within which that person is situated. The external situation determines the person's relative position, just as the position of a pawn on a chessboard is considered safe or dangerous, powerful or weak, according to its relation to the other chess pieces. . . . The positional definition . . . makes her identity relative to a constantly shifting context, to a situation that includes a network of elements involving others, the objective economic conditions, cultural and political institutions and ideologies, and so on.[8]

When Alcoff speaks of "women" as positionality, she is not referring to a place in which one is situated that is natural, ahistorical, or essential or even fixed. Rather she is pointing to a social relationship that produces external constraints that affect the lives of the people who are ascribed or categorized as "women."

But Alcoff also speaks of subjectivity as positionality in terms of ways in which women can take up their subject position as a point of departure for feminist politics. Although identity is always a construction and positioned, actual women are not merely passive recipients of an overdetermined identity. By recognizing and understanding the social position they are in, women can also *actively utilize* this recognition, and while not being able to transcend it, they can construct new meanings and practices. This is

exactly what having feminist consciousness means—acknowledging one's positionality but employing that understanding to conceive of the world as otherwise. Collectively, women, according to Alcoff, can contribute to transforming the social context they find themselves in.

Young's notion of seriality takes Alcoff's analysis one step further. A series not only depicts the external constraints that women experience but also the behavior-directing and meaning-defining environment in which they are situated. In other words, assigned identity compels certain practices and performances on series members. If one is seen as a woman, one is impelled to behave and expected to behave in certain ways, and one is induced to have certain beliefs and certain attitudes. Expected performances, beliefs, and attitudes, however, cut across other dimensions of oppression and are context dependent. For example, the expected performances of a white middle-class woman differ from the expected performances of a poor woman of color. As the former slave, abolitionist, and feminist, Sojourner Truth is known to have remarked during a women's rights convention in Akron, Ohio in 1851, "Ain't I a Woman?"[9] In all cases, however, these expected performances are experienced as a "felt necessity" that are given or natural.[10]

In terms of personal identity (not how one is perceived and treated by others but how one sees one's self), Young (like Alcoff) argues that series membership is not necessarily definitive. An individual woman can be so determined by her external position that the meaning of assigned identity and her personal identity coincide. But a woman can also "choose to make none of her serial memberships important for her sense of identity."[11] Moreover, it is within the possibility of contradiction between ascribed and personal identity that political agency referred to by Alcoff and Young can arise.[12] Thus, the series "women" is not about designated attributes that attach to series members nor is it necessarily definitive of personal identity. It is rather about the social environment or milieu that delimits or constrains actions of a social group and impels certain behavior, attitudes, and beliefs. This understanding of the category "women" has the advantage of describing women as a social group "without false essentialism that normalizes and excludes" and it also explains how resistance is possible.[13]

The strategy that Alcoff and Young recommend for explaining the category of women illuminates the complex relationship between individual agency and social structure by providing an explanation as to how women can sustain oppressive systems but also how they can resist. These models of self provide means for conceptualizing a notion of moral agency that both takes social location seriously but is not immobilized by determinism. Although, primarily focused on marginalized identity, these models also help to account for dominant group identity and moral agency.

According to these models, dominant group identity is not static or stable, but rather is relative to a constantly shifting context; it intertwines with and is affected by other positionalities in complex and altering ways (for example, gay men, men of color, white women). As a category, a dominant group identity (for example, men, whites, or heterosexuals) does not necessitate reference to essences, biologically or socially constructed. Alcoff's and Young's models are useful in that they not only explain how dominant group identity can play a major role in sustaining and naturalizing hierarchical

social systems, but these models also provide for the possibility of resistance. In addition, the seriality model highlights the behavior-directing and meaning-defining environment in which individuals are located. Being in some way affiliated with a dominant group will involve some pressure to exercise practices that are rewarded with taken-for-granted, unearned privileges that not only sustain but also camouflage unjust social hierarchies. Dominant group members will likely not even be conscious of the performances they enact, perceiving them to be "just what is normal."

The models, however, also suggest ways in which these mechanisms can be challenged. Dominant group members, these models imply, can take up their social position as a point of departure for anti-racist politics. Sandra Harding discusses the ways in which she can *activate* her dominant group identity in ways that have antiracist feminist goals.[14] Alison Bailey discusses "traitorous identities" and explicates how whites, who are critically reflective of their privilege and who challenge the racial scripts that we all learn at a very young age, can make a "shift in their way of seeing, understanding, and moving through the world."[15] But why should this model of self and the socially situated notion of agency that it hints at matter to dominant group members who claim to be committed to the eradication of social injustice?

Situated Moral Agency—Why it Matters

Recall Pratt's experience of moral education with which I opened this essay. Pratt underscores the sense in which her moral education led her to believe that she was on the side of "right," and that her moral agency was connected to a sense of moral control. Trina Grill and Stephanie Wildman refer to this as the "center staging" character of white identity.[16] They contend that growing up with white privilege creates the expectation not only that white people will be in control but also that their concerns will be central in every discourse. As a white woman educator, I was initially resistant to any intimation that my sense of moral agency and the moral agency I try to promote in my classrooms may actually work to sustain the very injustice I claim to be committed to eradicating. But the control that Pratt is talking about (and the centering that Grill and Wildman refer to) is very subtle and often not visible to those in dominant social locations. Two classroom incidents made this extremely clear to me.

After what I understood to be an in-depth discussion of the epistemic privilege of the oppressed (that the oppressed may have more accurate knowledge of their oppression than those who are in a privileged state), the topic of the objectification and degradation of women in rap music came up. Two well-intentioned white women, mistakenly thinking that they were *giving* epistemic privilege to the oppressed, turned to the only Black woman in the class and asked, "As a Black woman, what do you think of rap music?" By making her feel noticed and marked *as Black*, these two women unintentionally marginalized their classmate. She was furious but was able to express her anger. In the ensuing discussion, it became clear to all the white people in our class (myself included) that what was so disturbing to the woman of color was not only her classmates' failure

to treat her as an individual (which is what I had originally thought). Rather, it was more an issue that the white women in the class assumed that they had the power to determine and the control over when and where her Blackness would matter.

Patricia Williams echoes a similar experience. Williams mentions a white colleague who rebuked her for making too much of her race.[17] In fact, her colleague told her, he did not even think of her "as Black." Yet at a later point in time when a Black colleague was experiencing difficulties with a tenure review, this same white colleague exclaimed to Williams that he wished the school could find more Blacks like her! As Williams explains, "I was acutely aware that the choice of identifying as black was hardly mine."[18]

In her discussion of white, feminist women's theorizing, Maria Lugones notes this white tendency to center and control,

> not all the selves we are make you important. . . . Being central, being a being in the foreground, is important to your being integrated as one responsible decision maker. Your sense of responsibility and decision-making are tied to being able to say exactly who it is that did what, and that person must be one and have a will in good working order. And you are very keen on seeing yourself as a decision maker, a responsible being: It gives you substance.[19]

Unintended patterns of discourse subtly absorbed from associations with dominant group privilege create expectations in dominant group members that their concerns must always be addressed and that they will be in control.

Lest one believe that all my white students had to do was to ask my student of color whether she minded being referred to as "Black," consider the following situation that complicates the matter. In my undergraduate course on communications, a student of color was giving a presentation about the insidious effects of labeling. The first white student, seemingly uneasy in addressing questions to her after her presentation, preceded her question with a polite, "Do you mind if I use the word 'Black'?" The woman of color responded that she felt ok with that word. Two minutes later, another white student asks a question, and again introduces her query with the same question regarding racial descriptors "Do you mind if I use the word 'Black'?" Civilly (though I sensed the student who was presenting was getting frustrated) she answered, "No problem." But it was not more than a few minutes later when yet another white student wanted to make a comment and prefaced his comment with, "I hope you don't mind if I use the word 'Black'?" to which the woman of color angrily burst out, "Give me a break! Do you like it if I always asked you if I can call you 'White?'" The white students in the classroom were aghast and one was so hurt, she had tears in her eyes. After all, they felt they were being sensitive to the woman of color by asking her what she prefers to be called but ignoring that she had told them it was ok three times! What can account for this "not listening" or "forgetfulness?" Did the white students not hear the student of color the first time? I highly doubt it. As I reflected on this incident, I wondered was this an issue of not hearing? Was this an issue of respecting and being sensitive toward the woman of color, a concern with *her*? Or was this an issue of needing moral vindication that "I

am a good white person?" Was what I was observing a reflection of each of my white student's need to have their moral agency affirmed and when the woman of color did not endorse their moral agency *they* got angry and offended?

This type of center staging strategy is not easily exposed because, in the experience of dominant group members, it is concealed by allusions (illusions?) to moral agency. In "The Limits of Cross-Cultural Dialogue: Pedagogy, Desire and Absolution in the Classroom," Alison Jones attempts to understand how anti-racist discourse that is designed to benefit the marginalized can be usurped by the privileged group.[20] In addition, this article serves as an illustration of how a dominant group member, Jones, can decenter and resist reinscribing systems of domination and oppression.

As a white educator of both Maori (native, marginalized) and Pakeha (European, dominant) students, Jones finds herself surprised to discover that in a course aimed to encourage dialogue across difference the Maori students in her class preferred separation rather than integration with the Pakeha students. Jones attempts to understand both her understanding of her Maori students' desire to have race-separated classes, as well as her Pakeha students' angry reaction to this decision by investigating the following questions: For whom is dialogue good? For whom is silence bad?

Dialogue has long been assumed to be a desirable pedagogic practice and the paradigm means of working through cultural and racial difference in education. Dialogue has the potential to reflect openness to difference, equality and reciprocity, a means by which to break down the silence of the marginalized and to allow a multiplicity of voices to be heard. Yet Jones's Maori students did not want to dialogue with her Pakeha students and preferred to be taught in separate classes. As Jones works through this incident, she realizes how asymmetric positions of social power affect the perceived outcome of dialogue. The Maori students have very little to gain from such mixed race dialogue. Indeed, the marginalized have no need to listen to the voices of the dominant as they are forced to be attentive to such voices daily.

Jones argues that the focus on marginalized voices in such dialogue has the effect of keeping the power in the hands of the dominant by implying that such a focus is a good benevolently bestowed upon the marginalized—an *allowing them* to speak. As Jones remarks, "This call for dialogue or shared talk or border crossing is, at root, a request for action by the dominant group—for them to *grant a hearing to* the usually excluded and suppressed voice and realms of meaning of the subaltern."[21] Moreover, while such dialogue emphasizes the telling of stories, what it obscures is who hears these stories and how. Jones is concerned that this desire to know the "Other" on the part of the dominant is a certain form of voyeurism and exploitation that further reinscribes privilege and marginalization. Even with the best of intentions on the part of dominant group members, the possibility of misunderstanding puts the marginalized in a position where they are doing all the work, and thus reinstating the authority of the dominant.

My point here is not to dismiss the potentially positive contributions of dialogue but rather to illustrate how dominant group moral agency is subtly reinscribed in a particular anti-racist strategy. The situation that Jones describes exemplifies how moral agency that ignores social location may unintentionally perpetuate the very injustice

it wants to eradicate. Jones, herself, (I contend) is an example of a dominant group affiliated individual who tries to challenge the "normal" way of being "moral" in her classroom.

Situated moral agency, particularly in reference to dominant group members, requires that we revisit the traditional role of intentions in our conceptions of moral agency. Moreover, situated moral agency requires that dominant group members decenter their "ability to do." Although "agency" traditionally refers to a "taking action," situated moral agency may require a "not doing" or more specifically a "not deciding on one's own what needs to be done." As Barbara Houston warns us "Do not take responsibility unaccompanied by those who can show you your part in the harm."[22]

Situated Moral Agency: Why it Matters

In her penetrating article, "Vertigo at the Heart of Whiteness," Cris Mayo astutely cautions social justice educators of the dangers in any reaffirmation of the moral agency of those affiliated with a dominant group.[23] Giving white students a greater sense of agency seems to Mayo to be mistaken. Mayo points to the voluntarism of men who assert their condemnation of rape and who assumed that their good intentions will exculpate them when they complain about their exclusion from a Take Back the Night march by women. Similarly, Mayo warns that the voluntarism of white moral agency will function as a "Good Housekeeping Seal of Approval" that allows whites to be "good people."

I share Mayo's suspicions of the voluntarism of dominant group agency and I concur with her contention that agency cannot be understood without appeal to social structures. Yet I believe her cautions raise deeper questions that require further attention. What are the pedagogical implications of advocating "vertigo"? Mayo argues against any rearticulation of the agency of white students. She contends that "in so many respects, white students have too much agency, although not of their own making, exactly."[24] If we understand agency as connected to structure, however, does this imply that pedagogically we must disallow agency? Do white people have to give up all notions of agency if they are to be anti-racist? Is this possible? On the one hand, if educators were to take the position that white people must give up their sense of moral agency, could this not generate a sense of immobilization that goes above and beyond the paralyzing effects of liberal guilt? On the other hand, would not such "giving up" of agency again be just another reinscription of dominant group privilege? I think Mayo's insightful comments compel us to demand a clearer explication of the pedagogically practical. Her comments also provoke us to clarify the notion of agency implied.

In her analysis of the debate between Seyla Benhabib and Judith Butler around the notion of agency required for feminist political projects, Fiona Webster is troubled by the practical implications of Butler's notion of agency.[25] According to Webster, both Benhabib and Butler reject the autonomous, rational subject of liberalism and they both agree that feminists require some account of agency. Benhabib, however, sees agency as that point at which we are "free" from our situatedness to deliberate and decide while

Butler rejects any sense of a "doer behind the deed." Butler insists that the meaning of agency is to be found in the very instability of the subject. Webster contends that while Butler's notion of agency is *theoretically* important for feminist theory, it is inadequate to deal with the *actual* freedom or the type of resistance required by embodied subjects or groups of subjects in the political arena.

To return to the perceptive cautions that Mayo calls forth, I want to underscore the deeper questions that, I believe, her arguments give rise to and that Webster's analysis underscores. The issue of clarifying the meaning of agency as connected to social structures and not merely to individual volition, and the question of the connection between theoretical analysis and practical issues, both political and pedagogical, require further examination and clarification.

In conclusion, I join Mayo in her call for making a "perpetual vigilance a necessary way to live one's life as a white anti-racist."[26] As she has explained to me in our on-going and stimulating communications, the type of vigilance she is trying to get at involves the "queasy suspicion" of one's own moral actions that "keeps one from thinking of oneself as heroic."[27] I nevertheless contend that such vigilance or, more specifically, such a willingness to be suspect of one's own moral actions, is unfathomable and practically unattainable without a lucid conception of situated moral agency.

Notes

Applebaum, Barbara, "Situated Moral Agency: Why it Matters" ed. Scott Fletcher, *Philosophy of Education 2002*, pp. 357–365. (Urbana, IL: Philosophy of Education Society, 2003). Reprinted with permission.

1. Minnie Bruce Pratt, "Identity: Skin Blood Heart," in *Yours in Struggle: Three Feminist Perspectives on Anti-Semitism and Racism*, ed. Elly Bulkin, Minnie Bruce Pratt, and Barbara Smith (Ithaca, NY: Firebrand, 1984).

2. Ibid., 14–15.

3. Dwight Boyd, "A Question of Adequate Aims," *Journal of Moral Education* 25, no. 1 (1996): 21–29.

4. Ann Ferguson, "Moral Responsibility and Social Change: A New Theory of Self," *Hypatia* 12, no. 3 (1997): 116–40.

5. Ibid., 117.

6. Linda Alcoff, "Cultural Feminism versus Post-Structuralism: The Identity Crisis in Feminist Theory," in *The Second Wave: A Reader in Feminist Theory*, ed. Linda Nicholson (New York: Routledge, 1997) and Iris Marion Young, "Gender as Seriality: Thinking about Women as a Social Collective, "in her *Intersecting Voices: Dilemmas of Gender, Political Philosophy, and Policy* (Princeton: Princeton University Press, 1997).

7. Alcoff, "Cultural Feminism versus Post-Structuralism," 23.

8. Ibid., 349.

9. bell hooks, *Ain't I a Woman? Black Women and Feminism* (Boston: South End Press, 1984).

10. Young, "Gender as Seriality," 25.

11. Ibid., 31.

12. Natasha Levinson, "Unsettling Identities: Conceptualizing Contingency," *Philosophy of Education 1997*, ed. Susan Laird (Urbana, IL: Philosophy of Education Society, 1998), 28.

13. Ibid., 31.

14. Sandra Harding, "Who Knows? Identities and Feminist Epistemology," in *(En) Gendering Knowledge: Feminists in Academe*, ed. Joan E. Harman and E. Messer-Davidow (Knoxville: University of Tennessee Press, 1991), 102.

15. Alison Bailey, "Locating Traitorous Identities: Toward a View of Privilege-Cognizant White Character," *Hypatia* 13, no. 3 (1998): 27–42.

16. Ibid., 33.

17. Trina Grillo and Stephanie M. Wildman, "Obscuring the Importance of Race: The Implications of Making Comparisons between Racism and Sexism (or Other Isms), "in *Critical Race Feminism: A Reader*, ed. Adrien Katherine Wing (New York: New York University Press, 1996).

18. Patricia Williams, *The Alchemy of Race and Rights: Diary of a Law Professor* (Cambridge: Harvard University Press, 1991).

19. Ibid., 10.

20. Maria Lugones, "On the Logic of Pluralist Feminism," in *Feminist Ethics*, ed. Claudia Card (Lawrence: University Press of Kansas, 1991), 42.

21. Alison Jones. "The Limits of Cross-Cultural Dialogue: Pedagogy, Desire, and Absolution in the Classroom," *Educational Theory* 49, no. 3 (1999): 307.

22. Barbara Houston, "A Conversation Beyond Argument: On a Bridge Over Troubled Waters," in *Philosophy of Education 1997*, ed. Susan Laird (Urbana, IL: Philosophy of Education Society, 1998) 28.

23. Cris Mayo, "Vertigo at the Heart of Whiteness," in *Philosophy of Education 2000*, ed. Lynda Stone (Urbana, IL: Philosophy of Education Society, 2001).

24. Ibid., 317.

25. Fiona Webster, "The Politics of Sex and Gender: Benhabib and Butler Debate Subjectivity," *Hypatia* 15, no. 1 (Winter 2000): 1–22.

26. Cris Mayo, "Vertigo," 319.

27. Cris Mayo, e-mail communication, February 2, 2002.

Not the Color Purple

Black Feminist Lessons for Educational Caring

Audrey Thompson

University of Utah

While working with kindergartners to better understand how young children perceive race, White researcher Robyn Holmes was asked by a young African American boy, Christian, to "draw a picture of him that he could keep." Christian's own drawing of Holmes had rendered her in purple, so Holmes asked Christian if she could color him purple in her drawing. He demurred: "I'm brown, so do me brown, Everybody's talking about I'm black, but I'm really brown. It's okay. You can color me any color you want, but I'm brown for real." In Holmes's analysis, this statement (and many like it from other children) "illustrates the children's desire to draw themselves or to have others draw them in accurate detail."[1] Although Holmes notes that most of the children in her study were rather literal minded about color—referring to color as a question of skin tone and usually not bringing to bear the more abstract idea of race—color was an important concern for the children, particularly for the African Americans in the study.

Holmes's story about Christian is strikingly different from the sentimental stories that White adults frequently tell about White children—stories in which the emphasis is on the child's failure even to notice race. In first-encounter narratives, for example, the point of the story is what the child *doesn't* notice. Asked what she thinks after meeting children of a different race for the first time, for example, the White child prattles innocently about the color of their sweaters or the color of their bicycles, but never mentions the color of their skin.[2] When such anecdotes are offered as evidence of childish innocence regarding race, they serve as "racial-innocence" narratives, intended to support the sentimental belief that being natural means not noticing racial differences. The White child's lack of awareness concerning race is seen as affirming the irrelevance of color identification.

Stories that African Americans tell about White children and race may reveal an entirely different narrative pattern, however, for what looks to Whites like charming innocence may look to people of color like the privilege of ignorance.[3] For example,

domestic worker Rosa Wakefield, an African American, recalls the fairy-tale world of the daughter of a White family for whom she once worked:

> They asked a little white girl in this family that I used to work for who made her cake at one of her little tea parties. She said that she made it and then she hid her face and said the good fairies made it. Well, you are looking at that good fairy.[4]

From Wakefield's perspective, it is not innocence that explains this child's obliviousness, but rather her position of privilege. She does not need to see the Blackness of the family's maid because she doesn't see the maid at all. It is her privilege to be ignorant.

Other White children, less oblivious, learn to associate maids with Blackness, but come to discover that it is indelicate to speak of either one. Wheeling her "two-year-old daughter in a shopping cart through a supermarket in Eastchester in 1967," Audre horde heard "a little white girl riding past in her mother's cart call . . . out excitedly, 'Oh look, Mommy, a baby maid.'" The "mother shushes" the child, Lorde tells us, "but she does not correct" her.[5] The little White girl thus learns that it is not polite to call attention to people of other races, but she does not learn to rethink her association of Blackness with servants.

Telling the story fifteen years later at a conference on racism, Lorde is not surprised when her White listeners "still find that story humorous."[6] Insofar as White listeners focus on the White child's political innocence, they may find Lorde's story amusing or quaint. But the political and ethical cost of such humor is high, for the foregrounding of innocence allows White listeners to ignore the structural racism that informs the White child's association of Blackness with service status. Whereas the point of the White racial-innocence narrative is to confirm the innocence of individuals prior to socialization, the point of Audre Lorde's story is that, in a racist society, there is no such thing as racial innocence; there is only racial responsibility or irresponsibility. In the story that Lorde tells, the mother is irresponsible, because instead of actually teaching her daughter about respect for racial difference—let alone talking to her about the racism of a society in which "Blackness" translates into "servant class"—she takes refuge in the polite suppression of "colortalk." By suppressing colortalk—the explicit recognition that someone is White, Black, or Brown—the White mother chooses to avoid rather than identify the racism that treats Blackness and Brownness as unmentionable.

In our schools and college education courses, we are similarly guilty of taking refuge in the suppression of colortalk at the expense of studying and teaching about issues of race, culture, and color. Well-meaning White educators often assume that to notice colors other than White would be to stigmatize non-White students. What passes for polite race discourse in education, therefore, is usually either racial obliviousness or the bestowal of honorary Whiteness on all students. Whiteness itself is not mentioned, of course. Rather than say "white," teachers may say "purple." Assuring students that they do not even notice their color, such teachers announce that "in this class, we're all purple!"[7] The purpleness euphemism, while sidestepping the issue of racial imbalance

implicit in bestowing honorary Whiteness on children of color, nevertheless betrays a White perspective: the pretense of purpleness is only necessary insofar as educators see "color"—that is, non-Whiteness—as a deficit.

Politely pretending not to notice students' color makes no sense unless being of different colors is somehow shameful. Colorblindness, in other words, is parasitic upon racism: it is only in a racist society that pretending not to notice color could be construed as a particularly virtuous act. In a society that is both culturally diverse and racist, colorblindness is a willed ignorance of color that, although well intended, insists on assimilating the experience of people of color to that of Whites. As Elizabeth Spelman observes, colorblindness as a moral position has meant for White people that "Black people [for example] were just like us—never, however, that we were just like Blacks."[8] From a Black-centered perspective, there are at least two problems with colorblindness. First, colorblindness fails to consider Black experience in terms of distinctively African-American cultural values, historical achievements, or social experience. Second, it treats racism as something that can be eradicated by simply ignoring it. By failing to take account of systems of oppression, colorblindness ignores the structures of race, class, and gender relations that together posit color as a deficit in the first place.

The Ethics of Care

Because theories of caring in education revisit and reframe the values and practices that organize much of child-centered teaching, they potentially offer a forum in which colorblindness in child-centered education can be addressed. Yet for the most part theories of care have themselves been colorblind. This is not to say that theories of care actively embrace colorblindness as a value; on the contrary, theorists of caring often proclaim a commitment to diversity. But insofar as theories of care fail to acknowledge and address the Whiteness of their political and cultural assumptions, they are in effect colorblind.[9]

Originally, theories of caring emerged as a corrective to the androcentrism of theories of justice. In 1977, Carol Gilligan pointed out that purportedly universal theories of justice such as Lawrence Kohlberg's moral stage theory implicitly assumed male, public-sphere values as a point of departure.[10] Theories of justice, argued Gilligan, either excluded or relegated to a lower plane moral concerns connected with women and the private sphere. Where justice theories asserted the centrality of public-sphere values and principles, therefore, theories of care pointed to the indispensable role played by values connected with the private sphere. Countering the public-sphere bias in theories of justice, caring theorists argued that the particularistic forms of responsiveness connected with intimate relationships were at least as morally defensible as their abstract, principled counterparts—if not more so.[11]

In her groundbreaking book, *In a Different Voice*, Gilligan set forth many of the themes that were to animate the ethics of care literature in the years to come: the moral import of exploitative situations that undermine lived values; a pragmatic orientation toward survival; the salience of the standpoint from which virtues and vices

are identified; and the moral contribution to be made by rich and complex narratives. The ethical ideal to which women and girls appeal, Gilligan and other caring theorists have argued, has to do less with rights than with responsibility; it is referenced not to disinterested principles of justice, equality, or rationality, but to the lived experience of caring relationships. Because women's moral work has all too often been dismissed as intuitive emotional responsiveness having little or nothing to do with morality (except, of course, when women *don't* practice it, in which case its absence quickly becomes a sign of selfishness and immorality), theories of care provide a much-needed account of the morality associated with relationships in the private sphere. Such theories have been particularly influential in education, where issues of policy and other public-sphere concerns had previously overshadowed inquiry associated with teacher-student relationships.[12]

But while theories of care have challenged the universalism claimed for theories of justice, caring theories themselves have usually been framed in universal terms. The argument that Carol Gilligan used regarding Lawrence Kohlberg's work many years ago thus has implications for her own work and that of other caring theorists. If theories of care are not to be essentialist, they cannot be modeled on one social group and then applied to (or modified for) others. In what follows, I explore some of the challenges that an understanding of racial and cultural diversity poses for colorblind approaches to caring.

Black feminist theorists and other scholars have long argued that the values that appear natural and universal to Whites are values that *work* for Whites, including White feminists. In 1977—the same year that Gilligan addressed the limitations of Kohlberg's theory—the Black feminist Combahee River Collective drew attention to White feminists' racial obliviousness:

> One issue that is of major concern to us and that we have begun to publicly address is racism in the white women's movement. As Black feminists we are made constantly and painfully aware of how little effort white women have made to understand and combat their racism, which requires among other things that they have a more than superficial comprehension of race, color, and Black history and culture.[13]

Just as it once seemed innocuous to claim justice as a universal moral framework, it has seemed to many theorists of care unproblematic to claim caring as a universal moral framework. From the perspective of Black feminist ethics, however, neither care nor justice has the character claimed for it in mainstream theories.

The Whiteness of the Ethics of Care Literature

What I wish to suggest in this article is how differently some of the themes that have proved generative for theories of care might have been interpreted if a Black feminist perspective rather than a liberal White feminist perspective had been assumed. Much of the work done in developing theories of caring took its initial impetus from the provocative

themes found in Gilligan's *In a Different Voice*. Any number of perspectives might have been assumed as a starting point for the theorizing that was to follow: the perspectives of Black women or pre-adolescents, of Chicana lesbians, of conservative married women, of Navajo grandmothers, or of working-class White women, for example. Theories stemming from any of these perspectives are problematic insofar as they generalize, for it is not as if there is some uniform perspective automatically shared by all members of a group. Insofar as members of a culturally and politically identifiable group share a situation, however, and share a particular cultural set of values passed on by the community, it is possible to speak of shared assumptions that make up an identifiable cultural perspective. Whether or not these assumptions are in fact shared depends in part on the character of individuals' connections to the community and their perception of their situation. What is notable in colorblind theories of caring is that the cultural specificity of what counts as caring is not taken into account.

Because theories of care have to such a large extent attempted to answer, challenge, complement, and/or compensate for theories of justice, they have also to a large degree accepted the public/private dichotomy assumed by theories of justice. Certainly they have worked within the White, Western tradition of describing ideal relational standards and principles. In some cases, the ideal caring relationships are patterned after the ideal home and an idealized mother's love for her children. In other cases, ideal caring relationships are understood in terms that privilege individual voices speaking socially unacceptable truths. Despite the important differences between various theories of caring, most of the mainstream ethics of care literature assumes that the work of caring requires retreating from society to a space of innocence.

Leftist Critiques of Theories of Care

In part because of this retreat from the politically charged public sphere to a space of innocence, theories of care have come in for considerable criticism from the left. In general, mainstream caring theories may be described as liberal in their goals and assumptions. Liberal theories tend to address social issues such as racial and gender inequality as problems to be solved by effecting more sensitive adjustments of institutions to individuals and groups. Leftist theories, by contrast, critique prevailing institutions (including, in many cases, the traditional family structure) as themselves being among the organizing causes of social inequities. According to such accounts, therefore, adjustments in social institutions may soften the effects of structured inequality, but they will not fundamentally change relations of inequality.[14]

Structurally oriented feminists, in particular, have criticized caring theory's acceptance of a predominantly White, middle-class, heterosexual feminine *ethic* as the basis for a supposedly feminist *ethics*. Among the objections that leftists have raised to the ethics of care are the inadequate attention given to issues of power within caring relationships; the deficit assumptions informing educational theories of care that offer to provide children of color with the kind of support supposedly not found in their homes; the apparent essentialism in theorists' attribution of an ethic of care to women in general; and their

disregard for the politically oppressive functions to which caring has been put, as well as for the unacknowledged support it may require from working-class women.[15] In short, leftist critics have objected to caring theories' ahistoricism, cultural bias, and obliviousness to systemic power relations. These important criticisms cannot be overlooked.

Yet it is also necessary to keep in mind the distinctive contributions made by theories of care. Not only did the theories originally serve a radical purpose insofar as they challenged the proclaimed universalism and narrow rationalism of androcentric ethical and educational theories, but they continue to underscore the need to theorize an often taken-for-granted social function. Whether or not in the form recognized by most mainstream theories of caring, the work of nurturance is vital to any society.[16] Many radical and liberal theories have tended to ignore this argument, however, and to focus on the enlightening aspects of education to the exclusion of its supportive and nurturing functions.[17]

There is no doubt that structural analyses can play a critical role in informing relational understanding—perhaps especially for those of us who are privileged enough not to notice the workings of power in our day-to-day affairs. But abstract, universal principles such as those of equality and respect cannot encompass the complexity of what it means to be engaged, responsive, responsible, and interested in particular relationships.[18] For educators, moreover, considerations of what will nurture and support students are crucial moral and pedagogical questions. We need theories of nurturing, accordingly, that help us to think about what will support students, theories that help us envision more responsive and fulfilling relationships, theories that help us to argue for the kinds of institutional changes that must be made in schools, the workplace, and government so that we can address the pressing needs of students, children, families, communities, and individuals. The important structural criticisms that have been raised with regard to caring, then, should not be used to dismiss theories of care, but should serve to inform and reorient them in ways that systematically account for race, class, gender, cultural, and other differences.

Colorblindness in Caring

At the most general level, caring theories are colorblind insofar as they fail to register the Whiteness of the problems and situations to which caring is enlisted as a response.[19] All too often, "caring" is spoken of in reference to the needs of "girls and women," for example, as if all girls and women had the same needs. The universal character assumed for these needs is underscored when the non-universal needs of non-White girls and women are acknowledged only on the periphery of the main discourse. For instance, African-American scholar Rebecca Carroll recalls attending a conference addressed to social and educational issues involving girls, and finding that the girls were assumed to be White unless otherwise identified. Explicitly, it is true, conference attendees were urged to think of "girls" as encompassing all races and classes. Yet almost all of the conference workshops were on the subject of girls in general, with one workshop set aside to address "African-American Girls Coming of Age."[20] The assumption betrayed in such

topical arrangements is that White girls do not have any special needs or problems not covered under the rubric of "girls," while African-American girls have extra problems that do not affect the "girl" category but that need to be added on if the girls in question should happen to be Black.

As at many other such conferences, the kinds of issues that were assumed to be most salient at the conference Carroll attended were issues concerning White girls. The point is not whether such issues are indeed significant issues, but whether they are universal issues for girls—and whether the focus on supposedly generic problems obscures any understanding of the cultural and political nature of the challenges that girls of different races, ethnicities, and socioeconomic classes actually face. Carroll acknowledges that anorexia and bulimia, for example, "are both serious diseases," but she does not see them as universal indicators of a crisis in female adolescence: "It is an exclusive issue. It is a white Issue."[21] The assumption of universality with regard to such issues reveals the colorblindness in their theorization: White (most often middle- or upper-middle-class White) girlhood is taken to be the foundational category, with all other girls experiencing variations on its themes.

Insofar as theories of caring appeal to White, middle-class ideals, too, they are engaged in colorblind theorizing. This may be true whether conventionally feminine relational values are invoked (as in the "homelike" models of caring proposed by Nel Noddings, Jane Roland Martin, and others) or challenged (as in the research on female adolescents conducted by the Harvard Project on Women's Psychology and Girls' Development).[22] Whether the ideals in question are referenced to White, heterosexual, middle-class domestic practices, for example, or to White conceptions of authenticity in relationship, what is assumed in colorblind caring is that "genuine" forms of caring can be identified without reference to questions of race or ethnicity.

The trouble with the ideals set forth in the mainstream literature on caring is twofold. First, they *are* ideals, and as Katie Cannon and other women of color have pointed out, many if not most women have to work with "real-lived" conditions that bear little resemblance to the choice-laden circumstances posited for the moral individual in mainstream ethical theories.[23] Second, the ideals described are by no means universal. When asked about the "ideal mother," for example, young women of color may resist the framing of the question. In *Between Voice and Silence*, Taylor, Gilligan, and Sullivan observe that several of the girls who were asked about the ideal mother "either misunderstood the question or resisted it by asking interviewers what they meant or responding 'I don't know.' "[24]

In "feminine" accounts of caring, the caring ideal may be treated either as generic or as pluralistic, but it is likely to be referenced implicitly to a White, middle-class ethic of domestic well-being.[25] Jane Roland Martin's *The Schoolhome*, for example, is intended to create the "moral equivalent of the home." and therefore features "a domestic curriculum."[26] Since, in Martin's view, one of the threats to creating a better society is "our culture's domephobia" and "fear of feminization"—"its devaluation of and morbid anxiety about things domestic"—Martin believes that it is vital to bring domestic values into the schools, where they can begin to infuse the public domain.[27] She acknowledges the

danger in such a project. "Will the Schoolhome become one more vehicle for imposing 'middle-class morality' on children?" she asks.[28] Because the basic principles of domesticity will be interpreted differently in each Schoolhome, depending on their different circumstances, Martin believes that it is safe to appeal to the generic "three Cs" of care, concern, and connection.[29]

It may appear, from a feminist standpoint, that such a project is too open-ended to be objectionable. Obviously, some kind of nurturing values are indispensable to any society, and it seems unproblematic to suggest that these values should be given far greater prominence in our schools and social policies than is currently the case. The problem, however, is that Martin's pluralistic approach does not require her to deconstruct the Whiteness of the caring that will prevail in many of the schools she envisions. Because Martin equates caring with the home and does not ask what relation homelike caring bears to the world outside the home, she does not consider how caring as idealized in our society might serve highly problematic functions or depend upon highly problematic circumstance.[30] She fails to take into account the fact that caring as it is practiced in White, middle-class homes is part of the fabric of values that has helped to perpetuate classism, racism, sexism, and heterosexism; it cannot be treated as a freestanding set of domestic values uncontaminated by the oppressive values of the public sphere.[31]

A different kind of colorblindness may be found in theories that look to childhood or adolescence as a reference point for relational authenticity. In contrast to Martin, who seeks to reclaim the "repressed" values of the domestic sphere, Lyn Brown, Carol Gilligan, Jill Taylor, and Amy Sullivan point to the *repressive* character of those values, seeing them not as the ground of caring relations but rather as a threat to authentic relations.[32] Not unlike Jean-Jacques Rousseau, they argue that if the child is to grow up whole and free, she must be buffered from any sense that she ought to shape what she says and does for the perception and approval of others.[33] Where Rousseau focused on boys, Taylor, Gilligan, Sullivan, and Brown focus on girls, arguing that adolescent girls undergo a crisis of self and relationship insofar as they are expected to suppress their natural feelings in order to preserve inauthentic, *nice* relationships. But while these theorists refuse conventional relational values, that refusal does not automatically carry with it a refusal of racism or other oppressive social relations. Insofar as conventional feminine values have served to reinforce social power relations, the refusal of conventional femininity is likely to be a step in the right direction; but the appeal to an authentic relational orientation grounded in social innocence effectively avoids engagement with social issues such as racism. Pre-social innocence is not only a mythical ideal but a specifically White, social ideal that provides us with no means of understanding or changing the ways in which we fail in our responsibilities to one another.

In sum, most of the research generated by White theorists of care has worked within a framework limited by the theorist's own distinctive cultural and class assumptions and by information from largely White, middle- and upper-middle-class respondents.[34] Even when studying students of color, White researchers have tended to look for the culturally White practices and values that they—and their theories—already recognize as caring.[35] Instead of "really read[ing] the work of black women" and other women of color, too

many White feminist theorists have "merely finger[ed] through [such work] for quotations which [they] thought might valuably support an already-conceived idea."[36] In caring theory as in much other White feminist work, research undertaken with young women of color and with working-class adolescents usually involves an application of previous research to new circumstances, not a radical rethinking of the assumptions that have guided previous research.

For years now, feminists of color and other leftist feminists have pointed to the cultural, racial, class, and other biases in White ethical and social theories. It is more than time for the rest of us to start learning those lessons. One of the important contributions that theories of care can make to education is to theorize educational caring practices so as to reveal their colorblindness, in order for change to become possible. Unless caring theorists take seriously the need to deconstruct and disassemble colorblindness, however, the Whiteness of theories of care will become further entrenched.

Reexamining Four Themes in the Ethics of Care Literature through the Lens of Black Feminism

To recognize the colorblindness of "caring" and to begin rethinking White assumptions about "inclusiveness" in theories of caring, it is instructive to revisit and reinterpret some of the themes in the early work in the ethics of care from a Black feminist perspective. Although the early work in caring theory showed no real sensitivity to issues of race, it took up generative themes that lent themselves to provocative inquiry about questions concerning caring and relationship. By returning to some of the ideas from which colorblind theories of caring have sprung, and reinterpreting them in the light of work by Black feminist theorists, I hope to dramatize the need for a rethinking of the colorblind assumptions that undergird theories of care.

In the remainder of this article, then, I revisit the four key themes identified earlier in Gilligan's In a Different Voice: the moral relevance of the situation; the pragmatic orientation toward survival; the significance of the standpoint from which values are understood; and the moral power of narratives. As framed and theorized by Black feminist and womanist scholars such as Katie Cannon, Patricia Hill Collins, Janie Ward, bell hooks, Toinette Eugene, Stanlie James, and Alice Walker, these themes assume a significance quite different from that found in most White versions of the ethics of care. Not a variation on or subset of the meanings found in mainstream caring theories, the distinctive meaning given to these themes from the perspective of Black feminist and womanist theorists is grounded in the moral, cultural, and political experience of African-American women.[37] In contrast to most White feminist and feminine theories of care, Black feminist theories have paid close attention to the issue of race; and whereas colorblind theories of care tend to emphasize innocence, Black feminist ethical theories emphasize knowledge. Indeed, an almost defining feature of Black feminist ethical theory is that, characteristically, it is referenced to Black culture as experienced, interpreted, and reproduced by Black women and "womanish" girls.[38]

Other themes, of course, could be similarly reinterpreted, and from a variety of non-White perspectives. The discussion that follows does not offer a comprehensive summary of the work being done in Black feminist ethics; still less does it account for the full scope of theoretical work that African American, Latina, Asian American, American Indian, and other feminists of color have offered. It is intended not as a wholly fleshed-out alternative account, but rather as a challenge to the Whiteness of colorblind ethical and educational theorizing.

Unlike colorblind theories of caring, ethical positions grounded in Black women's lives do not address caring as if it were synonymous with the home or the private sphere. White, middle-class culture takes for granted the status of the home as a "haven in a heartless world," but, historically, there has been no sure place of refuge for African Americans, since racism and poverty can invade any home.[39] No home is altogether safe from the effects of low wages, and no home can prevent the burning of crosses on the front yard, invasion from lynch mobs, sexual harassment on the job, or joblessness due to racism. In any case, most African-American women have not had the luxury of spending much time in their own homes; most have had to watch other—White—women's children and clean other women's homes, coming back to their own only well after the school day was over.[40] The home, then, has not been the protected site for African-American women that it has been for White, middle-class women. Nor is it claimed as a distinctly feminine space in which private-sphere values can be nurtured in isolation from the surrounding society.[41] On the contrary, caring in the Black family has had to be, in part, *about* the surrounding society, because it has had to provide children with the understanding and the strategies they need to survive racism.

Moreover, the work of caring in the Black community has never been solely the job of the family; it has been shared by the Black church, by extended and fictive kin, and by the Black community at large.[42] "Community is essential for reconstructing ideology, as it may provide the context and validation for rejecting negative stereotypes and developing new ways of knowing."[43] Whereas caring in the White tradition is largely voluntary emotional labor performed in an intimate setting or else underpaid work in a pink-collar profession like teaching or nursing, caring in the Black community is as much a public undertaking as it is a private or semi-private concern.[44] It is not surprising, therefore, that caring in the Black community is not understood as compensatory work meant to remedy the shortcomings of justice, as in the "haven in a heartless world" model. Instead, caring means bringing about justice for the next generation, and justice means creating the kinds of conditions under which all people can flourish. In the Black social activist tradition of Martin Luther King, Jr., for example, love is intrinsically tied to justice.[45] Love and caring do not step back from the world in order to return to innocence, but step out into the world in order to change it.[46]

It is significant, therefore, that Black women have figured as importantly in networks of community support and in social activist networks as they have in the domestic sphere. As Cheryl Townsend Gilkes, Patricia Hill Collins, Toinette Eugene, and many others have pointed out, Black women are powerful figures in their communities; in addition to being behind-the-scenes caretakers, they are key strategists in African-American programs for social change and "racial uplift."[47] The kind of work involved in Black women's car-

ing activities, accordingly, is hard to categorize in the public/private sphere terms often applied to White or colorblind caring, for the work of caring here is understood to include not only emotional labor, but also political labor, physical labor, and intellectual labor (as in the work of educational uplift).

Framed not just by the need to care for this particular child, this particular family, or this particular group of students, the Black feminist tradition of caring requires helping all African Americans to survive racism without loss of integrity; in part, this means helping to make society more just for generations as yet unborn. It is not that the "particularity" foregrounded in colorblind caring is not also a valued dimension of Black relationships. As Patricia Hill Collins, Katie Cannon, and others testify, uniqueness and individuality are highly valued in the Black community. But under the terms of racism, survival tactics that work only for the individual and do not address the systemic conditions threatening survival are suicide tactics.[48] Racist measures that harm any Black person harm all Black people.[49] As the pastor of my church often reminds us, don't think that it's just the guy at the other end of the boat who is sinking.[50]

Theme One: The Moral Relevance of the Situation

In Black feminist ethics, and indeed in Black ethical traditions more generally, it is impossible to separate questions of ethics from situational considerations. Historically and politically, the situation is part of the meaning of action. Specifically, racism is a moral situation with crucial implications both for White moral agency (it is not enough for White people to disavow racism if structural racism nevertheless continues to serve White interests) and for Black possibility. It is no use referring to action under ideal circumstances if the ideal does not remotely resemble the real.

White morality is predicated on individual freedom of choice; African Americans, however, have not experienced the freedom of choice assumed by White morality. Because African Americans' situation has never met the assumed criteria of the White ethical ideal, what it means to act morally cannot be judged with reference to that ideal. Cannon argues that "ethical ideas predicated upon . . . freedom and a wide range of choices [have] proved null and void in situations of oppression. The real-lived texture of Black life requires moral agency" of a kind unknown or even antithetical to dominant ideals. Forced by their situation to "create and cultivate values in their own terms," African Americans have interpreted moral integrity in ways that are referenced to a Black rather than a White standpoint.[51] Under slavery, for example, runaways were viewed as thieves who had stolen their owners' property—namely, themselves. Under segregation, Blacks who failed to stay "in their place" could be arrested or set upon by dogs, in the name of law and order. Today, White vigilantes and policemen who describe themselves as feeling threatened by unarmed Black men can be acquitted of assault. In order to develop an ethical code predicated on their own dignity, survival, and self-respect, therefore, Blacks have had to disregard or overtly challenge dominant codes of ethics.

What this means for Black feminist ethical theory is that the construction of ethical ideals is simply the wrong way to go about constructing a moral life, when the conditions of one's living cannot possibly sustain the ideal. Idealized versions of affectionate

mother love, for example, may be inappropriate models for women putting their life's energy into earning enough money or otherwise striving to make a better future for their children.[52] The caring work of Black mothers, Collins notes, may be too laborious to allow time or energy for the kind of affectionate display that is associated with mothering in the dominant culture. But sheer physical, wage-earning labor is "an act of love," a commitment to the survival and flourishing of one's children.[53] As Eva says to her daughter Hannah in Toni Morrison's *Sula*, "What you talkin' bout did I love you girl I stayed alive for you."[54]

The oppressive conditions under which African American women labor should not be allowed to obscure the creativity and richness of the ethical values that Black women have developed, however. For example, the tradition of "othermothering" is not simply an adaptation to conditions in which birth mothers (due to slavery or to economic extremity) might not be available, nor is it a makeshift or second-best approximation of mothering.[55] It is not what children have to make do with when their "real" mothers are not available to them. Rather, it is an honored tradition dating back to African Americans' West African roots, a tradition in which childrearing was shared by adults even when birth mothers were available.[56] As Collins, hooks, Ward, James, and others have observed, othermothering is a tradition that enriches communal bonds as well as the lives of children.[57] Significantly, then, othermothering is not solely about caring for children, but is also a way of sustaining adult and community relationships.

Theme Two: A Pragmatic Orientation toward Survival

"Contemporary African-American communities," says James, "struggle around the dual themes of survival and social change," just as they have since slavery.[58] Not only are the forms of oppression that Black women face multiple (and therefore difficult to address systematically), but they may also take forms unlike those that have been theorized by Black men, White feminists, or White Marxists, for example. The kind of sexism that Black women face is not simply a subset of the sexism described in White feminist theory, nor is the racism that Black women experience always identical to that faced by Black men.[59] Both because of the urgent threats to survival Black women have faced and because of the complex nature of those threats, African-American women have adopted a pragmatic, strategic orientation to survival and to working for social change. "Making a way out of no way" is simply a fact of life.[60]

In a hostile, racist society, Black families cannot risk having their children caught unaware by racism. One of the tasks of the Black family, therefore, is to prepare children to cope: to face racism with resilience. What White children (not to mention adults) can afford to ignore, children of color may be forced to learn. For example, African-American children may he taught about economic struggle, racial trouble, and their own history as props supporting the American dream. Far from trying to protect childish innocence, caring African-American adults are intent on alerting young people to the various threats to their survival and flourishing, to help them to cope with racism (and sexism) without loss of integrity. Numerous works testify to the various ways in which—both directly and

indirectly—African-American children and adolescents learn the coping skills required to survive in a racist society.[61] Janie Ward, for example, describes the family's role as giving "the child criteria for determining malice" when confronted with racism, and as helping "the child determine what action was then appropriate for retribution or reconciliation." At the same time that they help young people to "make sense of painful personal attacks," families also must help their children to "maintain self-worth and value."[62]

If innocence has not been an option for African-American children, still less has it been one for African-American women. In a culture that values female strength and competence, the idealized values attached to pure, "innocent," White femininity are less likely to be seen as desirable; yet even if Black women had aspired to these values, they would not have been available to them. Not only are such values irrelevant and "non-functional in the pragmatic survival lifestyle of Black women"[63] but, as Toni Morrison argues, the ideal qualities of White femininity are predicated on the contrast they offer to other, less favored forms of femaleness.[64] Because White femininity is identified as pure and moral only so long as it is not the femininity of all women, the contrast between White femininity and the mere femaleness of other women—servants, say, or Black women—makes femininity an impossible ideal not only materially but ideologically.

Black feminists' orientation to caring thus does not borrow from White feminine ideals, but must be understood in relation to an overarching ethic of responsibility to family, church, and community. This is not to say, though, that the virtues associated with the Black feminist tradition are grounded in a freestanding ethical ideal. Rather, they are grounded in a pragmatic vision of the possible; while changing what is possible is also part of that vision, survival is at times a more pressing concern.

Theme Three: A Black Standpoint

To understand Black feminist ethics, one must understand the history of African-American women and must approach both culture and politics from a Black-centered perspective. Virtues, vices, and what counts as authentic are all understood at least in part from a Black communal, historical, and political perspective—but also from a distinctively feminist perspective. Significantly, the ground of meaning and value is not innocence, then, but knowledge, and the reference point for knowledge is not the solitary individual but the committed member of the community. The standpoint claimed by African-American feminists is different, however, from the Black standpoint claimed by many Black male activists. Against Black nationalists, for example, Patricia Hill Collins argues that nationalism itself is a patriarchal undertaking in which women are regarded merely as the carriers of Black heritage and Black blood.[65] By contrast, a Black feminist standpoint recognizes African-American women as both partners and leaders in the movement for justice and racial uplift.

From a Black feminist standpoint, the ideals of White womanhood that the girls in Brown and Gilligan's work struggle with are unlikely to be an issue in the development of adolescent girls, because they are not Black women's ideals of womanhood.[66] The Black feminist and to some extent Black cultural model for womanhood is, in Alice

Walker's term, "womanist."[67] Being womanist is not about being nice, or being a lady, or not upsetting people. Instead, it represents a full-bodied view of womanhood encompassing "outrageous, audacious, courageous" and inquisitive behavior. It's about "wanting to know," being responsible and "in charge." It's about being "committed to [the] survival and wholeness of entire people." It's about being capable and competent.[68] It's about being someone to reckon with.

The womanish woman that Walker evokes is the kind of vibrant, powerful woman we see when Audre Lorde engages White women with her anger. Told by White women to couch her anger at their racism nicely, so that they can "hear" her, Lorde nevertheless maintains her confrontational stance.[69] Refusing to consider her anger as misbehavior, not-niceness, or a failure of relationship, Lorde insists that it is because she is in relationship with the White women whom she addresses that she is willing to act on and express her anger. Her anger expects a response, expects responsibility. It is, in fact, an expression of love and of trust in the relationship.[70] Interestingly enough, Lorde seems to represent a model from whom women of color and White women alike might profit. A central theme in both *Meeting at the Crossroads* and *Between Voice and Silence*, for example, is that adolescent girls find that, to he loved by adults, they must repress any signs of conflict, anger, disagreement, or disapproval that they might feel.[71] They have to be *nice*. Yet among themselves girls prefer open conflict: Brown and Gilligan point out that Lauren trusts that she can tell her friend Nina what she thinks and feels *because* they fight and reconcile on a daily basis.[72] To girls like Lauren and Nina, therefore, "nice" behavior on the part of teachers may signal inauthenticity. In something of the same way, many African-American students, male and female, may regard the polite avoidance of colortalk as a betrayal of trust because it denies real conflict and real relationships.[73]

From a Black standpoint, racist conflict is too obvious to be denied. Given Black cultural and political experience, the existence of racism is common sense; it is something that one can see for oneself.[74] To the extent that they adopt a Black standpoint, though, African-American students may find themselves in something like the quandary that Gilligan described in "Shakespeare's Sister."[75] The students can see what is going on perfectly well, but all around them teachers and other adults connected with the schools deny that anything at all is happening. For the (mostly White) girls that Gilligan describes, the result is a growing self-doubt and a lack of trust in one's own instincts. For African-American students who are grounded in the Black community (and of course not all African-American students are), or who face overt racism on a daily basis, the result is more likely to be loss of faith in teachers and loss of interest in school. Betrayed both by specific teachers and by White cultural norms concerning race, culture, and individualism, Black students may decide that their schools have little or nothing to offer them.

Theme Four: The Moral Power of Narrative

Some things one can see for oneself. Other things depend on the telling of the tale. In most—if not all—cultures, stories have enormous moral power. Sometimes the power

lies in the resonance and familiarity of a story, its capacity to describe what we know or believe; sometimes the power of a story lies in its rich complexity and its capacity to show us things we never saw before. Both kinds of stories have important roles to play in informing moral understanding.

The import of the first sort of story is suggested by the significance of folk tales, folk wisdom, and parables, as well as the commonsense cautionary stories that provide benchmarks for a people. Many such stories are recounted in John Langston Gwaltney's *Drylongso* interviews, for example, and Zora Neale Hurston's collected folk narratives are repeatedly invoked by Black feminists as stories that tell the truth, stories that allow women to recognize their own lives.[76] Collins has shown us, too, the power of the knowledge of the "outsider-within," the working woman who can provide the inside story not only on African-American women, but also on the White women for whom they work.[77]

This function of moral and political storytelling is sometimes referred to as a communal truth-telling, in which the play of call and response generates a shared understanding of the way things are; alternatively, it may be described as authors calling out recognition and empathy when the stories that are told resonate with others' experience. In some cases, the telling of recognizable stories may even be described as fulfilling a documentary function. Katie Cannon, for example, sees Black women writers' work in general, and Hurston's work in particular, as telling, showing, proving, authenticating, and documenting Black women's moral ways of acting in the world—as "delineat[ing] the many ways that ordinary Black women have fashioned value patterns and ethical procedures in their own terms, as well as mastering, transcending, radicalizing and sometimes destroying pervasive negative orientations imposed by the mores of the larger society."[78] Such truth-telling narrative functions are important for all people, but perhaps particularly so for oppressed peoples, whose stories are likely to be misshapen beyond all recognition by the time that they appear in mainstream media—if they ever appear at all.

The moral importance of the second kind of story is more distinctively literary, for it is a matter of creatively reshaping experience so that what is revealed is not simply what is already known, but rather what is there but not understood. Here, the emphasis is less on readily recognizable "aha" moments than on providing a rich, complex, and nuanced story that captures more than the eye can see, thus giving the reader or listener insight into the as yet not fully known. This sort of story teaches the reader or listener how to read, how to see or hear; it does not show things as literal truths, but calls upon the reader to engage in the process of meaning-making and interpretation. Thus, for example, the artistry with which great Black women writers depict relationships in the Black community gives us new ways to think about those relationships, and shows us possibilities that may not be apparent to common sense or to the documentary eye.

In both sorts of narratives, the past may be brought forward and brought to life in the present. Whether in the form of folk tales, novels, spirituals, sermons, or poetry, Black narratives tend to refuse the literal-minded presentism characteristic of mainstream ideology; according to mainstream ideology, the past is dead and gone, and progress demands a no-nonsense, unsentimental, forward-looking grasp of the possibilities that

offer themselves. In Black narratives, though, integrity is likely to depend in part on remembering and reclaiming the past. In any case, the past is not fully gone, but lives on in the present. Not to know Black history is not to know oneself or the possibilities that one can claim with integrity.

As witnessed by the Black renaissances in arts and letters, Black narratives have played crucial roles in shaping a distinctive Black consciousness.[79] Countless Black feminist scholars have shown us the creativity and artistry that Black women novelists, poets, and short story writers, specifically, have used in shaping a new vision of the possible. What is perhaps distinctive in the work of Black women writers is their focus on relationships within Black culture. Whereas the writing of Black men tends to focus on racial conflict between Blacks and Whites, Black women writers are more likely to focus "on the Black community and the human relationships within that community."[80] This inward focus represents the kind of moral, political, and artistic attention to Blackness that commentators as varied as Zora Neale Hurston, Alain Locke, and Carter G. Woodson have all seen as a necessary way to avoid playing into the defensive discourse of race propaganda. By focusing on internal dynamics and avoiding the endless play of action and reaction between White racists and Black race defenders, African Americans can focus their attention on their own needs and avoid the defensive posture of answering White assumptions about Blackness. In so doing, they may also provide a means of engaging outsiders on terms other than those set by Whiteness. In turning their gaze inward toward the community, Black artists help make it possible for literature and art to bridge the cultural gap between those who have been there and those who have not, by teaching readers (and viewers) to engage with Black experience as constructed and reconstructed on Black terms.

Stories have an enormous amount to teach us about race, racism, and racial relationships. It matters both what the stories are, though, and how we have learned to read them. When the stories that Whites tell themselves are racial-innocence narratives, and when those stories are read as sentimental proof of the added-on (as opposed to systemic) character of racism, stories serve not to alert us to what is important but to buffer us from knowledge and to inoculate us against the contamination of guilt. Racial-innocence narratives—including but not limited to stories about children who do not notice skin color—appear to affirm children's apolitical nature, their indifference to race until they become contaminated by social prejudice. Because, from a colorblind perspective, the child who does not notice skin color is a model for the non-racist adult, many teachers imitate the innocence that they believe that they see in children.[81] Saying, "I don't care if my students are purple, green, or polka dotted! I care about them as individuals," child-centered teachers may stress their own racial innocence because they see teacherly innocence as necessary to the maintenance of children's social ignorance.[82] This sort of racial-innocence narrative mythologizes race relations; the stories that teachers and students need are those that demythologize race relations and make it possible for us both to see ourselves and one another as we really are and to see ourselves together as we yet might he.

Educational Implications

Much educational research has spoken to the need for an anti-racist curriculum as a way to provide students of all colors with the intellectual materials necessary to understand both their different and their shared histories.[83] Obviously, such a curriculum would provide students with information not filtered through racist systems of selection, but it would also provide them with tools for appreciating unfamiliar cultural and political materials and for critiquing racism in its various manifestations. Because the arguments and recommendations for such an alternative curriculum have been discussed extensively elsewhere, I will not repeat them here. It is important to note, however, that such a curriculum is a necessary component of caring relations in the classroom. African-American students cannot trust teachers who (wittingly or unwittingly) lie to them about racism, ignore Black achievements, gloss over slavery and segregation, or confine the study of Black history and culture to Black History Month.

The curriculum is pivotal in part because defensible and desirable relationships must be predicated on knowledge rather than innocence, and in part because teachers are responsible for helping students to develop and pursue questions that matter to them. If African-American students find that teachers are unwilling to provide them with that support, they have no reason to turn to them for an education. When twelve-year-old Myesha, for example, told her teacher "that I wanted to learn a little more about my history and that everyone else should learn as much about black history as we do about white history," her teacher told her "that she had taught black history last year and this year she wanted to teach something else."[84] Ironically, Myesha goes on to note, "we talk about white history all the time non-stop."[85] When Black history is addressed, more often than not it is addressed in terms that mystify that history.[86] Thus, fifteen-year-old Nadine, a Haitian, recounts how, "when I came here, all I learned about black culture in America was that black people were slaves, and then Martin Luther King showed up and single-handedly freed us all!"[87] Because their teachers will not support their inquiry, both young women are forced to educate themselves without help from their schools.

African-American students will not receive the kind of guidance and support that they need to flourish if teachers teach them not to know or mention what their communities have taught them or what they can see for themselves. What this means is both similar to and importantly different from what Brown, Taylor, Gilligan, and Sullivan mean when they speak of the danger of girls having to not know what they know in order to be in relationship.[88] As these theorists represent girls' authentic knowledge, it is a kind of innocence: that is, it is direct knowledge of the world, uncontaminated by and independent of the conventions, delicacies, and euphemisms of polite, adult society. Yet, for many African Americans, it is not adult society but White society that is the source of lies and hypocrisy. Adult African-American knowledge, by contrast, is honest, but not innocent. It is capable of making meaning of experience in a way that childhood intuitions and knowledge cannot, because it is specifically historical and communal knowledge.[89]

While an anti-racist curriculum helps to set the ground for the kinds of relationships that will honor all students and help them to flourish, curriculum alone cannot do the work of developing supportive, nurturing relations between teachers and students, or between students and students or (an often neglected aspect of educational relationships) between teachers and teachers. An anti-racist curriculum helps to organize and focus educational relationships in all three of these areas, but there are at least five other dimensions of school practice that would need to change if Black feminist ethics and epistemology were to be taken seriously.

First, teachers need to show their students respect by knowing about and understanding students' situations. To give students guidance and support, teachers need to know the whole child, and this includes his or her situation, Such situations include but are not limited to the home life of students. They also include students' cultural histories and the political situation that they confront outside the classroom. Indeed, a student's situation does not disappear when she enters the classroom. Immediate political pressures may and should be lifted, but teachers can only hope to suspend the consequences of racism or sexism in the classroom. They cannot eradicate those pressures by ignoring them. On the other hand, teachers cannot tap into and develop the possibilities latent in students' cultural knowledge if they do not understand students' cultural situations—as is likely to be the case, for example, when "teachers neither live in nor choose to frequent" the neighborhoods in which predominantly African-American schools are located.[90] Administrators also need to understand the full picture of the worlds in which their students move. And if students are to work together productively and supportively, they too need to understand one another's situations.

Second, teachers need to help students develop strategies for survival. As Lisa Delpit points out, the expressive, nurturing, celebratory character of whole-language and other child-centered traditions in education tends to ignore students' need for strategies that may help them to survive and flourish in a racist society.[91] Yet the point is not to turn instead to either liberal arts or back-to-basics models in which the knowledge codes of the dominant order are treated as sacrosanct. As Delpit indicates, students need to be able to code switch, which in turn means that they need to recognize that they are learning strategies that have instrumental value, culturally and politically, so that those strategies need to be evaluated in terms of what consequences they produce. For White students as well as for students of color, this means attending to the relation that such strategies bear to the social order. It means not being "innocent." Demythologizing race relations will be possible only if all students understand that the strategies most highly valued in our society are historically and politically contingent.

Third, the classroom must be a place in which the various standpoints of people of color are treated with respect. This means displacing Whiteness as the implicit, "neutral" position from which all arguments, analyses, and narratives stem and by which all arguments, analyses, and narratives may be judged. Much of the task described here refers to the class readings, projects, writing assignments, and problem-posing represented by the curriculum, of course. But there is also a sense in which the adoption of different standpoints is a relational issue. Being women-identified means that a woman does not regard

other women from a patriarchal or sexist standpoint, but from a standpoint that values and supports women as ends in themselves; being Black-identified means that African Americans do not view one another in terms of racist or culturally White assumptions and values, but from a standpoint that assumes the beauty, power, and intrinsic value of Blackness. While our bodies, histories, cultures, and situations are too central to who we are for men to be women-identified in the way that women can be, or for Whites to be Black-identified in the way that African Americans can be, it is nevertheless important for cultural outsiders to study and learn as much as possible about what it would mean. to address others in these terms. Otherwise, we risk treating those unlike ourselves as, at best, mirror images of ourselves, and at worst as inferior, exotic, or instruments for our own purposes.[92]

Fourth, teachers and students need to become versed in a variety of cultural narratives, attuned to the significance of different narrative framings and genres and modes of telling, and acquainted with the cultural contexts from which particular cultural narratives emerge. Neither the richly complex and problematic character of our own lives nor that of others unlike ourselves can fully be comprehended through analytic modes of study. Understanding responsibility and knowing how to act on that responsibility require being able to grasp our own situations. The possibility of adequate responsiveness to others depends upon our being able to understand their situations in ways that do not simply reduce them to projections of our own interests or assumptions. Developing the skills necessary to appreciate, perform, and participate in—but also to revisit and critique—different narrative constructions of meaning is an important step toward becoming both responsive and responsible.

Finally, teachers and students alike need to embrace an inquiring stance such that inquiry is supported, and new views are explored and considered. What sometimes passes for critical inquiry or dialogue in intellectual circles is what might better be termed martial maneuvering: under the pretext of getting someone to better explain her position, an aggressor demands that the other person defend her position with reference to an opposed position. This martial maneuvering should not be confused with the expression of anger, although obviously the expression of anger can be a form of war or of manipulation. When grounded in relationship—in the expectation of responsiveness—anger is the call for a response, whereas perfectly "nice" requests to have a position defended can function as ways to silence the other person or force her to sound incoherent. The issue, then, is what kind of response is sought: whether the request is a way to gain information and understanding or, instead, serves as a way to challenge and undermine the other's position. In martial maneuvering, a defender of colorblindness (for example)—starting from colorblind values as a given—demands that someone arguing for cultural awareness prove that cultural awareness is not "bias." There is really nowhere to go with such discussions; they are simply a politer form of war. Classroom inquiry, if it is to avoid the circularity, hostility, and cliquishness of such forms of dialogue, needs instead to embrace processes that allow all participants to move, to learn, and to contribute. What this means, then, is taking an interest in other positions, rather than reacting to them defensively or protectively. It is generally possible to find others who already agree with

us—either fellow students, for example, or writers encountered in the course readings—but it is not terribly productive simply to align ourselves with them. Such alignments may be important in helping inquirers to work through a position, but they cannot be treated as ends in themselves, for the point of education is not for students merely to register agreement or disagreement, but rather for them to learn to engage productively with positions that they do not fully understand or appreciate.[93]

Conclusion

To the extent that feminist theories of care appeal to ideals such as innocence, the perfect home, and selflessness, or virtues like trust and reciprocity, they seem to support the colorblind orientation in the classroom. Indeed, theories of care have found a welcome in many classrooms in part because they seem to affirm so much of what many teachers already believe about the ethics of teaching. They urge attention to individual needs, respect for student authenticity, and support for genuine, caring relationships. Yet in the attempt to respect and respond to all students' needs by caring for children and adolescents in distinctively White, feminine/feminist ways, colorblind child-centered pedagogy introduces a kind of cultural and political universalism. The distinctiveness of each student's situation is lost in the insistence that color doesn't matter.

From a colorblind perspective, color is merely a superficial characteristic irrelevant to who a student "really" is; it is a trait whose only salience is as the illegitimate basis for discrimination. From a color-conscious perspective, however, it is not the *color* purple or green—or, more to the point, black or brown—that is at stake, but communal and personal, as well as historical and political forms of experience *connected* with color. Insofar as colorblind caring ignores cultural and political issues that are vital in the lives of students, it insists upon an interpretation of experience—and of caring—that is likely to be alien to many students of color.[94] While intended as a sign of respect for who students really are, the avoidance of colortalk among educators in fact undermines the child-centered commitment to focus on what matters to students. The refusal to engage in colortalk is not, as we might like to think, about students and their needs, but about our own ignorance and discomfort regarding questions of race relations.[95]

What, then, are ways that White feminist ethical theorists (and others) may approach the development of more politically and culturally and racially nuanced theories? Let me suggest three important avenues for learning to rethink colorblind caring. First, and most obviously, White feminists (and others) have an enormous amount to learn from African-American feminist ethical theorists. What this means is studying: learning to recognize and work with theoretical framings that allow one to reorganize and rethink the already known, as well as to approach the new and unknown. Second, White theorists and educators can immerse themselves in Black literature and other forms of culture; once one has learned how to read Black folklore or Black women novelists without simply assimilating them to White cultural experience, it becomes possible to begin to fill in the theoretical frameworks with nuanced understanding. And, finally, we can change how we live: our habits, our neighborhoods, our circumstances, our political activities, our

relationships. If the relationships and situations that we live with on a day-to-day basis allow us to rest comfortably in the knowledge that works for us, we will not see any reason to change or to inquire into other lives. The question is, as a visiting minister recently asked those of us at my church, "How big is your world?"[96]

If White theorists of care are to respond to the call of Black feminists, the metaphor of innocence has to be discarded. It is no longer possible to recover the mythological time "before the fall"[97]—the imaginary time when children were "innocent" of racism. What we have a shot at is knowledge of good and evil—knowledge that, borrowing from Alice Walker, we might call womanist knowledge. Insofar as colorblind feminism refuses knowledge of race or culture, it insists upon its Whiteness. Insofar as feminism simply "adds on" knowledge of race and culture, while treating its own constructions of meaning as foundational, it shades pale colors in with Whiteness. But womanist knowledge and ethics are not simply variations on the knowledge and ethics that, in White feminism, are assumed to be foundational. Rather, they offer profound engagements with the situations that are part of all of us. As Walker says, "Womanist is to feminist as purple is to lavender."[98] In that sense, of course, Blackness *is* about the color purple.

∼

I am grateful to Bryan Brayboy, Ed Buendía, Kathy Spencer Christy, Kris Fassio, Johanna Hadden, Bobbie Kirby, and Ivan Van Laningham for their careful and insightful readings of earlier drafts of this article. A shorter version of the piece was presented in a symposium entitled "Care, Justice, and African American Voices" at the annual meeting of the Association for Moral Education, Atlanta, November 1997.

∼

Notes

Thompson, Audrey, "Not the Color Purple: Black Feminist Lessons for Educational Caring," *Harvard Educational Review*, 68(4): 522–554. Copyright © 1998 by the President and the Fellows of Harvard College. All rights reserved. Reprinted by permission of the publisher.

1. Robyn M. Holmes, *How Young Children Perceive Race* (Thousand Oaks, CA: Sage, 1995), p. 58.

2. Supposedly, the child does not notice skin color because she doesn't know that it is considered relevant. Yet, in probing, the adult may alert the child that there is something at

issue that is of special interest to the adult—something that needs attending to. Tone, timing, or degree of interest, too, may signal to the child that something's up. From then on, she will be alert to further clues. Ironically, then, questions asked to reassure ourselves as to children's racial innocence may provide children with their first introduction to racial prejudice.

3. The "privilege of ignorance" is a rephrasing of a term I borrowed from Eve Kosofsky Sedgwick, "Privilege of Unknowing," *Genders, 1*(1988), 102–124.

4. Rosa Wakefield, quoted in John Langston Gwaltney, *Drylongso: A Self-Portrait of Black America* (New York: Random House, 1980), p. 88.

5. Andre Lorde, *Sister Outsider: Essays and Speeches* (Freedom, CA: Crossing Press, 1984), p. 126.

6. Lorde, *Sister Outsider*, p. 126.

7. Parents and educators alike may recognize this phrase, for it is frequently used in colorblind classrooms. Ironically, its use tells children that one does notice color, but that it is considered "nice" or "polite" to pretend not to notice. For discussions of colorblindness and pretending not to notice, see Gloria Ladson-Billings, *The Dreamkeepers: Successful Teachers of African American Children* (San Francisco: Jossey-Bass, 1994); and Audrey Thompson, "For: Anti-Racist Education," *Curriculum Inquiry, 27*, No. 1 (1997), 7–44.

8. Elizabeth V. Spelman, *Inessential Woman: Problems of Exclusion in Feminist Thought* (Boston: Beacon Press. 1988), p. 12.

9. Many if not most theorists of caring have participated in colorblind theorizing; in discussing particular ethics of care positions, my intention is not to single out particular theorists for blame. Because theorists such as Carol Gilligan, Jane Roland Martin, and Nel Noddings have been highly influential, and because other theorists (including myself, and including, in some cases, men and women of color) have drawn upon their language or their ideas, many of us have participated in the dissemination and development of colorblindness in caring. All theorists of caring must take responsibility for deconstructing the Whiteness of their positions.

10. See Lawrence Kohlherg, *The Philosophy of Moral Development: Morol Stages and the Idea of Justice* (San Francisco: Harper & Row, 1981); Carol Gilligan, "In a Different Voice: Women's Conception of the Self and of Morality," *Harvard Educational Review, 47* (1977). 481–517; Carol Gilligan. "Woman's Place in Man's Life Cycle." *Harvard Educational Review, 49*(1979), 431–446; and Carol Gilligan, *In a Different Voice: Psychological Theory and Women's Development* (Cambridge, MA: Harvard University Press, 1982).

11. There is an enormous literature on the ethics of care, much of it informed by Gilligan's *In a Different Voice*. See especially Nel Noddings, *Caring: A Feminine Approach to Ethics and Moral Education* (Berkeley: University of California Press, 1984); Eva Feder Kittay and Diana T. Meyers, eds., *Women and Moral Theory* (Savage, MD: Rowman & Littlefield, 1987); and Carol Gilligan, Janie Victoria Ward, and Jill McLean Taylor, with Betty Bardige, eds., *Mapping the Moral Domain: A Contribution of Women's Thinking to Psychological Theory and. Education* (Cambridge, MA: Harvard University Press, 1988).

12. Influential works concerned with caring in education include Carol Gilligan, Nona P. Lyons, and Trudy J. Hanmer, eds., *Making Connections: The Relational Worlds of Adolescent Girls at Emma Willard School* (Cambridge, MA: Harvard University Press, 1990); Lyn Mikel Brown and Carol Gilligan, *Meeting at the Crossroads: Women's Psychology and Girls' Development* (Cambridge, MA: Harvard University Press, 1992); Jill McLean Taylor, Carol Gilligan, and Amy M. Sullivan, *Between Voice and Silence: Women and Girls, Race and Relationship* (Cambridge, MA: Harvard University Press, 1995); Jane Roland Martin, *The Schoolhome: Rethinking Schools for Changing Families* (Cambridge, MA: Harvard University Press, 1992); and Jane Roland Martin, *Reclaiming a Conversation: The Ideal of the Educated Woman* (New Haven, CT: Yale University Press, 1985).

13. Combahee River Collective, "A Black Feminist Statement," in *All the Women Are White, All the Blacks Are Men, But Some of Us Are Brave: Black Women's Studies*, ed. Gloria T. Hull, Patricia Bell Scott, and Barbara Smith (New York: Feminist Press, 1982), p. 21.

14. Leftist theorists analyze race, class, gender, and sexuality, for example, in terms of conflicting interests rather than cultural differences. Many but certainly not all Black feminists would fit the leftist rubric. Black feminist leftists would differ from many other leftists, however, in not assuming the private/public-sphere dichotomy that tends to characterize much of leftist theorizing.

15. See, for example, Rosemarie Tong, *Feminine and Feminist Ethics* (Belmont, CA: Wadsworth, 1993); Sarah Lucia Hoagland, *Lesbian Ethics: Toward New Values* (Palo Alto, CA: Institute of Lesbian Studies, 1988): Cynthia Willett, *Maternal Ethics and Other Slave Moralities* (New York: Routledge, 1995); Katha Pollitt, "Marooned on Gilligan's Island: Are Women Morally Superior to Men?" *The Nation*, December 28, 1992, pp. 799–807; and Audrey Thompson, "Surrogate Family Values: The Refeminization of Teaching," *Educational Theory, 47* (1997), 315–339.

16. Carole Pateman argues that the social and human importance of love and nurturance have been systematically ignored in liberal political, educational, and psychological theories. To some extent, this argument could he extended to radical theories. See Carole Patentan, "'The Disorder of Women': Women, Love, and the Sense of Justice," in *The Disorder of Women* (Stanford, CA: Stanford University Press, 1989). pp. 17–32.

17. I use the term "nurturing" here to distinguish the nurturing functions that any society must include from the culturally specific "caring" practices that are celebrated in theories of care.

18. An excellent discussion of the lived tension between romantic desire and feminine/feminist principles of self-respect, for example, was offered in Lyn Mikel Brown, "Anger, Ambivalence, and Longing: White Femininities and Working-Class Girls." Paper presented at the conference of the Association for Moral Education, Atlanta, November 1997.

19. In recent years, a considerable literature on Whiteness has emerged. Among the important works in that area are David R. Roediger, *The Wages of Whiteness: Race and the Making of the American Working Class History* (London: Verso, 1991); Toni Morrison. *Playing in the Dark: Whiteness and the Literary Imagination* (New York: Vintage: Random House, 1992); Ruth Frankenberg, *White Women, Race Matters: The Social Construction of Whiteness* (Minneapolis: University of Minnesota Press, 1993); and Mike Hill, ed., *Whiteness: A Critical Reader* (New York: New York University Press, 1997).

20. Rebecca Carroll, *Sugar in the Raw: Voices of Young Black Girls in America* (New York: Crown, 1997), p. 139.

21. When young Black women do develop these diseases, Carroll says, it is a sign of their resignation to having to conform to "white social behavior." *Sugar in the Raw*, p. 141.

22. See Noddings, *Caring*; Noddings, *Challenge to Care*; and Martin, *Schoolhome*. Among the books published in connection with the Harvard Project are Gilligan, Ward, and Taylor, *Mapping the Moral Domain*; Gilligan, Lyons, and Hanmer, *Making Connections*; Brown and Gilligan, *Meeting at the Crossroads*; and Taylor, Gilligan, and Sullivan, *Between Voice and Silence*.

23. Katie G. Cannon, *Black Womanist Ethics* (Atlanta: Scholar's Press, 1988), pp. 2–5.

24. This was "the reaction of six of the eight Black girls and four of the six White [working-class] girls in the study." Taylor, Gilligan, and Sullivan, *Between Voice and Silence*, p. 75. The question was intended to elicit possible cultural differences in girls' relational values.

25. As Angela Davis points out, the idealization of "the sphere of personal love and domestic life . . . as the arena in which happiness [is] to he sought" is specifically tied to the split between the public and private spheres that is characteristic of White, mainstream culture. Angela Y. Davis, *Blues Legacies and Black Feminism: Gertrude "Ma" Rainey, Bessie Smith, and Billie Holiday* (New York: Pantheon Books, 1998), p. 9. Whereas the idealization of the private sphere in mainstream

culture is reflected in the sentimentalization of domesticity and of romance, in African-American culture neither parent-child relations nor romantic relations between adults are conceived in purely private-sphere terms.

26. Martin, *Schoolhome*, p. 33. The domestic curriculum is not the only curriculum in the Schoolhome, but it is pivotal.

27. Martin, *Schoolhome*, pp. 155, 193, 155.

28. Martin, *Schoolhome*, p. 34.

29. Martin, *Schoolhome*, p. 38. Ironically, when caring values are construed in generic terms, as in the case of Martin's "three Cs," it is simply more difficult to see their Whiteness. In contrast, Nel Noddings's discussions of caring are theorized in considerable detail. (See *Caring*, especially.) As a result, the Whiteness of her assumptions is more readily apparent than is the case in more generically framed discussions of caring, but this is not to say that her theory is therefore more saturated in Whiteness than are other theories. It may be, in fact, that it is easier to work to deconstruct Whiteness from such a position because the values it focuses on are more explicitly developed and theorized.

30. See George J. Sánchez, "'Go after the Women': Americanization and the Mexican Immigrant Woman, 1915–1929," in *Unequal Sisters: A Multicultural Reader in U.S. Women's History*, ed. Ellen Carol DuBois and Vicki L. Ruiz (New York: Routledge, 1990), pp. 250–263; Robert A. Trennert, "Educating Indian Girls at Nonreservation Boarding Schools, 1878–1920," in DuBois and Ruiz, *Unequal Sisters*, pp. 224–237; Maxine Seller, "The Education of Immigrant Women, 1900–1935," *Journal of Urban History, 4* (1978), 307–330; and Barbara Ehrenreich and Deirdre English, *For Her Own Good: 150 Years of the Experts' Advice to Women* (Garden City, NY: Anchor/Doubleday, 1979).

31. When, some years ago, Patricia Hill Collins argued in a public lecture that the values of the home are, for the most part, values that help to maintain and reproduce the prevailing social order, her largely White, female audience was horrified, for they had expected to be told that they were the lone standard bearers against racism, sexism, and other forms of oppression (as became evident in their attempts to "remind" her that this was the case). Collins's lesson, for them, was a very difficult one to hear: that racism is not a problem just for men, or for other White people, or for other, less enlightened theorists of care; it is a problem in which all of us participate. Patricia Hill Collins, "On Moms, Mammies, Madonnas, and Matriarchs: Racism, Nationalism, and Motherhood," University of Utah, Salt Lake City, March 1993.

32. Martin, *Schoolhome*, ch. 4: Brown and Gilligan, *Meeting of the Crossroads*; and Taylor, Gilligan, and Sullivan, *Between Voice and Silence*.

33. Jean-Jacques Rousseau, *Emile, or On Education,* trans. Allan Bloom (1762; rpt. New York: Basic Books, 1979).

34. In *Between Voice and Silence*, Taylor, Gilligan, and Sullivan focus on girls and young women of color, as well as White, working-class adolescents, in order to move outside the privileged social circles in which much of the previous research for the Harvard Project had been done. To some extent the authors encountered material that challenged their working assumptions, but the continuity of themes and interpretations between this work and other work in the Harvard Project is troubling, as it suggests that the authors for the most part found what they expected to find.

35. The listening guide described in Taylor, Gilligan, and Sullivan's *Between Voice and Silence* (pp. 27–38) represents an important attempt to address ideas of race *as* issues and to listen for cultural values different from those found in the mainstream. Yet insofar as the users of such a method bring to bear White and middle- or upper-class assumptions about self, relationship, car-

ing, and authenticity, it will be difficult for such researchers to hear or make sense of unfamiliar positions. Some of the interpretive difficulties and conflicts that the authors and their extended "interpretive community" (p. 16) encountered are described at various points in the book, as are the anger, anxiety, tensions, and failures of communication that may attend the efforts of mixed-race groups to address issues of race and class directly.

36. Audre Lorde, "An Open Letter to Mary Daly," in *This Bridge Called My Back: Writings by Radical Women of Color*, ed. Cherríe Moragu and Gloria Anzaldúa (1981; rpt. New York: Kitchen Table/Women of Color Press, 1983), p. 95.

37. At times, however, Black feminist scholars have drawn on White feminine/feminist theories of caring unproblematically in developing their analyses. As E. Frances White notes, Collins's "Afrocentric feminist values," for example, overlap to a fair degree with "the essentialistic cultural feminism of Carol Gilligan, including the ethic of caring and the ethic of personal accountability." White also points out that Collins's interpretation of the experience of Black women is treated too generically, without regard for class or other differences. See E. Frances White, "Africa on My Mind: Gender, Counterdiscourse, and African American Nationalism," reprinted in *Words of Fire: An Anthology of African-American Feminist Thought*, ed. Beverly Guy-Sheftall (New York: New Press, 1995), p. 520.

38. The term "womanish" comes from Alice Walker, *In Search of Our Mothers' Gardens: Womanist Prose* (New York: Harcourt, Brace, Jovanovich, 1983), p. xi. Examples of Black feminist ethical work focusing on women include Cannon, *Black Womanist Ethics*; Patricia Hill Collins, *Black Feminist Thought: Knowledge, Consciousness, and the Politics of Empowerment* (Boston: Unwin Hyman, 1990); bell hooks, "Love as the Practice of Freedom," in *Outlaw Culture: Resisting Representations* (New York: Routledge, 1994). pp. 243–250; Toinette M. Eugene, "Sometimes I Feel Like a Motherless Child: The Call and Response for a Liberational Ethic of Care by Black Feminists," in *Who Cares? Theory, Research, and Educational Implications of the Ethic of Care*, ed. Mary M. Brabeck (New York: Praeger, 1989), pp. 45–67; and Stanile M.James, "Mothering: A Possible Black Feminist Link to Social Transformation?" in *Theorizing Black Feminisms: The Visionary Pragmatism of Black Women*, ed. Stanile M. James and Abena P. A. Busia (London: Routledge, 1993), pp. 44–54. An important exception to Black feminist theorists' focus on. women is the work of Janie Ward. Her work—like that of Gilligan and her other colleagues—has focused primarily on adolescent girls. See Janie V. Ward. "Cultivating a Morality of Care in African American Adolescents: A Culture-Based Model of Violence Prevention," *Harvard Educational Review, 63* (1995), 175–188;Janie Victoria Ward, " 'Eyes in the Back of Your Head': Moral Themes in African Americas Narratives of Racial Conflict," *Journal of Moral Education, 20* (1991), 267–281: and Janie Victoria Ward, "Racial Identity Formation and Transformation," in Gilligan, Lyons, and Hanmer, *Making Connections*, pp. 215–232.

39. The phrase "haven in a heartless world" comes from Christopher Lasch's book by that title. See Christopher Lasch, *Haven in a Heartless World: The Family Besieged* (New York: Basic Books, 1977). Regarding the politically unprotected status of the home for African Americans, see Rose M. Brewer, "Black Women in Poverty: Some Comments on Female-Headed Families," *Signs, 13* (1988), 331–339. To say that the home is politically unprotected is not to say that the home is not in some sense a refuge and protected space, but rather is to say that it is not an innocent space. On home as a site of resistance and support, see bell hooks, "Homeplace," in *Yearning: Race, Gender, and Cultural Politics* (Boston: South End Press, 1990), pp. 41–49.

40. See Judith Rollins, *Between Women: Domestics and Their Employers* (Philadelphia: Temple University Press, 1985); Collins, *Black Feminist Thought*; hooks, "Homeplace." Ironically, while Black women are often stereotyped as "bad" or "ineffective mothers" of their own children, when

employed in a service role they "are thought to be entirely competent at parenting the children of the elite." Leith Mullings, *On Our Own Terms: Race, Class, and Gender in the Lives of African American Women* (New York: Routledge, 1997), p. 95.

41. For different reasons, other women of color may also reject the appeal to private-sphere values. In Navajo culture, for example, the White Anglo distinction between the public and private spheres, with the public sphere designated as the site of merit and the private sphere designated as the site for emotional expression, does not fit with traditional values. See Donna Deyhle and Frank Margonis, "Navajo Mothers and Daughters: Schools, Jobs, and the Family," *Anthropology and Education Quarterly, 26* (1995), 135–167.

42. On fictive kin relations, see Carol B. Stack, *All Our Kin: Strategies for Survival in a Black Community* (New York: Harper & Row, 1974).

43. Mullings, *On Our Own Terms*, p. 121. Mullings points out that "these new ways of knowing are often much more difficult to document than stereotypes are, because they do not always appear in sources to which scholars traditionally turn" (p. 121). One implication for educators is that displacing the "knowledge" about Blackness found in the dominant culture will require discovering new sources of knowledge.

44. In order to focus on systematic patterns of difference between White and Black approaches to caring, the discussion in this article overlooks the diversity within Black experience. However, it should be noted that phrases such as "the Black community," used here and elsewhere in the article, are misleading in that there is no single Black community with unproblematically shared values and commitments; nor is there a single, uniform category called "the Black family." As Frances White points out in "Africa on My Mind," discussions that treat Blackness as giving rise to generic forms of experience, standardized Black knowledge, and uniform ethical stances are as essentializing in their way as are White, colorblind, gender-based theories. Were my project to give a full theoretical account of caring from a Black-centered perspective, I would need to address the diversity within Black experience, but because my project is to problematize the Whiteness of colorblind caring, I concentrate on identifiable patterns in Black experience that give rise to needs and expectations different from those theorized in colorblind accounts of caring.

45. Cannon, *Black Womanist Ethics*, p. 166.

46. This view is different not only from the compensatory or return-to-innocence conception of caring that one finds in Catharine Beecher and her modern adherents, but is different also from the view that Carol Gilligan has suggested, that caring and justice may he distinct ethics referring to different ways of organizing and thinking about moral experience. In this connection, she has suggested that switching from a justice to a caring orientation may require a gestalt shift. See Carol Gilligan, "Moral Orientation and Moral Development," in Kittay and Meyers, *Women and Moral Theory*, p. 20.

47. See Cheryl Townsend Gilkes, " 'Holding Back the Ocean with a Broom': Black Women and Communtty Work," in *The Black Woman*, ed. La Frances Rodgers-Rose (Beverly Hills, CA: Sage, 1980), pp. 217–231; Patricia Hill Collins, "The Meaning of Motherhood in Black Culture and Black Mother-Daughter Relationships" in *Double Stitch: Black Women Write about Mothers and Daughters*, ed. Patricia Bell-Scott, Beverly Guy-Sheftall, Jacqueline Jones Royster, Janet Sims-Wood, Miriam DeCosta-Willis, and Lucie Fultz (Boston: Beacon Press, 1991), pp. 51–52; and Eugene, "Sometimes I Feel Like a Motherless Child," pp. 46–48. See also Paula Giddings, *When and Where I Enter: The Impact of Black Women on Race and Sex in America* (New York: William Morrow, 1984); and Gerda Lerner, ed., *Black Women in White America: A Documentary History* (New York: Vintage/Random House, 1972). The term "uplift" represents rather dated usage but is still used from time to time. It now refers, however, not to the "improvement" of the race but to the political and economic advancement of African Americans as a group.

48. See Carter Godwin Woodson, *The Mis-Education of the Negro* (1933; rpt. Washington, DC: Associated Publishers, 1972).

49. From a moral rather than an economic perspective, it can also be argued that racist measures harm racists as well as their victims. Many of the people that Gwaltney interviews in *Drylongso*, for example, make this point. On the moral and political harm that injustice does to oppressed and oppressor alike, see Martin Luther King, Jr., *Why We Can't Wait* (New York: Mentor, 1964).

50. The Reverend France A. Davis, pastor of the Calvary Baptist Church [National Baptist Convention, U.S.A.], Salt Lake City, UT. Preaching in Black churches often takes up themes of solidarity, support, and community responsibility. Parallel to these themes, the call-and-response tradition in the Black church represents the embodied expectation of group support for the individual and individual engagement with the group.

51. Cannon, *Black Womanist Ethics*, p. 2.

52. See Collins, *Black Feminist Thought*, pp. 123–129; Gloria Wade-Gayles, "The Truth of Our Mothers' Lives: Mother-Daughter Relationships in Black *Women's* Fiction," *Sage, 1* (1984), 8–12; and Gloria I. Joseph and Jill Lewis, *Common Differences: Conflicts in Black and White Feminist Perspectives* (Garden City, NY: Anchor/Doubleday, 1981),

53. Collins, *Black Feminist Thought*, p. 129. Collins's observation is prompted by the discussion of mothering in June Jordan, *On Call* (Boston: South End Press, 1985), p. 105.

54. Toni Morrison, *Sula* (New York: Random House, 1974), p. 69, quoted in Collins, *Black Feminist Thought*, p. 127.

55. "Othermothers" are women who share mothering responsibilities with birth mothers.

56. James, "Mothering," pp. 46–47. Also see the extensive discussion of othermothering in various chapters of Collins, *Black Feminist Thought*.

57. See Collins, *Black Feminist Thought*; James, "Mothering"; and bell hooks, *Feminist Theory: From Margin to Center* (Boston: South End Press, 1984), pp. 144–146. Drawing on Sue Jewel's work, Janie Ward also notes that "the interdependent nature of traditional mutual aid networks, in both the Black church and the Black extended family, fostered a mutuality of care between the recipient and the caregiver." See Ward, "Cultivating a Morality of Care," p. 177. See also K. Sue Jewell, *Survival of the Black Family: The Institutional Impact of U.S. Social Policy* (New York: Praeger, 1988). This emphasis on mutuality between adults, as well as between young people and the adults who help them, marks a contrast with the adults-helping-children emphasis found in both Noddings's and Martin's work, and in Gilligan's work with Brown, Taylor, and Sullivan.

58. James, "Mothering," p. 51.

59. Hull, Scott, and Smith, *But Some of Us Are Brave*; and Micheline R. Malson, Elisabeth Mudimbe-Boyi, Jean F. O'Barr, and Mary Wyer, eds., *Black Women in America: Social Science Perspectives* (Chicago: University of Chicago Press, 1990).

60. See Juanita Johnson-Bailey and Ronald M. Cervero, "An Analysis of the Educational Narratives of Reentry Black Women," *Adult Education Quarterly, 46* (1996), 146; Eugene, "Sometimes I Feel Like a Motherless Child," p. 47; and Jacqueline Woodson, ed., *A Way Out of No Way: Writings about Growing Up Black in America* (New York: Fawcett Juniper, 1996). See also poet/activist June Jordan's lyrics for "Oughta Be a Woman," reprinted in *A Way Out of No Way*, pp. 84–85, and performed on Sweet Honey in the Rock, *Breaths* (Chicago: Flying Fish Records, 1988).

61. In many cases, both sexism and racism must he negotiated. For discussions of various African American coping strategies, see Cannon, *Black Womanist Ethics*; Signithia Fordham, "'Those Loud Black Girls': (Black) Women, Silence, and Gender 'Passing' in the Academy," in *Beyond Black and While: New Faces and Voices in U.S. Schools*, ed. Maxine Seller and Lois Weis (Albany: State University of New York Press, 1997), pp. 81–111; Johnson-Bailey and Cervero,

"Educational Narratives"; John U. Ogbu, "Societal Forces as a Context of Ghetto Children's School Failure," in *The Language of Children Reared in Poverty*, ed. Lynne Feagans and Dale Clark Farran (New York: Academic Press, 1982), pp. 117–138; and Rodgers-Rose, *Black Woman*. The girls in Carroll's *Sagar in the Raw* also tell of being explicitly taught about racism.

62. Ward, "Racial Identity Formation and Transformation," p. 223.

63. Cannon, *Black Womanist Ethics*, p. 125.

64. Morrison, *Playing in the Dark*.

65. Collins, "On Moms, Mammies, Madonnas, and Matriarchs." See also White, "Africa on My Mind"; Hull, Scott, and Smith, *But Some of Us Are Brave;* and Malson et al., *Black Women in America*.

66. Compare Brown and Gilligan, *Meeting at the Crossroads*.

67. In this article, I use the term "womanist" in Alice Walker's original sense, as referring to strong Black feminist women who are outrageous and courageous. As used in other contexts, however, "womanist" is not necessarily a synonym for "Black feminist." Some African American women prefer the term "Black feminist" to describe their politics (as in many of the articles reprinted in Guy-Sheftall, *Words of Fire*, for example. See also Angela Davis's discussion of Black feminism in *Blues Legacies*, xi–xx.). Some womanists, moreover, do not consider themselves feminists. Finally, the term womanist is used in a number of different ways by women of color. The term has been used, for example, to refer to "Black women who do not consider themselves 'feminists,' [but] . . . who are working toward the survival and liberation" of all Black people (as in the case of African Canadian author Annette Henry) and (in the case of Chicana author Maria de la Luz Reyes) to refer to "a woman concerned with [the] empowerment of the entire oppressed community of color." Annette Henry, "Missing: Black Self-Representations in Canadian Educational Research," in *Radical In<ter>ventions: Identity, Politics, and Difference/s in Educational Praxis*, ed. Suzanne de Castell and Mary Bryson (Albany: State University of New York Press, 1997), p. 145; and Maria de la Luz Reyes, "Chicanas in Academe: An Endangered Species," in de Castell and Bryson, *Radical In<ter>ventions*, p. 20. In religious studies, the term womanist has come to refer to the emergent theological tradition grounded in the experience of progressive women of color, particularly Black women. See the sections of *Journal of Feminist Studies in Religion*, 5, No. 2 (1989) and *Journal of Feminist Studies in Religion*. 8, No. 2 (1992) devoted to womanism. Also see Katie Geneva Cannon, *Katie's Canon: Womanism and the Soul of the Black Community* (New York: Continuum, 1995).

68. Walker, *In Search of Our Mothers' Gardens*, p. xi.

69. Lorde, "The Uses of Anger," P. 125.

70. Johanna Hadden, a member of the graduate student reading group with which I meet every week, called my attention to the lovingness of Lorde's expression of anger.

71. Brown and Gilligan, *Meeting at the Crossroads*; and Taylor, Gilligan, and Sullivan, *Between Voice and Silence*.

72. Brown and Gilligan, *Meeting at the Crossroads*, p. 84.

73. Kathy Spencer Christy, "Lying and Trust in Race Relations: What African American Students Say about Their White Teachers," Paper presentated at the meeting of the American Educational Studies Association, San Antonio, October 1997.

74. See the many statements to this effect in Gwaltney, *Drylongso*.

75. Carol Gilligan, "Teaching Shakespeare's Sister: Notes from the Underground of Female Adolescence," in Gilligan, Lyons, and Hanmer, *Making Connections*, pp. 6–29.

76. See Gwaltney, *Drylongso*; and Zora Neale Hurston, *Mules and Men* (1935; rpt. New York: Harper Perennial, 1990). See also Alice Walker, cited in Collins, *Black Feminist Thought*, p. 214; and Cannon, *Black Womanist Ethics*.

77. Collins, *Black Feminist Thought*.

78. Cannon, *Black Womanist Ethics*, pp. 77, 76. While this "documentary" view may be defensible with regard to Hurston's work as a folklore anthropologist, it ignores the artistry in Hurston's work both as a novelist and in recounting tales collected from other sources.

79. See, for example, Alain Locke, ed., *The New Negro: An Interpretation* (1925; rpt. New York: Arno Press/New York Times, 1968); and Addison Gayle, Jr., ed., *The Black Aesthetic* (Garden City, NY: Doubleday, 1971).

80. Cannon, *Black Womanist Ethics*, p. 89. Here, Cannon is drawing on the work of Barbara Christian, *Black Women Novelists: The Development of a Tradition, 1892–1976* (Westport, CT: Greenwood Press, 1980), p. 241; and Mary Helen Washington, *Midnight Birds: Stories of Contemporary Black Women Writers* (Garden City, NY: Doubleday, 1979), p. xv.

81. This "imitation" is similar to that practiced with regard to femininity: femininity is a social ideal that girls and women are expected to imitate and thereby bring into being. Similarly, innocence is an ideal that is imitated or constructed rather than found. On imitations of femininity, see Susan Brownmiller, *Femininity* (New York: Fawcett, 1984); and Judith Butler, "Imitation and Gender Insubordination," in *Inside/Out: Lesbian Theories, Gay Theories*, ed. Diana Fuss (New York: Routledge, 1991), pp. 13–31. On the construction of innocence, see Morrison, *Playing in the Dark*.

82. This stance recalls Catharine Beecher's insistence that women—by which she meant White, middle-class, heterosexual women—were particularly well-suited to educate children due to their own childlike innocence, preserved by the sanctity of the private sphere. See Kathryn Kish Sklar, *Catharine Beecher: A Study in American Domesticity* (New York: W. W. Norton, 1973).

83. See, for example, Cameron McCarthy and Warren Crichlow, eds., *Race, Identity, and Representation in Education* (New York: Routledge, 1993); bell hooks, *Teaching to Transgress: Education as the Practice of Freedom* (New York: Routledge, 1994); Theresa Perry and James W. Fraser, eds., *Freedom's Plow: Teaching in the Multicultural Classroom* (New York: Routledge, 1993); Sonia Nieto, *Affirming Diversity: The Sociopolitical Context of Multicultural Education*, 2nd. ed. (White Plains, NY: Longman, 1996); Roxana Ng, Pat Staton, and Joyce Scane, eds., *Anti-Racism, Feminism, and Critical Approaches to Education* (Westport. CT: Bergin & Garvey, 1995); James D. Anderson, "How We Learn about Race through History," in *Learning History in America: Schools, Cultures, and Politics*, ed. Lloyd Kramer, Donald Reid, and William L. Barney (Minneapolis: University of Minnesota Press, 1994), pp. 87–106; Beverly M. Gordon, "The Necessity of African-American Epistemology for Educational Theory and Practice," *Journal of Education, 172* (1990), 88–106, 190; Joyce E. King, "Dysconscious Racism: Ideology, Identity, and the Miseducation of Teachers," *Journal of Negro Education, 60* (1991), 133–146; William H. Watkins, "Black Curriculum Orientations: A Preliminary Inquiry," *Harvard Educational Review, 63*(1993), 321–338; Thompson, "For: Anti-Racist Education"; and Woodson, *Mis-Education of the Negro*.

84. Carroll, *Sugar in the Raw*, p. 104.

85. Carroll, *Sugar in the Raw*, p. 109.

86. See Anderson, "How We Learn about Race through History"; Woodson, *Mis-Education of the Negro*; Linda M. McNeil, "Defensive Teaching and Classroom Control," in *Ideology and Practice in Schooling*, ed. Michael W. Apple and Lois Weis (Philadelphia: Temple University Press, 1983), pp. 114–142; Elizabeth Higginbotham, "Designing an Inclusive Curriculum: Bringing All Women into the Core," in Guy-Sheftall, *Words of Fire*, pp. 474–486; and Frances FitzGerald, *America Revised: History Schoolbooks in the Twentieth Century* (New York: Vintage, 1979).

87. Carroll, *Sugar in the Raw*, p. 123.

88. Brown and Gilligan, *Meeting at the Crossroads*; and Taylor. Gilligan, and Sullivan, *Between Voice and Silence*.

89. A recurrent theme in several accounts of African-American teachers who take a caring and supportive stance toward African-American students is the importance of telling students over and over again that, in a White, racist society, Black students will need to do *better* than their White counterparts. When Vanessa Siddle Walker describes Black teachers who focus on the "whole child," for example, it is clear that the child in question is not only an embodied, physical, and intellectual being, but also a political being. See Vanessa Siddle Walker, *Their Highest Potential: An African American School Community in the Segregated South* (Chapel Hill: University of North Carolina Press, 1996). Also see Michele Foster, *Black Teachers on Teaching* (New York: New Press, 1997); and Ladson-Billings, *Dreamkeepers*. Insofar as teachers are to play such a role for Black students, one possible implication is a need for more African-American teachers in the schools.

90. Ladson-Billings, *Dreamkeepers*, p. 63.

91. Lisa D. Delpit, "The Silenced Dialogue: Power and Pedagogy in Educating Other People's Children," *Harvard Educational Review, 58* (1988), 280–298.

92. Study does not automatically lead to engagement with racialized experiences other than one's own, however. As María Lugones observes, if one starts from a colorblind stance, one will see everything through the eyes of one's own culture. Thus, she says, White women can learn from reading women of color only if they begin from a recognition of and engagement with their own Whiteness. María Lugones, "Hahlando Cara a Cara/Speaking Face to Face: An Exploration of Ethnocentric Racism," in *Making Face, Making Soul/Hacienda Caras: Creative and Critical Perspectives by Women of Color*, ed. Gloria Anzaldúa (San Francisco: Aunt Lute Foundation Books, 1990), p. 51.

93. In "For: Anti-Racist Education," I discuss a performance conception of pedagogy as a way to problematize the givenness of students' existing experiences and assumptions. For example, students can be assigned to unfamiliar positions (represented by particular authors) as provisional standpoints from which to address and evaluate other unfamiliar positions.

94. For critiques of child-centered approaches that address their refusal to theorize racial/cultural/political issues, see Delpit, "The Silenced Dialogue"; and Arlette Ingram Willis, "Reading the World of School literacy: Contextualizing the Experience of a Young African American Male," *Harvard Educational Review, 65* (1995), 30–49. My focus here is less on issues connected with expressiveness or access to power than on specifically moral questions.

95. For a discussion of educators' avoidance of race relations as a topic of discussion, see Kathe Jervis, "'How Come There Are No Brothers on That List?' Hearing the Hard Questions All Children Ask," *Harvard Educational Review, 66* (1996), 546–576. Even among teachers dedicated to progressive and anti-racist teaching, Jervis observes, it is easy to gloss over questions related to race because they make us uncomfortable.

96. The Reverend Raymond L. Lassiter of Antioch Baptist Church, Hampton, VA.

97. The Genesis themes of the time before the fall and of knowledge of good and evil were discussed briefly in Carol Gilligan's keynote address for the Association for Moral Education: "Remembering Larry: The 1997 Kohlberg Memorial Lecture," Atlanta, November 1997.

98. Walker, *In Search of Our Mothers' Gardens*, p. xii.

Befriending Girls as an Educational Life-Practice

Susan Laird

University of Oklahoma

A Fictional Case

In Sapphire's contemporary African-American *bildungsroman, Push,* Miz Blue Rain befriends its 16-year-old girl-hero, abused by her mother and expelled from school because she is pregnant by her father a second time.[1] Illiterate after many years' schooling in Harlem, Precious Jones becomes a student in Miz Rain's basic literacy class of six girls. There, besides reading and writing, she learns to live her life as an affectionate, proud, responsible single mother, able to resist abuse and to develop mature loving relationships with others who can help her sustain both herself and her baby.

Miz Rain listens and responds to each girl's most painful feelings and oppressive needs. In return, Precious listens and responds to Miz Rain with shock upon discovering this teacher who so generously befriended her is lesbian, but feels a new compassion that challenges Precious to unlearn her own heterosexism. Rather than fixing Precious's problems, Miz Rain befriends her students by making her class an intimate circle of mutually devoted friends who help one another find the many resources they need for learning to love themselves and diverse others and to survive their many difficulties, such as domestic violence, homelessness, racism, rape, and HIV. Sapphire likewise indirectly befriends girl readers overwhelmed by such problems themselves, for her novel offers them rare recognition and makes transformative life strategies and circumstances imaginable not only for such girls, but also for adults who care about them. So, too, do I aim to befriend girls with this attempt to conceptualize for educators what it might mean to "befriend girls."

A Concept of Befriending Girls

Befriending girls can be for any thoughtful adult, as it is for Miz Rain and for Sapphire, an educational "life-practice."[2] I have read other narratives of it within both qualitative inquiries on girlhood and culturally diverse women's fictions about/for girls, and I have

witnessed it in my friends' and colleagues' lives. This deliberate practice on the part of Black women and white adults of both sexes in my own extended family, rural neighborhood, 4-H, Girl Scouts, and schools also educated (and miseducated) me as a lonely, bashful, clumsy, cross-eyed, curious, middle-class, white girl, and I have engaged in it myself as both a public high school English teacher and an adult Girl Scout. Although those who have made a habit of this practice with educative intent are likely to have done so thoughtfully, I have yet to find a name for it, much less a theoretically elaborated concept of it. Yet many contemporary girls' writings evidence some clear consciousness of its potential value. Thus I have named it *befriending girls* and embark now upon theorizing it, so that this educational life-practice might become more widely acknowledged, valued, taught, learned, understood, undertaken, and critiqued—also much more aggressively financed.

Befriending girls can be an individual or collective practice, a private or public practice, or both simultaneously. It can be a professional practice, as in Miz Rain's case. It can be simultaneously professional and nonprofessional when it occurs within recreational organizations such as 4-H and Girl Scouts. It can be entirely nonprofessional as well, as exemplified within the African-American cultural context theorized by bell hooks and Patricia Hill Collins, of "revolutionary parenting" by "Organized, resilient, women-centered networks" of "bloodmothers and othermothers" and "other nonparents" that "challenge prevailing property relations."[3] Befriending girls may also become a life-practice for men who respect such networks as it does for fictional street character Uncle John in Ntozake Shange's *Sassafrass, Cypress and Indigo*. Uncle John gives Indigo a "new talkin' friend," a violin, to comfort and express her grief at menarche, when her mother forces her to give up her dolls, "friends" whom she has artfully made for herself.[4] Thus distinct from seeking or holding onto friendship for oneself, *befriending* here refers instead to giving friendship—a gift offered as neither reward nor bribe, but as "a companion to transformation, . . . the actual agent of change, the bearer of new life" any girl may accept or leave.[5] Grades, credits, rankings, and diplomas saturate schooling with a market-economy notion of commodity exchange, whereas Lewis Hyde might call befriending girls as an educational life-practice a "gift labor" of developing girls' communities through "the give-and-take that ensures the livelihood of their spirit."[6] Within this gift-exchange economy, "special needs or areas of disadvantage are compensated for rather than . . . used as justification for limiting participation," notes Ruthanne Kurth-Schai, and girls are valued as having special gifts to offer one another, too, rather than merely as dependent recipients of adult protection and assistance.[7]

The gift of friendship may be direct, a gift of one's own friendship, such as domestic worker Carrie gives pre-teen Betsey in Shange's *Betsey Brown*.[8] Or it may be indirect, as when a Camp Fire club leader gives help to girls learning to make and sustain friendships with one another, with someone else or some others, with the non-human natural world or an artistic medium, or with themselves. Optimally girls should be beneficiaries of both sorts of befriending, although too often they are not. Such a gift may be, especially when indirect or impersonal, a material gift—cultural, institutional, or economic help toward such ends—such as Juliette Gordon Low gave the Girl Scout movement that

she founded in the United States. But, especially when direct and personal, the gift may in some sense be spiritual, and, like Uncle John's to Indigo, artfully given. Whenever such gifts, direct and indirect, personal and impersonal, are unevenly and unreflectively bestowed, especially within commodity-exchange settings like schools, befriending girls can become a dispensing of favoritism and privilege to some girls at other girls' expense.

Thus any generously attentive partiality to girls in all their diversity can be political, especially within a society that empowers, enriches, and otherwise privileges straight white male adults as well as boys coming of age to claim such manhood, often at girls' expense.[9] In this context, questions must also arise about what it might mean to befriend sexually, racially, and economically diverse boys. Whether befriending girls or boys with educative intent, however, a practical attitude akin to what Jane Roland Martin has named "gender-sensitivity" will be necessary if gender oppression is thereby to be resisted.[10] Barbara Houston has characterized this attitude as "self-correcting," insofar as it entails a habit of asking constantly, "Is gender operative here? How is gender operative? What other effects do our strategies for eliminating gender bias have?"[11] Befriending girls may initially seem to render such questions irrelevant since policy issues concerning sex equality and bias may seem unlikely to arise in this context of affectionate partiality to girls. Some critics may even consider that partiality itself an instance of sex bias that I am wrong to advocate, although I would beg such critics to explain on what grounds girls should be denied helpful affection from friends who try to understand what they are going through, especially when girls so often do have to cope with oppressive gender effects to which others are, in their alleged impartiality, blind or indifferent. Beyond mere quantifiable or legalistic "equity," then, gender-sensitivity in befriending girls must be a generous "wide-awakeness," an educated alertness to *gender*'s dynamic contingencies, complexities, contradictions, and consequences, coupled with "the loving eye" that *sensitivity* itself requires, a disciplined resistance against what Marilyn Frye calls "the arrogant eye."[12]

In focusing adult attention upon girls and "the great surprising variety" of the worlds they inhabit, befriending girls is not premised upon some fantastic fixed identity that "girls" represent in opposition to "boys."[13] Rather, my concept of this life-practice's possible gender-sensitivity is indebted to Iris Marion Young's feminist conceptions of women as a series and of gender as seriality and to Iris Murdoch's notion of "freedom from fantasy, that is the realism of compassion."[14] Metaphors borrowed from Sartre and Frye may help sketch Young's ideas roughly. People standing in line waiting for a bus may constitute what Sartre called a *series*, becoming a self-conscious *group* only when they start to complain among themselves that the bus does not arrive; similarly for women in relation to the "practicoinert milieu" of gender, on Young's account.[15] As *seriality*, gender is a dynamic structure that puts constraints on the modes and limits of people's actions, often oppressive constraints like those of the birdcage that is Frye's metaphor for oppression.

As I apply it here, the label "girls" refers to individuals on their way to becoming "women," whose identities cannot escape effects of gender. But how gender affects girls' lives is as particular to each girl as being caged is to each bird that may retreat passively

to a top perch, wildly peck the hand that pokes through the rungs, try to escape when-ever the cage-door opens, refuse to fly free when it does, or simply while away hours playing or singing. Gender effects' analogous particularity, together with the many other serialities that may also be constitutive for diverse girls, their responses to gender, and their friendships with one another—serialities such as age, class, race, sexual orientation, ethnicity, religion, disability, and so on—raises a difficult question. Can it be valid to conceptualize "girls" as having certain personal attributes universally in common, except perhaps their youth relative to women? In grappling with this question, we need not to lose sight of the fact that, however different, girls' actions are oriented toward the same or similarly structured objects that construct their bodies' social meanings, values, and challenges as gendered. Menarche is a regular and vastly consequential event occurring in most girls' bodies within a general age range, but this biological fact alone does not locate individuals in the series "girls." Social rules and practices surrounding menarche construct gender as a principle both for division of labor and for compulsory heterosexuality, thus constituting girls in a relation of growing vulnerability to boys' and men's appropriation.

Many girls choose to join some group that self-consciously and mutually acknowl-edges such gender effects upon their lives—such as a teen-queen pageant, a girls' bas-ketball team, a girl gang, Riot Grrrls, Delta Sigma Theta, or Future Homemakers of America. Not all girl groups resist gender oppression, but some do. For example, Girls Inc. advocates for the Girls' Bill of Rights, and schoolgirls whom Lyn Mikel Brown befriended responded to their male classmates' "Hooters" shirts with a shirt design of their own featuring a rooster logo, "Cocks: Nothing To Crow About."[16] Yet many girls face the challenge of menarche engaging no such mutual support or acknowledgment within a self-conscious group of girls. Befriending girls may therefore occur in relation to groups of girls or simply to individual girls or to girls at large, as that passively unified "amorphous collective" Young calls a "series."[17]

Gender will figure in every case, albeit probably not identically in all, for, like birds responding to their cage, girls may respond to gender in myriad ways. Although some gender effects are more or less common than others, can one credibly claim that the label "girls" predicts much about who they are, what they believe or want or need or do, or about their precise social location? Any group of girls' histories, experiences, and identities may have much significant or apparently almost nothing in common with one another. May not their actions and goals therefore sometimes coincide and other times differ as well? A girl may precociously "perform gender" by imitating a torch singer's seductive performance, while another may enact "gender insubordination" so well she is routinely mistaken for a boy.[18] A girl may feel compelled to take on domestic labors while her mother does wage-labor to support them, and yet another may take to the fighting streets because she only knows home as a site of violence. Still another may have the rare privilege of growing up in a comparatively affluent, caring, egalitarian household which makes her wonder what all the fuss over gender is about as she befriends both boys and girls and even feels free to acknowledge sexual feelings for this girl as well as that boy. Yet all these girls, even the lucky one who wonders, are confronting gender effects in others, if not also in themselves, whether they are yet more than dimly conscious of

such effects or not. I have yet myself to meet an adolescent schoolgirl who has neither experienced nor witnessed sexual harassment.

Befriending girls with gender-sensitivity will entail that same loving quality of attention to diverse girls and their particular differences, changes, and potentials that Sara Ruddick, following Murdoch and Simone Weil, considers vital to maternal thinking.[19] I take seriously Murdoch's insight that "our ability to act well 'when the time comes' depends partly, perhaps largely, upon the quality of our habitual objects of attention."[20] Therefore, if such loving attention is indeed to help girls resist oppression of various sorts, it must be deeply informed by what Frye calls a "macroscopic perspective." Metaphorically speaking, this is ability to see the cage as a structural impediment to the birds' freedom, as distinct from a "microscopic perspective" whose particularism is blind to oppression because it assesses this or that metaphoric bar of the cage as no impediment whatsoever.[21] Gender-sensitivity in befriending girls requires a macroscopic perspective that is open and fluid, sensitive also to other serialities and their consequential interactions with gender, variously narrated and divergently theorized.

Whenever befriending girls becomes a means of girls' resisting oppression, it becomes a political life-practice. But what makes befriending girls potentially an *educational* life-practice? It exemplifies what Martin has recently named "multiple educational agency," conceptually challenging the taken-for-granted essentialist notion of education as schooling and acknowledging that professionals at school and parents at home are not the only important educators of young people.[22] Befriending girls can occur within settings as various as street life, athletics, fine arts, employment, health care, travel, community and outdoor activities, religious life, extended-family or home life, school life, and even the world-wide web. Befriending girls may therefore be a site for transmitting hidden curriculum or a site for resisting it. It may occur with or without feminist sensitivity to gender and its consequences in girls' lives. Thus variously practiced, it may foster or resist oppression of any kind. Insofar as befriending girls can be undertaken manipulatively, aimlessly, or unreflectively, especially so long as it remains un-theorized, the practice may do as much to miseducate girls and put them at risk of harm as it does to educate them and give them new opportunities to improve their lives.

The Aims of Befriending Girls

Befriending girls may be either educative or miseducative for girls. It is not mothering, but mothering may become one context and source of insight for befriending girls. In its educative sense, befriending girls entails active pursuit of a specific educational achievement conceptually derived from Audre Lorde's autobiographical account of Black lesbian-feminist mothering, and culturally diverse girls' books authored by women offer fictional cases of child-rearing that clearly aim for this same educational achievement: *girls' growing capacities and responsibility for learning to love themselves and diverse others, including the non-human natural world, to survive and thrive despite their troubles.*[23] You might call it practical wisdom—a kind of practical wisdom that may entail resistance

against oppression but involves much more than that, since girls' troubles are not all instances of oppression. With this "hidden" curricular aim, befriending girls can be a generous educational practice premised upon the insight that assigning responsibility for this particular achievement only to mothers and schoolteachers, as an obligation that others should not share with them to any great extent, oppresses both women and girls. Indeed, the more contexts beyond home and school where befriending girls with such educative intent occurs, the greater likelihood of success at this culturally anomalous educational achievement.[24] I leave open for now the question whether or not this educational achievement requires *teaching* to be an integral phase of befriending girls as an educational practice. Whatever the verdict on that conceptual question may turn out to be, educative befriending implies a morally strong sense of friendship as both means and end to its educational achievement, reflecting Marilyn Friedman's insight:

> The needs, wants, fears, experiences, projects, and dreams of our friends can frame for us new standpoints from which we can explore the significance and worth of moral values and standards. In friendship, our commitments to our friends, as such, afford us access to a whole range of experiences beyond our own.[25]

And beyond our own families' experiences, as well, offering inspiration and support for "personally as well as socially transformative possibilities usually lacking in other important tradition-based close relationships, such as family ties."[26] Friedman draws an important conceptual distinction between "found" communities of origin (such as home, school, and religion) and "communities of choice," friendships—mutually trusting and inspiring relationships with others who share our interests and concerns, relationships within which we can learn openness of heart and mind to differences from ourselves that we may fear until we encounter them in those we have come to like or love.[27] Diverse girls and adults who befriend them within such communities of choice may learn how to create with one another those "pluralisms" that Ann Diller has theorized as co-existence, co-operation, co-exploration, and co-enjoyment.[28] Thus befriending girls with educative intent aims, implicitly at least, to give girls some experience within what Virginia Woolf calls a "Society of Outsiders."[29] For, typically undertaken in relative poverty outside the institutional restrictions even if still within the settings of family, school, worship, or workplace, befriending girls educatively may occur in obscurity, involve creation and sustenance of intentional and purposeful, but loosely structured and pluralistic communities of choice, and invite popular derision.

The courage and moral strength of such educative befriending offer girls thoughtfulness, worldliness, and life-gladness that, for Janice Raymond, are the distinctive fruits of adult female friendship as "two sights-seeing."[30] Raymond warns that such morally strong friendship is not easy, as she maps and conceptualizes various obstacles to it under three categories: dissociation from the world, assimilation to the world, and victimization in the world.[31] She does not write about girls' friendships, but I recognize all these categories of obstacles to friendship as obstacles also to that educational achievement for which befriending girls in its educative sense aims.

It is possible, then, also to read onto Raymond's conceptual map the most distinctive markers of befriending girls in its miseducative sense, which implies a morally weak sense of friendship that censors its invitations to re-examine lived realities as well as moral standards, values, and possibilities, thereby limiting girls' growing capacities and responsibility for learning to love, survive, and thrive despite their troubles. The miseducative hidden curriculum of befriending girls may undermine others' best efforts at that educational achievement; it may blind girls to oppression; it may even foster their oppression or their oppressiveness to one another or to others outside their group. Gangs, cliques, romancers, charming harassers, competitive and jealous peers, racist companions and mentors, seductive and over-protective family members, lecherous teachers and clergymen, xenophobic and homophobic church groups, conversion therapists, mass-media stars that court hero-worship, trendy girl-talkers, and other cordially manipulative adults in various roles who are eager to convert, control, patronize, or exploit girls all offer examples of miseducative befriending. Within this context, befriending girls educatively can require passionate commitment that may make it something like a worldly devotional practice, a worldly liberation lay-ministry. But, as such, it can also become a controlling and homogenizing "pastoral power" such as Megan Boler has justly critiqued, and give, as Kurth-Schai warns, "the appearance of working on behalf of children while maintaining adults' vested interest in children's powerlessness."[32] When this happens, befriending girls ultimately becomes miseducative. Seeking or clinging to a girl's friendship for one's own advantage or for a team's or an institution's or another collective's advantage—without primary regard for her learning to love, survive, and thrive despite her difficulties—is miseducative befriending.

Such awareness that befriending girls is so often miseducative leads its educative practitioners and theorists to reflect upon hidden curriculum in widely various contexts. It therefore prompts critical inquiry concerning coeducation, its sexism and heterosexism, its sexual and racist harassment, its other gender-troubled and racialized relations, and its unjust, unethical political economy of gender and race. Befriending girls educatively will also require further inquiry concerning educative and miseducative aims and activities of befriending boys. For, whether undertaken within a sex-segregated or coeducational community of choice, befriending girls educatively requires an ecological perspective on girls' living and learning that presumes men's and boys' presence in their lives for better and for worse.

Befriending girls cannot alter the total environment of girlhood, nor can it often even alter home or school environments where girls learn to love or denigrate themselves, to love or fear others, to survive their difficulties and thrive, or to be diminished and defeated by them. Befriending girls is not a strategy for massive, total social change, but it can take various forms that together may haphazardly constitute a kind of radical social formation that resists oppression, albeit one always vulnerable to co-optation, backlash, and other reactionary subversions and contestations. There is no grand narrative here. However, befriending girls can be a micropolitical strategy for changing some societies closest to girls and making material, cultural, social, and spiritual resources available to them so that they can learn to love, survive, and thrive despite their difficulties within a world often hostile to them.

The Activities of Befriending Girls

The activities of befriending girls are as various as the activities of living itself. Befriending girls and teaching them practical wisdom may upon occasion coincide in one individual's relationship with a girl, but need they do so? Even if not, befriending girls cannot be educative in a context of indifference to their learning practical wisdom. Befriending girls can, however, be educative, even skillfully so, and still fail. Girls may accept or even seek miseducative befriending that makes them more vulnerable to harm than they need to be. That risk is the price of educative befriending. For there can be no befriending girls educatively without girls' freedom to pick their own friends, make mistakes, and learn from them. As an adult commitment, therefore, befriending girls makes its practitioners vulnerable to griefs, disappointments, delusions, temptations, and risks both small and large. When undertaken seriously, it always requires active engagement in *self-educative self-befriending*, a practice that can simultaneously present possible instructive examples for girls learning to love themselves, survive, and thrive despite difficulties. When befriending girls in difficulty with educative intent, self-educative self-befriending in the context of befriending girls also entails *befriending women* and learning from us about our myriad ways of loving, surviving, and thriving despite our adult difficulties.

A broad leap of faith in girls' untried possibilities is necessary, too, one that makes habitual and deliberate practice of befriending girls, self, women, and perhaps also boys very much like a spiritual discipline composed of activities such as attention, study, self-examination, consciousness-raising, service, guiding, exploration, play, bearing witness, letting go, celebration, and giving. Such activities neither require nor rule out religious beliefs and affiliations, but some knowledge of religious spiritualities may help one learn how and why one might choose to engage in such activities during political struggles to befriend girls. At the same time, religious beliefs and affiliations dutifully sustained for direction in such activities, without any gender-sensitive and otherwise pragmatically critical inquiry, may render any effort at befriending girls miseducative. Fortunately, a growing new feminist scholarship on girls offers abundant secular examples of such disciplined activities.

I believe philosophers of education can learn from that new feminist scholarship and contribute to it. Many other thoughts and questions about befriending girls as an educational life-practice, and obviously also about befriending boys in their company, remain unwritten here. But I hope this limited effort can at least stimulate among us some lively and sustained conversations about them.[33]

Notes

Laird, Susan, "Befriending Girls as an Educational Life-Practice," ed. Scott Fletcher, *Philosophy of Education 2002*, pp. 73–81. (Urbana, IL: Philosophy of Education Society, 2003). Reprinted with permission.

1. Sapphire, *Push* (New York: Vintage, 1996).
2. Richard Shusterman, *Practicing Philosophy* (New York: Routledge, 1997), 4.

3. bell hooks, "Revolutionary Parenting," in *Feminist Theory* (Boston: South End, 1984), chap. 10 and Patricia Hill Collins, *Black Feminist Thought* (New York: Routledge, 2000), 178, 182.

4. Ntozake Shange, *Sassafras, Cypress and Indigo* (New York: St. Martin's, 1982), 26.

5. Lewis Hyde, *The Gift* (New York: Vintage, 1983), 45.

6. Ibid., 106, xvi.

7. Ruthanne Kurth-Schai, "Ecofeminism and Children," in *Ecofeminism,* ed. Karen J. Warren (Bloomington: Indiana University Press, 1997), 202–3.

8. Ntozake Shange, *Betsey Brown* (New York: St. Martin's, 1985).

9. Marilyn Friedman, *What Are Friends For?* (Ithaca, NY: Cornell University Press, 1993), part I.

10. Jane Roland Martin, *Reclaiming a Conversation* (New Haven: Yale University Press, 1985), chap. 5.

11. Barbara Houston, "Gender-Freedom and the Subtleties of Sexist Education," in *The Gender Question in Education,* ed. Ann Diller, Barbara Houston, Kathryn Pauly Morgan, and Maryann Ayim (Boulder, CO: Westview, 1995), 61.

12. Maxine Greene, *Landscapes of Learning* (New York: Teachers College, 1976), chap. 3 and Marilyn Frye, *The Politics of Reality* (Freedom, California: Crossing, 1983), 66–76.

13. Iris Murdoch, "On 'God' and 'Good,'" in *Existentialists and Mystics,* ed. Peter Conradi (London: Penguin, 1997), 354.

14. Ibid.

15. Iris Marion Young, "Gender as Seriality," in *Intersecting Voices* (Princeton: Princeton University Press, 1997), 24.

16. Lyn Mikel Brown, *Raising Their Voices* (Cambridge: Harvard University Press, 1998), 1.

17. Young, "Gender as Seriality," 27.

18. Judith Butler, "Imitation and Gender Insubordination," in *Inside/Out,* ed. Diana Fuss (New York: Routledge, 1991), chap. 1.

19. Simone Weil, "Reflections on the Right Use of School Studies with a View to the Love of God," in *Simone Weil Reader,* ed. George A. Panichas (Wakefield, RI: Moyer Bell, 1977), 44–45 and Sara Ruddick, *Maternal Thinking* (Boston: Beacon, 1989), 119–23.

20. Murdoch, "On 'God' and 'Good,'" 345.

21. Frye, *The Politics of Reality,* 4–7.

22. Jane Roland Martin, "The Wealth of Cultures and the Problem of Generations," in *Philosophy of Education 1998,* ed. Steven Tozer (Urbana, IL: Philosophy of Education Society, 1999), especially 28–31.

23. Audre Lorde, "Man Child," in *Sister Outsider* (Trumansburg: Crossing, 1984), 74; Susan Laird, "The Concept of Teaching," in *Philosophy of Education 1988,* ed. James Giarelli (Normal, IL: Philosophy of Education Society, 1989), 32–45; Laird, "Learning from Marmee's Teaching," in *Little Women and the Feminist Imagination,* eds. Jan Alberghene and Beverly Lyon Clark (New York: Garland, 1998), 285–321.

24. Susan Laird, *Maternal Teaching and Maternal Teachings: Philosophic and Literary Case Studies of Educating* (Cornell University, dissertation, 1988).

25. Friedman, *What Are Friends For?* 197.

26. Ibid., 207.

27. Ibid., 244–45.

28. Ann Diller, "An Ethics of Care Takes on Pluralism," in Diller et al., chap. 12.

29. Virginia Woolf, *Three Guineas* (San Diego: Harcourt Brace Jovanovich, 1938), 106ff.

30. Janice G. Raymond, *A Passion for Friends* (Boston: Beacon, 1986), chap. 5.

31. Ibid., chap. 4.

32. Megan Boler, *Feeling Power* (New York: Routledge, 1999), 146 and Kurth-Schai, "Ecofeminism and Children," 197.

33. Thanks to Susan Birden, Deanne Bogdan, Jayne Fleener, Susan Franzosa, Lissa Frey, Linda Gaither, John Green, Catherine Hobbs, Irene Karpiak, Glorianne Leck, Jane Martin, Jeff Milligan, Marlo Nikkila, Al Neiman, Kate Scantlebury, Deborah Shinn, Lesley Shore, Linda Steet, Amy Sullivan, and anonymous members of the PES Program Committee for reading and responding helpfully to this essay in early and/or recent drafts.

Befriending (White) Women Faculty in Higher Education?

Barbara J. Thayer-Bacon
University of Tennessee

Introduction

As a little girl, I started first grade when I was 5½ years old, two weeks after my peers' first day of school, as my parents were on leave when school started. I remember my first grade teacher well, Mrs. Rogers, as I was terrified of her. Mrs. Rogers gave me some ditto sheets to do when I arrived in her class, without giving me any explanation of what I was supposed to do. Since I could not read, I could not read the instructions. I stared and stared at that paper, hoping to make sense of the pictures when a little boy sitting catty-corner behind me offered to help. He told me what to do and I followed his directions, completed the assignment, and turned in the work. I had it returned to me that same day with red lines through what was wrong, and figured out from the corrections what I was supposed to have done, which was *not* what my new-found friend had directed me to do. I was mortified! That day probably marks the beginning of my mistrust of teaching assistance from *that* little boy, although it certainly didn't cause me to lose interest in him as a friend. As I think back on this scenario today, I remember that there were several little girls sitting around me, three, I believe, and not one of them offered to help. Even if my male neighbor's assistance turned out to be less than helpful, at least he tuned in to my distress and tried to help.

The little girls who sat around me in that first grade classroom, or others like them, have grown up to be my colleagues in my various departments in higher education. Unfortunately, I am still finding many of the men whose offices are around me more willing to offer assistance and mentoring than the women whose offices are near by. Even more disturbing, I have had to put significant amounts of energy into defending myself from harm by various women colleagues over the years and have witnessed and helped to defend others from similar attacks. Not only do many women in higher education lack the ability to collaborate with each other in healthy ways, they have been known

to actively sabotage the work of both male *and* female colleagues. I write this essay in an effort to explore this issue, a chilly climate in higher education that is generated by some women, and the destructive behavior they bring to higher education that damages their programs, as well as their working relationships with colleagues and students. I seek to find ways to befriend women in higher education, my sisters of color as well as my White sisters. My focus here will be on White women.

It is important that this essay be written by a White woman, as an insider to the social group in question. If a man tried to write this essay he would likely be accused of sexism. If a woman of color tried to write this essay she would be vulnerable to accusations of having a chip on her shoulder. It is also important that it be written by a feminist scholar, who is appreciative of gender inequities and sexist practices that exist in American society and takes these inequities seriously, for one of my biggest concerns is writing an essay that does not "blame the victims," knowing that all of my female colleagues have grown up in sexist societies, many of them under misogynist conditions. This essay needs to be written by someone who values the work of other feminist scholars and tries to live a life consistent with feminist theory, in terms of pedagogical practices in her classrooms as well as in terms of her leadership style as a program coordinator, department head, and chair of various professional organizations.

What I am pointing to is a hidden story, not spoken of publicly for fear of being accused of sexism. It may be a generational story, unique to the baby boomer generation and not a problem for younger White women in higher education but I am not convinced this is so. My hope is that because I am a woman, and a feminist scholar, what I have to say will not be dismissed as sexism. I also hope that because I am a cultural studies scholar, what I have to say will not be dismissed as *essentializing women*. I think this topic is an *elephant in the room* kind of topic, one that most of us in higher education have much experience with, and yet we are not talking about publicly. Let me leap into the topic before my courage disappears, and hope for the best. If I can open up a conversation on this issue, and get people talking to each other in caring, generous ways, maybe we can befriend women in higher education and find ways to help them/us heal from the harm they/we have experienced in our sexist societies.

I begin by explaining what I mean by *befriending women in higher education* with the help of Susan Laird (2003) and Paulo Freire (1970) in section one. In section two I will return to the scenario I opened with and look deeper at girls' relationships with each other, or the lack thereof, in comparison to their relationships with boys, with the help of research on coeducation versus single sex schools. This discussion will need to be troubled by looking at the research on girls' of color relationships with each other and boys, as their relationships differ from those of White girls. With the help of JoAnne Pagano (1994) and Jane Roland Martin (2000), I will move the discussion to higher education in section three. My approach will be to use stories from the field to illustrate problems we can then analyze, a narrative style of philosophical argument often used in feminist scholarship. My stories are a compilation of many experiences, mine as well as others', accumulated during the course of a career in higher education.

Befriending Girls and Women

In 2002, Susan Laird presented a paper to the Philosophy of Education Society titled, "Befriending Girls as an Educational Life-Practice." In this paper she made the case for a need to name an educational life-practice that seeks to give the gift of friendship to girls. This gift labor can be given individually or collectively, privately or publicly, professionally or nonprofessionally, as a direct or indirect gift that is material or spiritual, given by men or women. Laird used the term, *befriending*, to distinguish holding on to friendship for oneself, versus giving friendship, a gift offered that any girl may accept of reject. Laird's aim was to assist and affirm *"girls' growing capacities and responsibilities for learning to love themselves and diverse others, including the non-human natural world, to survive and thrive despite their troubles"* (Laird, 2003, p. 77, italics in original). Laird recognized that she may be vulnerable to charges of sex bias or inequality because she advocates befriending as needed for *girls*. She responded:

> I would beg such critics to explain on what grounds girls should be denied helpful affection from friends who try to understand what they are going through, especially when girls so often do have to cope with oppressive gender effects to which others are, in their alleged impartiality, blind or indifferent. (Laird, 2003, p. 75)

Laird addressed the issue of how she defines "girls" and "women" with the help of Iris Marion Young's (1997) feminist concept of "gender as a series" that allows us to recognize that girls come from a variety of differing social class backgrounds, religious beliefs, ethnicities, physical shapes and sizes, shades and hues of skin color, with different sexual orientations and they may respond to gender in different ways. Still, Laird stressed that girls have bodies that menstruate, and while these biological facts alone don't locate individuals in the series "girls," "(s)ocial rules and practices surrounding menarche construct gender as a principle both for division of labor and for compulsory heterosexuality, thus constituting girls in a relation of growing vulnerability to boys' and men's appropriation" (Laird, 2003, p. 76). Girls can have much in common or very little, performing gender in a variety of ways, from embracing highly sexualized forms to resisting gender norms to the point of being identified as a boy. "Yet all these girls, even the lucky one who wonders, are confronting gender effects in others, if not themselves, whether they are yet more than dimly conscious of such effects or not" (Laird, 2003, p. 76). Laird described *befriending girls* with loving attention, so that gender-sensitivity will also allow us to attend to girls in all their diversity. Laird recommended that to befriend girls we need to take "a macroscopic perspective that is open and fluid, sensitive also to other serialities and their consequential interactions with gender, variously narrated and divergently theorized" (Laird, 2003, p. 77).

Befriending girls is political life-practice but also an educational life-practice, according to Laird. It can occur in any setting. As a political practice befriending girls can

become a means of girls' resisting oppression, but it can also be used to foster oppression, it is not necessarily good. Befriending girls can be done in ways that are manipulative, aimless, or unreflective, that teach girls hidden curriculums or it can be done in ways that teach girls how to resist hidden curricula. Befriending girls can be used in miseducative ways if unevenly and unreflectively bestowed, especially in schools, so that befriending can become a "dispensing of favoritism and privilege to some girls at other girls' expenses" (Laird, 2003, p. 74).

There is always a risk in befriending girls as to whether or not the girls will even accept such friendship, as the girls have the freedom to pick their own friends. "As an adult commitment, therefore, befriending girls makes its practitioners vulnerable to griefs, disappointments, delusions, temptations, and risks both large and small" (Laird, 2003, p. 80).

If we are to undertake befriending girls seriously, Laird recommended we must actively engage in *self-educative self-befriending*, "a practice that can simultaneously present possible instructive examples for girls learning to love themselves, survive, and thrive despite difficulties" (Laird, 2003, p. 80). This self-educative self-befriending entails "*befriending women* and learning from us about our myriad ways of loving, surviving, and thriving despite our adult difficulties" (Laird, 2003, p. 80, italics in original). Laird recommended "a spiritual discipline composed of activities such as attention, study, self-examination, consciousness raising, service, guiding, exploration, play, bearing witness, letting go, celebration, and giving" to help us engage in self-educative self-befriending (Laird, 2003, p. 80).

In a response to Laird's essay, a doctoral student in my program, Katharine Sprecher (2008), wrote about the difficulty women face learning to love ourselves, to heal, and fully befriend other women. Sprecher gave several examples of times she has worked with various groups of feminist women only to find their good intentions go awry "in the face of deeply embedded behavior patterns, expectations, and wounds" (Sprecher, 2008, p. 2). It is not easy to learn to love ourselves and other women "in a society that has taught us since we were children to mistrust, disrespect, denigrate, and often hate all that is female, including ourselves" (Sprecher, 2008, p. 2). Sprecher reminded us that we are bombarded by negative messages about women from all forms of media such as the radio, television, magazines, billboards, etc. She also pointed out that "in a male supremacist society, it is not safe for women to express and feel anger towards men, . . . we have instead learned to direct suppressed angers at safe targets like other women, children and ourselves" (Sprecher, 2008, p. 3). Laird's call to engage in self-educative self-befriending in order to have a chance at successfully befriending girls, is not going to be easy for women who grew up, and continue to live, in a patriarchal, sexist society. It will require a proactive commitment to self-healing that is on-going.

Sprecher pointed us to a problem for women that Paulo Freire (1970) described quite well in his chapter one of *Pedagogy of the Oppressed*. For Freire, his description of oppression focused on socio-economic class issues, but his analysis works well for other categories of discrimination too, such as race, sexual orientation, and gender. Freire explored the relationship that exists between the oppressor and the oppressed and how

the oppressed will identify with the oppressor and "have no consciousness of themselves as persons or as members of an oppressed class" (Freire, 1970, p. 30). He described how people who are oppressed unconsciously internalize their oppression, and find in their oppressor their model of freedom and adulthood. When they have the opportunity to seize a little power and acquire land, in Freire's example, they will use that power to turn on others like themselves, and become even more tyrannical bosses over the workers that were once their co-workers, than the owners were toward them. Freire pointed to examples where men, in the public world of work, go from working on a factory line or for a landowner to becoming the foreman. However, we can see this same phenomena in the private world of homes, where men who have little power in their public worlds come home and act abusively toward their wives, and where women who have little power and freedom in their married relationships will turn around and be tyrants with their children. We see this with older siblings in abusive home settings who will in-turn be abusive toward their younger siblings. It is a cycle of oppression that is difficult to break.

Freire said that "the oppressor, who is himself dehumanized because he dehumanizes others, is unable to lead the struggle" for a fuller humanity (Freire, 1970, p. 32). "Any attempt to 'soften' the power of the oppressor in deference to the weakness of the oppressed almost always manifests itself in the form of false generosity . . ." (Freire, 1970, p. 29). "It is only the oppressed, who, by freeing themselves, can free their oppressors" (Freire, 1970, p. 42). How do the oppressed free themselves, and thus their oppressors? Through love. In learning to love themselves and each other, they free themselves and each other. They learn to perceive the reality of their oppression as a limiting situation that can be transformed rather than as a fixed reality. Freire's act of love points us right back to Laird's idea of befriending, and the importance of self-befriending as part of the healing process from experiences of oppression.

The women in higher education whom I want to consider, ones who create much animosity and consternation among their colleagues due to their troubling styles of relating and communicating, were once little girls in need of befriending. They grew up in a sexist society surrounded by negative messages about girls and women, as well as being continually exposed to the modeling of behavior that puts boys' and men's needs ahead of girls and women. They learned about *his* story, and how to write, speak, and think like a man, so they would be listened to and treated as respectable scholars. They got the grades, passed the exams, and defended their dissertations, then took jobs in higher education, like the workers who become foremen, and now they exert power in abusive forms on students and colleagues.

The women in higher education whom I want to consider will gossip about colleagues behind their backs, and blame them for problems rather than take responsibility for their own actions. They will manipulate communications and data such as email messages to try to make themselves look good and others look bad. This is what Freire (1970) referred to as *horizontal violence*, when oppressed people strike out at their own comrades. These women will take credit for work done by their students and/or colleagues and pass it off as their own, however if any questions come up in regard to that work they will wash their hands of any responsibility and blame their colleagues, students, and/or

staff for any mistakes they have made. They will demand immediate attention and insist on having more than their fair share of resources, and cry foul if others complain at the unfairness of the situation. They will set up impossible situations that stretch university policies to their limits or beyond, and then, after everyone bends over backwards to try to accommodate their needs for fear of discrimination charges, if things do not go in their favor (e.g., tenure and promotion votes), they will complain that the policies were not adhered to and that they've been disfavored somehow in the process. When pushed into a corner or caught in the act, when decisions do not go their way, they will turn to a higher authority such as an associate dean, or dean, even the provost or university president, to step in on their behalf and give them what they want.

Let us return to the scenario with which I started and consider further what little girls experience in schools and what it would mean to befriend them. In this next section I want to add race and class as other categories in the analysis and consider what makes the situation different for little girls of color.

Gender Equity in K-12 Schools

Remember, I was 5½ years old, and trying to cope with my first day of school in a classroom full of strangers, as the "new kid" who started two weeks later than everyone else. I was given an assignment to do without any guidance from my teacher as to how to do it. I should add to the story that my parents enrolled me in first grade for two weeks in Pennsylvania, while on vacation because they were confident I was ready for school and the Pennsylvania age cut-off date for 1st grade was January 1st, allowing me to qualify, while the October 1st age cut-off date in Indiana, disqualified me from starting school. My parents thought that by going ahead and enrolling me at Grandma's, and then "transferring" me to my school back home, they might be able to get me in—in spite of the age-limitation. The school in Indiana agreed to let me start with the understanding that if I was not doing well, they would pull me out and restart me the next year. It was a gamble on my parents' part, but it worked. I really wanted to go to school and I was ready to do so. However, as I sat there on my first day in Indiana, trying to figure out that worksheet, I knew that if I did not convince my teacher I was ready for first grade, I would be pulled out. That added to my pressure to decipher that matching work (I still remember what it was, a picture worksheet on association of objects such as shoe to foot, cup to saucer, dog to doghouse).

When I think back on the situation, not only am I struck by the lack of help offered by the little girls sitting around me, I also wonder about that teacher, Mrs. Rogers. What kind of teacher would give a child new to her classroom an assignment with no directions on how to do it? I am fairly confident she was trying to assess my abilities, but she did not succeed in finding out my skills that day. What she did find out were the abilities of my neighbor catty-corner behind me, although she did not know that. Fortunately for me, from that day on I was in attendance when instructions were given and I was able to complete her assignments by relying on my own abilities,

and thus counter whatever damage I did to her assessment of my ability levels that first day. Still, what kind of teacher would give a child so little attention? I wonder, is there a commonality between my unique, individual experience and that of other little girls?

During the second wave of feminism (1960s–80s) there was a significant amount of research generated on gender discrimination issues in schools, as well as a heated debate on the pros and cons of coeducational schooling versus single sex schools for boys and girls (Frazier & Sadker, 1973; Sadker & Sadker, 1982; Spender, 1982; Stacey, Bercaud, & Daniels, 1974; Stanworth, 1983). Researchers studied language patterns in classroom discussions such as direct speech versus indirect, qualified speech, who was called on more often by teachers, who had opportunities to correct their mistaken answers, or not, how what was said was received by the teacher and classmates, etcetera (Association of American College, 1982; American Association of University Women, 1992; Thorne & Henley, 1975). Researchers noted linguistic bias, stereotyping, invisibility, imbalance, unreality, and fragmentation in textbooks (Sadker, Sadker, & Long, 1989; Sadker & Sadker, 1995). Studies were also done on discipline patterns, in terms of gender, such as what was tolerated as "boys will be boys" behavior that is coded differently if done by a girl, (e.g., amount of physical movement in classrooms), and much effort was placed on trying to define "sexual harassment" behaviors (Frazier & Sadker, 1973; Sadker & Sadker, 1982; Spender, 1982; Stacey et al., 1974; Stanworth, 1983). Scholars debated ways to counter "gender bias" in our schools, with "gender free" educational practices that sought to ignore and disregard gender, versus "gender sensitive" educational practices that sought to pay more attention to gender, not less, and take a situational strategy that can be self-correcting and maintains a constant vigilance (Diller, Houston, Morgan, & Ayim, 1996; Houston, 1994; Martin, 1982).

It was shocking to discover from the research that giving girls more than a third of one's attention felt as though the teacher was favoring the girls, by all of us in the classroom (Spender, 1982). And, that teachers failed to notice who was interrupting whom (boys would routinely interrupt girls when they were talking without getting in trouble for doing so), or whose points were taken up as serious and whose were ignored (girls could offer a point that teachers would ignore, until a boy offered it, and then they would note it) (Spender, 1980; Spender & Sarah, 1980). This kind of daily interaction and behavior leads to deep-seated, acculturation that is unconsciously taken for granted.[1]

Add to the complexity of gender bias in our schools the point Barbara Houston made, that even though teachers may ignore gender (which they do not), *students* do not, and we have a whole other layer of research that was developed during the second wave of feminism (Houston, 1994). For me, the focus on gender discrimination that goes on in schools between students was best illustrated in the co-ed versus single-sex schools research (Gilligan, Lyons & Hanmer, 1990). I learned from this research that coeducational schools served boys' interests more than girls, as not only did girls face discrimination by their teachers, peers, and the curriculum in schools, girls came to school already having learned from their social surroundings the importance of paying attention to boys' needs. When one grows up in a society where men and boys have more power than women and girls, mothers teach their little girls what they have

learned, the importance of being able to communicate with and relate to those who have more power, for one's own safety and protection. In the language of Freire, the possible chances of improving one's conditions depend on the ability to understand those in power, "the oppressors." Little girls came to school already knowing how to befriend little boys, and help them settle in to school, do their work, and recover when they have disappointments or setbacks. However, girls did not do this befriending for each other. Instead they competed against each other for the boys' attention, often enacting passive/aggressive forms of horizontal violence against each other (maybe in the form of taunting, and belittling, or ignoring, but also in the form of tattle-telling or gossiping, or even physically fighting—hair-pulling, scratching, kicking, biting) (Clarke, 2007; Laird, 1994a, 1994b; Morse, 1998; Spielhagen, 2008).

Researchers studied single-sex schools to see if they helped girls improve their self-esteem and their academic skills with the goal of empowering girls to overcome society's sexism and reach their full potentials. Some studies indicated that it may be valuable to separate girls from boys to ensure that girls have an equal opportunity to participate and develop their skills (Finn, Reis, & Dulberg, 1980; Laviqueur, 1980). However, what Gilligan et al., (1990) found in their study of a selective single-sex school was that even though the girls had strong women role models with their teachers, and much encouragement to do well in their classroom environments, once the girls stepped outside of their classrooms, they passed on society's norms and standards for girls to each other through their informal interactions. In the halls, bathrooms, and lunchroom, they passed on expectations for girls' appearances and attraction to boys, what society considered beautiful, how society viewed smart women, for example, even though these cultural norms were contrary to what the girls were being taught in their classrooms by their teachers or reading in their textbooks. The cultural norms for girl behavior were so strongly represented through popular culture (such as commercials on television, advertisements in teen magazines, representation of girls and women in movies, television shows, and through music lyrics, as well as the role modeling musicians and actors/actresses present to girls) that the girls policed themselves and oppressed each other, very similar to what Foucault (1965, 1979) uncovered in his work on "criminal" and "insane" behavior in prisons and asylums. The ways that affluent, White girls treated each other in single-sex schools serve as a powerful example of horizontal oppression that result in internalized oppression for girls, even in a school environment that sought to counteract the sexist norms of society.

What about girls of color and/or working-class girls? For girls who must negotiate their self-esteem and learn to befriend themselves, as well as each other, in conditions that involve class and racial discrimination, not just gender, how do they fair in terms of their relationships with each other, against multiple forms of oppression? As Ruth Zambara (1994) pointed out in regards to Latina women, "Latina women have had to teach themselves" for there is a "critical absence of scholarly work on race/ethnicity," and even more of an absence in regards to Latina women (p. 135). Second wave feminist theory was grounded in the experiences of White, middle-class and affluent women and girls of the majority society, and failed to take into consideration racial and class oppression

and its impact on the lives of women and girls of color. While second wave feminism exploded the myth of gender-neutral research, third wave feminists exploded the myth of feminism as representing all "women," by exposing the lack of attention second wave feminists gave to race, class, ethnicity, and sexual orientation, for example (p. 136).

Patriarchy implies that men have power and access to material resources, however, as Zambara (1994) pointed out, historically Latinos and Black men have not had power and resources, only White men. Men *and* women of color, *and* their communities, have historically lacked power in American society. Zambara recommended that in order for us to move forward in a proactive way on research on girls and women, we must be sure to clearly recognize the historical conditions of Latina women and that these continue to be different from those of dominant culture women.

Bonnie Dill Thorton (1994) described how Black women supporting each other, as a sisterhood, is not new to the Black community, in fact it has been institutionalized in Black churches and women's clubs. Black women have historically experienced an objective equality with Black men, due to their common experiences of struggling against racism. As a result, Black women have always been a part of a collective movement toward liberation. That theme is found in the ideas and experiences of women as diverse as: Audre Lorde (1984), Shirley Chisholm (1970), Gwendolyn Brooks (2006), Patricia Hill Collins (1990), Angela Davis (1981), Alice Walker (1974), and bell hooks (1984, 1989). Thorton recommended that we look at the structures that shape women's lives and their self-presentations. We need to take a more pluralistic approach to sisterhood, where we "concentrate our political energies on building coalitions around particular issues of shared interest" (Thorton, 1994, p. 53), and recognize that "feminist questions are only one group of questions among many others that are being raised about public education" (Thorton, 1994, p. 54).

Patricia Hill Collins (1990) helped us understand that U.S. Black women's efforts to construct individual and collective voices have occurred in at least three safe places: in their relationships with each other, in Black churches, and in Black women's organizations. "In the comfort of daily conversations, through serious conversation and humor, African-American women as sisters and friends affirm one another's humanity, specialness, and right to exist" (Collins, 1990, p. 102). Mothers and daughters enjoy strong relationships with each other, as mothers seek to empower their daughters "by passing on the everyday knowledge essential to survival as African-American women" (Collins, 1990, p. 102). Even among African-American women who are strangers to each other, they share a recognition of the need to value Black womanhood, and will seek to encourage each other's daughters to succeed. As Collins pointed out, with several levels of oppression to deal with, if Black women "will not listen to one another, then who will?" (Collins, 1990, p. 104).

Are girls of color better able to nurture each other, due to their common experiences of racial discrimination and class oppression? It appears to be so. While patriarchy alone causes girls to fight against each other for boys' attentions, racism positions girls of color in camaraderie with each other and boys of color, in order to protect their community against the dangers of racism. Signithia Fordham (1993), as an anthropologist,

wrote about this very issue in her analysis of her data obtained from an ethnographic study of academic success in an urban high school (Capital High). "Those Loud Black Girls" examined how African-American girls must negotiate the normalized definition of "femaleness"—as well as their Blackness—based on While middle-class standards of womanhood. Fordham used the metaphor of "loudness" to symbolize African-American girls' contrariness and resistance to dominant racism and sexism that asserted their "nothingness" in American urban schools. In her study, we found the evidence of sisterhood that girls of color learned while young, to help them negotiate two levels of domination, racism and sexism.

Others' and my personal experiences in higher education make sense when we take into consideration the research work on gender, race, and class in K-12 schools that I have shared. In the current world of higher education, where affirmative action policies have opened the doors of higher education to more women (Black, Brown, Red, Yellow, and White), and men of color, women of color are better able to negotiate and collaborate with each other, and their male colleagues of color, than White women. Women of color may be better able to work with their White male colleagues too. White women stand out as less able to work well with others, regardless of race, class, or gender. As one who is from this population group, it is a very sad statement for me to make. Once again, Freire (1970) helped us understand why women of color are better able to work with others, for learning to protect oneself from various forms of oppression is vital to one's own survival. For women of color, that means learning how to read danger signs from men in general, as well as from White people in general, and White men of means in particular, as well as danger signs from White women who seek to shore up their own positions of power within patriarchal culture by disassociating themselves from women of color.

Now that we have re/discovered how difficult it is for White girls to learn how to work well with each other, as well as with their sisters of color, and we have uncovered some of the social pressures that make it difficult for girls to befriend themselves, let us move the focus of our analysis to women in higher education. I want to explore the chilly climate in higher education that is generated by White women, and their destructive behavior toward their colleagues and students. Again, my goal is not to blame White women for their harmful behavior but to encourage them/us to engage in self-educative self-befriending so as to better be able to befriend others, and help us all overcome the oppressive, harmful conditions within which we were raised and educated, and which we continue to perpetuate through our own thoughtless actions of horizontal violence.

Gender Equity in Higher Education

In 1988, as feminist theory was entering into its third wave, and turning its attention to the claim of feminism as representing all "women," Jo Anne Pagano (1994) published an essay that explored women's roles in higher education titled "Teaching Women." I was a graduate student working on my doctoral degree then, not being exposed to any feminist scholarship in my classes, even though I had a strong woman philosopher of

education as one of my major professors. My major professor used the male measuring stick she learned as a graduate student to measure women's work, and found them wanting, therefore not including women's work in her course curriculum, except her own. Nor did either of her male colleagues include any women in their curriculums. I did not discover Pagano's essay asking, "(w)as there ever a creature so riddled with self-doubt as the female professor?" until I was a female professor myself. My answer to her was resounding agreement—"No. There never was!" (Pagano, 1994, p. 262).

What made Pagano's essay even more powerful for me in particular was that she uses the metaphor, plagiarist, to describe how women feel in higher education, and at the time when I read that essay I knew someone (let us call her Kim) who was in the process of defending herself against a charge of plagiarism, by another woman in higher education, another White feminist scholar whom she had mistaken for a friend (let us call her Chris).

As a brand new assistant professor in her first year of work in higher education, Kim was invited by Chris to collaborate with her on an article, based on Chris's read of a paper from Kim's dissertation that she submitted as part of her application file for the job she was offered, and accepted. Chris was on the search committee that invited Kim to campus for her interview. She had a paper addressing similar themes that she had presented at a conference, and proposed that Kim and she could put these two papers together as an article. What Kim discovered Chris meant by her invitation was: would Kim put their two papers together for a quick and easy publication for her, as Chris was nearing the time for her to have to submit her tenure case and she had three publications to date (or was it five?). Later, as Kim went through the appeal process and tried to defend herself against Chris's charge of plagiarism, Chris denied even entering into a collaborative relationship with Kim. Fortunately for Kim, she still had the post-a-note invitation Chris had written on a copy of her original paper submitted for her job application, as well as every copy of every draft of her efforts to try to do what Chris asked, along with Chris's editorial comments and suggestions/feedback, and Kim's notes from every meeting they had. Still, Kim had to get all the way to the vice-provost of academic affairs before she found sanity within the university appeals process—another White woman, who told her, "What you tried to do, in taking two completed papers and putting them together as one single essay, was a very dangerous thing to do, even for senior professors with much experience in publications, let alone for you, so new to this process." Of course, by then Kim knew that! Kim is the only junior, untenured faculty member I know who has survived a research misconduct hearing and lived to tell about it. That is not saying much though, as who talks about these things? I am not aware of any empirical evidence documenting cases like these. Kim may have been a trusting, naïve fool trying to be a friend, but she was not someone intentionally stealing someone else's words and ideas of any significance and trying to claim them as her own.

However, as Pagano (1994) so poignantly pointed out, at some level all women in higher education are plagiarists. Our teachers have all been men, even if in female body form, as I had with my lone female professor, a surrogate patriarch, for the male voice rules in higher education in the form of "the great Western tradition." We have all had to

learn the father's language and the male stories, and master them if we are to be allowed to teach in higher education. In the role of teacher, we are narrators who tell the story (his/story) all the while feeling like imposters full of professional anxieties. Women are charged with guarding the culture (though not its production). "Women do not beget culture: they mind it—both in the sense of tending and in the sense of obeying" (Pagano, 1994, p. 256). In the great Western tradition, men have judged women's works to be sentimental or minor and inconsequential, and have represented women in the canons as angels or whores. Women are either locked out or we are plagiarists. Pagano helps women understand, "the cards are stacked against us" (Pagano, 1994, p. 270). Barbara McKellar makes a similar point when she describes the role of the Black teacher: "Only the fittest of the fittest survive" (McKellar, 1994). "She is a woman who certifies male knowledge and is constructed as an object of that knowledge" (Pagano 1994, p. 270).

With competition so keen for women in higher education, and all of us struggling with feeling like imposters and plagiarists, as we master our abilities to be bicultural, it's no wonder we have problems working well with each other. Kim's collaborative "friend" was wrestling with her own feelings of inferiority and self-doubt about her abilities to write and get published, a prerequisite for being awarded tenure and keeping her job. Maybe she saw Kim as a competent writer who had mastered the male language, as a social foundations scholar, someone who could help her add to her vitae. Unfortunately for both of them, Kim was not able to fulfill this role for Chris; really it was an editor Chris wanted, not a collaborator. After Kim spent three months trying to put their two papers together, and mainly cutting her own words rather than changing Chris's, they agreed to stop their collaborative effort and go their own separate ways. Chris then sent her original paper to the journal Kim was planning to submit their joint paper to, and Kim sent her rewritten paper with Chris's words taken out of it to the same journal. She did not go back to her original paper, as her thoughts had continued to develop through the process of three months of writing (later she kicked herself for *not* doing that). Unbeknownst to either author, both papers were reviewed by the same editor and both were selected for publication. It was after they were both in print that Kim found herself under attack, when Chris discovered that in Kim's 17-page paper, three sentences of Chris's were still scattered in amongst Kim's text. It was a stupid mistake on Kim's part, certainly not intentional, and easy to correct, which she did immediately in the next issue of the journal, by citing Chris. However, three years of defending herself against a false charge for a mistake that a friend would have laughed with her about over a beer, gave her plenty of time to think about it. "Was there ever a creature so riddled with self-doubt as the female professor? No. There never was" (Pagano, 1994, p. 262).

In 2000, Jane Roland Martin came out with an examination of present conditions for women in higher education, presented like a report, as if she had been charged by The Society of Feminist Scholars and Their Friends to study the lay of the land and report back to the general public. In her report back, Martin described how women are more critical of other women's work than they are of men's. Just as when they were little girls and they ignored their sisters' points but attended receptively to what the little boys had to say, as scholars women tend to be much harsher critics of their

sisters (other female scholars) while being forgiving and generous to male scholarship. This is what little girls from my generation saw modeled each day they were in school, as well as in their informal education at home, in church, in the media, and in their community. Society taught us to be more critical of each other and more forgiving of males. It taught us to discount female contributions but take seriously what males have to say. I am not convinced things have improved that much for the current generation of girls either. From a Freirian perspective, females learned that dominant power is in the hands of males, they are the gatekeepers (in school they were the principals and superintendents, in higher education they are the deans and department heads as well as the editors of journals, publishers of books, and reviewers of submissions). One way to claim some authority of one's own in research is to use a razor sharp knife of critique on others' research from one's own social group, other women with little power (the oppressed), by sharply and unforgivingly critiquing their scholarship, thus perpetrating horizontal violence upon them.

Researchers have shown women and men, as students, tend to be more critical of female professors than of males (Martin 2000). Men can maintain a distant relationship with their students and be perceived as objective, principled, and professional, while women faculty will be perceived as distant, unapproachable, and cold. Men can embrace a more connected and personal role as a professor and make themselves stand out as outstanding teachers as a result, often nominated for "teacher of the year" awards by their students for being so caring. However, students expect their female professors to be more nurturing, as women, and do not give them any recognition when they do so, rather they are critical of them if they do not. At the same time students expect scholastic rigor. Feminists have discussed this as "the bearded mother" syndrome (Morgan, 1987; Bogdan, 1994). There is also research that shows work that is submitted for grading by professors, or for review for publication in journals, or acceptance for a conference program, if the very same work has a woman's name on it, it will be more harshly critiqued, given a lower grade, and/or be less likely to be accepted for publication or presentation (Martin, 2000). Men *and* women judge women's work more harshly than they do men's. As Martin said, women are held to "a higher double standard of intellectual 'prowess'" (Martin, 2000; p. 92). Such judgments keep women in higher education from getting hired, tenured, promoted, and awarded in all the ways that faculty in higher education are awarded. As Martin pointed out in her report, where women were once excluded from higher education, they are now contained. "Was there ever a creature so riddled with self-doubt as the female professor? No. There never was" (Pagano, 1994, p. 262).

Befriending Women in Higher Education

What would it mean to befriend women in higher education, and for women to actively engage in *self-educative self-befriending*? Both Laird (2003) and Freire (1970) pointed us in the direction of love. The oppressed (women in higher education) free themselves, and thus their oppressors (men in higher education), by learning to love themselves and

each other. We have learned that women in higher education are struggling against very deep-seated fears, and pain. Only the fittest of the fit survive to become professors in higher education. Those who have survived have learned how to overcome the oppressive, harmful conditions encountered through milieu education (television, films, and songs, etc.), our informal education (home, church, community, and peers), and our formal education (school, teachers, textbooks, principals, and guidance counselors). If we have learned to overcome our oppressive sexist conditions by becoming oppressors ourselves, as so many others have done in dealing with racist and classist conditions, then we fit right into Freire's description of how people deal with oppressive conditions. White women in higher education who commit horizontal violence on their colleagues are no better or worse than all those others who fight violence with violence, and become oppressors themselves.

I am a pacifist at heart. I do believe in the power of love. However, it is not easy to offer love to a person who is actively seeking to harm one's reputation as a scholar, a teacher, or as a colleague in a program, department, or college. In fact, to offer love to such a person can be quite foolish, for it is likely to make oneself vulnerable to harm by this person. Offering love to a person who means to do you harm is similar to positioning oneself as an enabler for an alcoholic or abusive partner. I do not mean to suggest we should set ourselves up for abuse, or allow someone to get away with bullying behavior. It's important that those who are being bullied stand up to that bullying behavior and not allow it to continue. However, it is equally important that the "standing up to" a person seeking to do harm is not done in a way that is perceived as retaliatory, harmful behavior given right back to the original perpetrator. Bullies need to be confronted calmly, firmly, and with care. "This kind of behavior will not be tolerated here. I know what you are doing and I will not let you harm myself or others." While I am a pacifist, I am also a fighter who will defend myself from harm.

In Kim's case, she had two senior faculty members in her department who befriended her, one was a woman from Chris's program whose office was next-door to Chris, let's call her JoAnne. Chris never confronted Kim directly with her accusation of plagiarism; she went straight to Kim's department head (John) and reported her version of what had happened to him. However, she also talked to JoAnne about it, in her anger, and JoAnne was kind enough to let Kim know that she had a problem she needed to address, and she should go talk to John. Kim did so, and that is how she found out that Chris was charging her with plagiarism. Her two senior colleagues, John and JoAnne, were fair, impartial, and open-minded in trying to help sort through this mess. That generosity, to not jump to a conclusion but listen and attend to both sides of the story, was perceived by Kim as acts of befriending. Not so for Chris. It was not enough that Kim apologize for her mistake and have Chris's three lines properly cited in the journal, Chris wanted to hurt Kim. She wanted Kim to lose her job.

Chris acted like she was satisfied with how the department handled the case, and when it was her time, submitted her tenure case. Once she was assured tenure, she proceeded to have a friend turn in Kim at the university level for research misconduct, triggering Kim to have to go through a university-level research misconduct hearing.

Because of Chris's extreme and vindictive response to three lines of hers ending up by accident in Kim's publication, both John and JoAnne moved from being impartial and nonjudgmental to supportive of Kim. Whatever had occurred in the women's failed effort to collaborate was not worth destroying someone's reputation and career over. As a junior faculty member, Kim could not know how much stress the situation with Chris probably caused both John and Jane, but she had an inkling, as both John and JoAnne retired from higher education during this time frame, John going first, when he turned seventy, but JoAnne following him shortly after, at a much younger age, after seeing Kim successfully make it through the tenure process (I believe she had over twenty publications).

Cases like Chris/Kim's have taught me to highly value department by-laws, faculty handbooks, and university policies. There are policies in higher education that can protect faculty from harm. If policies are not in place, they need to be written and that might mean volunteering to serve on the committee that writes them and gets them passed. Standing up to bullying behavior in higher education means turning to policies and procedures for help. It means creating a paper trail, and gathering documentation of the bullying behavior. It means keeping copies of all hateful email sent, and making notes of conversations (with dates, times, and locations, and hopefully witnesses, although there are often none). It means turning to the administration for help by keeping one's department head informed, and keeping notes of those meetings and copies of those emails as well. The department head should keep the dean informed. One can only succeed in "standing up" to bullying behavior if those in positions of authority have the strength and wisdom to use the university policy to protect their colleagues (and themselves) from the heat that will be generated by "standing up" to a bullying woman.

Once we have established ways of protecting ourselves from the harm some women in higher education are doing, we still need to try to find ways to befriend women. We need to return to the recommendation of loving the oppressed as the way to free them/us (and our oppressors) from our oppressions. I relied on some important lessons I learned as an elementary teacher, to help guide me as a department head. One, I learned it was important to let all the people who were working well together know that I noticed their positive contributions to our (classroom/department) community, and thank them for their help. Two, as an elementary teacher I learned to find something I liked about all the students with whom I worked. I learned to find a way for everyone to be able to positively contribute, and then make sure I showed my appreciation for their contribution.

Faculty in higher education are not leaving a department any time soon. In fact, in tough fiscal times, if they do leave, the program risks losing that line, and not being able to replace that faculty member with a new hire. It is an expensive, time-consuming process to hire a new faculty member. All motivation is in favor of trying to help hired faculty members thrive and achieve tenure at the university. This means, our colleagues are not people we live with for a year or two, but maybe twenty years, or longer. This is why it is essential that all faculty feel safe around each other, and that a healthy environment is maintained where everyone can thrive. People don't have to like each other, or be friends, and we certainly do not have to all agree. We just need to treat each other

with respect and decency, creating a space where all can feel like they can contribute, and that our diverse contributions are valued and appreciated. I learned from Herbert Kohl (1984) a very important lesson, that children want to feel included and a part of a classroom community. They need to feel like they belong. The same is true for women faculty members in higher education. They want to feel included and valued for what they have to contribute to their programs and departments. They want to be treated with respect and recognized for their contributions. They want to be heard, and know that their views are sought out, not ignored, belittled, or dismissed. My suspicion is that the more we find ways to offer support for women in higher education, and help them in their efforts to grow and thrive, the more we make room for them and find ways to let them contribute to the college community, the more we can consistently show women in higher education that we value them and appreciate their contributions, the more we will find women helping to improve conditions in higher education, rather than generating harmful conditions. These are acts of love, including efforts to hold women accountable for their acts of horizontal violence.

Conclusion

My hope in writing this essay is to get individuals talking about "the elephant in the room," the chilly climate generated by some women in higher education which most of men and women experience. This is not an easy topic, for most people are aware that little girls and boys in America grow up in a sexist society that favors boys over girls in so many ways. I have tried to remind readers of the various ways that sexism manifests itself in our school classrooms and that little girls are victims of that sexism not only in our schools, but when they walk out of the school building as well. There are committed, caring men and women who work hard to try and address gender inequity problems and concerns in higher education. No matter how hard one works to address these issues, one cannot ignore the fact that every day little girls grow up under harmful conditions that effect who they become. Sexism harms little boys too. I have tried to be mindful of sexism's harm to oppressors as well as the oppressed by connecting this gender equity issue to Freire's analysis of oppression.

I wrote this essay as one who has grown up experiencing sexist treatment, not just in school, but also at home and in my larger community. I have had to learn to self-educate and befriend myself, something I continue to work on as I seek to heal from the harm that continues to be done to me, much of that harm being unintentional. It is bad enough to have to worry about the harms others who hold more power than us might do to us. It is even worse to have to worry about the harm we seek to do to each other. It is my concern for the horizontal violence that women in higher education do to each other, in particular White women from my generation, which has motivated me to write this essay. I have experienced this horizontal violence myself, watched many others experience it, and have had to step in and try to help protect students and colleagues from this violence, as a department head.

Martin (2000) made numerous suggestions in *Coming of Age in Academe* to help us continue our efforts to reform the academy (higher education). This essay is an attempt to act on her suggestion that we take the academy seriously as a bona fide object of study and look further at what is going on in schools and colleges in terms of gender equity. As Martin recommended, and many have discovered during their careers in higher education, they need to reject the idea of a female essence, but they should not reject the concept of *women* itself, as it is how the world perceives them. Martin warned that rejecting *women* will lead to a lack of self-understanding and their own containment. Studying *women in higher education* will help better understand those in the workplace and will help in healing, befriending, and even learning to love each other.

Note

Thayer-Bacon, Barbara, "Befriending (White) Women Faculty in Higher Education?," *Advancing Women in Leadership*, 31 (2011): 23–33. Reprinted by permission of the publisher.

1. What Harry Broudy (1954) referred to as *mileau education* and curriculum scholars referred to as the *hidden curriculum* (Giroux & Purpel, 1983; Sadker & Sadker, 1995).

References

Association of American College. (1982). *The classroom climate: A chilly one for women.* Washington DC: Association of American College.

American Association of University Women. (1992). *How schools shortchange girls.* Washington DC: Association of American College.

Bogdan, D. (1994). When is a singing school (not) a chorus?: The emancipatory agenda in feminist pedagogy and literature education. In L. Stone (Ed.), *The education feminist reader* (pp. 349–358). New York: Routledge.

Brooks, G. (2006). Selected poems. New York: HarperCollins Publ.

Broudy, H. S. (1954). Definition of education. *Building a Philosophy of Education.* New York: Prentice-Hall.

Chisholm, S. (1970). *Unbought and unbossed.* Boston: Houghton Mifflin.

Clarke, S. (2007). *Single-sex schools and classrooms.* Alexandria: Educational Research Service.

Collins, P. H. (1990, 2000). *Black feminist thought* (2nd ed.). Boston: Unwin Hyman with New York: Routledge.

Davis, A. (1981). *Women, race, and class.* New York: Random House.

Diller, A., Houston, B., Morgan, K., and Ayim, M. (1996). *The gender question in education: Theory, practice, and politics.* Boulder, CO: Westview Press.

Finn, J., Reis, J., & Dulberg, L. (1980). Sex differences in educational attainment: The Process. *Comparative Educational Review, 24,* 333–352.

Fordham, S. (1993). 'Those loud black girls': (Black) women, silence, and gender 'passing' in the academy. *Anthropology and Education Quarterly, 24,* 3–32.

Foucault, M. (1965/1967). *Madness and civilization* (Vol. I). (R. Hurley, Trans.). New York: Random House, and London: Tavistock.

Foucault, M. (1979). *Discipline and punishment.* (A. M. Sheridan Smith, Trans.). New York: Pantheon.

Frazier, N., and Sadker, M. (1973). *Sexism in school and society.* New York: Harper and Row.

Freire, P. (1970). *Pedagogy of the oppressed* (M. B. Ramos, Trans). New York: Seabury Press.

Gilligan, C., Lyons, N., and Hanmer, T. (Eds.). (1990). *Making connections.* Cambridge: Harvard University Press.

Giroux, H., and Purpel, D. (Eds.). (1983). *The hidden curriculum and moral education.* Berkeley: McCutchan Pub. Corp.

hooks, b. (1984). *Feminist theory.* Boston: South End Press.

hooks, b. (1989). *Talking back: Thinking feminist, thinking black.* Boston: South End Press.

Houston, B. (1994). Should public education be gender free? In L. Stone (Ed.), *The education feminism reader* (pp. 122–134). New York: Routledge.

Kohl, H. (1984). *Growing minds: On becoming a teacher.* New York: Harper & Row.

Laird, S. (1994a). Coeducational teaching: Taking girls seriously. In A. C. Ornstein (Ed.), *Teaching: Theory into practice* (pp. 355–371). Boston: Allyn & Bacon.

Laird, S. (1994b). Rethinking 'coeducation.' *Studies in Philosophy and Education, 13,* 361–378.

Laird, S. (2003). Befriending girls as an educational life-practice. In S. Fletcher (Ed.), *Philosophy of Education Yearbook 2002* (pp. 73–81). Urbana, IL: Philosophy of Education Society.

Laviqueur, J. (1980). Co-education and the Tradition of Separate Needs. In D. Spender and E. Sarah (Eds.), *Learning to lose* (pp. 180–190). London: Women's Press.

Lorde, A. (1984). *Sister outsider.* Trumansburg, NY: Crossing Press.

Martin, J. R. (1982). Excluding women from the educational realm. *Harvard Education Review,* 52, 133–148.

Martin, J. R. (2000). *Coming of age in academe: Rekindling women's hopes and reforming the academy.* New York and London: Routledge.

McKellar, B. (1994). Only the fittest of the fittest will survive: Black women and education. In L. Stone (Ed.), *The education feminist reader* (pp. 229–241). New York: Routledge.

Morgan, K. (1987). The perils and paradoxes of feminist pedagogy, *Resources for Feminist Research,* 16, 50.

Morse, S. (Ed.). (1998). *Separated by sex.* Washington, DC: The Foundation.

Pagano, J. (1994). Teaching Women. In L. Stone (Ed.), *The Education feminist Reader* (pp. 252–275). New York: Routledge.

Sadker, M., and Sadker, D. (1982). *Sex equity handbook for schools.* New York: Longman.

Sadker, M., and Sadker, D. (1995). *Failing at fairness.* New York: Touchstone Press.

Sadker, M., Sadker, D., and Long, L. (1989). Gender and educational equality." In J. A. Banks and C. A. McGee (Eds.), *Multicultural education.* Boston: Allyn & Bacon.

Sprecher, K. (Spring, 2008). Response paper: Susan Laird's 'Befriending girls,'" for CSE 544, Contemporary philosophy of education. Knoxville: University of Tennessee.

Spender, D. (1982). *Invisible women.* London: Writers and Teachers Publishing Cooperative Society.

Spender, D. (1980). *Man made language.* London: Routledge & Kegan Paul.

Spender, D., and E. Sarah (Eds.). (1980). *Learning to lose.* London: Women's Press.

Spielhagen, F. R., (Ed.). (2008). *Debating single-sex education.* Lanham: Rowman & Littlefield Education.

Stacey, J., Bercaud, S., and Daniels, J. (Eds.). (1974). *And Jill came tumbling after.* New York: Dell.

Stanworth, M. (1983). *Gender and schooling.* London: Hutchinson.

Thorne, B., and Henley, N. (Eds.). (1975). *Language and sex: Differences and dominance.* Rowley: Newbury House.

Thorton, B. D. (1994). Race, class, and gender: Prospects for an all-inclusive sisterhood. In L. Stone (Ed.), *The education feminist reader,* (pp. 42–56). New York: Routledge.

Walker, A. (1974). *In search of our mothers' gardens.* New York: Harcourt Brace Jovanovich.

Young, I. M. (1997). Gender as seriality. *Intersecting Voices.* Princeton: Princeton University Press.

Zambrana, R. E. (1994). Toward understanding the educational trajectory and socialization of Latina women. In L. Stone (Ed.), *The education feminist reader,* (pp. 135–145). New York: Routledge.

Ecofeminism as a Pedagogical Project

Women, Nature, and Education

Huey-li Li
University of Akron

In 1974, French feminist Françoise d'Eaubonne, in suggesting that women have the potential to solve today's ecological crises, coined the term "ecofeminism."[1] Gradually, ecofeminism has come to refer to a variety of feminist modes of inquiry into the conceptual linkages between sexism and other forms of oppression, such as racism, class exploitation, militarism, and ecological destruction.[2] The naming of "ecofeminism" reflects ecofeminists' intent to carve out an independent position within feminist and environmentalist communities. In effect, the theorizing of ecofeminism represents feminists' efforts to address and redress interrelated forms of oppression. By emphasizing the interconnections among various forms of oppression, ecofeminism does not appear to privilege gender oppression. Instead, the praxis of ecofeminism underlines women's active participation and leadership in integrating environmental movements, women's movements, and democratic movements across cultural and national boundaries.[3]

In response to the worsening of ecological problems, many educators such as David Orr have made efforts to advocate that "all education is environmental education."[4] The call for an all-inclusive environmental education echoes the ecofeminist movement, which declines to compartmentalize today's environmental problems as a specific form of social oppression. However, an all-inclusive environmental education movement does not deliberately inquire into the links between sexism and other forms of oppression, as delineated by ecofeminists. Likewise, the pedagogical implications of ecofeminism remain relatively unexplored. Consequently, while the ecofeminist and the environmental education movements are not mutually exclusive, the common ground between these two movements has yet to be fully explored.

The purpose of this essay is to appraise how ecofeminist analyses of today's ecological problems could expand the scope of environmental education and engender more ecologically congenial pedagogical actions. Specifically, I first inquire into how ecofeminism sheds light on rethinking the concept of "nature" for promoting a more inclusive

environmental education movement. Then I explore the underlying ethical principles of ecofeminism as a pedagogical project.

Ecofeminist Rethinking of the Concept of Nature

Although there are different strands of ecofeminism, ecofeminism is primarily a feminist discourse. Heidi Hartmann notes that the marriage of Marxism and feminism "has been like the marriage of husband and wife depicted in English common law: marxism and feminism are one, and that one is marxism."[5] In a parallel manner, ecofeminism also represents a marriage between feminism and environmentalism. But, "the one" in this marriage appears to be feminism. In other words, sex- and gender-based systems of oppression have served as the anchor for ecofeminists' analyses of the conceptual, empirical, socioeconomic, linguistic, symbolic and literary, spiritual, religious, epistemological, political, and ethical interconnections between the domination of women and nature.[6]

One could argue that ideally, ecofeminism should serve as an encompassing political discourse that transforms and eventually integrates both the environmental and the women's movements. However, despite ecofeminists' efforts in the last three decades, ecofeminism remains a specialized yet marginalized theoretical discourse in the fields of women's studies and environmental studies.[7] Critics of ecofeminism point out that ecofeminist analyses oversimplify the conceptual roots of today's ecological problems at the global level.[8] Nevertheless, the sex/gender role system has been entrenched within the major social institutions, including modern schools, which in turn shape the interhuman and the human-earth relations. From this standpoint, it is critical to examine the relation between the gendering of modern schools and today's ecological problems.

Due to limited space, I will not undertake an in-depth and comprehensive examination of divergent ecofeminist perspectives in relation to the environmental education movement. Instead, in what follows, I focus on how ecofeminist analyses shed light on the conception of "nature" within the environmental education movement.

Beginning with Sherry B. Ortner's controversial argument that the distinction between female and male is related to the more basic distinction between nature and culture,[9] the feminization of nature has been a salient yet highly polemic theme in the ecofeminist literature.[10] In line with psychoanalytic theory, Dorothy Dinnerstein claims that the feminization of nature can be traced to the human infant's inability to distinguish clearly between its mother and nature.[11] Elizabeth Gray further argues that men's need to conquer women and feminized nature is the result of sexual differentiation in gender role development. In other words, the female infant's sense of oneness with her mother is sustained by her identification with her mother, whereas the male infant's gender development leads to rejection and denial of his dependence on and attachment to her. Gray argues that male ambivalence toward dependence upon the mother has enormous psychosexual repercussions on males' relations with women and with whatever is perceived within the culture as feminine, including nature. In order to ensure men's continuous independence from the mother and the female in general, it becomes essential

for patriarchal culture to define the wife's role as submissive and inferior. According to Gray, the advancement of technology mainly aspires to "transform [men's] psychologically intolerable dependence upon a seemingly powerful and capricious 'Mother Nature' into a soothing and acceptable dependence upon a subordinated and non-threatening 'wife.' "[12]

Beyond psychoanalytic theory, Rosemary Ruether argues that both the human destruction of nature and women's oppression are legitimized and perpetuated by a hierarchical social structure that allows one group to dominate another. According to Ruether, this hierarchical social structure is rooted in a dualistic ideology, "transcendent dualism," which stresses separation, polarization, and detachment between sexes, classes, and human and nonhuman beings. In these binary oppositions, man/upper-class/white/human beings are considered superior to woman/lower-class/people of color/nature. "Woman as Mother" is a central theme of Ruether's demystification of transcendent dualism. She asserts that the female capacity for human reproduction led women to an implicit acceptance of and identification with the cyclical ecology of death and rebirth in the woman-identified culture. In contrast, men's inability to bear children eventually induced them to contrive a male deity who creates human beings and transcends finite bodily existence. Rooted in transcendent dualism, patriarchal religion seeks to pursue the infinitude of human existence. Following patriarchal religion, science and technology also seek to "realize infinite demand through infinite material 'progress,' impelling nature forward to infinite expansion of productive power. Infinite demand incarnate in finite nature, in the form of infinite exploitation of the earth's resources for production, eventually results in ecological disaster."[13]

Corresponding to Ruether's analysis, Carolyn Merchant claims "the ancient identity of nature as a nurturing mother links women's history with the history of the environment and ecological change."[14] According to Merchant, the identification of nature with a nurturing mother prevented human destruction of nature in early history. However, nature can also be identified as a disorderly woman who called forth human control over nature in the scientific revolution. Merchant points out that early scientists such as Francis Bacon utilized the image of the disorderly woman to develop scientific objectives and methods. As a whole, the Baconian doctrine of domination over nature is correlated with the perception of disorder in a feminized nature. Merchant's critique of mechanism complements Ruether's demystification of transcendent dualism. It is this dualism that lays the foundation for a mechanistic worldview, and it is mechanism that eventually severs the organic relation between humans and nature.

Tellingly, Gray, Ruether, and Merchant employ "women" and "nature" as inclusive and universal categories. In view of the cross-cultural variation in gender construction and modes of conceptualizing "nature," their analyses appear to be based on a circular, simplistic, and reductive argument.[15] If there were no well-established sex/gender role system, the development of masculinity would not require a rejection of man's early dependence upon his mother. Moreover, although the presence of a woman as the infant's primary caretaker reduces the influence of male adults, especially the father, on the male infant's development, "the total and exclusive exposure of mothers to their young children" seems to be a myth rather than reality.[16] Insofar as men's abrupt rejection of their

mothers appears to be a mystification, women's connection to nature also seems to be a reified cultural phenomenon. Val Plumwood further points out that "the reproductively related features of masculinity and femininity . . . were (until recently at least) universal, but the alleged consequence, the transcendent apriority of the rational, is not a universal feature."[17] To illustrate, the feminization of nature and the accompanying devaluation of nature are not cross-cultural phenomena.[18] In non-Western societies such as China, nature as a whole has not been associated with woman. The traditional yin-yang cosmology in China, while revealing dyadic thinking, does not associate the yin (female) principle with the all-encompassing immanent nature.[19] Yet the absence of transcendent dualism does not preclude the oppression of women. In actuality, ancient Chinese misogyny coexisted with an organic world-view, which has proven capable of sanctioning the massive transformation of natural environments.[20]

From this cross-cultural perspective, women's closeness to nature is neither biologically determined, nor is the perception of an affinity between women and nature an inherent feature of the human psyche. Instead, both the association of woman and nature and the human domination of nature result from a social construction. According to Kathy Ferguson, there are three types of feminist essentialism. The first type—namely, "essentialism per se"—attributes "women's psychological and social experiences to fixed and unchanging traits resident in women's physiology or in some larger order of things." "Universalism," the second type of essentialism, "takes the patterns visible in one's time and place to be accurate for all." The third type of essentialism is what she calls "the constitution of unified categories," which "entails any constitution of a unified set of categories around the terms *woman* and *man*."[21] At first glance, ecofeminist analyses of the affinities between woman and nature appear to be based on an essentialist assumption that women's presumably fixed biological and physiological traits entail the feminization of nature. By acknowledging cultural pluralism, one can easily cast doubt on essentialist arguments. One can also point to the fact that nature is neither fixed nor unchanging. For example, in the face of seemingly irreversible globalization and rapid urbanization, the recent announcement of "the end of nature" seems inevitable: "By changing the weather, we make every spot on earth man-made and artificial. We have deprived nature of its independence, and that is fatal to its meaning. Nature's independence is its meaning; without it there is nothing but us."[22]

However, Carol Bigwood cautions us not to go so far as to dismiss "nature as a cultural fiction" and assume that culture is solely responsible for constituting reality and all living beings. In line with ecofeminism, she argues that affirming women as women must be based on an effort to recognize the link between the female body and women's way of being. To Bigwood, such a link is a focal point for us to inquire into all the binary oppositions, that is, the masculine versus the feminine, culture versus nature, mind versus body, and public versus private.[23] In addition, it is also important to examine the feminization of nature as an imported idea that has been accepted and popularized in non-Western societies in the age of globalization. For instance, it has become common for Chinese people to employ the metaphor of "the rape of mother

earth" to refer to human exploitation of nature even though they traditionally did not identify earth as a mother. While such a recent feminization of nature reflects Western cultural hegemony, it also reveals how the image of woman has been used as an available and powerful metaphor to describe and further prescribe the human perception of nature across cultural boundaries.

More specifically, in the process of metaphorization, the subject who utters the metaphor and the metaphoric vehicle usually represent two distinct groups, such as men and women. Eva Feder Kittay notes that women are persistently used as a metaphor for men's activities and projects, while there are no equivalent metaphors using men as vehicles for women and women's activities.[24] Gerda Lerner further argues, "When humankind made a qualitative leap forward in its ability to conceptualize large symbol systems which explain the world and the universal, women were already so greatly disadvantaged that they were excluded from participation in this important cultural advance."[25] Men also hold a monopoly on cultural formation in Chinese society. The recent affiliation of woman and nature certainly reflects men's privileged status in Chinese society where an elaborate sex/gender-role system is indispensable for sustaining such a patriarchal structure.[26] Therefore, while the feminization of nature may not be the main contributing factor in today's ecological destruction, it is still critical to attend to how male hegemony facilitates the successful transplantation of gender imagery across cultural boundaries. In short, although men's psychosexual reaction against nature and women, as analyzed by Dinnerstein and Gray, may be unverifiable at the level of the individual, the deployment of gender imagery has played a key role in shaping the historical and contemporary construction of political, economic, and social institutions.

Joan Wallach Scott points out, "The point of the new historical investigation is to disrupt the notion of *fixity*, to discover the nature of the debate or repression that leads to the appearance of timeless *permanence* in binary gender representation."[27] The affinity of women and nature appears to be "fixed," "permanent," or even "given" in Western cultural contexts. On the one hand, Ruether's and Merchant's historical analyses do not challenge the fixity of the age-old association of women and nature. On the other hand, their analyses reflect contemporary feminists' efforts to unveil the hidden sexism informing the historical construction of dominant social institutions, including the construction of scientific knowledge.[28] Christine Littleton points out that the efforts to reconstruct sexual equality should attend to "the difference gender makes" rather than "gender difference."[29] In analyzing this issue it is crucial to divulge the seemingly imperceptible differences gender makes. Marilyn Frye points out that "women's experience is a background against which phallocratic reality is a foreground. . . . It is essential to the maintenance of the foreground reality that nothing within it refer in any way to anything in the background, and yet it depends absolutely upon the existence of the background."[30] Like women, "nature" also serves as a background that obscures the foreground of human interventions, especially in the modern era. For that reason, ecofeminist analyses of the women-nature affinity do not reinforce sex/gender stereotypes of women/nature.[31] Rather, ecofeminists recognize that the "backgrounding" of both women and nature is an invisible

yet indispensable device for reifying the foreground reality, and they call for a radical reconstruction of reality along nonoppressive lines.

From this perspective, while the construction of modern schools as gendered institutions may not originate from men's psychosexual reactions against their mothers and against feminized nature, it should be noted that the establishment of modern schools corresponds with the split between the private and the public spheres—that is, modern public schooling is mainly responsible for educating prospective citizens for their civic engagement in the public domain. As the divide between the private and the public spheres is correlated with sex/gender roles, modern schooling's embracing of individual autonomy, human rationality, the pursuit of progress, and contractual relations mainly derives from men's experience in the public sphere while excluding women's experience in the private sphere.[32] In the meantime, modern schools as gendered institutions have also served as what Ivan Illich describes as "a social womb" in which we sever our ties with the earth in order to become "productive" citizens for development and progress.[33] In the name of pursuing "progress," the gendering of modern schooling inadvertently has contributed to the normalization of human domination of nature and has fostered what Edward O. Wilson calls "bio-phobia" (an aversion to nature).[34]

To redress the worsening of ecological problems ensuing from industrialization and scientific advancement, diverse environmental education movements have focused on reestablishing the connections between human beings and the earth. In the nineteenth century, Nature Study and Outdoor Education, the forerunners of today's environmental education movement, not only echoed the "back-to-nature" movement but also promoted the belief that children's experiences with nature play a key role in shaping their lifelong development. Friedrich Froebel, the founder of the modern kindergarten, advocated that the child "should early view and recognize the objects of nature in their true relations and original connections; . . . there shall draw upon him early . . . the great thought of the inner, continual, vivid connection of all things and phenomena in nature."[35]

However, the environmental education movement's efforts to reclaim the connections between humans and nature do not include a critical inquiry into "the differences gender makes." Kim Tolley points out that historians of education conventionally attributed the creation of the Nature Study movement to a few progressive male educators when documentary evidence clearly shows that women played an important role in the movement. At the same time, social critics of the Nature Study movement claimed that studying nature contributed to "feminizing" boys and characterized the movement as "romantic" or "sentimental."[36] Granted, sexist ideology alone cannot fully explicate the decline of the Nature Study movement in the twentieth century. Yet, the technocentric mode of the environmental education movement (for example, Conservation Education for development and rational Resource Management education programs) ensuing from the Nature Study movement endorses to a certain degree what Val Plumwood described as "the master category of reason" that "provides the unifying and defining contrast for the concept of nature."[37] Interestingly, "reason" as a Western cultural ideal has been defined as standing in opposition to the feminine, the natural, and the material.[38] By emphasizing "rational" management of natural resources and ecological risks, the technocentric mode

of the environmental education movement continues to reflect the ideology of human domination of nature.

In view of the interconnections of various forms of social oppression, ecofeminists realize that "women must see that there can be no liberation for them and no solution to the ecological crisis within a society whose fundamental model of relationship continues to be one of domination."[39] Advocates of environmental education and environmental ethicists also have commonly identified domination, grounded in dualism, as the critical conceptual root of today's ecological problems without taking gender into consideration.[40] For instance, deep ecologists such as Arne Naess cónsider anthropocentrism as the root of "domination."[41] But, in light of ecofeminist analyses, one must question whether anthropocentrism is androcentrism in disguise.[42] After all, gender differentiation and male domination epitomize unequal social relations and imbalanced human-nature relations.

Drawing on ecofeminist analyses, it becomes critical to challenge the myth that environmental education is all about celebrating and preserving "nature." Instead, an all-inclusive environmental movement must examine, critique, and rectify the unequal social relations embedded in contemporary society. Kathleen Weiler points out,

> feminist theory . . . validates difference, challenges universal claims to truth and seeks to create social transformation in a world of shifting and uncertain meanings. In education, these profound shifts are evident on two levels: first, at the level of practice, as excluded and formerly silenced groups challenge dominant approaches to learning and to definitions of knowledge; and second, at the level of theory, as modernist claims to universal truth are called into question.[43]

Likewise, advocates of an all-inclusive environmental education movement must unveil the complex dialectical intersections between the perceived "natural world" and the "social world."

To Ulrich Beck, ecological problems are indeed the social problems of the inner world of society rather than the problem of the environment or our surrounding world. It follows that presumably "natural" or "ecological" questions must center on "fabricated uncertainty within our civilization: risk, danger, side effects, insurability, individualization and globalization."[44] While such a sociological analysis of ecological problems acknowledges the inseparability of the "natural" and the "cultural," it also reflects a current trend toward defining "nature" as "an artifact of language" or a project of "social construction."[45] This trend presents an insightful critique of an essentialist and monolithic conception of "nature." As human beings are capable of undertaking massive transformations of both "natural" and "cultural" environments, environmental education certainly cannot solely focus on constructing, disseminating, and transmitting objective scientific knowledge about flora, fauna, coal, water, metals, and forests, as suggested by the early proponents of Nature Study. Instead, a more comprehensive understanding of the cultural aspects of today's ecological problems is crucial to the reorientation of our ecologically exploitative practices.

At the same time, we must also be aware of the problems associated with a radical constructivist conception of "nature" that reduces "nature" to a variety of discursive ideas or socially constructed artifacts. Specifically, from the vantage point of radical constructivism, nature as "a singular and unified living material/physical world" does not exist.[46] Instead, there are different genres of "nature"—or "natures"—constructed by a range of cultural institutions. However, such constructivist accounts of pluralistic "natures" can be a double-edged sword. On the one hand, the constructivist standpoint is helpful for exposing anti-urban biases. On the other hand, there are neither epistemological bases nor ethical grounds to invalidate any discourses on "nature," despite potentially dreadful empirical consequences. It is often noted that divergent perspectives on global warming, to a certain degree, have paralyzed the international community's efforts to reach consensus and to take responsive collective actions. Clearly, such radical constructivism can "assimilate nature to an exclusive anthropocentric 'reality.' And it should be seen as expressing long-term industrialist tendencies to separate the 'human' and the 'natural' realms and to assimilate the latter to the former."[47]

In view of the debates concerning the nature of "nature," including the feminization of nature, it has become clear that an inclusive conception of environmental education must rectify the polarized conceptions of "nature." Accordingly, it is essential to raise awareness of the changing nature of "nature" and of the changing cultural contexts in which "nature" exists and changes occur. In other words, the "natural" realm does not necessarily preclude the occurrence of "changes," which include industrialization and urbanization. Therefore, instead of sustaining the polarization between essentialism and constructivism, the ecofeminist movement especially underlines the interactive intersections of the "natural" realm and the "human" realm, which can be seen as the vicissitudes of both the "natural" order and the "cultural/social" order. The recognition of the interaction of the "natural" and the "cultural/social," then, calls for a more prudent collective inquiry into why, how, and what kind of "natural" and "cultural" knowledge should be constructed and disseminated across generational lines. In this next section, I will explore how ethical activism embedded in the global ecofeminist movement can expand the scope of environmental education and engender ecologically congenial pedagogical practices.

Ecofeminism as a Pedagogical Project

While the social movements for peace, ecology, human rights, and women's rights are based upon grassroots participation, the convergence of these local activities tends to transcend geographical and cultural boundaries.[48] Emerging out of these interrelated grassroots social movements, ecofeminists, in general, appear to be more concerned about undertaking political actions rather than engaging in rigorous theorizing. In the early days, the primacy of gender analyses by academic ecofeminists seemed to suggest a political move to reposition women at the center of the environmental movements, challenging their traditional relegation to the periphery. In recent times, however, the ecofeminist movement has placed greater emphasis on women's ethical and political agency in promoting

multilayered social movements that contest interrelated forms of oppression at the global level.[49] In other words, the contemporary ecofeminist movement has made a noticeable shift from prosecuting the double domination of women and nature to redressing inter-related ecological, economic, and social problems ensuing from capitalistic globalization.

To illustrate, growth-oriented development continues to "sustain" the ecological crisis and economic distress for people of color in many so-called developing countries where industrialization was often subsidized without responsive environmental regulation and labor protection.[50] In addition to the aforementioned ecological and economic oppression, women of color in these countries also experience gender oppression. As a result, while women of color are the bona fide victims of the ongoing capitalist globalization, their victimization may bestow upon them a special stake as participants and leaders in grass-roots environmental movements.[51] For instance, Maria Fernanda Espinosa, in working with the Indigenous Organization of the Ecuadorian Amazon (CONFENIAE), came to realize that Amazonian indigenous women as "local leaders with scarce political experience and often very little formal education" play a key role in the local environmental movement and show a strong commitment to collaborating with other nonelite indigenous women in strategizing about how to address their respective local environmental issues.[52] Without participating in the theorizing of ecofeminism, these women environmental activists have committed themselves to healing the alienation between humanity and nature and, eventually, to solving today's environmental problems. Indigenous women environmental activists acknowledge through their practice the critical fact that no one is exempt from today's global ecological problems. In the meantime, by incorporating the ideas and actions of these grassroots women environmental activists into its theorizing, "ecofeminism has been an important international political location at the intersection of environmentalism and feminism, which has become a globalized space for political demands by women in many countries who might not otherwise have had a voice or an opportunity to create coalitions."[53] In short, women-led grassroots environmental movements in the developing countries have been a salient feature of eco-feminist discourse. Thus, although Euro-American ecofeminists such as Karen Warren acknowledge that their version of ecofeminism is grounded in Western cultural and academic traditions, in their work they continue to celebrate the Chipko movement (a grassroots movement to call Indian villagers to "hug the trees" in order to stop lumber companies from clear-cutting mountain slopes) as a primordial example of women-led movements.

By attending to the leadership role of Third World women, ecofeminist discourse has shifted its focus from the "feminization of nature" to the "capitalization of nature," which entails "colonial and capitalist practices, and the so-called development schemes sponsored by international organizations like the World Bank."[54] Gradually, ecofeminism has evolved into a feminist intervention focused on replacing the mainstream development discourse with international and interdisciplinary discourses on women in development (WID), gender and development (GAD), and women, environment, and development (WED). Gendered development studies do not regard Third World rural women as scapegoats for population growth, a serious problem within mainstream development studies. Instead, WID, GAD, and WED advocate that women should be the beneficiaries

of the pursuit of ecologically congenial development. Beyond WID, GAD, and WED, the establishment of Development Alternatives with Women for a New Era (DAWN) offers judicious critiques of the "Western development model" that fails to empower women as policy makers.[55]

On the whole, grassroots ecofeminist movements adopt a more inclusive approach to address interrelated environmental problems associated with the ongoing "capitalization of nature." Beyond the typical environmental concerns (such as antipollution and conservation of natural resources), grassroots women environmentalists make concerted efforts to attend to the interconnections among militarism, capitalism, and neocolonialism. For instance, the preamble of "Women's Action Agenda 21," a document outlining the key issues addressed in the World Women's Congress for a Healthy Planet in November 1991, asserts that "a healthy and sustainable environment is contingent upon world peace, respect for human rights, participatory democracy, the self-determination of peoples, respect for indigenous peoples and their lands, cultures, and traditions, and the protection of all species." The interconnections among world peace, human rights, participatory democracy, indigenous peoples' rights, and the protection of endangered species are based on the assumption that "as long as Nature and women are abused by a so-called 'free-market' ideology and wrong concepts of 'economic growth,' there can be no environmental security."[56]

I would argue that in light of the praxis of ecofeminism in building coalitions among international environmental activists, it is vital to situate an all-inclusive environmental education movement in the context of capitalist globalization. First and foremost, the pursuit of global economic justice should play a key role in reshaping curriculum development and in fostering international environmental activism. More specifically, parallel to feminist educators' efforts to recruit more women into science and to make women scientists more visible, the theorizing of ecofeminism embraces key women scientists' inclination to construct ecologically congenial scientific knowledge. In the eyes of ecofeminists, Rachel Carson and Ellen Swallow are exemplars for women scientists in their construction of alternative scientific knowledge that is not based on a perceived "masculine" desire to control feminized nature.[57] Beyond challenging the binary gender representation in science, it is also critical to unveil hidden assumptions in the various fields of science.[58] For instance, science education is known for excluding personal lived experiences. In line with the second wave of the women's movement, feminist science educators endeavor to "center" lived experience and revise science accordingly.[59] Advocates of feminist science make special efforts to attend to other marginalized peoples' experiences of modern science because "the experience and lives of marginalized peoples, as they understand them, provide particularly significant problems to be explained, or research agendas."[60] For that reason, the voices of Third World women have gained a special recognition when ecofeminists such as Vandana Shiva envision "new intellectual ecological paradigms":

> In contemporary times, Third World women, *whose minds have not yet been disposed or colonized*, are in a privileged position to make visible the invisible

oppositional categories that they are the custodians of. It is not only as victims, but also *as leaders in creating new intellectual ecological paradigms*, that women are central to arresting and overcoming ecological crises. . . . Marginalization has thus become a source for healing the diseased mainstream patriarchal development. Those facing the biggest threat offer the best promise for survival because they have two kinds of knowledge that are not accessible to dominant and privileged groups. First, they have the knowledge of what it means to be the victims of progress, to be the ones who bear the cost and burdens. Second, they have the *holistic and ecological knowledge* of what the production and protection of life is about.[61]

Shiva's viewpoint represents a "post-victimology" study of ongoing capitalist globalization.[62] In view of the dynamic and interactive nature of cultural formation in the age of capitalist globalization, one cannot help but point to the disappearance or assimilation of Third World women endowed with "holistic and ecological knowledge." Still, Shiva's argument pinpoints that educational reform cannot simply focus on recruiting women and ethnic minorities into the fields of scientific studies and making women scientists visible. Rather, it is essential to attend to the "invisible" burden on subaltern groups and to explore ecologically congenial epistemological traditions.

Perhaps most important, ecofeminism as a political and pedagogical project can play a key role in promoting moral agency in oppressive contexts. In modern liberal states, one must become a "speaking subject" in order to take formal or informal political action. However, as nature itself cannot function as a speaking subject, it is not surprising that most educators more or less exclude wounded yet silent "nature" from critical educational discourse. The historical Western affinity between woman and nature might place ecofeminists in a particularly favorable position to "speak for nature."[63] Yet, as the essence of ecofeminism is to question the existing social structure, one can also question the imperative of becoming a "speaking subject" in order to make a political speech. For example, poststructuralists' remarkable efforts to destabilize varied human identities especially question the existence of the singular and unified "subject." While subalterns may lament their destabilized "subjectivity," their presumably "problematic" subjectivities have not prevented them from undertaking discursive practices, either to reassert or to further negotiate identities. It seems that questionable subjectivities have no bearing on regulating discursive practices concerning individual human actions and political coalitions. In the same vein, concerned educators need not assume a specific subjectivity in order to address ecological risk.

Poststructuralism and postcolonialism have argued strongly that the "universalizing" of "women" ignores the differences among "women." Similarly, the emergence of bioregionalism as a movement to counter capitalist globalization also pinpoints the risks of "totalizing" nature and instigating a global environmental movement. From this standpoint, "women" as a universal category is problematic because the universalizing of women not only eradicates vital differences among women but also "essentializes" women. Still, must we in consequence abandon the use of universal categories such as "women" and "nature"?

Judith Butler points out that "no subject is its own point of departure."[64] Although it is essential to demystify "women" as a unified and monolithic group in culturally pluralistic societies, overemphasizing differences among women can lead to fragmentation of the women's movement.[65] In response to the critics of essentialsm, Diana Fuss points out that the deployment of more specific subcategories of "woman"—such as "French bourgeois woman" or "Anglo-American lesbian"—is not less essentialist. To a certain degree, these subcategories "re-inscribe an essentialist logic at the very level of historicism."[66] In the same vein, Maria Nzomo points out "while postmodernist discourse would emphasize *difference* and *diversity* among women, African feminists are emphasizing unity in diversity as a necessary strategy for strengthening the women's movement, their solidarity and their empowerment."[67] In line with Susan Bordo, Nzomo, and Fuss, Noël Sturgeon believes that we ought to "de-essentialize our understanding of essentialism: to differentiate what kinds of essentialism we are objecting to, and pay attention to the consequences."[68] According to her, the "universalizing" and "essentializing" of women and nature by ecofeminist activists can be justified because of their actions. Embracing such a strategic essentialism leads to an ecofeminist theorizing that is pragmatic rather than essentialist. Sturgeon states, " 'ecofeminism' as a term, indicates a double political intervention; of environmentalism into feminism and feminism into environmentalism, that is as politically important as the designations 'socialist feminism' and 'black feminism' were previously."[69]

The pragmatic outlook of the ecofeminist movement, as a radical democratic movement, appears to embrace unstable or even problematic political subjectivities. Instead of "essentializing" women and nature, the identification of woman as nature or nature as woman appears to signify a playful queering of identity politics.[70] By disrupting essentialized identities, the affinity of women and nature also makes clear that ecological problems are basically human problems. Just as Andrew Bard Schmookler points out that power over nature is a human problem and "the problem of man's power over nature can be solved only by solving first the problem of power among people,"[71] ecofeminists argue that in order to solve ecological problems we must attend to how gender shapes the power relations among all people across cultural and national boundaries.

Furthermore, as discussed earlier, the theorizing of ecofeminism emphasizes the integration of ecofeminists' academic inquiry and the environmental activism of grassroots women. In fact, ecofeminism as a pragmatic undertaking more or less invites academic ecofeminists from the North and the South to regard the actions of women environmental activists as an ecofeminist testimony. For instance, it is common for academic ecofeminists to depict Linda Wallace Campbell's leadership in African Americans' struggle against toxic waste in Alabama and Wangari Maathai's leading the Kenyan Green Belt Movement as ecofeminist actions even though these two distinguished women do not identify themselves as ecofeminists. Although academic ecofeminists' appropriation of the actions of grassroots women activists in the name of strategic essentialism is indeed problematic, it makes clear that ecofeminist theorizing embraces environmental activism over theoretical coherence.

Above all, ecofeminism appears to center on transforming women as victims of ecological destruction into political activists and moral agents. Claudia Card argues that

feminist ethics originates from a need to identify opportunities for the oppressed to reclaim their agency in oppressive contexts.[72] More specifically, ecofeminism not only generates feminist critiques of patriarchal cultural values, but it also calls for timely educational and social reforms for articulating ecologically congenial cultural practices. In other words, ecofeminism as a pedagogical project offers an inclusive framework that addresses interrelated oppressive systems and endorses strategic essentialism in order to foster environmental activism at a global level. Within this inclusive framework, active ecofeminists do not consider gender as a superordinate category that organizes hierarchal and oppressive social relations across cultures. Instead, gender serves as a starting point from which women undertake the educational task of transforming ecologically uncongenial cultural practices. The women-led indigenous grassroots environmental movements in the Third World especially assume this educational task without any reservations. Shiva points out that these indigenous grassroots movements "are creating a feminist ideology that transcends gender and a political practice that is humanly inclusive."[73] In particular, "the perspective of poor and oppressed women provides a unique and powerful vantage point from which we can examine the effects of development programmes and strategies."[74] At the same time, as Mitu Hirshman cautions, this strain of ecofeminism reminds us of the primacy of the proletariat's standpoint within the Marxist framework.[75] She contends that it is essential to challenge the production-reproduction grid within the development discourse. In other words, it is not apt to regard the poorest Third World women as universal "laborers" for production and reproduction.

In their search for alternative development models, erudite academic feminists and environmentalists must inquire into the dialectical interplay between the pursuit of unity endorsed by strategic essentialism and the recognition of cultural pluralism. The international ecofeminist movement not only validates the possibility of instituting collaboration among diverse women, but it also underscores the need to integrate theoretical discourse on political identities with political activism. In view of the complementary relation between the universalistic and the particularistic social reform movements, the inclusive framework of ecofeminism reaffirms a common humanity through interactive and dialogical actions that reconstruct human-nature relations in the age of capitalist globalization. Hence, ecofeminism is not an exclusive feminist discourse on the oppression of women. Rather, the ethical praxis of ecofeminism as a pedagogical project lies in engendering international environmental coalitions among academic theorists and grassroots activists.

Conclusion

As gender has emerged as a legitimate category of analysis in the academy, it is not uncommon for many women to proclaim that they were born feminists. Since women as existential subjects have long been concerned about what differences sex/gender should make, the claim that there has always been a women's movement is not absurd.[76] The underlying assumption is that women are aware of how the sex/gender role differentiation sustains patriarchy. At the same time, as feminists are inclined to exonerate women from the creation

of patriarchy,[77] they also believe that women have been colonized within their own cultural traditions.[78] Instead of dwelling on women as the victims of patriarchy, the recent development of ecofeminism represents a collaborative feminist coalition aimed at redressing interrelated oppressive systems in patriarchal societies. While the woman-nature affinity is not a cross-cultural phenomenon, ecofeminists' analysis of the interconnections between various forms of oppression shed light on how gender ideology influences our worldview and the construction of educational institutions.

Above all, ecofeminism as a pedagogical project emphasizes ethical activism within oppressive contexts. As victimization does not justify moral apathy, both dominant groups and subordinate groups ought to make collective educational efforts to critically examine the existing social norms and to explore the possibilities of establishing new ethical norms in the global community.

Notes

Li, Huey-li, "Ecofeminism as a Pedagogical Project: Women, Nature, and Education," *Educational Theory*, 57(3) (2007): 351–368. Reprinted by permission of Wiley-Blackwell.

1. Françoise d'Eaubonne, *Le Feminisme ou la mort* (Paris: Femmes en Mouvement, 1974).

2. For an overview of the emergence and evolution of ecofeminism, see Karen J. Warren, "Feminism and Ecology: Making Connections," *Environmental Ethics 9*, no. 1 (1987): 3–20; and Karen J. Warren, "The Power and the Promise of Ecological Feminism," *Environmental Ethics 12*, no. 2 (1990): 125–146.

3. Catriona Sandilands, *The Good-Natured Feminist: Ecofeminism and the Quest for Democracy* (Minneapolis: University of Minnesota Press, 1999); Rosemary Radford Ruether, *Integrating Ecofeminism, Globalization and World Religions* (New York: Rowman and Littlefield, 2005); Maria Mies and Vandana Shiva, *Ecofeminism* (London and Atlantic Highlands, NJ: Zed Press, 1993); and Susan Baker, "The Challenge of Ecofeminism for European Politics," in *Europe, Globalization and Sustainable Development*, ed. John Berry, Brian Baxter, and Richard Dunphy (New York: Routledge, 2004).

4. David W. Orr, "Reassembling the Pieces," in *The Heart of Learning: Spirituality in Education*, ed. Steven Glazer (New York: Penguin Putnam, 1994).

5. Heidi Hartmann, "The Unhappy Marriage of Marxism and Feminism," in *Feminist Frameworks*, 2d ed., ed. Alison M. Jaggar and Paula S. Rothenberg (New York: McGraw-Hill, 1984), 172.

6. Karen J. Warren, *Ecofeminist Philosophy: A Western Perspective on What It Is and Why It Matters* (Lanham, MD: Rowman and Littlefield, 2000).

7. Greta Gaard, "Misunderstanding Ecofeminism," *Z Magazine 3*, no. 1 (1994): 22.

8. Janet Biehl, *Rethinking Ecofeminist Politics* (Boston: South End Press, 1991).

9. Sherry Ortner, "Is Female to Male as Nature Is to Culture?" in *Woman, Culture, and Society*, ed. Michelle Rosaldo and Louise Lamphere (Stanford, CA: Stanford University Press, 1974).

10. The representative ecofeminist works on the twin oppressions of woman and nature are Elizabeth D. Gray, *Green Paradise Lost* (Wellesley, MA: Roundtable Press, 1981); Carolyn Merchant, *The Death of Nature* (New York: Harper and Row, 1980); Vandana Shiva, *Staying Alive:*

Women, Ecology, and Development (London: Zed Books, 1988); and Mary Judith Ress, *Ecofeminism in Latin America* (New York: Orbis Books, 2006).

11. Dorothy Dinnerstein, *The Mermaid and the Minotaur: Sexual Arrangements and the Human Malaise* (New York: Harper and Row, 1976).

12. Gray, *Green Paradise Lost*, 15.

13. Rosemary Radford Ruether, *New Woman, New Earth: Sexist Ideologies and Human Liberation* (New York: Seabury Press, 1975), 194.

14. Carolyn Merchant, *The Death of Nature* (New York: Harper and Row, 1980).

15. Janet Biehl, *Rethinking Ecofeminist Politics* (Boston: South End Press, 1991).

16. Ann Dally, *Inventing Motherhood* (London: Burnett Books, 1982).

17. Val Plumwood, "Ecofeminism: An Overview and Discussion of Positions and Arguments," *Australasian Journal of Philosophy*, supplement to vol. 64 (1986): 130.

18. Alison H. Black, "Gender and Cosmology in Chinese Correlative Thinking," in *Gender and Religion: On the Complexity of Symbols*, ed. Caroline Walker Bynum, Stevan Harrell, and Paula Richman (Boston: Beacon Press, 1986).

19. Undoubtedly, the Confucian conception of *t'ien or ch'ien* was gendered. For instance, the Neo-Confucian scholar Chang Tsai stated that "Heaven is my father and Earth is mother, and even such a small creature as I finds an intimate place in their midst." See Chang Tsai, "Chang-tzu cheng-meng chu, ed. Wang, 9/2a–4b," in *A Source Book in Chinese Philosophy*, trans. Wing-tsit Chan (Princeton, NJ: Princeton University Press, 1963). Still, it was clear that neither Heaven as father nor Earth as mother symbolizes nature in the Confucian cultural context.

20. Lester J. Bilsky, "Ecological Crisis and Response in Ancient China," in *Historical Ecology: Essays on Environment and Social Change*, ed. Lester J. Bilsky (Port Washington, NY: National University Publications, Kennikat Press, 1980): 60–70, 185; and Yi-Fu Tuan, "Discrepancies Between Environmental Attitudes and Behaviour: Examples from Europe and China," *Canadian Geographer* 12 (1968): 176–191.

21. Kathy Ferguson, *The Man Question: Visions of Subjectivity in Feminist Theory* (Berkeley: University of California Press, 1993), 81.

22. Bill McKibben, *The End of Nature* (New York: Anchor Books, 1989), 58.

23. Carol Bigwood, *Earth Muse: Feminism, Nature, and Art* (Philadelphia: Temple University Press, 1993).

24. Eva Feder Kittay, "Woman as Metaphor," *Hypatia* 3, no. 2 (1988): 63–86.

25. Gerda Lerner, *The Creation of Patriarchy* (New York: Oxford University Press, 1986).

26. The following celebrated statement from the Book of Rites clearly indicates Chinese women's subordinate status: "The woman follows and obeys the man:—in her youth, she follows her father and elder brother; when married she follows her husband; when her husband is dead, she follows her son."

27. Joan Wallach Scott, *Gender and the Politics of History* (New York: Columbia University Press, 1988), 43 (emphases added).

28. Maralee Mayberry, "Reproductive and Resistant Pedagogies: The Comparative Roles of Collaborative Learning and Feminist Pedagogy in Science Education," in *Meeting the Challenge: Innovative Feminist Pedagogies in Action*, ed. Maralee Mayberry and Ellen Cronan Rose (New York: Routledge, 1999), 1–22.

29. Christine A. Littleton, "Reconstructing Sexual Equality," in *Feminist Social Thought: A Reader*, ed. Diana Tietjens Meyers (New York: Routledge, 1997).

30. Marilyn Frye, *The Politics of Reality* (New York: Crossing Press, 1983), 167.

31. Alice Echols, *Daring to Be Bad: Radical Feminism in America, 1967–1975* (Minneapolis: University of Minnesota Press, 1989), 288.

32. Carol Gould, "Private Rights and Private Virtues: Women, the Family, and Democracy," in *Beyond Domination: New Perspectives on Women and Philosophy*, ed. Carol C. Gould (Totowa, NJ: Rowman and Allanheld, 1983); Susan Okin, *Women in Western Political Thought* (Princeton, NJ: Princeton University Press, 1979); Jean Bethke Elshtain, *Public Man, Private Woman: Women in Social and Political Thought* (Princeton, NJ: Princeton University Press, 1981); Nancy J. Hirschmann, *Rethinking Obligation: A Feminist Method for Political Theory* (Ithaca, NY: Cornell University Press, 1992); and Carole Pateman, *The Sexual Contract* (Stanford, CA: Stanford University Press, 1989).

33. Ivan Illich, *Toward a History of Needs* (Berkeley, CA: Heyday Books, 1978), 76–77.

34. Stephen R. Kellert and Edward O. Wilson, eds., *The Biophilia Hypothesis* (Washington, D.C.: Island Press, 1993); and Edward O. Wilson, *In Search of Nature* (Washington, DC: Island Press, 1996).

35. Friedrich Froebel, *Froebel's Chief Writings on Education* (1826; repr. New York: Longman, 1912), 234–235, quoted in David Hutchison, *Growing Up Green: Education for Ecological Renewal* (New York: Teachers College Press, 1998), 86.

36. Kim Tolley, *The Science Education of American Girls: A Historical Perspective* (New York: RoutledgeFalmer, 2003), 127.

37. Val Plumwood, *Feminism and the Mastery of Nature* (London and New York: Routledge, 1993), 3–4.

38. Genevieve Lloyd, *The Man of Reason* (London: Methuen, 1984).

39. Ruether, *New Woman, New Earth*, 204.

40. Holmes Rolston III, *Environmental Ethics: Duties and Values in the Natural World* (Philadelphia: Temple University Press, 1988); J. Baird Callicott, *In Defense of the Land Ethic* (Albany, NY: State University of New York Press, 1989); and Fox Warwick, *Toward a Transpersonal Ecology* (Boston: Shambhala, 1990).

41. Arne Naess, *Ecology, Community, and Lifestyle: Outlines of an Ecosophy*, ed. and trans. David Rothenberg (Cambridge: Cambridge University Press, 1989).

42. Ariel Kay Salleh, "Deeper than Deep Ecology: The Eco-feminist Connection," *Environmental Ethics* 6, no. 4 (1984): 339–345.

43. Kathleen Weiler, "Freire and a Feminist Pedagogy of Difference," *Harvard Educational Review* 61, no. 4 (1989): 449–450.

44. Ulrich Beck, "World Risk Society as Cosmopolitan Society? Ecological Questions in a Framework of Manufactured Uncertainties," *Theory, Culture and Society* 13, no. 4 (1996): 1.

45. On nature as an "artifact of language," see William Chaloupka and R. McGreggor Cawley, "The Great Wild Hope: Nature, Environmentalism, and the Open Street," in *In the Nature of Things: Language, Politics, and the Environment*, ed. Jane Bennett and William Chaloupka (Minneapolis: University of Minnesota Press, 1993), 5. On nature as a "social construction," see Elizabeth A. R. Bird, "The Social Construction of Nature: Theoretical Approaches to the History of Environmental Problems," *Environmental Review* 11, no. 4 (1987): 255–264.

46. Undoubtedly, constructivism is a complicated and contested concept. Because I do not have space to elaborate on divergent constructivist perspectives, my analysis focuses on constructivists' argument against the independent existence of a physical "natural" realm.

47. David W. Kidner, "Fabricating Nature: A Critique of the Social Construction of Nature," *Environmental Ethics* 22, no. 4 (2000): 339.

48. Peter Harries-Jones, "Introduction," in *Making Knowledge Count: Advocacy and Social Science*, ed. Peter Harries-Jones (Montreal: McGill-Queen's University Press, 1991).

49. Ruether, *Integrating Ecofeminism, Globalization and World Religions*.

50. Denis Goulet, *The Cruel Choice: A New Concept in the Theory of Development* (New York: Atheneum, 1971); Denis Goulet, "The Ethics of Power and the Power of Ethics," in *The Cruel Choice: A New Concept in the Theory of Development* (New York: University Press of America, 1985); Michael Redclift, *Sustainable Development: Exploring the Contradictions* (London and New York: Methuen, 1987); Hilkka Pietila and Jeanne Vickers, *Making Women Matter: The Role of the United Nations* (London: Zed Books, 1991); Shiv Visvanathan, "Mrs. Bruntland's Disenchanted Cosmos," *Alternatives* 14, no. 3 (1990): 377–384; Larry Lohmann, "Whose Common Future?" *The Ecologist* 20, no. 3 (1990): 82–84; and Rajni Kothari, "Environment, Technology, and Ethics," and Denis Goulet, "Development Ethics and Ecological Wisdom," both in *Ethics of Environmental and Development: Global Challenge, International Response*, ed. J. Ronald Engel and Joan Gibb Engel (Tucson: University of Arizona Press, 1990).

51. Ynestra King, "Toward an Ecological Feminism and a Feminist Ecology," in *Machina Ex Dea: Feminist Perspectives on Technology*, ed. Joan Rothschild (New York: Pergamon Press, 1983).

52. Maria Fernanda Espinosa, "Indigenous Women on Stage: New Agendas and Political Processes among Indigenous Women in the Ecuadorian Amazon" (paper presented at the Feminist Generations Conference, Bowling Green State University, February 1996), quoted in Noël Sturgeon, *Ecofeminist Natures: Race, Gender, Feminist Theory and Political Action* (New York: Routledge, 1997).

53. Sturgeon, *Ecofeminist Natures*.

54. Brinda Rao, "Dominant Construction of Women and Nature in Social Science Literature," *Capitalism, Nature, Socialism*, Pamphlet 2 (New York: Guilford Publication, 1991).

55. Sabine Haüsler, "Women, the Environment, and Sustainable Development: Emergence of the Theme and Different Views," in *Women, the Environment, and Sustainable Development: Toward a Theoretical Synthesis*, ed. Rosi Braidotti, Ewa Charkiewicz, Sabine Haüsler, and Saski Wierings (London and Atlantic Highlands, NJ: Zed, 1994).

56. See Sturgeon, *Ecofeminist Natures*, 158.

57. Ethlie Ann Vare, *Adventurous Spirit: A Story about Ellen Swallow Richards* (Minneapolis: Carolrhoda Books, 1992); Mary Joy Breton, *Women Pioneers for the Environment* (Boston: Northeastern University Press, 1998); and Kim K. Zach, *Hidden from History: The Lives of Eight American Women Scientists* (Greensboro, NC: Avisson Press, 2002).

58. Sandra Harding, *Whose Science? Whose Knowledge? Thinking from Women's Lives* (Ithaca, NY: Cornell University Press, 1991), 11.

59. Angela Calabrese Barton, *Feminist Science Education* (New York: Teachers College Press, 1998).

60. Sandra Harding, "Reinventing Ourselves as Others: More New Agents of History and Knowledge," in *American Feminist Thought at Century's End*, ed. Linda S. Kaufmann (Cambridge, MA: Basil Blackwell), 154.

61. Shiva, *Staying Alive*, 46–47 (emphasis added).

62. Deborah Slicer, "Toward an Ecofeminist Standpoint Theory," in *Ecofeminist Literary Criticism: Theory, Interpretation, Pedagogy*, ed. Greta Gaard and Patrick D. Murphy (Urbana, IL: University of Illinois Press, 1998), 55.

63. Sylvia Bowerbank, *Speaking for Nature: Women and Ecologies of Early Modern England* (Baltimore, MD: Johns Hopkins University Press, 2004).

64. Judith Butler, "Contingent Foundations: Feminism and the Question of 'Postmodernism,'" in *Feminists Theorize the Political*, ed. Judith Butler and Joan Wallach Scott (New York: Routledge, 1992), 9.

65. Susan Bordo, "Feminism, Postmodernism, and Gender-Scepticism," in *Feminism/Postmodernism*, ed. Linda Nicholson (New York: Routledge, Chapman and Hall, 1990), 250–260.

66. Diana Fuss, *Essentially Speaking* (London and New York: Routledge, 1989), 19–20.

67. Maria Nzomo, "Women and Democratization Struggles in Africa: What Relevance to Postmodern Discourse?" in *Feminism/Postmodernism/Development*, ed. Marianne H. Marchand and Jane L. Parpart (New York: Routledge, 1995), 136 (emphasis in original).

68. Sturgeon, *Ecofeminist Natures*, 9.

69. Ibid., 168.

70. Catriona Sandilands, "Mother Earth, the Cyborg, and the Queer: Ecofeminism and (More) Questions of Identity," *NWSA Journal* 9, no. 3 (1997): 18–40.

71. Andrew Bard Schmookler, *The Parable of the Tribes: The Problem of Power in Social Evolution* (Berkeley, CA: University of California Press, 1984).

72. Claudia Card, "Introduction," in *Feminist Ethics*, ed. Claudia Card (Lawrence, KS: University Press of Kansas, 1991), 26.

73. Shiva, *Staying Alive*, xvii.

74. Gita Sen and Carin Grown, *Development, Crisis, and Alternative Visions: Third World Women's Perspectives* (New York: Monthly Review Press, 1987), 23–24.

75. Mitu Hirshman, "Women and Development: A Critique," in *Feminism/Postmodernism/Development*, ed. Marianne H. Marchand and Jane L. Parpart (New York: Routledge, 1995), 42–55.

76. Here, I am extending the major theme addressed in Dale Spender, *There's Always Been a Women's Movement This Century* (Boston: Pandora Press, 1983).

77. Lerner, *The Creation of Patriarchy*.

78. Mary Daly, *Gyn/Ecology: The Metaethics of Radical Feminism* (Boston: Beacon Press, 1978).

Transformando Fronteras

Chicana Feminist Transformative Pedagogies

C. Alejandra Elenes
Arizona State University

Introduction

My vision of education and teaching centers on social justice and constructing coun-ternarratives that offer alternatives to contemporary hegemonic discourses of race, class, gender, and sexuality. My efforts are to open educational spaces where multicultural democracy can be enacted. This philosophy can be described as a multicultural liberal arts perspective that is more concerned with constructing knowledge and critical think-ing than with so-called "pragmatic" or vocational education. I also claim to engage in a democratic practice "where everyone feels a responsibility to contribute" (hooks, 1994, p. 39). However, at times my educational views and practices bring me at odds with my educational philosophy because I have many students who view their education in very different ways. Not only do many undergraduates believe in their education as techni-cal and pragmatic, i.e., as a means to get a better-paying job, but many also do not see the need for, or do not agree politically with multicultural education.[1] Thus, much of my discussion here focuses on the tensions between Chicana faculty and students in terms of the problems that multiple subjectivity/positionality brings to pedagogical discussions when efforts to democratize education might seem to be more autocratic than democratic. There is a paradoxical position entailed in having the goal of teaching for change and transformation when students either are not interested in such changes or presume that teachers are the conduits for students' consciousness (Ellsworth, 1989; Lather, 1991; Gore, 1993).

This chapter examines observations of my classroom dynamics and students' com-ments in class and on teacher evaluations. As such, much of my discussion here is self-reflexive. I am basing most of my comments on a "Race, Class, and Gender" course that I teach in a Women's Studies Department. I teach this course at a campus that forms part of a three-campus "geographically distributed" university. The majority of students

are returning adults, and most of them are female. Indeed, a considerable number of the women's studies students are women in their 40s and 50s who interrupted their educational paths for a variety of reasons including marriage and family responsibilities. There are a few students who decided to return to college to start new careers.

Demographically most of the women's studies students share similar characteristics: they are White, female, lower-middle and working class, single parents, and heterosexual. Chicana, African American, and Native American students are also mostly single mothers, of working-class origin, and first generation attending college. Most self-identified lesbians are women of color. Nevertheless, even the White students who share many demographic characteristics differ in significant ways: in their political ideologies (i.e., outlook on national politics and party affiliation), the ways in which they understand how gender is constructed and women's position in society, and in feminist politics.

"Race, Class, and Gender"[2] forms part of the core of courses that every women's studies major, minor, and certificate-seeker must take. (It is also cross-listed with sociology and social and behavioral studies.) Unlike its development in women's studies programs that originated in the 1970s and 1980s, this course has been part of the core since the inception of the department in the early 1990s. But more importantly, it is part of the core because it is consistent with the philosophy of the department. "Race, Class, and Gender," is not the only course that addresses race, class, gender, and sexuality issues, nor the only one that has a focus on women of color. For example, the introductory course "Women in Contemporary Society" also analyzes the aforementioned intersections. In order not to duplicate the efforts from "Women in Contemporary Society" but to build on the foundations it offers, I redesigned "Race, Class, and Gender" following a cultural studies perspective. It is an interdisciplinary course that analyzes how culture in the United States has been transformed as a result of the feminist, civil rights, and gay and lesbian movements. We approach this by combining history, sociology, literature, cultural studies, education, and anthropological perspectives. However, because of the history of exclusionary practices in women's studies, the course focuses on four groupings of women of color: African American, Asian American, Latinas, and Native American. The main "textbooks" and readings reflect this. Included in the readings are theories of racial formation and the social construction of whiteness; the tensions between predominantly White feminist theory and that developed by women of color; and critiques of male-centric class theories. The class format includes whole and small group discussion, lecture, and extensive use of videos. In order to provide context to understand the significance of the intersection of race, class, and gender, I provide a historical overview of people of color in the United States.

The pedagogical issues I discuss in this chapter deal with the ways in which democratic practices can be enacted using border/transformative pedagogy in order to find ways to deal with the multiplicity of ideologies present in the classroom. Additionally, my theorization and discussion is based on the sometimes-tense relationship between Chicana faculty and White women students.

Border/Transformative Pedagogy

Most of my research and thinking on pedagogy has looked at Chicana/o cultural productions as part of those narratives that offer an alternative to the official (educational or social) scripts for Chicanas/os (Elenes, 1999). I have named these practices border/transformative pedagogies, which "can draw from Chicana/o aesthetic experiences that deconstruct the notion of a unified subject and essentialist notions of culture" (Elenes, 1997, p. 373). Border/transformative pedagogies involve cultural politics that incorporate as social practices the construction of knowledge(s) capable of analyzing conflicts over meanings. As such they offer a cultural critique of material conditions of subaltern communities that invoke politics of change to transform society in order to become truly democratic. I claim these pedagogical practices as border or borderlands because they blur many distinctions artificially created in cultural productions and classroom practices: mainly the incorporation of the everyday cultural practices as a source for the construction of knowledge outside the officially sanctioned space for such a creation, as well as the transcendence of disciplinary boundaries. Border/transformative pedagogy is also concerned with the elimination of racial, gender, class, and sexual orientation hierarchies by decentralizing hegemonic practices that place at the center of cultural practices a homogenous belief in U.S. society that has marginalized the cultural practices of people of color, women, and gays and lesbians. The "border" part of the term refers to the multiple boundaries between race, class, gender, sexuality, and age differences that have been built by dominant hierarchical discourses, and efforts to resist these forms of domination. It refers, as well, to oppositional politics that try to alter existing power relations. Thus, it is a transformative practice that seeks to change the conditions that limit and undervalue marginalized identities and cultures. It offers an alternative vision of society, culture, and education. As a discourse, then, it can be viewed as oppressive for those students who do not want to be "liberated" or do not see any reason for liberal or progressive politics, and as liberatory by those students who engage in progressive or leftist politics.

For the most part, my theorization of border/transformative pedagogy centers around the struggles of the Chicana/o community, particularly the material conditions that keep Chicanas working in the fields, the garment industry, and the service sector, as well as the limited educational opportunities they encounter in U.S. society. Border/transformative pedagogy also connects the limitations of social mobility of Chicanas with essentialist definitions of Chicana/o identity. As part of borderlands discourses it engages in a discussion of the social conditions of subjects with hybrid identities (Elenes, 1997). A particular characteristic of borderlands discourse is that it refutes dualistic, essentialist, and oversimplified thinking. Chicana/o border pedagogy seeks to construct theoretical and political movements based on an understanding of a multiplicity of constructions of identity markers, dominant ideologies, and modes of resistance. That is, it refuses to work with neat dualistic axes of domination and resistance where dominant and dominated are always already clearly identified (Elenes, 1997). In my early theoretical discussions I

proposed that in order to accomplish this it is necessary to take into consideration the many discontinuities within Chicana/o subjectivity. Given that one of the goals of border/transformative pedagogy is to undo dualistic thinking, it is necessary to understand that all identities must be viewed as flexible. That is, students and teachers cannot be viewed in monolithic terms.

Mestiza Consciousness: Epistemology and Pedagogy

The pedagogical issues and problems that I am raising here come from my experiences as a woman of color teaching counternarratives to predominantly White and/or conservative students. I have been very cognizant from the beginning of my academic career that the way students and colleagues perceived me was based on my race, class, gender, and sexuality. I am *mexicana*/Chicana. I was born and raised in México in a bilingual/ bicultural home. My father is Mexican and my mother Anglo-German. I have always traveled and transversed borders. After a short time in the United States, and as I became involved with the Chicana/o community, I soon understood the struggle of people of Latin American descent and embraced the Chicana/o movement for liberation. I have, thus, identified myself as a *Chicana* as a result of my politics, not from the experience of growing up Mexican American in the United States. Like many other Chicanas, I bring this cultural and political perspective into my teaching.

Moving to the Same Side of the River

Gloria Anzaldúa's (1987) conceptualization of *mestiza consciousness* seeks to undo dualistic thinking in a variety of discursive practices such as identity formation and feminist and ethnic/racial oppositional movements. This line of thought, then, includes social and political transformation. Thus, she proposes that in order to transform existing unequal social relations it is necessary for all parties to participate in this new form of consciousness: "It is not enough to stand on the opposite river bank, shouting questions, challenging patriarchal White conventions. A counterstance locks one into a duel of oppressor and oppressed; locked in mortal combat, like the cop and the criminal, both are reduced to a common denominator of violence" (p. 78). My pedagogical efforts are to try to get us all to the "same side of the river" or, at least, to agree that there is a river (e.g., racism, discrimination, double standards, et cetera).

Most of us have the tendency to fall back into the "comfortable" territory where the world gets divided into an "us" vs. "them": teacher/student, male/female, White/ non-White. Sometimes we do this because we do not have, or cannot find, another language by which to express our feelings and thoughts; other times because we work on preconceived perceptions of who we are according to social position. Whatever the reasons for our slippage, I find myself constantly engaged in a process where first I must continuously be self-reflective of my own participation in dualistic thinking. And

students do point it out. As one student wrote[3] in a course evaluation, "I felt there was no balance in the presentations. I took the course to learn about the issues, but I felt that opposing viewpoints could not be articulated." In a similar vein, another student pointed out: "I think there should be more articulation of other viewpoints which would enrichen [sic] everyone's experience." Given such comments, I keep working to find ways in which we can learn to communicate in the classroom, where we can find a "common language," where multiple and even contradictory discourses can be discussed, respected, and understood. This is not easy because often even a mere articulation of my point of view is perceived by students who are not in agreement as not being able to express their opinions. If we are to move to the "same side of river" we[4] must constantly negotiate the tensions that emerge in the classroom as a result of the multiplicity of identities and ideologies present.

Working with Multiple Ideologies and Opinions

There are two pedagogical problems here: (1) the recognition that there are multiple perspectives present in the classroom and, (2) some of these perspectives can reproduce forms of oppression. That is, while a democratic classroom is one where all perspectives are welcome, a course that studies the effects of race, class, gender, and sexuality oppression recognizes that there are ideologies that are oppressive. Thus, taking a liberal stance that accepts all discourse as equal might leave racism, sexism, classism, and homophobia unchallenged. A simplistic answer to this problematic is to accept all viewpoints. However, that is at odds with the goals of progressive and transformative pedagogy. There are opinions and discourses that are hurtful and that aim to maintain social inequalities. White supremacist ideologies and the acceptance of rape, for example, are harmful. Thus, they cannot be presented in the classroom as just one of many ideas present within a discursive field; these are ideologies that must be challenged in order to create a democratic society. But there are other issues at stake as well. Not only are there discourses that should not be acceptable within a classroom, it is also important to learn to distinguish between discourse and opinion. Often, students bring to classroom discussion ideas that they have based on their personal opinions, which are not necessarily based on any type of knowledge or even a coherent set of well-thought-out arguments. These ideas can range from their own popular culture beliefs to mimicking dominant ideology.[5]

I have found that the best way to avoid dualistic, or "commonsensical" thinking is by moving the discussion outside the ideological realm, to a philosophical standpoint. By outside the ideological realm what I mean is to elevate the conversation from personal opinion based on "common sense" logic to a discussion of the philosophical principles involved in certain ideologies. In this sense, I am taking an Althusserian understanding of ideology when he proposes that the developmental principle of an ideology is found outside the particular ideology: "its author as a concrete individual and the actual history reflected in this individual development according to the complex ties between the individual and this history" (Althusser, 1970, p. 63). And, as Eagle-

ton (1991) proposes, for Althusser ideology "is a particular organization of signifying practices which goes to constitute human beings as social subjects, and which produces the lived relations by which such subjects are connected to the dominant relations of production in a society" (p. 18). Ideologies, perspectives, and opinions are based, in part, on an individual's own history. While it is important to encourage students to use their own personal experience to understand and make sense of the world, students should not stay within the narrow confines of experience. A goal of transformative pedagogy is to enable students to expand their horizons. Although, I do not necessarily agree that ideology refers exclusively to the ideas of dominant groups in a society, I do find that in my classroom practices many students accept dominant ideologies as basic commonsensical "truths." We cannot avoid the mystifying power of certain ideologies. One of the efforts of transformative pedagogy is to enable students to demystify their own ideologies, whether on the left or the right.

Therefore, more than rejecting ideology per se, what I propose is to use a philosophical approach to analyze and critique beliefs, to get to know how they are conceptualized and formulated. I, then, distinguish ideology from philosophy in that the latter offers a process of reflection and understanding of where certain ideologies and opinions come from. My intentions are not to avoid ideological discussions, or for students not to express their own opinion. Rather, what I strive for in a democratic classroom is for all (this includes myself) to be cognizant of where our ideas and opinions come from. How is it that we know and understand how we are formulating our opinions? How do we arrive at certain conceptualizations of the world? Through this process of self-scrutiny we avoid simply speaking from an unfounded point of view. For example, when we discuss welfare policies I try to extend the definition and purpose of welfare and taxation. As an alternative to the arguments about who is deserving of government subsidies, the discussion moves to the purpose of distribution of resources and how a society might decide who receives such benefits. Instead of only discussing the issues regarding whether welfare families deserve their grants or not, I try to move the discussion to a philosophical discussion of the role of the welfare state and government.

A key aspect of this pedagogy is to avoid trying to convince people to change their minds (although it would be nice!). Rather, what "moving to the same side of the river" means is to elevate the discussion to a "common language" of the philosophical arguments in any particular issue. I do not mean to find a common ground of agreement and consensus. Rather, what I seek to do is to learn how to communicate our own position by being able to name what this position might be. The purpose of this is to dilute any notion that there is one exclusive "truth," thus denaturalizing the hegemony of dominant discourses. In order to avoid the dualistic counterstances, it is necessary to learn to understand and respect the adversary (Nadesan & Elenes, 1998). My efforts here are to point to inconsistencies in arguments based more on exclusionary practices than philosophical standpoints. By naming our opinions, and knowing that there are other viewpoints, we can learn to discuss the philosophies at an abstract and not personal level. And this can lead us to the same side of the river.

Aren't We All Women: Racism in Women's Studies

The concept of mestiza consciousness can serve as a framework to negotiate and survive oppressive formations that we encounter in classrooms, especially within a conservative climate within the United States that is trying to deny the significance of race, class, gender, and sexuality in the formation of identities of students and teachers. Particularly, I am addressing the problems that Chicana and other women of color encounter when dealing with racism in the classroom. The frustrations that we are encountering in college classrooms are the result of multitudes of contradictory discourses and ideologies that push us all in opposite directions. Classroom dynamics have become a contortionist battleground where all these different ideologies try to get center stage, or at least, claim their ground. I start with two similar quotes from students in course evaluations:

To paraphrase Sojourner Truth: "Ain't I a color, too?"

I guess not, at least not according to the Women's Studies department (. . .) Since I am neither Black nor Asian, Hispanic not Native American, I don't count. Because I am white, euro-american woman, my history, my culture, my art and literature don't rate attention in the course called "Race, Class and Gender."

(. . .) "Race, Class, and Gender," is described in the syllabus as addressing "the intersections of race, ethnicity, class, gender, sexual orientation, age et cetera in the lives of women of color in the U.S." Well, excuse me, but don't white euro-american women (who probably don't rate capital letters like Hispanics and Blacks) have race and gender? Aren't there poor white euro-american women, and aren't they oppressed by classism as poor Blacks and Asians are, even if not in exactly the same way? Aren't white euro-american lesbians discriminated against? Doesn't agism affect all women, of all colors, all ethnicities, all classes, in one way or another?

I honestly thought that when I enrolled in this course, I'd be in an environment where educated, enlightened women and men would be practicing a higher level of egalitarianism that in the general population. Instead, I've found what I can only call reverse discrimination. (Adeline)[6]

"[the instructor] appears to give a BIASED point of view. There was a lot of putting down anglo/white [sic] people. All semester this happened. Not all whites treat people bad. I'm tired of reading about 'LATINOS' . . ." (emphasis on the original). (Anonymous student)

Adeline's and the anonymous student's words are paradigmatic of the tensions that exist in women's studies between white women and women of color. If anything, ever since women of color became professors engaged in area studies (i.e., ethnic and women's studies) and challenged existing theoretical and methodological paradigms in

traditional disciplines they have expressed the difficulties of doing their job in a system that continues to be racist, sexist, classist, and homophobic (Reyes, 1997; Ng, 1997; hooks, 1994; Williams, 1991; Sandoval, 1990; Utall, 1990). Even at the beginning of the new millennium, the subject of women's studies and feminism is still contested. For years the tensions among whites and feminists of color have centered on issues of race, exclusionary practices, and the tendency to generalize the experience of White middle-class women as normative. The appropriation of the rubric "woman" by White feminists, according to Chicana feminist theorist Norma Alarcón (1990b) "leaves many a woman in this country having to call herself otherwise, i.e., 'woman of color,' which is equally 'meaningless' without further specification" (p. 362). Indeed, more than a hundred years after Sojourner Truth dared to claim the subject position "woman" by rhetorically asking, "Ain't I a Woman?" the tendencies to monopolize "woman" as White are still operating within feminist circles. While women's studies has struggled to ease the tensions occasioned by such appropriation, the problem is still present in many college classrooms, creating a pedagogical dilemma that needs to be addressed. This is particularly the case in classrooms where discussions of multiple markers of difference (i.e., race, class, gender, and sexual orientation) are central. There are still many feminists who are continuing to enact the theoretical position that views women's oppression exclusively though the axis of gender. This position, additionally, looks at oppressive formation in static terms. That is, it does not accept that we can all move from a position of oppressed to oppressor. Thus these women find it difficult to deal with racism and homophobia within feminist circles.

Additionally, as faculty of color are entering women's studies as "full citizens," there is a new form of racism that is emerging. A new "logic" has emerged that argues that exclusionary practices are coming from women of color's insistence on rethinking the narrow confines of the subject of feminism. What is happening in my classrooms (as in many other women's studies classrooms) is that the mere mention of race and racism is seen as racist discourse. In this rearticulation of the meaning of racism, the perception is that women of color and lesbians are not marginalized anymore. When the struggles to deal with differences among women are seen as "reverse racism," feminists are situating themselves within a neo-conservative discourse of color blindness. To me, this represents a desire to return to a time and place where the central subjects of feminism and women's studies were White women and hence the universalization of their experiences to all women. Adeline's words, an ironic appropriation of Truth, represent the efforts to return women's studies to a place where White women would take central space. For her and Anonymous a curriculum that centralized race, class, and gender, and one that presents a global perspective, is problematic because White/Euro-American women must share that central stage with other women. Women's studies curricula in general, and "Race, Class, and Gender" in particular, are not marginalizing White women, but are decentralizing the hegemony and universalization of whiteness. If women's studies continued to only tokenize women of color, these tensions would not exist.

Adeline's and Anonymous's words are troubling because they take a dialectical oppositional stand where discussions of racial differences can only occur as mutually exclusive. That is, for both Adeline and Anonymous any of the discussions we had in "Race,

Class and Gender" meant that the experiences of Euro-American or White women were erased. Consciously or unconsciously both students are invoking neo-conservatism and the universalization and normativity of whiteness. There is an odd logic at play here when studying one group means the erasure of another. It is one thing to generalize from one's own experience and another to scrutinize how multiple markers of oppression affect one's social position. Naming one's position in the world is not the same as erasing others' existence. Instead of making connections between multiple and interlocking systems of oppression and privilege where these students could have explored their own subject position within the social order, they could only see "reverse racism."

These positions are not new; there is plenty of evidence that many faculty of color get similar statements in their evaluations (e.g., Nieto, 1998; Reyes, 1997; Ng, 1997).[7] And, although no doubt racism is behind the students' view, I want to discuss ways in which we can deal with this polarization. Gloria Romero's (1991) point that "Race, class and gender—when intertwined—do not necessarily make for pleasant polite discourse, and [the] need to allow for that" (p. 215) is a starting point for discussion. These tensions have surfaced when the normative space of women's studies is altered. Although an integral component of the course is to study the social construction of whiteness, it is not always possible in one semester for students to self-reflect on many years of conditioning. While I do not advocate that we "give in" to these views, I do think that it is important to think about how we can construct communication practices that lead toward the dismantling of the "us" versus "them" mentality and the ensuing racism that is enacted. We are asking students to become border crossers when they are not ready, willing, and able. Although we need to continue pushing toward that goal, we do need to take into account that crossing those borders might take more than a semester.

Relational Theory of Difference

The main strategy I have started to implement is to be much clearer about how race, class, and gender theories have advanced in the last years. We read Patricia Hill Collins's (1998) book *Fighting Words*, where she discusses how the emerging paradigm of intersectionality of race, class, and gender "problematizes [the] entire process of group construction. As a heuristic device, intersectionality references the ability of social phenomena such as race, class, and gender to mutually construct one another" (p. 205). That is, recent theoretical discussion has advanced the understanding of race, class, and gender as interlocking systems of oppression and privilege.

In order to adequately account for multiple subject positions encountered in contemporary classrooms a relational theory of difference is necessary (Yarbro-Bejarano, 1999). According to Yvonne Yarbro-Bejarano a relational theory of difference examines "the formation of identity in the dynamic interpretation of gender, race, sexuality, class and nation" (p. 340). Quoting Stuart Hall, Yarbro-Bejarano argues that this theory is similar to new conceptualizations of ethnicity in cultural studies that incorporate "recognition of the extraordinary diversity of subject position." (pp. 340–1). By not accepting

a construction of identity based on only one social category, Yarbro-Bejarano demonstrates that "no representation of sexuality or desire is free of racialization (even in the absence of people of colour)" (p. 341). Yet, that is a position that is still not accepted in women's studies and by some feminist theorists, as exemplified in Yarbro-Bejarano's critique of Theresa de Lauretis and Judith Butler's "articulated position against the relational paradigm" (p. 341). Adeline's words are also a manifestation of the reluctance of many women to see their oppression in more than the axis of gender.

This reconceptualization helps in better understanding the similarities and differences among women. For example, I continue to use Angela Davis's (1981) essay "Racism, Birth Control and Reproductive Rights" to study reproductive rights and women of color. Although the article is more than twenty years old, the issues Davis presents are still pertinent. In class we update the essay to contemporary reproductive technologies. I used to start class discussion by lecturing on Malthusian and eugenic ideologies and how they have influenced reproductive rights policies in the United States. I changed my approach to discuss how these policies have affected all women, not only women of color. The limitations on reproductive choices for women of color have also resulted in curtailing White women's personal decisions. Our discussion centered on how defining people of color as inferior (and thus the need to limit their ability to have children) also affects White women, in that society has decided it is they who should have children. Soon White women in the class were talking about their experiences of how their reproductive choices had been limited by racism. This time the conversation was one of solidarity and not in any polarizing way, and our classroom discussion centered more on the issues rather than on feelings of exclusion and alienation. I did not change classroom practices in order to appease racist attitudes; rather, my intention was to avoid as much as possible any type of polarization that results in reproduced racist hierarchical practices. White women were able to see that what seemed to be someone else's problem, was indeed theirs as well. And, if all women were to be able to make their own reproductive choices we all needed to know the history of birth control in the United States and we all needed to work together to improve the limited choices that all women have right now.

Conclusion

I conclude this paper with another anecdote—this time a positive one. During one of the few gay and lesbian rallies on my campus, a White gay former student of mine spoke of how a women's studies course he had taken had helped him open his eyes and make connections between different forms of oppression. I was surprised by his words because during the semester he had struggled with the feminist content of the course. This story is a reminder that whatever it is that we do in the classroom can impact students beyond the semester in which they are in our classes. It took this particular student more than a semester to make the connection I was struggling to make, but the point is that eventually he did.

In this chapter, I have presented ways in which pedagogical practices can change in order to accommodate the multiplicity of ideologies present in a classroom. Most of

my discussion centered on the relationship between Chicana faculty and White women, and the tensions that these relationships present for feminist pedagogies. Even though I strongly believe and acknowledge that racism is what creates these tensions, in my experience it is more productive to look at how certain philosophical positions let us out of the impasse that racism presents than to dwell on it. As Gloria Anzaldúa (1990) reminded us, "to call a text or a methodology under discussion in a classroom or conference 'racist,' or to call a White person on her or his Racism, is to let loose a stink bomb" (p. xix). My experience in the classroom and in political organizing has been that whenever I confront racism head on, the changes I have been looking for do not occur. On the contrary, we hit a dead-end. We need to find ways to make this recognition not less painful but more productive. Similarly, Grossberg (1997) proposes that cultural studies do not begin from what we already know. As I have demonstrated in this paper, there is plenty of evidence of racism in the classroom. The point, then, is to look at ways in which we can name that racism and its practices without throwing the "stink bomb" that limits any form of productive discourse. My strategy has been to move the discussion from the merits (or lack of) any particular issue to an analysis of how certain philosophies are implicit in the creation of forms of oppression.

Much of the problem we have in contemporary classroom discussion is that students enter classrooms with their minds made up about what feminism is, or what perspectives are expected of them in ethnic studies. Most of us also work on pre-conceived notions of how certain people act (e.g., feminists), and how we will deal with those who are different from us. It is our job as teachers who are preparing a workforce to deal with a diverse environment, to enable students to learn to be self-reflexive of their own ideologies, preconceived notions, and stereotypes. This is not an easy task. If we all learn how to be flexible, to name our own ideologies, and to question the assumptions we take for granted, we might move into a more democratic society. However, one course cannot do this by itself. Colleges and universities need to take this as a holistic approach in the teaching of diversity and critical thinking skills. And most especially, this task cannot be the exclusive or main responsibility of faculty of color.

Gloria Anzaldúa's mestiza consciousness can help us all—Chicanas/os and non-Chicanas/os—learn to deal with differences in a productive way. Her conceptualization and my notions of border/transformative pedagogy are not intended to reproduce forms of oppression or to sanitize classroom practices. On the contrary, this methodology offers ways in which we can all bring our different, contradictory, and oppositional points of view for discussion. In contemporary classroom settings, we need to learn to present our views in ways that do not personally attack those who might disagree with us. A democratic society is one where everybody believes that they can contribute to discourse; the same is true in a classroom setting.

Notes

Elenes, C. Alejandra, "*Transformando Fronteras:* Chicana feminist transformative pedagogies," *International Journal of Qualitative Studies in Education*, 14(5) (2001): 689–702. Reprinted with permission.

1. I must point out that I do not believe that multicultural and pragmatic education are at odds with each other. Rather, I think this is a false dichotomy. Moreover, there is enough evidence that competencies in dealing with diverse populations are skills that many employers are looking for.

2. Although the course is titled "Race, Class, and Gender" I have always added sexuality to the three dynamics. I am not sure why sexuality is not included in the name. Perhaps it is a reflection of the internalized homophobia that still plagues many Women's Studies Departments, including my own. Or it could be the result of living in such a conservative state as Arizona. After all, in recent years women elected officials moved to close Women's Studies Departments in the whole state because we are teaching lesbianism. And one legislator proposed to change the name to Lesbian Studies so there would be truth in advertising.

3. I decided not to assign pseudonyms to student's course evaluations because these are anonymous. I don't even know the gender of students whose statements I am quoting in this chapter. That is why I use the vague terminology "student."

4. By "we" I mean the students and myself.

5. This is another contradictory point. *Mestiza consciousness* is constructed, in part, by the experiences of Chicana women and it could be argued that it is an ideological position. I do not want to argue that students should not bring their own experience to the classroom, or their ideological beliefs. What I am proposing is to be cognizant of the philosophical foundations of a particular way of thinking, and argue from a perspective that is based on some fundamental knowledge. That is, to move away from "this is the ways things are or ought to be" to "this is how I suggest things can be, and why."

6. Because this student identified her gender, I gave her a pseudonym.

7. Additionally, when I presented an earlier version of this paper at the American Educational Research Association conference in New Orleans, April 25, 2000, many audience members nodded their heads as I gave these examples. Several people shared similar experiences during the question and answer period.

References

Alarcón, N. (1990). The theoretical subject(s) of *This Bridge Called My Back* and Anglo-American feminism. In G. Anzaldúa (Ed.), *Making face, making soul: Haciendo caras* (pp. 356–369). San Francisco: Aunt Lute Press.

Althusser, L. (1970). *For Marx* (B. Brewster, Trans.). New York: Vintage Books.

Anzaldúa, G. (1987). *Borderlands/la frontera: The new mestiza*. San Francisco: Aunt Lute Press.

Anzaldúa, G. (1990). Haciendo caras, una entrada: An introduction by Gloria Anzaldúa. In G. Anzaldúa (Ed.), *Making face, making soul: Haciendo caras* (pp. xv–xxviii). San Francisco: Aunt Lute Press.

Collins, P. H. (1998). *Fighting words: Black women and the search for justice*. Minneapolis: University of Minnesota Press.

Davis, A. (1981). *Women, race and class*. New York: Vintage Books.

Delgado Bernal, D. (1998). Using a Chicana Feminist Epistemology in Rducational Research. *Harvard Educational Review* 68(4), 555–582.

Delgado Bernal, D. (this volume). Learning and living pedagogies of the home: The Mestiza consciousness of Chicana students.

Delgado Bernal, D. (1998). Using a Chicana Feminist Epistemology in Educational Research. *Harvard Educational Review 68*(4), 555–582.

Eagleton, T. (1991). *Ideology: An introduction.* London and New York: Verso.

Elenes, C. A. (1997). Reclaiming the borderlands: Chicana/o identity, difference, and critical pedagogy. *Educational Theory 47*(3), 359–375.

Elenes, C. A. (1999). Toward the construction of Chicana/o identity: Borderlands and the educational discourses. In A. Sosa-Riddell, M. J. Hernández, and L. San Miguel (Eds.), *Expanding raza world views: Sexuality and regionalism* (pp. 8–25). National Association for Chicana and Chicano Studies.

Ellsworth, E. (1989). Why doesn't this feel empowering?: Working through the repressive myths of critical pedagogy. *Harvard Educational Review 59,* 297–324.

Gore, J. (1993). *The struggle for pedagogies: Critical and feminist discourses and the regimes of truth.* New York: Routledge.

Grossberg, L. (1997). *Bringing it all back home: Essays on cultural studies.* Durham, NC: Duke University Press.

hooks, b. (1994). *Teaching to transgress: Education as the practice of freedom.* New York: Routledge.

Lather, P. (1991). *Getting smart: Feminist research and pedagogy with/in the postmodern.* New York: Routledge.

Nadesan, M. H., and C. A. Elenes (1998). Chantal Mouffe: Pedagogy for democratic citizenship. In M. Peters (Ed.), *Naming the multiple: Postructuralism and education* (pp. 245–263). Wesport, CT: Bergin & Garvey.

Nieto, S. (1998). From claiming hegemony to sharing space: Creating community in multicultural courses. In R. Chávez Chávez and J. O'Donnell (Eds.), *Speaking the unpleasant: The politics of (non) engagement in the multicultural education terrain* (pp. 16–31). Albany, NY: SUNY Press.

Ng, R. (1997). A woman out of control: Deconstructing sexism and racism in the university. In S. De Castell and M. Bryson (Eds.), *Radical in<ter>ventions: Identity, politics and difference/s in educational praxis* (pp. 39–57). Albany, NY: SUNY Press.

Reyes, M. L. (1997) Chicanas in academe: An endangered species. In S. De Castell and M. Bryson (Eds.), *Radical in<ter>ventions: Identity, politics, and difference/s in educational praxis* (pp. 15–37). Albany, NY: SUNY Press.

Romero, G. (1991). "No se raje Chicanita": Some thoughts on race, class, and gender in the classroom. *Aztlan: Journal of Chicano Studies 20*(1 & 2), 203–218.

Sandoval, C. (1990). A report on the 1981 National Women's Studies Association conference. In G. Anzaldúa (Ed.), *Making face, making soul: Haciendo caras* (pp. 55–71). San Francisco: Aunt Lute Press.

Utall, L. (1990). Inclusion without influence: The continuing tokenism of women of color. In G. Anzaldúa (Ed.), *Making face, making soul: Haciendo caras* (pp. 42–45). San Francisco: Aunt Lute Press.

Williams, P. (1991). *The alchemy of race and rights.* Cambridge, MA: Harvard University Press.

Yarbro-Bejarano, Y. (1999). Sexuality and Chicana/o studies: Toward a theoretical paradigm for the twenty-first century. *Cultural Studies, 13,* 335–345.

II. Teaching and Pedagogy

Feminism and Curriculum

Getting Our Act Together

Madeleine R. Grumet and Lynda Stone

University of North Carolina, Chapel Hill

Introduction

Many of us share some uneasiness about the millennial moment. This artifact of calendars and clocks issues from no material cause. It is one more thing we have made up, but it is a popular fiction, reaching around the globe, and its subscription list is sufficient to give it meaning. Those of us in curriculum studies care about what matters to other people, for the construction of curriculum is always a decision about what matters. Our students come to us from families and communities organized around concerns, and they meet us, teachers, curriculum workers who have our own concerns, some similar to those of our students, some very different. Although, as Heidegger (1962) argued, all human experience is rooted to concern—our search for comfort, for pleasure, for connection to other people, for activity that stimulates our muscles and memory—the making of curriculum, draws us into moments that are both intentional and reflexive. It invites us to step back from the scene, and to deliberate about the concerns and interests that are taking up our attention and energy. It allows us to consider how we need to speak about and understand our world so that we might live fuller lives within it.

The millennial moment suits a particular reflective pause in curriculum. For American feminists of a certain age who eagerly read the first printing of Friedan's (1963) *The Feminine Mystique* and who cheer on the women's soccer teams of today, it offers an opportunity to consider the feminist project in curriculum, to ask how feminism's ambition to first reveal the ways that gender constrains human experience and then to make other ways of being and living accessible to men and women, has supported a similar intention in curriculum design and development.

Feminism

Let us start by examining a principal strand of feminism that has developed in this century, although, significantly, feminism is not a single project or discourse. And, although this paper invites us commit egregious sins of generalization and synoptic theorizing, some distinctions demand acknowledgement. Consider these texts:

1. Journal of 10 year old Louisa May Alcott from the nineteenth century (Moffat and Painter 1975):

 A sample of our lessons

 'What virtues do you wish more of?' asks Mr L.

 I answer: Patience, Love, Silence, Obedience, Generosity, Perseverance, Industry, Respect, Self-denial.

 'What vices less of?'

 Idleness, Willfulness, Vanity, Impatience, Impudence, Pride, Selfishness, Activity, Love of cats.

2. *Newsweek* Issue of July 19 (Starr and Brant 1999):

 - 90 185 fans attended the sold-out final game of the Women's World Cup between the US and China, setting a record for a women's sporting event;

 - 650 000 tickets were purchased for the 32 matches, bringing in almost $23 million;

 - 2.9 million households watched the US beat Brazil on July 4, giving it a higher TV rating than game 7 of the NHL's (i.e., National Hockey League) Stanley Cup Finals;

 - 19 companies ponied up $6 million for sponsorship rights; and 100 000 girls began playing soccer betwen 1990 and 1997.

These two pieces, an excerpt from Louisa May Alcott's journal written in 1842 and a recent story from *Newsweek Magazine*, a US weekly news magazine, celebrating the US women's soccer team's triumph over China in the World Cup final in 1999, illustrate the dramatic change in the status of women that has been achieved in the intervening years. The capacity of young women to play the game, win it, and win attention and economic resources is testimony to strides in equity, the provision of equal rights and resources, and in social role status, with women achieving attention and resources previously reserved for male athletes.

These are the gifts of liberal feminism, perhaps best characterized by the resolution of the Seneca Falls convention of 1848 that declared 'woman is man's equal.' Donovan (1985) summarizes the central tenets of liberal feminism: faith in rationality, confidence

in individual conscience, conviction in the similarity of male and female rationality, belief in education as a force to change society, independence and ultimate isolation of the individual, doctrine of natural rights. Liberal feminism assumes that men's lives are what women want, and, rejecting the private sphere for the prison that it was, it valorizes men's rationality, individualism, and public activity.

We do not quarrel with the contention that women have benefited from the liberal feminism that arose in a contemporary form in the 1970s, although we do need to note that its gains have not been universal. Feminism, a stream of knowledge, has become currency in cultural capital, running along the fault lines that fracture our society. Poor and working-class women have not received the economic gains and access to cultural power that feminism has brought to middle-class women. Nevertheless, the efforts of liberal feminism in education— providing girls with the resources extended to boys— have produced changes represented in the US federal legislative, i.e., Title IX, provisions requiring the athletic training and experience necessary to the U.S. Women's Soccer Team triumph celebrated above.

In addition to access and rights, the feminist agenda in education, influenced by the social psychology that stressed role theory, also began to attend to the images of women and girls available in readers or textbooks. Efforts were made to diversify images limited to domestic labor and childrearing and to portray women engaged in all kinds of public work and physical and athletic activity. Role theory addresses our capacity to imitate what we see; it rests on a behavioural approach to learning. Assuming that women would desire to do the work in the world that is associated with high social status, role theory appropriated images of male labour to create a visual display of what women might be. Now it is reasonable to assume that young people will be interested in participating in all of the varieties of productive work that are going on around them. Work is both necessary for subsistence and also significant to the achievement of personhood within the human community.

Because role theory, sometimes referred to as "modelling" is a significant aspect of the educational implications of liberal feminism, it is important to note its assumptions about how people learn about the world and direct their lives. What role theory relies on is a very limited set of rewards to explain how people come to select their work and place in society; it does not encompass the complexity of human motivation rooted in reaction and negation as well as its proactive desires. Moreover, within role theory, the analytic feature of reflexivity is denied to both men and women since it takes up descriptions of what people do in everyday life including their actions, but does not explain them. So, while liberal feminism expands the choices available to women and girls and supports their access to a greater range of professions and rights, role theory provides a behaviourist psychology that gives women access to the status quo of male practice, but importantly without extending insight into the conditions or limitations of that practice—for either women or men. Grumet offers this brief story from personal experience to illustrate the point:

> Coming home late one night from work, I came into my 7-year-old daugher's room to say goodnight before she fell asleep. I was then acting dean of

William Smith College, and when she asked me how my day had been, I told her about meeting with architects who were designing a new dining room for the campus, about counselling students, etc. 'You really do interesting things,' she said. 'When I have children, I am going to tell them all about all the things you do.' 'Well, that's nice,' I said, 'but you won't have to tell them about me; you will be doing all those interesting things yourself, properly articulating the role-modelling mantra of a 1980s feminist. 'Oh no, she said, I don't want to work as hard as you. I like to play tennis, ride my bicycle. I'll just tell them about you.'

This abstention expresses the richness and complexity of subjectivity, of a child's desires, still rooted in her body, in play. It reminds us that we do not necessarily choose to be whatever we see before us. The road to role is paved with negation and differentiation as well as with mimesis. It further suggests the great range of possibilities that the world provides, a multiplicity, however, that is reduced when we are limited to the dualism that structures the sex/gender system.

Male and female are two terms of the sex/gender system, standing in dominant and subordinate positions, respectively. This hierarchy sustains the identity and separation of the two terms, but works to give subordinate woman the rights and privileges of dominant man. Overall, liberal feminism, sustaining this two-term structure, is the least tumultuous of its sister feminisms. Cultural feminisms sustain the terms, but assert differences between male and female interests that equity can not assuage. Poststructuralist feminisms challenge the separate identities and complementarity of the two terms.

The achievements of liberal feminism—equity and role appropriation—still mirror the dualistic structures that shape curriculum.

Dualisms

Now, we must consider the possibility that the dialectical character of our lives may have nothing to do with gender. There is also life and death, dark and light, up and down, near and far. Maleness and femaleness are two terms, maybe just language that decorates anatomy. But, male and female are terms that function as magnetic poles, gathering habits, gestures and dreams around them through the millennia. The two terms, male and female, organize the practices, prohibitions and promises through which we live our lives. For the past three decades feminist research and theory have tried to understand the differences of the lives identified by these two terms, trying to distinguish the necessary from the accidental, the biological from the cultural, and to assess individual variation within categorical definitions. The so-called complementarity of the sexes has provided the rationale for the care and nurture of sexually-based stereotypes, generalizations and restrictions on the life-experience of both men and women, whether it is understood in terms of reproduction: alienation or immanence (O'Brien 1981); affect: stoicism or emotional expressivity; or relationality (Chodorow 1978): independence or connection (Gilligan 1982).

This two-term system dwells in the very heart of education, where home and world were opposed in the structuring of our earliest schools. The word *liberalis* designated in Latin a free man, and also the root *liber*, the bark of a tree, from which texts were made. From this pair, we derive our term "liberal," as in liberal arts, or library, used by the Romans to distinguish a free man, who might be able to read, from his illiterate servants and slaves, making literacy a marker of class and power dualisms: rich/poor, free/enslaved, literate/illiterate. The cultured Roman was brought to the world through education and conquest. The Latin word for education, *educere*, meant to lead out, setting up a contrast between here and there, making "there" the goal and object of effort and interest. Here, the place to leave, has become associated with all that is female: the womb, home, childhood, the body—and education has functioned as a bridge between here and there, but a bridge with a single lane, routing children away from home into the public world.

Curriculum cannot be disassociated from the dualism that splits school from home. Curriculum is the name for the agenda of that other place; curriculum is the name for the knowing of things gathered up and separated from their doing. Curriculum was the name for a world that was ordered, predictable, rather than one that would surprise us constantly. Most significantly, in Western culture, curriculum encoded a knowledge that thought about the world instead of acting on it, impugning the tactile, sensuous, embodied world of action as inferior to the interest and status of education. Feminism, a more recent phenomena, emerged to critique the repudiation of the body that curriculum, along with other cultural practices, had achieved. As indicated above, it promoted a recognition of women's presence, specificity and difference, exploring the relation of these terms to women's experience of sexuality. Declaring that the personal was political, women's groups blended these domains of action, from examination of the erotic politics that organized their relationships and families to legal discourses on domestic violence and sexual harassment. Thus, curriculum and feminism have been born in negation of another term: for curriculum that term was private and domestic life; for feminism it was male privilege and female oppression.

Both curriculum and feminism have aspired to enlarge human possibilities, but feminism has recognized the dual structure of its origins, whereas that configuration remains tacit in curriculum. Out of a millennial history of domination, women, and especially feminists, have recognized the hierarchical and dualistic nature of gendered social relations. Almost without exception, that which is naturally, biologically and culturally male is defined as superior to that which is female. Invidious dualisms have abounded in a social order in which *man* controlled *woman*: culture vs. nature, reason vs. emotion, objective vs. subjective, and so on (Stone 1994).

Modern feminist writings encode women's resistance (Lerner 1986) to this societal, dualistic hierarchy. One aspect of response has been to explore origins of dualism *per se*. An influential example comes from French philosopher and novelist, Simone de Beauvoir, an existentialist who shared Hegel and Sartre's ineluctable systems of adversarial dyads. Rooted in anthropological structuralism, she describes the human process of self-formation, of naming the world through selves and others, we and them. Consider these statements from *The Second Sex* (de Beauvoir 1974: xviii–xx):

> Passage from the state of Nature to the state of Culture is marked by man's ability to view biological relations as a series of contrasts; duality, alternation, opposition . . . (citing Claude Levi-Strauss).

> No group ever sets itself up as the One without at once setting up the Other against it.

> The terms *masculine* and *feminine* . . . [are not symmetrical] for man represents both the positive and the neutral . . . whereas the woman represents only the negative . . . without reciprocity.

Duality, opposition, and alternation suggest fairness, turn-taking that is interrupted by the last of these statements, pointing to the absence of symmetry and reciprocity in the sex/gender system.

De Beauvoir's philosophy of cultural development rests on a concept of nature that she critiques but does not challenge. Nature is hard to find, for its roots are deep within the great misogynist tradition of Western philosophy. Although not the first to circumscribe nature within the subject/object relations that constitute male epistemology, Aristotle found a nature that flattered male dominance. He asserts that the natures of man and woman are based in reproduction (what he names generation) and names woman as "an infertile male," a passive creature whose reproductive function is only to receive semen. In this static and passive posture of reception, woman develops a logos distinct from that of the male. His logos, rationality, produced by his activity, is of course the norm (see Aristotle 1983: 267 and Okin 1979). Interestingly, and ironically, nature must give males capacities to control "nature," that with which females are identified. As the feminist philosopher of science, Fox Keller (1983) so ably explains, man has to dominate that which he is not, whatever has power that is not his. Through the centuries, nature, god, and history have all been used as rationalizations for the hierarchy of this dualism.

Whatever its cause, dualism is endemic to what another French philosopher, Jacques Derrida, names as the logic of western thought, its logocentrism (Derrida 1981). Traditionally, this is a logic of identity and distinction (again we and them, it and other). This logic remained paramount until the German philosopher of history, Georg Hegel (Taylor 1975) introduced the idea of "the third," of thesis and antithesis whose contradiction is resolved by a teleologically-ordained new synthesis.

Hegel's other contribution, the direction of a modern historicism, was also vitally important: ideas change and are relative to changing times. As Hegel challenges the standard conception of western logic, so does a Swiss linguist, de Saussure (1972). His contribution is to posit the theory of the sign—as part of the twentieth-century linguistic turn. Whereas identity in the Aristotelian system depended on congruent relations between an idea and its referent in empirical reality, in de Saussure's system difference, rather than sameness, is salient. The word now refers not to an object but to its meaning, signifier to signified, and identity is derived from the difference between terms. Signifi-

cantly, difference enters as there is always openness or ambiguity between the signifier and the signified, the term and its meaning.

Dualisms within Feminism

Relative to the issue of sameness and difference and to dualisms in general, feminism's diverse theoretical positions have emerged as diverse scholars have engaged in the critique of heriarchy. Recognizing the universalizing and generalizing strategies of partriarchy, contemporary feminisms have researched gendered experience by eliciting specific and first-person accounts of situated knowing. The field is today very diverse with authors claiming 'particularist' theoretical roots based in ideology, identity, and philosophical or political background. Among these numerous designations are ones named liberal, Marxist, radical, anarchist, socialist, African American, Latina, lesbian, post-modern, and more (e.g., Tuana and Tong 1995).

Let us assume that negation and distinction have, in part, motivated the expression of all these feminist specificities. Following de Saussure, maybe it is only linguistic for us to find our project in relation to another which is close, but not exactly what we're after. Nevertheless, distinctions found through opposition for the sake of distinction too often collapse into opposition alone. Historically this opposition has devolved into internal dualistic hierarchies, with groups claiming either cultural or theoretical superiority and embracing the categorical and concomitant political savvy.

But, despite these surface struggles, the analysis of dualism and hierarchy that animates feminism is alive and well. In order to portray feminist positions without tripping on our specificities, we suggest the following terms to represent four strands of feminist theory: experiential, categorical, psychoanalytic, and deconstructive. Initially, one might posit these as related, as pairs derived from two linked sources within the life-world: self (embracing the experiential and psychoanalytic) and language (embracing categorical and deconstructive). These terms encompass intentionality and reflexivity. The basic positing of sense-making, the thetic move, is swept up in its intentionality, fully focussed on its object (Earle 1972). The reflexive moment recovers its intentional precursor, interrogating its conditions, motivations, and meanings. This alteration of intentionally and reflexivity constitutes consciousness, first asserting through thetic positing, then bracketing through questioning that takes the earlier assertion as provisional, exploring other possibilities. As these terms interact there is emergence and submersion, claims asserted, then reconsidered as experiential confidence gives way to psychoanalytic suspicion and categorical assertion gives way to deconstructive ironies and contradictions. Each response form also is positioned relative to feminist issues of difference and essentialism, a dualism that pervades contemporary feminist theorizing. What distinguishes this analysis of dualism from curriculum's tacit reliance on dualism and from liberal feminism's utilization of dualism in the service of women's rights, is that contemporary feminism is investigating the dualism that inheres in its own theories.

Experiential

Central to many feminist theories, especially in the United States, is the notion of experience—it arises right from politics of the personal. Whereas liberal theorists posited sameness for women as equal to men, later cultural radical theorists asserted differences between the genders, especially valuing the attributes of females. Still more recently, feminist thought has highlighted experiential differences among women, and especially those experiences of women shrouded in silence and invisibility. Of the latter, one excellent example is found in the writings of legal theorist, Williams (1991), who describes the generational changes among women in her family as a foundation for Black feminist response. For 'identity' theorists, issues of race, sexual preference, class and the like, intersect (and often are superordinate to) woman–woman and woman–man relations. For this group in general, dualistic hierarchy is overcome by shifting from a comparison of the two terms to a historical process which reveals the variety latent within a single term.

Categorical

In contrast to the historically grounded, concrete response of the experiential group, the second group of feminists has turned to language as a site of intervention. Here, again, there is both historical as well as contemporary diversity. Liberal feminist political theorists first analysed and critiqued central concepts of the logos, especially rationality. This "maleness of reason," as Australian feminist Lloyd (1984) names it, determined the western history of social life in all respects since women lacked "it." Defining "it" in women's terms, drawn from their own rationality, was the first radical task. In recent years poststructuralist feminists such as Scott (1988) analysed "gender" as a part of "history." Difference as differentiation is found throughout this work, but with an important historical distinction: earlier writings posed an aim of clarity that was later understood as misleading and impossible.

Psychoanalytic

This group of feminists focuses primarily on the self, as does the experiential group. Initially, there was a body of writings that were "psychological" (although not primarily influenced by Freud, e.g., Miller (1976)), but the most important work on women's psychology has been based in Freudian, or post-Freudian theory. Herein, sameness and differences are both important. First, universalism is basic in the separate psychologies of all women and all men, but difference, in this case of what cannot be known, pervades each individual life. Rather than marking the difference between men and women, difference marks the repressed possibilities within every gendered individual. A central theme in various writings is domination, one explanation for the formation of repressed content.

Deconstructive

Beginning with language as the categorical group above, this body of feminist writing focuses primarily on difference (although there is some critique about their own brand of essentialism). For present purposes, although often based in Derrida, this group also is comprised of feminists influenced by other French poststructuralists such as Lyotard or Deleuze and, in an important connection to the previous category, to Kristeva (1984). Her work is particularly interesting, because it first sought difference for women from men through language and a critique of Lacan (1968), but has developed more and more in a strongly psychoanalytic vein. In general in this grouping, strong difference is posited through referral to "unknowns," to that which cannot be "got at." Various formulations focus on language, on cultural exchange, and on the unconscious. A well-known example is from U.S. philosopher Butler (1990), whose Foucaultian analysis of gender "destroys" the essentialism of the category (see also Derridean-inspired contributions from postcolonial feminist, Spivak (1999)).

As we have suggested, the presence of dyads does not necessarily doom the dynamism of a theoretical discourse. At least, they animate an adversarial, or to put it more politely, "critical" discourse. Recall that the Hegelian solution to the interminable struggle of two terms was to suggest the mediation of a third that would emerge from their interaction and surpass them. This spiral, that provided the design for dialectical materialism, has demonstrated itself to be more compelling in theory than in material everyday life. But, curriculum *is* everyday life. It is a gathering of social practices, of relationships, events, coming and goings, inscriptions and erasures. It is politics, funding, certifications, and social mobility. The new synthesis in curriculum requires incorporating the denied values of reproduction that have been split off from its self-understanding. And, because learning requires both intentionality and reflexivity, it cannot advance without understanding its own structures and lenses. When we ask how feminism has influenced curriculum, we must also recognize that we are asking one question of multiple feminisms. As we will now show, many of the positions taken by liberal, cultural or poststructuralist feminists have analogues within the field of curriculum itself. We are also asking about a causal process between terms that cannot be neatly isolated from each other into cause-and-effect.

Curriculum Instantiations

It is difficult to pull apart self and language, for we know that each phenomena depends on the other for its existence. But, these terms have come to stand for the nature/culture continuum that generates human consciousness and action. In feminism, "self" has come to stand for embodied experience, for sensuous connection to the world, for intuitions and feelings that float beneath language. Language has come to stand for cultural systems of representation with complex intertwined relations and histories. Although the designa-

tion of these two poles of the human continuum may serve as a heuristic for feminist thought, helping us to bring to language what has been silenced or unspoken, and helping us to bring language to account for experience it has excluded, in curriculum—the process of learning about the world—both are necessary.

Because the experiential, categorical, psychoanalytic, and deconstructive projects are alive in both feminist and curriculum theory, it is useful to examine how we may work with their oppositions so that they are generative and not deadly.

Let us consider an intentional and reflexive pairing of these terms, each part of which contains reference to self and language:

Intentionality vs. Reflexivity
Experiential/categorical vs. Psychoanalytic/deconstructive

The arrangement best fits our commonsense, in which daily existence is described from the standpoint of persons interacting in the world, either individually or in groups. Herein, standard forms of knowledge organize life and curriculum often as "lived" and "real." Examples from educational theory include the current movement in constructivism with its roots in an earlier reformist pragmatism as well as ordinary lanaguage analysis from educational philosophy. Eschewing reliance on formal laws and analytic concepts, both feminist consciousness-raising and curricular constructivism invite us to make lived-experience the focus of our inquiry. Moreover, the categorical terms through which we name and understand that experience still retain their gendered dualism, as in liberal feminism and in curriculum perenialism. So, in science as well as society, conventional meanings remain intact even though inquiry may point to other phenomena which the salient terms exclude. Thus, these are uneasy pairs for both feminism and curriculum, for they ask us to force experience into the containers of extant categories, whether or not they provide a good fit.

The separation of experience and category from psychoanalysis and deconstruction places activism on one side of the divide and theory on the other. Equity politics in the public sphere and in curriculum operate without the critiques of psychoanalysis and deconstruction. Because this pair separates activity from what Habermas (1971) called depth-hermeneutics, intentionality and reflexivity are separated from one another. In this division, as Freire (1970) among others recognized, we relinquish the *praxis* (critical theory realized through action) that we need to transform our world. Cut off from experience and category (the everyday working terms through which experience is negotiated) these depth-hermeneutics critique the behaviourism and dualistic role theory of liberal feminism but actually generate little action, fearful that any act would commit the sin of dualism that they proscribe.

Furthermore, we find psychoanalysis and deconstruction offering scepticism to undermine the strong sides of the self and the categorical. By revealing the pretensions of narcissim and the self-deceptions of the ego, this language-based psychoanalysis undermines the ground that experience gives to curriculum. In addition, by revealing the contingency and historicity of the language that forms us, Lacan (1968) undermines

the essential meanings of our organizing categories, shifting from Freud's genetic, drive-driven categories to language and culture as providing the categories of experience itself.

In curriculum, this reflexive dyad (psychoanalytic/deconstructive) generates a critique of hegemony and ideology. The psychoanalytic thematic in curriculum has led to an emphasis on subjectivity and humanism, placing the self at the centre of the culture. But, the deconstructive project has generated a critique of subjectivity which expels the individual from the centre of discourse, recognizing self and identity as cultural constructions thoroughly pervaded by material cirumstances and contingency. Because they are separated, intentionality and reflexivity frustrate each other's attempts at interaction.

Now, let us reverse these relations, keeping intentionality and reflexivity together, but permitting a split between self and language.

Self vs. Language
Experiential/psychoanalytic vs. Categorical/deconstructive

While intentionality and reflexivity remain in each dyad, but self and language are separated, distancing embodiment from thought, a hard act to commit. In curriculum, attention to self is expressed in projects to enhance self-esteem and identity-development, for example. Separating these aspects of ego-psychology from the culture and contingency of language generates a sentimental psychology that endows its subjects with aspiration, but removes the context within which it can be realized.

Within curriculum one emphasis on experience has led to a reifying developmentalism, featuring stage-theory, and the selection of learning activities that are appropriate to children of a certain age. The emphasis on experience has also led to a focus on culture that has encouraged the discourse of educational disadvantage and children "at risk." Such attention to persons and to the experience that they bring with them into the classroom trips up on its own solicitude, too often imposing large and heavy generalizations on the subtlety and contradictions of the subjects who receive these descriptions. There is little presence of the psychoanalytic in curriculum, save for the reader-response processes in the study of literature and nascent attempts to connect experience in the arts to curriculum areas.

The second pairing (categorical/deconstructive) is difficult to situate in curriculum because curriculum must be about the relation of the student to the world. This separation of self from language removes persons from culture and from the processes of expression and communication through which we act in and on the world. On the language side of this equation, we find the categories that organize the curriculum: The deconstructive strand offers critiques of the epistemological and ethical categories that we have at hand, showing how correspondence theories of knowledge, universal theories of ethics, structures of historicity, of literary form, of mathematical certainty and scientific specialization collapse the specificity of phenomena into totalizing and spurious knowledge claims. Actual changes in curriculum derived from these critiques are rare, however, because this kind of change requires persistent and deliberate political action. Without a structure that engages critique with agency, critique flourishes—without much effect.

The language theme in this dyad resides in critical pedagogy that works to expose the limitations of positivist epistemologies as well as those of self-report and ethnocentrism. Lacking a psychology and a sociology to compensate individuals for this assault on their self-understanding, the deconstructive move in curriculum often provokes resistance in the classroom. Given the separations just noted, the unfortunate effect of these pairings and oppositions is a stalemate: nothing much happens, since for interactions in the world both person and language are needed.

In sum, feminist theory and curriculum theory have both emerged from the practical experience of everyday life to address the arrangements and meanings that organize, ground, and sustain our lives. Both discourses take as the object of their thoughts, practices that have existed for centuries and centuries, actions that are so enduring and present that we don't even recognize that they have been tightly choreographed. Curriculum, the event, takes place in a world organized around dualistic structures that we cannot escape. Even such attempts as interdisciplinarity, applied learning, and multiculturalism rest on a subtext of adversarial terms that they are bravely challenging: examples here are the integrity of the discipline, knowledge for knowledge's sake, and white supremacy. As we have illustrated above, there have been various feminist attempts toward "basic change." While much of this work has been interesting, it has not been effective at the school or curriculum levels. Perhaps, we must ironically live within this dualistic world even as we try to subvert it. To live within these dyads is to acknowledge the ways they structure our experience. However, because academic feminists often situate themselves within these disciplinary specializations, either dealing with language or self, action or analysis, relationships between these discourses often remain unexplored.

However, when feminism does visit curriculum, these relations are hard to ignore, for, even if feminism has floated into a poststructuralist idealism, life in classrooms is stubbornly sticky. Although the feminism of the 1970s declared that the personal was political, at the turn of the century it may be the immediacy and performative cogency of curriculum that offers the most productive space where these dualisms can be worked through. In curriculum theory, an earlier effort to theorize this working-through occurs in Grumet's *Bitter Milk: Women and Teaching* (1988). In that text, dualisms structuring our experiences of reproduction were reinterpreted in pedagogical generativity. Repudiating the separation of production and reproduction, or representation through self and language, Grumet argued that curriculum is the deliberate attempt to transcend the limitations of our original relations to our own progeny and to our own parents, and so, in this scheme, education assumes a dialectical relationship to reproduction. Drawing on object-relations theory and the work of Chodorow (1978), these dialectical relations differ for men and for women. For men, paternity is inferential, mediated by relation to woman, thus transitive. For women, maternity is direct and symbolic. Significantly, education is first drawn into the father's project to claim the child and into the mother's project to differentiate from the child. Object-relations theory further suggests that when the mother is the primary parent for infants of both sexes, the development of gender is a process that is different for males and females. Males must learn to differentiate from the one who has cared for them, who has been the

world for them, the one with whom they have immediately and globally identified. That one is mother and so male gender is the repudiation of that identification. What is male becomes whatever is not-female. Disconnection becomes the theme of male gender-identity and of male epistemology, as subject and object are not seen as related and continuous, but as separate, with connection being the relation that remains to be proven, rather than taken for granted. An important difference here is that, unlike men, women need not repress their earliest connections. Although heterosexual women shift their erotic cathexis from mother to father, their gendered identity permits them to maintain continuity with their earliest sense of connection to their mothers and to the world. But, in adolescence this connection is subordinated to the heterosexual agenda, and becomes a suppressed project of reunion.

Conclusion

As Grumet's work illustrates, these connections between the projects of reproduction and projects of gender-identity invite our exploration and transformation for education and the curriculum. For, if the father's project is to claim the child against an epistemological supposition that asserts separation, and the mother's project is to claim differentiation against an epistemological supposition that asserts connection, then, instead of educating a new generation to change the world, we are, despite our rhetoric, sweeping hope into the compulsive rush to recover what we have relinquished to biology and culture. The aspiration of this dialectical exemplar is that, by recognizing the dualisms that structure our reproductive and educational experience, we may make education a process that offers us and our children some new possibilities instead of just the same old couple, dressed up in new clothes.

Action requires community, for the dyads of home and school, private and public, reproduction and production, self and language, and intentionality and reflexivity cannot be mediated only intellectually. These domains must be engaged and worked through, and the setting for that work is the community that encompasses families, schools, workplaces, and government. Nevertheless, finding a community is difficult these days, as the globalization of the economy accompanied by the geographic displacement of the internet have fostered visions of labor that appear to make community unnecessary, particularly communities rooted in real space and time.

Even without a currently strong agenda for action, feminist theory is still fairly noisy as the debates between self and language, gender and ethnicities, and sexuality and social morality rage on. Ironically, feminist theory has stepped beyond promoting the interests of women only, for the addition of the psychoanalytic and deconstructive projects has called the epistemological and ethical relations of both men and women into question. Liberal feminism, which has been the most, if not only, effective feminist discourse in education, is now muted because it is identified as representing a special interest group, rather than addressing the learning and development of *all* children, who are after all our students.

The task that lies before us is to bring the insights and possibilities suggested in the psychoanalytic and deconstructive feminisms to the field of curriculum with the same fervour and practical strategies that animated the fight for equity in an equally compelling search for contemporary ethics. What this next step will require, however, is an occasional if not frequent dismount from the theoretical high horse. We would jump down ourselves, at this very moment, were our boots not caught in the stirrups.

Note

Grumet, Madeleine R. and Stone, Lynda, "Feminism and Curriculum: Getting Our Act Together," *Journal of Curriculum Studies*, 32(2) (2000): 183–197. Reprinted with permission.

References

Aristotle (1983) On the generation of animals. In M. B. Mahowald (ed.), *Philosophy of Woman: An Anthology of Classic and Current Concepts*, 2nd ed (Indianapolis, IN: Hackett), 266–272.

Butler, J. (1990) *Gender Trouble: Feminism and the Subversion of Identity* (New York: Routledge).

Chodcrow, N. (1978) *The Reproduction of Mothering: Psychoanalysis and the Sociology of Gender* (Berkeley, CA: University of California Press).

De Beauvoir, S. (1974) *The Second Sex*, trans. H. Parshley (New York: Vintage).

De Saussure, F. (1972) From Course in General Linguistics. In R. de George and F. M. De George (eds), *The Structuralists from Marx to Lévi-Strauss* (Garden City, NY: Anchor), 59–79.

Derrida, J. (1981) *Positions*, trans. A. Bass (Chicago: University of Chicago Press).

Donovan, J. (1985) *Feminist Theory: The Intellectual Traditions of American Feminism* (New York: Continuum).

Earle, W. (1972) *Autobiographical Consciousness* (Chicago: Quadrangle).

Freire, P. (1970) *Pedagogy of the Oppressed* (New York: Continuum).

Freidan, B. (1963) *The Feminine Mystique* (New York Norton).

Gilligan, C. (1982) *In A Different Voice: Psychological Theory and Women's Development* (Cambridge, MA: Harvard University Press).

Grumet, M. R. (1988) *Bitter Milk: Women and Teaching* (Amherst, MA: University of Massachusetts Press).

Habermas, J. (1971) *Knowledge and Human Interests*, trans. J. Shapiro (Boston, MA: Beacon).

Heidegger, M. (1962) *Being and Time*, trans. J. Macquarie and E. Robinson (New York: Harper).

Keller, E. F. (1983) Gender and science. In S. Harding and M. Hintikka (eds), *Discovering Reality: Feminist Perspectives on Epistemology, Metaphysics, Methodology, and Philosophy of Science* (Dordrecht, The Netherlands and Boston, MA: D. Reidel), 187–205.

Kristeva, J. (1984) *Revolution in Poetic Language*, trans. M. Waller (New York Columbia University Press).

Lucan, J. (1968) *The Language of the Self: The Function of Language in Psychoanalysis*, trans. A. Wilden (Baltimore, MD: Johns Hopkins University Press).

Lerner, G. (1986) *The Creation of Patriarchy* (New York: Oxford University Press).

Lloyd, G. (1984) *The Man of Reason: 'Male' and 'Female' in Western Philosophy* (Minneapolis,

MN: University of Minnesota Press).

Miller, J. B. (1976) *Toward a New Psychology of Women* (Boston, MA: Beacon).

Moffat, M., and Painter, C. (eds) (1975) *Revelations* (New York: Random House).

O'Brien, M. (1981) *The Politics of Reproduction* (Boston, MA: Routledge & Kegan Paul).

Okin, S. M. (1979) *Women in Western Political Thought* (Princeton, NJ: Princeton University Press).

Scott, J. (1988) *Gender and the Politics of History* (New York Columbia University Press).

Spivak, G. (1999) *A Critique of Postcolonial Reason: Toward a History of the Vanishing Present* (Cambridge, MA: Harvard University Press).

Starr, M., and Brant, M. (1999) It went down to the wire . . . and thrilled us all. *Newsweek*, July 19, 46–51.

Stone, L. (1994) Toward a transformational theory of teaching. In L. Stone (ed.), *The Education Feminism Reader* (New York: Routledge), 1–3.

Taylor, C. (1975) *Hegel* (Cambridge: Cambridge University Press).

Tuana, N., and Tong, R. (eds) (1995) *Feminism & Philosophy: Essential Readings in Theory, Reinterpretation, and Application* (Boulder, CO: Westview).

Williams, P. (1991) On being the object of property. In K. Bartlett and R. Kennedy (eds), *Feminist Legal Theory: Readings in Law and Gender* (Boulder, CO: Westview), 165–180.

A Womanist Experience of Caring

Understanding the Pedagogy of
Exemplary Black Women Teachers

Tamara Beauboeuf-Lafontant

DePauw University

Over the last 15 years, educational researchers and theorists have decried the lack of caring in our schools (Grumet, 1988; Noddings, 1984; Valenzuela, 1999). As researchers have sought to address this problem, they have called for teachers to transform themselves into adults who can relate to and thus more effectively teach all children in our schools (e.g., Bartolome, 1994; Cochran-Smith, 1995; Delpit, 1995; Nieto, 1999). Amidst these calls for teacher transformation have been examples of the types of teachers who are effective. Striking about such portrayals is that a number of these exemplars are black women, which I believe is more than coincidence. I believe that researchers have come across a womanist tradition of caring that extends throughout the history of African-American women.

Womanism

Womanism is a standpoint epistemology (Collins, 1991). It is derived from Alice Walker's (1983) term *womanist* and is used generally to represent the cultural, historical, and political positionality of African-American women, a group that has experienced slavery, segregation, sexism, and classism for most of its history in the United States. Used interchangeably with *black feminism*, it is a theoretical perspective that sees the experiences of black women as normative, not as a derivation or variation of black male or white female behavior (Collins, 1991). Womanists recognize that because so many black women have experienced the convergence of racism, sexism, and classism, they often have a particular vantage point on what constitutes evidence (Collins, 1991), valid action (Welch, 1990), and morality (Cannon, 1995). Three central points support womanism. First, womanists understand that oppression is an interlocking system, providing all people with

varying degrees of penalty and privilege. Second, they believe that individual empowerment combined with collective action is key to lasting social transformation. Last, they embody a humanism, which seeks the liberation of all, not simply themselves (Collins, 1990). Given that womanism seeks to elucidate the experiences, thoughts, and behaviors of black women, in order to understand the caring demonstrated by African-American women teachers, it is critical that we contextualize their thoughts and actions within their particular cultural and historical legacies. In doing so, three characteristics are noteworthy: the embrace of the maternal, political clarity, and an ethic of risk.

Embrace of the Maternal

In both lay and academic analyses of exemplary teachers committed to social justice, the maternal image is particularly visible in the pedagogy of African-American women teachers. A public example of such teaching is that of Marva Collins, the founder of the renowned Westside Preparatory School in Chicago. Over the last 25 years, Collins has drawn out "extraordinary" capabilities from her students, who are "at risk" for school and social failure because they are poor African-American children living in the neighboring housing projects. While her successes are clearly significant and have garnered the attention of many Americans wanting to see improvements in our public schools, notable about her work is the maternal sensibility she brings to her pedagogy. As the jacket of her book, *"Ordinary" Children, Extraordinary Teachers* (1992), reads:

> Marva Collins embodies all that is meant by that hallowed word . . . teacher. She gives of herself tirelessly so that those whose minds are supple may grasp knowledge and power through her love. Indeed love, like that of a mother for her children, is the essence of the Marva Collins Way . . . love of learning, love of teaching, and love of sharing.

Such a connection with a maternal form of caring is also evident in Collins's own descriptions of her work. Reflecting on her frustration with the public school she left to begin her own academy, Collins explicitly connects her teaching visions to her sensibilities as a mother:

> The search for a school for my own three children opened my eyes: the public schools had no monopoly on poor education. . . . What was once the poor man's burden had become everyone's.
> With this came another realization, that I couldn't escape the problem, as a teacher or as a mother. These parts of my life were inextricably interwoven; at Delano I was fighting for the kind of education I wanted for my own children. As a parent I tended to be protective, and I always felt that same driving concern as a teacher. I could never walk out of Delano at 3:15 and leave the school and the students entirely behind me. Were my students going

home or would they wander the streets? Were their clothes warm enough? Would their stomachs be full tonight and would they have sheets on their beds? (Collins and Tamarkin, 1990/1982, p. 73)

Collins views her inability not to mother her students as a matter of fact, and as an emotional strength rather than as a weakness. If anything, her parenting experiences as a mother seem to have informed her teaching so that she has brought the same standards of care and accountability to her students as she would to her own children. "If the school was going to be good enough for other children, it had to be good enough for my own," she reasoned (Collins and Tamarkin, 1990/1982, p. 80). As a public school teacher, caring like a mother focused her decision to take maternal steps, that is, to create a structure in which she could educate and shelter her students/children from adversity. Indeed, in the Ten Teaching Commandments that she has developed for her own faculty, the first reads, "Thou shalt love the students as you would love your own children" (Collins, 1992, p. 178).

Such a maternal caring for students is also a central theme of a *People* magazine article entitled "Momma Knows Best." Affectionately called "Momma Hawk" by her middle-school students, Corla Hawkins is another Chicago teacher. Like Collins, Hawk began her own school, Recovering the Gifted Child Academy, after seeing too many poor children systematically failed by the public schools. For Hawkins, her teaching very clearly emanates from a vocation to extend herself to those children who needed her most:

I felt I could take the dysfunctional family structure these children were used to and replace it with a new family structure that stresses success, personal achievement and self-esteem. . . . God gave me a dream—to take care of children of rejection. I literally saw myself going around the world hugging and loving children nobody else wanted. (Valente, 1996, pp. 45, 47)

Describing Momma Hawk, a board member of the school says, "Corla is so successful because she is so human. . . . She's not on a pedestal. She feels things deeply. She hurts" (Valente, 1996, p. 46). At the same time, however, such emotional connection with her students does not preclude Hawkins from "run[ning] my school based on a corporate model" (p. 46), complete with a time clock and strict discipline.

As educator Lisa Delpit (1995) and others have described, schools too often replay the racial and economic biases of the larger society. Distinctions, both overt and subtle, abound between majority member students ("our children") and children from minority groups ("other people's children"). Drawing attention to this split, Delpit identifies educational reform as centrally concerning our identities and relationships as educators:

The teachers, the psychologists, the school administrators . . . look at "other people's children" and see damaged and dangerous caricatures of the vulnerable and impressionable beings before them. . . . What are we really doing to better educate poor children and children of color? . . . What should we be

doing? The answers, I believe, lie not in a proliferation of new reform programs but in some basic understandings of who we are and how we are connected to and disconnected from one another. (Delpit, 1995, pp. xiii, xiv, xv)

If school failure is a result of a "relational breakdown" (Ward, 1995) between teachers and students, where both groups see little in common or shared in purpose, then the academic success of poor, immigrant, and minority children lies very much in the quality of the relationships that their teachers establish with them.

Exemplary African-American women teachers use the familiar and familial mother-child relationship as a guide for their interactions with students. As Kathe Jervis (1996) concludes in her article about an innovative public school:

> For such a promise of personalized schools to be fulfilled, faculties have to adopt Carrie's [an African-American teacher's] attitude about children. She often says, "When I am in a quandary about how to handle a child, I think, 'What would I do if that child were my child?' and 'How would I want that child handled were my son or daughter in that situation?'" Parents have an urgency about their own children. We need to feel the same urgency when we teach other people's children. (p. 570)

However, to have such an urgency about children is to recognize that teachers may be failing precisely those students considered to be failures. As Momma Hawk notes, when a student is disruptive, "the teacher's first reaction is to get him out of the class instead of saying maybe this child doesn't have anybody" (Valente, 1996, p. 44). Too often, in her opinion, teachers lacking a parental urgency take the easy, nonfamililal/nonmaternal way out of difficult situations.

As insightful and active as the maternal connection to students appears among womanist teachers, not all women adopt it in their pedagogy. Kathleen Casey's (1990, 1993) phenomenological study of teaching and women-identified values perhaps best illuminates the differences in caring among women. Investigating the role of such values in the work of socially progressive Jewish, Catholic, and African-American teachers, Casey (1990) found that many of these women had a desire to "deconstruct the maternal." Both the secular Jewish women and the Catholic nuns interviewed saw schools as sites of the patriarchal domination closely resembling traditional middle-class families. In these families, maintains Casey, there is a pattern of "maternal nurture and paternal authority" (p. 307). Significantly, neither group of teachers had experienced this stereotypical family pattern in their own upbringing. However, both the Jewish and Catholic teachers felt that the only concept of mother that they could manifest in the classroom was that prescribed by the school culture: "mother" as an agent of the patriarchal domination of women and children. As a result, they sought to assert an identity in the classroom that challenged such a conception of teacher as mother.

In a very real manner, these educators were trapped in a mainstream, patriarchal notion of teaching. Significantly, they did not call on the ennobling models of women

as mothers from their personal lives and use these to resist the patriarchal expectations of women. Rather, as they decried hierarchical gender distinctions, the Jewish teachers resented the gender stereotyping within schools and thought of teaching "in terms of intellectual challenge and political efficacy" (p. 305), not in terms of making school family-like. Similarly, in their criticism of school patriarchy, the Catholic nuns portrayed themselves as the sisterly allies of students. In other words, for both groups of these women educators, commitments to social justice hinged on their reworking of their professional relationships, as women, to both children/students and men/administrators. Casey's (1990) interviews with older white teachers who taught before and after raising their own children led her to conclude that "since the maternal relationship can leave a woman in our society so materially and psychologically vulnerable, it is no wonder that so many look for another metaphor to describe their connections with children" (p. 313).

The black women teachers in Casey's study, however, did not evidence a domesticated view of womanhood or mothering in their reflections on their educational philosophies and practice. Within their cultural construction of womanhood, they profoundly embraced a maternal image. Based in their lives and experiences outside the classroom, the maternal served as a relational compass for their teaching. Like the Jewish teachers and Catholic nuns, these educators did not accept the definition of "mother" found in the schools and in society. However, unlike their colleagues, the African-American women did not rely on the school's appropriation of the maternal to circumscribe their own desire to relate to students in a familiar, maternal way. In fact, these teachers saw their maternal qualities and the mother-child relationship as *central* to their resistance to domination, both patriarchal and racial. As Casey (1990) clarifies the black teachers' maternal orientation to students:

> The relationship between mother and child is not exclusive and private, but is part of the wider family which is one's "people." . . . Because of the social context out of which this understanding has been constructed, the maternal is not seen as an individual burden, but as reciprocity among members of the group. Whatever nurture these teachers provide, it comes back to them; as one teacher says about her students, "they love your very soul." (p. 316)

Rather than envision mothering primarily in terms of women's individual relationships with men and children (as Casey reports the Jewish and Catholic teachers doing), the African-American teachers regarded mothering broadly as a communal responsibility. Casey (1990) explains, "The definition of nurture which is presented in the narratives of these Black women teachers is inclusive in several senses: it is not limited to women, it is expressive of relationship within community and it is not separate from the exercise of authority. An exceedingly powerful version of nurture emerges from this particular social context" (p. 317).

Racism and the collective struggle against injustice comprise the particular social context of which Casey speaks. The black women teachers were raised in households in which their identity as African Americans, as people treated as second-class citizens in a

democracy, was discussed. Furthermore, in conceptualizing their own agency, these black women did not believe that their view of maternal responsibility implicated them in a patriarchal family structure. Drawing on the cultural norms of West Africa and the oppressive realities that people of African descent have faced in this country, these women viewed the maternal as a profound commitment to the well-being and survival of black children and black people. The maternal lens they brought to their practice powerfully connected their personal relationships with students to an active engagement with social reality.

Several recent studies have suggested a similar cultural connection between the pedagogy of culturally relevant black teachers and a concept of the maternal in their practice (Case, 1997; Delpit, 1995; Foster, 1993). For example, Michele Foster (1993) maintains that the use of kin terms among black women teachers as "mothers, aunts, and grandmothers" toward their students is a long-standing practice within black communities. In this tradition, teachers often see themselves as "othermothers" or women who, through feelings of shared responsibility, commit themselves to the social and emotional development of all children in a community (Collins, 1991). "Othermothering" has also been described as a "universalized ethic of care" or a "collective social conscience" (Case, 1997, pp. 26, 36) in which the caring that othermothers engage in is not simply interpersonal but profoundly political in intent and practice. Explains Patricia Hill Collins (1991):

> By seeing the larger community as responsible for children and by giving other-mothers and other nonparents "rights" in child rearing, African-Americans challenge prevailing property relations. It is in this sense that traditional bloodmother/othermother relationships in women-centered networks are "revolutionary." (p. 123)

This concept of othermothering is germane to education because teaching in the African-American community, as in other ethnic groups, has been dominated by women since the turn of the twentieth century. However, the profound relational capacities of womanist teachers are vitally connected to another dimension—their identity as political beings who make constant parallels between schooling and society, school practices and social reality. Thus, as the traditions of caring in which black women have been involved have had an explicit focus on helping other women and their children survive the degradations of physical, economic, and political enslavement (Collins, 1991), so has womanism provided an interpersonal base for social action in education.

Political Clarity

Political clarity is the recognition by teachers that there are relationships between schools and society that differentially structure the successes and failures of groups of children (Bartolome, 1994). Womanist teachers see racism and other systemic injustices as simultaneously social *and* educational problems. Consequently, they demonstrate a keen awareness of their power and responsibility as adults to contest the societal stereotypes imposed on children.

The presence of political clarity among womanist teachers is a recurring theme in historical and autobiographical analyses of black segregated schools that were valued by their communities (Beauboeuf-Lafontant, 1999). In taking on the role of surrogate parents toward their students (Cecelski, 1994; Siddle-Walker, 1996), the teachers believed that they were both ethically and "ethnically responsible for preparing these youth for future leadership and for making contributions to this unique mission, namely the liberation and enhancement of the quality of life for Black people" (Adair, 1984; cited in Siddle-Walker, 1996, p. 206). Educators were exhorted to use their sense of collective responsibility to help the masses of their fellow African Americans understand and act on their rights as citizens in a democracy (Higginbotham, 1992; Perkins, 1983).

As a result, their concern was for the "whole child," not simply their students' academic well-being. As Mamie Garvin Fields (1983) recalls from her lifetime of teaching in the segregated state of South Carolina:

> I taught the schoolchildren the same way I taught my sons, but not everybody approved. . . .
>
> My point always was that the "good manners" of some black people didn't help their black child to "come up in the world." Those manners kept us "in our place." They conditioned us in the Old South ways. So the next thing you know, that black child is grown up and calling white people "sir" and "ma'am." . . . For example, many teachers would say, "Don't bother the white people to get necessities for your school." Afraid, you see. My attitude was, "He's a man and speaks English. I will ask him." So the other teachers would send me to see Mr. Welch in his office. I became the spokesman. (p. 221)

Most black teachers during segregation had few illusions about their freedom and knew · that, even as adults, they were considered inferior to all whites. Thus, for Mamie Fields to refuse to model subservience for all her children—those of her family as well as of her classroom—was to "teach against the grain" (Cochran-Smith, 1993) in a profoundly political manner. As she also says, "White people had so many ways to degrade the Negro. I always tried to oppose that" (Fields, 1983, p. 214). Thus, her caring and pedagogy were very much contextualized by and responsive to the needs of her students for someone who would value them and expect greatness of them, even if the larger society (and some of their other black teachers) did not. In the words of one former student of a segregated school, "Our teachers could see our potential even when we couldn't, and they were able to draw out our potential. They helped us imagine possibilities of life beyond what we knew" (Foster, 1997, p. 99).

In a similar way, Marva Collins emphasizes the promise of her students, finding something admirable about each child every day (Collins and Tamarkin, 1990/1982, p. 61). This habit is tied to her fundamental belief that

> a good teacher can always make a poor student good and a good student superior. The word *teacher* has its roots in the Latin word meaning *to lead* or

to draw out. Good teachers draw out the best in every student; they are will-
ing to polish and shine until the true luster of each student comes through.
(p. 6; emphasis in original)

In "shining" her students, Collins also confronts them with social reality. In other words,
she does not uncritically glorify children. Nor does she simply strive to make students
feel good about themselves. The purpose of her teaching is much more political: to help
them question reality along with her and to discuss its implications for them.

Because Collins's students are poor children from housing projects located in an
urban ghetto, the social assumption (and perhaps desire) is that they will fail, both
in school and in life. Rather than ignoring or minimizing the presence of derogatory
stereotypes, Collins makes the political ramifications of their failures to learn clear to
them:

> If you throw away your life, you're just letting society have its way. . . . You
> know, boys and girls, there are some people who look at places like this,
> neighborhoods like Garfield Park, and they say, "Oh, children from there are
> not very smart. They aren't going to grow up to be anyone or do anything
> special." If you decide to waste your lives, you are letting all those people be
> right. No one can tell you what you will be. Only you have the power to
> decide for yourselves. (Collins and Tamarkin, 1990/1982, p. 85)

While Collins speaks of her children needing to make choices that have lifelong impli-
cations, she also recognizes that they need guidance and sponsors, in their families as
well as in their school:

> In this messed up world, the only children who are going to make something
> of themselves are those who come from strong parents or those who have
> had a strong teacher. One or the other. Or both. (Collins and Tamarkin,
> 1990/1982, p. 54)

As a result, Collins repeats to her students, "I am not going to give up on you. I am
not going to let you give up on yourself" (Collins and Tamarkin, 1990/1982, p. 87).

Very significantly, Collins lays bare the political realities that her students, all ele-
mentary-aged, are experiencing. Such honesty about the stakes of getting an education,
particularly when one is marginalized and oppressed by society, is not common practice
in our schools, even at the secondary level (Fine, 1991). Teachers apparently fear that
being truthful with minority children will demoralize them even further and seal their
fate. Yet, from the perspective of these African-American teacher-mothers, to withhold
knowledge *is* to disempower those children.

Politically clear womanist educators understand the necessity of seeing through
stereotypes as false representations of children's realities and possibilities. As one com-
munications teacher remarks:

I teach you the way I perceive you to be. . . . [One of the problems I had with Teach for America] is that, you know, "White savior" type thing. Susie Bonnie Joe . . . is going into 125th, you know, and Adam Clayton Powell Boulevard, and teaching people who *look* nothing like her, people who are of a *totally* different economic class, and she's "taming the savages." But she sees them as savages. She's perpetuating [bitter chuckle] the very self-hatred and degradation that, I think, is characteristic of so many people who have been othered by our society. . . . So you've got to start with a base level of understanding these kids as *human beings*. We're all subject to the stereotypes of our society, and we can't assume that because we're well-intended [chuckle], we don't carry with us all of that. You know, that sheltering, "Don't teach them that history." Or, "Don't tell them that." Or, "I feel so sorry for you. I *expect* you to be poor. I know you only have one parent. Your mother probably doesn't know how to be a mother" [all said in a gentle, yet condescending voice]. Hey, you've got to help them see within their own situation the strength and the richness. (Beauboeuf, 1997, pp. 122–123)

Thus, womanist teachers readily demonstrate their political clarity: With their students, both in deed and in word, they share their understanding of society, an understanding that does not shy away from the reality of domination nor from the existence of resistance struggles against oppression. In essence, loving students means discussing such insights with them, not withholding knowledge from them. Audrey Thompson (1998) describes the cultural significance of such openness: "Caring in the Black family has had to be, in part, *about* the surrounding society, because it has had to provide children with the understanding and the strategies they need to survive racism. . . . [Thus] love and caring [in the womanist tradition] do not step back from the world in order to return to innocence, but step out into the world in order to change it" (p. 532; emphasis in original). Being a womanist educator entails more than simply having a professed love for children: A womanist educator loves children, especially those considered "other" in society, out of a clear-sighted understanding of how and why society marginalizes some children while embracing others.

While political clarity and a maternal sensibility are central to the everyday practice of womanist teachers, their overall investment in the teaching profession emerges from an ethical perspective of risk taking. It is this ethic of risk that provides such educators with the moral fortitude and vision to persevere in their fundamentally political and maternal form of caring.

An Ethic of Risk

A womanist engagement with oppressive realities occurs in spite of an educator's recognition that social injustice is deep-seated and not easily dismantled. Sharon Welch (1990), a white feminist theologian, has remarked on the "ethic of risk" she observed

in the literature of noted black women authors, all of whom describe intergenerational struggles against injustice:

> Within an ethic of risk, actions begin with the recognition that far too much has been lost and there are no clear means of restitution. The fundamental risk constitutive of this ethic is the decision to care and to act although there are no guarantees of success. . . . It is an ethos in sharp contrast to the ethos of cynicism that often accompanies a recognition of the depth and persistence of evil. (p. 68)

Thus, when Momma Hawk (Valente, 1996) speaks of her dream of "tak[ing] care of children of rejection" or of her belief that "every child is a gift from God and our job as teachers is to find the gift in each" (p. 44), she frames her teaching as a mission and sees herself as a child of God and as having the spiritual resources to undertake that mission. A similar belief in students and in oneself emanates from a high school English teacher's conviction that students "can be *great* achievers. It's so *much* in them, you know, but it takes a *skillful* teacher, it takes a skillful *woman* to draw it out" (Beauboeuf, 1997, p. 83). Or in the words of a junior high school communications educator, teaching becomes a process of "manifest[ing] the divinity within you":

> And that means for me. . . . I want to develop a *kindness* and a *love* and a *patience* . . . [a] level of *understanding*, of *humility*, of *groundedness*, of *good-ness*. . . . I think that there's something really *spiritual* about being an educa-tor, because I think the only reason to learn is to teach. (Beauboeuf, 1997, p. 126)

Because their ethic of risk is rooted in their sense of an existential interdependence, womanist educators recognize and accept "not that life is unfair, but that the creation of fairness is the task of generations, that work for justice is not incidental to one's life but is an essential aspect of affirming the delight and wonder of being alive" (Welch, 1990, p. 70).

While individuals have an ethic of risk, their commitments to working for social justice rest on a concept of self that is part of rather than apart from other people. From their embrace of an ethic of risk, womanist educators understand morality not in abstract principles but in personal, and specifically maternal, terms (Colby and Damon, 1992; Koonz, 1987). In other words, their capacity to act morally is based in "the ability to perceive people in their own terms and to respond to need" (Gilligan, 1986, p. 292). It is an intimacy with and not an aloofness from other people that motivates womanist educators to see personal fulfillment in working toward the common good.

From this sense of interdependence, womanist educators establish classroom routines that model such mutual responsibility. Such routines are well described by educational researcher George Noblit (1993) in his ethnography of the classroom dynamics of one African-American teacher, Pam. Noblit maintains that Pam created rituals with her sec-

ond-grade students so that as they performed daily tasks—such as cleaning the board, sharpening pencils, and reading the calendar—they were "serv[ing] the collective good" (p. 29). Moreover, academically weak children were not left to themselves, and no one was ever singled out for praise at the cost of others. In her interactions with students who were unable to answer questions, Pam still held them responsible for acquiring academic skills; however, she allowed them to do so in a supportive environment filled with "a lot of coaching to get it right and a lot of room to figure it out for yourself" (p. 29). Even when asking a question and choosing one student to answer, Pam would try to include the whole class: She would "let the hands wave for a while—long enough to allow the maximum number of hands to raise . . . smile and make eye contact with all she could" (p. 33). And regardless of whether the answer given was correct, "she would connect for a brief moment with her eyes, words, humor, and attention" (p. 33). Instructive about Pam's teaching is how she acknowledged, but did not resign herself to, the "difficult" students and parents: "She could laugh at a lot of the tribulations of classroom life because neither the events nor her enjoyment of her students threatened her authority. In many ways, they constituted her moral authority" (Noblit, 1993, p. 27, 28).

In emic discussions of African-American culture, such an assertion of the individual existing within a web of community and history is very common (Collins, 1991; Hord and Lee, 1995). Not only is the tie between the individual and the community a guiding cultural belief, but the conditions of slavery and continued oppression have heightened this interdependence as not simply a preferred existential state but a critical component of survival: "Black service providers and community activists alike have long recognized that their own destiny was inextricably linked to the destiny of other Blacks, and that in forging ties of mutual support, collective survival and racial progress would be achieved" (Ward, 1995, pp. 176–177). Significant about this concept of interdependence is its charge that "you *must* have some practical *purpose* and *benefit* to others and to self. You *must*" (Beauboeuf, 1997, p. 83). As a junior-high-school history teacher explains, the interdependence of womanist caring requires that teachers see both teaching and change as interpersonal processes:

> I mean, it's not that you have all the answers. . . . I think you have to have the right attitude, the right outlook that, "I'm about change; I'm not perfect." . . . And I think we've got to sort of remove it from being sort of a personal attack to like trying to help us understand who we are so that we can help our students understand better who they are. (Beauboeuf, 1997, p. 95)

Because they include self-change in the project of social change, womanist educators are guided by a humility in their teaching:

> To suggest "I'm going to change you," is to suggest, "I know everything, and I have the right answer." . . . *People aren't victories.* It's about, "So, what have you got to tell me? So let's talk for awhile, let's keep the conversation going, and maybe we'll both be changed by the end of this." . . . [Change]

is increments. It's little steps. And I value the process. . . . It's the process through which we go that's often the time during which you learn the most. (Beauboeuf, 1997, p. 127; emphasis added)

Thus, informed by an ethic of risk, womanist caring encourages educators to see their action as a humble, yet essential, contribution to an extensive, collaborative, and enduring project of social change.

Conclusion and Implications

If black women exemplars are truly models of the types of teachers that our students need, then recognizing a womanist orientation to teaching compels us to reconsider several assumptions we may make about women, caring, and education. First, it suggests that caring need not be regarded simply as an interpersonal, dyadic, and apolitical interaction; to see caring in such terms is to disregard its potential for communal engagement and political activism. Furthermore, to see children as innocent and incapable of wondering about the problems of our society is in fact to condemn them to the same despair we have about our social ills. Once we begin to see caring and mothering in larger, sociohistorical realms, we can recognize how in sharing knowledge we can also share power. As Alice Walker (1983) notes, womanists pride themselves on "wanting to know more and in greater depth than is considered 'good' for one" because they like being "responsible. In charge. Serious" (p. xi). Thus, for those women (and men) uncomfortable with the political nature of teaching, we might ask, "Whose limitations are they embracing as their own? And to what end?" Noblit's (1993) admission of his own uneasiness with the authority and caring of Pam's womanist pedagogy is instructive here:

> I understood caring as relational and reciprocal. . . . I, who saw power linked to oppression in everything, did not want caring to be about power, and thereby about oppression. . . . I wanted the "ethic of caring" to be pristine, to be somehow beyond issues of power that I considered to be essentially hegemonic and masculine. (p. 26)

By associating power with masculininty and oppression and caring with femininity and liberation, Noblit acknowledges that he erroneously left no room to explain the pedagogy of Pam, a woman whose pedagogy combined both power and caring. However, as a result of being instructed in her methods as a participant-observer in her class, he realized that power in and of itself is not hurtful and that power is not the same as the exploitation or oppression of another person. As a result, he concludes that the real task of teaching is to find ways of holding truth to power, of using power to promote rather than thwart human development. A key way of manifesting this "good" power, notes Noblit, is heeding Pam's "emphasis on collectivity . . . as a corrective for the seemingly rampant individualism of Americans in general" (p. 37).

Lacking such interdependence and an ethic of risk, one can easily succumb to despair given the many problems of urban education. However, to subscribe to a form of mothering in which the nature and purpose of one's caring are not interrogated, out of the belief that good intentions necessarily result in good actions, is also deeply problematic. Alice McIntyre (1997) describes the politically unclear caring of several white female students in a preservice teaching program:

> The observations that are made by the participants reveal several stereotypes about students of color (e.g., unkempt, violent, unprepared). Confounding that is the fact that the participants' perceptions of themselves as caring and benevolent teachers make it difficult for them to even recognize those stereotypes. . . . Rather than expressing anger and rage at children coming to school with no coats and "not having" what "they have," the participants' discourse lacked a sense of urgency about the need to restructure educational institutions. The participants conceptualize the problem as being internal to their students. The solution then is to "save" them. (pp. 667, 668)

In resorting to such a paternalistic pedagogy or what Sara Ruddick (1992) terms "maternal miltarism" (p. 147), women fail to see or care about "others," those beyond their immediate families and communities. As teachers, they also run the risk of succumbing to self-righteous despair about the enormity of the social problems of poverty, racism, and general injustice, by seeing these problems as insurmountable because they are rooted in the ways of "other people."

Womanism, however, in positing our fundamental interdependence, regardless of the social divisions of class, race, and gender, offers heartening, yet sobering, information about the nature of social activism. It suggests that caring may not result in immediate, self-congratulatory successes. In fact, because the struggle is long and social in nature, one cannot egocentrically base one's commitment on seeing instantaneous change: One must have the faith, as Noblit (1993) writes of Pam, that "You'll love me more after you leave me." As a womanist educator, one must reconcile oneself to the paradox that "peace is the struggle"—that is, "life is [lived] on the edge, and that's when the best self emerges" (Beauboeuf, 1997, p. 150). Thus, womanist teachers see themselves as dynamic agents for social justice precisely because they define themselves as having a sense of connection with and responsibility to the human struggle for freedom and justice. In other words, the hopefulness of the ethic of risk keeps people from falling into the numbness and self-absorption of despair. From a womanist standpoint, we understand that oppression, as a misuse of power, occurs when there is a disconnection between people—when people refuse or fail to care for each other. As a result, womanist teaching offers ways to repair such relational breakdowns by emphasizing the following: the agency that each of us has to treat others as our own; the obligation we have to understand as fully as we can the world around us; and the responsibility we have to make sure that our actions contribute to the larger human goal of freedom for all.

I have intended the foregoing examples of black womanist teachers to help teachers reflect on their own pedagogy. Not all black teachers are womanists, and not all womanists are African-American women. Because womanism is a politicized appropriation of some of the cultural values of black women, people choose whether or not to become womanists. It is my hope that teachers will use the womanist tradition to inform their own pedagogy and professional identities and will begin to see themselves as part of a long-standing *American* tradition in which women and men have seen teaching as their contribution to the making of a socially just society. We exist at a time when our access to multicultural histories is a powerful tool at our disposal for "rewriting autobiography" (Cochran-Smith, 1995) to create empowering images of our possibilities, culled from various cultural and political legacies.

Note

Beauboeuf-Lafontant, Tamara, "A Womanist Experience of Caring: Understanding the Pedagogy of Exemplary Black Women Teachers," *The Urban Review*, 34(1) (March, 2002): 71–86. Reprinted with permission.

References

Bartolome, L. (1994). Beyond the methods fetish: Toward a humanizing pedagogy. *Harvard Educational Review* 64(2): 173–194.

Beauboeuf, T. (1997). *Politicized Mothering Among African American Women Teachers: A Qualitative Inquiry.* Unpublished doctoral dissertation, Cambridge, Harvard Graduate School of Education.

Beauboeuf-Lafontant, T. (1999). A movement against and beyond boundaries: "Politically relevant teaching" among African American teachers. *Teachers College Record* 100(4): 702–723.

Cannon, K. (1995). *Katie's Canon: Womanism and the Soul of the Black Community.* New York: Continuum.

Case, K. (1997). African American othermothering in the urban elementary school. *The Urban Review* 29(1): 25–39.

Casey, K. (1990). Teacher as mother: Curriculum theorizing in the life histories of contemporary women teachers. *Cambridge Journal of Education* 20(3): 301–320.

Casey, K. (1993). *I Answer with My Life: Life Histories of Women Teachers Working for Social Change.* New York: Routledge.

Cecelski, D. (1994). *Along Freedom Road: Hyde County, North Carolina and the Fate of Black Schools in the South.* Chapel Hill: University of North Carolina.

Cochran-Smith, M. (1993). Learning to teach against the grain. In K. Geismar and G. Nicoleau (Eds.), *Teaching for Change: Addressing Issues of Difference in the College Classroom*, pp. 191–223. Cambridge, MA: Harvard College.

Cochran-Smith, M. (1995). Uncertain allies: Understanding the boundaries of race and teaching. *Harvard Educational Review* 65(4): 541–570.

Colby, A., and Damon, W. (1992). *Some Do Care: Contemporary Lives of Moral Commitment.* New York: Free Press.

Collins, M. (1992). *Ordinary Children, Extraordinary Teachers*. Charlottesville, VA: Hampton Roads.

Collins, M., and Tamarkin, C. (1990/1982). *Marva Collins' Way: Returning to Excellence in Education*. New York: Putnam.

Collins, P. (1991). *Black Feminist Thought: Knowledge, Consciousness, and the Politics of Empowerment*. New York: Routledge.

Delpit, L. (1995). *Other People's Children: Cultural Conflict in the Classroom*. New York: The New Press.

Fields, M. (1983). *Lemon Swamp and Other Places: A Carolina Memoir*. New York: Free Press.

Fine, M. (1991). *Framing Dropouts: Notes on the Politics of an Urban Public High School*. Albany, NY: State University of New York Press.

Foster, M. (1991). Constancy, connectedness, and constraints in the lives of African American teachers. *NWSA Journal* 3(2): 233–261.

Foster, M. (1993). Othermothers: Exploring the educational philosophy of black American women teachers. In M. Arnot and K. Weiler (Eds.), *Feminism and Social Justice in Education: International Perspectives*, pp. 101–123. Washington, DC: Falmer Press.

Foster, M. (1997). *Black Teachers on Teaching*. New York: New Press.

Gilligan, C. (1986). Exit-voice dilemmas in adolescent development. In A. Foxley, M. McPherson, and G. O'Donnell (Eds.), *Development, Democracy and the Art of Trespassing: Essays in Honor of Albert O. Hirschman*, pp. 283–300. South Bend, IN: University of Notre Dame.

Grumet, M. R. (1988). *Bitter Milk: Women and Teaching*. Amherst: University of Massachusetts.

Higginbotham, E. (1992). *Righteous Discontent: The Women's Movement in the Black Baptist Church, 1880–1920*. Cambridge, MA: Harvard University.

Hord, F., and Lee, J. (1995). *I Am Because We Are: Readings in Black Philosophy*. Amherst: University of Massachusetts.

Jervis, K. (1996). "How come there are no brothers on that list?" Hearing the hard questions all children ask. *Harvard Educational Review* 66(3): 546–576.

Koonz, C. (1987). *Mothers in the Fatherland: Women, the Family, and Nazi Politics*. New York: St. Martin's Press.

Ladson-Billings, G. (1994). *The Dreamkeepers: Successful Teachers of African American Children*. San Francisco: Jossey-Bass.

McIntyre, A. (1997). Constructing an image of a white teacher. *Teachers College Record* 98(4): 653–681.

Nieto, S. (1999). *The Light in their Eyes: Creating Multicultural Learning Communities*. New York: Teachers College Press.

Noblit, G. (1993). Power and caring. *American Educational Research Journal* 30(1): 23–38.

Noddings, N. (1994). *Caring: A Feminine Approach to Ethics and Moral Education*. Berkeley: University of California.

Perkins, L. (1983). The impact of the "Cult of True Womanhood" on the education of black women. *Journal of Social Issues* 39(3): 17–28.

Ruddick, S. (1992). From maternal thinking to peace politics. In E. Cole and S. Coultrap-McQuin (Eds.), *Explorations in feminist ethics: Theory and practice*, pp. 141–155. Bloomington: Indiana University.

Siddle-Walker, V. (1996). *Their Highest Potential: An African American School Community in the Segregated South*. Chapel Hill: University of North Carolina.

Thompson, A. (1998). Not the color purple: Black feminist lessons for educational caring. *Harvard Educational Review* 68(4): 522–554.

Valente, J. (1996). Momma knows best: Chicago's Corla Hawkins simply won't let kids fail. *People* (November 18), pp.

Valenzuela, A. (1999). *Subtractive Schooling: US-Mexican Youth and the Politics of Caring*. Albany, NY: SUNY Press.

Walker, A. (1983). *In Search of Our Mothers' Gardens: Womanist Prose by Alice Walker*. New York: Harcourt Brace Jovanovich.

Ward, J. (1995). Cultivating a morality of care in African American adolescents: A culture-based model of violence prevention. *Harvard Educational Review* 65(2): 175–188.

Welch, S. (1990). *A Feminist Ethic of Risk*. Minneapolis, MN: Fortress Press.

Critical Race Theory, Latino Critical Theory, and Critical Raced-Gendered Epistemologies

Recognizing Students of Color as Holders and Creators of Knowledge

Dolores Delgado Bernal
University of Utah

I have to say that I think my high school was pretty discriminatory because I feel that I wasn't tracked into a college program and I think I had the potential to be. Except because I was from the other side of the tracks, no one really took the time to inspire me. . . . I had a high school English teacher who had asked us to write an essay. And I had written it about the death of my sister. And when she gave it back to me, she gave me a D. And she said it was all wrong. And I just couldn't get how she was, first of all, insensitive, and then second of all, criticizing me on an experience she didn't have and that only I could write about. And so that's when I think I started to feel the discrimination, almost in the way, I guess in the expectations of what you talk about or what you don't talk about in school. And what's academic and what's not academic. (Angela, a graduating Chicana college student)

Actually, after my second semester of my sophomore year, I took my first Chicano studies course, "Chicano Life History" with Ledesma, and that just opened my eyes to everything, a passion. . . . That class helped me a lot . . . *y tambien* [and also] basically gave me identity 'cause I was lost. . . . So, if the students were exposed to that . . . it would make a huge difference, learning our history *y todo* [and all]. . . . I wish that somehow I could [teach at] the elementary school 'cause I think it's important that we start that early, just giving that gift of giving someone their . . . history *y todo* [and all]. . . . And

I don't think it should even be a gift, it's a right. It's a right; unfortunately, it's not happening [in schools]. (Chuy, a graduating Chicano college student)

Although students of color are holders and creators of knowledge, they often feel as if their histories, experiences, cultures, and languages are devalued, misinterpreted, or omitted within formal educational settings. The above quotes address how two undergraduate students of color reflect on what counts as valid knowledge in schools and how this has directly affected their lives.[1] Angela speaks to how she learned as a young high school student that her real life experiences "from the other side of the tracks" were not considered an acceptable source of knowledge from which to draw on in academic settings. Her personal experience embodied knowledge that her teacher seemed to disregard, perhaps because she did not consider it to be objective or authoritative knowledge. Chuy points to how his cultural and/or ethnic history was omitted from the curriculum until he was in college and how this has motivated him to want to teach younger students. He expresses his disappointment in the schools' focus on a Eurocentric history that denies the history of students of color. Both students are addressing epistemological questions that deal with power, politics, and survival as well as the need for educators to recognize the knowledge, histories, and experiences of students of color.

Epistemology, in general, refers to the nature, status, and production of knowledge (Harding, 1987) and the way one knows and understands the world. However, the concept of epistemology is more than just a "way of knowing" and can be more accurately defined as a "system of knowing" that is linked to worldviews based on the conditions under which people live and learn (Ladson-Billings, 2000). Ladson-Billings argues that "there are well-developed systems of knowledge, or epistemologies, that stand in contrast to the dominant Euro-American epistemology" (p. 258). Indeed, a number of education scholars have begun talking about critical raced and raced-gendered epistemologies that emerge from a social, cultural, and political history different from the dominant race (e.g., Delgado Bernal, 1998; Dillard, 1997, 2000; Gordon, 1990; Ladson-Billings, 1995, 2000; Scheurich & Young, 1997). These raced and raced-gendered epistemologies directly challenge the broad range of currently popular research paradigms, from positivism to constructivism and liberal feminism to postmodernism, which draw from a narrow foundation of knowledge that is based on the social, historical, and cultural experiences of Anglos (Stanfield, 1994). As part of the challenge to popular research paradigms, this article demonstrates how critical race theory (CRT) and Latina/Latino critical theory (LatCrit) give credence to critical raced-gendered epistemologies that recognize students of color as holders and creators of knowledge.

In this chapter, I refer to critical raced-gendered epistemologies that offer unique ways of knowing and understanding the world based on the various raced and gendered experiences of people of color. In my mind, there is not just one raced-gendered epistemology but many that each speak to culturally specific ways of positioning between a raced epistemology that omits the influence of gender on knowledge production and a White feminist epistemology that does not account for race. Collins (1998) speaks to

this balance when she states, "Black feminism must come to terms with a White feminist agenda incapable of seeing its own racism, as well as a Black nationalist one resistant to grappling with its own sexism" (p. 70). Whereas White feminisms often define themselves against a male-centered perspective, critical raced-gendered perspectives avoid male-female polarisms, instead examining how oppression is caught up in multiply raced, gendered, classed, and sexed relations. In other words, these systems of knowledge, or critical raced-gendered epistemologies, emerge from the experiences a person of color might have at the intersection of racism, sexism, classism, and other oppressions.

To demonstrate how critical raced-gendered epistemologies recognize students of color as holders and creators of knowledge, I first discuss how CRT and LatCrit provide an appropriate lens for qualitative research in the field of education. I then look to how different epistemological perspectives view students of color. More specifically, I compare and contrast how a Eurocentric perspective and a specific raced-gendered perspective offer very different interpretations of the educational experiences of Chicana/Chicano students.[2] I then offer implications of critical raced-gendered epistemologies for both research and practice. I conclude by discussing some of the critiques against the use of these epistemologies in educational research. Throughout this article, I emphasize how a critical raced-gendered epistemology recognizes students of color as holders and creators of knowledge who have much to offer in transforming educational research and practice. Indeed, I argue that students of color represent what Castillo (1995) describes as holders of knowledge who can transform the world into a more just place.

> Today, we grapple with our need to thoroughly understand who we are . . . and to believe in our gifts, talents, our worthiness and beauty, while having to survive within the constructs of a world antithetical to our intuition and knowledge. . . . Who, in this world of the glorification of material wealth, Whiteness, and phallic worship would consider *us* holders of knowledge that could transform this world into a place where the quality of life for all living things on this planet is the utmost priority? (p. 149)

CRT and LatCrit as a Lens for Educational Research

Although numerous frameworks could be used to move toward a critical raced-gendered epistemology in educational research, in this article, I use a lens that builds on the work of CRT and LatCrit.[3] As theoretical frameworks in the field of law, CRT and LatCrit explore the ways that so-called race-neutral laws and policies perpetuate racial and/or ethnic and gender subordination. They emphasize the importance of viewing laws and lawmaking within the proper historical and cultural context to deconstruct their racialized content (Crenshaw, Gotanda, Peller, & Thomas, 1995). These frameworks challenge dominant liberal ideas such as colorblindness and meritocracy and show how these ideas operate to disadvantage people of color and further advantage Whites (Delgado & Stefancic, 1994).

"The task for critical race scholars is to uncover and explore the various ways in which racial thinking operates" (Flores, 2000, p. 437) to move toward a more just society.

LatCrit is similar to CRT. However, LatCrit is concerned with a progressive sense of a coalitional Latina/Latino pan-ethnicity (Valdes, 1996), and it addresses issues often ignored by critical race theorists. I see LatCrit theory adding important dimensions to a critical race analysis. For example, LatCrits theorize issues such as language, immigration, ethnicity, culture, identity, phenotype, and sexuality (Espinoza, 1990; Garcia, 1995; Hernández-Truyol, 1997; Johnson, 1997; Martinez, 1994; Montoya, 1994). LatCrit is a theory that elucidates Latinas/Latinos' multidimensional identities and can address the intersectionality of racism, sexism, classism, and other forms of oppression. It is a theory that has a tradition of offering a strong gender analysis so that it "can address the concerns of Latinas in light of both our internal and external relationships in and with the worlds that have marginalized us" (Hernández-Truyol, 1997, p. 885). Indeed, this tradition and its necessary intersectionality offers an important lens from which to envision a raced-gendered epistemology, especially for Chicanas/Latinas. LatCrit is conceived as an anti-subordination and antiessentialist project that attempts to link theory with practice, scholarship with teaching, and the academy with the community (*LatCrit Primer*, 1999). LatCrit is not incompatible or competitive with CRT.

> Instead, LatCrit is supplementary, complementary to [CRT]. LatCrit . . . at its best, should operate as a close cousin—related to [CRT] in real and lasting ways, but not necessarily living under the same roof. (Valdes, 1996, pp. 26–27)

To use CRT and LatCrit together as a lens for educational research, I adapt and borrow from both groups of theorists. CRT and LatCrit in education can be defined as a framework that challenges the dominant discourse on race, gender, and class as it relates to education by examining how educational theory, policy, and practice subordinate certain racial and ethnic groups (Solórzano & Delgado Bernal, 2001; Solórzano & Yosso, 2000). Critical race and LatCrit theorists acknowledge that educational structures, processes, and discourses operate in contradictory ways with their potential to oppress and marginalize and their potential to emancipate and empower. CRT and LatCrit are transdisciplinary and draw on many bodies of progressive scholarship to understand and improve the educational experiences of students of color (Parker, Deyhle, & Villenas, 1999).

Solórzano (1998) outlines the following five defining elements of CRT in relationship to educational research. I believe these elements form the basis of both CRT and LatCrit, and I offer examples of how they support raced-gendered epistemologies.

1. *The importance of transdisciplinary approaches.* CRT and LatCrit's transdisciplinary approach allows educational researchers to draw on the strengths and research methods of various disciplines in understanding and improving the educational experiences of students of color. Ethnic studies and women's studies, in particular, "have opened the way for

multiple theoretical and epistemological readings in the field of educational research," and scholars of color have provided "a needed critique as well as an 'endarkenment' on society as a whole" (Dillard, 2000, p. 676).

2. *An emphasis on experiential knowledge.* For too long, the experiential knowledge of students of color has been viewed as a deficit in formal learning environments. Critical raced-gendered epistemologies allow this experiential knowledge to be viewed as a strength and acknowledge that the life experiences of students of color are "uniquely individual while at the same time both collective and connected" (Dillard, 2000, p. 676). An emphasis on experiential knowledge also allows researchers to embrace the use of counterstories, narratives, *testimonios,* and oral histories to illuminate the unique experiences of students of color.

3. *A challenge to dominant ideologies.* CRT and LatCrit give meaning to the creation of culturally and linguistically relevant ways of knowing and understanding and to the importance of rethinking the traditional notion of what counts as knowledge. Raced-gendered epistemologies also push us to consider pedagogies of the home, which offer culturally specific ways of teaching and learning and embrace ways of knowing that extend beyond the public realm of formal schooling (Delgado Bernal, 2001). Because power and politics are at the center of all teaching and learning, the application of household knowledge to situations outside of the home becomes a creative process that challenges the transmission of "official knowledge" and dominant ideologies.

4. *The centrality of race and racism and their intersectionality with other forms of subordination.* Raced-gendered epistemologies emerge from ways of knowing that are in direct contrast with the dominant Eurocentric epistemology, partially as a result of histories that are based on the intersection of racism, sexism, classism, and other forms of subordination. This means that the research process must recognize that multiple layers of oppression are followed by multiple forms of resistance (Solórzano & Yosso, in press).

5. *A commitment to social justice.* Critical raced-gendered epistemologies are grounded in raced and gendered histories, and their legacy of resistance to racism and sexism can translate into a pursuit of social justice in both educational research and practice. Indeed, research and practice grounded in a critical raced-gendered epistemology seek political and social change on behalf of communities of color.

These five defining elements come together to offer a unique way to approach educational research and to move researchers and educators into spaces of moral and critical practice.[4] I concur with Gloria Ladson-Billings (2000), who states, "The 'gift' of CRT is that it unapologetically challenges the scholarship that would dehumanize and deperson-

alize us" (p. 272). I, therefore, also believe that CRT and LatCrit can help to uncover the possibilities of raced-gendered epistemologies in educational research and practice.

How Different Epistemological Perspectives
View Chicana/Chicano Students

In this section, I present an example of how the educational experiences of one group of students of color, Chicanas/Chicanos, may be interpreted very differently based on the different epistemological perspectives educators and/or researchers employ. First, I outline a Eurocentric perspective and illustrate how this perspective has been used as the basis for a deficit understanding of Mexican culture throughout the 1900s and into the twenty-first century. Then, I outline a specific raced-gendered perspective and demonstrate how we can reconceptualize the so-called deficits of Mexican culture into assets and view Chicana/Chicano students as holders and creators of knowledge.

A Eurocentric Perspective

Western modernism is a network or grid of broad assumptions and beliefs that are deeply embedded in the way dominant Western culture constructs the nature of the world and one's experiences in it (Foucault, 1979, 1988). In the United States, the center of this grid is a Eurocentric epistemological perspective based on White privilege. The Council on Interracial Books for Children (1977) defines this perspective as (a) the belief that the perspective of the Euro-Americans is the norm and (b) the practice of ignoring and/ or delegitimizing the experiences, motivations, aspirations, and views of people of color. Traditionally, the majority of Euro-Americans adhere to a Eurocentric perspective founded on covert and overt assumptions regarding White superiority, territorial expansion, and "American" democratic ideals such as meritocracy, objectivity, and individuality. What this means is that their way of knowing and understanding the world around them is very naturally and subconsciously interpreted through these beliefs. For example, the notion of meritocracy allows people to believe that all people—no matter what race, class, or gender—get what they deserve based primarily on an individual's own merit and how hard a person works. Those who believe that our society is truly a meritocratic one find it difficult to believe that men gain advantage from women's disadvantages or that Euro-Americans have any significant advantage over people of color. This way of knowing and understanding the world is at least partially based on White privilege, which is "an invisible package of unearned assets" (McIntosh, 1997, p. 120) or a system of opportunities and benefits that is bestowed on an individual simply for being White. Tatum (1999) writes about the invisibility of White privilege, yet points out its very real effects and states that "despite the current rhetoric about affirmative action and reverse discrimination, every social indicator, from salary to life expectancy, reveals the advantages of being White" (p. 8). But because, especially to Whites, this privilege is often invisible, it is legitimized and viewed as the norm or the point of departure. Standards (especially

those in education) are based on this norm, and individuals or knowledges that depart from this norm are often devalued and subordinated.

The insidious nature of a Eurocentric epistemological perspective allows it to subtly (and not so subtly) shape the belief system and practices of researchers, educators, and the school curriculum while continuing to adversely influence the educational experiences of Chicanas/Chicanos and other students of color. For example, throughout the twentieth century, the Euro-American social belief system about Mexicans helped support the many political, economic, and cultural reasons for their de jure and then de facto school segregation (Delgado Bernal, 2000). First, some individuals openly argued that Mexican students should be segregated from White students because they were genetically and physically inferior. One school official stated, "We segregate for the same reason that the Southerners segregate the Negro. They are an inferior race, that is all" (Taylor, 1934, p. 219). Another common assertion was that the standard of cleanliness among Mexican children was lower than that of Anglos. "I don't believe in mixing. They are filthy and lousy, not all, but most of them," declared one school board member (Taylor, 1934, p. 217).

Indeed, the beliefs about Mexicans held by many educators shared a common trait during this period. Tate (1997) observed that educators' beliefs were "premised upon political, scientific, and religious theories relying on racial characterizations and stereotypes about people of color that help support a legitimating ideology and specific political action" (p. 199). A case in point is how prohibiting Spanish-language use among Mexican school children was a social philosophy and a political tool used by local and state officials to justify school segregation and to maintain a colonized relationship between Mexicans and the dominant society (Delgado Bernal, 1999). Today, bilingualism often continues to be seen as "un-American" and considered a deficit and an obstacle to learning.

A Eurocentric epistemology that is based on White superiority, capitalism, and scientific theories of intelligence has provided the cornerstone of de jure and de facto segregated schooling for Mexicans and the historic and current devaluation of the Spanish language (Crawford, 1992; G. G. González, 1990; Menchaca & Valencia, 1990; San Miguel, 1987). The epistemological orientation that for generations has viewed Chicanas/Chicanos as "culturally deficient" and characterized them as ignorant, backward, unclean, unambitious, and abnormal, remains unchanged and has been unaffected by major judicial and policy decisions throughout the Southwest (Donato, 1997; González, 1990; Moreno, 1999). In fact, a belief in the cultural and linguistic deficiency of Chicana/Chicano students remains in place in the twenty-first century and is supported by political action and ideological domination that continues to exclude and silence Chicanas/Chicanos and other Latinas/Latinos. Villenas and Deyhle (1999) powerfully stated one way in which this exclusion and silencing takes place at the institutional level through the curriculum.

In the schools, the colonization of the mind is continued through the instilling of a historical amnesia that renders Latino/indigenous peoples as "immigrants," foreigners who have no claim to the Americas, while European Americans

are constructed as the natural owners and inheritors of these lands. The rich knowledge, beliefs and worldviews of Latino and Mexicano/Chicano communities are not validated, let alone taught. (p. 421)

The message that Chicana/Chicano students are inferior and not agents of knowledge continues to affect the institutional level and also translates into overcrowded and underfinanced schools, low graduation rates, and overrepresentation of these students in special education classes (Kozol, 1991; Valencia, 1991). A CRT and LatCrit lens "can unveil and explain how and why 'raced' children are overwhelmingly the recipients of low teacher expectations and are consequently tracked, placed in low-level classes and receive 'dull and boring' curriculums" (Villenas & Deyhle, 1999, p. 415). In the next section, I use a CRT and LatCrit lens to examine how a specific racedgendered epistemology offers a very different understanding of the knowledge and experience that Chicanas/Chicanos bring to their formal schooling.

A Chicana Feminist Perspective

I view raced-gendered epistemologies as dynamic and encompassing various experiences, standpoints, and theories that are specific to different groups of people of color. In earlier work, I have proposed a particular raced-gendered epistemology by outlining the characteristics of a Chicana feminist epistemology in educational research (Delgado Bernal, 1998). This epistemological orientation challenges the historical and ideological representation of Chicanas and is grounded in the sociohistorical experiences of Chicanas and their communities. Chicana feminist ways of knowing and understanding are partially shaped by collective experiences and community memory. Community and family knowledge is taught to youth through legends, *corridos*, and storytelling. It is through culturally specific ways of teaching and learning that ancestors and elders share the knowledge of conquest, segregation, patriarchy, homophobia, assimilation, and resistance. If we believe "in the wisdom of our ancient knowledge," as Ana Castillo (1995, p. 148) suggests, then the knowledge that is passed from one generation to the next can help us survive in everyday life. Therefore, adopting a Chicana feminist epistemology will expose human relationships and experiences that are probably not visible from a Eurocentric epistemological orientation. Within this framework, Chicanas and Chicanos become agents of knowledge who participate in intellectual discourse that links experience, research, community, and social change.

As a case in point, I draw from my current research, which focuses on the knowledge Chicana/Chicano college students learn in the home and successfully employ when confronted with challenges and obstacles that impede their academic achievement and college participation (Delgado Bernal, 2001). The life history interview and focus group data with more than 50 Chicana/Chicano college students are educational "counterstories" that are told from a nonmajoritarian perspective—offering stories that White educators usually do not hear or tell (Delgado, 1989, 1993). My analysis of these "coun-

terstories" indicates that the students develop tools and strategies for daily survival in an educational system that often excludes and silences them. In fact, the communication, practices, and learning that occur in the home and community can be viewed as a cultural knowledge base that helps students survive the daily experiences of racism, sexism, and classism. What are often perceived as deficits for Chicana/Chicano students within a Eurocentric epistemological framework—limited English proficiency, Chicano and/or Mexicano cultural practices, or too many nonuniversity-related responsibilities—can be understood within a Chicana feminist perspective as cultural assets or resources that Chicana/Chicano students bring to formal educational environments.

The application of household knowledge, specifically in the form of bilingualism, biculturalism, and commitment to communities, interrupts the transmission of "official knowledge" and even helps students navigate their way around educational obstacles. For instance, the students in my study experienced their bilingualism in various ways throughout their educational journey. Most of them felt that their bilingualism had a positive impact on them academically and socially. They seemed to draw strength from using both Spanish and English in academic and social settings. As one young woman put it, "It's a great resource to my community, the people that I work with, the university itself." Students stated over and over again that knowledge in Spanish helped them acquire English and that their bilingualism had been an asset to their education. A few students also spoke passionately about their bilingualism in terms of identity and the importance of maintaining their home language.

In addition, students discussed how they and others benefited from their bicultural insights. Many also spoke of how they consciously rejected assimilation and attempted to hold onto different aspects of their culture while they learned from other cultures. As one female sophomore said,

> I think I'm acculturated, and I don't think I've assimilated by the simple fact that I have decided to learn about all these other cultures. . . . I am not giving up my own, and I think when you assimilate you give something up to gain something.

In spite of a Eurocentrism that has fostered a history of cultural repression in the United States, these students embrace the cultural and linguistic strengths and assets of Chicana/Chicano family education. As Mesa-Bains (1999) explained, it is important to affirm how our biculturalism and family knowledge have contributed to this country.

> Our *quinceaneras*, our *bailes*, our *bodas*, our *pastorelas*, our *fiestas patrias*, our foods, our music, and our arts are all part of the cultural contributions we have made to the vibrant life of the United States. . . . In such a time of growing xenophobia it is important to affirm for ourselves and for others the myriad ways in which we have enriched this country, from our historic beginnings as ancient people to our contemporary lives. (p. 107)

The students also voiced a very strong commitment to their families or the Mexican communities from which they came, a commitment that translated into a desire to give back and help others. Many of the students spoke of their role as examples for their younger siblings and in promoting education or ideas of social justice. One woman commented that "I'm teaching [my younger brothers] to be responsive to women, to believe in them, to not be like the other *machistas* at home." In addition, the words of the students I interviewed paralleled Villalpando's (1996) national research, which found that in comparison to White students, Chicana/Chicano students enter college with higher levels of altruism, stronger interests in pursuing careers serving their communities, and stronger interests in "helping their communities." Students spoke of their commitment to their families and communities as a source of inspiration and motivation to overcome educational obstacles. This male freshman spoke about his commitment to helping out other people in his community after he graduates from college.

> I kind of want a good income, but the only way I'll accept that is if I do something good . . . and I'm active in the community, and I'm helping out other people, I'm not just helping myself. . . . I've always seen it as you're just a wasted person if you just help yourself.

The voices of these students illustrate the vastly different worldviews about what is considered "valid knowledge." They see their home knowledge—their bilingualism, biculturalism, and commitment to communities—as a critical tool that has helped them navigate through educational obstacles, go onto college, and make a positive difference to others. As documented in the previous section, this contrasts with educators who operate within a traditional Eurocentric epistemological framework and often see the home knowledge of Chicana/Chicano students as lacking, limited, and inferior to the "norm." Situated within a particular raced-gendered framework, my work rejects the dominant culture's text and vision of what Chicana/Chicano students know and of who they are. At the same time, this epistemological orientation allows educators to better understand the different knowledges Chicana/Chicano students bring from their homes and communities.

Implications of a Critical Raced-Gendered Epistemology

Methodological and Pedagogical Insights

The focus of this article is epistemology, particularly those systems of knowing that counter a dominant Eurocentric epistemology, yet, it is interconnected to the critical race methodologies and pedagogies discussed in this volume. As Pillow (2000) states, "One cannot separate the epistemologies of feminist or race theory from their methodological and epistemological practices" (p. 23). None of the three—epistemology, methodology, and pedagogy—can be isolated from one another, as they are closely interdependent and

directly influence the research process. Thus, I believe a critical raced-gendered epistemology offers the following methodological and pedagogical insights.

A critical raced-gendered epistemology allows educational researchers to "bring together understandings of epistemologies and pedagogies to imagine how race, ethnicity, gender, class, and sexuality are braided with cultural knowledge, practices, spirituality, formal education, and the law" (F. González, 2001, p. 643). F. González (1998, 2001) works from a prism of CRT, LatCrit, and U.S. third-world feminisms to develop a methodological approach that affirms the community and cultural knowledge of students of color. She names this methodological approach *trenzas y mestizaje*—the braiding of theory, qualitative research strategies, and a sociopolitical consciousness. This approach incorporates various qualitative strategies to examine and appreciate the cultural knowledge of students of color. F. González (2001) describes *trenzas y mestizaje* and elaborates

> on how a braiding of different ways of knowing, teaching, and learning brings cultural knowledge to the fore of discourses on human rights, social justice, and educational equity as well as to inform the formulations of holistic educational policies and practices. (p. 643)

In addition, it is through a raced-gendered epistemology that Trinidad Galván (2001) proposes how "womanist" pedagogies speak directly to third-world women's knowledge and experiences. She explores three pedagogical formations (spirituality, well-being, and *convivencia*) as the teaching, learning, and creation of knowledge among a group of *Mexicana campesinas*. These pedagogical formations expand our traditional notion of pedagogy "by situating it among groups of people traditionally unheard and spaces continually unexplored" (p. 607), thus extending our understanding of Mexicana/Mexicano knowledge. Therefore, researching from within a critical raced-gendered epistemology allows the experiential knowledge of communities of color to be viewed as a strength and an asset. It also allows us to "create *nuevas teorías* (new theories) that understand, penetrate, define, and elucidate the content and meaning of our multidimensional identities" (Hernández-Truyol, 1997, p. 884).

A critical raced-gendered epistemology, grounded in CRT and LatCrit, also supports methodological and pedagogical approaches that affirm experiences and responses to different forms of oppression and validates them as appropriate forms of data. By incorporating a counterstorytelling method based on the narratives, *testimonios*, or life histories of people of color, a story can be told from a nonmajoritarian perspective—a story that White educators usually do not hear or tell (Delgado, 1989, 1993). At the same time, counterstorytelling can also serve as a pedagogical tool that allows one to better understand and appreciate the unique experiences and responses of students of color through a deliberate, conscious, and open type of listening. In other words, an important component of using counterstories includes not only telling nonmajoritarian stories but also learning how to listen and hear the messages in counterstories. Legal scholar Williams (1997) believes that counterstorytelling and critical race practice are "mostly about learning to listen to other people's stories and then finding ways to make those

stories matter in the legal system" (p. 765). Likewise, learning to listen to counterstories within the educational system can be an important pedagogical practice for teachers and students as well as an important methodological practice for educational researchers.

Insights for Policy and Practice

As my research on Chicana/Chicano college students demonstrates, CRT and LatCrit give credence to culturally and linguistically relevant ways of knowing and understanding and to the importance of rethinking the traditional notion of what counts as knowledge. The implications of this go beyond the methodological and pedagogical to affect both policy and practice. Rather than focus on the failures of students of color, an endarkened feminist epistemology allows us to ask how cultural knowledge contributes to the educational success of some students and how educational institutions can respond appropriately.

For example, universities that have language or diversity requirements might develop innovative curricular and pedagogical ways to include the bilingualism and biculturalism of students into the curriculum. In other words, institutions can acknowledge and give credit for these resources while helping students develop these resources even further. Rather than view students with limited English skills as a liability to the university (because the university has to provide language development classes for these students), the university should see these students as an asset. These are students who might be able to work as tutors in the university language department.

In addition, elementary, secondary, and postsecondary schools can incorporate the family knowledge of bilingual students by sending out information to parents in languages other than English. This would allow parents, especially at the elementary and secondary level, to stay involved and better understand the process of their children's formal education. It would also nurture the family and school relationship that is so important at all levels of formal schooling. Too often, students of color believe they have to choose either family and culture or school success (Nieto, 1996). Yet, researchers have found that for Latina/Latino students attending college full-time, maintaining family relationships is among the most important aspects that facilitates their adjustment to college (Hurtado, Carter, & Spuler, 1996). Other studies demonstrated that when college students maintain a supportive relationship with their parents, they are better adjusted and more likely to graduate (Cabrera, Castaneda, Nora, & Hengstler, 1992).

Finally, the national movement to dismantle race-based admissions policies at universities ignores current societal inequalities and the fact that the admissions process is based on a very Eurocentric measure of knowledge. Legislation that outlaws considerations of race and/or ethnicity in the university admissions process is supported by a myth of meritocracy and continues to validate a very subjective and highly selective admissions process (Delgado Bernal, 1999; Villalpando, in press). If race and/or ethnicity is not to be part of the admissions equation, educators need to think about creative ways to move away from a solely Eurocentric measure of knowledge to one that weighs "other" knowledges that emerge from communities of color (e.g., bilingualism, biculturalism, commitment to communities). Legal scholar Delgado (1995) argues for "an overhaul

of the admissions process and a rethinking of the criteria that make a person a deserving . . . student" (p. 51). He and many others have argued for admission standards that would result in an increased number of women and students of color gaining admission, yet, he points out that these recommendations are often ignored and never instituted. A critical raced-gendered epistemology enables educators to consider creative admissions, curricular, and pedagogical policies that acknowledge, respect, and nurture the ways of knowing and understanding in communities of color.

Critiques of a Critical Raced-Gendered Epistemology

Without a doubt, there are those who will argue against the use of a critical raced-gendered epistemology in general and more specifically within the area of educational research and practice. Some of the potential critiques will probably parallel the numerous critiques already given against CRT and LatCrit within legal studies, and others may be unique to the field of education. In this section, I will briefly address two potential arguments that critics may put forth in relationship to a critical raced-gendered epistemology: the essentialist argument and the argument against the use of personal stories and narratives.

The Essentialist Argument

As Brayboy (2001) noted, postmodernists and other progressive scholars may be uncomfortable with CRT because they believe that it essentializes race and treats all people of color the same. The essentialist argument is rooted in a critique of identity politics that is based on a unidimensional characteristic, such as race or ethnicity. Identity politics is "an approach that is founded on parochial notions of race and representation" (Darder & Torres, 2000) and ignores or glosses over differences based on class, gender, sexuality, and culture. Rightly, critics argue that an essentialist notion of identity is simplistic and does not allow for the myriad experiences that shape who we are and what we know.

What many critics do not understand is that critical race theorists and LatCrits "have pushed the envelope of the ways in which we talk about race and racism, so that we focus on the intersectionality of subordination" (Solórzano & Yosso, in press). What this means is that one's identity is not based on the social construction of race but rather is multidimensional and intersects with various experiences. Certainly, "critical legal scholarship of race (and gender or sexual orientation) in recent times has interrogated and helped debunk various essentialisms and power hierarchies based on race . . . and other constructs" (Valdes, 1996, p. 3). LatCrit in particular has pushed scholars forward in analyzing identity construction of racially subordinated people at both the individual and group levels (Johnson, 1998) and within postidentity politics (Valdes, 1996). They have added layers of complexity to the formation of identity and construction of knowledge by looking at the intersections of immigration (Garcia, 1995; Johnson, 1996–1997), migration (Johnson, 1998), human rights (Hernández-Truyol, 1996; Iglesias, 1996–1997; Romany, 1996–1997), language (Romany, 1996), gender (Rivera, 1997), and class (Ontiveros, 1997).

With increased globalization and transnational labor and communication, we have to move beyond essentialist notions of identity and of what counts as knowledge. So although race and gender are central components of a critical raced-gendered epistemology, they are but two of the many components that are woven together, and they are anything but static. Dillard (2000) pointed out that the "intent here is not to present race/ethnicity or gender as being essentialist, unchangeable, or immovable. Instead, these positionalities must be seen as shifting and dynamic sets of social relationships which embody a particular endarkened feminist epistemological basis" (p. 670). Although a critical raced-gendered epistemology is anti-essentialist, it also allows us to grasp core values within communities of color such as education, self-determination, resistance, family, and freedom. Researching from within this framework offers a way to understand and analyze the multiple identities and knowledges of people of color without essentializing their various experiences.

The Argument Against Personal Stories and Narratives

There have been numerous critiques in legal studies regarding the use of stories and narratives by CRT and LatCrit theorists (see Farber & Sherry, 1997, for one of the more substantial critiques). The argument against using personal stories and narratives is a critique against alternative ways of knowing and understanding and is basically an argument over subjectivity versus objectivity. The critique states that CRT and LatCrit theorists

> relentlessly replace traditional scholarship with personal stories, which hardly represent common experiences. The proliferation of stories makes it impossible for others to debate. . . . An infatuation with narrative infects and distorts [their] attempts at analysis. Instead of scientifically investigating whether rewarding individuals according to merit has any objective basis, [they] insist on telling stories about their personal struggles. (Simon, 1999, p. 3)

It is interesting that the critics do not acknowledge that Eurocentrism has become the dominant mind-set that directly affects the mainstream stories told about race. Because Eurocentrism and White privilege appear to be the norm, many people continue to believe that education in the United States is a meritocratic, unbiased, and fair process. These individuals might find it difficult to accept the notion that a critical raced-gendered epistemology is important to educational research and practice. Yet, the stories, beliefs, and perspectives regarding race and gender in the United States often ignore the stories, beliefs, perspectives, and experiences of people of color in general and women of color in particular. Delgado (1993) points out that "majoritarians tell stories too. But the ones they tell—about merit, causation, blame, responsibility, and social justice—do not seem to them like stories at all, but the truth" (p. 666). In other words, they believe their stories are based on facts, and because Eurocentrism and White privilege are invisible, they fail to see how subjective their stories are.

A critical raced-gendered epistemology does not position the debate between objectivity and subjectivity. Rather, it sees all stories as subjective and the production of knowledge as situated. And those working from this perspective understand that education in the United States has a way to go before it is a meritocratic, unbiased, and fair process. Working from within a critical raced-gendered epistemology does not mean that one is interested in replacing an old body of knowledge that purports to be the truth with an alternative body of knowledge that claims to be the truth. It does mean that one acknowledges and respects other ways of knowing and understanding, particularly the stories and narratives of those who have experienced and responded to different forms of oppression. This has not been the case in education, where for too long, family cultural narratives have not been considered a legitimate part of research or practice. Many researchers have begun to demonstrate how the cultural resources and funds of knowledge such as myths, folktales, *dichos, consejos,* kitchen talk, autobiographical stories, and pedagogies of the home are indeed educational strengths and strategies found in communities of color (e.g., Collins, 1998; Delgado Bernal, 2001; Delgado-Gaitan, 1994; Moll, Amanti, Neff, & González, 1992; Silko, 1996; Suárez-Orozco & Suárez-Orozco, 1995; Villalpando, in press; Villenas & Deyhle, 1999; Villenas & Moreno, 2001). Tapping into these strengths and strategies is an important first step in moving away from a Eurocentric epistemological orientation to a critical raced-gendered perspective.

Conclusion

By comparing and contrasting the experiences of Chicana/Chicano students through a Eurocentric and a critical raced-gendered epistemological perspective, I demonstrated that each perspective holds vastly different views of what counts as knowledge, specifically regarding language, culture, and community commitment. The Eurocentric perspective has for too long viewed the experiential knowledge of students of color as a deficit or ignored it all together. The focus on Eurocentric knowledge and history can be alienating and frustrating for students such as Angela and Chuy, who were quoted at the beginning of this article. To recognize all students as holders and creators of knowledge, it is imperative that the histories, experiences, cultures, and languages of students of color are recognized and valued in schools.

Together, CRT and LatCrit form a lens for educational research that acknowledges and supports systems of knowing and understanding that counter the dominant Eurocentric epistemology. CRT and LatCrit's emphasis on experiential knowledge allows researchers to embrace the use of counterstories and other methodological and pedagogical approaches that view the community and family knowledge of communities of color as a strength. In addition, critical raced-gendered perspectives in educational research become a means to resist epistemological racism (Scheurich & Young, 1997) and claim one's cultural knowledge as a legitimate and valid body of knowledge. Through a CRT and LatCrit lens, students of color can be seen as holders and creators of knowledge

who have the potential to transform schools into places where the experiences of all individuals are acknowledged, taught, and cherished.

Notes

Delgado Bernal, Delores, "Critical Race Theory, Latino Critical Theory, and Critical Raced-Gendered Epistemologies: Recognizing Students of Color as Holders and Creators of Knowledge" *Qualitative Inquiry*, 8(1) (2002): 105–126. Reprinted with permission.

1. To protect the privacy of students, they are identified with a pseudonym and/or their gender and class status at the time of the interview.

2. Chicana and Chicano are cultural and political identities that were popularized during the Chicano movement of the 1960s. They are composed of multiple layers and are identities of resistance that are often consciously adopted later in life. The term *Chicana/Chicano* is gender inclusive and is used to discuss both women and men of Mexican origin and/or other Latinas/Latinos who share a similar political consciousness. Because terms of identification vary according to context and not all Mexican-origin people embrace the cultural and political identity of Chicana/Chicano, it is sometimes used interchangeably with Mexican.

3. In discussing raced-gendered epistemologies, I clearly draw from a rich body of U.S. third-world feminist literature that I do not discuss in detail in this article. I put this literature together with critical race theory (CRT) and Latina/Latino critical theory (LatCrit) to form a lens that allows me to address how some knowledges and ways of knowing are subordinated within educational institutions.

4. Although CRT and LatCrit emerge from legal studies, they have intellectual roots in ethnic studies and women's studies. Their methodologies (i.e., storytelling, narratives), pedagogies, and underlying assumptions echo many of those found in these disciplines. Therefore, it is important to note that each of the defining elements "is not new in and of itself, but collectively, they represent a challenge to the existing modes of scholarship" (Solórzano, 1998, p. 123).

References

Brayboy, B. M. (2001, April). Racing toward an interviewing methodology for the "Other": Critical race theory and interviewing. Paper presented at the American Educational Research Association, Seattle, Washington.

Cabrera, A. F., Castaneda, M. B., Nora, A., and Hengstler, D. (1992). The convergence between two theories of college persistence. *Journal of Higher Education, 63*, 143–164.

Castillo, A. (1995). *Massacre of the dreamers: Essays on Xicanisma.* New York: Plume.

Collins, P. H. (1998). *Fighting words: Black women and the search for justice.* Minneapolis, MN: University of Minnesota Press.

Council on Interracial Books for Children. (1977). *Stereotypes, distortions, and omissions in U.S. history textbooks.* New York: Racism and Sexism Resource Center for Educators.

Crawford, J. (1992). *Hold your tongue: Bilingualism and the politics of English only.* Reading, MA: Addison-Wesley.

Crenshaw, K. W., Gotanda, N., Peller, G., and Thomas, K. (Eds.). (1995). *Critical race theory: The key writings that formed the movement.* New York: New Press.

Darder, A., and Torres, R. D. (2000). Mapping the problematics of "race": A critique of Chicano education discourse. In C. Tejeda, C. Martinez, and Z. Leonardo (Eds.), *Charting new terrains of Chicana(o)/Latina(o) education* (pp. 161–172). Cresskill, NJ: Hampton.

Delgado, R. (1989). Storytelling for oppositionists and others: A plea for narrative. *Michigan Law Review, 87,* 2411–2441.

Delgado, R. (1993). On telling stories in school: A reply to Farber and Sherry. *Vanderbilt Law Review, 46,* 665–676.

Delgado, R. (1995). The imperial scholar: Reflections on a review of civil rights literature. In K. W. Crenshaw, N. Gotanda, G. Peller, and K. Thomas (Eds.), *Critical race theory: The key writings that formed the movement* (pp. 46–57). New York: New Press.

Delgado, R., and Stefancic, J. (1994). Critical race theory: An annotated bibliography 1993, a year of transition. *University of Colorado Law Review, 66,* 159–193.

Delgado Bernal, D. (1998). Using a Chicana feminist epistemology in educational research. *Harvard Educational Review, 68,* 555–582.

Delgado Bernal, D. (1999). Chicana/o education from the civil rights era to the present. In J. F. Moreno (Ed.), *The elusive quest for equality: 150 years of Chicano/Chicana education* (pp. 77–108). Cambridge, MA: Harvard Educational Review.

Delgado Bernal, D. (2000). Historical struggles for educational equity: Setting the context for Chicana/o schooling today. In C. Tejeda, C. Martinez, and Z. Leonardo (Eds.), *Charting new terrains of Chicana(o)/Latina(o) education* (pp. 67–90). Cresskill, NJ: Hampton.

Delgado Bernal, D. (2001). Learning and living pedagogies of the home: The mestiza consciousness of Chicana students. *International Journal of Qualitative Studies in Education, 14*(5), 623–629.

Delgado-Gaitan, C. (1994). *Consejos*: The power of cultural narratives. *Anthropology & Education Quarterly, 25,* 298–316.

Dillard, C. B. (1997, March). *The substance of things hoped for, the evidence of things not seen: Toward an endarkened feminist ideology in research.* Paper presented at the American Educational Research Association annual meeting, Chicago.

Dillard, C. B. (2000). The substance of things hoped for, the evidence of things not seen: Examining an endarkened feminist epistemology in culturally engaged research. *International Journal of Qualitative Studies in Education, 13,* 661–681.

Donato, R. (1997). *The other struggle for equal schools: Mexican Americans during the civil rights era.* Albany, NY: State University of New York Press.

Espinoza, L. (1990). Masks and other disguises: Exposing legal academia. *Harvard Law Review, 103,* 1878–1886.

Farber, D., &and Sherry, S. (1997). *Beyond all reason: The radical assault on truth in American law.* New York: Oxford University Press.

Flores, L. A. (2000). Constructing national bodies: Public argument in the English-only movement. In T. A. Hollihan (Ed.), *Argument at century's end: Proceedings of the 11th SCA/AFA conference on argumentation* (pp. 436–453). Annandale, VA: National Communication Association.

Foucault, M. (1979). *Discipline and punish: The birth of the prison.* New York: Vintage.

Foucault, M. (1988). *Madness and civilization: A history of insanity in the age of reason.* New York: Vintage.

Garcia, R. J. (1995). Critical race theory and Proposition 187: The racial politics of immigration law. *Chicano-Latino Law Review, 17,* 118–154.

González, F. (1998). The formations of Mexicananess: Trenzas de identidades multiples. Growing Up Mexicana: Braids of multiple identities. *International Journal of Qualitative Studies in Education, 11,* 81–102.

González, F. (2001). Haciendo que hacer: Cultivating a Mestiza worldview and academic achievement, Braiding cultural knowledge into educational research, policy, practice. *International Journal of Qualitative Studies in Education, 14*(5), 641–656.

González, G. G. (1990). *Chicano education in the era of segregation.* Cranbury, NJ: Associated University Presses.

Gordon, B. M. (1990). The necessity of African-American epistemology for educational theory and practice. *Journal of Education, 172,* 88–106.

Harding, S. (Ed.). (1987). *Feminism and methodology.* Milton Keynes: Open University Press.

Hernández-Truyol, B. E. (1996). Building bridges: Bringing international human rights home. *La Raza Law Journal, 9,* 69–79.

Hernández-Truyol, B. E. (1997). Borders (en)gendered: Normativities, Latinas and a LatCrit paradigm. *New York University Law Review, 72,* 882–927.

Hurtado, S., Carter, D. F., and Spuler, A. J. (1996). Latino student transition to college: Assessing difficulties and factors in successful adjustment. *Research in Higher Education, 37,* 135–157.

Iglesias, E. M. (1996–1997). International law, human rights, and LatCrit theory. *Inter-American Law Review, 28,* 177–213.

Johnson, K. R. (1996–1997). The social and legal construction of nonpersons. *Inter-American Law Review, 28,* 263–292.

Johnson, K. R. (1997). Some thoughts on the future of Latino legal scholarship. *Harvard Latino Law Review, 2,* 101–144.

Johnson, K. R. (1998). Immigration and Latino identity. *Chicano-Latino Law Review, 19,* 197–212.

Kozol, J. (1991). *Savage inequalities: Children in America's schools.* New York: HarperCollins.

Ladson-Billings, G. (1995). Toward a theory of cultural relevant pedagogy. *American Educational Research Journal, 32,* 465–491.

Ladson-Billings, G. (2000). Racialized discourses and ethnic epistemologies. In N. K. Denzin and Y. S. Lincoln (Eds.), *Handbook of qualitative research* (2nd ed., pp. 257–277). Thousands Oaks, CA: Sage.

LatCrit Primer. (1999, April 29–May 5). Fact sheet: LatCrit. Presented at the 4th annual LatCrit conference, Rotating Centers, Expanding Frontiers: LatCrit Theory and Marginal Intersection, Lake Tahoe, Nevada.

Martinez, G. A. (1994). Legal indeterminacy, judicial discretion and the Mexican-American litigation experience: 1930–1980. *U. C. Davis Law Review, 27,* 555–618.

McIntosh, P. (1997). White privilege: Unpacking the invisible knapsack. In B. Schneider (Ed.), *An anthology: Race in the first person* (pp. 119–126). New York: Crown Trade Paperbacks.

Menchaca, M., and Valencia, R. R. (1990). Anglo-Saxon ideologies and their impact on the segregation of Mexican students in California, the 1920s–1930s. *Anthropology and Education Quarterly, 21,* 222–249.

Mesa-Bains, A. (1999). As Latinos in America. In E. J. Olmos, L. Ybarro, and M. Monterey (Eds.), *Americanos: Latino life in the United States. La Vida Latina en Los Estados Unidos* (p. 107). Boston: Little, Brown.

Moll, L. C., Amanti, C., Neff, D., and González, N. (1992). Funds of knowledge for teaching: Using a qualitative approach to connect homes and classrooms. *Theory into Practice, 31,* 132–141.

Montoya, M. (1994). *Mascaras, trenzas, y grenas*: Un/masking the self while un/braiding Latina stories and legal discourse. *Chicano-Latino Law Review, 15,* 1–37.

Moreno, J. F. (Ed.). (1999). *The elusive quest for equality: 150 years of Chicano/Chicana education.* Cambridge, MA: Harvard Educational Review.

Nieto, S. (1996). *Affirming diversity: The sociopolitical context of multicultural education* (2nd ed.). White Plains, NY: Longman.

Ontiveros, M. L. (1997). Rosa Lopez, Christopher Darden, and me: Issues of gender, ethnicity, and class evaluating witness credibility. In A. K. Wing (Ed.), *Critical race feminism: A reader* (pp. 269–277). New York: New York University Press.

Parker, L., Deyhle, D., and Villenas, S. (1999). *Race is . . . race isn't: Critical race theory and qualitative studies in education.* Boulder, CO: Westview.

Pillow, W. S. (2000). Deciphering attempts to decipher postmodern educational research. *Educational Researcher, 29*(5), 21–24.

Rivera, J. (1997). Domestic violence against Latinas by Latino males: An analysis of race, national origin, and gender differentials. In A. K. Wing (Ed.), *Critical race feminism: A reader* (pp. 259–266). New York: New York University Press.

Romany, C. (1996). Gender, race/ethnicity and language. *La Raza Law Journal, 9,* 49–53.

Romany, C. (1996–1997). Claiming a global identity: Latino/a critical scholarship and international human rights. *Inter-American Law Review, 28,* 215–221.

San Miguel, G. (1987). *Let all of them take heed: Mexican Americans and the campaign for educational equality in Texas, 1910–1981.* Austin: University of Texas Press.

Scheurich, J. J., and Young, M. D. (1997). Coloring epistemologies: Are our research epistemologies racially biased? *Educational Researcher, 26*(4), 4–16.

Silko, L. M. (1996). *Yellow woman and a beauty of the spirit: Essays on Native American life today.* New York: Touchstone.

Simon, T. W. (1999). Racists versus anti-semites?: Critical race theorists criticized. *Newsletter on Philosophy, Law, and the Black Experience, 98*(2), 1–11.

Solórzano, D. G. (1998). Critical race theory, race and gender microaggressions, and the experience of Chicana and Chicano scholars. *International Journal of Qualitative Studies in Education, 11,* 121–136.

Solórzano, D. G., and Delgado Bernal, D. (2001). Examining transformational resistance through a critical race and LatCrit theory framework: Chicana and Chicano students in an urban context. *Urban Education, 36,* 308–342.

Solórzano, D. G., and Yosso, T. (2000). Toward a critical race theory of Chicana and Chicano education. In C. Tejeda, C. Martinez, and Z. Leonardo (Eds.), *Charting new terrains of Chicana(o)/Latina(o) education* (pp. 35–65). Cresskill, NJ: Hampton.

Solórzano, D. G., and Yosso, T. (2005). Maintaining social justice hopes within academic realities: A Freirean approach to critical race/LatCrit pedagogy. In Critical pedagogy and race, ed. Zeus Leonardo, 69–81. Massachusetts: Blackwell Publishing.

Stanfield, J. H., II. (1994). Ethnic modeling in qualitative research. In N. K. Denzin and Y. S. Lincoln (Eds.), *Handbook of qualitative inquiry* (pp. 175–188). Newbury Park, CA: Sage.

Suárez-Orozco, C., and Suárez-Orozco, M. (1995). *Transformations: Migration, family, life, and achievement motivation among Latino adolescents.* Stanford, CA: Stanford University Press.

Tate, W. F. (1997). Critical race theory and education: History, theory, and implications. *Review of Research in Education, 22,* 195–247.

Tatum, B. (1999). *Why are all the Black kids sitting together in the cafeteria? And other conversations about race.* New York: Basic Books.

Taylor, P. S. (1934). *An American-Mexican frontier, Nueces County, Texas.* Chapel Hill: University of North Carolina Press.

Trinidad Galván, R. (2001). Portraits of mujeres desjuiciadas: Womanist pedagogies of the everyday, the mundane and the ordinary. *International Journal of Qualitative Studies in Education, 14*(5), 603–621.

Valdes, F. (1996). Foreword: Latina/o ethnicities, critical race theory and post-identity politics in postmodern legal culture: From practices to possibilities. *La Raza Law Journal, 9*, 1–31.

Valencia, R. R. (Ed.). (1991). *Chicano school failure and success: Research and policy agendas for the 1990's*. London: Falmer.

Villalpando, O. (1996). *The long term effects of college on Chicano and Chicana students: "Other oriented" values, service careers, and community involvement*. Unpublished doctoral dissertation, University of California, Los Angeles.

Villalpando, O. (in press). Self-segregation or self-preservation? A critical race theory and Latina/o critical theory analysis of a study of Chicana/o college students. *International Journal of Qualitative Studies in Education*.

Villenas, S., and Deyhle, D. (1999). Critical race theory and ethnographies challenging the stereotypes: Latino families, schooling, resilience and resistance. *Curriculum Inquiry, 29*, 413–445.

Villenas, S., and Moreno, M. (2001). To *valerse por si misma*: Between race, capitalism and patriarchy—Latina mother/daughter pedagogies in North Carolina. *International Journal of Qualitative Studies in Education, 14*(5), 671–687.

Williams, R. A. (1997). Vampires anonymous and critical race practice. *Michigan Law Review, 95*,

Turning the Closets Inside/Out

Towards a Queer-Feminist Theory in Women's Physical Education

Heather Sykes
University of British Columbia

The Cranial Cavity Contains the Brain.
Its Boundaries Are Formed by the Bones of the Skull.

Let me penetrate you. I am the archeologist of tombs. I would devote my life to marking your passageways, the entrances and exits of that impressive mausoleum, your body.

—Janette Winterson, *Written on the Body*

Only in my most fanciful dreams could I hope to emulate Janette Winterson's imagery; all the same, this paper is similarly concerned with bodies, boundaries, tombs, and writing. My concern is with female bodies in physical education—how genders and sexualities are written onto these bodies. Like her, I am concerned with boundaries—not the (im) penetrable boundaries of the bones of the skull, but the boundaries between lesbian/ heterosexual bodies, inside/outside of the closet, and the doubt/certainty of sexual identity. As for tombs and mausoleums, the professional body of physical education has long been haunted by the specter of the lesbian. And so this paper is an archeology of the closet that entombs physical education's lesbian specter and a theoretical exploration of the unstable boundaries that keep her there.

My starting point for the exploration are insights about lesbian sexuality that have previously been uncovered by feminist research in physical education and sport sociology. A primary focus of this research has been the techniques lesbian physical educators used to conceal and reveal their sexual identities in schools (Clarke, 1996; Griffin, 1991, 1992; Sparkes, 1994; Woods & Harbeck, 1992). Undoubtedly, this has started to document the experiences of lesbian teachers but, however nuanced and rigorous the intersections

with other identities/subjectivities (Dewar, 1993), this research maintains the "lesbian" as the marginalized Other to heterosexuality. Poststructural feminist and queer theories approach lesbian sexuality from a different epistemological perspective that allows different research questions to be asked. For example, Steven Seidman (1993) suggested that poststructuralists aim to destabilize identity as a grounds for politics in order to create alternatives and that this may involve a shift from the resisting gay subject to an analysis of the homo/hetero codes that structure Western thought:

> Repudiating views of identity as essence or its effect, poststructuralists propose that the identity of an object or person is always implicated in its opposite. "Heterosexuality" has meaning only in relation to "homosexuality"; the coherence of the former is built on the exclusion, repression, and repudiation of the latter. . . . If homosexuality and heterosexuality are a coupling in which each presupposes the other, each being present in the invocation of the other, and in which this coupling assumes hierarchical forms, then the epistemic and political project of identifying a gay subject reinforces and reproduces this hierarchical figure. (p. 130)

If one accepts this poststructuralist stance, it becomes clear that a continuing focus on lesbian experiences in physical education runs the long-term risk of reproducing the privileged status of heterosexuality and the marginal status of lesbianism. Heterocentrism is let off the theoretical hook, as it were. The purpose of this paper is to illustrate one way in which queer and feminist theories of sexuality can be combined to examine the relations between lesbian sexuality and heterosexualities or, as Michael Messner (1995) succinctly put it, to study up on sex.

I think a few brief notes about the emergence of queer theory might help set the scene for the analysis that follows. Queer theory arose in a context of sex debates between feminists, critiques of feminism, the rise of postmodern theory, and the right-wing backlash against homosexuality in the AIDS crisis that in turn led to radical politics and theorizing (Seidman, 1994; Walters, 1996). While much queer theory draws on the early poststructural/modern work of Foucault and Derrida of the 1970s (Namaste, 1994)[1] and has been heavily influenced by French poststructuralism and Lacanian psychoanalysis (Seidman, 1994), the term "queer theory" really began to gain currency in 1991. Queer theory no longer focuses only upon lesbian (and gay male) sexualities but brings into view the workings of heterosexuality by interrogating the hierarchical relations between homo/hetero, inside/outside, self/Other and normal/transgression. The privileged discursive position of heterosexuality—our ways of speaking, seeing, experiencing sexuality—presumes that heterosexuality is the most normal, natural form of sexuality. This heterocentrism is contingent upon taken-for-granted links between gender identity, biological sex, sexual acts, and so on. It could be said that heterosexuality occupies a center surrounded by marginal sexualities—homo, bi, trans, celibate—that are less privileged. But in order to maintain this opposition, a boundary between inside and outside is required, and it is the "production and management" (Namaste, 1994, p. 224) of this boundary that queer

theory interrogates. The inside/outside trope, explicated by Diana Fuss (1995), is proving to be fertile ground for current queer theorizing. As Ki Namaste (1994) explained, the relation between inside/outside—sometimes but not exclusively read as homo/hetero—leads to the realization that "we cannot assert ourselves to be completely outside heterosexuality, nor entirely inside, because each of these terms achieves its meaning in relation to the other. What we can do, queer theorists suggest, is negotiate these limits" (p. 224).

It would be misleading to suggest that all queer research pursues similar lines of inquiry. Historical research into heterosexual identities may represent a significant queering in some areas, identifying how heterosexuality has been normalized may form a queer project in another area, while deconstructing boundaries between sexualities may be appropriate elsewhere. For example, a queer-feminist line of inquiry might be how the gendered practices of sport have attached particular meanings to the categories "lesbian" and "heterosexual." Given the Eurocentric and heterocentric history of the physical education profession, research into the construction of while, heterosexual identities is an important queer project—especially because "queer" emerged partly in response to the exclusions of people of color by lesbian and gay theories and political movements of the 1980s (Seidman, 1994).

This work has been started by Susan Cahn (1994a, 1994b) who documented historical changes in lesbian and heterosexual femininities within the racialized context of U.S. women's sport.

Another queer-feminist approach might focus upon heterosexism's need for the continual marginalization of lesbian sexualities for its own existence and ways that heterosexual identities are performed to maintain their privileged position. The feminist work of Pat Griffin (1991, 1992) and Helen Lenskyj (1991) has started this process by describing the negative impacts of homophobic lesbian stereotypes on straight women in physical education.

Once a queer perspective is adopted, the project of reclaiming lesbian voices changes into an examination of how heterocentrism silences those voices. The 1990s life history research, spearheaded by Andrew Sparkes (Sparkes, 1994; Sparkes & Squires, 1996; Sparkes & Templin, 1992), started to reclaim the experiences of lesbian physical educators. A primary purpose of these lesbian life histories, according to Sparkes and Squires (1996), is "to reduce the invisibility of one particular group of teachers and fracture the silence that surrounds issues of sexual identity in the world of PE and sport" (p. 79). A queer approach to life history builds upon these feminist intentions by requiring women's experiences of heterosexuality to be considered in relation to lesbian sexuality and other marginalized aspects of identity. Accordingly, this paper uses data from the life histories of both lesbian and heterosexual physical educators to illustrate how "the lesbian closet" has been used to maintain normal versions of female heterosexuality. It also shows how a queer perspective allows the boundaries between the inside and outside of this closet to be viewed somewhat differently.

These varying perspectives may all be called "queer" but have different ties to materiality, feminism, and the academic disciplines in which they occur. They are not simply "queer" questions, nor feminist questions, nor poststructural questions—they owe

a considerable amount to lesbian and materialist feminism, just as they borrow from the work of some, but not all, queer theorists. Additionally, to the extent that they are poststructural questions, they need to be responsive to the critiques of feminists suspicious about their political aims and efficacy (Ebert, 1996; Hennessy, 1995; Landrey & McLean, 1993; Walters, 1996).

Methodology

The feminist-queer analysis of the lesbian closet included in this paper is part of a larger study into the life histories of six female teachers, ranging in age from 25 to 70, who have been involved with physical education in Western Canada over the past 40 years. The overall study examined how the teachers accepted or resisted various discourses concerning sexualities that were available to them at different historical periods. In this paper excerpts from the women's life histories are used to illustrate how they accepted and resisted discourses of the closet, while using queer theory to highlight how the closet is integral to heterosexuality's privileged status as the normal sexuality for women teaching physical education.

Personal contacts and recommendations were used to contact women of different ages who had taught or trained in physical education in the western provinces of Canada. Women were invited to participate however they described their sexualities and, while I knew the sexual identities of some women prior to the first interview, serendipity resulted in three women who identified as "lesbian" and three who described themselves as "married" or "heterosexual" taking part in the study. Two or three interviews were conducted with each individual, taking place in coffee shops and kitchens, sometimes by the ocean or after playing squash according to the wishes of each narrator. These semistructured, life history interviews covered a range of topics of the life history of each person, including: early memories of gender relations in the family and learning about sexuality in adolescence; reasons for entering physical education and experiences of discrimination in schools; and experiences and moral values regarding sexual and intimate relationships. Interviews were transcribed using pseudonyms, then returned to the women for verification, accuracy checks, and editing.

My approach to life history has much in common with the "socially theorized life history" used by R. W. Connell (1992) to study the construction of masculinity in gay men, an approach that extends beyond the unstructured narratives of individuals into a theoretical analysis of broader social structures. I used both feminist and queer theories about gender and sexuality in sport and physical education in the theoretical analysis, with some themes being influenced more by feminist theories and others more by deconstructive queer theory. My approach was also based upon poststructural assumptions about experience, subjectivity, and discourse rather than empiricist or standpoint epistemologies that have informed much lesbian (Lapovsky Kennedy, 1995; Lesbian Oral History Group, 1989; Sparkes, 1995; Sparkes & Squires, 1996; Sparkes & Templin, 1992) and educational (Casey, 1993; Goodson & Walker, 1988; Knowles, 1991; Middleton, 1993)

life history research. Traditionally, life history research has relied upon an individualistic humanism that valorized the "reality" of personal experience and the transparency of oral accounts, but some feminist and poststructuralist notions of language and subjectivity have begun to challenge such assumptions. Several poststructural theorists (Clough, 1993; Davis, 1990; Scott, 1991; Weedon, 1987) have developed different accounts of subjectivity and identity that are, of course, fundamental to all forms of oral research including life history. For instance, Chris Weedon (1987) sketched the poststructural relation between experience and language in the following way:

> As we acquire language, we learn to give voice—meaning—to our experience and to understand it according to particular ways of thinking, particular discourses, that pre-date our entry into language. (p. 33)

Thus the ways the women described their sexual identities were profoundly affected by the discourses about sexuality, not least "the lesbian closet," that were always already circulating within their families, schools, and communities, and the poststructural task was to attend to how each woman took up or resisted these discourses. Similarly, Joan Scott (1991) detailed how poststructuralism has altered the way historical research conceptualizes "experience" as evidence:

> From one bent on "naturalizing" experience through a belief in the unmediated relationship between words and things to . . . how have categories of representation and analysis—such as class, race, gender, relations of production, biology, identity, subjectivity, agency, experience, even culture—achieved their foundational status? (p. 796)

Indeed, one of the purposes of this paper is to explore how the figure of "the lesbian closet" has been essential to the foundational status of heterosexuality as the normal sexuality in the women's life histories within physical education.

Accepting that the interpretive process necessarily appropriates the experience, stories, and texts of people being researched, and that the researcher's authority can never be fully undermined are important methodological admissions. The textual appropriation of the Other is inevitable in qualitative research, argued Anne Opie (1992), and can be countered but never eliminated by making the strategic location of the researcher explicit. Also, as Michelle Fine (1994) stressed, the problem is not that researchers edit, interpret, and tailor data but that so few researchers reveal how they do this, which is my purpose in the discussion below.

I did not easily identify as an insider with the "lesbian" women and as an outsider with the "straight" women because, as Jayati Lal (1996) observed, for each boundary of insider status that the researcher crosses, another border zone seems to define oneself as an outsider. My status as an "insider" with each of the narrators depended largely on how much we knew about one another prior to the first interview. I made no explicit mention of race or ethnicity in the invitation to participate, but given the historical

hegemony of white teachers in physical education throughout Canada, I anticipated that the older teachers would probably be white. I was less certain if the younger teachers would be women of color, given the racial and ethnic diversity of Vancouver, especially. As it turned out, all the women in the study and myself were white, Anglo-Canadians, and our immediate recognition of one another as "white" created some superficial common ground early in the first interview based on assumptions about our shared ethnicity and language, assumptions that became more complicated as the women talked in more detail about their backgrounds. Our initial uncertainties about each other's age and class backgrounds decreased as the interviews progressed, but it was our sexual identities that were the most difficult aspects of the narrator-researcher relationship to negotiate. I came out as lesbian to some but not all the women and am still unaware how one woman perceived my sexuality. Equally, each woman revealed different aspects of her sexual identity to me, sometimes unsolicited and sometimes in response to my questions. And so the figure of the closet was ever-present in the interviews, being actively constructed through our silences, avoidances, stories, and confessions.

I used what Steinar Kvale (1995) termed "interpretation analysis." This method of analyzing interview data allows interpretation from a particular theoretical perspective, in my case a poststructural, queer framework, whereby the "interpreter goes beyond what is directly said to work out the structures and relations of meaning not immediately apparent in the text" (Kvale, 1995, p. 201). My decision to use "interpretive analysis" was borne from a conflict between the methodological literature about feminist/lesbian life history and theoretical literature of poststructuralism and queer theory. Much feminist and lesbian life history literature has cautioned that not writing the women's stories "as they were told" risked subjecting the women to textual erasure and silencing, but once the realism underpinning this demand is questioned as the ongoing crisis of representation has done for more than a decade, the task of interpreting life history data becomes more complex. To complicate matters further, from a poststructural perspective memories are never completely accurate, transparent repetitions of events; rather, each memory is a reconstruction, a retelling of the told that is fully imbued with shifts and slippages of meaning and intention (Mischler, 1995). Kvale captured the dilemma confronting all types of poststructural interviewing by asking whether the purpose of a text interpretation is to get at the *author's intended meaning* or the *meaning the text has for us today?* Although referring specifically to literary criticism, Umberto Eco (1992) laid out how the crisis of representation, particularly poststructural responses to the crisis, has changed the dilemmas facing the interpretation of texts:

> The classical debate aimed at finding in a text whether what its author intended to say, or *what the text said independently of the intention of the author.* Only after accepting the second horn of this dilemma can one ask if what is found is what the text says by virtue of its textual coherence and or an original underlying signification system, or *what the addressees found in it by virtue of their own systems of expectations.* (p. 64)

In my use of socially theorized life history, the issue concerns the extent to which the theoretical framework—Eco's systems of expectations—influenced the interpretations made. My analysis of the lesbian closet was heavily influenced by Judith Butler's (1990) theory of gender as imitation and Eve Sedgwick's (1990) deconstruction of the closet in various literary texts. As Kvale (1995) observed, different questions put to an interview text will produce different interpretations, and so the verbatim quotations I used could well have provided different interpretations if, say, liberal feminist or radical lesbian theories had been used as the framework for interpretation. Acknowledging this plurality of possible interpretations does not imply an endless range of interpretations, unless one adopts the radical stance of skeptical postmodernists (Rosenau, 1992) that I did not. A pragmatic stance I found helpful was forwarded by poststructural literary critic. Jonathan Culler (cited in Eco, 1992), who distinguished between *understanding*, that asks questions the text insists upon, and *overstanding*, that asks questions the text does not pose. As Culler explained, overstanding "asks not what the work has in mind but what it forgets, not what it says but what it takes for granted" (p. 115). My use of queer theory directed my analysis towards themes not immediately apparent in the interviews, for example, how heterosexuality was implicated in discourses of the closet.

While my analysis was informed directly by queer theory, I attempted to avoid the antifeminism of some queer theories and political nihilism of skeptical poststructuralism. Therefore, I adopted a pragmatic "feminist-queer" approach that had more than one purpose driving the interpretative analysis. I wanted to understand and overstand, to both listen to the stories women told me and hear the silences that surrounded our interviews. This meant considering the women's accounts in ways that they might have intended, but at other times using queer theory to deconstruct the most obvious meanings. Thomas Barone (1995) captured something of the complexity caused by these concurrent strategies of interpretation. The paradoxical task of the emancipatory storyteller, he suggested, is to "trust his or her readers, grant them interpretive space, even as he or she artfully persuades them to reflect critically upon and reconstruct the selves of particular characters" (p. 69). And so it was with me: I had several routes and layers to my interpretations that were by no means neatly separable. I attempted to incorporate the "active voices" of the women by using verbatim quotations surrounded by my own realist voice about the probable meaning intended by each woman that allows you, the reader, to create a "realist" reading if desired. I also wrote queer deconstructive interpretations with the explicit intention of disrupting the "realist" meanings of the women's quotations and creating fictions that turn inside/out some of the taken-for-granted meanings of the closet. Upon being subjected to a queer analysis, memories that once seemed undistinguished became remarkable for their ability to normalize heterosexuality.

Some of my interpretations aimed to disrupt and open up the immediate, heteronormative meanings of the interview texts and, to this limited extent, could be termed deconstructive. *Deconstruction* is a highly contested term that by its very nature defies definition, but some explanation of my use of the terms *deconstructive* and *deconstruction* is warranted. Derrida himself refused any fixed definition of deconstruction as method,

analysis, or critique and was quoted as saying that "all sentences of the type 'deconstruction is x' or 'deconstruction is not x' *a priori* miss the point, which is to say that they are at least false" (Collins & Mayblin, 1996, p. 93). In retrospect, however, Jack Sanger's (1995) metaphor broadly describes the way I approached deconstruction:

> Deconstruction (the act of using text to undermine its own rhetoric) allows the analyst to explore the text as a kind of water tank wherein conflicting ideologies are submerged under the surface calm of an attempted unitary resolution. (p. 91)

I attempted to undermine some of the most obvious meanings of the ways the women and I talked about the closet in our life history interviews, using a feminist-queer framework to suggest how heterosexuality relies upon silence and speech to maintain its privileged position. Finally, these interpretations are put forward as one of several possible interpretations, each of which could itself be undermined by successive deconstructive readings—which is where you, as the active reader, enter or refuse the fray.

The Gendered Closet in Women's Physical Education

Heather: Is she a lesbian do you know?

Linda: The one that all the kids used to call a dyke and everything? I don't know actually. To this day she's not married. I know that when I moved to Kerrimoor, she had played on the broomball team that I went to play with and played with a lot of the women, and they said they never knew. So it was . . . yeah, I don't know . . .

Heather: Still a secret?

Linda: Yeah, still a secret.

Secrets such as this, concealing the specter of the lesbian in the closet, have been a central feature of the social construction of sexuality in women's physical education. The longevity of "the closet" in physical education is inextricably connected to the way masculinities and femininities are etched into the material bodies of female physical educators. In the words of Elizabeth Grosz (1990):

> Masculinity and femininity are not simply social categories as it were externally or arbitrarily imposed on the subject's sex. Masculine and feminine are necessarily related to the structure and the lived experience and meaning of *bodies*. (p. 73)

Just as discourses of gender are etched into the body, the discourses of physical education are indelibly written on the bodies of women who teach it. Discourses of physical education, especially those derived from sport, more often than not valorize hegemonic masculinity while denigrating homo-masculinity and most femininities (Dewar, 1990; Messner & Sabo, 1990; Scraton, 1986; Whitson, 1994). In women's physical education and sport, perhaps like nowhere else, discourses of athletic masculinity have been etched into the female body, disrupting the normal links between female/femininity and male/masculinity. As a result, the heterosexuality of women who participate in sport and physical education has long been recognized as fragile due to the masculinizing effects of sport. This association between sport, masculinity, and fragile heterosexuality began in the 1920s and 1930s, as Cahn (1994b) documented:

> Mannishness, once a sign of gender crossing, assumed a specifically lesbian-sexual connotation; and the strong cultural association between sport and masculinity made women's athletics ripe for emerging lesbian stereotypes. (p. 335)

Additionally, sexes are often segregated in physical education through student grouping, activity selection, hiring practices, and administrative duties. This means that women teachers frequently find themselves in all-female contexts, be they physical education classes, sporting teams, or social or professional cohorts. Thus, women in physical education must negotiate not only discourses of masculinity written onto their bodies, but also the implications of frequently working in female-only contexts. The question then arises how these concerns about gender are translated into concerns about sexuality or, more specifically, how the gendered discourses of physical education have made the lesbian closet feature so prominently in women's physical education. Building on feminist theories about gender and sexuality, Eve Sedgwick (1990) analyzed the historical links between gender and homosexuality, while Judith Butler (1990) detailed the normative but false relation between gender and heterosexuality. Both of these arguably queer theories lead to a more detailed account of why the lesbian closet has entombed women in physical education for so long and so effectively.

Sedgwick (1990) pointed out that all ideas about homosexuality follow two main tropes of gender, namely, *inversion* and *sameness*. The trope of inversion works when homosexuality is associated with masculinity in women. In this case, heterosexual desire (male-female) continues to work but has been transferred, or inverted, via masculinity into the female body. In sport and physical education, this idea of homosexuality as inversion underpins the association of athletic masculinity in women with lesbian sexuality. It also supports such homophobic clichés as "she looks like a man," "he throws like a girl," "the sissy boy," and "the mannish lesbian."

Conversely, the trope of sameness works when homosexuality is viewed as sexual desire between the same gender—as in "woman-identified woman" notions of lesbianism. The trope of separatism invokes suspicion about lesbian desire whenever women work, socialize, or live together. Indeed, the erotic power of female-directed relations, Teresa

de Laureis (1994) argued, has been valorized in the "popular imagination of all-female sociosexual spaces, amazonic or matriarchal, ranging from girls' boarding schools to prisons and from alternative worlds to convents and brothels" (p. 265). Given the frequent segregation of women in the profession, it is quite feasible to add women's physical education to this list of female-directed spaces. The recognition that women's physical education, where masculinity is frequently negotiated in female-only spaces, is subject to both these tropes of homosexuality, goes part way to explaining why the women's profession has been especially associated with lesbian sexuality.[2]

Butler's (1990) work can also explain why the link between femininity and female heterosexuality has been taken for granted for so long. She contended that, even though all genders are imitations, feminine heterosexuality presents itself as the "real" thing. She illustrated her argument using the example of male drag, suggesting that "drag constitutes the mundane way in which genders are appropriated, theatricalized, worn, and done; it implies that all gendering is a kind of impersonation" (p. 185). Her theory of gender as imitation turns on the notion that there is no primary gender that drag imitates.[3] In other words, drag is not an imitation of "real" femininity by males; rather, "all gender is a kind of imitation for which there is no original" (p. 185). She goes on to suggest that the very idea of a real, proper gender is actually an "effect" of the imitation—what has been naturalized as correct gender for particular sexes is no more than a "phantasmic ideal of heterosexual identity" (p. 185). Applying this logic to women in physical education, it follows that athletic women are not trying to emulate a form of masculinity that is "naturally" male, nor are lesbians trying to imitate a masculine form of sexuality by copying "natural" heterosexuality; rather, the masculine, feminine, and hyperfeminine genders of women in physical education are all imitations. The important difference is that feminine heterosexuality presents itself as more than that—presents itself as the real, the natural, the genuine article. Butler goes on to argue that if feminine heterosexuality is only an imitation but sets itself up as the original, it is bound to fail and "precisely because it is bound to fail, and yet endeavors to succeed, the project of heterosexual identity is propelled into an endless repetition of itself" (p. 185).

This queer insight means that the construction of normative heterosexuality is crucial to any understanding of lesbian desire, lesbian stereotypes, and the secrets of the lesbian closet. Research into lesbian lives, the isolation of the closet, and the violence of homophobias[4] requires analyses of the relations, boundaries, and overlaps between hetero- and lesbian sexualities. Based on Butler's work, one might ask how the constant repetition of normative heterosexuality is linked to the marginalization of lesbian sexualities? This paper concentrates on the lesbian closet, but similar inquiries could be directed at the material, economic, or psychoanalytic relations of lesbian identities to heterosexualities. The final section of the paper suggests ways in which the lesbian closet is actually fundamental to heterosexuality even while it threatens heterosexuality's privileged status at every turn.

Inside and Outside the Closet

Keeping lesbian sexuality safely contained within the closet is vitally important to normative heterosexuality. One of the main purposes of the closet is to discursively uphold the

boundary between either/or, homo/hetero, and self/Other. Indeed, this boundary has been and continues to be very effective. Lesbian sexuality is still hidden inside the closet in many physical education contexts, thereby maintaining the obvious, visible, and natural status of heterosexuality. The following narrative illustrates how normative heterosexuality presented itself as the only option for a group of outdoor education students:

Heather: Are they [the students] all in straight relationships?

Jenny: As far as I know. You know, in the 7 years of teaching that program, I still have no sense of any of those kids being gay. I can't think of any. There was one guy I thought for sure was, and I don't think he is. Last I heard he had a girlfriend—which doesn't mean he's not gay, as we all know. I can't think of any. . . . Yes, to my knowledge there aren't gay and lesbian relationships happening in the kids that I'm aware of anywise. But *lots* of *straight* ones!

Another teacher recollected it wasn't until her thirties she found out that several close friends were lesbian and gay.

Heather: Can you remember when you first met someone who you thought was gay or lesbian, when you first read about it, when you first heard about it?

Connie: Probably not till university and probably not till . . . I don't know, until the last 8 to 10 years. So not that long ago. But I have many close friends now and had then but didn't know and who told me after that. So I've had that sort of experience a couple of times.

The difficulty Jenny and Connie faced in finding out whether students or friends were lesbian testifies to the efficiency of the closet, of passing, of the heterosexual masquerade—both were confronted with convincing heterosexual performances. Such is the power of normative heterosexuality, especially in adolescence, to construct an impenetrable closet, and in turn, present itself as the "one-and-only" sexuality.

Inside = Silences

Silence has been the most obvious and enduring feature of the closet, often a permanent feature in a discursive world where there simply were no words to name the closet and its secrets. For instance, Denise reminisced about the silence surrounding lesbian sexuality in her youth, recalling that "gay wasn't even a term" in the 1950s:

Denise: There was no discussion at school on sexuality. There was no TV to give you any indication that there was anybody else in the world that was gay. I mean there wasn't . . . *gay* wasn't even a term.

This silence meant that the subject position of "gay" or "lesbian" was not available as such to Denise. The only subject position available was a default, unnamed otherness—a

sense that no one else in the world was like herself. On other occasions, some women recalled the length of time their friendships thrived despite silences echoing around the closet. Reaching back into her days playing basketball in the early 1970s, Denise recalled how this silence persisted during a long-standing friendship:

> Denise: I mean, I didn't know if she was gay. She was in a very long-term relationship in the States, like a 25-year relationship, and we had never talked about it until just a couple of years ago. We were chatting, and she had just broken up . . .

Similarly, Linda remembered a silence that lasted throughout a close friendship at her rural high school during the late 1980s:

> Linda: I wouldn't have talked to my best friend, even though it turns out 4 years later that she's gay, too! [laughs] Probably could never have told each other as we were growing up.

These are emotive testimonies about silences that deeply colored the life histories of these lesbian teachers—memories filled with pathos and resignation. Such memories illustrated how enduring, and therefore effective, the silent closet has been for these women since the post-World War Two social repressions of the 1950s, through the sexual revolutions of the 1960s and 1970s and well into the 1980s-era of lesbian and gay rights.

Outside = Straight Talk

But silence is never just silence. Silences communicate meaning—consider metaphors such as "a pregnant silence hung in the air" or "an awkward silence filled the room." Silences can almost be regarded as speech acts that become remarkable only in relation to what else has been said:

> Silence itself—the things one declines to say, or is forbidden to name, the discretion that is required between different speakers—is less the absolute limit of discourse, the other side from which it is separated by a strict boundary, than an element that functions alongside the things said, with them and in relation to them within over-all strategies. (Foucault, 1978, p. 27)

As Sedgwick (1990) artfully stated, the silences of the closet only have meaning when the discursive situation in which they are produced is considered:

> "Closetedness" itself is a performance initiated as such by the speech act of a silence—not a particular silence, but a silence that accrues particularity by fits and starts, in relation to the discourse that surrounds and differentially constitutes it. (p. 3)

Broadly speaking, then, the lack of explicit discussion about lesbian sexuality only becomes remarkable because of the constant, explicit discussion and representation of heterosexuality. Avoidance, implication, and everyday ways of talking were examples of heteronormative speech acts that occurred during my interviews with the six women. The following exchange between Marion and myself illustrated how we avoided a discussion about lesbian stereotyping by reverting to talk about femininity:

Heather: [Have you come across] some of the stereotypes of teachers with short hair that are big and muscular—

Marion: I know.

Heather: —that play sports. I mean, "Well, she's not a real woman."

Marion: I know.

Heather: "She would never marry," and all that sort of thing.

Marion: Yes, yes.

Heather: I mean, have you come across that sort of thing?

Marion: Yes . . . *oh* . . . and I've found myself . . . like when I was planning my year, I always bought my little track outfits. I always had to have new Nikes or whatever, and I always would think about what do I want to wear for the parent-teacher meetings, too. Because I wanted to look nice and not look so, you know, I didn't wear my track outfits to the parent-teacher thing. So I would think about wearing something kind of tailored yet feminine and everything.

In this excerpt, I asked a series of deliberately leading questions to encourage Marion to talk about if, or how, she encountered any lesbian stereotyping of women in physical education. Our exchange moved towards a discussion of a lesbian stereotype but never quite arrived. The mannish lesbian can be glimpsed beneath the text, but my indirect questions and Marion's talk about femininity avoided any direct discussion. By talking in terms of "short hair," "big and muscular," "would never marry," I talked about the lesbian as if she were a ghost, present but not visible, present but not speakable, present despite my silence. Marion's response focused on her feminine appearance, implying also her heterosexuality, discreetly but effectively silencing the lesbian specter that inhabited our subtext. This particular example also demonstrated the inseparability of femininity and heterosexuality within physical education discourse—what Sedgwick (1990) called the "indissoluble knot" of masculinity/femininity and homo/heterosexuality.

Connie's recollection about learning sex as she grew up in rural Ontario during the 1960s provided another example of how each retelling of a memory can function to naturalize heterosexuality. This excerpt from our interview illustrates how a simple speech act helps to maintain a coherent heterosexual story line:

Heather: Are there any memories that come about sex as a kid?

Connie: I can remember thinking that babies came out of the stomach. I'm sure that's what I thought for a long time. I remember learning it at school. I remember my first period.

Heather: Were you able to talk to your Mum about it?

Connie: Well, yeah. I mean my bed was just covered with . . . I felt that I was swimming.

Heather: Did you know what was happening?

Connie: Yeah, I guess I did. Oh parties . . . and pajama parties and kissing your girlfriends. . . . We'd turn the light out and kiss. [laughing]

Connie used the singular pronoun in her recollections about birth and periods but shifted to the plural pronoun when she talked about kissing girlfriends. Comments such as "*I* can remember thinking that babies came out of the stomach" and "*I* remember my first period" changed to "*your* girlfriends" and "*we'd* turn the light out." Shifting from "I" to "we" positioned[5] herself alongside others, and thereby implicated others in this apparently same-sex experience, depicting her memory as a common part of learning heterosexuality shared by many young Canadian women. Thus, a subtle grammatical change naturalized a memory, haunted by the lesbian specter, as a heterosexual rite of passage—an unremarkable speech act closed the closet door once again.

It is important to note that neither speech acts or the silences they evoke have any permanence; indeed, a never-ending task faces heteronormative discourse to continually repeat or perform its silencing functions. Maintaining a heterosexual story line relies on continual repetition to the extent that it may appear that a person simply "talks like that." As Bronwyn Davis and Rom Harré (1990) explained:

Participants may not be aware of their assumptions nor the power of the images to invoke particular ways of being and may simply regard their words as "the way one talks" on this sort of occasion. (p. 49)

Mundane ways of talking play an important role in normalizing heterosexuality. Heterosexual subject positions can be claimed and repeated on numerous opportunities in everyday and professional conversation. These repetitive performances, if unchallenged and uncomplicated as they frequently are, grant security and certainty to heterosexual

story lines. This in turn allows a heterosexual subjectivity to be firmly and deeply anchored so that a heterosexual sense of the self can be readily experienced as coherent, life-long, and "natural." Lesbian subject positions can, of course, be claimed within physical education, but doing so has impact—"my girlfriend and I . . . ," "yes, I prefer women . . . ," "from my lesbian perspective . . ." Such speech acts are extraordinary, remarkable, and usually remembered, whereas heteronormative speech acts thrive in being unremarkable, mundane, and so very ordinary. Thus the lesbian closet is maintained through an amalgam of long-lasting silences about lesbian sexualities and our everyday ways of talking about, usually feminine, heterosexualities. But what happens when these apparent differences between silence/speech, inside/outside, lesbian/heterosexual are not taken-for-granted, as some poststructural and queer theories refuse to do?

Turning the Closets Inside/Out

We might start by considering Derrida's notion of *differànce,* where difference can be constructed but never fully present or fixed, instead of working with the more familiar, binary concept of difference (Collins & Mayblin, 1996; Derrida, 1982; Sampson, 1989). In Derridan terms, female heterosexuality requires a lesbian Other, because it only acquires significance in the play of differànce between the two. Marion provided quite a literal example of this play of differànce when she recounted a conversation that took place while she was at graduate school in the early 1970s:

> Marion: One of the graduate students said to me one time, because she knew I was married and everything, and she said, "I want to be married and have a family." She said, "I don't want to live the way some of these others live." And she meant the single. . . . But I was. . . . It was just her feelings about the whole thing. If you want to get married and have a family, that's good, too.

Not only did this story illustrate the language Marion used at that time to refer to "heterosexuality" and "lesbian," but also how her identity as "married" and "having a family" existed only in the play of differànce. The terms *marriage* and *having a family* referred to Marion and the graduate student, while the terms *the whole thing, single,* and *others* euphemistically referred to a way of life that was somehow different. The story demonstrated how the meaning of each term relied upon its difference from the others, but the precise meaning of *single, these others,* or *this whole thing* was left slightly open—that is, any absolute meaning was necessarily deferred.

This notion of differànce occurs in any talk about heterosexuality, even when the lesbian Other is not mentioned directly. As Sampson (1989) explained, the category *lesbian* always already exists within the category *heterosexual* as the absent trace, the absent presence that is required and yet not visible. It is what Fuss (1995) called the interiority of the exterior that the closet hides from view. Fuss went on to argue that

"the greater the lack on the inside, the greater the need for an outside to contain and to defuse it, for without that outside, the lack on the inside would become all too visible" (p. 235). In the case of the lesbian closet, this lack can be read as a lack of certainty underlying the naturalized status of heterosexuality. If we return to Butler's (1990) theory that normative heterosexuality sets itself apart by claiming the certainty of its "natural origin," the closet persistently threatens to reveal this *lack* of certainty. Thus, normative heterosexuality is compelled to defend against the recognition that its ontological status, its claim to naturalness, is less than certain. If one accepts Derrida's notion of differance, one begins to see that *doubt* of the closet and *certainty* of normative heterosexuality can never fully be contained on either side of a watertight boundary. So often, doubt and suspicion leak outside the closet and so, rather than being a hermetically sealed confine for lesbian sexualities, the closet is in fact highly contagious, capable of transmitting doubt, suspicion, and secrecy (Sedgwick. 1990).

Heterosexual Closets

Closets of (an) Other

One of the outcomes of this permeable boundary is that heterosexuals may find themselves inside the closet of someone else, coping with the secrets of someone else's clandestine sexuality. As we no doubt know, secrets are paradoxically thrilling burdens—so often the thrill of being entrusted with a secret is quickly tempered by the burden of keeping that secret. Again, Sedgwick (1990) articulated this feature of the closet so eloquently. She observed that coming out to others charges them with secret knowledge that, in turn, draws them into the closet that has just been vacated. For instance, Denise explained how her mother prefers to "keep up the pretense" of not knowing Denise is gay, because it means she doesn't have to explain to anyone why her daughter is still not married. If Denise came out of the closet to her mother, she would have been burdened by "having to explain" to relatives and friends, explanations riddled with decisions about what to say, what not to say, which secrets to maintain and which to expose. Similarly, Denise was not out to a straight colleague at work with whom she discussed the trials and tribulations of their emotional lives, because coming out to this straight colleague would have placed the burden of secrecy, decision, and discretion onto her friend. So, the closet is not the exclusive property of lesbians: its burdens of secrecy can be displaced onto others. This means that heterosexuals may find themselves in the closet of another and suddenly the inside/outside boundary becomes less watertight than one might have imagined.

Closets of Association

Another destabilizing aspect of the closet is its potential to generate doubt and suspicion about all sexual identities, irrespective of their normative or marginal status. Not only

does heteronormative speech construct the silent closet; it also allays suspicions about the "natural" status of heterosexuality. Thus, to be silent about heterosexuality breeds suspicion. For instance, not to stress one's femininity, discuss one's boyfriend or husband—to articulate one of the many heterosexual scripts—is to create silence about heterosexuality. This in turn can position an individual perilously close to the suspicion of being inside the closet. Thus, heterosexuality is compelled to repeat itself on two counts: to construct the silence of the closet and to allay suspicion that it inhabits the closet. This means that unconvincing performances of heterosexuality can breed suspicion that the lesbian specter is at large, as Bethany recalled quite clearly:

> Bethany: I know during university my roommate and I were very close, and she's very attractive and very much into dating men, but still people labeled us with "we were too close, we spent too much time together, we read each others thoughts a little too closely." So I've had some friendships with women that have been questioned, and I always think it's interesting when I hear that, because what do people base it on? What do people think? I don't know, but I have never ever cared. It doesn't upset me.

Part of the suspicion directed towards Bethany stemmed from the trope of homosexuality as gender sameness. Single sex contexts, such as female roommates, ostensibly designed to regulate (hetero)sexuality can work through a reverse discourse to intensify (homo)sexuality. Likewise, segregated changing areas, saunas, and steam baths are designed as de-sexualized spaces within heteronormative logic; yet, these very same spaces may be saturated with lesbian desire. Thus, a heterocentric view of sexuality is perhaps nowhere more powerful than in the "internal discourse" (Foucault, 1978. p. 28) of physical education and sport where separation of the sexes is blindly assumed to dissipate, if not entirely remove, any eroticism. At the same time, the haunting specter of lesbian sexuality, which is the absent trace in these heterocentric assumptions, continually poses a threat to the certain and natural status of normative heterosexuality. Thus, any woman in physical education may be suspected of being lesbian if her performance of heterosexuality is not sufficiently convincing.

Paranoid Closets

Resolving doubts about the sexuality of others may seem to be no more than personal curiosity. Or wanting to know who is and is not lesbian could simply be a matter of sorting out the differences between hetero/homo. Often the "suspicion" that someone is lesbian is confirmed by the "fact" that they are physical educators. Arguably, the lesbian PE teacher has become an icon within some North American lesbian communities, as those familiar with Meg Christian's (1982) lesbian anthem, "Ode to a Gym Teacher," will testify. In the excerpt below, Linda and I recognized the irony of repeating this familiar lesbian script:

Linda: Well, a lot of the women that I play sports with, there's a lot of phys ed teachers. So, no, I haven't really. . . . "Oh, you're a phys ed teacher, you're one of *them* are you? A phys ed teacher—I should have guessed."

Heather: And a wry smile or a knowing look!

Linda: Yeah, that's right! When I say that I'm a teacher, they say, "Phys ed teacher?" And I say, "Yeah! That's right." [both laugh]

This excerpt illustrates a common assumption that lesbians can detect other lesbians more accurately than anyone else, and Sedgwick (1990) pointed out how this assumption involves a degree of paranoid homosexual[6] knowledge that pulls heterosexuality ever closer to the closet. She outlined how a form of "homosexual-homophobic knowing" (p. 97) underlies the cliché, "it takes one to know one," and so doubt about someone else's sexuality may elicit doubt about one's own (hetero)sexuality. This paranoid doubt may be intensified after having one's suspicions confirmed, that is, when someone comes out. So it is when female athletes, coaches, and PE teachers come out: The heterosexuality of other women is cast into doubt. Indeed, this is one of the epistemological features of the closet artfully described by Sedgwick (1990), whereby "the double-edged potential for injury in the scene of gay coming out . . . results partly from the fact that the erotic identity of the person who receives the disclosure is apt to be implicated in, hence perturbed by it" (p. 81). Moreover, there may be a mourning for the loss of the previous relationship, the loss of innocence, and the loss of certainty, as Linda recalled when she came out:

Linda: Oh, no, I had my friends from sport. They were my main support group, but I did have a nucleus of girlfriends who I went to school with who were very supportive. A couple of them backed off after a while, but then they came back after they realized that I'm still the same person.

The realization that Linda was "still the same person" may not have been the only realization at work in this process of recovery. The loss of certainty about the Other (Linda's sexuality) is accompanied by a paranoid uncertainty about the Self (their own heterosexuality), as the haunting refrain, "it takes one to know one," lingered in the background. Linda's coming out no doubt unsettled her friends' sense of their own heterosexuality, and it is quite feasible that their return was dependent upon the realization that "they are still the same" as much as "she is still the same." Thus, the paranoid doubt that accompanies the suspicion of others is yet another threat against which normative heterosexuality is compelled to defend itself, another element in the orchestra of challenges posed by homosexuality to the stability and certainty of heterosexuality. The excerpts above outline three ways in which the boundary between certainty/doubt and hetero/homo are less than watertight. Heterosexuals might find themselves in the closet of someone else, may be suspected of being closeted, and may even suspect their own heterosexuality.

In Conclusion

Constructing the silent closet, foreclosing the very possibility of lesbian subjectivity within discourse, stabilizes the rickety boundary between self-assured heteronormativity and obscured lesbian sexuality. Heteronormative speech also allays suspicion by repeatedly staging convincing performances of normal heterosexuality. The very normalcy and commonsense nature of heteronormative discourse strengthens the boundary, by precluding doubts and discourses of the Other. Furthermore, Sedgwick (1990) argued that because discourses about homosexuality are confined to the always, already tropes of inversion and sameness, it is unlikely that any resolution can occur given that "the same yoking of contradictions has presided over all the thought on the subject" (p. 90). Thus, heteronormative discourses repeatedly deploy the logics of misplaced masculinity and misdirected femininity to describe and defend against lesbian desire. These tropes construct homosexuality through mundane and everyday ways of talking, of remembering, of silencing, of telling stories. Queer theory allows us to read these mundane, everyday ways of talking as heteronormative scripts enlisted to uphold normalcy.

The last section of this paper presented a queer re-reading of moments taken from life history interviews I conducted with female physical educators in the course of a larger work-in-progress. The purpose of my queer reading has been to explore how heterosexual normativity simultaneously depends upon and is challenged by the figure of the closet within a small area of women's physical education. I have tried to illustrate how our silences and everyday talk about heterosexuality sustained "the closet," keeping lesbian sexuality inside and heterosexuality outside. Using a deconstructive queer analysis, I offered interpretations that start to turn this closet inside/out or at least begin to undermine the certainty of the boundaries between inside/outside, doubt/certainty, and homo/hetero. My purpose has been to penetrate the oppresive mausoleum of physical education's body politic by speculating how the lesbian closet both sustains and threatens the false certainties of heteronormativity.

Notes

Sykes, Heather, "Turning the Closets Inside/Out: Towards a Queer-Feminist Theory in Women's Physical Education," *Sociology of Sport Journal*, 15 (1998): 154–173. Reprinted with permission.

1. Ki Namaste (1994) insightfully assessed the contributions made to queer theory by Michel Foucault's analysis of the discursive production of the category homosexual and Jacques Derrida's concept of supplementarity.

2. The tropes of inversion and sameness, and therefore notions of homosexuality, work quite differently for gay men in sport because of the discourses of masculinity upon which many sporting practices are contingent.

3. Drawn from Derrida's argument that the mime does not copy some prior original, but rather the phantasm of the original.

4. From a psychoanalytic view, Elizabeth Young-Bruehl (1996) proposed that instead of one form of homophobia, there are obsessional, hysterical, and narcissistic homophobias that variously intersect with specific racisms and sexisms.

5. Here I am drawing on sociolinguistic analyses informed by positioning theory of Rom Harré (van Langenhove & Harré, 1993, 1994) and Bronwyn Davis (Davis, 1990: Davis & Harré, 1990), and as employed by Deborah Schiffrin (1996).

6. It is important to point out that Sedgwick's (1990) depiction of homosexual (gothic) paranoia was specifically concerned with male homosexual identity in turn of the century literature.

References

Barone, T. (1995). Persuasive writings, vigilant readings, and reconstructed characters: The paradox of trust in educational storysharing. *Qualitative Studies in Education*, 8, 63–74.

Butler, J. (1990). *Gender trouble: Feminism and the subversion of identity*. New York: Routledge.

Cahn, S. (1994a). *Coming on strong: Gender and sexuality in twentieth-century women's sport*. New York: The Free Press.

Cahn, S. (1994b). Crushes, competition, and closets: The emergence of homophobia in women's physical education. In S. Birrell and C. Cole (Eds.), *Women, sport, and culture* (pp. 327–340). Champaign, IL: Human Kinetics.

Casey, K. (1993). *I answer with my life: Life histories of women teachers working for social change*. New York: Routledge.

Christian, M. (1982). Ode to a gym teacher. Thumbelina Music. BMI.

Clarke, G. (1996). Conforming and contesting with (a) difference: How lesbian teachers manage their identities. *International Studies in Sociology of Education*, 6, 191–209.

Clough, P. (1993). On the brink of deconstructing sociology: Critical reading of Dorothy Smith's standpoint epistemology. *The Sociological Quarterly*, 34, 169–182.

Collins, J., and Mayblin, B. (1996). *Derrida for beginners*. Cambridge, UK: Icon.

Connell, R. W. (1992). A very straight gay: Masculinity, homosexual experience, and the dynamics of gender. *American Sociological Review*. 57, 735–751.

Davis, B. (1990). The problem of desire. *Social Problems*, 37, 501–516.

Davis, B., and Harré, R. (1990). Positioning: The discursive production of selves. *Journal for the Theory of Social Behavior*, 20, 43–64.

de Lauretis, T. (1994). *The practice of love: Lesbian sexuality and perverse desire*. Bloomington, IN: Indiana University Press.

Derrida, J. (1982). *Margins of philosophy* (A. Bass, Trans.). Chicago, IL: University of Chicago Press.

Dewar, A. (1990). Oppression and privilege in physical education: Struggles in the negotiation of gender in a university programme. In R. Tinning (Ed.), *Physical education, curriculum and culture: Critical issues in the contemporary crisis* (pp. 67–100). Philadelphia: Falmer.

Dewar, A. (1993). Would all the generic women in sport please stand up? Challenges facing feminist sport sociology. *Quest*, 45, 211–229.

Ebert, T. (1996). The matter of materialism. In D. Norton (Ed.), *The material queer: A LesBiGay cultural studies reader* (pp. 352–361). Boulder, CO: Westview Press.

Eco, U. (1992). *Interpretation and overinterpretation*. Cambridge, UK: Cambridge University Press.

Fine. M. (1994). Working the hyphens: Reinventing the self and other in qualitative research. In N. Denzin and Y. Lincoln (Eds.), *Handbook of qualitative research* (pp. 70–82). Thousand Oakes, CA: Sage.

Foucault, M. (1978). *The history of sexuality, Volume I: An introduction*. (R. Hurley, Trans.). New York: Vintage.

Fuss, D. (1995). Inside/out. In C. Caruth and D. Esch (Eds.), *Close encounters: Reference and responsibility in deconstructive writing* (pp. 233–240). New Brunswick, NJ: Rutgers University Press.

Goodson, I., and Walker, R. (1988). Putting life into educational research. In R. Sherman and R. Webb (Eds.), *Qualitative methods in education: Focus and methods* (pp. 110–122). Philadelphia: Falmer.

Griffin, P. (1991). Identity management strategies among lesbian and gay educators. *International Journal of Qualitative Studies in Education.* 4, 189–202.

Griffin, P. (1992). Changing the game: Homophobia, sexism, and lesbians in sport. *Quest.* 44, 251–265.

Grosz, E. (1990). Inscriptions and body-maps: Representations and the corporeal. In T. Threadgold and A. Carry-Francis (Eds.), *Feminine/masculine representation* (pp. 62–74) Sydney, Australia: Allen & Unwin.

Hennessy. R. (1995). Queer visibility in commodity culture. *Cultural Critique,* 29, 31–76.

Knowles, G. (1991). March 20–22). *Life history accounts as mirrors: A practical avenue for the conceptualization of reflection in teacher education.* Paper presented at the Conference on Conceptualizing Reflection in Teacher Development. Bath, UK: University of Bath.

Kvale, S. (1995). *InterViews: An introduction to qualitative research interviewing.* Thousand Oakes, CA: Sage.

Lal, J. (1996). Situating locations: The politics of self, identity, and "other" in living and writing the text. In C. Deere (Ed.). *Feminist dilemmas in fieldwork* (pp. 185–211). Boulder. CO: Westview Press.

Landrey, D., and MacLean. G. (1993). *Materialist feminisms.* London: Blackwell.

Lapovsky Kennedy, E. (1995). Telling tales: Oral history and the construction of pre-Stonewall lesbian history. *Radical History Review,* 62, 58–79.

Lenskyj, H. (1991). Combating homophobia in sport and physical education. *Sociology of Sport Journal,* 8, 61–69.

Lesbian Oral History Group. (1989). *Inventing ourselves: Lesbian life stories.* London: Routledge.

Messner, M. (1995). *Studying up on sex.* Keynote speech at North American Society for the Sociology of Sport, Sacramento, CA.

Messner, M., and Sabo, D. (1990). *Sport, men and the gender order: Critical feminist perspectives.* Champaign. IL: Human Kinetics.

Middleton, S. (1993). *Educating feminists: Life histories and pedagogy.* New York: Teachers College Press.

Mischler, E. (1995). Models of narrative analysis: A typology. *Journal of Narrative and Life History,* 5(2), 87–123.

Namaste, K. (1994). The politics of inside/out: Queer theory, poststructuralism, and a sociological approach to sexuality. *Sociological Theory,* 12, 220–231.

Opie, A. (1992). Qualitative research, appropriation of the "other" and empowerment. *Feminist Review,* 40, 52–69.

Rosenau, P. M. (1992). *Postmodernism and the social sciences: Insights, inroads and intrusions.* Princeton, NJ: Princeton University Press.

Sampson, E. (1989). The deconstruction of the self. In J. Shotter and K. Gergen (Eds.), *Texts of identity* (pp. 1–19). Newbury Park, CA: Sage.

Sanger, J. (1995). Five easy pieces: The deconstruction of illuminatory data in research writing. *British Educational Research Journal,* 21, 89–98.

Schiffrin, D. (1996). Narrative as self-portrait: Sociolinguistic constructions of identity. *Language in Society*, 25, 167–203.

Scott, J. (1991). The evidence of experience. *Critical Inquiry*, 17, 773–797.

Scraton, S. (1986). Images of femininity and the teaching of girls' physical education. In J. Evans (Ed.), *Physical education, sport and schooling: Studies in the sociology of physical education* (pp. 71–94). Philadelphia: Falmer.

Sedgwick, E. (1990). *Epistemology of the closet*. Berkeley, CA: University of California Press.

Seidman, S. (1993). Identity and politics in a "postmodern" gay culture: Some historical and conceptual notes. In M. Warner (Ed.), *Fear of a queer planet: Queer politics and social theory* (pp. 105–142). Minneapolis, MN: University of Minnesota Press.

Seidman, S. (1994). Symposium: Queer theory/sociology: A dialogue. *Sociological Theory*, 12, 166–176.

Sparkes, A. (1994). Self, silence and invisibility as a beginning teacher: A life history of lesbian experience. *British Journal of Sociology of Education*, 15, 93–118.

Sparkes, A. (1995). Writing people: Reflections on the dual crisis of representation and legitimation in qualitative inquiry. *Quest*, 47, 158–195.

Sparkes, A., and Squires, S. (1996). Circles of silence: Sexual identity in physical education and sport. *Sport, Education and Society*, 1, 77–101.

Sparkes, A., and Templin, T. (1992). Life histories and physical education. In A. Sparkes (Ed.), *Research in physical education and sport: Exploring alternative visions* (pp. 118–145). Philadelphia: Falmer.

van Langenhove, L., and Harré, R. (1993). Positioning and autobiography: Telling your life. In N. Coupland and J. Nussbaum (Eds.), *Discourse and lifespan identity: Language and language behaviors, Vol. 4* (pp. 81–99). Newbury Park, CA: Sage.

van Langenhove. L., and Harré, R. (1994). Cultural stereotypes and positioning theory. *Journal for the Theory of Social Behavior*, 24, 359–372.

Walters, S. (1996). From here to queer: Radical feminism, postmodernism, and the lesbian menace (Or, why can't a woman be more like a fag?). *Signs*, 21, 830–869.

Weedon, C. (1987). *Feminist practice and poststructuralism*. New York: Basil Blackwell.

Whitson, D. (1994). The embodiment of gender: Discipline, domination, and empowerment. In S. Birrell & C. Cole (Eds.), *Women, sport, and culture* (pp. 353–373). Champaign, IL: Human Kinetics.

Winterson, J. (1993). *Written on the body*. Toronto, ON: Vintage.

Woods, S., and Harbeck, K. (1992). Living in two worlds: The identity management strategics used by lesbian physical educators. In K. Harbeck (Ed.), *Coming out of the classroom closet: Gay and lesbian students, teachers, and curricula* (pp. 141–166). New York: Harrington Park Press.

Young-Bruehl, E. (1996). *The anatomy of prejudices*. Cambridge, MA: Harvard University Press.

Queer Politics in Schools

A Rancièrean Reading[1]

Claudia Ruitenberg
University of British Columbia

Introduction

In 1996, the Salt Lake City School Board (Utah, USA) was so desperate to keep a Gay-Straight Alliance from being formed as an official school club that they "voted 4-3 to keep all noncurricular clubs from the district" rather than allow one Gay-Straight Alliance among the other sports and social clubs (Lee, 2002, p. 15). It wasn't until 2000 that the school board, under legal and community pressure, reversed its decision and allowed noncurricular clubs, including Gay-Straight Alliances, in the district again.

In 1997 a public school board in Surrey, British Columbia (Canada) decided that children's books featuring queer families did not belong in its classrooms. Teacher James Chamberlain, who had asked the school board for permission to use these books in his kindergarten and grade one class, took the school board to task for perpetuating the curricular invisibility of gay and lesbian parents. In 2002 the Supreme Court of Canada ruled that the school board had to reconsider its decision based on secular criteria. The Board again rejected the original three books but selected two other books in which queer families were represented.

In 2002 graduating high school student Marc Hall took the Durham Catholic School Board (Ontario, Canada) to court after he had been told he could not appear at the prom with his boyfriend. Hall won and made use of his legal right to attend his high school prom and be seen dancing with his boyfriend there.

These are merely a few examples of instances in which the representation and visibility of queer students, teachers, and parents in schools have been a central objective of queer politics in education. Can queer families be represented in curriculum materials and discussed in classrooms? Can queer relationships be seen at school? Can queer teachers be 'out' to their colleagues and students? Can the word 'queer' be used in school? In short: can queerness be shown and seen, spoken and heard in educational spaces and discourses?

Visibility and sayability *matter*: the more examples of living, working, loving queer youth and adults they see, the more queer students will know that they are not alone and not impossible, and the more spaces they can imagine for their lives. Cris Mayo (2006, p. 480) gives the example of same-sex marriage, acknowledging that, while this is not the only and, arguably, not the most important issue for queer youth and adults today, "gay marriage rights are important . . . for showing queer youth that they have a future where they can enjoy the kind of social recognition and respect that other children may enjoy." In addition, activist groups such as Queer Nation have taken visibility to be "a crucial requirement if gays are to have a safe public existence" (Hennessy, 1995, p. 51). By this logic, the visible presence of queer students, parents and teachers makes school spaces physically and emotionally safer for all of these groups.

Visibility's Vicissitudes

However, visibility and sayability—or, more generally, perceptibility and intelligibility—are by no means uncontested political goals. One source of concerns about the assumed desirability of visibility is the work of Michel Foucault. Foucault (1975/1977, p. 208) comments on the changed status of visibility from the privilege of the sovereign, whose visibility distinguished him from the invisibility of his subjects, to the disciplining surveillance of the many, and the privilege of invisibility for the few, in modern society. Where visibility was once—and, in certain contexts, such as the red carpet of the Oscars, remains—a sign of status, in many contexts today visibility has become "a trap" (Ibid., p. 200), exposing the subject to actual or potential surveillance by security cameras, employers, teachers, opinion polls, and other sources. As the student who requests a seat in the back row understands, invisibility provides a space free from scrutiny. By this logic, invisibility might be a boon rather than a bane for queers.

Moreover, it is difficult for queer and other minority groups to achieve a desirable degree of visibility. Daphne Patai (1992) proposes the concept of 'surplus visibility' to describe the perception of excess and exaggeration whenever minorities become perceptible at all: "There seems to be no middle ground for 'Others' to inhabit: They are forced to choose between invisibility and surplus visibility, between silence and the accusation that they are making excessive noise." This automatic amplification of audibility and magnification of visibility means for queer subjects that it can be tempting to forfeit visibility and audibility rather than be accused of unnecessary flaunting and attention-seeking. Within "the powerful silent force of the heterosexual matrix . . . [the] whisper of another possibility is inevitably constructed as scream" (Atkinson & DePalma, 2008, p. 33).

An entirely different cause for concern about visibility as political goal is the way in which visibility for queer subjects has become bound up with marketing and commodity culture. Marxist feminist theorist Rosemary Hennessy (1995, p. 36) understands that visibility has been an important goal in the various iterations of gay, lesbian and queer politics: "Like lesbian feminism and the gay liberation movement, the queer critique of

heteronormativity is intensely and aggressively concerned with issues of visibility." However, she argues, queers ought to be more attentive to who benefits from the current strategies for making queer lives visible as 'lifestyles': "If gay visibility is a good business prospect, as some companies argue, the question gay critics need to ask is 'for whom?' Who profits from these new markets?" (Ibid., p.66). Her concern is that while queers may be taken seriously as consumers, this visibility may not translate into visibility in more political spheres of life.

None of these vicissitudes of visibility, however, get at the particular difficulty I want to address here. This difficulty is the one identified by Judith Butler when she warns that the singular focus on the recognition of identity, especially in American identity politics, assumes wrongly that the achievement of visibility and sayability is "the end of [the] struggle, as if becoming visible, becoming sayable is the end of politics" (Butler, Olson & Worsham, 2000, p. 743). The concern Butler expresses is not that visibility is a trap in Foucaultian surveillance, or that it is read as surplus-visibility, or that visibility has been co-opted by commodity culture, but rather that this focus can eclipse deeper questions "about how political structures work to delimit what visibility will be and what sayability will be" (Ibid., p. 744). In other words, in their eagerness to become perceptible and intelligible, queer subjects may settle for intelligibility and perceptibility within the existing, dominant order and forget to question or attempt to change the structures that kept them unintelligible and imperceptible in the first place. In Judith Roof's (1996, p. 146) words, "Predictably, the problem visibility appears to solve, then, is invisibility—which is a product of the very same logic that produces visibility as an answer," By contrast, queer theory and politics—especially as distinct from gay and lesbian theory and politics—have been "interested in altering the standard of vision, the frame of reference of visibility, of what can be seen and known" (Hennessy, 1995, p. 37). Can the achievement of visibility, audibility, sayability of queer subjects in schools be coupled with the deeper questions Butler calls for? And how can it be judged whether particular instances of making the queer visible and audible are instances of recognition within existing structures, or whether they change the structures themselves?

The Distribution of the Sensible

Jacques Rancière's work on the "distribution of the sensible" (*partage du sensible*) offers a promising new lens for analyzing the political risks and benefits of visibility for queer students and teachers.[2] The distribution of the sensible, for Rancière (2000/2004, p. 12), is "the system of self-evident facts of sense perception that simultaneously discloses the existence of something in common and the delimitations that define the respective parts and positions within it. A distribution of the sensible therefore establishes at one and the same time something common that is shared and exclusive parts."

Gender and sexuality constitute precisely such a system of self-evident facts of sense perception that simultaneously discloses the existence of something in common—

everyone is gendered and sexualized in one way or another—and the delimitations that define the respective parts and positions within it. Being perceptible and intelligible as having a gender and sexuality is a prerequisite for being perceptible and intelligible as a human subject. Gender, in its dominant mode, is indeed considered 'self-evident'; it is one of the most important axes ordering social relations, and it provides, for those who share in it, a common experience of living on one side or another of a stable binary. In Butler's (2004, p. 42) words, which underscore the role of gender in the distribution of the sensible, gender is a norm that "governs intelligibility, allows for certain kinds of practices and action to become recognizable as such, imposing a grid of legibility on the social and defining the parameters of what will and will not appear within the domain of the social."

Although gender and sexuality are not synonyms, sexuality is an important and inalienable part of gender norms. 'Queer' can never be treated as a matter of sexuality separate from gender, and although the term 'genderqueer' is used by some intersex, transsex, intergender, and transgender activists to distinguish themselves and the kind of interrogation of norms they enact from those who are (merely) sexually queer, I will use 'queer' for all those who do not fit the social norms of stable and unambiguous sex (either female or male), stable and unambiguous gender (either feminine or masculine), sex-gender congruity (feminine females and masculine males), and/or heterosexuality. As Hennessy (1995, pp. 35–36) notes in terms that echo Rancière's emphasis on the distribution of the sensible, "queer theory and activism . . . acknowledge that heterosexuality is an institution that organizes more than just the sexual: it is socially pervasive, underlying myriad taken-for-granted norms that shape what can be seen, said, and valued." Failing to comply with the dominant sex, gender, and sexual norms results in the subject becoming abject and unintelligible: "This exclusionary matrix by which subjects are formed . . . requires the simultaneous production of a domain of abject beings, those who are not yet 'subjects,' but who form the constitutive outside to the domain of the subject" (Butler, 1993, p. 3).

Gabriel Rockhill (2004, p. 3) explains that the separation between those who share in the common and those who are excluded from it "presupposes a prior aesthetic division between the visible and the invisible, the audible and the inaudible, the sayable and the unsayable." Queer persons have been imperceptible and unintelligible *as queer and equal persons*, and have been perceptible and intelligible only to the extent they could be seen, spoken, and heard *in terms of and as constitutive outside to* straight sex, gender, and sexual norms. Queer students and teachers' desire to gain visibility, audibility and sayability *as queer and equal* thus involves a change to the dividing line between those who are included in and those who are excluded from the visible, audible and sayable; it involves a shift in the distribution of the sensible. Such a shift is precisely what marks *politics*, in the way Rancière defines it: "The essence of politics consists in interrupting the distribution of the sensible by supplementing it with those who have no part in the perceptual coordinates of the community, thereby modifying the very aesthetico-political field of possibility" (Rockhill, 2004, p. 3).

The risk, of course, is that the entrance of those who have no part in the perceptual coordinates of the community will lead not to a change in the aesthetico-political field

of possibility, but rather to the assimilation or absorption of those who have no part by the aesthetico-political field, which, itself, remains unchanged. If this is the case, then gaining perceptibility or intelligibility amounts to gaining recognition but only on the terms of those who are already in a position to recognize; the terms of recognizability themselves do not change. Rancière's conception of politics is thus crucially different from a politics of recognition. When the distribution of the sensible is shifted, the terms of recognizability themselves change; moreover, where the politics of recognition seeks recognitive equality and thus operates from the assumption of inequality, a shift in the distribution of the sensible is an affirmation and verification of the fundamental equality those previously excluded already possessed.

Identification and Subjectification

Rancière's distinction between identification and subjectification is helpful in discerning when the becoming visible, audible, sayable of queer students and teachers has political effects, in the sense of a shift in the distribution of the sensible, and when it does not. Rancière (1995/1999, p. 35) argues that "politics is a matter of subjects or, rather, modes of subjectification" rather than of identities and modes of identification (see Biesta, Friedrich *et al.*, and Simons & Masschelein in this Issue). I quote Rancière on this point *in extenso*:

> A mode of subjectification does not create subjects ex nihilo; it creates them by transforming identities defined in the natural order of the allocation of functions and places into instances of experience of a dispute. 'Workers' or 'women' are identities that apparently hold no mystery. Anyone can tell *who* is meant. But political subjectification forces them out of such obviousness by questioning the relationship between a *who* and a *what* in the apparent redundancy of the positing of an experience . . . 'Worker' or better still 'proletarian' is . . . the subject that measures the gap between the part of work as a social function and the having no part of those who carry it out within the definition of the common of the community. . . . Any subjectification is a disidentification, removal from the naturalness of a place, the opening up of a subject space where anyone can be counted since it is the space where those of no account are counted, where a connection is made between having a part and having no part. (Ibid., p. 36)

The crucial distinction between identity and subjectivity, as Rancière uses the terms, is that subjectivity questions the apparent naturalness of the rank and order implied in identities. The (in Western societies) now fairly commonplace term 'gay' or even the more clinical 'homosexual' *can* in certain contexts be used as simply descriptive of one's own or someone else's sexual desires and activities, without challenging the homosexual/heterosexual binary or assumptions about stable and unambiguous sex and gender, and sex-gender congruity.

In order for 'gay' or 'homosexual' to become political subjectivities, they need to become instances of disidentification from the seemingly obvious identities signified by these terms. Such disidentification is more often carried out under the signifier 'queer' because, as Rancière (1995/1999, p. 59) explains, the demonstration of the gap between the identity and the subjectivity "operates more clearly when the names of subjects are distinct from any social group identifiable as such." 'Queer' is more sharply political—and I will discuss the specific force of this signifier shortly—which is illustrated by its relative uncommonness in schools. When 'gay' is presented as what Rancière (2007) calls a 'counteridentity' rather than as disidentification, it fails to become a political intervention. A counteridentity is complementary, diversifying the original identity category rather than fundamentally challenging it, and is posited:

> . . . when, for instance, we oppose a French plural identity to a French monoidentity, making France a mosaic composed of French Men and French Women, Natives and Immigrants, heterosexuals and homosexuals, etc. This is what is often thought of when people use the word multiculturalism: a mosaic of identities, each of which is endowed with its own culture. (Rancière, 2007, p. 560)

When 'gay' and 'lesbian' are used to signal simply that there are more options in life than sexual attraction to and sexual relations with members of the opposite sex, they are named as counteridentities. This is not a bad thing—just as I would argue the French plural identity Rancière describes above is preferable to French mono-identity—but it does not go far enough if the political objective is to shift the distribution of the sensible.

For that it is necessary that a signifier does not add an identity, but that it critically interrogates the identity to which it might be perceived to be an addition. Through a political subjectivity "any order or distribution of bodies into functions corresponding to their 'nature' and places corresponding to their functions is undermined, thrown back on its contingency" (Rancière, 1995/1999, p. 101). Queer politics is political in this Rancièrean sense only when it exposes the contingency of sex, gender, and sexual categories and designations, and challenges the social norm that the proper place of queerness is the private sphere. Whenever it is suggested that queerness is, exclusively or primarily, about sex, 'queer' is treated as an *identity* and, in this, case, one that is perceived to belong in the home rather than in public space. By contrast, 'queer' as *political subjectivity* insists on having a voice in the public sphere by 'measuring the gap,' as Rancière puts it, between the possibility of same-sex relations in the home, and the impossibility of social life on queer terms, that is, terms that challenge the way gender structures society.

The question of the distribution of spaces in which queerness is and is not supposed to appear, is of particular relevance to queer politics in schools. A common objection to the appearance of queerness in schools, whether in the form of queer bodies or queer discourses, is that it introduces sexuality into a space where sexuality has no business. Of course, as Kerry Robinson (2002, p. 420) points out, sexuality is already part of schooling, even in early childhood education where sexuality is most disavowed: "The

incorporation of mock weddings, the encouragement of various activities in home corner, such as mothers and fathers, and young children's participation in kissing games and girlfriends/boyfriends are all part of young children's narratives of their experiences in early childhood education" (Ibid.). However, Robinson found that many educators do not connect "such heterosexualized activities . . . to understandings of sexuality" (Ibid.). And that is precisely the point of queer politics as politics: that it undermines the naturalness of sexuality *not* belonging in early childhood and later education, that it "shifts a body from the place assigned to it or changes a place's destination. It makes visible what had no business being seen" (Rancière, 1995/1999, p. 30). By insisting that queerness does have a place in schools, queer politics makes the questioning of dominant sex, gender, and sexual norms the business of schooling.

In the context of schools, the suggestion that queer is a sexual identity, then, leads to both the rejection of queerness in the supposedly asexual place of schools and the silencing of queerness as political subjectivity by relegating it back to its 'natural function' of sexuality. The latter is a move that is in a line with the fundamentally anti-political nature of schools. As I have argued elsewhere (Ruitenberg, 2008), schools are part of what Rancière (1995/1999, p. 28) calls the 'police' (*la police*) or 'police order' (*l'ordre policier*), by which he means the social order in which people and institutions are distributed and legitimized into their proper roles and places. By definition, schools do not facilitate the disruption of that order (although politics may still be able to enter in spite of school order). When queer students, teachers or parents insist on being seen and heard as political subjects they not only disrupt the order of gender that structures schooling as it structures society at large, they also insist on their equality, and thus disrupt the order of inequality by ranks and positions on which the school rests.

How Political is 'Coming Out'?

What is at stake in queer politics in the Rancièrean sense of politics, then, is the introduction of queer as subjectivity, not as identity, because an identity, even a counter-identity, fails to challenge the distribution of the sensible, the structures of recognition. While Butler said in 1993 that "it is necessary to assert political demands through recourse to identity categories, and to lay claim to the power to name oneself and determine the conditions under which that name is used" (p. 227), by 2000 she had become concerned "that many mainstream gay organizations have become very identity-based; coming out has become a very big thing because that's the moment of rendering visible your identity" (in Butler, Olson & Worsham, 2000, p. 754).

Butler's mention of 'coming out' as a common instance of becoming visible and sayable in a way that does not challenge the structures of recognizability is particularly significant for queer politics in schools. As Mary Lou Rasmussen (2004) observes, 'coming out' has been greatly emphasized in queer politics in schools as transformative for both the person coming out and for her or his social environment. However, the 'coming out imperative' not only fails to examine the complex intersections of sexuality with race,

ethnicity and religion—a point also stressed by Butler (1993, p. 227)—but also assumes that coming out is always politically beneficial. Using Rancière's distinction between identification and subjectification, this assumption is not sustainable.

In many contexts coming out is an instance of identification: the claiming of an identity, a group membership, name or label in a declarative discursive act. When a male student tells a school counselor, for example, "Stop asking me when I will get a girlfriend: I am gay," it is clear that the identity 'gay' already existed, and that its meaning was clear to the student and counselor, but that the counselor had wrongly assumed the student did not inhabit this identity. No matter how liberatory or empowering it may feel to the student individually to put an end to the misidentification, this act of coming out is not political in a Rancièrean sense, as it does not name a political dispute and does not shift the conditions of visibility. As DePalma and Atkinson (2007, p. 511) understand very well,

> . . . the rendering of certain things invisible, the designation of certain people as 'others,' operates on a societal level. It is not within the individual's power to become visible, no matter how much that individual might accept, embrace, and even celebrate him or herself.

By contrast, when a group of students 'comes out' on their school registration forms by writing 'trans' or 'queer' or 'intersex' across the 'M' or 'F' boxes under the heading 'Gender,' they do name a political dispute. The registration form becomes "a place and a way for two heterogeneous processes to meet. The first is the police process. . . . The second is the process of equality" (Rancière, 1995/1999, p. 30). The students insist that they are fundamentally equal, and insist on being sayable and visible as gendered on their own terms. By doing so, they push against an order in which only binary gender is intelligible and in which having an identifiable gender is a requirement for social intelligibility. Coming out, then, can be a political act, but is not inherently so.

Having made this distinction between political and non-political moments of coming out, Butler's work on the reiterative nature of discursive change helps to soften the hard binary distinction between political and non-political acts. Butler (1993, p. 12, emphasis added) has emphasized that performativity, the cumulative power of discourse to effect that which it seems merely to describe, "is always a *reiteration* of a norm or a set of norms, and to the extent that it acquires an act-like status in the present, it conceals or dissimulates the conventions of which it is a *repetition*." Although Rancière focuses frequently on the singular political moment in which the distribution of the sensible is first contested, he also acknowledges that repetition is needed to consolidate such shifts and that later political disruptions build on earlier ones.[3] In other words, there may be moments, whether of 'coming out' or other forms of gay or lesbian activism, that are not political moments in the strict sense because they do not shift the distribution of the sensible, but that are not without political import in that they are "repetitions of egalitarian words" that have shifted the distribution of the sensible in the past (Rancière, 1992/1995, p. 49).[4]

Queer as the New Proletarian?

Let me attend now in more detail to my choice of the signifier 'queer politics' for what others might call lesbian, gay, bisexual, intersex, transgender, and two-spirit politics, often in the form of an acronym (e.g., LGBITT). I have mentioned that I use 'queer' to refer to all those who do not fit the social norms of stable and unambiguous sex (either female or male), stable and unambiguous gender (either feminine or masculine), sex-gender congruity (feminine females and masculine males), and/or heterosexuality. In this way, 'queer' is deliberately wider ranging than 'gay' or 'lesbian' as signifiers of sexuality alone. I have also indicated that 'queer' tends to be more sharply political, but have not yet explained this claim.

I follow Annamarie Jagose's (1996) definition of queer as "those gestures or analytical models which dramatise incoherencies in the allegedly stable relations between chromosomal sex, gender and sexual desire." In this definition it is clear that queer is not about *being* something, but about *doing* something, such as, in the above definition, gesturing, analyzing, and dramatizing. Thus, as many other queer theorists have noted, queer is better understood as verb than as noun or adjective (e.g., Sedgwick, 1993; Britzman, 1995).

Some people whom I would think of as queer never use the term in reference to themselves or others, for example because they have experienced physical or verbal violence under that term and find the term too inscribed with such violence to be willing to use it for political purposes. Although I do not want to trivialize such discomfort with the term, I will insist here that it is important that it is the term 'queer' that is used in this Rancièrean reading of politics, precisely because it signifies the space on the outside. It is the term that marks the boundary between the intelligible and the unintelligible, and its use in queer politics is an example of what Rancière (1995/1999, p. 126) calls:

> . . . the heterological mode of political subjectification: the stigmatizing phrase of the enemy . . . was taken at face value, then twisted around and turned into the open subjectification of the uncounted, a name that could not possibly be confused with any real social group, with anyone's actual particulars.

Butler is well known for writing about heterology in terms of "affirmative resignification" (1993, p. 223) or 'insurrectionary speech' (1997, p. 163). Significant in such resignification is that the previous injurious and stigmatizing force of the signifier is not lost or resolved, but rather redirected.

Other examples of affirmatively reclaimed signifiers that work in political subjectification are the Eastern European dissidents who reclaimed the term 'hooligans,' "with which they were stigmatized by the heads of these regimes" (Rancière, 1995/1999, p. 59) and the use of 'unAustralian' by certain residents of Australia who had been stigmatized as unAustralian (Rancière, 2007, p. 560). Based on Rancière's discussion of the prefix 'un-,' queer can be considered as *un-straight* in the multiple senses of gender and sexuality. 'Queer' is perhaps the 'un-identity' par excellence, for, as queer theorist Lee Edelman (2004, p. 17) observes, "the queer must insist on disturbing, on queering,

social organization as such—on disturbing, therefore, and on queering ourselves and our investment in such organization. For queerness can never define an identity; it can only ever disturb one."

The 1990s slogan "We're here, we're queer, get used to it," signaled the defiant appearance of queers as queer, the refusal to be invisible or to be visible only as something other than queer. It also signaled the taking back of 'queer' as epithet, as a term that had ranked sexual minorities as morally, legally, and socially lower than the sexual majority. Writes Rancière (1992/1995, p. 33), "in the first place, being a member of the militant class means only this: no longer being a member of a lower order." Deborah Britzman (1995, p. 153) observes that 'queer' is militant in precisely this way: "The term is defiant but can be heard as accusatory." The accusation is of a wrong, in the Rancièrean sense, which is to say not only the observation that the count of those who are included *is wrong* but also the charge that *one has been wronged* (Panagia, 2001, n.5). Rancière (1995/1999, p. 38) emphasizes that becoming a political subject means defining oneself as 'a subject of wrong,' and such a:

> . . . political wrong cannot be settled—through the objectivity of the lawsuit as a compromise between the parties. But it can be processed—through the mechanisms of subjectification that give it substance as an alterable relationship between the parties, indeed as a shift in the playing field. (ibid., p. 39)

Britzman (1995, p. 155) also reiterates the importance of taking 'queer' not as identity, but as instance of political subjectification, the naming of a dispute, when she writes, "I want to hold the hope that . . . one might work with the provision queer without recourse to ontological debate. One might suspect the very limits of intelligibility that allow some ontological claims to be more natural than others." The political promise of the signifier queer lies not in its use as new identity category but in its interrogation of the limits of intelligibility.

According to Rancière (1995/1999, pp. 88–89) 'proletarian' has been the particular signifier, the 'privileged name,' under which politics has taken place. I work in theoretical traditions in which class is no longer seen as the privileged signifier, but rather one signifier among several that name a wrong. Since gender is so fundamental for achieving intelligibility and perceptibility that pronouns are lacking for all who do not fit unequivocally in the gender binary, one might even wonder whether 'queer' is a new 'proletarian.' When Rancière describes politics by "a third people, operating as such or under some other name and tying a particular dispute together on behalf of the uncounted" (Ibid., p. 88), this appears to be an apt description of queer politics.

'Queer' should not be presented as a new 'proletarian,' however, without noting the irony in connecting these two signifiers. Rancière (1995/1999, p. 121) notes that the term 'proletarian' is derived from the name *proletarii* which lawyers in ancient Rome created to refer to "those who do nothing but reproduce their own multiplicity and who, for this very reason, do not deserve to be counted." Elsewhere, Rancière (2007, p. 564) describes this Roman name *proletarii* even more plainly as meaning "those who are no

more than children makers, men who are entrapped in the domestic world of production and reproduction, and thereby excluded from the symbolic order of the political community."[5]

There is an ironic contrast between the reproductive orientation of the *proletarii* and the opposition to "reproductive futurism" embodied by queerness (Edelman, 2004, p. 3). According to Edelman, the figure of the queer is fundamentally opposed to the figure of the Child; where the latter drives the desire to reproduce the existing social order or to establish a new, better social order, queerness is opposed to civil order and the investment any such order must necessarily have in stable identity categories. He notes that conservative, religious voices that have described queer relationships as about pleasure rather than reproduction, and that have warned that queers are a threat to the social order, "might be right . . . or, more important, that [they] ought to be right: that queerness *should* and must redefine such notions as 'civil order' through a rupturing of our foundational faith in the reproduction of futurity" (Ibid., pp. 16–17). When I present 'queer' as the new 'proletarian,' therefore, it is based on the idea of queers as 'third people,' not on the queer as figure of reproduction.

Even though queer seems, currently, a particularly apt name for the dispute of those who are uncounted because of being 'un-straight,' this signifier, too, can be used for identification rather than subjectification. It is not unlikely that, like other terms, the performative force of 'queer' is time-sensitive and, as the edge of 'queer' wears off, a new term will be required to name the dispute of the 'un-straight.' Writes Butler (1993, p. 230) about the signifier 'queer':

> That it can become such a discursive site whose uses are not fully constrained in advance ought to be safeguarded not only for the purposes of continuing to democratize queer politics, but also to expose, affirm, and rework the specific historicity of the term.[6]

Allies and Alliances

Rancière's work on the role of allies in political interventions that shift the distribution of the sensible provides a fresh reading of the role of queer allies in schools. One of the most obvious places for queer allies in North American educational contexts, especially high schools, is in Gay-Straight Alliances (GSA), extracurricular clubs of both queer and straight students, typically with the support of a sponsor teacher. The first GSA was launched in 1989 in the United States and currently more than 3,000 GSAs in the United States are registered with the national Gay, Lesbian and Straight Education Network (GLSEN). The question pertinent to this article is to what extent GSAs can be said to have a political role in the Rancièrean sense of shifting the distribution of the sensible, and how allies play a role in such queer politics.

Camille Lee (2002), in a qualitative study with seven members of the first GSA in Utah, emphasizes not the role of straight allies, but the empowering effects that a school-

based alliance with each other provides to out gay and lesbian students. The gay and lesbian members of the GSA emphasized not having to attempt to 'pass' anymore, and enjoying visibility and sayability as gay and lesbian once they knew they were not alone.[7] Lee noted that although the "students were aware that they were living and going to school in a heterosexist society [they] were not consciously able to identify specific strategies they used for handling the heterosexist assumptions" (Ibid., p. 20). The question of 'queering' spaces and discourses within and outside of the school was not addressed in the study.

One of my misgivings about Gay-Straight Alliances as sites for queer politics in schools is that they are typically called just that, *Gay*-Straight Alliances, and in some places operate under even more innocuous-sounding terms such as 'Rainbow Alliance' (e.g., Collins, 2004) or 'Spectrum' (Blumenfeld, 1995). The political 'sting' is taken out of the signifier in order to appear less accusatory and thus more acceptable in the consensus-oriented order of the school. As Macintosh (2007, p. 37) observes, "GSAs establish the undeniable presence of sexual minority youth within the wider heterosexual school population, by allowing the queer body to legitimately occupy a space" while the broader school context can remain comfortably heteronormative. The result is a visibility that is strongly circumscribed, "a marginally defined and firmly negotiated discourse of gay and lesbian visibility" (Ibid.). Collins (2004, p. 109) writes that the name 'Rainbow Alliance' was "a more inclusive name chosen over 'Gay-Straight Alliance,'" but even as 'Gay-Straight Alliances' the emphasis is often on inclusion. From Rancière's point of view, inclusion as political objective is suspect:

> Consensus thinking conveniently represents what it calls exclusion in the simple relationship between an inside and an outside. But what is at stake under the name of exclusion is not being inside-outside. It is the mode of division according to which an inside and an outside can be joined. (Ibid., pp. 115–116)

If a GSA is a mode of including queer students in school spaces and discourses, it does not contest the structures that continue to create an inside and outside. Britzman (1995, p. 158) refers to inclusion as "the belief that one discourse can make room for those it *must* exclude," thus indicating that the necessity of exclusion for the establishment of a norm is left unquestioned by an emphasis on inclusion. This does not mean that GSAs do not serve a purpose in schools, but rather that the existence of GSAs should not be taken as a sign of queer *politics* that shifts the distribution of sensible genders, sexualities and subjects more generally.

Of course the work of allies need not take place in designated 'alliances.' In several texts Rancière describes the ally work of the French revolutionary Auguste Blanqui. When, in 1832, Blanqui was on trial for his revolutionary activities, he was asked to state his profession and answered 'proletarian.' Rancière (1995/1999, p. 37) describes how the magistrate at Blanqui's trial objected to this response: "'That is not a profession,' thereby setting himself up for copping the accused's immediate response: 'It is the profession of thirty million Frenchmen who live off their labor and who are deprived of political rights.'"

Blanqui spoke for or on behalf of the proletarians, in order to create a place where proletarians might speak in the future, by opening up the signifier 'proletarian' as a signifier under which one could speak and be heard. Rancière comments that Blanqui's political intervention "turns on the double acceptance of a single word: profession" (Ibid., p. 37). Where the prosecutor takes 'profession' to mean "job, trade: the activity that puts a body in its place and function . . . Blanqui gives the same word a different meaning: a profession is a profession of faith, a declaration of membership in a collective" (Ibid., pp. 37–38). This same mechanism of double acceptance of a single word is at play in the example of queer politics I provided above: when students refuse to check one of two boxes provided under the heading 'Gender' but, instead, write 'trans' or 'queer' or 'intersex' across the item, they reinterpret the key signifier 'gender.' Where the administrative creators and processors of the form interpret this signifier as involving a necessary binary choice, the students take a different stance. More obvious in the French *genre*, 'gender' need not refer to a binary choice any more than 'profession' need refer to a recognized trade. Derived from the Latin *genus*, which meant 'kind' or 'sort,' these queer activists are pointing out precisely that people inhabit a variety of 'genres' and that they are wronged by invisibility and unsayability of those genres.

In the example as I have provided it, I have created the suggestion—although not in so many words—that the students 'are' trans or queer or intersex by describing them as 'coming out' as such. Rightly or wrongly, the automatic assumption with 'coming out' is that one can only 'come out' as who or what one really is. This is a significant difference from Blanqui's proletarian ally work as recounted by Rancière. If 'coming out' were to be used as a strategic occupation of a subject position, it would likely be perceived as lying, so terms and discursive approaches other than 'coming out' have to be found for the contestation or 'queering' of gender as binary category by those who do not identify as queer.

Rancière (1995/1999, p. 127) appears pessimistic about the possibility for ally work today when he writes that, since 1968,

> . . . the advocates of progress as well as those of law and order have decided to accept as legitimate only those claims made by real groups that take the floor in person and themselves state their own identity. No one has the right now to call themselves a prole, a black, a Jew, or a woman if they are not, if they do not possess native entitlement and the social experience.

According to Rancière, the connection between identity and subjectivity has become the dogma of identity politics to the point that only those with 'real' identity to underpin the subjectivity can occupy that political subjectivity. However, Jacques Derrida performatively suggested ally work may still be possible when in 1996 he spoke out as ally of the *sans papiers*, the illegal immigrants in France known metonymically by their lack of documents.

> We are here for this, we are here to protest and to act first by speaking. This means we are raising our voice for the 'sans-papiers,' of course, on behalf

of the 'sans-papiers,' and as a sign of solidarity with them: *for them* in this sense but not *for them* in the sense of *in their place.* They have spoken and they speak for themselves, we hear them, along with their representatives or advocates, their poets and their songsters. To speak here means that the 'sans-papiers' have a right to speak: we are here to hear them and to listen to them tell us what they have to tell us, to speak with them, and not only, therefore, to speak about them or in their place. (Derrida, 1997/2002, pp. 134–135)

Derrida signals that he is aware of the risk that 'speaking for' becomes speaking 'in the place of' the very subjectivity one seeks to give a place to speak. This risk of what might be called 'appropriation' is never absent—it was a risk that both Blanqui and Derrida took—and only in retrospect can it be judged whether the discursive acts of allies have been successful in creating a part for those who had no part, in shifting the distribution of the sensible.

Rancière's (1995/1999) comments about the current expectation that one only speaks in and from one's own identity, do highlight that allies should expect to be questioned about their motives by those on whose behalf they speak. Rancière contrasts the political work of allies such as Blanqui with what he calls 'humanitarianism' today, in which:

> . . . the eligible party pure and simple is . . . none other than the wordless victim, the ultimate figure of the one excluded from the logos, armed only with a voice expressing a monotonous moan, the moan of naked suffering, which saturation has made inaudible. (Ibid., p. 126)

'Queer allies' are not allies but humanitarians, in the Rancièrean sense, if they treat queers as wordless victims and expect gratitude for what the 'ally' does on their behalf. Queer politics requires not compensation for exclusion from the logos but rather a shift in the logos, the distribution of intelligibility and perceptibility itself. In order to contribute to such a shift, queer allies can occupy queer subjectivity and, in an era in which subjectivity is assumed to be predicated on identity, they accept the risks to their own identity this entails. Those who, as I have witnessed, claim support for queer politics but follow this comment immediately with a straight coming out of their own so as to avoid being perceived as queer, do not accept this risk and undermine rather than strengthen queer politics.

The interventions of allies who sustain ambiguity in their identity because they insist it is their political subjectivity and not their identity that matters in queering the distribution of the sensible, can be unsettling and powerful. A female teacher who is presumed heterosexual is in a great position to ask why colleagues assume the 'partner' she refers to is her husband or boyfriend; a male teacher who is presumed unambiguously sexed and gendered is in a position to ask why students assume he was once a little boy.

Such ambiguity is also maintained in the allies who participate in the 'Day of Silence,' a day of silent protest against the silencing and resultant inaudibility of queer voices. For those who are used to equating resistance and agency with voice or speech—as

Rancière does—silence might appear an ineffective political strategy to combat inaudibility, and raise concerns that "the lack of speech allows for a queer-sanctioned 'homophobia as usual' and allows too many people to dodge behind silence as if nothing were happening" (Mayo, 2004, p. 45). However, the intervention offered on the 'Day of Silence,' is that this silencing is made visible by queer students and allies who remain deliberately and ostentatiously silent for a day and hand out cards that explain the refusal to speak as way of calling attention to those who have been silenced, and that include the incitement, "Think about the voices you are not hearing" (as cited in Mayo, 2004, p. 44). There is no telling whether the silent protesters identify as queer and they do not respond to questions about their identity; the focus is on contesting the wrong and shifting the everyday borders between the sayable and unsayable, audible and inaudible.

A similar approach is taken in the 'Call in Gay for a Day' campaign launched in December 2008 in California, in which the organizers encouraged people to call in 'gay' to work and donate their time as a volunteer (Day Without a Gay, 2008). Just as the activists of the Day of Silence wanted people to think about the voices they were *not* hearing, the Call in Gay for a Day campaign intended to show how much is lost when gays and lesbians cannot fully participate in society. One of the strengths of the campaign is its inherent ambiguity: it remains unclear whether the person who calls in gay for a day identifies as gay the rest of the time. In this way, the subjectivity of the political protest is disconnected from identity, and a space is opened for ally work. Anticipating the questions of straight allies uncertain about the possibility of disconnecting this political subjectivity from identity, the organizers tell straight allies, "You are welcome to call in 'gay,' too. And consider yourself free to use this 'Gay For A Day' pass as needed to volunteer!"

In this campaign 'gay' was chosen simply because it rhymes with 'day,' but the idea behind the campaign can be used with other terms and in other contexts. As Rancière's examples of political disputes show, the political interruption of the existing order by those who do not have a voice requires strength *by status* (as in the case of Blanqui's claim that 'proletarian' was a profession) or strength *by numbers* (as in the case of the demand of the commoners on the Aventine Hill in Rome (494 BCE) to be heard by the patricians (Rancière, 2004)). How would the distribution of sensible genders and sexualities be shifted in a school if the hockey team called in 'un-straight' to a game? How would the terms of queer visibility and audibility shift if the cheerleading squad launched a 'queer-leading' campaign?

Conclusion

Imposed invisibility and unsayability have rightly been fought by queer individuals and groups for centuries. The demand for visibility and sayability is a political demand in the sense that it contests a dominant order that would prefer to keep queerness invisible and silent. However, the achievement of visibility and sayability may not be a political achievement by Jacques Rancière's criterion of the political as shifting the division between what genders and sexualities can and cannot be shown, seen, spoken

and heard. In schools, when a safe and controlled amount of space is allotted to queer visibility and sayability, we would do well to ask ourselves how political this visibility and sayability are. Do they name a dispute? Has anything changed in the distribution of the sensible? The borders of "what visibility will be and what sayability will be" (Butler in Butler, Olson & Worsham, 2000, p. 744), need to be unsettled in the curriculum as well as in the staffroom, on school sports teams and in teacher education programs. There are no sure-fire recipes for who or what will successfully queer the distribution of the sensible, but taking queer politics *qua politics* seriously in schools means not resting content with gaining permission to be visible and sayable in the existing school order, but, instead, seeking to change the 'grid of legibility' of that existing order itself (Butler, 2004, p. 42).

Notes

Ruitenberg, Claudia, "Queer Politics in Schools: A Rancièrean Reading," *Educational Philosophy and Theory*, 42(5–6) (2010): 618–634. Reprinted by permission of Wiley-Blackwell.

1. I am grateful to Jinting Wu for spurring me to think about connections between Butler's and Rancière's ideas.

2. The French noun *partage* derives from the verb *partager*, which means 'to divide' as well as 'to share.' The closest connection in English is between 'parting' and 'having part.' *Le partage du sensible* is translated sometimes as 'the division of the sensible' or 'partition of the perceptible' but the English 'distribution' preserves the ambiguity between inclusion and exclusion inherent in *partager*.

3. See, for example, Rancière, 1992/1995, p. 49.

4. I am grateful to Gert Biesta's insights on this point.

5. Rancière does not discuss the gender implications of the public/domestic and production/reproduction binaries.

6. Butler uses the idea of 'democratization' here in a way that is different from Rancière's conception of democracy. Because the purpose of the section is to highlight the fact that names of political subjectivities can wear out, I will not elaborate this point here.

7. Lee does not use the term 'queer' anywhere in her article, and no reference is made to bisexual, transgender, transsex, or intersex students.

References

Atkinson, E., and DePalma, R. (2008) Imagining the Homonormative: Performative subversion in education for social justice, *British Journal of Sociology of Education*, 29:1, pp. 25–35.

Blumenfeld, W. J. (1995) 'Gay/Straight' Alliances: Transforming pain to pride, in: G. Unks (ed.), *The Gay Teen: Educational practice and theory for lesbian, gay, and bisexual adolescents* (New York: Routledge), pp. 211–224.

Britzman, D. P. (1995) Is There a Queer Pedagogy? Or, stop reading straight, *Educational Theory*, 45:2, pp. 151–165.

Butler, J. (1993) *Bodies That Matter: On the discursive limits of 'sex'* (New York: Routledge).

Butler, J. (2004) *Undoing Gender* (New York, Routledge).

Butler, J., Olson, G. A., and Worsham, L. (2000) Changing the Subject: Judith Butler's politics of radical resignification, *JAC: A Journal of Composition Theory*, 20:4, pp. 727–765.

Collins, A. (2004) Reflections on Experiences in Peer-Based Anti-Homophobia Education, *Teaching Education*, 15:1, pp. 107–112.

Day Without a Gay (2008) Retrieved on 8 December 2008 from http://www.daywithoutagay.org/

DePalma, R., and Atkinson, E. (2007) Strategic Embodiment in Virtual Spaces: Exploring an on-line discussion about sexualities equality in schools, *Discourse: Studies in the Cultural Politics of Education*, 28:4, pp. 499–514.

Derrida, J. (1997/2002) Derelictions of the Right to Justice (But What Are the 'Sans-Papiers' Lacking?) in: *Negotiations: Interventions and Interviews* 1971–2001 (Stanford, CA: Stanford University Press), pp. 133–144.

Edelman, L. (2004) *No Future: Queer theory and the death drive* (Durham, NC: Duke University Press).

Foucault, M. (1975/1977) *Discipline and Punish: The birth of the prison*, A. Sheridan, trans. (New York: Vintage).

Hennessy, R. (1995) Queer Visibility in Commodity Culture, *Cultural Critique*, 29, pp. 31–76.

Jagose, A. (1996) QueerTheory, *Australian Humanities Review*, 4. Retrieved on 21 July 2008, from <http://www.australianhumanitiesreview.org/archive/Issue-Dec-1996/jagose.html>.

Lee, C. (2002) The Impact of Belonging to a High School Gay/Straight Alliance, *The High School Journal*, 85:3, pp. 13–26.

Macintosh, L. (2007) Does Anyone Have a Band-Aid? Anti-homophobia discourses and pedagogical impossibilities, *Educational Studies*, 41:1, pp. 33–43.

Mayo, C. (2004) The Tolerance That Dare Not Speak Its Name, in: M. Boler (ed.), *Democratic Dialogue in Education: Troubling speech, disturbing silence* (New York: Peter Lang), pp. 33–47.

Mayo, C. (2006) Pushing the Limits of Liberalism: Queerness, children, and the future, *Educational Theory*, 56:4, pp. 469–487.

Panagia, D. (2001) Ceci N'est Pas un Argument: An introduction to the Ten Theses, *Theory and Event*, 5:3. Retrieved on 4 June 2009 from <http://muse.jhu.edu/journals/theory_and_event/v005/5.3panagia.html>.

Patai, D. (1992) Minority Status and the Stigma of 'Surplus Visibility' [Electronic version], *Education Digest*, 57:5, pp. 35–37.

Rancière, J. (1992/1995) *On the Shores of Politics* (London: Verso).

Rancière, J. (1995/1999) *Disagreement: Politics and philosophy*, J. Rose, trans. (Minneapolis, MN: University of Minnesota Press).

Rancière, J. (2000/2004) *The Politics of Aesthetics: The distribution of the sensible*, G. Rockhill, trans. (New York: Continuum).

Rancière, J. (2004) Introducing Disagreement, *Angelaki: Journal of Theoretical Humanities*, 9:3, pp. 3–9.

Rancière, J. (2007) What Does it Mean to Be *Un?*, *Continuum: Journal of Media and Cultural Studies*, 21:4, pp. 559–569.

Rasmussen, M. L. (2004) The Problem of Coming Out, *Theory into Practice*, 43:2, pp. 144–150.

Robinson, K. H. (2002) Making the Invisible Visible: Gay and lesbian issues in early childhood education, *Contemporary Issues in Early Childhood*, 3:3, pp. 415–434.

Rockhill, G. (2004) Translator's Introduction: Jacques Rancière's politics of perception, in: J. Rancière, *The Politics of Aesthetics: The distribution of the sensible* (New York: Continuum), pp. 1–6.

Roof, J. (1996) *Come As You Are: Sexuality and narrative* (New York: Columbia University Press).

Ruitenberg, C. W. (2008) What If Democracy Really Matters?, *Journal of Educational Controversy*, 3:1. Retrieved on 4 June 2009 from <http://www.wce.wwu.edu/Resources/CEP/eJournal/v003n001/a005.shtml>.

Sedgwick, E. K. (1993) *Tendencies* (Durham, NC: Duke University Press).

Cold Case

Reopening the File on Tolerance in Teaching and Learning Across Difference

Ann Chinnery
University of Saskatchewan

Introduction

Although tolerance was long considered a core virtue for citizenship in a pluralist democracy, it has recently fallen out of favour. In a nutshell, tolerance suggests having to put up with something (or some person or idea) that one would really rather not have to put up with. And while tolerance is obviously better than hatred or overt discrimination, it is, at best, a minimal virtue. Tolerance neither implies nor requires a commitment to social justice, to questioning the status quo, understanding, or having genuine respect for the other. Therefore, in societies committed to the ideals of participatory democracy with equality and justice for all, tolerance simply does not suffice as either a political or moral virtue. However, I wonder whether there are situations—specifically in teaching and learning across difference—in which tolerance might serve a strategic function not as readily achieved by other means. Let me begin by recounting an experience from my own practice that forced me to challenge my understanding of what it means to "meet the other morally" in pedagogical relations marked by radical difference.[1]

The Scene of the Crime

In various courses I have taught in pre-service teacher education, students repeatedly express a desire to grapple with the kinds of situations and ethical dilemmas they imagine having to face once they are in the field. But, as experienced practitioners know only too well, there are no hard and fast rules or codes of conduct that can spare us the often conflicting moral demands and messiness of classroom life.

In the second week of an undergraduate course on ethical issues in education, we had begun to explore David Purpel's argument that education ought to be reframed as a vehicle for social justice and social transformation.[2] I planned to show a video that

consists of candid conversations between an off-screen interviewer and several local high school students on issues such as racism, sexism, homophobia, and class privilege. The conversations reveal a wide range of perspectives on the various issues, and the video is intended as a classroom resource to spark conversation amongst high school students. However, upon reviewing the film a few days before class, I recognized one of the students in the video as "Jack," a student in my class that term. During the conversation about homophobia, Jack stated that, according to the Bible, which he holds to be literally true, homosexuality is wrong, and a sin punishable by death. He said, among other things, that he did not know "how or why people choose to be that way" and that "maybe, in some cases, they have been abused or something."

I had previewed the video before the course began, but, at that time, none of the students in the film were known to me. Now I was not sure how to proceed. Should I go ahead with the lesson as originally planned? Modify it somehow? Or should I simply drop my plan to show the video and prepare a different lesson? If I chose to go ahead with it, I certainly needed to speak with Jack first to ask his permission to show it in class. After all, since the interview had been conducted about five years prior, he might have changed his views on the subject, or he might not feel comfortable watching it with the rest of the class. For the better part of the next day, I tried to reach him by phone, and when we were finally able to connect later that evening, I explained the situation. I then asked whether he was comfortable with me using the video in class. He said that he had only a vague recollection of the interview and asked me what he had said. When I recounted his words to him, he said that it was fine if I wanted to use it in class. I then posed the second part of my dilemma. I explained that we were coming to the issue of homophobia from very different positions because I am a lesbian. I told him that initially I had not known how to frame the lesson, but that after giving it some thought, I wondered if he would be willing to work with me. I suggested that we share with the class what had transpired and attempt, as a group, to think through the pedagogical implications of trying to teach and learn across apparently incommensurable difference. He agreed, so I suggested that I prepare an introductory "script" which we would review the following evening. I reworked the lesson plan, shifting the focus from a general discussion about anti-oppressive education to an emphasis on teaching and learning across difference. When Jack and I spoke again the following evening, we went through the plan together and he offered some suggestions as to additional directions he would like to see the discussion go. By the time the next class rolled around, however, I was quite apprehensive about how things would actually unfold.

After the students had settled into their seats, I began by saying that it had become crystal clear to me over the preceding week that when we are talking about ethical issues in education we are not talking about abstract theories of morality and justice, but rather about confronting the ethical dilemmas that are the very stuff of everyday classroom life. I recounted to the class the experiences of the past two days, my uncertainty about how to deal with the situation, as well as the conversations Jack and I had had. I reminded them that the particulars of the situation were just that—particulars—and that a similar situation could have just as easily arisen on any number of axes of difference. I asked

them to watch the video with an eye to examining their own social positioning regarding race, class, gender, and sexuality, and the pedagogical questions that might emerge for them in a similar situation. I also emphasized that in our post-viewing discussion we were not going to discuss the moral status of homosexuality *per se*—partly because that question was not something we could possibly resolve in this context, but, more importantly, because I wanted to focus on the pedagogical issues at hand.[3]

Much has been written about the complexities of classroom dialogue in pluralist societies.[4] However, the fact remains that, as professors and teacher educators, we cannot simply abandon the attempt to communicate with our students (and to create opportunities for our students to attempt to communicate with each other), even across apparently incommensurable differences. But if we want neither to foreclose on the possibility for dialogue in classrooms marked by difference, nor to remain naïve about the power dynamics in such classrooms, what conditions, attitudes, or dispositions might be required to make teaching and learning possible across points of radical difference? In other words, how can we move toward receiving and responding to those whose identifications and commitments run counter to our own, and whose identifications and commitments may, in fact, deny the validity of our own?

Moral Dialogue and the Fundamentalist Student

In an essay published twenty years ago, but no less relevant today, David McKenzie addresses the particular challenges of teaching introductory philosophy to Christian fundamentalist students.[5] While the visibility of fundamentalist students and student organizations on campuses is somewhat late coming to publicly funded Canadian colleges and universities, their presence is now increasingly being felt, and the way in which teacher-student relationships play out in individual classrooms varies widely.

As McKenzie points out, there are both fruitful and fruitless ways of approaching our fundamentalist students. When faced with a student response of, "That's what the Bible says," or "That's what God says," one might initially be tempted to confront the student with questions about the nature of belief and knowledge in order to demonstrate that the student does not really know what she or he is talking about. However, while that kind of response might give us some immediate satisfaction, it is not the kind of teacher-student relationship most educators would aspire to—at least those of us who hope to cultivate in our students a desire to think seriously about questions of moral significance. After such an encounter, McKenzie says, students will typically respond in one of two ways: either they will remain silent for the rest of the term, or they will take up the implicit challenge by the instructor and see the class as an opportunity for evangelism. Neither response will lead to a positive outcome. In the first case, one can pretty much assume that if the fundamentalist students continue to attend class at all, they will simply tune out the instructor, fulfill the minimum requirements needed to pass the course, and continue on their way with their fundamentalist assumptions intact. In the second case, the instructor is backed into a corner. She must either take up the incessant

stream of biblical quotes, faith claims, and arguments (thereby surrendering the intended course content to the student's agenda) or ignore the outbursts and interruptions, possibly leading the student to think that the instructor is incapable of responding and that the student has therefore "won" by default.[6] Again, nothing of educational worth is gained.

In contrast, McKenzie suggests an approach of "simple friendship"—a relationship characterized not necessarily by affection, but rather by a "willingness to engage in lengthy and private discussion." He invites the students for private conversations in which he asks them how they have come to know that the Bible is true. This question can then lead to a deeper exploration of the issue in a non-confrontational atmosphere. His approach, he claims, is one that "respects fundamentalist students as persons but which also focuses critical analysis directly on the core ingredients in their faith, honours these ideals and enhances the possibility of effective communication of the discipline of philosophy."[7]

Now this may indeed be a sensible, and obviously more pedagogically sound, alternative to ridicule and embarrassment, but it is not without its limitations. While I am somewhat drawn to the notion of the pedagogical relation as a kind of friendship, I question whether the term "friendship" is appropriate when one party denies the very validity of one or more aspects of the other's identity or subject positions. Returning to the example I cited above, while my identification as "teacher" is an important part of my self-conception, it is not as constitutive of who I am in the world as my identification as "lesbian." But it seems that in order for our teacher-student relationship to meet the criteria of even a "simple friendship," I might be required to ease Jack's discomfort by relinquishing, or at least veiling, my attachment to the identification "lesbian"; and that in order for me to receive him as student-friend, he must do the same around his religious convictions regarding the moral status of those who identify as homosexual. Suffice it to say that there may in fact be situations wherein the ideas and ideals one holds are so constitutive of one's moral, social, or political identity that they are non-negotiable and a harder line must be drawn. The desire for friendship in such situations, on my view, risks obscuring the educational goals that ought to be at the fore.

Now, this is not to say that the quality of the pedagogical relationship is irrelevant. And, admittedly, there are many stories of teacher-student relationships that have been irrevocably damaged over similarly incompatible beliefs and world-views. But my point is that the dissolution of relationship is not a necessary outcome. While the relationship may not be friendly, or even comfortable, incommensurable moral commitments need not prevent genuine pedagogical engagement. One way in which this has been theorized in recent years is as a "pedagogy of discomfort."[8]

Moral Dialogue and Discomfort

Situations of discomfort, Megan Boler says, are an important part of pedagogy and ought not to be avoided:

The path of understanding, if it is not to "simplify," must be tread gently.
Yet if one believes in alternatives to the reductive binaries of good and evil,

"purity and corruption," one is challenged to invite the other, with compassion and fortitude, to learn to see things differently, no matter how perilous the course for all involved.[9]

In a similar vein, Eamonn Callan says that the discomforting experience of "moral distress" is an inevitable consequence of real moral dialogue, especially in pluralist societies where people strongly disagree about what is good and right. By "moral distress" he means "a cluster of emotions that may attend our response to words or actions of others or our own that we see as morally repellent."[10] These feelings may be provoked by the perceived failings of others, or by a negative assessment of one's own words or actions, but moral distress is, by definition, "painful and seriously disturbing" (*CC*, 200).

For both Boler and Callan, this kind of distress is almost inevitable in societies where people strongly disagree about things that matter. It is therefore also inevitable in public school and university classrooms within those societies. Yet despite the discomfort such situations entail (or perhaps precisely because of it), both Callan and Boler claim that there is something educationally worthwhile in engaging conversations or situations that may shatter the cherished ideal of classrooms as safe spaces.[11] As Callan says, while moral distress is, by its very nature, an unwelcome experience, "a discriminating susceptibility to moral distress is a fundamental aspect of virtue, and therefore, that troubling cluster of emotions must be evoked, and suitably shaped, in the process of moral education" (*CC*, 200).

The problem arises as to how we can profitably take up those moments of distress or discomfort. On Callan's view, it is indefensible to gloss over moral differences in the name of preserving a comfortable classroom atmosphere:

> To treat a topic of serious moral dialogue as something to be subordinated to the value of our interlocutors and our relationship to them is to treat moral questions as if they were external to the constitution of one's own self and the self of the other, matters of mere volitional commitment that should not distract us from the real business of who we are and why we matter. (*CC*, 205)

As the situation between Jack and me illustrates, one's moral position on a particular issue is often not merely a matter of volitional commitment. Our respective stances on the moral status of homosexuality are, albeit in different ways for each of us, constitutive of our moral selves. On the other hand, if any meaningful teaching and learning are to take place, the pedagogical relationship must be preserved. We cannot ignore or gloss over our differences, but neither can we afford to close down conversation.

Due to constraints of space, I have not done justice here to either Boler's or Callan's very thoughtful arguments, but I wanted simply to draw out the tension between an emphasis on classrooms as potential sites for social transformation, on the one hand, and the moral and educational losses that might be incurred by a pursuit of justice and moral truth at the expense of relationship, on the other. I return to this issue below, but first let me sketch the current trend in moral education toward viewing empathy as the key to dialogue across difference.

Empathy, Similarity, and Difference

In an attempt to understand moral motivation, and thereby foster increased social responsibility, much research in moral education over the past ten to fifteen years has focused on the heroic altruism of rescuers of Jews during the Holocaust.[12] In the often-cited work of Kristen Monroe and her colleagues, researchers asked the rescuers why they had risked their own lives and well-being, as well as that of their families, for the well-being of another—specifically a stranger who had been so thoroughly demonized and declared the enemy.[13] The researchers found only one common motivational factor: recognition of the essential sameness of all human beings and a self-perception as part of this common humanity. These individuals did not see the stranger at the door as someone who was irreconcilably different, but rather someone who was basically just like them, and, therefore, someone whose misfortune (save for contingent differences) could just have easily befallen them. And it is largely on the basis of this claim that moral educators have increasingly come to see empathy as *the* pivotal moral emotion and a necessary precondition for dialogue across difference. However, while there is much to be said in its favour, I share the concerns of those theorists who are wary of an apparently uncritical embrace of empathy as a cure for the challenges of moral dialogue in a pluralist society.[14]

My own concerns arise from the commonsense understanding of empathy, which is based on an imaginative projection of oneself into the experiences of another. If I can only come to see, the thinking goes, that in all significant respects, the other is basically just like me, then I will be able to understand how or why that person thinks, feels, and acts the way she does, even if her life experience is very different from my own and/ or if we hold widely disparate views about matters of conscience. However, perceiving the other as a fellow human being rests in turn on one's conception of what it is to be human—a conception that is inevitably historically and culturally constituted. In the example I am drawing on here, Jack's conception of a human life worth living does not include a homosexual life. When the moral domain includes only those persons and situations into which one is able, imaginatively, to project oneself, one need only deny the other possession of the requisite set of human qualities in order to reasonably deny his or her status as a being worthy of moral concern.

A second, related problem is that by focusing so strongly on similarity, I worry that we will lose sight of the importance of perceiving the other *as other*—that what we are advocating is, in effect, an erasure of difference. To put it another way, if we constantly focus on the idea that "beneath the skin we are all just the same" we seem to be implying that difference (one's Aboriginal heritage, or identity as a Jew, gay man or lesbian, for example) is not finally that important, even though, in the context of our own particular lives, those identifications may be central to who we think we are, and not so contingent that we can easily surrender them in the name of essential similarity.

In light of these concerns, as well as the salient critiques that Boler and others have raised, I am not at all convinced that empathy provides the best way in to addressing the complexities of teaching and learning across radical difference. Let me return, then, to the notion of tolerance with which I opened the paper. Specifically, I want to begin

to explore how we might use tolerance to facilitate dialogue in classrooms marked by significant moral disagreement.

Revisiting Tolerance

As I said at the outset, tolerance implies putting up with something or someone that one would rather not have to put up with; but, more positively, it also means a recognition of the beliefs and practices of others despite disagreement over the worth of those beliefs and practices. As a rule, tolerance is only required in situations of conflict where the parties neither seek agreement nor consider such agreement possible. But what kind of disagreement are we talking about here? What degree of conflict must be reached before tolerance is required? A disagreement over something of minimal consequence—whether or not Margaret Atwood should have been on the list of candidates for the Greatest Canadian, for instance—is not the kind of disagreement that necessitates tolerance. In such a situation, one can simply resign oneself to the obvious cultural ignorance of the other, or at least feign indifference. Disagreement over the moral status of homosexuality, on the other hand, is a significant disagreement, especially in the context of a pre-service program that leads to teacher certification for public schools.

Tolerance walks a fine line between acceptance and rejection. We only demonstrate tolerance toward that which we have, presumably for good reasons, rejected. And yet, in tolerating someone or something, we are also giving it space. In an address to the Berlin-Brandenberg Academy of Sciences in 2002, Jürgen Habermas departed from his typical emphasis on rational discourse to distinguish the requirements tolerance makes in situations of competing religious claims from what is required in situations of reasonable disagreement. Tolerance is especially difficult, he says, where one party derives his or her moral convictions from religious doctrine that lays claim to universal validity.[15] This is precisely the nature of the conflict between Jack and me. For Jack, a person who identifies as homosexual is not just different, but fundamentally and fatally mistaken.

In a pluralist democracy, Habermas suggests, all that can be expected in a situation of conflict between fundamental convictions is a strategic appeal to peaceful coexistence wherein what is asked of the believer is not a concession of his particular conception of the good, but rather an agreement not to act on his religiously derived claims to truth.[16] The material effect of tolerance, then, is that it simply renders an ongoing conflict latent:

> The conflict continues in the sense that tolerance does not do away with the source of the conflict, because the subject of the dispute remains; but it is in a state of latency because even if the cause of the conflict is still there, its antagonistic power has been virtually cancelled out. If the source of the conflict disappears then tolerance is unnecessary; if the conflict flares up then tolerance no longer exists.[17]

As an educator, however, I cannot rest easy with a veneer of peaceful co-existence in classrooms marked by fundamental disagreement over matters of moral consequence. The

moral losses incurred in opting for tolerance may not, in fact, be insignificant, especially for Jack's future students and colleagues. And, since Jack was only one of thirty-seven students in the class, I needed to consider my responsibilities to the others as well (especially, in this case, the sexual minority students). That said, however, I want to suggest that we look at tolerance from a slightly different angle.

Callan criticizes Nel Noddings for elevating the maintenance of relationship over the pursuit of moral truth in the face of conflicting moral commitments. The requirements of caring relationship, Callan argues, seem to suggest a world in which ethical differences amount to little more than "a matter of varying talents, strengths, interests, and ethnic colour"—a position which obscures the serious nature of real moral pluralism (*CC*, 206–209). However, I am not sure that Noddings's emphasis on maintaining caring relations does, in fact, preclude the kind of genuine moral dialogue that Callan is after. Specifically, I wonder whether we could foreground relationship, introducing tolerance strategically—as a way of keeping a foot in the door, so to speak, and thereby keeping open the possibility of genuine moral dialogue somewhere down the road.

Since Jack and I have had only minimal contact since the course ended over three years ago, I do not know the "end of the story" from his perspective. I do know, however, that the encounter has stayed with me, and has caused me to think and rethink how best to facilitate teaching and learning across such a contested point of difference. In working with students whose conceptions of right and wrong are derived from faith rather than reason, I wonder whether tolerance (or at least a refusal to refuse the intolerant) might create a kind of cognitive dissonance that ultimately disturbs long-held notions of good and evil, saints and sinners. Therefore, while I agree that tolerance ought not to be seen as a virtue or moral ideal, it may be time to reopen the file, and to investigate whether a measured use of tolerance might, in fact, serve a strategic function in classrooms marked by apparently incommensurable difference.

Notes

Chinnery, Ann, "Cold Case: Reopening the File on Tolerance in Teaching and Learning Across Difference," ed. Kenneth R. Howe, *Philosophy of Education 2005*, pp. 200–208. (Urbana, IL: Philosophy of Education Society, 2005). Reprinted with permission.

1. I borrow the phrase "meeting the other morally" from Nel Noddings, *Caring: A Feminine Approach to Ethics and Moral Education* (Berkeley: University of California Press, 1984), 4.

2. David E. Purpel, *Moral Outrage in Education* (New York: Peter Lang, 1999).

3. The question of whether lesbian and gay teachers ought to come out to their students remains a contentious issue even at the post-secondary level. For contrasting views, see Didi Khayatt, "Sex and the Teacher: Should We Come Out in Class?" *Harvard Educational Review* 67, no. 1 (1997): 26–143; and Mary Mittler and Amy Blumenthal, "On Being a Change Agent: Teacher as Text, Homophobia as Context," in *Tilting the Tower: Lesbians, Teaching, Queer Subjects,* ed. Linda Garber (New York: Routledge, 1994).

4. See, most recently, Megan Boler, *Democratic Dialogue in Education: Troubling Speech, Disturbing Silence* (New York: Peter Lang, 2004).

5. David McKenzie, "The Fundamentalist Student and Introductory Philosophy," *Teaching Philosophy* 7, no. 3(1984): 205–216.

6. Ibid., 208–209.

7. Ibid., 209, 214.

8. Megan Boler, *Feeling Power: Emotions and Education* (New York: Routledge, 1999), 175–203.

9. Ibid., 175.

10. Eamonn Callan, *Creating Citizens: Political Education and Liberal Democracy* (Oxford: Clarendon, 1997), 200. This work will be cited as *CC* in the text for all subsequent references.

11. The ideal of classrooms as safe spaces has been critiqued by several theorists, but it still holds currency in many teacher education programs. See, for example, Elizabeth Ellsworth, "Why Doesn't This Feel Empowering?" *Harvard Educational Review* 59, no. 3 (1989): 297–324; Boler, *Democratic Dialogue;* and Suzanne de Castell and Mary Bryson, eds., *Radical In<ter>ventions: Identity, Politics, and Difference/s in Educational Praxis* (Albany, NY: SUNY Press, 1997).

12. See, for example, Lawrence Blum, *Moral Perception and Particularity* (Cambridge: Cambridge University Press, 1994); Eva Fogelman, *Conscience and Courage: Rescuers of Jews During the Holocaust* (New York: Doubleday, 1994); and Arne Vetlesen, *Perception, Empathy, and Judgment: An Enquiry into the Preconditions of Moral Performance* (University Park: Pennsylvania University Press, 1994).

13. Kristen R. Monroe, Michael C. Barton, and Ute Klingemann, "Altruism and the Theory of Rational Action: Rescuers of Jews in Nazi Europe," *Ethics* 101, no. 1 (1990); and Kristen R. Monroe, *The Heart of Altruism: Perceptions of a Common Humanity* (Princeton: Princeton University Press, 1996).

14. See especially Boler's chapter on the risks of empathy in *Feeling Power;* and Zygmunt Bauman, *Life in Fragments: Essays in Postmodern Morality* (Oxford: Blackwell, 1995), 62–63. See also Susan Verducci, "A Conceptual History of Empathy and a Question It Raises for Moral Education," *Educational Theory* 50, no. 1 (2000): 63–80.

15. This address has not yet been translated from the German, but the ideas cited here come from the summary of his talk by Antonia Loick, "Tolerance Makes Great Demands. Jürgen Habermas Shows What Is Involved," http://www.goethe.de/kug/ges/phi/thm/en24456.htm.

16. Ibid.

17. Mark Hunyadi, "Tolerance: A Philosophical Contribution Taking the Drama Out of Difference-Based Conflicts" (paper delivered at the First Intercultural Forum, (Re)Thinking Stereotypes: Constructing Intercultural and Inter-religious Dialogue, Sarajevo, December 2003), 6.

Unveiling Cross-Cultural Conflict

Gendered Cultural Practice in Polycultural Society

Sharon Todd
Stockholm Institute of Education

Drawing on political theorist Bhikhu Parekh's work, which lists the twelve most common cultural practices that give rise to clashes between cultures,[1] Seyla Benhabib raises an important question: "How can we account for the preponderance of cultural practices concerning the status of women, girls, marriage and sexuality that lead to intercultural conflict?"[2] Here she is referring to the overbearing weight that gender carries in relation to "hot" issues such as female circumcision, polygamy, arranged marriages, withdrawal of Muslim girls from school activities, the wearing of *hijab* by Muslim girls, and the subordinate status of women and all that it entails. This seems to suggest that cross-cultural conflict appears on the scene largely when it concerns issues of relations between the sexes, or of women's and girls' roles in particular communities. Practices of reproduction, family life, and sexuality are all coded, to a large degree, through our cultural systems of meaning. Indeed, Susan Moller Okin notes that "most cultures are suffused with practices and ideologies concerning gender," underscoring the idea that gender is not simply an "add-on" to culture but is integral to defining it.[3] The deep-seated ways in which our understandings of culture are gendered give rise to a particular vulnerability when we are confronted with another's cultural understandings.

This is particularly the case with one of the most salient debates to emerge in the European context over the past fifteen years: the right of Muslim girls and women to wear *hijab* to school.[4] The debate rages across the European federation, but it has taken shape quite differently in various countries. Sweden has passed regulations permitting girls who wear a *burqa* to be expelled from school. Belgium does not have a national policy restricting the wearing of *hijab*, but such restrictions have been created and enforced at the local level. In Germany, while teachers are not allowed to wear a headscarf, it has been argued that a nun's attire is perfectly acceptable on "professional" grounds. France has banned all religious symbols in public education institutions and officials have admitted that it was the headscarf in particular that the law was meant to target.[5] Despite

these marked differences, what is common to all these countries' ways of dealing with the educational rights of Muslims is the singling out of Muslim girls and women as symbols of deep tensions within their respective societies.

These tensions are often characterized in terms of the demands of multicultural society, on the one hand, versus the right of the nation to instantiate its own values for civil society, on the other hand. What bears some mention here is how discussions of multicultural society often do not take gender into account in making claims for the respect, recognition, and equality of cultural communities and in promoting cultural rights. Moreover, these cultural communities are frequently depicted as though they were monolithic, with little internal contradiction or dissent.[6] Thus, what I seek to do in this paper is to address these gaps with specific reference to the cultural practice of wearing *hijab*, which has been the source of much cross-cultural conflict, particularly in France. My aim is to highlight the nature of gender in developing a complex understanding of culture, and to propose a shift from a depiction of society as one that contains a variety of cultures (multicultural) to one that embodies cultural variety (polycultural).

Gendered Cultural Practices

When discussing the aims of multiculturalism as trying to rectify social inequality, it is not always clear whose histories, whose voices, and whose experiences are to be heard—a particularly important question to ask given the implicitly gendered aspect of culture itself. Unlike the conservative challengers to multiculturalism who seek to deny cultural rights on the basis of dominant cultural norms, some feminists have been wary of promoting cultural rights on the basis that most cultures embody an imbalance of power that disadvantages women and girls. Hence, in upholding and respecting diverse cultural values, the risk is that Western states will actually encourage gender discrimination as opposed to alleviating it. On the face of it, the argument is a compelling one, since it sees that the multicultural commitment to respecting all values can fall short of protecting the basic rights of some members of cultural communities. This line of argument carries with it two central points: namely, that culture is fundamentally gendered and that, insofar as it is so, cultural rights can be seen to be legitimating discrimination of women and girls. However, the latter does not logically lead from the former. That is, although there are legitimate concerns to be raised with respect to how patriarchal communities treat women and girls, this is not because gender is produced in and through cultural practices. Indeed, I think the two issues need to be treated separately.

The first point, with respect to the way sexual difference is given meaning in and through culture, allows us to see that cultural communities are not unified wholes. Not only are they divided along expressions of gender differences, but even within those expressions there is much variety. Gender itself is not an essence, it is not a noun, but is based on fictions of coherence.[7] As Judith Butler suggests, it is a process of performing those regulatory cultural practices that deem women as women and men as men; in other words, we cannot understand gender outside of those cultural attributes that

give meaning to sexual difference. "There is no gender identity behind the expressions of gender; that identity is performatively constituted by the very 'expressions' that are said to be its results."[8] Yet, she also suggests, that as performance, gender can also resignify these cultural practices so that they come to mean something other than what they were intended to regulate.

With such plurality within cultural practices, it is difficult to see how we can continue to speak of how *a* culture acts homogeneously to oppress women. This is not to suggest that women are not oppressed, but to hold "a" culture responsible misses, I think, the complexity through which women and girls participate in gendered constructions of meaning that cannot always be captured under the term patriarchy. This brings me to my second point.

The claim that culture can be used to legitimate gender discrimination is a serious one. And there are many cases indeed where culture has been used as the "reason" to justify just such attitudes, both in public discourse and in courts of law. Defenders of this argument claim that tradition is reason enough to allow continued violence and maltreat of women. Yet, in critiquing this position through holding *a* culture responsible for inequality also means accepting the very same static definition of culture that the defenders themselves use. It means refusing to see that cultures change over time, and that within cultural communities themselves there are always members who contest such claims to tradition as a justificatory means. It also suggests that "we" have defined what is essential to a particular culture, as if one's membership in a community is solely given shape by its traditional cultural practices.[9]

It seems to me, then, that in order to ensure that the concerns of women and girls are taken seriously, one needs to be ever vigilant about not slipping into the very discourse of culture that is used against them by cultural traditionalists. That is, in providing cultural critique, one ought to be mindful of not repeating the same imaginary logic that fixes culture into a homogenized "reason," for that same reason can be used in favor of oppression as much as it can be used against it. Moreover, in articulating and defining the "problems" with others' cultures, we need to recognize the ways in which "we" implicate ourselves in defining such problems—after all, it is our values that act as warrants for our arguments. I am not claiming that one should not intervene in cultural practices of violence, but merely suggesting that, since most cross-cultural conflict does not fall into the category of violence, we do a disservice to the project of easing social tensions when we see cultures in homogeneous terms. And we do a particular disservice, I think, to the complexity of women's and girl's lives as expressed through non-violent forms of cultural practice when we reduce these to a discourse of cultural oppression.

Wearing Hijab as a Gendered Cultural Practice

Taking as my point of departure both the feminist insistence on the inherently gendered nature of culture and a broad view of culture that includes religious beliefs, rituals, and practices, I examine here some of the aspects of the Muslim practice of wearing a

headscarf or *hijab*. In viewing the wearing of *hijab* as a cultural practice my point is not to diminish the religious significance that this practice carries for some Muslim women, but to stress that the meaning it carries for European societies also places this practice within the sphere of cultural intelligibility. To explore it as a cultural practice, as one that implicitly also marks a gender identity, enables us to consider more deeply the force of social controversy it has generated.

We see enormous energy being focused on whether or not covering one's head is acceptable to Western democratic values. On the surface, the issue seems almost absurd. But we would do well to analyse the nature of the controversy precisely because it appears as a symptomatic expression of the worries around multiculturalism (as an ideology) and about how to live with cultural diversity in society (as a fact). What I wish to stress here is a simple point: there is nothing inherent in the headscarf itself that "causes" such controversy—it is, after all, a piece of cloth. Rather, controversy is created in the dynamic between cultural contexts, ideals of gender, and the values ascribed to the practices of wearing it.

Feminist scholar Leila Ahmed has traced the history of wearing the veil amongst women in the Middle East, attributing it equally to Christians as well as Muslims and to upper-class women in particular.[10] Within Islam, she claims that during Mohammed's life it was a practice peculiar to his wives alone and it is not known how the custom spread after the Muslim conquests. Her study makes a straightforward point: veiling has deep historical ties across many cultural communities.

Criticisms of veiling practices within the Arab and Muslim world also have a long history, their roots lying in late nineteenth and early twentieth century colonialist discourses, which sought to depict the repression of women within these societies as a justification for Western cultural superiority.[11] Indeed, the veil played a central role in this discourse and, consequently, our current discussions have inherited the legacy of valuations and meanings granted to it from within an imperialistic politics. Ahmed writes:

> When items of clothing—be it bloomers or bras—have briefly figured as focuses of contention and symbols of feminist struggle in Western societies, it was at least Western feminist women who were responsible for identifying the item in question as significant and defining it as a site of struggle and not, as has sadly been the case with respect to the veil for Muslim women, colonial and patriarchal men . . . who declared it important to feminist struggle.[12]

The upshot here is that the gendered cultural practice of veiling was very much seen as a sign of inequality, and was subsequently used by colonials to further their own self-interests: the point was to get women to abandon those customs seen to be antithetical to the project of colonisation and the cultural assimilation it entailed.

The question that Ahmed's work raises for me is how *women's* cultural practices were so central to the question of cultural assimilation. From this history, it appears we still have much to learn. Current fixations with the wearing of headscarves in Western Europe and their potential to cause so much cross-cultural conflict within these societies

still mirror the question of cultural assimilation for many. Only now, it is occurring within a discourse of democracy and equality, not empire. Veiling is seen to be an issue in the context of deciding which values and cultural practices are to be deemed acceptable to a democratic nation, which is self-determining and egalitarian. Similarly, even feminists who are critical of veiling on the grounds that it promotes gender inequality might also be seen as coming dangerously close to a colonial and patriarchal habit of labelling a practice as unequal on behalf of, instead of with, those women who wear headscarves. Thus under the banners of democratic right and gender equality, the practice of veiling continues to be a major issue in furthering certain political agendas. What Ahmed's historical account of veiling suggests is that we need to be aware of which self-interests are being sustained in seeing the practice of veiling as a source of cultural conflict in the first place. Since cross-cultural conflicts can only arise as a dynamic, the question is *not* about defining some abstract, universal meaning of the headscarf, but in asking: What does the current labelling of headscarves as symbols of inequality mean in particular contexts? What self-interests and worries are being expressed in the current obsession with wearing them to school?

The Hijab Ban in France

To take the complicated case of the recent French law on Secularity and Conspicuous Religious Symbols in Schools as an example—a law which was put into effect in September 2004—we can see how the values of the Republic and the nation's perception of itself are very much bound to the notion of *laïcité* (which broadly refers to secularity).[13] The law was meant to curb a perceived threat to the secular nature of public institutions within France. The law prohibits the wearing of "conspicuous" religious symbols, including large Christian crosses, Jewish *kippa*, and Muslim *hijab* (it does allow for small crosses, Stars of David and hands of Fatima). Although the law applies across genders to include Sikh and Jewish boys' practices of wearing the turban and *kippa*, respectively, the discussion, both in public and in official reports was specifically aimed at counteracting what many believed to be increasing Muslim militantism, especially after September 11, 2001. In addition, in debates leading up to the law, the wearing of *hijab* was seen to be oppositional to promoting gender equality in society at large.

These debates began in a 1989 crisis known as *l'affaire du foulard* (the headscarf affair), which was sparked by the expulsion of three girls from school for wearing headscarves.[14] In solidarity, other girls wore *hijab* to schools across the country. This launched a heated discussion of the values of French civil society (particularly that of *laïcité*) vis-à-vis those of a multicultural society. The French term *laïcité* refers to a complex and deeply held set of cultural meanings about the necessity of having all public institutions free from any signs of religious expression. It also has at its center the freedom of conscience to choose one's spiritual and religious beliefs and equality in rights with regard to spiritual and religious matters. Largely growing out of notions of the autonomous and rational subject that informed the French Revolution and Enlightenment, *laïcité* is very much

concerned with creating a state that respects personal liberties. It serves as the principal means to assure the common good in civil society.[15]

Although response to *l'affaire du foulard* was, of course, not all of a kind, Parekh also notes that "the dominant view was firmly committed to the practice of *laïcité* and hostile to any kind of compromise with the Muslim girls."[16] That is, Muslim girls were never fully consulted as to the various meanings the *hijab* held for them, a point also echoed by Benhabib.[17] The school was seen as central to upholding *the* national culture and was responsible for assimilating "others" into that culture. As one newspaper editor put it: ". . . behind the scarf is the question of immigration, behind immigration is the debate over integration, and behind integration is the question of *laïcité*."[18]

What the *l'affaire du foulard* debate revealed was that girls who wore headscarves were perceived to challenge French national integrity by challenging *laïcité*. As Jacqueline Rose has noted, states are founded on fantasies of commonality that do not make them "any less real for that."[19] "Something irrational—not in the sense of unreasonable, but as in relying on a power no reason can fully account for—has entered the polity."[20] Indeed at the heart of all states is the inevitable fantasy of authority, which enables them to bind their members to one another in the project of national identity and which enables individuals to accept the primacy of law as one of the conditions of membership. When they feel threatened, states, like individuals, need either to give up the fantasy or to defend it.

Fifteen years after the *l'affaire du foulard*, the new law can be seen as just such a defence. In choosing now to highlight a ban on "conspicuous" religious symbols in schools, the state has asserted its right to defend its constitutional—and democratic—values. But why would such a reassertion be necessary? If already protected by law, why would *laïcité* need to be reclaimed and extended? My suggestion is that it is not simply the wearing of religious attire that is at stake here; nor is it *only* a question of *laïcité*, for Catholic, Jewish, and Sikh practices have been tolerated for many decades without this reassertion. Rather, there is something about the veiling of Muslim girls that appears to crystallize a wider range of concerns.

A Commission chaired by Bernard Stasi was struck in 2003 to inquire into the possibilities of creating new legislation reinforcing the principle of *laïcité*. Its report noted two major worries, especially as expressed by those who spoke at the commission's hearings. The first was the rise of politico-religious influence in society, particularly on the part of Muslim groups. The second was how the practice of veiling was very much seen to rub against the grain of French views on sexual equality. Although it mentioned that women wear headscarves for a number of reasons, the report cited that the increase of their appearance was largely due to a shift in the politico-religious temperament from the 1980s onward. What is striking here is how both these worries—equality with respect to gender and a general unease with Muslim political activity in the wake of September 11—collapsed, to a large degree, into a single image. The wearing of *hijab* was seen to be nothing short of a provocation to France's public well-being and national sensibilities, both politically and civilly speaking. Moreover, what this image reveals is the central place gendered cultural practices have in on-going debates of integration and assimilation. For not unlike the colonial discourse of the past, cultural integration is here buttressed by an appeal to sexual equality.

Underlying these concerns, however, is a tendency to proclaim the uniformity of culture in a way that risks blinding the nation to the plurality of views and traditions within Muslim communities and the complexity of cultural practices that make up girls' lives within them. Gendered expressions of Islam are instead read as representative of a failure of *a* community to integrate into French public life. Thus the social and cultural burden that these girls bear is great: they are to refrain from public expressions of religious observance in the service of cultural integration to the point of forfeiting their right to education should they fail to comply. What lies behind the scarf, behind integration, and behind *laïcité* are the silenced experiences and voices of those most affected by the law.

Polycultural Society and Gender

What I wish to suggest here is that the failure to appreciate the ambiguities, contestations, and diversity *within* cultural communities has led to assumptions about the cultural meanings of *hijab* for the women and girls who wear it. At stake is the nation's right to define for itself the constitutional pillars that support the common good in political, social, and cultural life. Without denying this right, I question the way in which its defensive reassertion has actually been based on an ideal of gender equality and a view of culture that cannot accommodate difference. Seeing veiling as already embedded in patriarchal relations that oppress women means viewing cultural communities as homogeneous with respect to expressions of gender identity. What is needed is a more careful and considered examination of the specific contexts and conditions under which headscarves are worn. As Bonnie Honig notes,

> veiling might be a sign of sexist, enforced female subservience . . . or it can also be one of a broader complex of efforts aimed at both sexes in order to manage a community's sexual and other relations. We need to know something about how veiling functions, what it signifies, in a particular context before we can decide that it means for everyone what it means for us.[21]

In other words, the reasons for wearing hijab are wide-ranging, from fervent religious observance to comfort in dealing with a new social life in the West; from enforced veiling to freely chosen expression of modesty. Moreover, pitting multicultural society against French values also evades the issue of how the collective "we" is implicated in the very process of naming a practice as a source of conflict. What this example shows is that the challenge to education in France does not come from Muslim girls, but from an essentialist view of culture (both French and Muslim) itself. As European nations continue to define the grounds for commonality and community within the terms of multicultural society, it seems that, at the very least, it owes Muslim girls a freedom from the burden from having to bear the unnecessary weight of "our" worries about cultural integration and from having to bear "our" anxieties over extremism.

One way of doing this, I think, lies in reformulating what the terms of culture mean in pluralistic societies. Insofar as the term multicultural is often used to describe cultures as

stable and fixed wholes, it acts as an impediment to exploring the complexity of affiliation within and across demarcations of those communities. That is, as it functions to demarcate and differentiate certain cultures from others, the term multicultural at worst actually feeds into a gender-blind conception of culture, or at best instantiates the reductionist claims of culture in the expression of gender identity. Instead, I think it is wise to heed Zygmunt Bauman's insight into depicting society as polycultural; that is, a society that is *constituted* by diversity as opposed to a society merely *containing* diverse elements.[22] This suggests that society is a complex of cultural practices in which individual belonging is not fixed to a single originary point of meaning, but instead participates simultaneously in various forms of cultural intelligibility. Culture is itself multiple, hybrid, and ambiguous. This view disturbs the insularity by which culture is too often characterised. This means that reference to *a* culture as a reason in defence of oppression, or as a critique of that defence, no longer holds. It further means that the flash points of cross-cultural conflict are expressed in dynamic terms as opposed to the either-or character of debate that continues to dominate so much of our public life in western democracies, particularly vis-à-vis Muslims. It also enables a plurality of meaning in cultural practices and invites inquiry into how others' self-understandings are produced in relation to the complexity of their lives. And finally, it provides space for us to question ourselves, to see how our own cultural meanings actually contribute to and sustain the very cross-cultural conflict we attribute to others. Such a shift in terms cannot, of course, provide practical answers to the plight of Muslim girls. Yet, I hope it can suggest that our obligations to others begin in taking responsibility for the discourses we ourselves produce, and the fantasies we live by.

Notes

Todd, Sharon, "Unveiling Cross-Cultural Conflict: Gendered Cultural Practice in Polycultural Society," ed. Daniel Vokey, *Philosophy of Education 2006*, pp. 283–291. (Urbana, IL: Philosophy of Education Society, 2007). Reprinted with permission.

1. Bhikhu Parekh, *Rethinking Multiculturalism: Cultural Diversity and Political Theory* (Balingstoke: Palgrave, 2000), 264–5.

2. Seyla Benhabib, *The Claims of Culture: Equality and Diversity in the Global Era* (Princeton, NJ: Princeton University Press, 2002), 84.

3. Susan Moller Okin, "Is Multiculturalism Bad for Women?" in *Is Multiculturalism Bad for Women?* eds. Susan Moller Okin et al. (Princeton, NJ: Princeton University Press, 1999), 12.

4. I will be using the terms veiling, headscarves, and *hijab* interchangeably. However, one needs to note that there are a number of names given to different veiling practices. For example, the *burqa* generally refers to a veil that covers the face with holes for the eyes. The *niqab* covers the lower part of the face, up to the eyes. Full *burqa* or *chador* covers the entire body and face with nets for the eyes. *Jilbab* is a long dress and headscarf which allows the hands and face to be exposed. *Hijab* is generally used to describe the wearing of a headscarf, but it can also refer to a modest form of attire as well.

5. IHFHR, *Intolerance and Discrimination Against Muslims in the EU* (International Helsinki Federation for Human Rights, 2005), 22.

6. Zygmunt Bauman, *In Search of Politics* (Stanford, CA: Stanford University Press, 1999), 199.

7. Judith Butler, *Gender Trouble: Feminism and the Subversion of Identity* (New York: Routledge, 1990), 24.

8. Ibid., 25.

9. Yael Tamir, "Siding with the Underdogs," in *Is Multiculturalism Bad for Women?* eds. Okin et al., 51.

10. Leila Ahmed, *Women and Gender in Islam* (New Haven, CT: Yale University Press, 1992), 5, 56.

11. Ibid., 165.

12. Ibid., 166–7.

13. The official name of the law is: *loi encadrant, en application du principe de laïcité, le port de signes ou de tenues manifestant une appartenance religieuse dans les écoles, collèges et lycées publics.* Although the term conspicuous *(ostensiblement)* is not used in the title of the law, it appears in its first article.

14. For a more detailed discussion of *l'affaire du foulard* and the French law see my "Ambiguities of Cosmopolitanism: Difference, Gender and the Right to Education," in *Critical Issues in Education in a Global World,* eds. Klas Roth and Ilan Gur Ze'ev (Springer/Kluwer Publishing, forthcoming).

15. Bernard Stasi, "Commission de Reflexion Sur l'application du Principe de Laïcité Dans la Republique: Rapport au Président" (2003), 9–18. See also Benhabib's discussion in *The Claims of Culture,* 95–100.

16. Parekh, *Rethinking Multiculturalism,* 250.

17. Seyla Benhabib, *The Rights of Others: Aliens, Residents, and Citizens* (Cambridge: Cambridge University Press, 2004).

18. Quoted in Parekh, *Rethinking Multiculturalism,* 251.

19. Jacqueline Rose, *States of Fantasy* (Oxford: Oxford University Press, 1996), 9.

20. Ibid.

21. Bonnie Honig, "My Culture Made Me Do It," *Is Multiculturalism Bad for Women?* eds. Okin et al., 37.

22. Bauman, *In Search of Politics,* 199.

Epilogue

Lynda Stone
University of North Carolina at Chapel Hill, USA

Twenty years ago, with the wonderful assistance of Gail Masuchika Boldt, we organized *The Education Feminism Reader*. Out of print for a while now, it nonetheless has had a long presence as the only collection of feminist papers in and for professional education—it is a classic many say.

This brief epilogue returns to some of the elements of the Introduction to that volume; it serves as a supplement to Thayer-Bacon's Introduction to *Education Feminism: Classic and Contemporary Readings*. I am honored to be associated with the efforts of Thayer-Bacon and Sprecher, especially to keep a history and tradition alive and to remind all of us that feminist work in education remains to be done. I return to this last purpose at the close.

Introduction

'Education feminism' was coined to demarcate a body of work by women scholars concerned with education. While used on occasion, it has not become a household word. It is not a feminism like others: political theories, scholarly traditions, identities politics, or activism movements. Examples of these are liberal feminism, psychoanalytic feminism, lesbian feminism, and eco-feminism that are extant today. Education feminism is rather a domain concept. No one is an education feminist but anyone can contribute to the domain who focuses on issues of education. 'Academic feminism' is a term of recognition; think what might be accomplished if welfare feminism, medical feminism, or military feminism were also bodies of recognized scholarship. Given this introduction, in the rest of the epilogue, I turn first to a comparison of contexts within which *Education Feminism: Classic and Contemporary Readings* is now situated and conclude with special attention to what it means to do feminist theorizing—and activism—today.

Contexts

The original Introduction was organized first within a context of discrimination and then a set of historical and other theoretical structures. In the early nineties, perhaps I confess

because of my own status as a former teacher and a new education professor, discrimination against educators and education seemed prevalent. Education feminism was to combat beliefs about inferiority in the quality and efficacy of institutions, practices and persons and writings about them. It has always been ironic that critics internal to the domain are themselves objects of severe and sometimes condescending external criticism. There remains 'trouble with ed schools.'

One element is evident and exemplified in the contemporary contributions to this present collection. Scholarship is of the highest caliber and stands on its own relative to other feminist writings. There is confidence in just 'doing the work' especially by a generation or two who follow the initial domain mothers. These include Maxine Greene, Jane Roland Martin and Nel Noddings. Another clear element is that contemporary writers are comfortable working with influences from peers as well as predecessors, from female and male authors, majority and minorities.

Three historical structures, forming a particular context, were and are educational, political, and intellectual. First, while the education of western girls and women is a universal right, today some receive the best education and others still do not. One important change is in perspective, in which all educational access and opportunity, if not realization, is globalized. Discrimination especially does remain against minorities and the poor. Second, fueled at least by economic changes and the emphasis of a globalized, neo-liberal, capitalist-controlled world, conservative politics reins. In the United States at least, the center has moved right and there is almost no left left. Politics often is virtually unworkable. Third, while left scholars continue to toil in the fields, they have little or no influence. One important difference is important contributions from minority scholars who write from a position in the academy in which their numbers remain relatively small.

Feminisms

Much has been written about the history of feminist theory; by the nineties it was widely understood that feminism is feminisms. In the original Introduction, a set of concepts was invoked to describe feminsims scholarship. The point in a historicist simultaneity was that all scholarship is both derivative and originative. Such a conception undermines more traditional dualisms that are generative or replicative, of pure and applied research, of academic and professional knowledge. Each and every piece of feminist scholarship can be evaluated and used on its own merit. Thus, contributions to this volume are both for teaching and for further theorizing. It is hoped that joining present generations stand ones ready to do the work, but this last may be as difficult as in the past but for different reasons.

In regard to contemporary feminist work, there do seem three significant changes from past times that influence difficulty. First, in the academy Women's Studies programs are alive. While occasionally they struggle for survival, what is even more significant in a general era of conservatism is a possible ghettoization of gender and feminist interests. The question is how much representation of feminist writings finds a way into courses

or researches in which gender as part of the social order is not 'the' primary factor. Second, in the United States at least issues of race and class and sexuality appear to 'trump' gender. One wonders how this is even logically possible; even concepts of positionality or intersectionality do not capture a complex societal context either for the researched or the researchers. One current fact is that in education schools, which are largely peopled by women, there is little attention to gender. Girls are getting educated and it may be time to consider a boy problem!

Third, there is little or no mention of feminist movement today that still seemed possible twenty years ago. Diversity through particularist feminisms is rightly valued. However, particularism in feminisms has also resulted in individual authors who need not and often do not identify with a feminist ideology or group. And, today this seems appropriate. The question then remains about feminist activism. The present answer is a localist orientation. This means that theorists take up and refer to specific exemplars in their writings. This means that groups of concerned citizens, feminists and non-feminists, women and men, join together to promote social justice projects that may focus on women and girls or are extensive and inclusive. Everyone can benefit. As Thayer-Bacon posited above, "there is plenty of work that we can do."[1]

June 2012, Chapel Hill, North Carolina, USA

Note

1. References for the epilogue follow; readers can use these as starting places for their own further inquiry: L. Stone. (1994). (Ed). *The education feminism reader*. New York: Routledge; D. Labaree. (2004). *The trouble with ed schools*. New Haven, CT: Yale University Press; W. Kohli and N. Burbules. (2012). *Feminisms and educational research*. Lanham, MD: Rowman & Littlefield; E. St. Pierre and W. Pillow. (2000). (Eds.). *Working the ruins: Feminist poststructural theory and methods in education*. New York: Routledge; b. hooks. (1994). *Teaching to transgress: education as a practice of freedom*. New York: Routledge. In addition to thanking Barbara Thayer-Bacon and Katherine Sprecher for their work, I also acknowledge conversations with Keren Dalyot.

Index